ART

CONTEXT
AND
CRITICISM

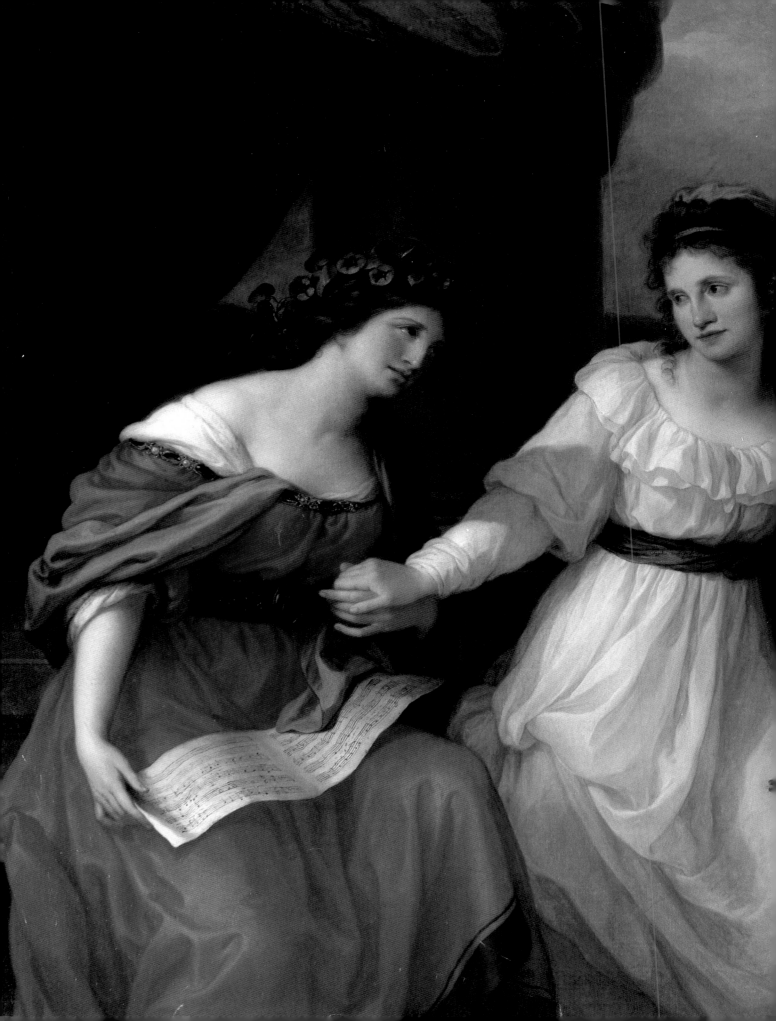

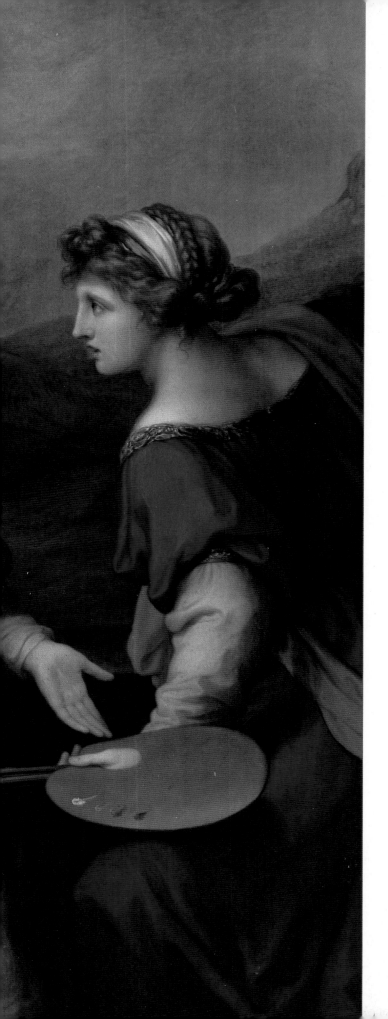

ART
CONTEXT
AND
CRITICISM

John Kissick
Penn State University

WCB Brown &
Benchmark

Book Team

Editor *Kathleen M. Nietzke*
Developmental Editor *Deborah Daniel Reinbold*

 **Brown &
Benchmark**
A Division of Wm. C. Brown Communications, Inc.

Vice President and General Manager *Thomas E. Doran*
Executive Managing Editor *Ed Bartell*
Executive Editor *Edgar J. Laube*
Director of Marketing *Kathy Law Laube*
National Sales Manager *Eric Ziegler*
Marketing Manager *Steven Yetter*
Advertising Manager *Jodi Rymer*
Managing Editor, Production *Colleen A. Yonda*
Manager of Visuals and Design *Faye M. Schilling*

Wm. C. Brown Communications, Inc.

Chairman Emeritus *Wm. C. Brown*
Chairman and Chief Executive Officer *Mark C. Falb*
President and Chief Operating Officer *G. Franklin Lewis*
Corporate Vice President, Operations *Beverly Kolz*
Corporate Vice President, President of WCB Manufacturing *Roger Meyer*

Library of Congress Catalog. Card Number: 92-71213

ISBN 0–697–11650–6

Designer *Karen Osborne*
Picture Researcher *Carrie Haines*
Maps by *Eugene Fleury*

Typeset by Wyvern Typesetting Ltd., Bristol
Printed in Hong Kong by South Sea International.

10 9 8 7 6 5 4 3 2 1

Front cover: Joan Mitchell
Low Water 1969
Oil on canvas, 112 × 79 in (284.5 × 200.7 cm)
Carnegie Museum, Pittsburgh, Patrons Art Fund

Back cover: Two Children Are Threatened by a Nightingale. (1924)
Max Ernst. ADAGP/SPADEM, Paris and DACS, London 1992

Frontispiece: (detail) Angelica Kauffman
Self Portrait Hesitating between the Arts of Music and Painting 1794
Oil on canvas, 58 × 86 in (147.3 × 218.4 cm)
Nostell Priory, Yorkshire

CONTENTS

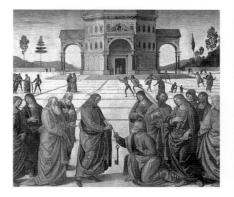

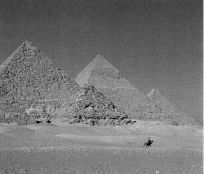

2

THE ART OF THE
CLASSICAL WORLD

Page 58

3

ART AND RELIGION
The visual worlds of Judaism,
Christianity, Islam, Hinduism,
and Buddhism

Page 98

4

ISSUES AND IDEAS
IN RENAISSANCE ART

Page 148

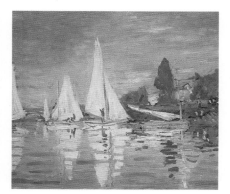

8

ART IN THE AMERICAS

Page 340

9

ART IN THE TWENTIETH CENTURY

Page 368

EPILOGUE
Contemporary Art, Issues, and Ideas

Page 416

MAPS

TIMELINES

▶ ACKNOWLEDGMENTS

An art text of this breadth requires the support and insights of many individuals. It has been my good fortune over the past two years to work with the editors at Brown & Benchmark, whose kindness, sincerity of vision, and inexhaustible patience often strengthened my resolve and provided the support necessary for such a project to come to fruition. As research assistant and capable author of the accompanying teachers' guide, Kathleen Dlugos has given to this book her keen sense of intelligence, purpose, and critical clarity. My thanks as well go out to Melanie White who anchored the production of this book with enthusiasm and thoughtfulness, and to the various reviewers who have helped shape its contents.

If learning is indeed a product of social interactions, then I have been particularly blessed with good friends and insightful colleagues. There are many individuals who participated, either directly or through inspiration, in the development of this text and to acknowledge everyone is perhaps impractical. However, I would be remiss if I weren't to thank a few special people who have been beacons of sanity, intelligence, and support throughout this ordeal. Penn State colleagues David Brown, Charles Garoian, James Hopfensperger, Thomas McGovern, Sallie McCorkle, Brent Oglesbee, and Chris Staley continue to be an inspiration to me in both their lives and their art. Department colleagues Micaela Amato and Jerry Maddox have likewise shared with me their insights into art, many of which have found their way into the text. I have also had the good fortune to be able to rely on a supporting cast of caring and understanding friends and family: Joseph Ansell, Chris and Madonna Buffett, Steve Holysh, Jamie, Cathie and Matthew Kissick, Peter Kissick and David Silva have all had a special role in the writing of this book, and to them I am particularly grateful.

If a text is the product of its author, then this author is likewise a product of his influences—none more so than my parents. They have instilled in me a respect for the educational process, and given me the strength to challenge it when necessary. If human culture is a searching for human dignity and integrity, then it is through the thoughts and loving deeds of my parents that I have come to understand such terms. This book is dedicated to them.

▶ PREFACE

In considering the proposition to write *Art: Context and Criticism* more than two years ago, I was inevitably forced to confront a number of questions of content and direction at the outset. But perhaps no single issue so completely preoccupied me as that most fundamental question of all: why thrust upon the world yet another "introduction to art" text when a veritable glut of such books already exists? The answer I developed, on both a professional and a personal level, is, I believe, the foundation of this book, and this is the time and place to give a brief outline of its *raison d'être*.

Most activities grow out of a need, and the execution of this book is no exception. To put it bluntly, I decided to write *Art: Context and Criticism* because I was extremely frustrated by the quality of the basic art and art appreciation offerings that exist for today's demanding university environment. For the most part, I have found that these works fall into two rather specific camps: the dogmatic connoisseurship of the traditional introduction to Western art books, and the supposed "new age" texts, which embrace the issue of plurality at face level and so supply the student with virtually no notion of how art functions in a social and historical context. Each of these book styles has its own particular strengths, but each also posits a world view sometimes at odds with the principles of art as an integral part of our consciousness. Take, for instance, the traditional art history introductory text. Since the development of art history as a scholarly pursuit, there has been an implicit notion that the canon of great works was founded in and upon the Western tradition. As a result, the cult of masterpieces we were all weaned on reflects a general cultural myopia, placing the idea of art next to supposedly compatible terms such as form, esthetics, and beauty, and excluding those that do not fit neatly into such a framework (women, peoples of color, etc.). The result has been a decidedly narrow view of the power and dignity of art as predominantly a Western rather than simply a human need. However, what this system did grant was an effective picture of continuity and evolution through history—ideas which are particularly enticing from the point of view of an educational system structured in the same way.

Recently, there has been an attempt to correct the errors and omissions of the past with texts that espouse a plurality of views, with an emphasis on inclusivity. The idea is to allow objects and images from various cultures to share the stage of cultural significance with the "old standards" without the sometimes troubling deliberations of quality and value. Though this promotes a greater degree of visual awareness of the contributions of traditionally disenfranchised groups, it does little to suggest how they have been historically understood or oppressed by other ideas, and where their own particular biases originate. The result is thus a relentless bombardment of images without any underlying structure, and relegates the social significance of art as an idea to the very corners of the discussion.

Art: Context and Criticism is an attempt to walk that precarious line between continuity and inclusivity. Of course, these notions are often seen as diametrically opposed in spirit, and thus it is in the dialogue between these critical positions that I see the text functioning. At the outset, it will become clear that my method of handling this treacherous path is to place considerable weight on the idea of art as a socially generated idea, carrying with it the values of its historical situation, and telling us, as a contemporary audience, about our own values and biases. To do this effectively, I have made the conscious decision to pare down (though not eliminate) many of the discussions of formal techniques in favor of what those techniques and formal biases actually mean. This way, many of the students' original predispositions toward art can be viewed and indeed dissected as documents of their historical situation.

The general structure of this book follows a roughly chronological path, exploring the development of ideas on and about art, and attempting to expose their social, political, and theological underpinnings. There are, however, times when a chronological approach is technically impossible, and in these instances I have attempted to develop more sweeping themes in the hope that drawing parallels to other periods will be of some assistance to the reader. To facilitate such discussions, I have attempted to bring in the thoughts and words of art critics, philosophers, and historians as well as of the artists themselves. I believe that the result is a broader, more diverse offering, introducing the art student to other authoritative voices.

One particularly tricky area in writing any "introduction to art" book is how to present new trends and insights effectively. I am thinking in particular here of women's art and the art of Afro-Americans—two groups who have suffered at the hands of older books. Simply (or better, simplistically) to place the work of artists from these groups beside old favorites from the Western canon is not always appropriate or even beneficial to the just causes of inclusivity and cultural fairness (a practise very popular among the "new" style of texts). Take, for instance, the problem of women's art, where many, indeed most, of the artists in question were either forbidden entry to the various art academies or censored from fundamental classes such as figure drawing. To compare an intimate painting by Rosalba Carriera with a Rubens (after all, they are roughly contemporary) is not only unfair but implicitly suggests and reinforces a hierarchy of quality based on standards of chauvinism. The same is true with the presentation of other disenfranchised groups, and obviously there are no easy answers. To include is thus to misrepresent; to treat separately is to ghettoize. With this in mind, I have tried conceptually to have my cake and eat it too, showing images of women artists alongside their male counterparts in the book proper, while devoting part of the Epilogue to the problems and interests of feminist criticism. Likewise, the Epilogue considers Afro-American art and art criticism, which I hope will contribute to greater class discussions. I am sure that there will be those who find fault with this layout, but I can think of no other way in which to present the information fairly and with dignity, considering the inevitable length restrictions of the book.

I believe that this is a workable format for the teaching of introductory art and one that reinforces today's most accepted critical and theoretical positions. However, I am not so naïve as to think that the book does not also reflect its social and historical position. I make no apologies for this, for one can write only in and about one's age and values, and I am certainly no exception to this rule.

I do hope that the information presented will move students to reconsider how art can be a vital component of their lives, and how inanimate objects and images can make a fundamental difference to the way we view ourselves and our world.

John D. Kissick
University Park, April 1991

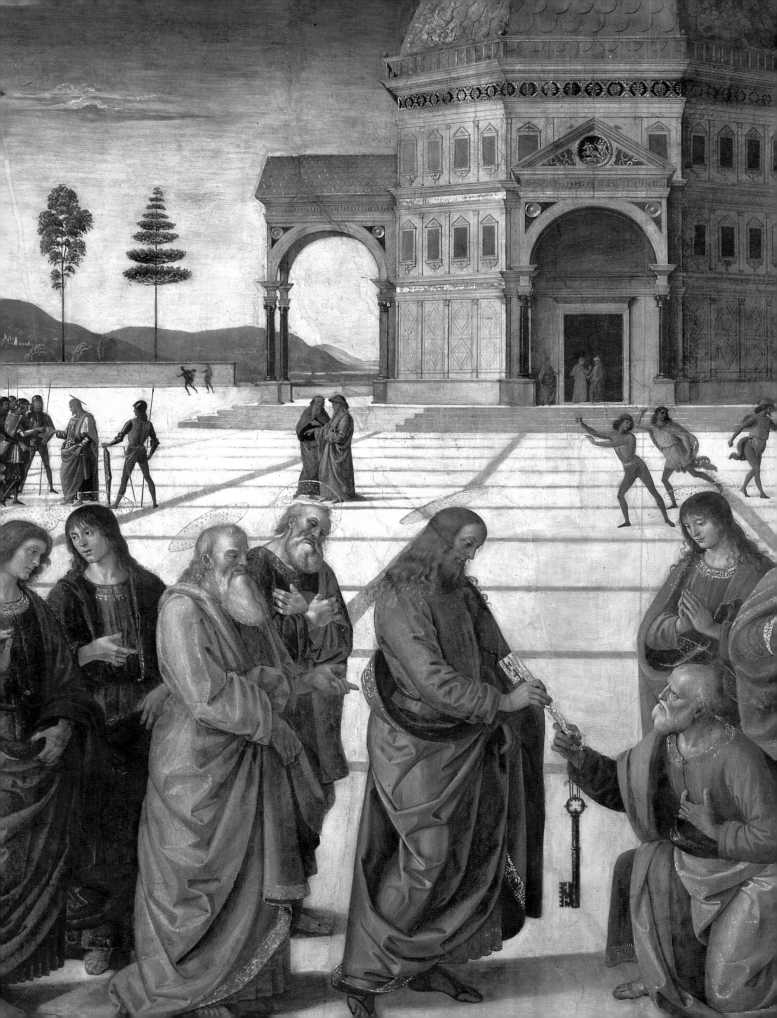

INTRODUCTION

■ I.1 Pietro Perugino
The Delivery of the Keys (detail) 1482
Fresco
Sistine Chapel, The Vatican, Rome

We know that the tail must wag the dog,
for the horse is drawn by the cart;
But the Devil whoops, as he whooped of old:
''it's clever, but is it art?''
RUDYARD KIPLING, *The Conundrum of the Workshops*

This is a book about art. Now, given the plethora of introductory art texts that grace the shelves of our book stores, and further taking into consideration the health of our forests, you might rightly ask, "Why another introduction to art book?" My justification for writing this text is straightforward: to facilitate a more contemporary, multi-faceted, and diverse approach to the understanding of art in our present age. Granted, looking at art is a tricky business these days. Once time-honored methods and supposed truths are falling by the wayside in the wake of recent debates. To replace them, we are now constructing a more tolerant, inclusive view of the role and importance of art in culture, a view which takes into consideration differences as well as similarities, and sees art not as a series of masterpieces whose value is etched in stone but as a collection of visual documents that enables us to grasp the fundamental notion of humanity. To do this, it is essential to reconsider how and why we have come to perceive art—and indeed culture in general—the way we do, and further, what implicit value judgments we embrace when we accept such standards. This is no easy task, and to be effective in pursuing it, we will have to reconsider the nature of certain "truths" in light of their original historical context. In this light, I hope that the ideas presented here will contribute to your greater understanding of the complexities of culture.

▶ THE POWER OF IMAGES

● A story is often told of a man who allowed his perception of people to be openly swayed by outward appearances. Like many of his friends, he equated an individual's physical appearance with certain character attributes: external features were thus considered an excellent indication of one's merits. For example, he readily accepted such arbitrary traits as a projecting voice, stiff formal posture, and cold penetrating eyes as admirable qualities for a leader, and time after time he would search out political candidates who corresponded most closely to this ideal. As a result, he supported a leader of considerable formal stature, believing him to be uniquely qualified, and naïvely relegated the politician's actual ideas to the furthest corner of his mind. The outcome was, of course, disastrous, and as a story this is meant to teach us just how deceptive prejudicial determinations can be. The story often ends with the leader becoming a tyrant who then goes on to banish the poor old man from the kingdom for his naïve views.

Twentieth-century history has sadly proven that we have yet to learn the lesson of this simple story, and the study of human affairs provides one glaring example after another of how the images one sees, the sounds one hears, and the interchanges one engages in are rarely as simple as they at first appear (need one look any further than the horrid dichotomy between Nazi politics and pageantry, Fig. **I.2**, in pre-Second World War Germany?).

Though most individuals will acknowledge that external appearance can give an indication of the character of an object, an image, or even a person, few would consider it the most reliable or accurate way of gauging meaning. On a more personal level, human beings desperately desire to be understood as more than a façade—our ideas, feelings, and aspirations are at least equally representative of our sense of "self." It has often been said that an individual's thoughts and social activities very much determine their outward appearance. If you need proof of this, consider something as simple as one's choice of wardrobe—a decision that is taken daily. Human beings are social animals,

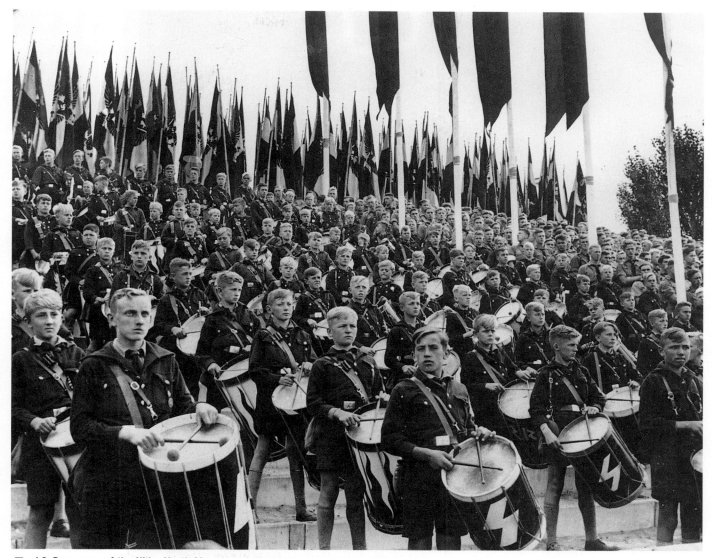

■ I.2 Drummers of the Hitler Youth Movement at Nuremberg, September 1933

and as such we are self-conscious about how we appear to others. Clothing is one of the many ways in which people attempt to project a specific kind of character to the world at large; it is an activity that is both conscious and manipulative.

Fashion and the fashion industry are illuminating examples of how complex social pressures can become intertwined with an activity as simple and seemingly innocuous as getting dressed. A brief look through fashion magazines such as *Vogue* or *Gentleman's Quarterly* provides the reader with a pot-pourri of clothing advertisements that sell not only sophisticated apparel but indeed a lifestyle to match. And if the

clothes one wears are an extension of one's personality, then the choices themselves become a projection of those characteristics the individual finds attractive. Many of the most popular fashion houses (such as Ralph Lauren, see Fig. **I.3** and Calvin Klein, see Fig. **I.4**) successfully promote wardrobes with an attitude —hence the term fashion "statement." Yet even this desire to project a certain image to the public is not as straightforward as it may first appear, for often other less obvious circumstances influence decision making. Consider again the example of fashion: certain kinds of clothing and certain makers' products are inevitably more expensive than others, which makes these items

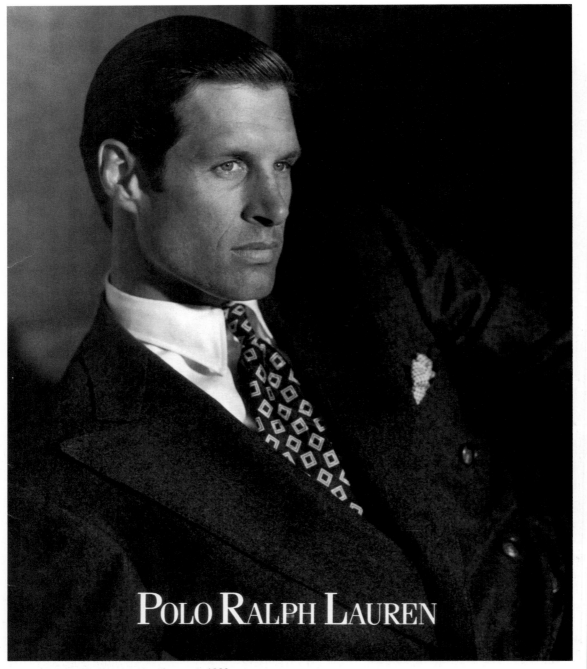

POLO RALPH LAUREN

■ I.3 Polo Ralph Lauren advertisement, 1990

more accessible to those with greater disposable income. In this scenario, the chosen fashion can become a projection not only of character traits but also of economic status as well.

In these examples it is possible to observe some intrinsic links between the idea of appearance and the sometimes complex and often unnoticed foundations on which it rests. To recognize these relationships is to understand better the workings of the world, and to do so effectively requires critical inquiry.

As was mentioned at the outset, this is a book on art, and though the history of fashion apparel is in itself a

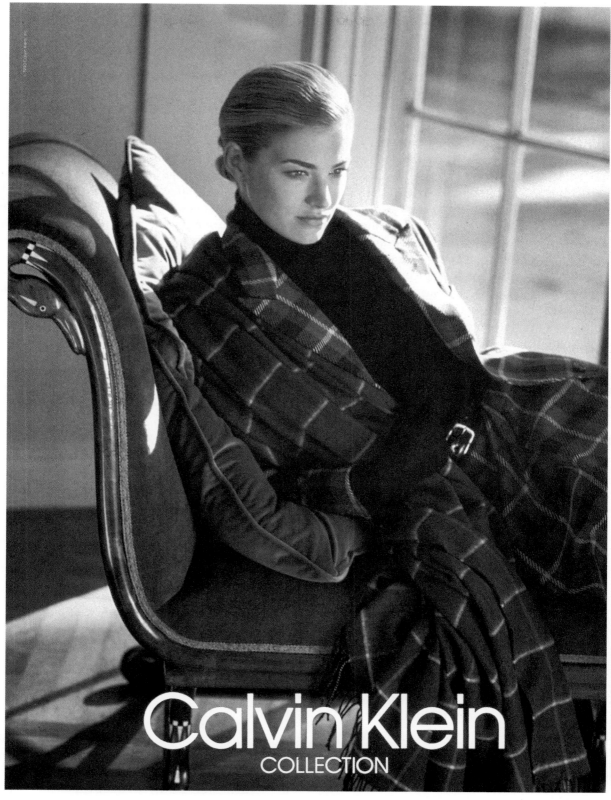

■ I.4 Calvin Klein "Eternity" advertisement, 1990

fascinating story of visual ideas, the purpose of this text is to introduce the subtleties of thinking that surround the "fine arts"—a term that will be discussed at length throughout the book. However, the analogy to fashion is a useful one, for if one agrees that "what one sees is not always what one gets," then the same underlying issues surface once again in any discussion of art—namely, the problem of determining what it means for something to be attractive or popular, and how that in turn is based on other issues of historical and social interest. What exactly does it mean for something to be attractive? What makes something appear beautiful or important over a number of generations? And further, where do the traditional standards of excellence in art originate? These are difficult questions, and ones not easily answered by a trip to the neighborhood museum, but since they reflect the very essence of art in culture, it is imperative that a critically aware viewer considers them fully.

From where do we get our notions of art? As readers of an art appreciation text, it is quite possible that many of you may hold very specific ideas on the nature of art—perhaps a well-crafted landscape painting or figure sculpture. The assumption is that art is something that takes talent, patience, and hard work, and thus should be appreciated for the considerable skills of its maker. Another assumption held dear by many a viewer is that art is supposed to look "like something." Since abstract art appears to have little or no reference to everyday life, it is often overlooked in conversation. Even the very teaching of art is grounded in exercises from observation, under the assumption that technical skills will make the student a "better" artist. (Take, for example, Fig. I.5, a leaf from a "learn to draw" book, which typifies such an approach.) But who is to say that rendering objects from observation has anything to do with art? An even better question might be to ask why it is that creating an illusion of three dimensions on a flat surface has been so intriguing to so many people for so many years. Obviously, such ideas had to come from somewhere, and it must have been based on a commonly held belief as to the nature of art—what it was, and how it was useful to a society. Once again the analogy to fashion resonates, for if art is produced, taught, and even sold under particular assumptions about quality and attractiveness, then it follows that art must be at least as susceptible to external pressures as any other expression or "statement." A study of art thus provides a looking-glass into the history of what it meant, and indeed means, to be human.

■ I.5 "Portrait drawing with ease" reproduced from *Drawing on the Right Side of the Brain* by Betty Edwards

Visualize an equal-sided right-angle triangle to locate the back of the ear.

Back of ear

Back of eye

Eye-level to chin equals back of eye to back of ear.

▶ VIEWING ART AS LANGUAGE

● Visual images are one of the most basic forms of communication available to the human community. It is through the eyes that the world is known in its most immediate and accessible state, and it is from this firsthand experience of nature that ideas were originally formed. Yet communication is a surprisingly complex, multi-faceted event; the successful transmission of even the simplest of ideas from one person to another requires that the exchange pass through a series of subtle operations (the study of which is generally referred to as semiotics). There are in fact six variables to consider during any process of communication. Take, for instance, a friendly conversation with an acquaintance. To begin the process of communication, one participant addresses the other—the addressor (1) says hello to the addressee (2). Between these two participants a message passes, "hello" (3), a shared code which makes the message intelligible (4)—let us assume both participants understand English—the medium of communication (5)—the actual spoken words—and finally the context of the conversation (6)—perhaps an introductory greeting. If any one of these six distinct aspects of communication breaks down, the interchange of ideas will in all likelihood cease. For instance, if one of the two participants does not understand English (the code), communication will be difficult. Likewise, if one of the participants enters into the conversation at mid-point and is not privy to the context of the ideas, they will "misunderstand" the message, and again communication is thwarted. The exchange of ideas is thus never as simple and complete an experience as one might at first assume.

Since visual images are created by individuals, exist in the world, and are viewed by others, they inevitably become the focus of possible communication, and as such enter into a series of operations identical to that of oral or written traditions. Traffic lights are but one of literally thousands of examples of visual communication the average person confronts on a daily basis. If all members of society did not possess the same shared code (the code being red equals stop, yellow warning, green go), chaos would ensue. It is not that red "is" stop, since red is a color, but rather that we as a society have been brought up to identify such a color, when situated

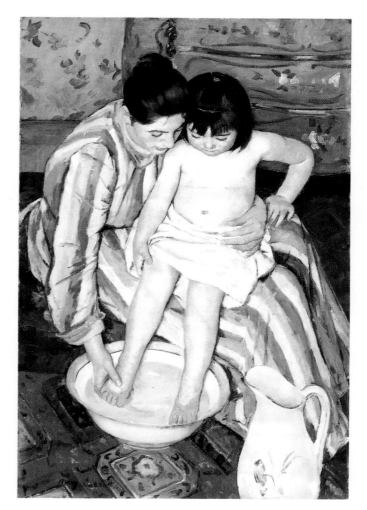

■ I.6 Mary Cassatt
The Bath 1891
Oil on canvas
39½×26 in (100.2×66 cm)
The Art Institute of Chicago
Robert A. Waller Fund

in that given medium (a traffic light) and in such a context (an intersection), as "meaning" stop. If one of those variables is taken away, red no longer means stop; indeed, depending on the culture and context, it might very well be comprehended as "go." This same set of operations goes on every time an individual looks at a piece of art. For example, in schematic form, an examination of Mary Cassatt's *The Bath* (Fig. **I.6**) of 1891 would be constructed in the following way:

Addressor: the artist (Mary Cassatt)

Addressee: the viewer (person X)

Message: the tenderness of the relationship between mother and daughter, the innocence of the child, the nurturing character of woman, etc.

Code: traditional Western pictorial devices such as shallow illusionistic space, modeling to produce volume, an influence of Japanese prints which surfaced in the late 1800s

Context: 1892 painting produced by a woman artist, now situated in a late twentieth-century museum environment

Medium of Communication: a 39½ x 26 in (100.2 x 66 cm) oil painting

Note how many possible variables there are within the context of communication: the message is dependent on characteristics of both the addressor's and the addressee's own histories, and even the context spans two very different eras. In fact, the only stable aspect of this whole operation is the physical painting itself.

Consider this schema within the context of another art form: literature. Anyone who has struggled through Chaucer's *The Canterbury Tales* will tell you that written English has changed a great deal over the past 600 years. Take, for instance, the opening lines from the "Prolog:"

Whan that Aprille with his shoures soot
The droghte of Marche hath perced to the roote,
And bathed every veyne in swich licour,
Of which vertu engendred is the flour;

Some parts of the manuscript are virtually impenetrable to today's reader, since both the code (late Middle English) and the context (fifteenth-century England) are removed from twentieth-century experience. To understand the code and context is to avail oneself of one of the true treasures of literature; to plunge freely into the writing without an "appreciation" of how communication works is to lose a considerable amount of what the author has to offer. The same is certainly true of the visual arts, where code and context also combine to promote clearer communica-

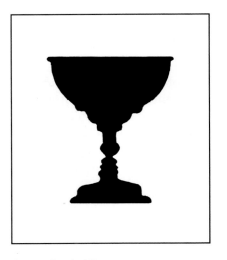

■ I.7 Grecian Urn

tion and meaning—and after all, isn't that why one takes the time and energy to look at art?

One might think from this discussion that "pure" communication can exist once all of the various operations are working in sync. Unfortunately, this is never completely possible, since each of the variables has a frustrating propensity to change or shift. The most obvious example of this occurs in the lives and experiences of the participants. Since no two individuals possess identical experiences, educational backgrounds, social surroundings, family structures, etc., their view of the world is never exactly the same. If you need proof of this, consider how often supposedly "eyewitness" accounts of crimes differ from one another, even though the witnesses are absolutely sure of what they saw. Another famous example is the so-called Grecian Urn (Fig. **I.7**), where two faces converge to create a vessel shape in the space between them. Depending on the viewer or the context, this image has chameleon-like characteristics, changing its identity from vessel to faces. In this way, the viewer becomes an integral part of the overall creative process, since it is their set of assumptions that ultimately gives meaning to any object or image. In other words, the viewer or audience is a vital player in the process of constructing meaning, and thus in the making of art.

▶ ART AND ITS CODES

● As we have seen, it is the availability of a shared code that allows images, words, and other forms of expression to become intelligible. A significant amount of one's early life is spent learning codes, be it the English language or street signs. A child learns to express itself through these codes; without them, it is nearly impossible to function in society. Like other forms of communication, art too has a series of codes that makes its images, objects, and buildings intelligible to others.

Consider Jan Vermeer's *Woman Holding a Balance* (Fig. **I.8**) of *c.* 1664, which utilizes a number of established pictorial devices (which are called conventions). Can you identify any aspects of the coding in this work? Today, we are so accustomed to looking at the world through the mediating eyes of history that it is often difficult to ascertain the nature of reality from the series of established codes we have developed to describe it. *Woman Holding a Balance* is a good example. The con-

■ I.8 Jan Vermeer
Woman Holding a Balance
c. 1664
Oil on canvas
16¾×15 in (42.5×38 cm)
National Gallery of Art,
Washington, D.C.
Widener Collection

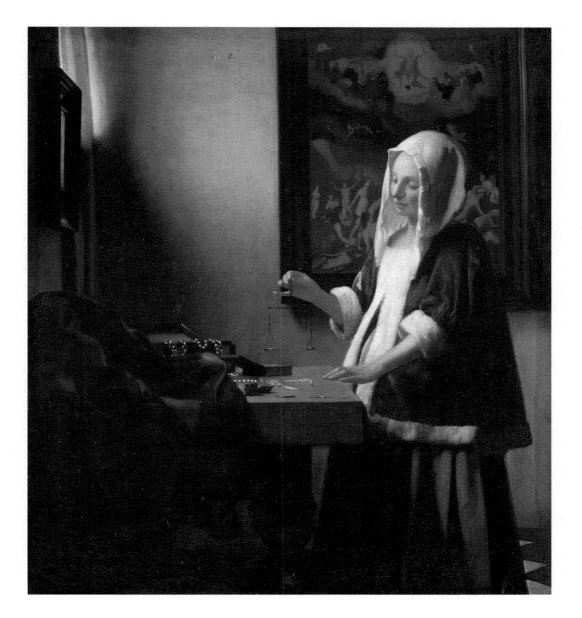

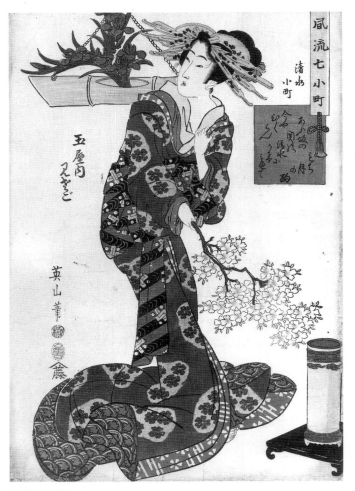

■ I.9 Eizan
The Courtesan Misado of the Tama-ya (House of Jewels) c. 1810
Oban color print
Private collection

siderable charm and convincing design of the painting leave the viewers vulnerable to one obvious manipulation—they perceive, even if only for a fleeting moment, that there is depth "in" that flat surface. If asked to examine this item as a physical object, you would be likely to respond that it is a series of colored oil-paint marks on a flat surface of stretched canvas. Yet asked what you "see," your response would probably be very different: a woman standing at a table in an interior space with daylight flooding in from the side. The transition from paint on canvas to woman in room requires a set of presumed notions about what certain combinations of paint and color "mean." It requires, in short, a code.

In this particular case, the code seems easy to access, since we have been brought up to "see" such images as visual equivalents of our own experience of the world. But is this really the case? Eizan's *The Courtesan Misado of the Tama-ya (House of the Jewels)* of *c.* 1810 also describes a female figure in an interior scene, yet the deep space and natural light of the Vermeer are nowhere to be found. Both images convey much the same information, yet each operates within very different assumptions about how a flat surface can best describe a scene. In Vermeer's Netherlands of the seventeenth century, it would be difficult to convince an audience that there was much merit to the Eizan print, since it did not attempt to model the figure in the round, and possessed no perspectival space—both of which are essential to producing a convincing illusion of space. In Eizan's Japan of the eighteenth and early nineteenth century, Vermeer's painting would have been viewed as an insensitive dismissal of the characteristics of flat design, which emphasized line, color, and pattern. Though space is certainly implied in the print (through devices such as overlapping), it is always within overall design considerations. Who was/is right? The answer is both, but to understand how and why it is necessary to expand our earlier definition of a code to accommodate these wide variations.

▶ THE CHANGING FACE OF QUALITY

● Let us now reconsider a question posed earlier in the Introduction: what makes something valuable or attractive to a society, or even generations of people? Is it possible for certain items to possess an intrinsic beauty or merit that can traverse cultural differences and the boundaries of time? The Vermeer–Eizan comparison is insightful here, for it is clear that during the time of their making, neither culture would have assigned much merit to each other's art—the code from which visual communication begins and value is assigned simply was not accessible. From this example, it is apparent that even the most basic standards for assessing quality in art are very much dependent on time and place. In other words, what is art today was not necessarily art yesterday, and may not be art tomorrow, since the notion of art is always contingent upon a series of culturally derived ideas—ideas which present themselves not only in the subject matter or even materials of art, but in the very visual code itself. Yet where do these codes originate? Quite simply, they develop and evolve from within the culture. The term "manifestation" is often used to describe the important relationship between the way one visually describes the world and the greater discourse of ideas and social influences which makes this description possible. And these visual strategies which help produce an accessible visual code are called "conventions."

Conventions are the specific tools used to form a visual or other cultural code. Conventions are also inherently social in nature; they come into existence through common agreement and are maintained through custom. What does a convention look like? A familiar example might be the gold halo (see Fig. **I.10**), which was an accepted feature of Christian art for many centuries. The halo "motif" (motif meaning a recurring image or theme) was used as a visual equivalent for the aura or inner glow holy personages were supposed to possess. As viewers, we are accustomed to "seeing" these gold discs as halos, and as a result we are cued in to the painting's possible subject matter. The blue dress of the Virgin is used in a similar manner; the color blue was symbolic of heaven, and its use throughout much of Christian art was to be a reminder of Mary's divine nature. Both these visual considerations are conventions—visual manifestations of then contemporary

■ I.10 Masaccio
The Virgin and Child 1426
Wood
53¼×28¾ in (135.3×73 cm)
National Gallery, London

notions about the nature of God and the Christian religion. It is irrelevant whether or not Christ and the saints actually walked this earth with gold-leaf plates attached to their heads, or that Mary's wardrobe included only variations of blue—these are conventions that are to be understood as part of a larger visual code which, when accessible to the viewer, makes the process of communication more complete or enriched.

Sometimes conventions are more subtle and complex than designating an idea to a color. Throughout history, there have been conventions so persuasive and pervasive that it has been difficult to view the world through art without them. This is true of an idea called linear perspective. First perfected by the Romans, and then rediscovered in the Renaissance, linear perspective is a geometric system for representing depth on a two-dimensional plane. One-point perspective, where all lines converge upon a single "vanishing point," was by far the most popular method of describing space in the early Renaissance. Note how in Perugino's painting *The Delivery of the Keys* (Fig. **I.11**) the scene unfolds in a very predictable, though perceptually impossible, manner from the central door, positioned above Christ as he gives the keys of Rome to the first pope, St. Peter. The balance and predictability of this design are due in part to the artist's strict adherence to the "rules" of perspective, which, when applied in such a manner, help suggest deep space. But this device does much

more than simply create the illusion of space; it further implies the unfolding of the entire world around the all-knowing view of the spectator. This is certainly not the world as we know it, but rather a carefully contrived, artificial, and rationally ordered world, where all things are granted a specific place in the larger design of nature and the entire universe seems little more than an extension of the viewer's gaze. That this notion parallels the Renaissance view of man as the center of all things and the world as an unfolding of human consciousness should come as little surprise, since all conventions, art or otherwise, are attempts to embody a community's world view in concrete form (a discussion of linear perspective will take place in greater detail in Chapter Four). In the twentieth century, the idea of a world conforming to a logical pattern has taken a severe beating, and one-point perspective now seems more interesting as cultural history than a fruitful way of looking at the world—it has been replaced by conventions more appropriate for our current outlook. But during its time, perspective was an important feature of a much larger visual code, and by studying its relationship to other ideas, it is possible to understand how issues of quality in art have evolved, and further, what they meant during various historical periods and across disparate cultures. It is for this very reason that we will spend a considerable amount of time discussing the nature of conventions in various societies.

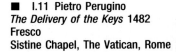

■ I.11 Pietro Perugino
The Delivery of the Keys 1482
Fresco
Sistine Chapel, The Vatican, Rome

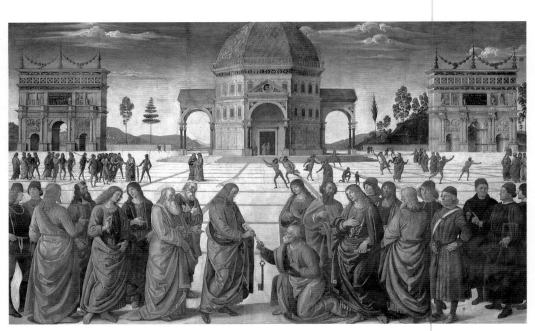

▶ THE GOOD, THE BAD, AND THE UGLY

● If quality is contingent upon a series of socially generated assumptions about the nature of good and bad or better and worse, then any discussion of quality as it pertains to art is always fixed to a given age and cultural context. Since quality is first and foremost an idea, its criteria are susceptible to influences from within a given society; everything from politics to the weather can have an effect on what is perceived as good and what as bad in a piece of art, and throughout history this has proven to be the case. Take, for instance, the example of the French Academy in the seventeenth century, when the ruling king, Louis XIV, and his sidekick Colbert designed a whole national art program to parallel the aspirations of the aristocracy. By carefully controlling commissions, and denying work to those individuals who operated outside the established code, they successfully determined the course of quality in French art for many years. What were those attributes of quality? A strong emphasis on drawing, solid forms, restrained color, balance of parts, clear design, and elevated subjects—which deliberately corresponded to the political notions of order, rationality, resolve, and firm structural management (see Fig. **I.12**). Since these were seen as fitting attributes for the nation, their manifestation in art soon became equated with ideas of quality. What didn't the French Academy like? Work that elevated the status of the average citizen, such as the essentially middle-class representations of contemporary Dutch painting (such as Vermeer's *Woman Holding a Balance*, Fig. **I.8**); the democratic nature of such art seemed an affront to the God-given authority of the crown. Eventually, this attitude toward good art was replaced by a different conception of quality, based on an alternative set of values generated by changing social, political, and intellectual conditions.

If all this seems a bit fickle on art's part, bending with every breeze, then consider the nature of virtually any collective human activity. Even such supposedly eternal codes such as Christianity have changed enormously over the past centuries, due exclusively to social pressures (even the Bible itself is the result of debate and compromise). In fact, the very nature of art is dynamic, in flux and never fixed, and that is why it has survived as an idea, indeed an essential part of the human community, since the dawn of consciousness. In other words, though art may indeed encompass an abundance of subjects, it is fundamentally about being human, and "being" has meant something different in every community.

■ I.12 Charles Le Brun
Louis XIV Adoring the Risen Christ 1674
Oil on canvas
Musée des Beaux-Arts
de Lyon

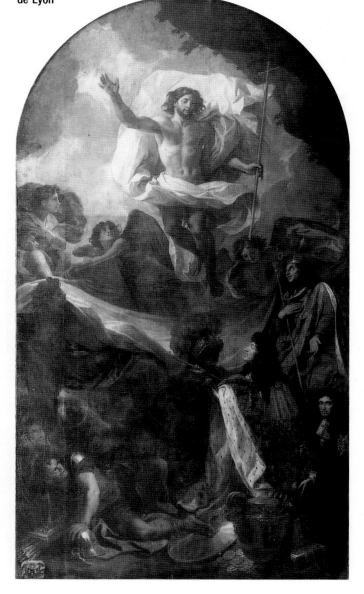

▶ MAKING AMENDS

● Despite the occasional setback, it appears that civilization is beginning to embrace a more inclusive, rather than exclusive, view of the world. Individuals once pushed to the periphery of cultural significance because of their gender, race, religious affiliation, or sexual preference are now actively participating in mainstream cultural debates, and the results have been both inspiring and important. Yet the road to change is arduous and difficult, particularly when there is an "accepted" view of history to compete against—a history of achievement and ideas based on white, male, European standards of truth, excellence, and quality. Since art embodies such notions, it too has undergone a dramatic re-evaluation over the past two decades, as critics and historians alike try to uncover less savory aspects of Western civilization implicit within its visual culture. For instance, where are all the women artists throughout history? Why does the history of Western art seem to exclude the work of visible minorities? And why are women so often portrayed in the history of art as helpless objects of desire, rather than active, capable participants (see Fig. **I.13**)? These are not simple questions, yet they strike at the center of art making and its role in society. This book attempts to address such concerns within the context of a traditional view of art history—and this apparent contradiction requires further explanation.

■ I.13 Pierre Andre Brouilet
A Clinical Lesson at La Salpêtrière 1887
Oil on canvas
Faculte de Medecine, Lyon

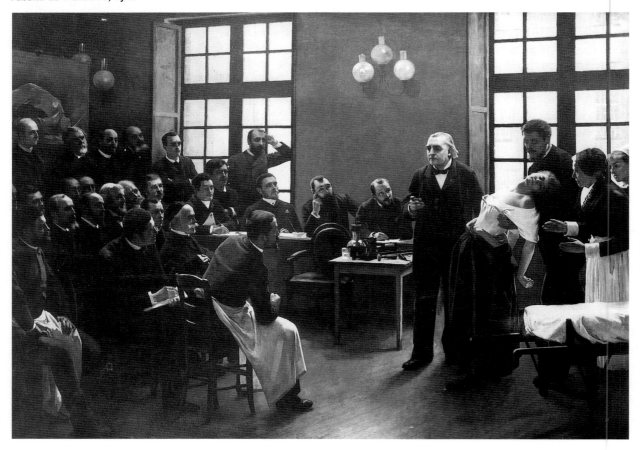

▶ PLOTTING THE COURSE

● The organization of a text will often expose the particular biases of the individual who writes it, and at least to this extent, this book is no different from any other. The decision to write the text in a chronological format (beginning with prehistoric society and moving toward our current age) reflects the nature of art and art making as a dynamic endeavor, and one influenced by the ideas in which it circulates. Without a basic understanding of the relationship between art making, art thinking, thinking, and finally being, it is virtually impossible to appreciate how art functions as an expression of a culture. Though it is certainly interesting to know how artists carved stone, or how brush marks can be made to look like clouds, simply to study art as a series of techniques is to miss the point; those techniques are relevant to us only *because* they are grounded in culture and its ideas. In this way, a study of conventions as diverse as color theory and perspective may give us some insights into why certain ideas and groups have been excluded from the story.

This text is written as a general overview of the history of art making as a collection of ideas, concentrating on the relationship between art and society. To this end, I have included an Epilogue at the end of the text which attempts to address a variety of issues now surfacing in the study of art. The substance of the Epilogue includes discussions on women's art, Postmodernism, revising art history, and other pertinent concerns, and are meant as a critical revision to the text proper. This format is not without its flaws, yet it has been my conscious decision to err on the side of ideas, rather than give the impression that art appreciation is simply a matter of recognizing technical prowess.

Like a piece of art or any other aspect of culture, this text reflects the pressures and influences of its age. I make no apologies for this. It is, however, my hope that this short journey through the history of art and ideas will make you a more critically aware viewer—with regard not only to art but also to the world in general. If art is to have any significance in this day and age, it must be made applicable to our lives; otherwise it becomes little more than a useless relic. By seeing art as an extension of ourselves and our society rather than as something apart and superfluous, we become active participants in culture—and it is through our cultural expressions that we collectively define what it means to be alive. There are few occupations as precious as this.

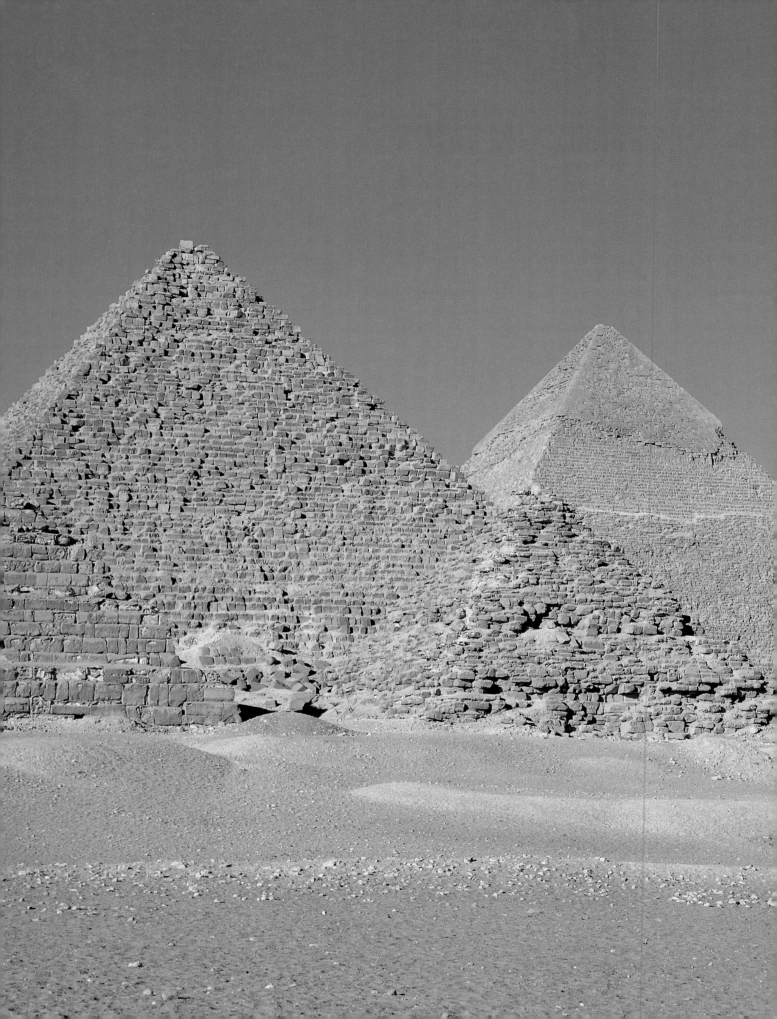

1
THE
BEGINNINGS
OF ART

■ 1.1 The Great Pyramids at Giza, Egypt, c. 2650–2575 BC

"Where shall I begin, please your majesty?" he asked.
"Begin at the beginning," the King said, gravely,
"and go on till you come to the end: then stop."
LEWIS CARROLL, *Alice's Adventures in Wonderland*

The human species is notorious for viewing the world as an extension of itself. Subsequently, ideas such as history and art take on a certain organic unity: they are born, they live, and, with the species, will someday die. For an introductory book on art as a collection of ideas, it is necessary to designate a "beginning," but the questions of exactly where and when are not easily answered. In fact any concept of a beginning in art is laden with assumptions about the nature of the activity itself, which changes with each generation. Keeping this in mind, this first chapter will attempt to examine some fundamental relationships necessary for image and object making, and with it begin what will be a text-long discussion on the nature of art.

On the surface, there might appear few obstacles to finding the beginning of art. Surely one simply starts with the cavemen and moves forward. This seems fair enough—that is, of course, until you are asked to determine which objects and artifacts constitute art, and which don't. Consider this problem in terms of an example. Suppose one generally assumes that art is any handmade artifact which infers some intent on behalf of the person responsible for its production. Using this rather simple definition, it would not be incongruous to consider an arrow head or an ax as a strong candidate for the label "art." Indeed, you might also cite the fact that such items are often on display at prestigious museums, and thus they must hold some value. Yet if

■ 1.2 Prehistoric Europe

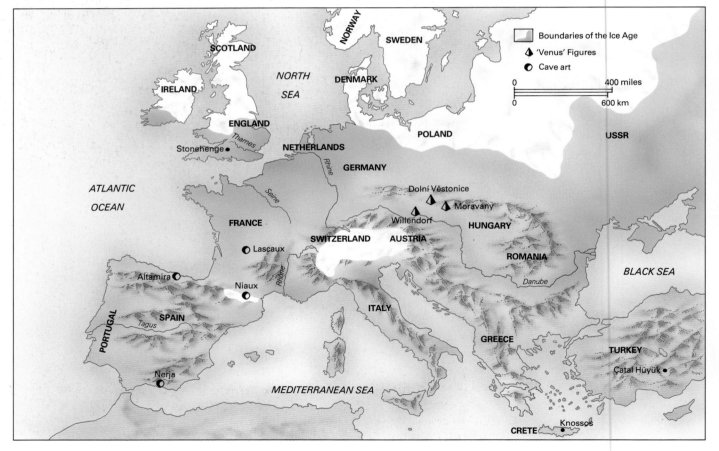

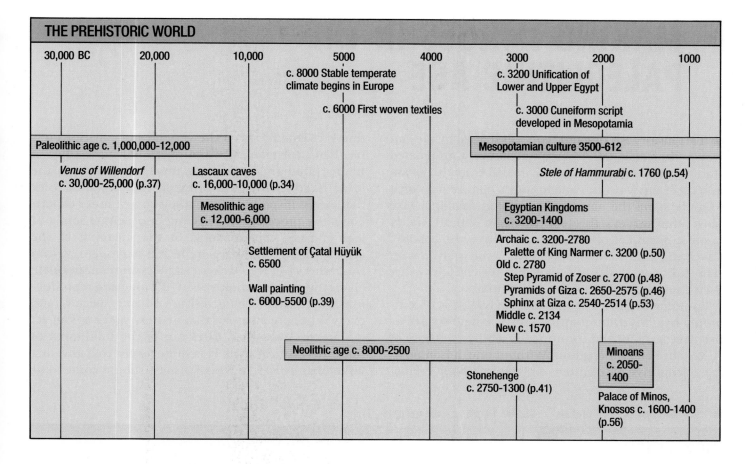

THE PREHISTORIC WORLD

30,000 BC	20,000	10,000	5000	4000	3000	2000	1000

c. 8000 Stable temperate climate begins in Europe

c. 6000 First woven textiles

c. 3200 Unification of Lower and Upper Egypt

c. 3000 Cuneiform script developed in Mesopotamia

Paleolithic age c. 1,000,000-12,000

Mesopotamian culture 3500-612

Venus of Willendorf c. 30,000-25,000 (p.37)

Lascaux caves c. 16,000-10,000 (p.34)

Stele of Hammurabi c. 1760 (p.54)

Mesolithic age c. 12,000-6,000

Egyptian Kingdoms c. 3200-1400

Archaic c. 3200-2780
 Palette of King Narmer c. 3200 (p.50)
Old c. 2780
 Step Pyramid of Zoser c. 2700 (p.48)
 Pyramids of Giza c. 2650-2575 (p.46)
 Sphinx at Giza c. 2540-2514 (p.53)
Middle c. 2134
New c. 1570

Settlement of Çatal Hüyük c. 6500

Wall painting c. 6000-5500 (p.39)

Neolithic age c. 8000-2500

Minoans c. 2050-1400

Stonehenge c. 2750-1300 (p.41)

Palace of Minos, Knossos c. 1600-1400 (p.56)

this is the case, then why are these ancient items considered more "art-like" than an ax in a local hardware store? Few if any would consider a power drill as worthy of art status. Almost immediately, one is forced to concede that art is something a bit more specific than a handmade object. But what, then, are its parameters? It is within this context that the history of ideas becomes essential to any fruitful discussion of art.

Contrary to conventional wisdom, which presumes that there are eternal, fixed standards for virtually all human endeavors, art has always existed in a state of flux. Since art is first and foremost based in ideas, its very survival is contingent upon its ability to change with the times. Or to reiterate an idea stressed in the Introduction, one might rightly conclude that art today was not necessarily art yesterday, and might never be art again. This contemporary mindset has certain repercussions for any subsequent discussions of history. If, for instance, a culture considers art as decoration, then it is only logical that it would search

through history for examples to reinforce such claims. One need look only as far as fourteenth-century Florence (a topic of discussion in Chapter Four) to see how popular ideas tend to distort history to support one's own needs. Sometimes the art of a previous age can be used to manipulate an audience. During the 1930s Italian dictator Benito Mussolini cited Roman culture as a precedent for his authoritarian regime, and attempted to construct virtual facsimiles of antique art and architecture for a modern audience. To Mussolini, as well as less despotic types such as Thomas Jefferson among others, the ideals of Classical civilization were reincarnated for deliberate political ends—ones that would effectively evoke concepts such as pride, power, stability, and destiny. Here the pedestrian notion of a fixed and static history shows itself in practise to be as malleable as clay, shaped by each generation to suit its own needs. History, and thus art history, are then as much a projection of the present as they are authentic documents of the past.

▶ MAKING IMAGES IN THE PALEOLITHIC AGE

● If art history is a dynamic concept shaped by present views, then it is fair to assume that any designated starting point for the origins of art will embody certain aspects of the way our contemporary culture has come to understand the nature of art and art making. Like most other surveys, this text will begin with two fairly popular examples of early visual culture, the Lascaux Caves (Fig. **1.3**) and the so-called *Venus of Willendorf* (Fig. **1.5**), but in doing so will further consider what such choices say about our current situation.

Consider the issue of human survival. It is a commonly held assertion that the most elementary activities necessary for the continuation of life are those of sustenance and procreation. Without one, it is impossible to conceive of the other, and without both, extinc-

tion is inevitable. Even the very idea of consciousness has had to evolve from the overriding necessities of finding food and continuing the species. Art, on the other hand, is an act of consciousness. Even in work that claims inspiration from a spiritual or inner experience, the processes of selecting and editing imply at least a basic consciousness of the meaning of the activity and its context. Simple as it may seem, within this rather crude set of circumstances one can speculate about the possible origins of art. If eating and reproducing are essential characteristics of our species (and every other organism for that matter), and art is an act of consciousness that arises out of the fulfillment of these necessities, then it is quite likely that the first visual expressions of consciousness should come to us

■ 1.3 Main hall, or "Hall of Bulls" c. 16,000–14,000 BC, Lascaux caves, France

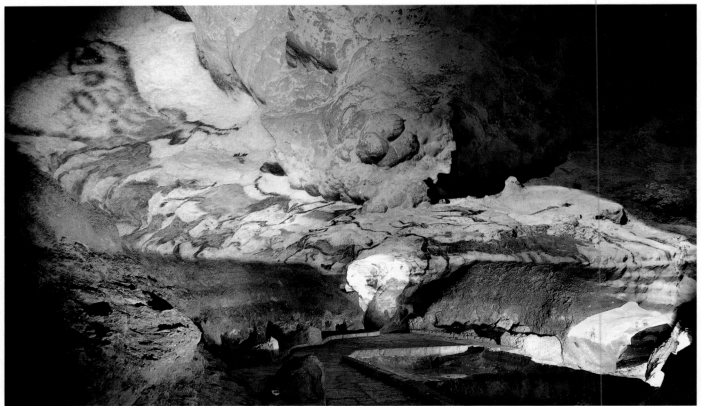

through images or objects associated with sexuality or the hunt. And in locating examples of such a correlation between basic survival and the expression of it, perhaps one can legitimately claim an appropriate starting point for the discussion of art.

THE LASCAUX CAVES

The Lascaux Caves in the south of France are considered among the most exquisite and well-preserved examples of prehistoric culture still available to modern eyes (remember that the term "prehistoric" simply means before historical documentation, and carries with it no intrinsic value judgment). Inside the impressive tunnel complex there remains a vast array of "drawings" which date back 15,000 to 20,000 years. Anthropologists are still debating the meaning of these images, but it appears that they served some function relating to the hunt. The Paleolithic peoples were essentially migratory; their very existence relied on the success of the hunt. Two consequences follow on from such a basic level of survival: the first is a reverence for the food supply (together with a respect for the natural order of things and a giving of thanks for the coming of the herds) and the second is the necessity of moving to find food. It is within this context that Paleolithic communities first produced visual expressions.

The hunt was most likely a central focus in these early communities, since the stabilizing influence of agriculture was not yet a feasible alternative. Given these severe conditions, it seems quite appropriate that beasts of prey, like other natural objects and events, should become the focus of enormous attention and admiration in the human communities—particularly since their very lives depended on them. It is from these conditions that religion and art evolve. Religion explains and orders the universe around a set of collectively assumed principles of reality, and if the reality of 15,000 BC was survival through the hunting of wildebeest or some such delight, then one can assume that the animal in question had a vital role in the continuation of the universe. Part of the anticipation of the hunt (an activity essential to the community's existence) would, then, be the necessary contemplation and appeasement of the animal's spirit through some form of ritual or ceremonial activity. The probable result was the production of visual expressions to serve as surrogates and objects of contemplation for the most basic experiences of life.

The *Black bull* (Fig. **1.4**) visually exemplifies this early organic relationship between the human community and its prey. The series of caves that make up the Lascaux complex are remarkably well preserved, and as a result most of the images remain clearly articulated. There are two primary "methods" of drawing utilized throughout Lascaux: "solid shape" and "contour." Due in part to the consistent pattern of contour drawing overlapping solid shape (note how in Fig. **1.3** one bull is superimposed over the other), historians now speculate that the solid images were the first to be produced, with the contour drawings appearing perhaps even centuries later. The "solid shapes" (meaning uniformly applied color across a plane, making the images appear solid and separate from their surroundings) bear a remarkable likeness to their sources; everything from the animal's anatomy to its coloring and scale is sensitively considered in terms of the natural world. Yet it appears that these early image makers were also aware of the suggestive qualities of the cave surface itself; many of the subjects' features are further articulated by the clever use of a bulge or crevice on the stone surface to imply a part of the subject's anatomy. The consistent use of this pictorial device throughout Lascaux and other Paleolithic cave complexes has given some credence to the "image by accident" hypothesis, popular since the Renaissance as a possible explanation for the original impulse of art. The argument, first suggested by the Renaissance scholar Leon Baptista Alberti (c. 1404–72), takes as its premise the notion that art began with the recognition of striking resemblances between everyday objects (a tree trunk or a boulder) and other objects (a face, say, or an animal). When human communities took the all-important step of adding another element (perhaps a stick to suggest horns, or a pebble to suggest a head) to the given natural occurrence in order to complete the likeness, art was born. If true, this argument helps explain the vivid relationship between the cave wall surfaces and the subsequent placement of images in Paleolithic art.

The contour drawing elements in the Lascaux complex exhibit a further development of the newly born visual language of image making. The idea may have started with the simple desire to reuse wall space already decorated with the older solid-shape designs. By articulating only the exterior edge of a bull or some other subject, these linear descriptions could be effectively drawn on top of other images without destroying

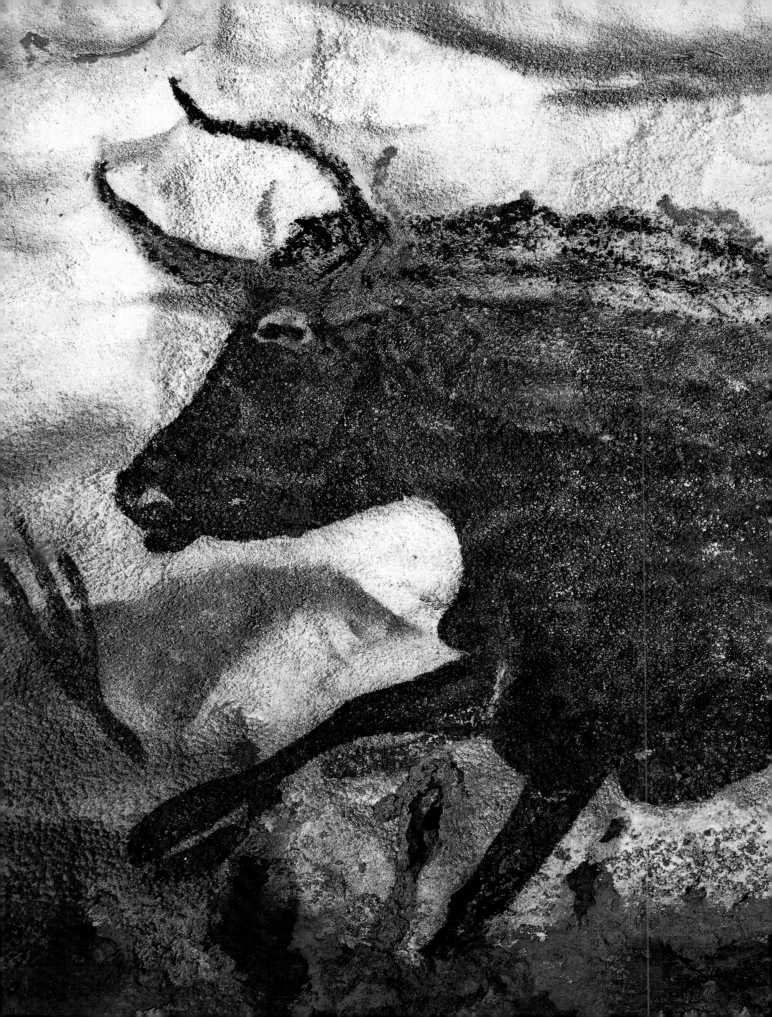

the former's visual identity. In any event, the experiment in line lent itself to a considerable degree of sensitivity, and as a result line was added to the visual repertoire. Even in such early examples, it is possible to see the expressive possibilities afforded by line; the meeting of slow curves (such as the inverted *C* shape of the neck of the bull) with more angular joints (such as the front legs) gives the image an appealing rhythmic flow, which further entices the viewer to follow the path of the line around the animal. This visual quality is called "line speed" and it refers to the ability of line, depending on its characteristic thickness or relative angularity, to suggest motion. And though still in its infancy at Lascaux, these line images are nonetheless an important preface to later drawing conventions.

THE VENUS OF WILLENDORF

The so-called *Venus of Willendorf* (Fig. **1.5**), perhaps the oldest surviving three-dimensional depiction of a human body, is approximately 8,000 to 10,000 years older than the images at Lascaux (it dates to approximately 25,000 BC), and it exhibits notably different characteristics. The "Venus" figure (Venus being the unfortunate catch-all label for virtually any unidentifiable female nude in earlier European scholarship) is portrayed in the round, possessing volume and interacting with real space—the same features our culture has come to recognize as essential characteristics of the art of sculpture. As with all three-dimensional forms, an important feature of the *Venus of Willendorf* is its ability to be viewed from any angle, a process which mimics our experience of the world. It also, like our own bodies, occupies tangible space.

Of over 200 surviving Paleolithic figurines, there has yet to emerge a single male statuette, thus anthropologists speculate that the mystery of childbirth elevated the status of the woman. This statuette is most likely a fertility symbol, and the expressive description of the body brings the symbolic intentions of the carving into sharp focus. The massive breasts and bulbous stomach suggest the life-giving qualities of the woman as childbearer. This body consciousness is further accentuated by the faceless, downward-turning head of the

1.4 Black bull c. 16,000–14,000 BC
Lascaux caves, France
Paint on limestone
Total length of bull 13 ft (3.96 m)

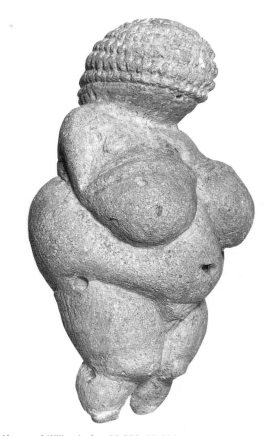

■ **1.5** *Venus of Willendorf* c. 30,000–25,000 BC
Lower Austria
Limestone
Height 4½ in (11.5 cm)
Naturhistoriches Museum, Vienna

figurine, which denies personality or individuality, and establishes the image as a more general expression of sexual power. Note that this fertility statuette is based less in the natural observation embodied in the bulls at Lascaux than in some more generalized, perhaps abstract considerations. This might give us a hint as to the hierarchic scale that developed around certain images and their representation. It appears that with god forms, the image maker was under less pressure (or had less interest) in producing an image that corresponded to something in nature; instead, emphasis was probably placed on creating images that appeared as embodiments of power and mystery. As a result, even at this early date we are witness to a process of conceptualization with regard to image making. The scale seems to appear as such: as the depicted forms move from animal life, through humans, to cult figures and godheads, their visual identities become increas-

ingly abstract, with certain features accentuated and others diminished.

● From these examples, it is clear that visual images were deliberately used as sources of order and understanding in the world. The visual description of figures and animals seems to have paralleled the development of religion as a means of appeasing an often hostile environment, and though it is unclear whether the initial representation of images inspired a devotion to their subject matter or, on the contrary, speculation about the nature of the world precipitated the production of images (most likely), the result was nonetheless significant. The question as to why certain subjects were portrayed in two dimensions and others in three is equally challenging. Small stone carvings certainly have the ability to be tucked away in times of travel, and considering the migratory nature of these early communities, the choice of materials and scale might have simply been practical considerations. There is also the possibility that three-dimensional work was thought to mimic more effectively the physical reality of the human body (though this does not explain the two-dimensional character of the human and animal forms at Lascaux). The cave drawings are more likely to have been a transitory form of image making—perhaps even a ritual of mock creation intended to insure a successful hunt. If this argument is true, then it supports the current notion that image makers had special status in the tribe, since they were responsible for initiating such rites. This position has important ramifications for the way Western culture has come to view the role of the artist in early societies. It insists that artists are supremely gifted personages (gifted implying that their talents were given to them by some higher order), performing a function vital to the greater community. However, implicit in such a view is the contrary notion that artists are up to no good, competing with the gods for creative supremacy. It is quite common in the history of culture to hear tales of magnificent technicians conspiring with the devil to enhance their power (the violin virtuoso Paganini is said to have sold his soul to the devil in exchange for greatness). The position contrary to the artist as holy person or shaman views the artist as little more than a trained craftsperson, whose abilities are fostered through simple trial and error. Most likely, the true nature of creative activity lies somewhere between the two extremes. It appears that technical skills (how to produce a bull that looks like it's running, how to carve a certain type of stone efficiently, etc.) were passed down from one generation to the next, allowing for the continuation of certain motifs and most likely securing a privileged position for the image maker in the tribe. In a sense, this dynamic of image making is a perfect analogy to life itself; the uneasy, sometimes volatile relationship between ideas, tradition, and individuality has unmistakable parallels to the trials and tribulations inherent in all social beings.

▶ SECURING THE HOMEFRONT: THE NEOLITHIC AGE

● The survival of the Paleolithic peoples depended primarily upon the hunt, and since the animals in question were usually migratory, so too were our ancestors. For any dramatic shift in civilization to occur, it was going to be necessary for at least a few communities to call one location home long enough to develop structures, decoration, and the all-important time to contemplate their place in the world. The breakthrough came in around 8000 BC, when a number of disparate communities developed the notion (perhaps accidentally) that running after dinner was far less appealing than cultivating it. The discovery of agriculture—the precept that nature can effectively be controlled and manipulated—was to have earth-shattering effects on the way the human community was to view itself, and subsequently its art.

It is indeed mind-boggling to contemplate how different the world might have been without the discovery of agriculture and the domestication of herds. First, the necessity of staying in close proximity to the crops and domesticated animals made permanent dwellings essential, out of which humans began to construct buildings. Likewise, with the previously frustrating constraints of scale and portability overcome, communities were soon able to develop more elaborate items (crafts). But more than any other feature brought on by the advent of agriculture, it was the greater sense of community that led to the organization of what is today called civilized society. It is interesting to note that the word "civilization" comes from the Latin root citizen, which simply means town dweller. Thus it is not surprising that we as a human community have come to understand civilization as rooted in the interrelations between people and ideas, rather than through concrete events and objects.

If communities were gaining increased confidence in their ability to manipulate their immediate environment, so too were their visual expressions gaining a degree of consideration and complexity. This telling shift in sensibility (or the way one views the world) is most apparent in the obvious re-evaluation of the human versus animal configuration in early Neolithic

■ 1.6 *Image of a Hunter* c. 6000–5500 BC
**Detail of wall painting in the main room of Shrine A.III.1
Çatal Hüyük, Turkey**

(the period of agriculture) wall painting. The *Image of a Hunter* (Fig. **1.6**) found in a recently excavated shrine at Çatal Hüyük, Anatolia, presents a dramatically different visual response to the role of the human in the world. In the previous Lascaux Caves imagery, emphasis was placed on the vitality of the animal figures—the few humans described in these early drawings played subordinate roles in the overall world picture. The mysterious comings and goings of the herds must have been a source of wonder for these early people, and it is understandable that these animals (on whose lives the survival of the community rested) would be expressed in the dominant position. Yet as the community's relationship to the world slowly changed from subordinate to master, so too did the representation of that relationship. In the drawing from Çatal Hüyük, a new type of figure emerges, full of a vibrance reminiscent of the Paleolithic animal renderings. Even the very abundance of human figures in these works signals a departure from the earlier isola-

tion of the past, and it gives an indication of the growing importance of community and social organization during the period. The natural hierarchy of power was changing in the Neolithic world, and as a result one may cautiously speculate that the drawings reflect such a confidence, not found in earlier representations.

Two-dimensional representation was not the only visual revolution to take place during the era. The cultivation of the land brought about an increased sense of place, since one could effectively survive in the same location for many years if conditions remained adequate. The cycle of birth, death, and renewal held particular importance to these early farming communities, as survival shifted from the luck of the hunt to the mysterious workings of the seasons. One result of this need to appease the natural world (which could on a whim bring famine or flood to the fragile community) was the construction of belief systems based on the workings of natural phenomena. The importance of worship and ritual to the health and welfare of the community seems to have made monuments an essential part of each town.

The term ''architecture,'' like its companion ''art,'' is tricky to pin down. It is common to define architecture as the art of designing space—an activity which includes everything from interior design and garden construction to the likes of stadiums. Its linguistic sources are in the ancient Greek roots of ''archi'' (meaning rule), and ''tecture'' (meaning construction or building), and it was used during that period to define structures of decidedly more purpose and influence than basic housing. By design, it was often larger in scale, more central in its role in the community, and usually more permanent than its domestic counterpart. In other words, there was the implicit assertion that architecture embodied certain specific features of the community in which it was built. That today the term architecture is used to define virtually all building construction, including basic housing, suggests a conscious re-evaluation of the domestic environment—an extension of the concepts of both individuality and private property. In this way, architecture exposes itself as no less susceptible to social pressures than any other culturally significant term.

STONEHENGE

One of the most famous surviving Neolithic building structures is Stonehenge in southern England (Fig. **1.7**). The site actually supported a number of different structures over its 1,400-plus years of intermittent construction, and today it stands in approximately the same configuration as it did around 1300 BC. Most likely constructed as a shrine, the outer of its two concentric rings has the interesting distinction of being laid out in exact accordance with the directional path of the sun at the summer solstice. This celestial consideration is indicative of the Neolithic community's growing awareness of natural phenomena and the cycle of the seasons. But perhaps its most important attribute is its very survival; Stonehenge remains one of the earliest examples of public architecture in Northern Europe to survive to this day.

It is certain that Stonehenge was a vital part of the local inhabitants' world, and no doubt has proven itself more permanent than virtually any other item produced by the culture. So within even the strictest of definitions, Stonehenge is certainly architecture. It also has the distinction of being possibly the first surviving structure to utilize post and lintel construction (Fig. **1.8**), the technical cornerstone of much of subsequent Western architecture (since the dates for the structure are so vague, it is impossible to be sure). The ''post,'' commonly identified as any vertical form, supports the horizontal ''lintel'' on its crown from which the later convention of the supported ceiling is derived. In the case of Stonehenge, massive stones (called megaliths, meaning ''big stones'') were propped upright to create a circular order of posts, on which a series of lintel stones once sat, enclosing the ring. The ingenuity and sheer will necessary to execute such an enormous and cumbersome building project have made Stonehenge the stuff of legend; today it is still a matter of speculation how the community actually found, transported, and erected the massive stones, but the very fact that the complex was built at all is striking evidence of the community's need visually to express the binding relationship between themselves and their immediate, sometimes hostile environment.

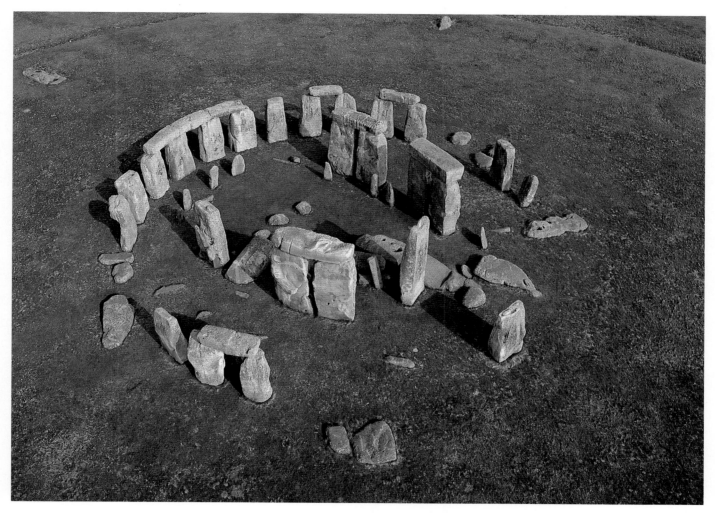

■ 1.7 (above) Stonehenge c. 2750–1300 BC
Salisbury Plain, England
Diameter of circle 97 ft (29.7 cm)
Height 13 ft 6 in (4.1 m)
(below left) Plan of Stonehenge

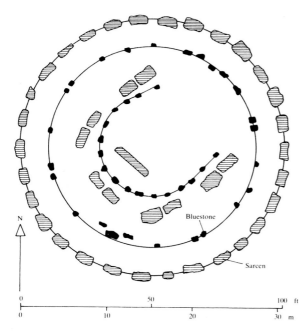

Bluestone

Sarcen

N

0 50 100 ft

0 10 20 30 m

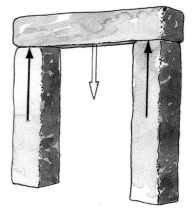

■ 1.8 Post and lintel construction

▶ PREHISTORIC AND TRADITIONAL CULTURES

● Before continuing any further in this discussion, it is necessary to clarify the important distinctions that exist between the terms "primitive" (popularly used to identify and label the visual artifacts produced by certain cultures in recent times) and "prehistoric." It was mentioned at the outset that the term prehistoric simply means before historical documentation, and implies no value judgment on the work itself. The same cannot be said of the term primitive. Taken at face value, primitive implies that something is in an early stage of development, from which more complex associations can blossom. Yet in recent times, the word has come to embrace a significant amount of visual material that possesses both considerable development and great insight—its primitiveness being little more than its obvious difference from mainstream Western culture. By the late nineteenth century, the term primitive had taken on a decidedly "social Darwinist" connotation (social Darwinism being an attempt to apply evolutionary theory to ethnic and racial groups) and it supported the notion that human communities developed in sophistication for biological as well as social reasons. To be labeled primitive was, in short, to be either considered of less value and less significance, or romanticized as somehow more pure and untainted by socializing influences. In other words, the use of the term primitive as a descriptive tool came to imply assumptions about both quality and importance.

Today, there remain, in small pockets, communities that continue with the same sort of social organization as our Neolithic ancestors, and it is to these traditional groups that the term primitive is still inappropriately applied. Yet even the term Neolithic is not particularly accurate here, for it wrongly suggests that such communities possess only a rudimentary social and intellectual organization; many of them have developed a complex cultural identity. Why these communities survived intact until the dawn of this century is open to speculation, yet their steady extinction during the years of Western colonialism may suggest that it was their isolation from larger population centers (and their influences) that very much determined their unchanged nature over centuries, even millennia. For this reason, such communities provide vital insights into the relationship between early social organization and the production of visual culture, which in turn provide clues into the nature of art and art making.

The opening up of Africa and the South Pacific during the nineteenth century signaled the beginning of the end for the few remaining Neolithic-like communities in the world. Until contact with white Europeans, many of the indigenous peoples of central Africa, Australia, and the Americas had capably survived without need of dramatic change in their social organization. The Australian Aboriginals are one such example. Destined to live as scavengers and hunters by the extreme conditions of the Australian outback, for them the issue of change meant one of adaptability rather than dramatic shifts of sensibility (under such extreme conditions, change was a very real gamble, since failure could result in death). Here, conditions similar to those confronted by the earliest human communities existed well into the twentieth century.

Despite some very real differences in social structure, there are striking similarities between the ancient Lascaux Caves images and the more recent visual culture of the Australian outback. In Fig. **1.9**, which shows an Aborigine rock painting, the subject matter once again shows clear indications that human experience is understood within the larger context of the natural world to which the community is inextricably bound. In aboriginal art it is common to see animals described in what we might refer to as "X-ray" images; the subject is viewed with its internal organs clearly visible—a conceptual shift that has little to do with what the animal looks like, and everything to do with what the animal is understood to mean. The kangaroo is depicted as a beacon of life, its complex system of organs supporting both the miracle of life within its own body and, by providing food for the community, the rest of the world as well.

The hunting motif is not the only recurring image that binds the ancient communities of the prehistoric

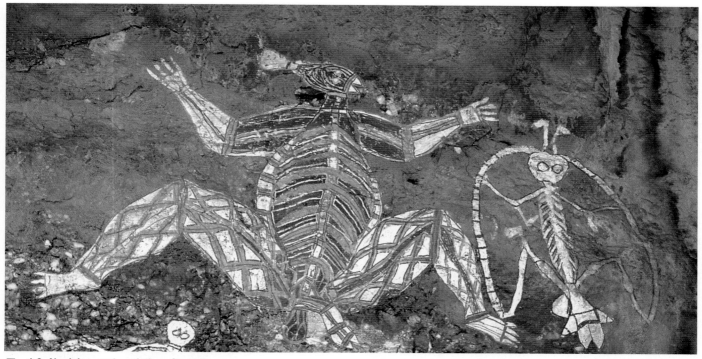

■ 1.9 Aborigine rock painting, Australia

era to the traditional communities of our current age. The concept of fertility has always been closely associated with survival, and thus it is not surprising that we find an abundance of images of the mother and child throughout these close-knit societies. The *Woman and Child* (Fig. **1.10**) produced in Cameroon *c.* 1912 is a good example. Here the female figure suggests the continuity of life, embodying the child-bearing qualities of woman as essential to the community's survival. The relationship between suckling child, bound to the nourishing breast of its mother, and woman, whose crouched body and extended neck visually enwrap and protect the infant, suggests a most basic bonding—on both a bodily and a psychological level. Note how the eyes of the mother and the pointing of the left breast fix our attention on the child's head, whose cradled body creates a *V* form. This line or visual rhythm is then met at the child's knees by the mother's right arm, which moves the eye up through the neck and back to the head. The resultant visual motion is that of a unified circle, interlocking parts in a satisfying and obvious manner (Fig. **1.11**). Like its companion fertility imagery, the mother and child motif continues to

occupy a central and prominent position in the tribe's visual expressions.

Ancestor worship is yet another manifestation of a community's desire for continuity from one generation to the next. This belief often takes on characteristics peculiar to the community in question, but there are general similarities from which one can draw certain conclusions for visual expression. One is the method of expressing reverence in visual form through the manipulation of the corpse of the deceased. If this seems morbid or drastic, then consider our own rituals of "making up" a corpse before a funeral. Both are excellent examples of the breadth of our visual needs as a culture, and show how issues such as mortality can become manifest in a body. Another notable interest in such forms of ancestor worship is the desire to "trap" or keep the spirit of the dead within the shell of their previous body. A fascinating example of this approach, consistent over thousands of miles and thousands of years, can be seen by comparing two skulls, one found at Jericho (Fig. **1.12**) dating to 7000 BC, and the other from nineteenth-century New Guinea (Fig. **1.13**). On the surface, both appear to allude to the same concerns

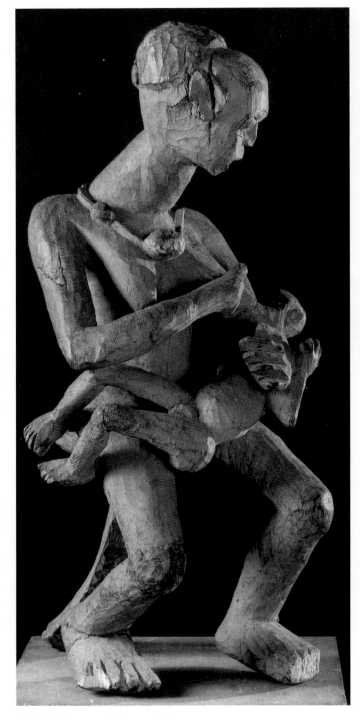

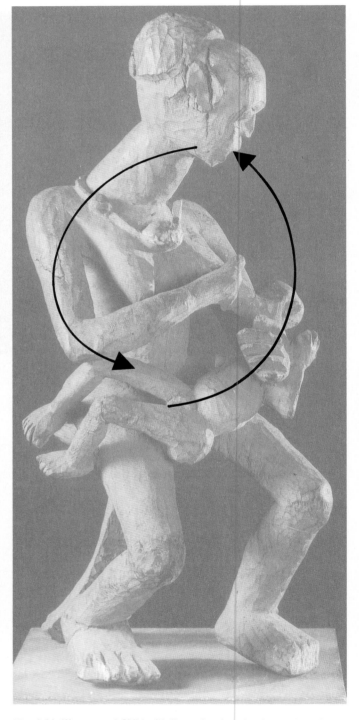

■ 1.10 Kwayep of Bamana Village
Woman and Child c. 1912
Bamileke Kingdom, Cameroon
Wood, pigment
Height 25¾ in (65.4 cm)
Musée d l'Homme, Paris

■ 1.11 *Woman and Child* with lines showing circular motion of the composition

■ 1.12 Neolithic plastered skull c. 7000 BC
Jericho
Lifesize
Archaeological Museum, Amman, Jordan

shall see, this simple form of what might rightly be called a visual strategy (since this was obviously considered a method of dealing with the problem of quieting the dead) will become a chief preoccupation with later image making, and it sets an important precedent for the way societies have come generally to define art.

What can be learned from such examples? One of the most apparent issues to surface from the preceding discussion is the degree to which human beings' social and environmental conditions are decisive in the production and conceptual makeup of their visual expressions. If one is willing to accept that the aforementioned objects came into being through very specific concerns and beliefs on the part of their makers, then it is clear that a fundamental link exists between makers and their historical contexts in all areas and through all ages in the visual arts. If this is not the case, then one might rightly ask the embarrassing question, Why is it important to study art in the first place? Luckily, it is the former that holds true.

■ 1.13 Plastered skull c. 19th century AD
Sepik River, New Guinea
Lifesize
British Museum, London

over the sanctity of, and the need for protection from, the spirit of the dead (in such societies, spirit is found in all things). In the case of the New Guinea example, it appears that the plastering of skulls is used to keep the internal spirit of the dead confined within. This also had the added benefit of gaining a sense of control over the living spirit inside the dead corpse—much like holding someone captive inside a prison. In each case, a reconstruction of the facial features of the deceased is modeled in plaster over the bone, with various embellishments (sea-shell eyes, graphic facial markings, etc.) added to give the image greater impact. In this type of visual expression, one can speculate how later artists and their societies came to view objects as embodiments of personalities, and then finally ideas. At the simplest level, the makers of these images have attempted to enclose, or more specifically embody, the spirit of the dead within an inanimate object. As we

▶ ART AND THE DEVELOPMENT OF MORE COMPLEX SOCIETIES

● It was stated earlier that visual expressions are always produced within the confines of time and place. Since human beings exist at a certain point in time, are schooled within the context of a current range of ideas, and participate and socialize within set boundaries, it is inevitable that their activities reflect that age. If this is the case with individuals, then it seems only logical that the objects they manufacture will also reflect such conditions. This is certainly the case with basic items such as pots or utensils, which reflect a community's most basic functional requirements for living. Such objects of "material culture" are often excellent indicators of a society's requisite daily rituals, and as a consequence they become objects of immense interest to anthropologists. Yet objects of utility are often poorer conductors of historical issues than their non-functional counterparts, since their physical requirements make them so form-specific. There are, however, items that seem to change with time, evolving and dissolving as periods change. It is to these items that meaning is commonly assigned, since they reflect their creators (who in turn reflect their times), and thus the quality of human existence during their creation.

THE GREAT PYRAMIDS AT GIZA

There are two important issues to consider when attempting to address such visual forms: the ideas of "self-referentiality" and of "audience." Let's first tackle the issue of self-referentiality. The Great Pyramids at Giza (Figs. **1.1** and **1.14**), built between 2650 and 2575 BC, were erected as burial monuments. In examining the three structures, one is immediately struck by their overwhelming presence, which is perhaps a poetic way of saying that they visually emanate a certain intelligible difference from their surroundings. On the surface, they appear to have no obvious function, and as a result the viewer is forced to consider them in terms of their own intrinsic characteristics. An object is self-referential when its form is derived primarily from

■ 1.14 The Great Pyramids at Giza
(right) Cheops c. 2650 BC, (center) Chefren c. 2600 BC, (left) Mycerinus c. 2575 BC

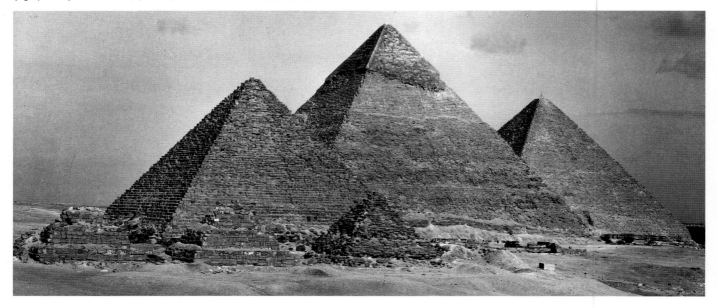

■ 1.15 Glen Canyon Dam, Arizona
Height 710 ft (216 m)
Length 1,560 ft (475 m)

considerations outside function. Consider this in the light of a simple tool such as a corkscrew. The spiral form of a corkscrew, which is derived from a very specific requirement—to pull a cork out of a bottle—refers first to its function. This is not to say that such an item cannot be appreciated for its formal characteristics but simply that the form evolves first out of a functional need, and its formal character is a necessary result of such considerations.

It has been rightly said that no item is without reference to the outer world; it is simply a matter of identifying the range and effect such references have on the formal character of the object. Consider this example: placing the Great Pyramids at Giza side by side with an equally colossal structure such as the Glen Canyon Dam, Arizona (Fig. **1.15**) may initially force

one to utilize very different standards in addressing the work. The Glen Canyon Dam is understood and appreciated for its function as a huge water obstruction, developed to hold back vast quantities of water. Thus its form is derived almost exclusively from its function. Its long sloping wall, massive vertical thrust, and awesome sense of mass are all tied directly to the need to hold back water. And though it is certainly true that such structures (indeed all material culture) can grant an observant viewer vast amounts of other information (such as construction practises, the environmental effects of increased energy demands on the environment, etc.), its form remains tied to its utility.

The Great Pyramids present a different scenario for the viewer. Since on the surface such structures appear to have little grounding in obvious utility, they are

■ 1.16 Step Pyramid and Palace (restored) of King Zoser c. 2700 BC Saqqara, Egypt

often considered in terms of formal principles, and the "intent" of their construction. When objects are divorced from obvious function, they begin to embody the circumstances from which they are created, and thus open themselves up to a dialogue with the viewer on a more pronounced psychological, intellectual, and instinctive level.

● There are, of course, problems with such generalizations when discussing art. The most obvious flaw in the self-referentiality argument is that in reality no item functions in a state of complete self-enclosure; even the most seemingly neutral and contentless creations are necessarily situated within an elaborate context of other issues. Look once again at the Great Pyramids. It is true that there appears little functional need for these monuments, but it is absolutely incorrect to claim that they exist without reference to then popular ideas and

issues, or that they evolved in a vacuum. It is known, for instance, that the form of the pyramids is derived from an older form of burial chamber, called a "mastaba," which was a four-sided sloped construction with a flat top and an access hole which led on a vertical axis into the ground. These chambers were originally adapted from early domestic architecture, and are in keeping with the Egyptian notion of the sanctity of the dead in the afterlife. Slowly, with the rise of the pharaohs, the mastaba form developed a stepped or piggyback appearance (see Fig. **1.16**), adding height and visual force, and suggesting the presence of authority granted to the deceased ruler in the afterlife. From this design, it was simply a matter of evening the slopes of the stepped walls to achieve the traditional pyramid form. So in this regard the form does pay obvious reference to the prevalent ideas of its age; even if it does not display a primary functional use, it did not simply

emerge in a social and intellectual vacuum. It is at this point one can begin to comprehend an important characteristic of art and art making: an object created outside the realm of functional considerations becomes a powerful agent for the expression of issues in which it, its creator, and its audience are immersed.

The notion of "audience" was previously mentioned as an intrinsic part of the art process. Whenever individuals approach an art piece (or any situation for that matter), they bring a multitude of experiences and learning to bear upon the work in question. As was discussed in the Introduction, the dynamic is akin to a conversation, the art piece performing a communicative link between artist and viewer. In this sense the art piece is a point of arbitration, and as such it has aspects of both artist and viewer within its realm of meaning. Of course, no two people have identical histories or experiences, and thus the communication is never complete. It is in essence a constant process of re-creation every time an individual enters into a dialogue with the piece. Further, artists are never in complete control of their part of the conversation either, since they too are required to enter into some form of a

relationship with their materials. In other words, attaching specific meaning to a piece is always a tricky business, and that fact will have significant ramifications for later art.

As Neolithic communities grew, there came a need for more complex systems of social organization. It is difficult to pinpoint how leadership was originally determined in those days—perhaps by brute strength, or even the luck of the draw, one can't be sure. Regardless, after a period political systems evolved, with a hierarchy of individuals guiding the fate of the community. Although positions of power were often sanctioned through the various godheads and religious organizations, the stability of the regime always rested upon the assumption that the leadership had special rights to their offices. One of the ways to enforce such beliefs was to initiate a series of highly visible reminders through the use of buildings and images. Public monuments are a testimony to society's need to communicate with itself, and in more complex societies, the monument became a reminder of the role and fate of the individual in the world—a world all too often controled by relationships of power.

■ 1.17 Ancient Egypt, Middle East and Mesopotamia

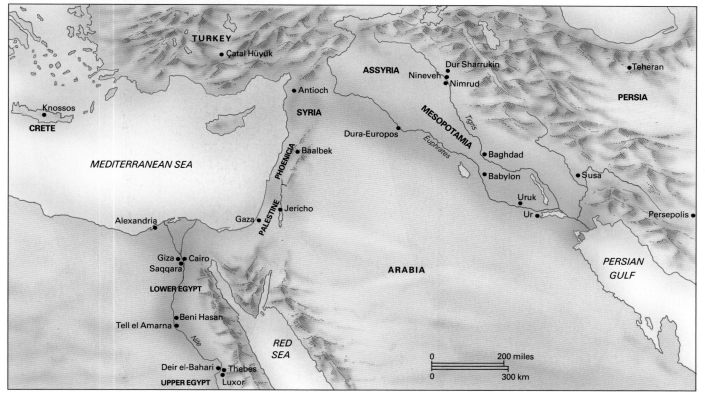

THE PALETTE OF KING NARMER

Egypt was one of the first locations to show signs of more complex forms of Neolithic social organization. Centered along the banks of the River Nile, there was enough fertile soil in an otherwise arid environment to allow the development of highly specialized communities. Historians date the beginnings of an organized Egyptian kingdom to around 3000 BC, initiating a 2,500-year reign until its collapse under Persian rule in 500 BC. One of the most interesting aspects of Egyptian visual culture is its overall consistency, particularly considering the rather lengthy span of time between

the civilization's rise and its fall. Take, for instance, two similar tablets, the first *The Palette of King Narmer*, dating to *c.* 3200 BC (Fig. **1.18**), and the second a wall relief from the Temple of Sethos I at Abydos, dating to *c.* 1300 BC (Fig. **1.19**). The palette is arguably the oldest ''historical'' work of art known today—since specific historical events can be linked in with the storyline, and individuals can be identified, it is considered an historical document. The palette commemorates the unification of Upper and Lower Egypt, and depicts in various sequences King Narmer's triumphant control over the will of his enemies and his subsequent establishment of the Egyptian kingdom. The palette is carved in a relief

■ 1.18 *The Palette of King Narmer* c. 3200 BC
Hierakonpolis
Slate
Height 25 in (63.5 cm)
Egyptian Museum, Cairo

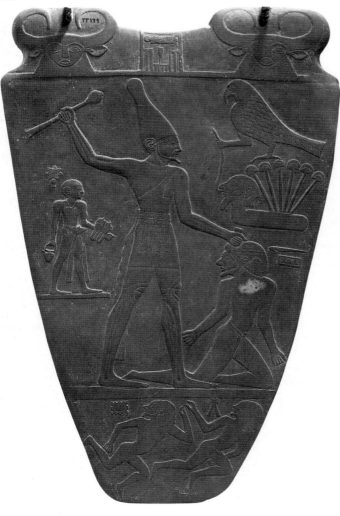
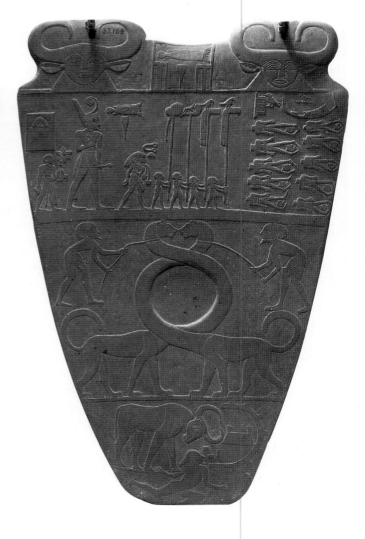

■ 1.19 Wall relief from the Temple of Sethos I,
Abydos c. 1300 BC
Sandstone

manner on both sides of the slate slab, with the visual information laid out in such a manner that a viewer is invited to consider the images as a somewhat symbolic account of the events proper. This use of specific images to suggest more complex ideas is fundamental to the later notion of written language, and its early connection to pictorial symbols can clearly be witnessed in this work. Take, for instance, the image of King Narmer, ominously standing over a kneeling, subservient figure on the obverse side of the palette. The obvious distortion of scale between ruler and defeated suggests power and control, while the generalized features of the victim further imply not a specific character but perhaps the personification of Lower Egypt itself. Thus these images act not just as simple representations of events but also as embodiments in pictorial form of more involved ideas. It is from these conventions that Egyptian hieroglyphs emerge, with certain images denoting various noises or words which connect in various manners to suggest particular ideas. What is perhaps most remarkable about the palette is its clarity of design, enabling the viewer to have access to an abundance of information. The exaggerated appearance of the figures and the inventive use of a differentiated scale combines in an abstract manner to create an image that is strikingly clear, inventive, and suggestive—the very dynamic of communication.

Unlike the previously discussed Neolithic objects, there is in the palette design a set of "conventions" or an understood visual "language" which emerges out of a communally assumed set of symbols. Up until this point, art performed an essentially ritualistic function, making tangible the workings of an otherwise hostile world. Yet in this very early example of Egyptian art, a move toward a more didactic or instructional character in the visual imagery is clear—something we generally refer to as "narrative." Narrative involves the progression of one idea to another, often encompassing time and thus a series of events. To arrange images in narrative, it is necessary to identify clearly a direction of movement, suggesting a possible entrance into the plot, as well as an exit. Because objects necessarily require observation from various angles to facilitate their understanding, the ancient Egyptians probably decided that three-dimensional images were poor conductors of a progressive storyline. As a result, it seems that emphasis shifted toward flat design, where one image could be effectively placed next to another, and understood with the brief scan of the eye. If this sounds like

reading a book, then you are on the right track. Today's common script is derived from this simple format, and it is through the progressive scanning of simple illustrations that written language has emerged. Language is, in fact, nothing more than a commonly accepted set of conventions from which ideas are transferred from one individual to another. This simple notion has had a profound effect on the way one views two-dimensional art, and it helps form the basis of our understanding of the different qualities and possibilities afforded by two- and three-dimensional work. The result certainly caught the attention of Ancient Egyptians, who were so taken by this method that their hieroglyphs changed remarkably little during their civilization.

● One inevitable repercussion of the rise of politics in complex social organizations is the sometimes subtle, but more often obvious, development of authority. Today, the public generally relies on the media for information about political leaders and their agendas, considering them in most cases a relatively accurate source. Yet it is also clear that government agencies spend millions of dollars each year bolstering their media image and learning to use it to their advantage, and thus the media are also seen as a valuable tool in the dissemination of government policy. In other words, since the media (like art, and every other human endeavor for that matter) are a product of their environment and time, they will inevitably find themselves bound to that system. In 3000 BC there were no television sets or newspapers to extoll the virtues and aspirations of those in authority, so instead energies were poured into mammoth and highly visible work projects. The result is a series of some of the most impressive monuments the world has ever known.

Next to the Great Pyramids at Giza there stands one of the most famous of Egyptian monuments, the Great Sphinx (Fig. **1.20**). Historians have speculated that the head of the Sphinx was modeled on the head of the pharaoh Chefren, with a lion's body—a common signifier of immortality—attached to it. The lion is, then, a "symbol" (a communally accepted set of meanings associated with a form), and when specifically attached to a personality it becomes part of the character's

▶ 1.20 Great Sphinx at Giza, Egypt, c. 2540–2514 BC
Limestone
Height 65 ft (19.83 m)
Length 240 ft (73.2 m)

"iconography" (the history of meanings associated with a figure). Such imposing sights do much to enhance the public reverence paid to leaders, and give a good indication of how monuments function; it is, indeed, hard not to feel moved and dwarfed beside such displays. The success of this form of communication may give us some indication of why there was so little change in Egyptian culture during its 2,500-year span. The belief in a divine right of kings probably enforced such forms of "language" as ordained from above and subsequently caused a degree of stasis in the art community. And when this kind of display was coupled with the ever-present Egyptian preoccupation with death and the afterlife, it is no wonder that little innovation took place.

Before leaving Egypt, there is one other aspect of Egyptian art relevant to this discussion: the development of representation. I mentioned with regard to the Sphinx that its head was probably fashioned after one of the important leaders of the age. You will note that this is the first time in the chapter that a specific name (and thus a personality) has been attached to an image. Unlike Neolithic figurines, which remained generic and thus somewhat universal in identity, the emphasis on producing a likeness meant that objects could now be charged with more specific meaning and often evoke very particular responses. As the Sphinx shows, the subtle streamlining of the viewer's response is an excellent way of bringing other issues into play when responding to a piece—a consideration that will be more fully explored in the next chapter.

Egypt was not the only location where more complex social arrangements took place. The area between the Tigris and Euphrates rivers provided enough fertile soil to support yet another developing culture—the Mesopotamians (3500–612 BC). Perhaps the greatest lasting achievement of the Mesopotamian world was the development of writing. The *Stele of Hammurabi* (Fig. **1.21**), with its elaborate series of marks carefully carved into soft basalt, is the logical extension of earlier pictures in series, where a narrative progression of recognizable images provided the framework for a coherent thought (Fig. **1.22**). This more simplified script (called cuneiform after the wedge-shaped

▶ 1.21 *Stele of Hammurabi*, 1760 BC
Basalt
Height 7 ft 4 in (2.23 m)
Louvre, Paris

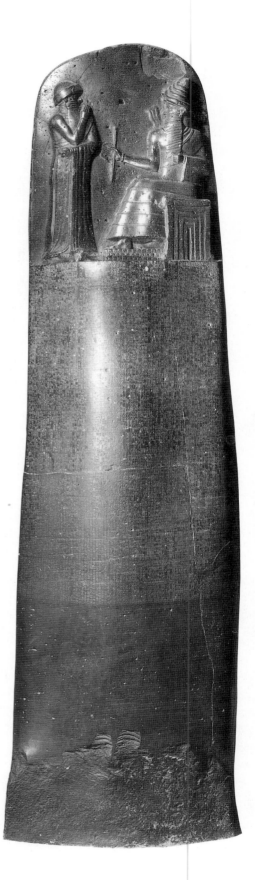

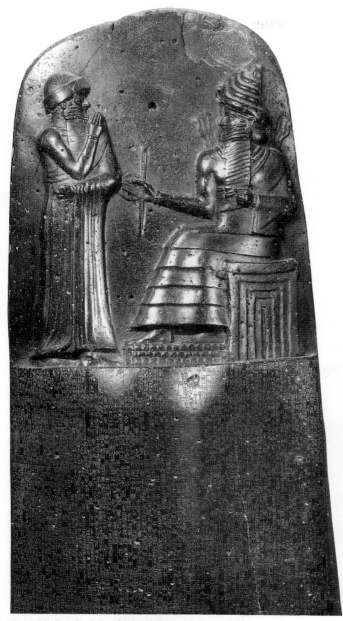

■ 1.22 Detail of the *Stele of Hammurabi* c. 1760 BC
showing (left) upper part of stele and (right) the inscription of the
Law Code

characters made by the writing tool) enabled the
Mesopotamians to engage in and transmit more com-
plex thoughts than ever before, since the abstract con-
figurations gave scope for a wider degree of variation in
expression and an economy of space.

Up until the late nineteenth century, little was
known of the communities to the west of Egypt and
Mesopotamia other than through legend. The dis-
coveries of Mycenae (by Heinrich Schliemann in 1876)
and Minoan culture (by Arthur Evans in 1900) forced
historians to reconsider the influences of these com-
munities on the development of later Greek culture.
Despite tireless research by archeologists, there is still
very little known about the two powers. Arthur Evans's
discovery of the Palace of Minos (which was apparently
so complex a configuration of rooms that it survives in

later Greek legend as the site of the labyrinth of the Minotaur) seems to date the culture from around 2000 to 1400 BC, when the community fell under the political control of the Mycenaeans and diminished as an important trading center. It appears that, unlike their Egyptian counterparts, the Minoans showed little interest in large-scale monuments. Instead, an abundance of smaller and more precious objects were produced, probably to ornament the body (see Fig. **1.23**). The same interest in decorative design can be found in contemporary wall painting, which shows an enthusiastic embrace of the forms of nature, and a vivid interest in color (see Fig. **1.24**). In the decorative beauty and celebratory character of this work, it is clear that the traditional struggle between self and world had, by 1500 BC, become increasingly harmonious and controlable.

■ 1.23 Wasp pendant from Mallia c. 1700 BC
Gold
Width 1⅞ in (4.5 cm)
Archaeological Museum, Heraklion, Crete

■ 1.24 Throne Room in the Palace of Minos, at Knossos, c. 1450 BC

▶ SUMMARY

● As this brief discussion of some 15,000 years of early civilization points out, the desire to create images with reference to experience was a major preoccupation with early artists. The examples here give a good indication of the perceived power of visual images to enhance the various communities' understanding of their place in the world—an anchor which would help them fix their identity. With each breakthrough there came a greater degree of sophistication, and with each increased degree of sophistication there came the inevitable change in the status of human beings in their world. Greater consciousness necessarily leads to introspection, and as a result the natural world is slowly subsumed into a world of human thought. This we have come to call Humanism, and that is the stuff of the next chapter.

The origins of art are situated deep within the mysterious recesses of the early human community and people's desire to express consciousness of their environment, their lives, their very humanness. Though today we can only posit reasonable hypotheses for the earliest construction of images and objects, it is apparent that such activities were central to the formation of early societies and their sense of self. With the shift from Paleolithic to Neolithic social organization, and its emphasis on more stable agricultural conditions, the scale and magnitude of art and art making increased dramatically. The result was the beginning of a binding relationship between artistic practise and the greater society's fluctuating social and political pressures. It is here that we see the rise of art as both a fundamental expression and a vivid document of the history of human culture.

Suggested Reading

Over the past two or three decades, there has been a dramatic re-evaluation of prehistoric and prehistoric-like cultures in both history books and anthropological surveys. Much of this is an attempt to rid older reference aids of their implicit cultural biases (as was discussed with regard to the term "primitive") and provide a fairer appraisal of the communities and their visual culture. The secret, then, is to utilize texts that are more up to date, since they are more likely to give a balanced view (a good hint for all texts you might use). Here are two suggestions: Pierre Amiet's *The Ancient Art of the Near East* (New York: Abrams, 1980) and H. A. Groenewegen-Frankfort and Bernard Ashmole's *Art of the Ancient World* (Englewood Cliffs, NJ: Prentice-Hall, 1972).

Glossary

architecture (*page 40*) Commonly defined as the art of designing space. Its roots are in the Greek "arch" (meaning higher or better) and "tecture" (meaning construction or building), but it is popularly used to address virtually all facets of the organization of spaces (landscapes and interiors, for example, as well as buildings).

audience (*page 49*) The viewer of an object who completes the process of communication between themselves, the artist, and the art, thus playing an intrinsic part of the art-making process.

cuneiform (*page 54*) A Mesopotamian script derived from pictures arranged in a narrative order named after the wedge-shaped marks created by the writing styles. Ancestor of our own script, it is the logical extension of earlier two-dimensional designs.

iconography (*page 54*) The meanings and symbolic associations attributed to a figure or idea.

intent (*page 48*) The interests of the artist as perceived by the audience, or why an artwork was made.

narrative (*page 52*) The progression of an idea from one image to another, often implying a passage of time.

primitive (*page 42*) A value judgment used to identify and label the visual artifacts produced by certain cultures in recent times as less sophisticated, and thus of poorer quality.

prehistoric (*page 42*) Meaning before historical documentation.

sculpture (*page 37*) Objects produced in the round, possessing volume and interacting with real space.

self-referentiality (*page 46*) An object or image that appears to serve no practical or obvious function, and as a result the viewer is forced to consider it in terms of its own intrinsic characteristics.

symbol (*page 52*) A set of communally accepted meanings associated with a form.

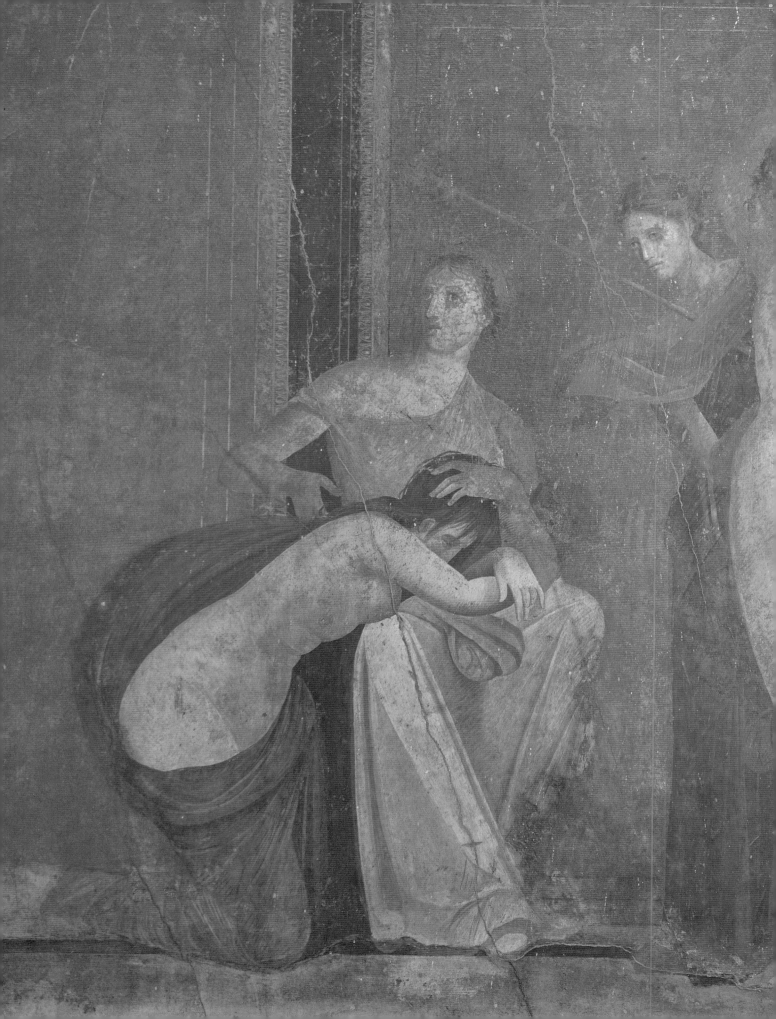

2

THE ART OF THE CLASSICAL WORLD

■ 2.1 Ritual passage into a mystery religion
Wall painting from the Villa of the Mysteries
Pompeii, mid 1st-century BC

Fair Greece! Sad relic of departed worth!
Immortal, though no more; though fallen, great!
LORD BYRON, *Childe Harold's Pilgrimage*

The word "classical" is often used to convey "authentic," "a standard of excellence," or "a work of enduring importance." Given these parameters, one might consider it suitable for a specific work of art, such as Shakespeare's *Hamlet* or Handel's *Messiah*—two pieces that have continued to inspire audiences for centuries. But if an entire era is to be described as classical it is necessary that a series of truly extraordinary events takes place within the context of an historical period, and further that later cultures accept such ideas and documents as a standard against which others are tested. It is in this context that the Western world has come to understand the societies of ancient Greece and Rome, and it is as a result of such admiration that today they are embraced as Classical.

It is virtually impossible to contemplate the fate of Western art without the influence of ancient Greek and Roman culture. "Classicism" is a popular and recurring term throughout art history; in many ways it is used to describe work that attempts to evoke or resurrect standards once favored in the heyday of Greek and Roman culture. Consider this example. The term

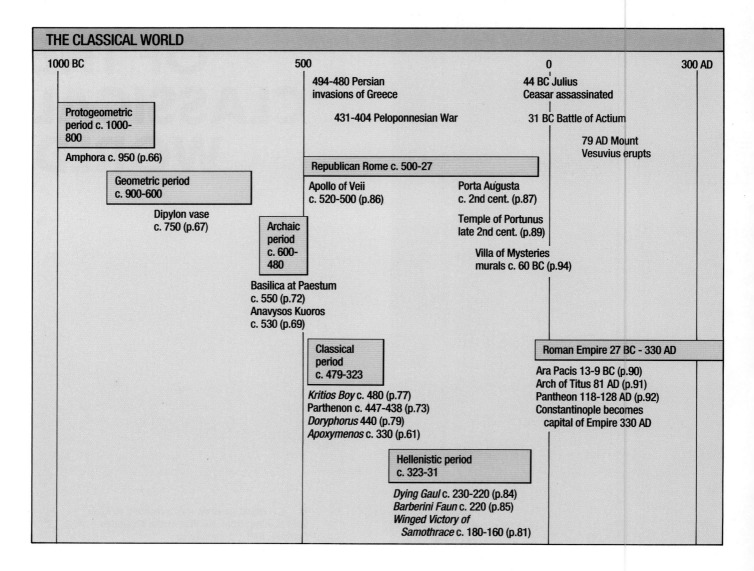

THE CLASSICAL WORLD

1000 BC 500 0 300 AD

494-480 Persian
invasions of Greece

44 BC Julius
Ceasar assassinated

431-404 Peloponnesian War

31 BC Battle of Actium

Protogeometric
period c. 1000-
800

79 AD Mount
Vesuvius erupts

Amphora c. 950 (p.66)

Republican Rome c. 500-27

Geometric period
c. 900-600

Apollo of Veii
c. 520-500 (p.86)

Porta Augusta
c. 2nd cent. (p.87)

Dipylon vase
c. 750 (p.67)

Temple of Portunus
late 2nd cent. (p.89)

Archaic
period
c. 600-
480

Villa of Mysteries
murals c. 60 BC (p.94)

Basilica at Paestum
c. 550 (p.72)
Anavysos Kuoros
c. 530 (p.69)

Classical
period
c. 479-323

Roman Empire 27 BC - 330 AD

Ara Pacis 13-9 BC (p.90)
Arch of Titus 81 AD (p.91)
Pantheon 118-128 AD (p.92)
Constantinople becomes
 capital of Empire 330 AD

Kritios Boy c. 480 (p.77)
Parthenon c. 447-438 (p.73)
Doryphorus 440 (p.79)
Apoxymenos c. 330 (p.61)

Hellenistic period
c. 323-31

Dying Gaul c. 230-220 (p.84)
Barberini Faun c. 220 (p.85)
Winged Victory of
 Samothrace c. 180-160 (p.81)

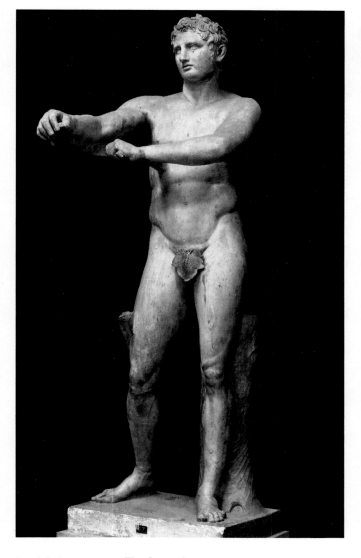

■ 2.2 *Apoxyomenos* (The Scraper)
Roman copy of original Greek bronze c. 330 BC by Lysippus
Marble
Height 6 ft 9 in (2.05 m)
Vatican Museums, Rome

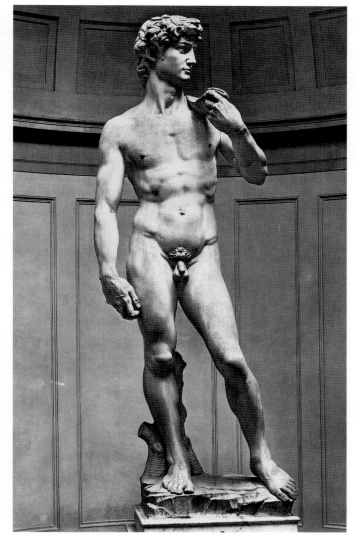

■ 2.3 Michelangelo Buonarroti
David 1501–4
Marble
Height 14 ft 3 in (4.34 m)
Galleria dell'Accademia, Florence

"Renaissance" (which literally means "rebirth") is commonly used to identify a cultural situation in Europe centuries removed from the Classical era, when the ideas and art forms of ancient Greece and Rome were emulated, and discussions of quality were inevitably based on those standards. Compare Lysippus' *Apoxyomenos* (The Scraper) of *c.* 330 BC (Fig. **2.2**) with Michelangelo's *David* (Fig. **2.3**) of 1501–4. This may give some indication of the breadth of influence Classical culture has had on later thought. Yet it also accentu-

ates this book's working premise that all art embodies ideas—and in this way quality can be seen not as some static code but as the relevance of a particular idea to a given situation. If this is indeed the case, then what is there inherent in Classical culture that has continued to inspire artists for centuries? And further, what does this obsession tell us about any absolute notion of quality in art? In attempting to address these issues, this chapter will, in the process, develop some basic foundations for later discussions on Western art.

▶ THE ART AND IDEAS OF ANCIENT GREECE

● The history of ancient Greece spans a considerable period of human history, from its beginnings in the Iron Age culture of Athens around 1000 BC to its demise in 146 BC with the sack of Corinth, which marked complete Roman control of the area (see Fig. **2.4**). Between these two dates there rose a civilization of considerable energy and sophistication, the likes of which, it has often been argued, have never been seen again. Yet why is it that Western society has historically embraced the art of Greece as a standard of quality, and is a society's political and intellectual sophistication necessarily any indication of the relative merits of its art? These are questions worth considering, for if art has no specific relationship to other issues, it is irrelevant. It is incumbent upon any student of Western civilization to consider fully the weight Classical concepts such as freedom and Humanism have exerted throughout history—ideas embodied in its art and culture. As this chapter will point out, Greek art is about the human condition and its social organization, and in this way it differs distinctly from civilizations where art was confined to religious ceremony, ritual objects, and the burial chamber.

There are three basic concepts which form the foundations of our understanding of Greek art: movement toward greater naturalism, a preoccupation with form and proportion, and the prominence of the human figure. In Greek art, human actions are carried out by gods and heroes who, for the most part, look and behave like human beings—compare Praxiteles'

■ 2.4 The Classical World showing sites and cities

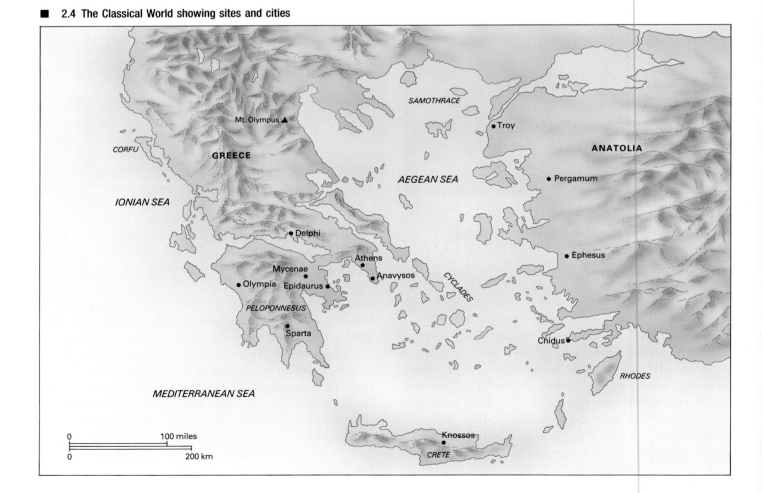

■ 2.5 Praxiteles
Aphrodite of Cyrene
Roman copy of 4th century AD original
Height 5 ft (1.52 m)
Museo Nazionale Romano, Rome

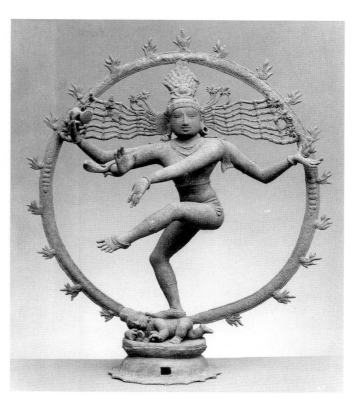

■ 2.6 *Shiva Nataraja, Lord of the Dance* c. 1000 AD
Early Chola Dynasty
Bronze
The Metropolitan Museum of Art
Harris Brisbane Dick Fund, 1964

Aphrodite of Cyrene (Fig. **2.5**) with the *Shiva Nataraja, Lord of the Dance* (see Fig. **2.6**), of the Hindu tradition. Unlike their contemporaries in other cultures, the gods were almost always depicted in human form—though notably idealized. In other words, one immediately recognizes these images as derived from the human figure, but it is safe to assume that the average citizen of ancient Athens or Cornith possessed far less inspired features. Like the super-heroes of today's comic books, these figures were "idealized" to imbue them with a greater degree of stature and significance. In this way, the imagery addresses not so much the specific attributes of an individual as the more universal characteristics of the human form as accepted by the culture of the day.

It is interesting to note that there are virtually no supernatural features (such as fire-breathing or multiple limbs) used in depictions of the deities in Greek art. This clearly separates them from the work of Egypt or the Near East, where attention was usually

■ 2.7 Polyclitus's Ideal Proportions

focused on death and the supernatural experience. Further, Greek artists often depicted their figures as nudes, calling attention to the humanness of their subjects. This consciousness of the body helps accentuate the Greek culture's decisive break from other contemporary societies, where the nude was utilized primarily for erotic or ritualistic impact. In Greek society, athletes and warriors trained naked, and the body was generally admired and appreciated without any of the accompanying moralizing baggage one might have expected elsewhere. This is not to say that later viewers did not come to look at the work with some suspicion (for example, the early Christians, as will be fully explored in Chapter Three), but rather suggests that discussions of morality are often more indicative of the values of later historical periods than they are of general perversion within Greek culture.

The human body has long been used as a gauge of self in relation to the world. One interacts with the world through a variety of bodily experiences such as sight, smell, hearing, taste, and touch. Perhaps one of the least acknowledged but fundamental manners in

which individuals interact with their world is through measurement and scale. In societies before the Greeks, the comparison of the figure to external stimuli such as trees or sacred objects provided the basis for idealized measurements in art. The Greeks established an important precedent in shifting interest away from "ideal measurement" to that of "perfect proportion." How are these different? It is true that both provide the artist with a set of assumed notions about the figure—pictorial standards formed outside the experience of the individual in question. What is different about the two concepts is the degree to which they are based on a desire for internal harmony. Ideal measurements can come from whatever set of natural or supernatural sources is deemed important to that community. Consider the Bible story of Noah's Ark, where God dictated that the vessel should be 300 cubits long, by 50 wide and 30 high—a cubit corresponding to the length of the human forearm from elbow to the tip of the middle finger. These standards provide vital information on the relative dimensions of the piece with regard to the human body, yet say little about how such

measurements corresponded to any greater principle of harmony. In Greece, emphasis was placed less on standards than on the interrelationships within human experience. Proportion supports the idea of an internal harmony, rather than imposing sets of standards or restrictions which are gathered from external or arbitrary considerations (see Fig. **2.7**). In short, the movement toward perfect proportion in Greek art coincides with the community's increasing self-consciousness—a disposition evident in almost every aspect of Greek cultural life.

The problem of representation is perhaps the most crucial feature in the understanding of Greek art and ideas. As the discussion of the Classical age continues, it will become increasingly apparent that its art shows a distinct and undeniable move toward greater naturalism, or what is sometimes inappropriately described as "realism." What exactly is realism in art? On the surface, the description appears simple enough, but implicit in such a term is both the idea that we as a human community understand the nature of reality, and that art is about representing this truth. Is that what Greek artists were attempting to do when they produced images such as *The Scraper* (Fig. **2.2**)? The question of representation is a tricky one, yet it has had a profound influence on the way we view art—and continues to do so today. As such, a short digression into the nature of realism and naturalism is perhaps in order.

If one accepts the premise that realism is an attempt to imitate experience or "reality," then one thing that is certain is that cold marble is nothing like warm flesh. So in this respect the Classical sculptor is a poor conductor of reality. And if the sculptor fails to achieve reality, the painter is even further diluted, since his/her world of three dimensions is a complete illusion. Given this, it is highly doubtful that such artists actually saw themselves creating reality. But if this was the case, then why did so many attempt to represent the world in such an exact manner? Obviously, there was at least some

intent on the part of Classical artists to sculpt, paint, and create architecture with overt references to the world of everyday experience, and if one concedes that this consistency is not the result of a series of random acts, then it is difficult not to conclude that the subjects in question must have related to a variety of ideas about life in general. Reality, then, is a commonly held understanding about one's position in the world, and the art of reality is an expression of those concepts—and not a static truth. In this sense, most visual artifacts address the nature of reality as seen through the eyes of an historical period. So, in further discussions of images and objects that correspond to the world of everyday perception, this text will use the term naturalism.

The movement toward greater representational accuracy is certainly one of the most interesting and important developments in Greek art. Today, the very act of "looking" at an object before drawing, sculpting, or painting its image may seem so ridiculously simple that one takes for granted the important shift of consciousness that must necessarily have taken place on the part of the artist. Why did this notion of deliberate representation seldom occur in art until Classical Greece? One feasible answer to this historical riddle can be found in the changing relationship between gods and humans in Greek communities during the period. In Greek society, the movement toward greater representation implies less reliance on the role and interference of deities in everyday events. In other words, as Greek society began to take greater responsibility for its affairs, it left the gods to represent the community's history and ideals. In other words, the gods figured less in everyday events. Predictably, then, the monster-like images of the pre-Greek age gave way to greater glorification of the human condition, reaching its height in the natural form. It is within this context that the shift toward representation becomes clear, reflecting the society's greater degree of independence from the awesome and inexplicable powers that generated earlier art.

▶ THE ORIGINS OF GREEK ART: 1000–600 BC

● In the preliminary discussion on Classical Greece, readers might have got the impression that the Greeks were a unified community. In reality, nothing could be further from the truth. The geography of Greece is severe, and its mountainous terrain made the transport of peoples and ideas initially difficult. By 1000 BC, the powerful Mycenaean empire had collapsed, leaving these Greek communities to fend for themselves. Each area, isolated from its neighbors by physical obstacles, slowly developed its own centralized governing structure. As peace continued, so too did these ''city-states'' flourish, creating in their wake an unprecedented degree of wealth and autonomy in the area.

POTTERY

To put it mildly, the beginnings of Greek art were neither particularly auspicious nor inspiring. The best surviving examples of early Greek art come in the form of pottery, which served the practical function of holding items or liquids. Though the construction of these vessels is in itself fascinating and worthy of attention, it is the decoration on their surface that most interests us as viewers. One of the earliest surviving vessels from the beginnings of Greek culture is an amphora (a storage jar with two handles protruding from either side of the neck) dating from *c.* 950 BC (Fig. **2.8**). Pottery

■ 2.8 Protogeometric amphora c. 950 BC
Clay
Height 21¾ in (56 cm)
Kerameikos Museum, Athens

■ 2.9 Geometric pitcher c. 800 BC
Clay
Height 31¼ in (80 cm)
National Archaeological Museum, Athens

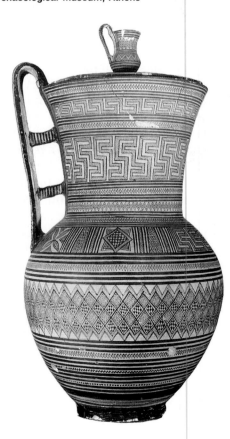

from this initial era in Greek art is termed "protogeometric" in that its decoration signals the rise of the more obsessive geometric stylings that would soon follow. By 800 BC, the simple designs of the earlier age had given way to more complex configurations. Semicircles and circles now blossom into zigzags, checkerboards, and a variety of maze-like meanders. The obsessive quality of this work (Fig. **2.9**) is mind-boggling, suggesting that the early artists were searching for a way to bring some form of subject matter into the monotony of earlier surfaces.

An important development in Greek pottery came in the eighth century BC, when human figures began to appear within these dense geometric patterns. This development signaled the rise of human content in Greek art—a subject that has preoccupied Western art ever since. The famed Dipylon vase (Fig. **2.10**) of *c.* 750 BC is one of the earlier surviving examples of the figurative motif in Greek art. The stylized silhouettes (Fig. **2.11**) mark a subtle but decisive break from the earlier geometric decorations, allowing artists the opportunity to use the pottery surfaces to indulge in storytelling. Like our present-day stick figures, these early attempts are more a shorthand suggestion of the body than a definitive representation, but they nonetheless serve the important function of describing an event in time and space—the beginnings of recognizable subject matter in Greek art.

■ **2.10 Dipylon vase (Attic geometric amphora) c. 750 BC**
Clay
Height 59 in (150 cm)
National Archaeological Museum, Athens

■ **2.11 Detail of Dipylon vase c. 750 BC showing stylized silhouettes**

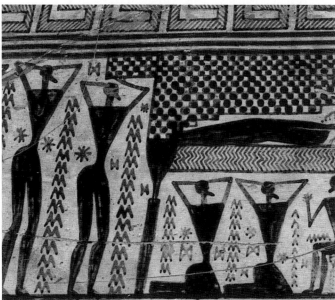

SCULPTURE

Sculpture has long been considered one of the most significant achievements in Classical Greek culture. As was mentioned in the Introduction, one of the goals of this book is to examine accepted truths such as this and attempt to uncover the context from which these opinions emerge. Greek sculpture is a case in point. First, think of some practical considerations. Unlike other visual artifacts, such as painting, traditional sculpture was produced in either bronze or stone, both of which are capable of surviving years, even centuries, in harsh environmental conditions. The very survival of these sculptures inevitably leads to their acceptance as a representation of the age, and thus their images become part of one's collective cultural vocabulary (and are seen in every introductory text!). Our current knowledge of Greek art comes from the study of these surviving artifacts and supporting documentation, so it is not outlandish to speculate that our present consensus on the aims and ideas of Greek art is only partially accurate. For instance, it is certain that painting played a significant role in Greek culture (period texts warmly praise certain paintings), but the lack of surviving examples makes it difficult to speculate on the intent of the artists.

As was mentioned in the discussion of the Dipylon vase (Fig. **2.10**), figurative art emerged in Greece around the eighth century BC as a logical extension of the earlier decorative motifs. During the eighth and seventh centuries, the Greek city-states began to establish important trade links throughout the Mediterranean region, which in turn stabilized the economies of the area. One such influential trading partner was Egypt—a kingdom with a significant legacy of outstanding visual monuments and images. The migration of Greek settlers to the region allowed for a certain degree of cross-fertilization between cultures. It is from this source one can see the origins of Greek sculpture.

The earliest surviving Greek statuary pays direct homage to contemporary Egyptian cult figures, though with some notable exceptions like the *Kouros* (Fig. **2.12**) of *c.* 600 BC. Such stone figures as these (the female types are called "Kore," the male "Kouros") exhibit many of the same generic features as the earlier Egyptian models, including a stiff frontal posture and relatively little articulation of joints. Most likely used as funerary monuments for cemeteries, the figures do

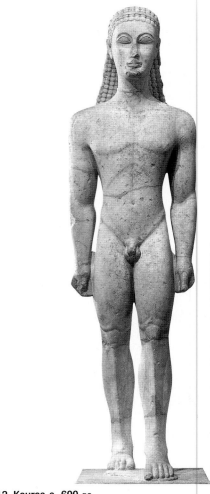

■ **2.12 Kouros c. 600 BC**
Island marble
Height 6ft 1½ in (1.87 m)
The Metropolitan Museum of Art
Fletcher Fund, 1932 (32.11.1)

possess a degree of suggested motion in their clenched fists and advanced legs. These forms, which keep a certain visual connection to their original block shape, are generally identified as "closed-form" sculpture; "open-form" is work that engages its surrounding space as an extension of the sculpture—an issue in later Greek work. Yet even in its infancy, Greek sculpture exerts a certain degree of body awareness; the description of the musculature and the nudity of these figures mark a dramatic departure from their Egyptian ancestry. This shift of consciousness on the part of Greek artists was to pave the way for a series of remarkable investigations in the following two centuries. And it was here that the revolution toward representation occurred.

▶ ARCHAIC ART: 600–480 BC

● The period between 600 and 480 BC saw unprecedented movement in Greek culture, including its visual artifacts. The so-called "Archaic era" (archaic meaning belonging to an earlier or outdated period) has unfortunate connotations of inferior quality, yet it remains crucial to the formation of Greek art. As is almost always the case, the revolution in art coincided with some equally important social changes that took place in the various Greek communities. The successes of trade and commerce within the area brought into existence a whole new merchant class, which in turn took power away from the earlier hereditary rulers. With such political change came an increased emphasis on the economy, a concern for personal prosperity, and the development of a certain intellectual freedom, giving individuals a sense of control over their destiny. This concept of "freedom" corresponds nicely with the changes that were taking place in Greek art, where depictions of humans were characterized by a similar loosening of restrictions—one of those frequent cases when it is possible to ask whether art mimics life or life art. Perhaps it will suffice to say that something was in the air, and both culture and politics were inevitable expressions of this changing climate.

SCULPTURE

The Anavysos Kouros (Fig. **2.13**) of *c.* 530 BC embodies the new sense of artistic individuality that permeated sixth-century Greek culture. The pose is certainly reminiscent of the earlier Kouros statues; the Archaic convention of engaging the viewer's space by projecting the figure's leg forward (implying movement toward the viewer, as if walking) is still present as a way of diminishing the closed-form nature of earlier stone figures, and the face remains stylized and impenetrable. There is, nevertheless, a noteworthy difference in the handling of the body. Here the anatomy is conceived with a degree of accuracy impossible without keen observation—a significant conceptual shift on behalf of the artist, who must move from a reliance on traditional formulas or conventions for the description of the body to observation from life. A good example of this reconsidering of previous conventional codes toward a more naturalistic image can easily be seen in

the comparison of "head to total height" ratios between the *"New York"* Kouros (Fig. **2.12**) and Anavysos Kouros (Fig. **2.13**) figures; the earlier presents a somewhat stunted and overexaggerated presence of the head in its 1:6 ratio, while the latter's 1:7 is much more in keeping with human proportions as we generally experience them.

■ **2.13 Anavysos Kouros c. 530 BC**
Marble
Height 6 ft 4 in (1.93 m)
National Archaeological Museum, Athens

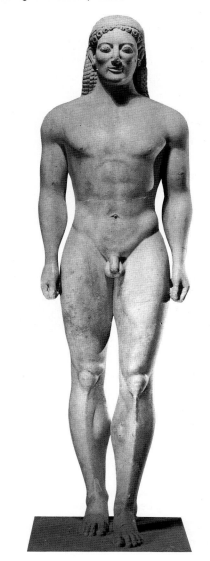

VASE PAINTING

A similar move toward greater representational accuracy occurs in vase painting during the period, and it supports our claim that any idea as important as freedom will find its expression in a variety of materials and techniques. By the middle of the sixth century BC, rigid geometric designs had slowly given way to more suggestive descriptions of the human form. But it was not until the end of the century that artists were finally able to free their figures from the flatness of the pottery surfaces. The turning point came with the introduction of the "red figure style," a simple inversion of the previous "black figure style." As the first examples of Greek vase painting attest, figure forms were painted in black slip on the terracotta surface. The result was a series of silhouette figures situated on a clay background (which was often red or orange after firing). This technique found its most profound expression in the hands of artists such as Exekias, whose figures show a remarkable degree of subtlety—particularly consider-

◀ 2.14 Exekias
The Suicide of Ajax c. 525 BC
Black figure vase
Height 21 in (54 cm)
Musée des Beaux Arts, Boulogne

■ 2.15 Skyphos by Hieron, painted by Makron showing Paris abducting Helen, c. 500–480 BC
Height 8½ in (21.5 cm)
Museum of Fine Arts, Boston
Francis Bartlett Donation

ing the obvious restrictions of the technique (see Fig. **2.14**). For forward-looking artists, the problem of such a style lay in the solid silhouettes' inability to suggest much illusion of volume or detail, so consequently they looked rather flat. Earlier artists had attempted to scrape back into the figures with a sharp stylus to create linear effects, but the technique was awkward and often resulted in stiff and unconvincing images. The answer came in the simple reversal of "figure" and "ground" colors, where the background terracotta was now painted black, leaving the figures open. Today, the terms figure and ground are often used to describe the relationship that necessarily exists between an object (figure) and its environment (ground), or the interaction of objects and space on a flat plane. This advance enabled artists to use a brush to describe the interior features of the form, instead of the previous reliance on an awkward scraping tool. A good example of the obvious advantages afforded by such an inversion can be seen on an Athenian cup, Skyphos by Hieron (Fig. **2.15**), painted by the artist Makron in *c.* 500–480 BC. Here the artist has capably depicted a rather complex arrangement of parts by utilizing a range of descriptive devices available through the new freedom of open red figures. Much like the strides being made in sculpture during the period, the red figure innovation in vase painting can be seen as yet another expression of an increasing self-confidence on the part of the early Greek society.

ARCHITECTURE

Sculpture and vase painting were not the only visual arts to exhibit dramatic movement during the Archaic era. The increased prosperity and expansion of the Greek states brought about a vast array of impressive building projects. Peering through the looking glass of history, there is certainly no shortage of examples of societies where economic stability has expressed itself in the desire to build monuments. Human beings instinctively seek out the secure and the stable, looking for anchors in a crisis-ridden world. Stability in turn grants us a sense of place and contact with our immediate community, and it is in this type of situation that individuals function most productively. Given this natural inclination, architecture becomes much more than simply a way of designing a building. As a stable structure and a focus for the community, it inevitably expresses certain truths about that community.

Up until the seventh century BC, it appears that the little architecture produced in Greece was constructed from crude and impermanent building materials such as mud, grass thatching, and undressed stone. This is of course speculation since none of it remains today, but had more sophisticated constructions and techniques developed, they would in all probability have survived. With increased trade and commerce from abroad, the Greek world was brought into direct contact with the impressive civilizations of Egypt and Mesopotamia—both of which had long-established building programs. Soon, economic prosperity gave the Greek cities the resources to compete on a similar level, leading to the development of a monumental building style.

The first specifically Greek style of architecture to emerge during the later part of the Archaic era was the austere Doric order, which had its roots in an earlier timber post and lintel design (see Fig. **2.16**). Like the older timber forms (which were essentially long sections of fallen tree propped up to support an overhang)

■ **2.16 Components of the Doric order**

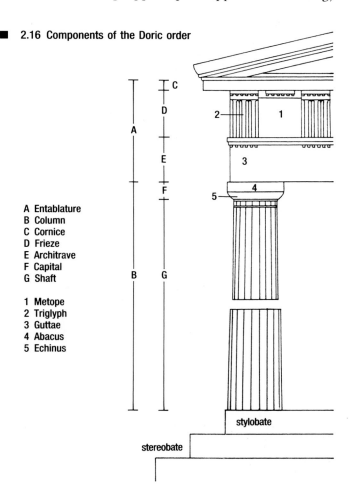

A Entablature
B Column
C Cornice
D Frieze
E Architrave
F Capital
G Shaft

1 Metope
2 Triglyph
3 Guttae
4 Abacus
5 Echinus

stylobate

stereobate

Doric columns rest directly on the floor or "stylobate," and taper like tree trunks as they move upwards. The top or head of the column (called the "capital") convincingly mediates between the cylindrical shape of the column and the angular forms of the supporting structure. It does so by utilizing a flattened funnel shape which ascends into a squared block—a subtle but important visual transition between the column and the "entablature." The entablature is comprised of three distinct parts. The band of rectangular blocks immediately supported by the columns is called the "architrave." Above it stands the "frieze," which consists of alternating blocks of relief sculpture or painting (the "metope") and vertical bands (the "triglyph"). Above this is the "cornice," on which sits the crowning "pediment," a triangular shaped construction which forms the roof. This was to be the standard from which all other variations of Classical building design would emerge.

What kind of an effect does such a design have on a building? The Basilica at Paestum (Fig. **2.17**), which dates from *c.* 550 BC, is one of the oldest surviving examples of the Doric order, and it grants some basic insights into the fundamental visual characteristics of that style. Almost immediately one senses a burden of weightiness, emphasized by the relationship between the columns and entablature. As has already been said, the shape of the Doric column is probably derived from the natural upwards tapering of timber, but this example demonstrates how early attempts at mimicking the lightness of organic forms often had the opposite effect. Here, the columns appear visually compressed by the burden they support. But as the Doric order became a more frequent choice of architectural arrangement, this squat quality seems to have been curtailed somewhat as builders became more aware of the strength and structural possibilities afforded by the design. Thus such initial visual problems can probably be attributed to structural overcompensation; the architects simply did not trust thin columns to hold up

■ 2.17 Basilica at Paestum, Italy, c. 550 BC

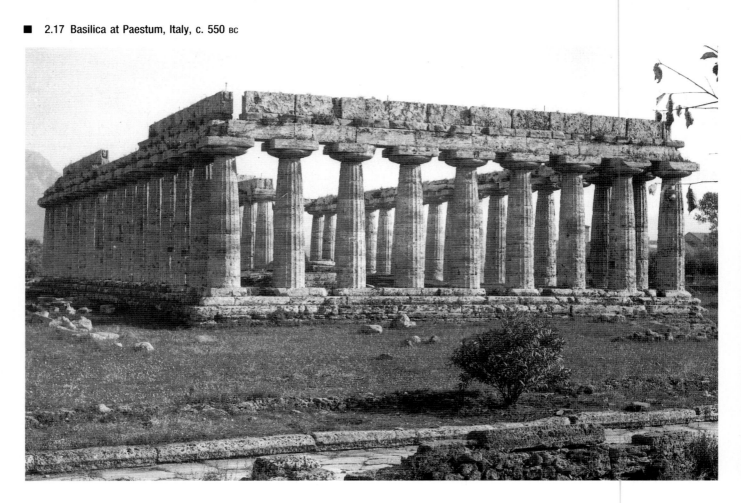

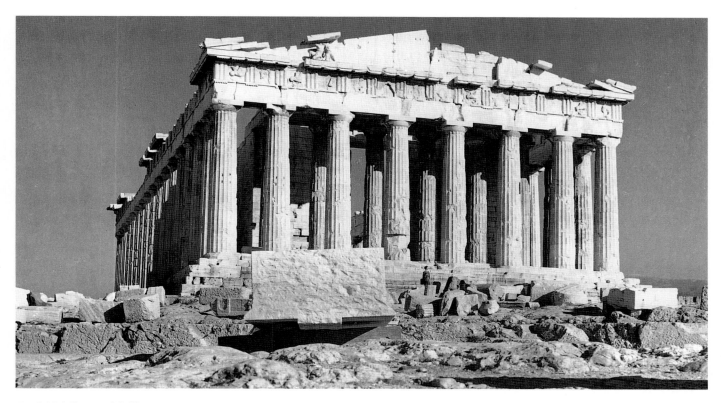

■ 2.18 Ictinus and Callicrates
The Parthenon 447–438 BC
Acropolis, Athens

■ 2.19 The Parthenon 447–438 BC showing a close up of the columns

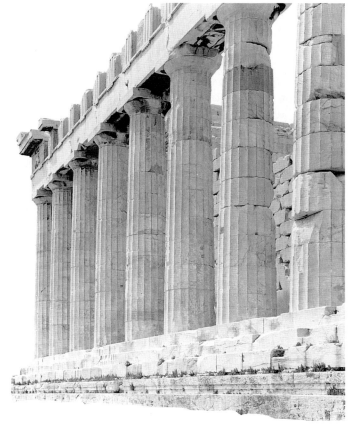

the heavy entablature. As the Greeks became more familiar with the properties of stone, they were better able to judge the distribution of mass over an area, giving designers more confidence in leaner column construction. The end result was a taller, more effective, and more dignified structure, which was to embody the new "Classical" era (see Figs **2.18** and **2.19**). Even 2,500 years after its inception as an architectural motif, the Doric order still inspires thoughts of integrity and austere authority—it evokes "power." And for these very reasons it has remained the preferred style for our current government buildings and banks.

THE ACROPOLIS COMPLEX

The Parthenon was constructed as a temple to Athena, the goddess of wisdom, and as such it set out consciously to embody the intellectual pursuits of mathe-

matical harmony and precision implicit in the Greek world view. Though today only a shadow of its former glory, it nonetheless exhibits symmetry, balance, and a sense of system—attributes which had evolved with the greater self-confidence of Greek community. It is in the subtleties of this design that the efforts of its creators, Ictinus and Callicrates, are most clearly illustrated. Take, for instance, the swelling curvature of the Doric columns, called the "entasis," which bulges to its thickest girth approximately one-third of the way up the cylinder form, rather than tapering predictably from the bottom of the column, as was the case with the timber-style Doric construction columns at Paestum. This design was meant to suggest connections to the human form, evoking parallels to the human hip in a standing figure. The result was a series of columns which can best be described as muscular, organic, stoic, and most certainly body-like—an extension of the very centrality of the human position in Greek thought.

If the Doric order follows predictable lines from earlier architectural traditions around the Mediterranean, then its graceful counterpart, the Ionic order (Fig. **2.20**), is firmly rooted in the East. Again, one may attribute such stylistic similarities between cultures to the increased importance of trade beyond the Mediterranean, which had initiated contacts in Persia (today Iran and Afganistan) by 500 BC. The Ionic order shares many of the same structural challenges as the older Doric style, but differs dramatically in its visual presentation. For comparison's sake, consider the visual differences between the Ionic Erechtheum (Fig. **2.21**), built between 421 and 405 BC, and its neighbor the Doric Parthenon (see Fig. **2.18**), which reside together on the Acropolis. How very different is the impression one receives from the Erechtheum. Instead of being impressed by the sense of a heavy load bearing down on the muscular Doric design, the columns in this structure appear both light and elegant. The columns give less the impression of weight than of burdenless ease, and the relaxed intersection between column and entablature almost defies the mass it must obviously endure. The double-scroll motif (called the "volute") disperses the vertical thrust of the tall and noticeably more slender columns without the awkward transition of the Doric capital, giving the entire structure a certain buoyancy. Even the relationship of the column to the floor has been reconsidered, with the insertion of a simple base. This alters the traditional "tree-like" properties of the column so evident in the Doric design

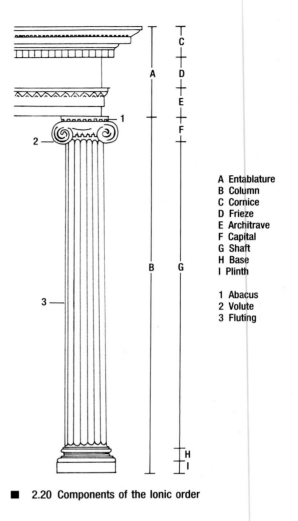

A Entablature
B Column
C Cornice
D Frieze
E Architrave
F Capital
G Shaft
H Base
I Plinth

1 Abacus
2 Volute
3 Fluting

■ 2.20 Components of the Ionic order

(remember that the older timber design derives from the natural orientation of the tree, which rises vertically from the ground and tapers). Having said this, it is quite probable that the volute design was derived from the palm or another organic element, since the Persians and Egyptians often used floral and vegetal designs in their architecture and art. When compared to its cousin the Doric order, human associations are once again obvious, but the suggestion appears more stereotypically feminine, with its softer curves and gentle transitions—a point not lost on the Greeks. One of the most fascinating designs to emerge with regard to this bodily association is the Porch of the Maidens (Fig. **2.22**), which stands attached to the very same Erechtheum. Here the implicit reference to the human body becomes explicit in the carved human supports, echoing one's own basic and intrinsic relationship to the world.

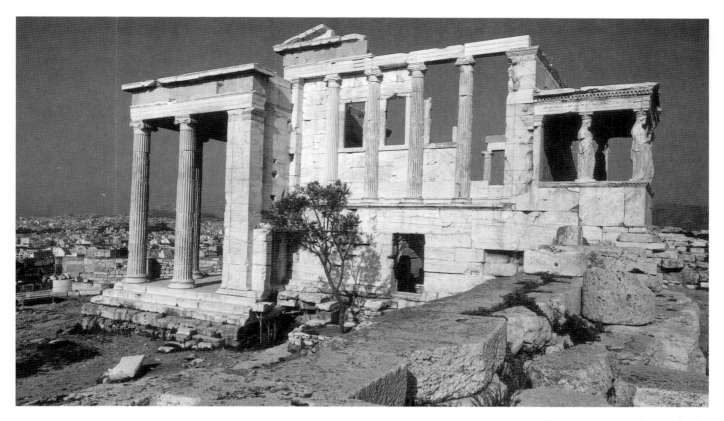

■ 2.21 The Erechtheum 412–405 BC
Acropolis, Athens

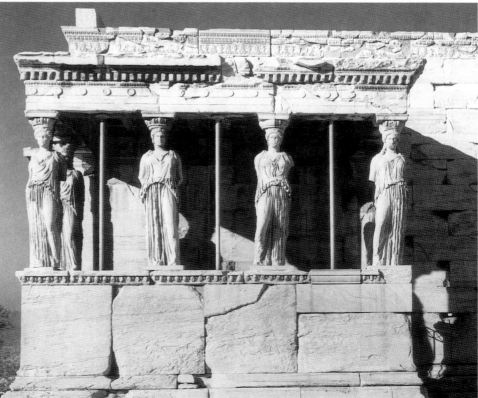

■ 2.22 The Porch of the Maidens
from the Erechtheum 412–405 BC

▶ CLASSICAL SCULPTURE: 479–323 BC

● Nowhere is the Greek notion of freedom and self-confidence better illustrated than in the remarkable achievements of sculpture between 479 and 323 BC (the period commonly referred to as the Classical age). From 494 to 480 BC, the Greek states suffered two attacks at the hands of Persian forces—first under Darius (whose armies were defeated by the Athenians at the famous Battle of Marathon) and then by his son Xerxes. Before falling in defeat, the Persians successfully captured and sacked Athens, and in the process destroyed most of the previous era's monuments. With little left standing, the Athenians initiated an enormous rebuilding program, culminating in vast enterprises such as the new Acropolis complex. But to get a clearer sense of the vitality that captivated post-Persian Wars Greece (and in particular Athens), it is to sculpture one must turn.

We left our discussion of sculpture with the various attempts of artists to instill "life" into the traditional Kore and Kouros figures, which probably originated in Egypt. One of the breakthrough achievements of the early fifth century BC is a marble figure popularly known as the *Kritios Boy* (Fig. **2.23**). The sculpture was partially destroyed during the Persian destruction of Athens, and later rather clumsily restored. Very recent conservation work has now stripped away the later accretions and we can now see the work of the classical sculptor unadorned. Rarely in the history of art will one find an individual artifact that so clearly embodies the shifting consciousness of its age—which reiterates the working premise of this book that art is an idea best understood within its historical context.

Comparisons are often helpful. Look back to Fig. **2.13**, the Anavysos Kouros of 530 BC, and notice the changes that have taken place over a fifty-year time span. One might generally describe the *Kritios Boy* as a more naturalistic representation of the human form in space. This can be partially attributed to the relaxation of the stiff frontal pose of the earlier Kouros pieces, and is a conscious attempt to activate the figure in its surrounding space. The head and body twist slightly, and the weight of the body shifts onto the back leg, allowing the front leg to rest free. This combination of free and engaged leg would later come to be known as

the "contrapposto" pose in Renaissance art, and has subsequently been endowed with enormous significance as an embodiment of Western values in visual culture. But, for the time being, it is sufficient simply to say that within the context of Greek art, the subtle twisting and shifting of weight appears to be a comfortable and natural posture for a human, and thus one tends to attribute specifically human characteristics to the art piece.

Another difference worthy of mention is the pensive expression of the *Kritios Boy*. Gone is the broad smile that typifies so much of the earlier work, and in its place there is a discernible meditative quality. To some degree, this shift of sensibility can be attributed to a keener observation of the human face, as artists began to rely more on the study of specific nuances of the form and less on previously established generalizations. Take, for example, the mouth. In earlier Archaic sculpture, the human lips were represented as two symmetrically arranged parts, the top lip mirroring the bottom. This balanced design is what causes the so-called "Archaic smile" evident in much of the period's sculpture—a convention based on earlier abstractions of the human form rather than on observation (since the upper and lower lips are not identical in humans). In general, the *Kritios Boy* exhibits a degree of anatomical inspection noticeably absent in previous figurative sculpture, and this is particularly evident in areas such as the joints. No longer is the human form rendered as a stiff, inflexible corpse; instead, the keen observation of the intersections of parts in the human body (joints such as the knees, hips, and shoulders) suggests elasticity and dynamism, as well as introspection and concentration on the part of the artist. Some scholars point to this change as an indication of a greater degree of introspection on the part of all Greek citizens with regard to their position in the world, as they entered a period of war (the Persian Wars were probably in progress when the *Kritios Boy* was produced), while others see such observation as a natural result of increasing Greek interest in the science of the human form. In any event, there emerged with the *Kritios Boy* a new manner of perceiving the body in three dimensions.

■ **2.23** *Kritios Boy* c. 480 BC
Marble
Height 2 ft 9 in (0.85 m)
Acropolis Museum, Athens

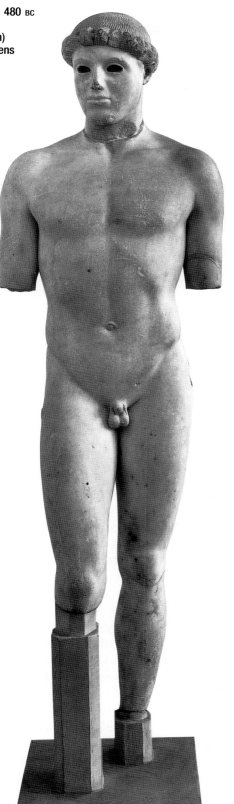

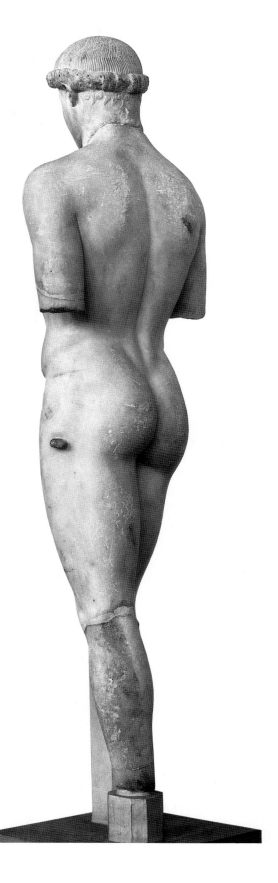

■ 2.24 Myron
Discobolos c. 450 BC
Roman copy of bronze original
Marble
Height 5 ft (1.52 m)
Museo Nazionale Romano, Rome

One of the most famous represen-
tations of athletic pursuit is the *Dis-
cobolos—The Discus Thrower* (Fig. **2.24**),
which was produced by the fifth-cen-
tury Athenian sculptor Myron. Today
the work is known only from its Roman
copy, and it seems that the original was
in fact a bronze not a marble. Even so,
the intent of the artist seems clear.
Probably produced around 450 BC, it
shows the unmistakable release of the
figure from its previous closed-form
confines, the result of which is the fur-
ther dismantling of the stiff, frontal
Archaic pose in favor of a more impos-
ing gesture. As well, the modest inter-
est in anatomical accuracy noted in the
Kritios Boy achieves a degree of subtlety
and rigor in the *Discobolos*, as the twist-
ing of muscles and tendons accentuates
the stresses imposed upon the figure.
The choice of a powerful, limber athlete
as subject matter may have originally
had something to do with an actual
commission (perhaps it was to be pla-
ced outside a sporting hall), but it also
enabled the artist to indulge in a series
of observations and speculations on the
human structure as it moves through
space. Given Myron's obvious interest
in musculature and the skeletal struc-
ture, one might assume that the
Discobolos is a highly naturalistic

representation of the human form. In reality, nothing could be further from the truth. Studies by Classical scholars on the viability of the pose have found that a human could not hold such a position without painful dislocation. As well, you will note a decidedly impersonal approach to the character, indicating an interest not in the idiosyncrasies of a given model but more in the generalization of humanness based upon the observation of a number of individuals—in other words, idealization. The comparison to our present-day store mannequin is not wasted here, for there is much in common between the two types of figures. Like the mannequin, whose proportions are based more on accepted ideals of the perfect figure than on the average consumer, so too do these powerful Greek physiques conform to the contemporary standards of perfection and idealism. For both figures, then, form is determined by very obvious social and intellectual considerations.

The idealization of the human form was brought to new heights in the work of the sculptor/theoretician Polyclitus, whose *Doryphorus—The Spear Bearer* (Fig. **2.25**) was allegedly executed as a model to illustrate his theory of internal proportion in the human figure. To Polyclitus, ideal beauty was achieved through a correct understanding of internal harmony, symmetry, and balance, and around 450 BC he set out to produce a formula for the depiction of the perfect figure (see Fig. **2.7**). Now, perhaps the idea of mathematically deriving proportions for the human body seems somewhat of an indulgence for a society, but the activity had implications far exceeding the human form. For artists such as Polyclitus, beauty was not to be found in the everyday but in the abstract idea of perfection to which one aspired. Thus these sensual, powerful bodies can be understood as artistic manifestations of a pervasive Greek interest in defining their position in the world. But as we shall soon see, ideals such as harmony and balance become increasingly difficult to manage when a society's external affairs are in shambles. At the very heights of activity, there were already indications of the culture's imminent demise.

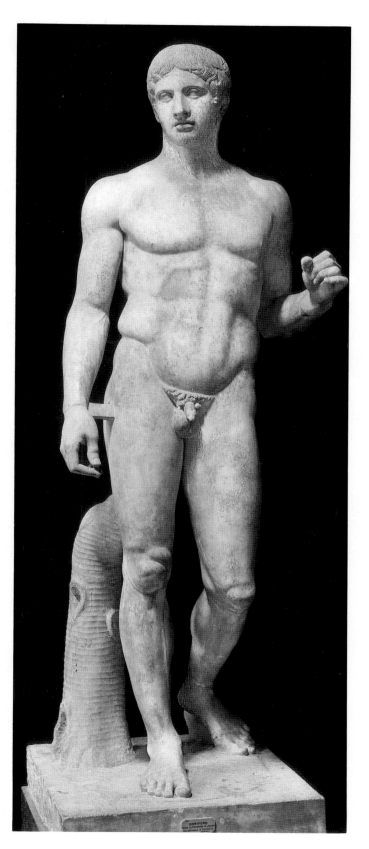

■ **2.25 Polyclitus**
Doryphorus
Roman copy after Greek original of 440 BC
Marble
Height 6 ft 6 in (1.98 m)
Museo Archeologico Nazionale, Naples

▶ PLATO AND ARISTOTLE LOOK AT ART

● There is always some difficulty in describing the ascension of Greek art as a move toward greater naturalism. Even during the fifth and fourth centuries BC, great minds contemplated the very validity of representational art. As the past few pages have illustrated, the Greek move toward representation is much more complex than a simple reproducing of visual experiences; it involves a degree of selection and discrimination that we identify as idealism. Yet the question remains, To what extent were the Greek artists consciously attempting to reproduce their tangible, visible world, and further, to what end? This issue interested the Greek philosopher Plato (427–347 BC), whose Tenth Book of *The Republic* wrestled with the legitimacy of artistic practise.

Plato describes artistic practise as an attempt to imitate the world of "sense-experience" (what one experiences through sight, smell, etc.). In Plato's world view, nature is organized in tiers, with ideal forms existing beyond the reach of human comprehension. Below these absolutes there stand poor imitations. Unfortunately for us, this is the world in which mortals live and function—the world of sense-experience. Enter the artist. Given Plato's premise that visual artists do little more than copy whatever is in front of them, they are in essence producing reproductions of reproductions. Thus the artist is responsible for creating an even less truthful description of reality, since its source is already an imitation. Plato's example of a bed might help here. He describes the reality of the bed in a descending order of truthfulness. First, there exists the "ideal" bed, which is inaccessible to humans. Next, there is the carpenter's bed—a copy of the idea of bed, but of poorer quality since it is an imitation produced by an imperfect craftsperson. Lastly, there is the artist's representation of the bed, which is based on the carpenter's bed in the world of sense-experience. It is further removed from the "real" bed, and is subsequently of the poorest quality. Thus, Plato concludes, artistic activity is a vain and lowly ambition, since it only furthers an inferior experience.

Plato was obviously suspicious of the role of the artist, and he saw his contemporaries as little more than imitators of sense-experience. But was that actually the case? In considering the sculptural examples we have viewed so far, it is hard to believe that artists were simply and arbitrarily copying from sense-experience. Concepts such as balance, harmony, and proportion often contributed to the production of art, and it seems safe to say that the artists believed themselves to be engaged in something more considered than simple reproduction. A good example is the *Doryphorus* (Fig. **2.25**), executed, as we have seen, to illustrate a theory of proportion. In this way, it might be better to equate the work of the artist with that of the carpenter who makes the bed, as the work does not derive exclusively from sense-experience but also from the world of ideas. In taking the best aspects of a number of sources and redistributing their content, the artist creates an object which aspires to true "form" rather than an imitation of an imitation. Plato simply believed that not enough art aspired to such heights, and too much was derived from inferior sources.

Later Greek philosophers such as Aristotle (384–322 BC) reworked the severe Platonic critique of visual art by attempting to reconcile representation with the contemplation of the art object. Aristotle was somewhat suspicious of Plato's metaphysical leanings, and attempted to ground art within sense-experience as a prerequisite to higher knowledge. Here art is still seen as derivative, but of the human soul rather than simply of brute experience. One might call this a watered-down metaphysics, but it is valuable because it explains our inclination to "read into" Greek art a degree of human insight that has little to do with imitation. Of course, these are issues that have perplexed thinkers for centuries, but they nonetheless give an indication of the intellectual context from which such images emerged.

▶ LATE CLASSICAL AND HELLENISTIC ART

● In 431 BC, the Peloponnesian War brought about an extended period of turmoil and chaos in Greece. When the dust settled in 404 BC, Athens had been displaced as a political, economic, and military center, though it still retained cultural significance. It wasn't until 338 BC that order was restored to the mainland, when the Macedonians (under Philip of Macedon) successfully unified most of the Greek cities. With his subsequent assassination in 336 BC, power was transferred to his energetic son Alexander (born 356/5 BC)—soon to be called "Great." Though he only survived another thirteen years, Alexander forever changed the face of Greek culture, spreading Classical civilization to the far corners of Greek territory. It is from this "Hellenization" or dissemination of Greek culture under Alexander that we give name to the era. It was to be the last gasp of energy for Greek culture, and it provided an important impetus for later developments in Roman art.

The Hellenistic age lasted less than 200 years, from

■ 2.26 *Nike—Winged Victory of Samothrace* c. 180–160 BC
Marble, height 8 ft (2.45 m), Louvre, Paris

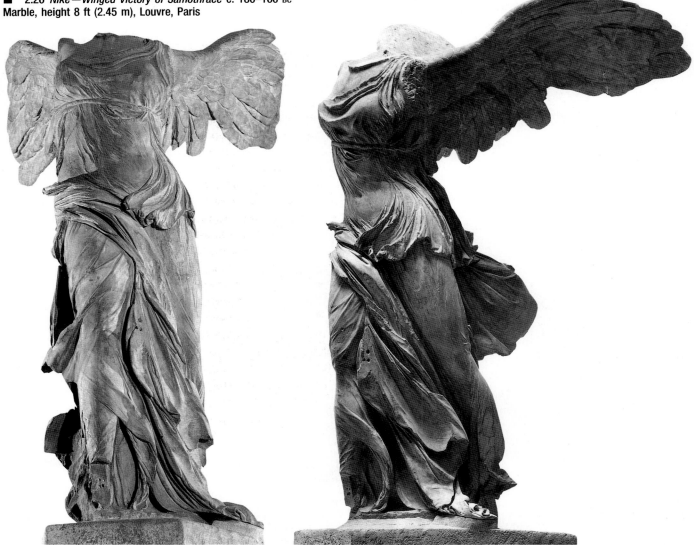

the death of Alexander the Great in 323 BC to the rise of the Roman Empire with the Battle of Actium in 31 BC. Between these two dates there emerged an identifiably different sensibility in Greek art, one which emphasized emotion over restraint, individuality over idealism, and personal patronage over the needs of the state. Changing economic and social conditions set important precedents for Hellenistic art, and one may attribute many of these dramatic changes to a shifting awareness of the artists' position in their community and the greater world of ideas.

If one were generally to attach the concepts of harmony and order to the Classical age, emotional turmoil and technical exuberance typically describe the Hellenistic period. In terms of technical prowess, there can be little doubt that Hellenistic sculptors understood the craft of stone carving better, and even took it further than earlier artists, as the dramatic *Nike— Winged Victory of Samothrace* (Fig. **2.26**) so visibly attests. These sculptors displayed considerable skill in their

■ **2.27 Statue of a Child Playing with a Goose**
Roman copy of a 3rd century BC composition
Marble
Height 2 ft 9 in (0.85 m)
Capitoline Museum, Rome

sensual depiction of clinging drapery; the expressive implication of wind raking across the body of the *Nike* only heightens one's appreciation of its vitality and movement. Though the earlier advances in proportion and balance were not lost with these artists, they were certainly offset by an equally strong interest in expressive character. Harmony, once of primary concern to Classical designers, now retreated in favor of overt dynamism, grounded more in the tangible aspects of the everyday than in the lofty concerns of Plato and Polyclitus. The delightfully unpretentious Statue of a Child Playing with a Goose (Fig. **2.27**) of the third century BC is one such example of the culture's increased grounding in the here and now, and those aspects of humanness more directly in touch with the senses. As well, the plight and fancy of the individual took on heightened significance in the subject matter of these last centuries, which may have had something to do with the new market for portraiture.

In the Classical era of Greek art, most if not all important monuments and art works were produced for public buildings and thus public consumption. The artist's patronage came directly from the oligarchy of leaders, so there developed a necessary correlation between art and the collective interests of the "demos" or free Greek people (one might go so far as to say that public patronage was the major factor behind the lofty choice of subject matter). After the death of Alexander, his Empire was quickly divided into a group of rich kingdoms, and with this came the establishment of a new ruling class and wealthy business community. It appears that few considered the Athenian attempts at democracy worthy of salvage, and patronage quickly fell into the hands of those who could afford the luxury of images and monuments. One significant result of this shift in patronage was the increased demand for portraiture, which paid reverence to the patron rather than necessarily to an idea (Fig. **2.28**).

■ **2.28 Roman portrait head of Alexander the Great**
1st half of 2nd century BC
Marble
Height 16 in (40.6 cm)
Archaeological Museum, Istanbul

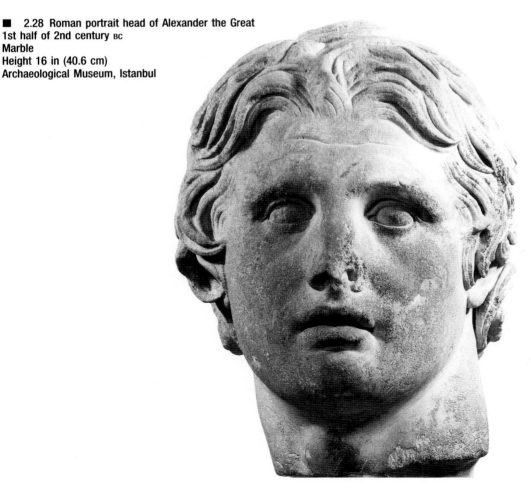

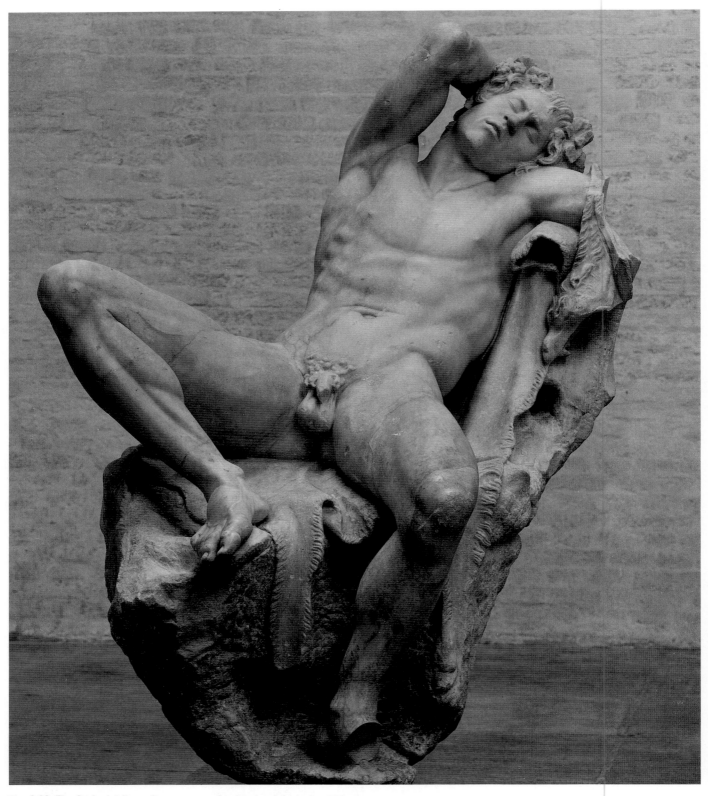

■ 2.29 *The Barberini Faun*, Roman copy of a Greek original of c. 220 BC
Marble, over lifesize, Staatliche Antikensammlungen, Munich

One of the more interesting repercussions of this new "individualization" was the range of emotions now considered worthy of depiction in art. Examples ranged from the unencumbered sensuality of *The Barberini Faun* (Fig. **2.29**) to the heroic *Dying Gaul* (Fig. **2.30**), which capture the complex nature of human experience in a much more definitive manner than the more Classical embodiments of, say, Polyclitus. Here the figure is presented not as an abstract ideal but as an embodiment of our most fragile, sensuous, and sometimes tragic experiences. This is as close as Greek culture would come to true naturalism, and it effectively characterizes the increasingly introspective and uncertain nature of the once indomitable Greek spirit.

It is popular in art history texts to define the Hellenistic period as one of moral and artistic decay, when order and discipline give way to embellishment and excess. In some ways, the period has suffered (like the Baroque era, which will be discussed at length in Chapter Five) from the general consensus that order and harmony are necessary for the production of art, rather than disquiet and emotion. It is certainly true that Hellenistic artists were adept at playing on emotions, and often this lack of subtlety leaves us with little more to admire than the sculptor's technical ability in handling marble. But we must be careful to temper these criticisms by remembering that this was a culture and a people in transition. In a world where order and idealism appeared increasingly suspect and peace was at the best of times precarious, it is certainly understandable that visual culture should exhibit a similar convulsion of ecstatic highs and introspective lows. Unable to reconcile the previous idealism with their contemporary world, artists resorted to elaborate technical formulas rather than the search for expressive new modes. Hellenistic art lacked the optimism and conviction of its predecessors, which was the belief that thought and action could result in universal harmony. And in that regard, their outlook seems sadly familiar.

■ 2.30 *Dying Gaul*
Roman copy after an original bronze c. 230–220 BC
Pergamum, Turkey
Marble, lifesize
Museo Capitoline, Rome

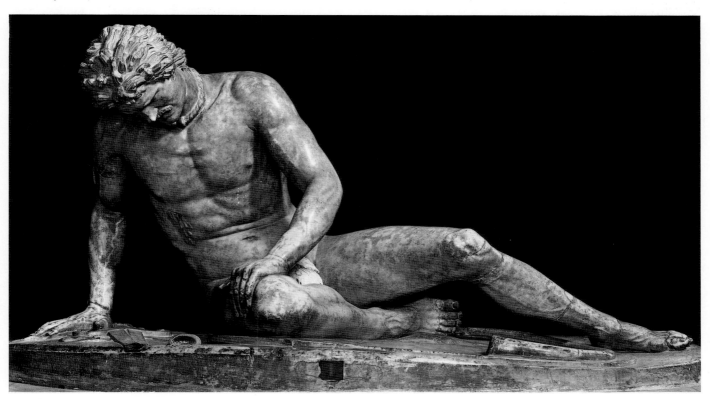

▶ THE TRANSITION TO ROME

● One of the most frequent criticisms of Greek culture was its inability to reconcile intellectual ideals with practical considerations. Even Athens, supposedly the pinnacle of Greek sophistication and democracy, was always just a stone's throw away from chaos and war. No doubt, the contributions of the Greeks to civilization are enormous and well documented, but it was the Roman Empire that insured the primary position of Classical culture in the Western tradition.

There are two primary sources for Roman culture: the Etruscan civilization and Hellenism. The Etruscans remain one of the most mysterious and least understood societies in history. It is known that by 700 BC they had established themselves in the area of northern Italy and through trade and agriculture they soon prospered. It appears that early Etruscan art possessed a tremendous degree of skill and craftsmanship, and as commercial links grew, so too did the influences on its art. Before long, aspects of contemporary Greek art began to have an impact on Etruscan design. The *Apollo* from the Portonaccio Temple in Veii, *c.* 520–500 BC (Fig. **2.31**) is an excellent example of the combined sensibilities. It most likely derives from the Kouros figures of Greece, but unlike its predecessors, this Apollo exhibits a degree of psychological power missing in the early Greek models.

The indebtedness of the Etruscans to Greek culture does not, however, end with sculpture; architectural conventions too provided the impetus for many a building program. Such was the case with the arch. Though the arch form had certainly been known to architects and builders for centuries (2,500 years earlier the Egyptians were already using it for burial chambers), the Etruscans followed the lead of the fourth-century Greek models and are credited with being the first to feel comfortable combining it in monumental architecture. The arch (as well as the vault and dome, which are derived from it) is a structural device which allows an opening in a wall, roof, etc. to exist without supports (see Fig. **2.32**). The arch consists of a series of

■ 2.31 *Apollo* from the Portonaccio Temple in Veii c. 520–500 BC
Terracotta
Height 5 ft 9 in (1.75 m)
Museo Nazionale di Villa Giulia, Rome

carefully cut stones (called "voussoirs") which butt one against another to create a semicircle. The central voussoir, called the "keystone," exerts pressure down through the arch, holding the form in place. Builders constructed such arches by way of a wooden support called a "centering," a semicircular device pushed up into the interior of the arch which kept the stones from collapsing inwards until the keystone was put in place. Despite its fragile appearance, the arch form is structurally very secure once in place, and it gave architects the ability to cover great expanses of space. This, combined with the transplanted Greek discovery of what would come to be called "opus caementicium" (concrete)—a cheap and readily available compound of materials such as sand, clay, and stone which was easy to produce and could be formed into a variety of solid forms—was to be the technical impetus behind the later great Roman building projects. The early, second-century BC Porta Augusta in Perugia (Fig. **2.33**) is an excellent example of the integration of the arch form into the environment of traditional Greek architectural orders.

■ 2.32 Arch construction

■ **2.33 The Porta Augusta, Perugia, 2nd century** BC

In 616 BC, Rome was little more than a rural outpost of Italic peoples with little to suggest such an auspicious future. It was in that year that the Etruscans began a century-long "occupation" of the city, one which would forever change the fortunes of the Western world. It is interesting to note that according to Roman tradition, the Etruscans never occupied the city but simply played a significant part in its cultural order. Others disagree, citing this view of history as little more than a form of Roman revisionism bent on preserving ethnic superiority. Whatever the case, it is clear that Etruscan involvement in the daily affairs of the city brought about unprecedented prosperity and diversity, and with it the kind of development befitting a commercial center. New trade routes were soon established, and for the first time Italic Romans were brought into contact with the outside world. Within 100 years, the Romans had successfully learned all the lessons of trade and organization from their captors, and by 510 BC had rid themselves of Etruscan influence. This was to mark the beginning of the end for the Etruscan civilization, as their once prosperous civilization slowly gave way before the aggressive Roman machine. But the legacy of emotional introspection and the love of the natural world would remain an identifiable feature of Roman culture long after the demise of the Etruscans, and it is to them that Roman art owes some of its most captivating characteristics.

The period between 510 and 44 BC saw tremendous change in Italy and the surrounding territories. Rome, becoming increasingly powerful and self-confident with each military campaign, began to occupy enormous areas of land; by the first century BC the entire Hellenistic world had fallen under its control. Local crafts remained intact, and often the very best craftspeople were sent to Rome or other important centers to engage in a vast array of building and decorative projects. This gave the general impression of a cultural continuum from Hellenistic to Roman rule, which proved itself to be a shrewd political as well as artistic maneuver.

One of the most interesting aspects of this inherited Roman art to emerge from the "Republican" (from *res publica*, or commonwealth) period, 500–27 BC, was the accepted use of art as propaganda. In previous discussions of both the Greek and Egyptian civilizations, it has become apparent that art and power are often inextricably linked; expensive art and architectural projects require tremendous financing and a large workforce,

■ 2.34 *A Patrician Holding Portrait Heads of his Ancestors* c. 15 AD
Marble, lifesize
Museo Capitoline, Rome

items often available only to the powerful. As the large-scale political regimes gave way to smaller and often less ambitious kingdoms, so too did the scale and use of the art. With the emergence of the Roman Republic, an interest in the grand project was rekindled—art and architecture that spoke of the power, majesty, and infallibility of the Republic—ideas they saw embodied in the great Hellenistic capitals of Antioch and Alexandria. During this early period, portraits were particularly popular with the patrician or ruling class as an extension of the Roman ideal of individual veneration and responsibility. *A Patrician Holding Portrait Heads of his Ancestors* (Fig. **2.34**) exhibits the peculiarities of such design; the patrician's figure is most likely a copy from Hellenistic sources, on top of which is positioned a highly naturalistic representation of the individual. Unlike the previous Greek examples of figurative sculpture, this high-ranking civic official is not at all idealized; his wrinkles and warts are very much in evidence—an obvious extension of the Roman virtue of individuality. Once again, the notion of naturalism and its representation is always a matter of contingency, never a fixed and static thing. One might say that this disposition toward the specific over the ideal or general on the part of the Romans is indicative of their aspirations as a people.

Republican architecture possesses a similar assortment of influences and innovations. One of the oldest surviving buildings from this era is the Temple of Portunus (Fig. **2.35**) in Rome, which was constructed in the late second century BC. Upon first glance, the structure appears to possess many of the attributes of earlier Greek buildings, including Ionic columns, a traditional pediment and frieze, and a design based on a sweeping 360-degree view of columns, sometimes referred to as a peripteral view. There is, however, one marked deviation from the original Greek design, and that is the use of "engaged" columns, which are actually non-structural decorations on the exterior wall. It appears the Romans inherited from their Etrusco-Italic ancestors a temple design history derived not from peripteral but frontal considerations, with conventions such as a high podium, steps located only at the front of the building, and an evident back wall—a design that gives a very specific directional character to one's interaction with the structure. The engaged column is thus a fascinating example of visual cross-fertilization and an important transitional motif between the Etrusco-Italic and Greek influences (hence the term "pseudo-peripteral" used to describe many of these structures). The engaged column effectively completes the exterior rhythm of vertical forms supporting the entablature, while keeping the wall intact—a practical solution for an eminently practical people.

■ **2.35 Temple of Portunus, Rome, late 2nd century** BC (Formerly called the Temple of Fortuna Virilis)

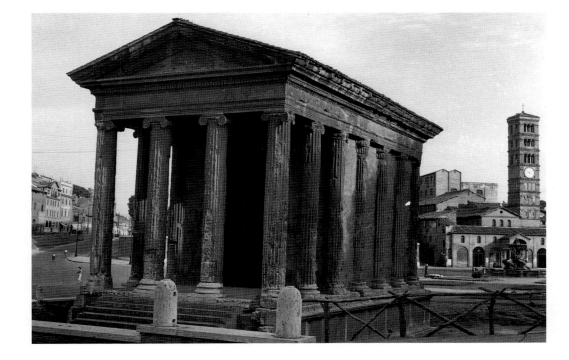

▶ AUGUSTUS AND THE EMPIRE

● In 44 BC, the assassination of Julius Caesar began a period of conflict and disorder in the Republic. Power was finally consolidated in 27 BC, when Octavian became emperor. This was to initiate a new era in the Roman world—now called the "Empire." Octavian took the name Augustus, and it was under his astute leadership that Rome reorganized, beginning what would prove to be the period of greatest prosperity in Roman history.

ARCHITECTURE

Peace and relative calm allowed Rome to concentrate on restoring pride and prestige to the regime. Soon massive building projects were begun with the aim of visually and psychologically reinforcing Roman authority. The artistic embodiment of this new regime was the Ara Pacis (Fig. **2.36**), the altar of peace. Here the delicate relief sculptures promote an image of the Empire and its leader as both pious and peace-loving

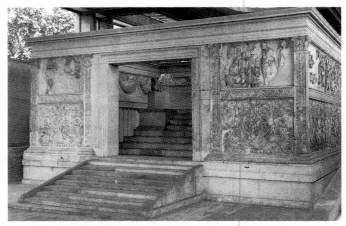

■ **2.36** Ara Pacis Augustae, Rome, 13–9 BC
Marble
Outer wall c. 34 ft 5 in × 38 ft × 23 ft
(10.5×11.6×7 m)

■ **2.37** Detail of the Ara Pacis Augustae 13–9 BC
showing the procession of the Imperial Family

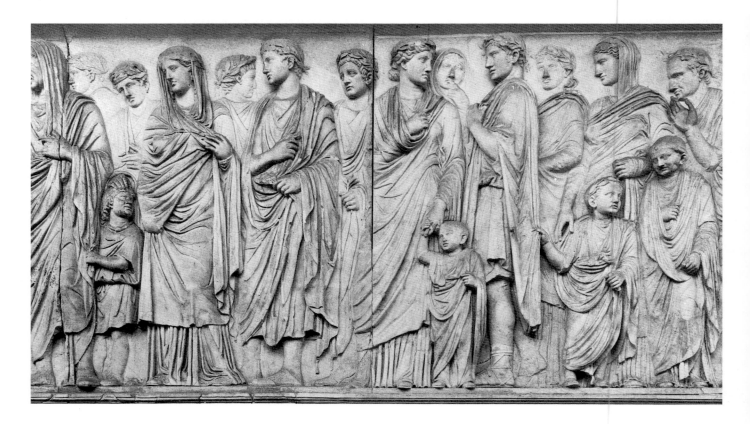

(Fig. **2.37**). Perhaps the most interesting aspect of this altar is its obvious borrowings from earlier Classical Greek sculpture. As early as 9 BC, it is clear that artists already recognized the implications of using or evoking styles of previous ages, and could successfully use them to political as well as artistic ends. The deliberate stylistic use of Classical relief sculpture gave artists (and thus Augustus himself) the opportunity to draw parallels between the lofty ideals of Athens and the aspirations of the new Empire. Yet despite the decidedly Greek overtones, the Ara Pacis remains essentially Roman in character.

To use a rather coarse but nevertheless appropriate analogy to music, if the Ara Pacis can be favorably compared to a well-crafted concerto, then the series of ceremonial arches produced after Augustus can best be described as an impressive marching band. The Arch of Titus (Fig. **2.38**) is characteristic of this popular form of monument. It takes as its source the long tradition of arch and vault construction handed down from the Etruscans, and it possesses a rather monolithic authority when set in the middle of a road. Apparently the tradition of constructing wooden and floral arches for victory parades originated much earlier, but as with much that the Romans touched, it became grander and

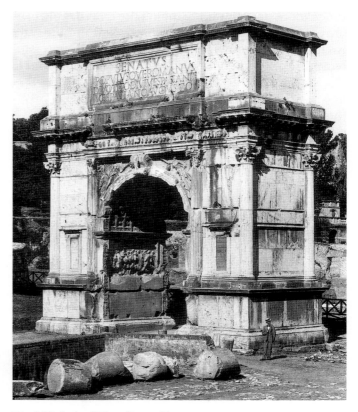

■ **2.38** Arch of Titus, Rome, 81 AD
Marble, height 47 ft 4 in (14.43 m)

■ **2.39** Detail from the Arch of Titus, 81 AD, showing the Menorah procession

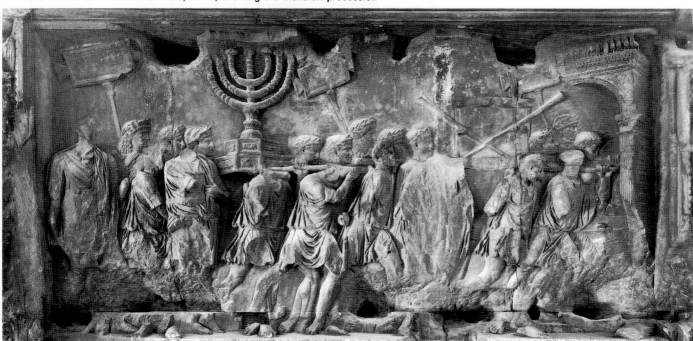

much more permanent—echoing the qualities of authority and longevity that symbolized their Empire. The Arch of Titus commemorates the Emperor's successful recapture of Jerusalem after the Jewish revolt in 66–71. The surfaces are decorated with narrative relief carvings describing the triumphal procession (Fig. **2.39**), the presentation of the spoils, and an image of Titus riding in his chariot. Like today's war memorials, these triumphal arches were erected to commemorate an event. At the height of the Empire, it is said there existed over fifty such arches within Rome's city limits.

The Pantheon (Figs **2.40** and **2.41**), built at the order of the Emperor Hadrian, is one of the greatest surviving examples of Roman engineering and architecture. It is one of only a very few examples of dome construction that remain intact from the days of the Empire, and it gives an indication of the immense power of vault architecture. The structure was built as a temple to all the Roman gods (pantheon means "every god") and thus possesses a number of significant attributes considered fundamental to the Roman world view. The "oculus" (a small circular opening at the very center of the dome) is one such example of the happy marriage of structural interests and the need to embody ideas; it is suggestive of the eye of Jupiter, who orders the world, while having the practical function of illuminating the interior space.

In terms of technical innovation, a dome is simply the intersection of a number of arches arranged around a central axis (an arch rotated 180 degrees), and thus is a

■ **2.40 The Pantheon, Rome c. 118–28** AD
Height of Portico 59 ft (17.98 m)

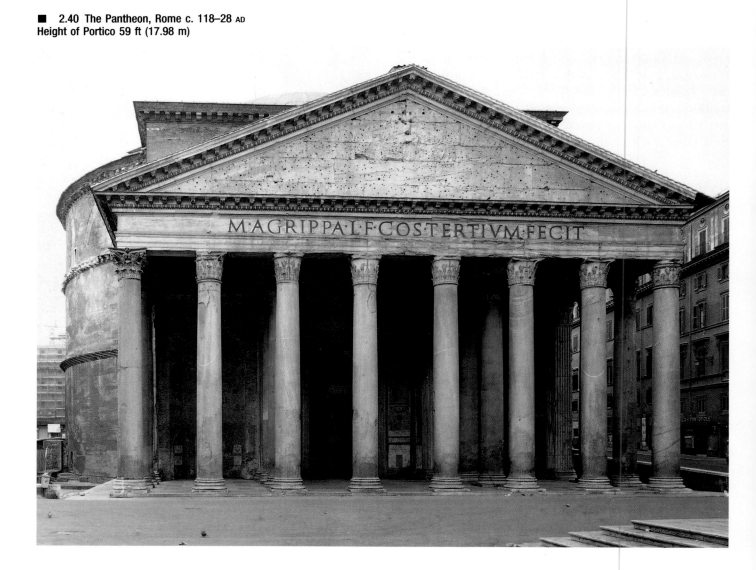

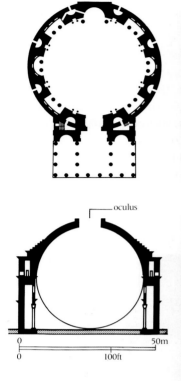

oculus

0 50m
0 100ft

**Plan and section
of the Pantheon**

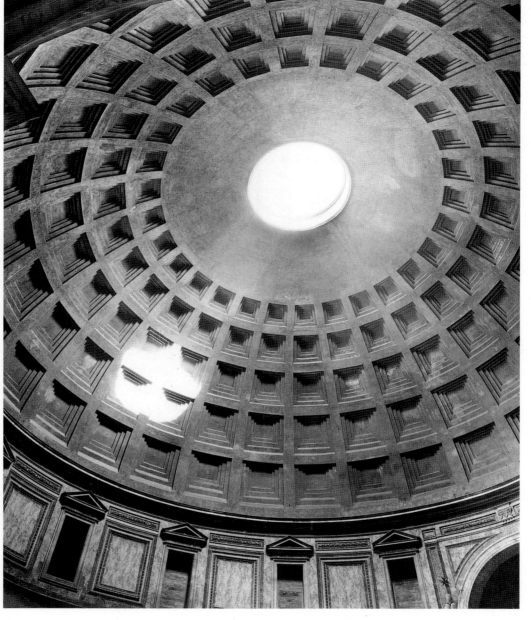

■ **2.41 Interior view of
the Pantheon c. 118–28 AD
showing the dome**

logical extension of earlier activity. However, the centering skeleton necessary for the pouring of such a vast amount of concrete is still mind-boggling to this day, making the structure a singular example of Roman ingenuity and perseverance. The result is breathtaking. Unlike monumental Greek entablatures, which rested flat on supporting columns, the dome allowed for a much grander and more expansive interior. The dimensions speak for themselves. Compare the Parthenon in Athens (Fig. **2.18**) with the Pantheon: the Parthenon rises 34 feet (10.3 m) from floor to entablature over a vast amount of floor area, whereas the Pantheon rises 142 feet (43 m) and is exactly the same distance in width, owing to the spherical form from which it is derived. This exact correlation between height and width gives the structure a unique symmetry and balance, and it remains one of the crowning achievements of Roman architectural engineering.

▶ PAINTING

● Before ending this brief discussion of Classical art, something should be mentioned of the Roman contribution to the art of painting. It is a standard opinion that the Roman artists were more successful at adopting earlier innovations than at providing new styles and solutions in themselves. However, the discovery of Roman wall paintings over the past few centuries may give one reason to reconsider the traditional position. It is difficult to comment on the quality and extent of painting in Classical Greece since almost nothing has survived. We do know from contemporary sources that paintings were highly prized, but today it is almost exclusively through Roman murals that we know about the state of painting in Classical society.

■ **2.42 Ritual passage into a mystery religion**
Wall painting from the Villa of the Mysteries
Pompeii, mid-1st century BC

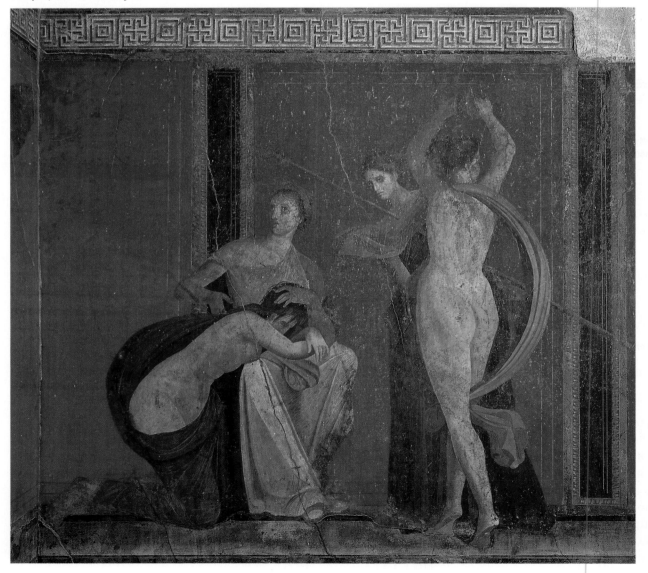

The best examples of Roman painting come from the ancient city of Pompeii, which was covered and preserved virtually intact by the volcanic ash and debris from Mount Vesuvius when it erupted in 79. Although this event was a huge catastrophe, it has proven itself to be of great value for art historians, who now have exquisite examples of remarkably well-preserved period painting. The wall paintings from the Villa of the Mysteries (Fig. **2.42**) give a good indication of the quality and technical abilities of painters during the Roman Empire. It appears that ideas such as depth and the description of forms in illusionistic space were well entrenched in Roman painting. As well, painters seemed to have understood the capabilities of painting to describe a narrative progression, and hence there is no shortage of storytelling.

THE ROOM OF THE MASKS

A more telling example of the expertise and technical prowess of the Roman painter can be seen in the recently discovered Room of the Masks (Fig. **2.43**) in Rome. In this wonderful series of murals, there exist the first surviving examples of perfect one-point perspective—a mathematically derived technique for describing space, and one that would not surface in Western painting again for another millennium (see the discussion of perspective in Chapter Four). It is impossible to say whether the Romans developed such sophisticated techniques on their own or derived them from earlier, perhaps Greek, sources; whichever is the case, these paintings remain essential to the story of Roman art.

■ **2.43 The Room of the Masks**
Wall painting from the House of Augustus on the Palatine Hill, Rome, c. 1st century BC

● The decline of the Roman Empire has been the subject of great debate, and it is difficult to pin its demise down to one historical event. Some blame the huge bureaucratic machine (still a popular excuse) for the atrophy that plagued late Rome. Others have made mention of the huge percentage of non-Roman troops needed to police the Empire—most of whom had little interest or loyalty to Rome and did little to stop its decay. There are those who see the shifting of power from Rome to Constantinople in 330 as the decisive blow, while there are still others who argue that this move secured the continued health of Roman civiliza-tion until the Renaissance. Whatever caused the decline, the Romans left a legacy of building and art that has survived to this day, and has provided gener-ation after generation with inspired notions. In short, it has played an essential role in the construction of Western culture. Few have influenced the course of history as dramatically as have the Greeks and Romans, and it was going to take an even greater authority to dismantle their legacy. That authority claimed by the successor to the Romans was that of the will of God —the substance of our next chapter.

▶ SUMMARY

● As this chapter shows, the ideas first exhibited in Greek and then Roman culture have become essential components to the notion of Western art and culture. For within the difficult notions of freedom, responsi-bility, and political organization there lie the corner-stones of later Western thought, its particular value system, and its notion of art. In Greek art, the develop-ment of complex forms of social organization was to find its voice in the culture's representations. Such manifestations as a new attitude toward the value of observing from nature, the philosophical belief in the existence of ideal forms, the visual conventions of proportion and internal harmony, all contributed to a world view centered by the gaze of the human com-munity. In Roman art, we witnessed the appropriation of Greek culture into more pragmatic arenas such as political monuments, portraits, and complex engineer-ing projects, all of which admirably reflect the enor-mous potential for images and objects to engage the community on both a social and a private level. Classi-cal conventions have continued to affect and direct aspects of civilization to the present day: the Classical age indeed provided the foundations on which all subsequent Western culture was to be built. Yet a closer study of the Classical era also makes clear that relation-ships between art and a society are often ones of power; the values generated by a community are thus also a reflection of the greater interests of those who control its policies.

Suggested Reading

The Classical world has been the subject of more writing and speculation than perhaps any era in the history of the Western world, so there is no shortage of suitable texts available. One particularly notable collection of essays is the very recent J. Boardman, J. Griffin and O. Murray text *The Oxford History of the Classical World. Volume One: Greece and the Hellenistic World* and *Volume Two: The Roman World* (Oxford and New York: Oxford University Press, 1988), which gives a good overview of the arts as a part of Classical thinking. Two other fine surveys are Martin Robertson's *History of Greek Art* (Cambridge: Cambridge University Press, 1975) and Denys Haynes's *Greek Art and the Idea of Freedom* (London and New York: Thames and Hudson, 1981). For further reading in the area of early and classical esthetics, Anne Sheppard's *Aesthetics* (Oxford and New York: Oxford University Press, 1988) is a clear and lucid introduction to an often impenetrable field.

Glossary

black-figure style (*page 70*) In early Greek pottery, the painting of figures in black slip on terracotta surfaces which were then scratched into with styluses to articulate forms. This style was followed in the middle of the sixth century BC by the subtler "red-figure style."

closed-form (*page 68*) Sculptural forms which keep a certain visual connection to their original block shape; generally sculptures which have little articulation and do not visually activate the surrounding space, giving the appearance of being self-enclosed.

Doric order (*page 71*) The first architectural system developed by the Greeks, and also the sturdiest and plainest looking. This was to be the standard from which all other variations of Classical building design emerged.

engaged columns (*page 89*) Non-structural decorations used on exterior walls in Roman temples, thus imitating Greek temple design while preserving an enclosed interior space.

idealism (*page 63*) A tendency in art in which representational images, often the human form, conform to an ideal esthetic standard rather than to a naturalistic or individualistic one.

Ionic order (*page 74*) A more refined and slender version of the earlier Doric design, its most noteworthy feature is the double scroll "volute" which acts as a mediation point between the entablature and the column.

kouros (*page 68*) A generic term for Archaic Greek figurative sculpture (the female types called "kore," the male "kouros"), much of which exhibits features evident in earlier Egyptian models, including a stiff frontal posture and relatively little articulation of joints.

naturalism (*page 65*) An attempt to imitate the world of everyday perception, or as things exist naturally.

open-form (*page 68*) Sculptural work that projects into and engages with its surrounding space. Many such pieces show little suggestion of their original source shape (see "closed-form").

perfect proportion (*page 64*) A system of determining the scale of a figure based on an interrelationship of parts within the body. Proportion supports the idea of an internal harmony, rather than imposing a set of standards or restrictions on the body, gathered from external considerations.

realism (*page 65*) A commonly accepted understanding of one's world. The art of reality is an expression of how one understands the world, and not necessarily contingent upon what one sees (see *naturalism*). In this sense, most visual artifacts address the nature of reality as seen through the eyes of an historical period.

red-figure style (*page 70*) The opposite procedure of the black-figure style evolving in the mid-sixth century BC. In this style the artist paints the background areas in black slip, leaving figures in terracotta, which are then articulated through painted lines, giving the figures a greater sense of form and detail.

3

ART AND RELIGION

The visual worlds of Judaism, Christianity, Islam, Hinduism, and Buddhism

■ 3.1 Detail from the cover of a Reliquary
for the Preservation of the True Cross
Cloissonné enamel, Limburg an der Lahn, Germany

*All things are artificial,
for nature is the art of God.*
SIR THOMAS BROWNE

Over the previous chapters, it has become possible to appreciate how the visual arts operate within an historical context. Since a community is the sum of its goals, beliefs, and aspirations, it should not come as a surprise to find that any ideology that attempts to explain the fundamental meaning of life should also have an important and dramatic relationship to art and art making. Such is the case between art and religion. Every faith has had to establish some form of a dialogue (whether it be tolerant or intolerant) with the visual arts, and through often lively deliberations each has contributed to our present understanding of art.

The primary focus of this chapter will be on five major faiths of our contemporary world: Buddhism, Christianity, Hinduism, Islam, and Judaism (see Fig.

3.2). To begin, we must clarify a few basic concerns, such as the concept of religion. To help in sorting out this important chapter, it may be fruitful to consider each faith as a "theory" of existence and reality, rather than fact set in stone. Each faith, as both a foundation and an extension of the civilization from which it once emerged, grants the greater human community insights into the mysterious workings of the world. And like art, religion both shapes and expresses those desires and needs that make meaningful our short time on earth. As this chapter will make clear, a typical understanding of art will change dramatically from one religion to another, and it will challenge some well-entrenched ideas and stereotypes—which is what this text is all about.

RELIGIONS OF THE WORLD

2000 BC	1500	1000	500	0	500	1000 AD
HINDUISM c. 2500 BC Origins in Indus Valley			2nd cent. BC Bhagavadgita		Shri Ranganatha Temple 5th cent. (p.137)	711 AD Muslim invasions begin / Kandariya Mahadeva Temple c. 1000 (p.137)
JUDAISM 1900-1700 BC? Abraham	1300 BC Moses	1010-970 BC David, King of Judah and Israel	Ivory lions of Samaria c. 722 BC (p.104) / 37 BC Roman occupation of Holy Land	70 AD Jerusalem falls to Rome The Diaspora		

CONFUCIANISM 551-479 BC Confucius — c. 500-600 AD Japan imports Confucianism

BUDDHISM c. 563-483 BC Gautama Buddha — 160 AD Buddhism reaches China / Seated Buddha c. 2nd-3rd cent. (p.141) — 520 Start of Ch'an Buddhism / c. 6th cent. Buddhism enters Japan — c. 1140 Introduction of Zen Buddhism / Jun Dish c. 12th cent. (p.144)

CHRISTIANITY 0-33 AD Jesus / 51 AD First church / 325 Council of Nicaea — Hagia Sophia, Constantinople 532-37 (p.111) / c. 675-749 John of Damascus — c. 1000 Development of cathedrals / St. Sernin (p.120) / Notre Dame (p.123)

ISLAM 570-632 Muhammad / Mosque of Damascus c. 715 (p.131) / Mosque of Cordoba 786 (p.135) / 750-1258 Cultural peak

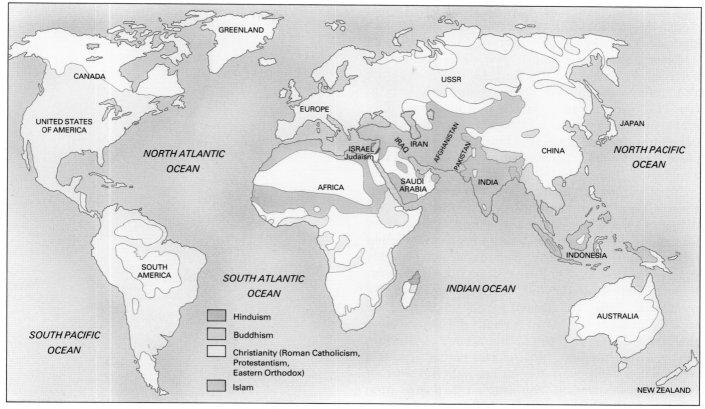

■ 3.2 Distribution of the major religions in the world today

▶ THE JEWISH TRADITION

● In the last chapter, specific mention was made of the Classical traditions that coincided with an outpouring of culture around the Mediterranean basin between 700 BC and AD 330. Thus it is perhaps appropriate to begin this discussion of religious art in roughly the same geographic vicinity and at approximately the same time. While the ancient Greeks were contemplating laws, democracy, and other such matters, there was yet another culture, located in what is today the State of Israel, that left an equally indelible mark on human civilization. They were the Jews, and it was from their rich religious tradition that the faiths of both Christianity and Islam would eventually spring. To understand fully the complex nature of Western art, it is necessary to discuss the Jewish interpretation of images and their use, for the Jewish philosophy of art

created a strong precedent for the younger faiths that followed in its footsteps.

It is popular to describe traditional Jewish art theory as essentially anti-art. Though this label is not altogether correct, there are of course specific reasons why the religion distrusted visual images. Judaism is an "iconoclastic" religion, which simply means it considers the creation or veneration of representational images an illegitimate activity—against the will of God. A quick look back at the Jewish community's justification for such a position will help in understanding later Western art theory, as well as giving further insights into the aspirations of the faith. And to do so it will be necessary to journey back to the time of Moses and the establishment of the Ten Commandments.

The Old Testament discussion of the flight of the

Israelites from Egypt is perhaps one of the best-known stories in the Bible. The tale of Moses' leadership also coincides with the first mention of a codified law in Judaism meant to establish precedents for correct behavior. According to tradition, Moses received the Ten Commandments on Mount Sinai, only later to crush the precious stone tablets in a fit of rage after witnessing his people worshipping a golden idol venerating the god Baal. It is here that an important precedent for the Jewish suspicion of images is established. The second of the ten laws speaks of the creation of "graven images" and warns against their construction. In art terminology, this translates as a denial of representational imagery on the grounds of blasphemy. Why were the Jews so restrictive in their tolerance of the visual arts? One reason was probably the need to develop a culture distinct from their polytheistic neighbors. A polytheistic faith is one in which a number of deities are granted special privilege in the worship of a people. Many religions develop as polytheisms, worshipping various items such as the sun, moon, water, fire, etc. Judaism was perhaps the first religion to develop as an absolute monotheism—meaning a belief in one God. This distinguished Jews from other cultural groups, and provided the impetus for a distinctive society.

The God of the Old Testament was transcendent, invisible, and apart from the world. His power lay in the ability to create and destroy—activities also associated with art making. Most polytheistic faiths were centered around physical manifestations of gods that survived in literal and figurative form. The god Baal from the Exodus story is a good example. These deities were worshipped by way of physical images, and thus the objects and representations became an essential part of worship (one need look no further than to the civilization of the Cyclades to see evidence of such an attitude: see Fig. **3.3**). Given this, it is hardly surprising that many of the world's more developed polytheisms (such as Hinduism) have a rather distinct legacy in the field of the visual arts. Yet in Judaism, the transcendent nature of God (invisible, omnipresent) denies the very possibility of describing him/her in physical form. Further, the Jewish community's outright dismissal of polytheism made them suspicious of the use of visual images in worship—something so central to their polytheistic neighbors. One can cautiously speculate that the early Jewish distrust of images had a lot to do with this historical connection between the visual arts and

■ 3.3 Cycladic figure from Amorgos, c. 3000 BC
Marble
Height 30 in (76.2 cm)
Ashmolean Museum, Oxford

■ 3.4 Model of Jerusalem in the Second (Herod's) Temple period showing the Second (Herod's) Temple with surrounding courtyards

the religious polytheism rampant in most of the cultures of the Mediterranean basin.

The explanation in the preceding paragraph is what might be called the "traditional" justification for iconoclasm or the denial of representation in Judaism. Yet there are other, perhaps less obvious reasons for the establishment of such strict laws. One is the nomadic lifestyle of the early Jews. The wandering nature of a people sustained by an unforgiving environment made art projects impractical and subsequently meaningless. This in turn left little in the way of an artistic heritage for later artists to derive inspiration. It seems that nomadic societies tend to develop rich oral and musical traditions, but the lack of secure grazing lands made permanent architecture and art work difficult if not impossible undertakings. The Jewish culture is a good example of a society that flourishes along very predict-able artistic lines; the creative magic of poetry and music is firmly implanted in the faith at an early stage, and is witnessed in such works as the Psalms. There was, however, a brief period in Jewish history when its people enjoyed a degree of stability and economic privilege, and the results in the field of art making were significant.

Though often soaked in blood, the reign of King David made possible a consolidation of disparate tribes and a brief (very brief) disappearance of war from the area. This meant that the subsequent rule of King Solomon was one of marked prosperity and growth. This in turn led to the development of communities that grew along more stable lines than those of the nomadic shepherd. It is here that the city of Jerusalem began to flourish, and with it came the need for a more permanent architecture. The opportunity was indeed unique for a group that had survived as nomads for centuries, and they aspired to create monuments fitting to their culture and their God. The result was the building of the first Temple by King Solomon c. 950 BC. This was destroyed in 586 BC and a second Temple was built in the later sixth century BC, which was restored by Herod the Great (Fig. **3.4**) and destroyed by the Romans in 70 AD.

The Temple was to be the central focus of the faith, housing the Ark of the Covenant—God's contract with the Children of Israel. What is noteworthy about con-temporary descriptions of the project is that it included items such as golden cherubim, which were to be placed at the entrance to the structure. This means that the steadfast iconoclasm of the Ten Commandments (reiterated in Deuteronomy:IV, 17–18) was obviously

■ **3.5 Ivory Lions of Samaria c. 722 BC, Collection of Israel Antiquities Authority**

not as strict as one might have originally presumed. Archeological evidence supports such claims, as witnessed in a pair of ivory lions (Fig. **3.5**) from Samaria which were probably fashioned by the Jewish people. What does this apparent contradiction say about art making in the development of the Jewish faith? One obvious conclusion is that iconoclasm was never completely adhered to as a tenet of the faith. This partially explains the occasional lapse into representation that occurs from time to time in Judaism. With specific regard to the Temple, perhaps one may cautiously speculate that social stability and material prosperity had an important effect on the production of art in the community. Before this point, the Jewish people were essentially migratory, traveling with their flocks to locations which could grant at least temporary sustenance. When the culture flourished with the establishment of peace and prosperity in the region, images seem to have emerged, and along with them a limited tolerance of representation.

Whatever the reasons may have been for such a deviation, it was certainly short-lived. In 586 BC the Babylonians sacked Jerusalem, destroyed the Temple, and led the children of Israel into yet another extended period of captivity. The result was a virtual vacuum of artistic activity for the next few hundred years.

JEWISH ART

What is one to make of the Jewish contribution to art in the light of the previous discussion on iconoclasm? When considering such issues, it is helpful to consider a couple of factors that may have contributed to such a discrepancy between religious law and later artistic practice. One is separation. As history so cruelly points out, the Jewish people had little opportunity to develop as a distinct nation. The Babylonian captivity was only one in a number of setbacks. It was followed by the invasion of Alexander the Great and then the Romans, which led to an angry uprising and the eventual Diaspora (meaning dispersal) in 70 AD, to all intents and purposes ending Jewish occupation of Israel. The forced migration of Jews to all areas of the Roman Empire and beyond led to the fossilization of religious law as a common thread between peoples growing further and further apart geographically. Following on from this there was both a more rigorous application of iconoclasm in the synagogue and also the establishment of more relaxed standards for the production of art in the secular world. Yet even this was not without its exceptions, as there exist a number of synagogues from the sixth century onwards which embrace representational aspects as part of the interior decoration. But for the most part, art for religious ceremony was essentially reduced to calligraphy and ornamentation of the Torah (see Fig. **3.6**). Like Protestant Christian iconoclasm (which will be more fully discussed in Chapter Five), the prohibition of representational images in worship did not prevent artists from creating work for everyday enjoyment. The result was a marriage of practical considerations and religious law that neither denied the authority of the faith nor prevented those who felt inclined to produce images for other functions from doing so. Thus the history of Jewish art is the result of practical compromise rather than religious sanction. In this way, the Jewish community was able to embrace art making while retaining a strong degree of suspicion about its aims.

■ **3.6 Curtain for the Ark of the Torah, Mannheim, Germany, 1728**
Velvet, silver thread embroidery
Collection Israel Museum, Jerusalem

▶ THE CHRISTIAN TRADITION

● It is perhaps appropriate to begin this discussion of Christian art by remembering that Christ was a Jew. But to Christians, he was more than simply a part of Jewish royal lineage—he was the fulfillment of earlier prophecy, and also the Son of God. This had enormous repercussions for both the formation of the religion and its art. As you will remember, the God of the Children of Israel is invisible and transcendent. But in Christianity, the "word" (*logos* in Greek) had become flesh—through Christ, God was made visible and lived among his people. This meant that God possessed an image—an identifiable whole which could be reproduced through representational imagery. This was to be the start of a distinctly Christian philosophy of art.

We have already considered the Jewish interest in forming a distinct culture, and looked at how iconoclasm can be partially understood as an extension of the need for religious identity. The same holds true for Christianity. The first Christians were themselves Jews, who either followed Jesus as disciples or had contact with some of the earliest missionaries. But the displacement of Jewish Christians in the Diaspora of 70 AD meant that the history of the Christian faith was to lie in the hands of the "Gentiles"—those from cultures not directly descended from Christ's own Jewish heritage. This ended the strict iconoclasm of the very beginnings of the Christian Church, and moved the faith into communities where visual images were both sophisticated and historically accepted (Corinth and Rome are two good examples). Soon, early missionaries began to adopt regional styles of expression (such as the making of visual images) to help converts better understand the significance of Christ's resurrection. It is from within this sometimes difficult and often controversial meeting of Christianity and native culture (in particular Classical society) that Western art was to blossom.

One of the first debates to ensue in the new Christian Church was the consideration of art forms. The discussion centered around the relative merits of both two- and three-dimensional art work within the context of the Scriptures. This debate quickly established important precedents in Christian art, and provides an interesting starting point from which to discuss the various ways we experience art. The issue was whether or not art in general, and sculpture in particular, was a

■ 3.7 *Good Shepherd* late 3rd century AD
Marble (restored)
Height 39 in (99 cm)
Vatican Museums, Rome

legitimate form of expression for the pious Christian, and the outcome of the deliberations initiated a shift away from three-dimensional art and toward painting for the best part of a millennium.

It is interesting how seemingly inconsequential debates can take on such important ramifications for later art theory. One of the more conclusive resolutions to come out of this debate was the opinion that painting was a more appropriate medium for representing the Christian faith. The logic went as follows: painting was essentially an illusion, and understood by all as simply a design born of experience but incapable of duplicating experience. In other words, its flatness was so obvious that theoretically it could not deceive us as three-dimensional reality. Now, anyone who has been terrified by a horror movie, or has felt the eyes of a portrait watch them as they move around a room, may have something to say about the abilities of flat planes to give the viewer a believable representation of reality. But what is essential here is the notion that painting and representation are justified on the grounds that they do not attempt to duplicate reality—they have no volume and thus do not exist in a real space. Sculpture, with its emphasis on forms existing in real space and having discernible volume, was not to fare quite so well under the critical eye of the early Church. It appears that sculpture came too close to pagan idolatry for many of the early Christians, who wanted to assert a very specific identity within the Gentile communities. Some of the first Christian excursions into sculptural forms, such as the *Good Shepherd* marble of the third century (Fig. **3.7**), exhibit this tenuous relationship with their Classical sources—a resemblance that no doubt made the pious uneasy. Between the third and sixth centuries, most Christian sculptural projects took the form of relief work, decorating sarcophagi and other essentially flat surfaces with shallow, narrative-like representations which were in sympathy with the tenets of two- rather than three-dimensional ideas. Soon, even painting and two-dimensional art would not be excluded from attacks by those who saw all representational art as a direct challenge to the creative authority of God. But during the first years of the Christian faith, the existing sculptural traditions of Gentile communities, such as Rome, were arguably so refined and convincing that they provided many iconoclasts with visible proof of the power of sculpture to compete with the handiwork of God.

Being Christian in the early years of the faith was not particularly easy; indeed it was a capital offense in Rome. One of the results of the relentless persecution was the need for secrecy with regard to rites and practises, and this led to a very interesting development: "camouflaged symbolism," which could be read and understood on a number of levels without revealing its true intentions to the wrong people. A good example of such symbolism is *Christ as Good Shepherd* (Fig. **3.8**). Though the story of the good shepherd is firmly entrenched in Christian lore, the subject was also a popular one in pagan mythology (such as the Greek story of Hermes Criophorus—the ram carrier). By carefully choosing subject matter with a variety of possible meanings, Christian sites of worship innocently appeared as rooms decorated with scenes from popular myths; the images were ambiguous enough to hide their real intent. Many of the most popular Christian symbols have their origins in pagan imagery: items as diverse as the dove (the Holy Spirit), the peacock, the fish (baptism, Christ), the sun (truth), the feast (the Eucharist), and the shepherd (Christ) can all be traced back to earlier cultures (see Fig. **3.9**). The end result of this intermingling of pagan iconography with early

■ **3.8** *Christ as Good Shepherd* **mid-4th century** AD
**Wall painting from the Catacombs
of SS Pietro and Marcellino, Rome**

■ 3.9 *Tombstone with Fishes* 3rd century AD
Stone fragment from Catacomb of St. Domitilla, Rome

▶ 3.10 *Colossal Head of Constantine* c. 313 AD
Marble
Height of head 8 ft 6 in (2.6 m)
Palazzo dei Conservatori, Rome

Christianity was the development of a hybrid system of symbolic language and imagery from which later artists would draw inspiration.

EARLY CHRISTIAN ARCHITECTURE

In 313 the Emperor Constantine (Fig. **3.10**) success-fully introduced Christianity as the official religion of the Roman Empire with the Edict of Milan, and for the first time the young faith was able to exist without the threat of persecution. Almost immediately, Christianity became a public institution, and with its new status came a degree of authority and stability. The first major development to evolve from this recognition was a drastic re-evaluation of the scale and impact of religious art. Within a few short years of Constantine's rise to power, officially sanctioned churches were being built on the sacred sites of Christendom. The Church—"Christ's house"—quickly became the sustained focal point for Christian art interests, and thus it is in the area of architecture that one is granted special access to some of the most important qualities of the faith.

Old St. Peter's Basilica (Fig. **3.11**) was one of the first architectural expressions of the new faith. Built in Rome, it was designed to house various relics from the Apostle Peter's martyrdom, and was held in particu-larly high regard as a place of contemplation and pilgrimage by the faithful. The design was simple and

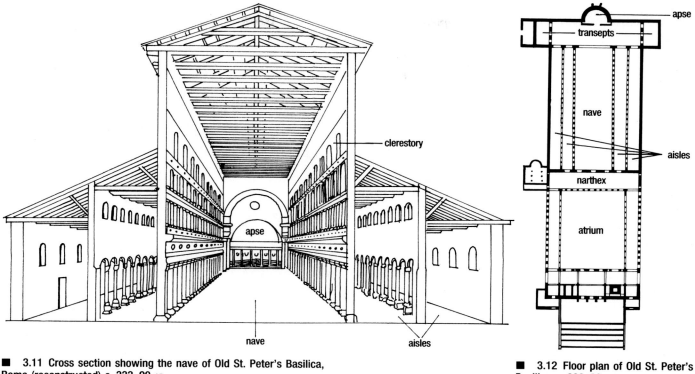

■ 3.11 Cross section showing the nave of Old St. Peter's Basilica, Rome (reconstructed) c. 333–90 AD

■ 3.12 Floor plan of Old St. Peter's Basilica c. 333–90 AD

austere, and it laid the foundations for Church architecture for many centuries. It appears from archeological evidence (the actual structure was destroyed in the Renaissance to make way for the current St. Peter's Basilica) that the faithful entered the shrine through an enclosed courtyard or "atrium," which was attached to the basilica proper. The interior plan was evidently modeled after the secular architecture then popular in Rome (the so-called "basilica design") and is likely to have been a reflection of the earlier Christian sites of worship, which, as we have seen, were generally the homes of the faithful. As a result, the "house of the faithful," or "God's house," tended to follow a very particular Roman legacy, mirroring not so much temple architecture as the intimacy of the domestic housing that had been the solace of the early Christian community.

To understand the fundamental structure of the basilica plan, it is necessary to consider further the union of form and function as each pertains to the complex proper (see Fig. **3.12**). The basilica was constructed with a long central "nave" which helped focus attention on the services conducted at the far end of the church. The nave was intersected by the "transept,"

which would later be introduced further down the nave to make a cross form (symbol of the crucifixion) rather than its original *T* shape. Originally, the transept was designed as a means of creating space around the altar so that the congregation could be more centralized. It also had the added benefit of visually isolating the tomb of the saint (in this case Peter) from those lesser figures buried in the nave, as well as serving the practical function of allowing pilgrims access to the shrine without interrupting normal services.

To light the building, windows were placed on a second level which rose above the central portion of the nave (called the "clerestory"). This ingenious device gave worshippers the impression that natural illumination (whether it implied Plato's notion of light as the symbol of wisdom or the divine light of the New Testament) was a sign of God's grace. The design enabled natural light to fall from above rather than raking on the diagonal or horizontal, which inevitably cast strong directional shadows—a problem sidestepped by placing relatively few windows on the first level. The result of such experimentation between sacred and secular architecture was to set an interesting precedent for later Christian building projects; its symbolic

■ 3.13 Church of the Holy Sepulchre, Jerusalem (reconstructed) 345 AD

language continues to inspire architects to this very day. The ability of basic elements such as directed light and a cruciform ground plan to evoke an emotional (some would say spiritual) response in a viewer may give an indication of the psychological power of architecture. But it also points to the uneasy realization that if art can (and does) enlighten and transform for the good the viewer's world, then it can also influence for less worthy ends. There is little doubt that good religious architecture effectively manipulates the faithful, and Christianity quickly learned the all-important lessons that had inspired the architects of the Great Pyramids at Giza and the Acropolis in Athens—that spaces and images (architecture and art) not only inspire the masses but often control them. It is in these terms that one comes to understand the grandeur of perhaps the greatest visual expression of the Christian faith: the cathedral.

The development of the cathedral in Christian art is a slow and arduous one, but its beginnings can be traced back to building programs such as Old St. Peter's Basilica in Rome and other contemporary churches. In 326 Helena, mother of Constantine, made her famous pilgrimage to the Holy Land in search of the locations of Christ's birth and Passion. The result was the consecration of specific sites: the Church of the Nativity in Bethlehem and the Church of the Holy Sepulchre in Jerusalem. The Church of the Holy Sepulchre (see Fig.

3.13), which was built c. 345, has much in common with the design of the Old St. Peter's Basilica in Rome, including the long nave with a transept placed at one end, and the clerestory that housed the ever-important windows. But the significance of this building project lies in its combination of the basilica plan (derived from Roman secular architecture) with a domed expanse—a structure used in major Roman monuments and civil buildings such as the Pantheon (Fig. 2.40) and thus commonly associated with power. This dome, which covered the supposed site of Christ's entombment, gave the church a degree of visual stature and prominence not easily discernible in the original Basilica of St Peter. It is also interesting to note that this same dome motif was the preferred structure for the burial chambers (mausoleums) of the great Roman emperors, and the use of such a device suggests that early Christian architects were attempting to evoke the same form of reverence for Christ's life. Even the Roman triumphal arch eventually found its way into church architecture, forming both a visual and a structural transition between the nave and apse (the front section of the church, usually separated by the transept in basilica-style buildings). Perhaps in passing, then, one might cautiously note that architecture, which is often considered a relatively neutral and practical art, is thus far more value-laden than one might have originally supposed.

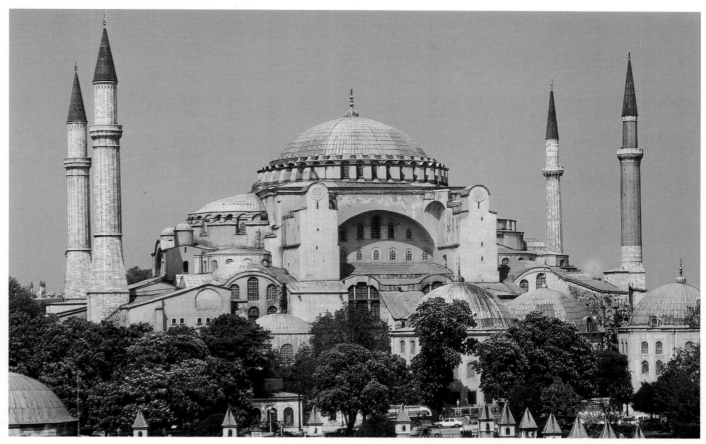

■ 3.14 Anthemius of Tralles and Isodore of Miletus
Hagia Sophia, Istanbul, 532–37 AD

HAGIA SOPHIA

On 11 May 330, Constantine made the ancient eastern city of Byzantium (today Istanbul, Turkey) his new capital, renaming it Constantinople. This fresh start enabled the weak Roman Empire to purge itself of its immediate history of conflict and instability and it helped establish a new image of the state and its religion. This shift of capital marks the beginnings of both the Byzantine era (named after the old city) and an uneasy relationship between Church and state that would continue to the present day.

The crowning architectural achievement of the Byzantine age is undoubtably Hagia Sophia (Fig. **3.14**) and though today it appears significantly altered (its conversion to a mosque precipitated the addition of four large minarets on the exterior and the dismantling of the mosaic works on the interior walls), it remains one of the truly magnificent visions of the young faith. Construction of "The Church of Holy Wisdom" began in 532, and it was to be the glory of the Christian world. It was conceived in accordance with the principle of light as a metaphor for wisdom. The structure was almost 41 feet (12.5 m) higher than the Pantheon in Rome, which then had the largest dome of its kind in the world (Fig. **3.16**). The most impressive feature of the work is the immense expanse the dome covers. Up

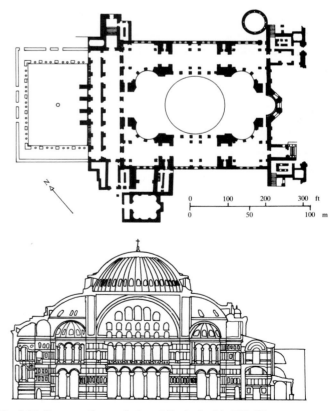

■ 3.15 Cross section and plan of Hagia Sophia 532–37 AD

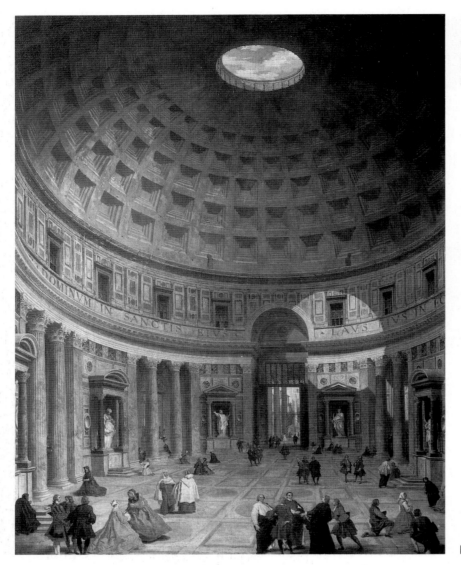

■ 3.16 Giovanni Paolo Pannini
The Interior of the Pantheon c. 1740
Oil on canvas
50½×39 in (128.3×99 cm)
National Gallery of Art, Washington, D.C.
Samuel H. Kress Collection

▶ 3.17 Interior view of Hagia Sophia 532–37 AD

until this point, domes had often rested directly on a cylindrical "drum," which extended the vertical field of the dome directly into the floor. This was suitable for less ambitious projects, but a larger dome meant increased strain on the drum, which had to support great weight on a relatively small base. Hagia Sophia circumvented this structural deficiency by placing the drum on yet another support, called the "pendentive," a triangular shaped segment of vaulting which effectively moved the stress away from immediately under the dome and dispersed it over a greater expanse of sturdy columns. The result was a stronger foundation, capable of supporting the vast weight of a monumental dome (Fig. **3.15**).

Once the architects successfully grounded the weight of the dome, light (the symbol of wisdom) was then used to accentuate the interior volume of the structure. To do this, forty windows were situated between the dome and the drum, giving the impression that the dome floats above its support. The impact is breathtaking, as light appears to support the expansive ceiling and contradict the massive weight of the roof. At this point, it is hard not to experience awe at the consummate poetry of space. Here Christ ("The Word that had become Light and shone amongst us," John:1) visually supports the heavens (which in this case is the dome interior), and the structure becomes its own living metaphor of the majesty of the faith (see Fig. **3.17**).

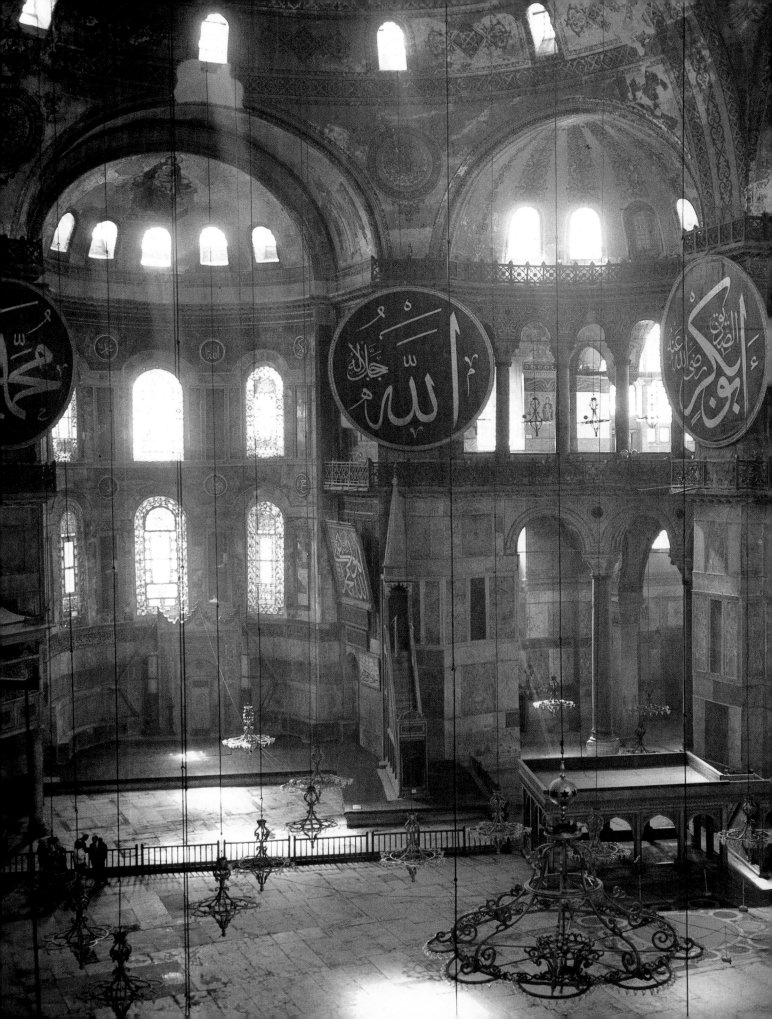

MOSAICS AND ICON PAINTING

The symbol of light had a continued effect on art making throughout the early years of the faith. Christianity also relied heavily on previous artistic and architectural traditions in its search for a grand visual expression. Early Christian architecture is a good example of such a dynamic. The architects consciously invested their buildings with a variety of deliberate quotations from assimilated cultures (the basilica format from Roman secular architecture and the dome, which was associated with Imperial monuments), while developing more specifically Christian concepts such as the divine quality of light. The two-dimensional arts have an obvious practical relationship to architecture; painting and other "flat art" have a hard time existing apart from on architectural structures such as walls. And if light had the ability visually to lift ceilings and speak of the mercy and wisdom of God, then it became imperative that these two-dimensional arts should likewise disseminate a similar kind of religious association. It was at this point that the age-old technique of mosaic came to establish itself as the favored medium among early Christian artists.

Mosaic is a very practical form of art making. Colored stone, glass or ceramic "tesserae" are adhered to surfaces such as floors, walls, and ceilings, and with little fuss are considered more or less permanent. The first documented mosaic works were floor designs, executed somewhere around the eighth century BC in simple black and white pebble designs. Soon, accessibility to rarer colored marbles allowed for a remarkably subtle range of tone and coloration. Like a rug, it gave the interior space of a building a more decorative feel

■ 3.18 *Head of Autumn*
2nd century AD
Mosaic from Cirencester,
Gloucestershire

■ 3.19 *Cross, Stars and Evangelists Symbols* Vault of the Galla Placidia, Ravenna, 5th century AD

than bare plaster or mud, plus it had the added incentive of needing almost no upkeep. Early Christian mosaics obviously derive much of their technical prowess from Roman precedents (for example, the *Head of Autumn*, Fig. **3.18**, from the late second century AD, which bears a resemblance to early Christian designs), yet it is interesting to note how quickly the art form took on other, more "theologically sound," associations. Take, for instance, the decree of the Emperor Theodosius II in 427, which forbade images of Christ to be exhibited on the floor. The idea of positioning a sacred figure such as Christ below that of the sinning human (and in the case of floor mosaics, this was exaggerated even further by stepping on that image) became blasphemy, and it opened the way for regulations governing the appropriateness of certain forms of composition—ideas we commonly call decorum.

Unlike wall painting, in which surfaces remain somewhat flat and static, the rough textures of glass and stone make mosaic surfaces undulate in an uneven manner. The development of glass tesserae gave artists even greater freedom with regard to color, and it also had the further advantage of reflecting light. The combination of the uneven surfaces and the reflective qualities of glass and stone made the material ideally suited to lighting effects. In the cases of the Mausoleum of Galla Placidia and the Baptistery in the Italian coastal town of Ravenna, such illumination was to come primarily in the form of candles, with their warm, golden glow. As a result of the necessary relationship between light and the mosaic medium, the interior spaces of these buildings possess many of the same dynamic qualities as the candle—something of profound interest to both artists and church officials attempting to evoke the presence of God in these spaces. The beautiful interior vault in the Mausoleum of Galla Placidia (Fig. **3.19**) is a particularly fine example. The gold tesserae dance in candlelight, and the vivid blue surroundings provide a dynamic counterpoint to the rich symbolic imagery.

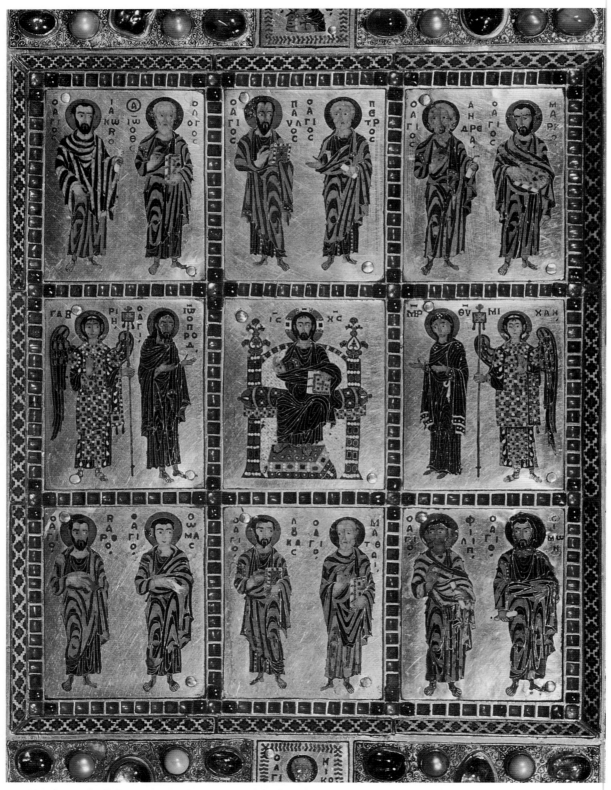

■ 3.20 Cover of a Reliquary for the Preservation of the True Cross
Cloisonné enamel, Limburg an der Lahn, Germany

Another popular medium for the Christian artist was cloisonné enamel work (see Fig. **3.20**). It had very specific technical complexities that did not easily translate into subtle modulations of tone and color, and like mosaic, it had important repercussions on how Christians continued to render figures. Simply put, cloisonné enamel is produced by baking enamels into pockets formed on the surface of the metal. The result is a relatively flat form, where the noticeable outline surrounding the color tends to discourage us from reading these figures as representations of three-dimensional objects. The clarity of design and strength of vision make these items at once striking, and along with mosaic, they helped set in motion a standard of design that was to last well into the next millennium.

The most significant two-dimensional art form produced by early Christians is arguably the icon. As visual representations, most icons possess the same pictorial qualities as both mosaic and cloisonné enamel: flatness of design, strong transitions of color, and abstracted figures, all of which enable the image to function on a number of levels simultaneously. For instance, an image can be rendered in a manner that enables a viewer to learn from it (it has a didactic function), while concurrently evoking emotional responses very different from the probable effect on original audiences. Icons grow out of such a situation. Early Christian art was primarily concerned with converting the masses, and used visual images to help tell stories about the life and deeds of Jesus Christ. Since clarity was of utmost importance for such missionary work, the best images became extremely illustrative. Further, since these images came out of a narration (the Bible) the subjects were always grounded in history (or "historical circumstance") and thus removed from the viewer by time. As group worship became more important in Christianity, there was a greater need for images and objects that not only reinforced aspects of Christian teaching but also provided a more introspective and contemplative focus. This meditative function of art was achieved by simply reorienting some of the features of the previous didactic format. Artists first removed the figures from the narrative, allowing the subject to exist in what is referred to as "non-historical time". In other words, when a background scene is removed from a figure, the subject is portrayed without a sense of place and is thus capable of entering into personal communion in the present tense (Fig. **3.21**). The early Church scholars agreed: since Christ died and had risen, he could be portrayed in the present, emphasizing both the resurrection and the omnipresence of God. This eventually led to the portrayal of the Virgin, the Saints, and the Apostles in non-historical time, allowing them also to remain fixed in the present. Inevitably, this whole movement toward a more personal and meditative art led to the exaltation of the image *as* the essence of God; in other words, the pictures quickly took on the role as intermediaries to the Divinity, and became an important part of the process of worship.

Stylistically, the icon developed with many of the same qualities as other early Christian art. Icons are produced in a variety of materials, ranging from mosaic and enamel to carved ivory reliefs and tempera paintings on wood panels (Fig. **3.22**). The design was, and remains, most often flat, with highly abstracted features which are both a predictable extension of the strong graphic tendencies of the earlier art, such as enamel work, and a necessary severing of the relationship with simple representation (which is based exclusively in our world of everyday perception, and thus of little meditative value). The most recognizable features of these images (such as the penetrating almond-shaped eyes and the gaunt descriptive faces) are attempts to find a visual vocabulary capable of evoking the spiritual in the everyday. And if 1,500 years of a still vital and uninterrupted tradition are any indication of the power and authority these images possess for Orthodox Christian communities (icon makers still hold to these precepts), then one may conclude that this format of picture making has succeeded in evoking the universal in the specific.

AN APOLOGY FOR IMAGES

As the history of icons illustrates, it doesn't take long for images and picture making to become a complex business, entangling within one image a host of other, seemingly unrelated, issues. The question then becomes one of differentiating between worshipping what the image is supposed to evoke, and simply worshipping the image as a manifestation of God (which Christians claim is idolatry). This issue came to a head in 726, when Emperor Leo III ordered the destruction of a mosaic figure of Christ over the palace gate in Constantinople, and replaced it with a simple cross. This was followed four years later with an official decree forbidding the use of icons of Christ or the saints in worship. Leo III based his argument on the Second

Commandment, and in so doing quickly lit a fire of controversy within the religious community—many of whom saw his action as a blasphemous denial of Christ's fulfillment of prophecy and the termination of the old law. Regardless, iconoclasm soon became a state-wide preoccupation, and it was up to one eloquent individual to form the basis of an argument to counter the claims of the iconoclastic authorities. His name was John of Damascus (c. 675–749) and his passionate apology for imagery is an excellent example of the sometimes antagonistic but often crucial relationship that exists between art and theory.

John of Damascus based his argument on Classical Greek thought, applying Platonic idealism to Christian principles. He started with the premise that appreciating visible beauty was a necessary step in the appreciation of the absolute (which in this argument was equated with God). Since the absolute is only apprehended by the soul, the visual form is perhaps one of the few references to God comprehensible to the human. Thus, he argued, a good picture could rightly guide the worshipper toward the absolute—but as a path, not as an end in itself. He asserted that the image was only a poor prototype, and simply a trigger for greater and more beautiful thoughts. This may help clarify the role of icons in church services, and it is an argument that remains popular to this day. Thanks in part to John's defence of figurative art through the employment of Platonic arguments, the development of a lively Christian art had a firm theoretical underpinning.

■ 3.22 Icon of the Mother of God
16th-century copy of 13th-century original
Detail from central panel

CHRISTIAN ART OF THE MILLENNIUM

As Europe converted to Christianity, the expressions of faith became decidedly more diverse. Two major art forms in particular stand out as significant achievements within the context of Christian religious art: the medieval cathedral and the illuminated manuscript. For all their great size and complexity as constructions, underlying the medieval cathedrals is a unified vision, deriving from many of the notions previously discussed in connection with Christian architecture: the symbolic nature of the design, the importance of light, and the intimate relationship between art and worship. A specific architectural style which developed originally in the north of Europe became particularly associated with the grandest of medieval cathedral building projects.

◄ 3.21 One of several icons of *Our Lady of Vladimir*
Icon, early 15th century
Attributed to Andrei Rublev
Vladimir Museum of Art, Russia

The style was later given the nickname "Gothic" in an attempt to associate it with the violent pagan invaders of parts of Europe during the Dark Ages. Because of the vibrant originality and occasional wildness and crudity of the Gothic style when compared to Classical architecture, the nickname stuck. The medieval cathedral is a striking testimony to the rising grandeur of Christianity after the passing of the millennium, and its ability to negotiate between the often mutually exclusive interests of esthetics and brute mechanics makes it one of the crowning achievements of the age.

It is not difficult to equate height with a quest for the heavens, and society's search for the absolute. The skyscraper has often been called the modern cathedral because of the way it reaches up to the sky, and the same premise was very much in the minds of medieval architects after the passing of the millennium. After years of warring, the Church and its secular benefactors began rebuilding with a vigor and enthusiasm unparalleled since Roman times. This era has been known since the nineteenth century as the "Romanesque" period (meaning Roman-like) after the renewed interest in monumental architecture reminiscent of the glory of the old Roman Empire that occurred between the tenth and twelfth centuries. Its architecture combined Roman stone arches with exterior sculptural decoration, and provided the impetus for a revitalized form of Church architecture—an architecture that had changed relatively little since the building of Hagia Sophia (Fig. **3.14**). The massive stone arches and masonry walls were able to support more weight than previous projects, and this resulted in an even larger interior spaces (see Figs. **3.23** and **3.24**). But higher structures meant more mass exerted on the walls (which had to support those weighty stone arches) and necessitated thick and awkward piers. As the image of the interior of St. Sernin suggests, a necessary result of such practical building considerations was the relative lack of windows, since such gaps made the walls less structurally sound. In the quest for a majestic interior space, architects were forced to sacrifice light, which had been such an important aspect in earlier architecture.

One interesting result of this lack of adequate interior illumination was the transferring of images to the exterior surfaces of the building (see Fig. **3.25**). The delicate nature of the painting medium made it impractical for most exterior settings, but stone relief sculpture was both resilient to climatic conditions and easily

■ 3.23 Exterior of St. Sernin, Toulouse, c. 1080–1120 AD
■ 3.24 Interior of St. Sernin

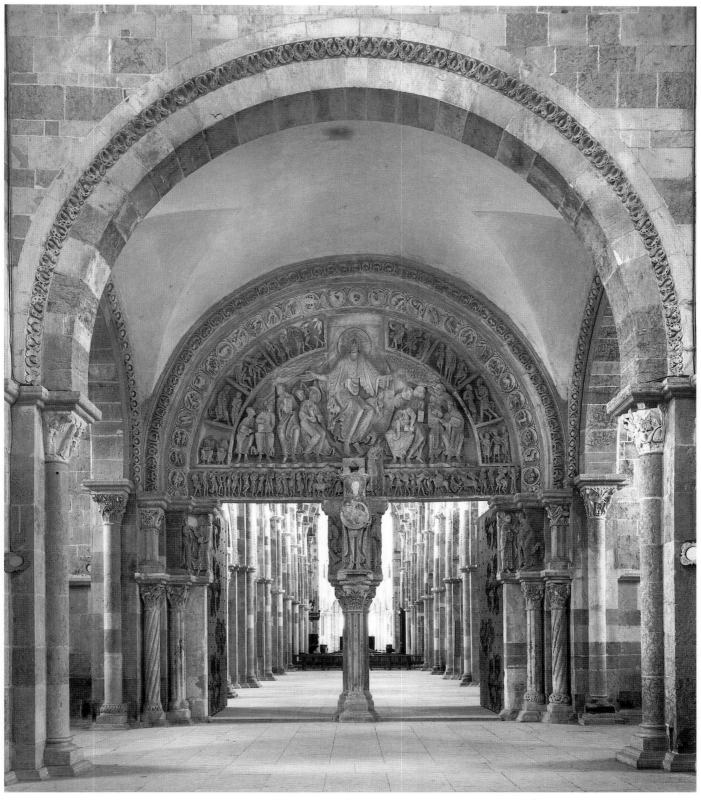

■ 3.25 Pentacost scene, tympanum; Abbey Church of La Madeleine, Vezelay, c. 1120–1132

■ 3.26 Jeremiah, from St. Pierre, Moissac, early 12th century

integrated into the various surfaces of the façade. There was, in fact, very little interest in interior decoration for churches in northern Europe (in other words, relief sculpture was a way of keeping images alive during a period when church interiors appeared inhospitable to art). This was to initiate a dramatic shift in Christian policy toward three-dimensional art forms, and it marks the resurrection of sculpture as a major force in Western art. The stone figures share many of the same abstract traits as the mosaics and icons of the previous discussion, but they also serve as reminders of one's own bodily associations to architecture. A good example of this is the figure of the prophet Jeremiah (Fig. **3.26**), which stands at the entrance to the Church of St. Pierre, Moissac, France. Carved around a functional support, the figure bends and undulates in such a manner that one immediately concentrates on the burden of weight on his shoulders. Thus, by manipulating a figure and successfully integrating it into the thrusts of the architectural structure, the anonymous sculptor has given us a visual reminder of Jeremiah's prophecies as the foundations of Christ's coming, and the support for his home.

As was previously mentioned, light has long been considered a principal characteristic of the cathedral, but as Romanesque buildings such as St. Sernin suggest, this was not going to be an easy undertaking in the more northern environs. The demands of greater interiors with higher vaulted ceilings necessitated strong, sound walls, and it was not until architects were able to relieve some of the pressure from these primary supports that the heavenly light of wisdom could once again illuminate cathedral interiors. The answer came in the form of the ''flying buttress,'' a supporting armature that deflected some of the structural strain away from the primary wall and alleviated pressure (Fig. **3.27**). Since the weight of the immense ceiling vaults was now distributed over a greater area by a series of buttresses, the thick walls which enclosed the cathedral were less important as structural supports. This had important ramifications for church architecture. First, it enabled architects to create even higher and more majestic buildings, since the mass of more expansive ceilings could be effectively distributed by the buttresses and not rest solely on walls (see Fig. **3.28**). Another repercussion of the flying buttress was the reintroduction of sunlight into the interior spaces of the cathedral, since windows were no longer a threat to the structure of the church. Together, light and the

immense enclosing of space were to be the supreme characteristics of the medieval cathedral.

One of the most opulent and exquisite examples of this form of architecture is Sainte-Chapelle (Fig. **3.29**) in Paris, built between 1243 and 1248. Though considerably smaller than many of the cathedrals of the time, this chapel stands out as arguably the best example of the concepts of medieval luminosity and majestic height left intact today. Note how colored or "stained" glass has now replaced the cement and stone of the early constructions; the once solid if perhaps somber cathedral interior has been transformed into a lively and delicate skeleton enveloped by light. Here technical innovations and esthetic considerations unite in one of the truly great expressions of faith and humanity. The cathedral, reaching skywards toward God and illuminated by God's holy light, effectively transcends simple building construction and becomes a living example of Christian art in physical, concrete form.

Once windows were in place, artists began to turn their attention to the possibilities of colored glass. Through relatively simple means, glass could be cut into various designs and attached to lead borders, producing images that glow when pierced by the sun's rays. This enabled coloristic effects impossible with mosaic and wall painting, and provided a unique opportunity for artists to introduce two-dimensional art into the church interior (see Fig. **3.30**). Stained-glass images are characteristically more abstract than icon images, with strong color contrasts. This is a common occurrence in early Christian art, due in part to the technical demands of the materials and the importance of making the images legible to the average worshipper. Pictures provided the means to communicate to an often illiterate public, and it is not surprising that artists found themselves more concerned with clarity of intent than with subtly rendered figures. A good analogy here is to the relationship between handwriting and type. People often enjoy very personal forms of script, and sometimes go so far as to "read into" these marks all sorts of autobiographical information (think of those individuals who make a living out of analyzing handwriting). But when it is necessary to communicate a message or thought to another person, it is essential to develop a more generic and predictable form of script, with as little deviation from the norm as possible, hence the popularity of type. This is the point behind much of the simple, straightforward design of the early Church and the seemingly strict adherence to

■ 3.27 Cross section of a flying buttress

■ 3.28 Exterior side view of Notre Dame, Paris, 1163–1250 showing flying buttresses

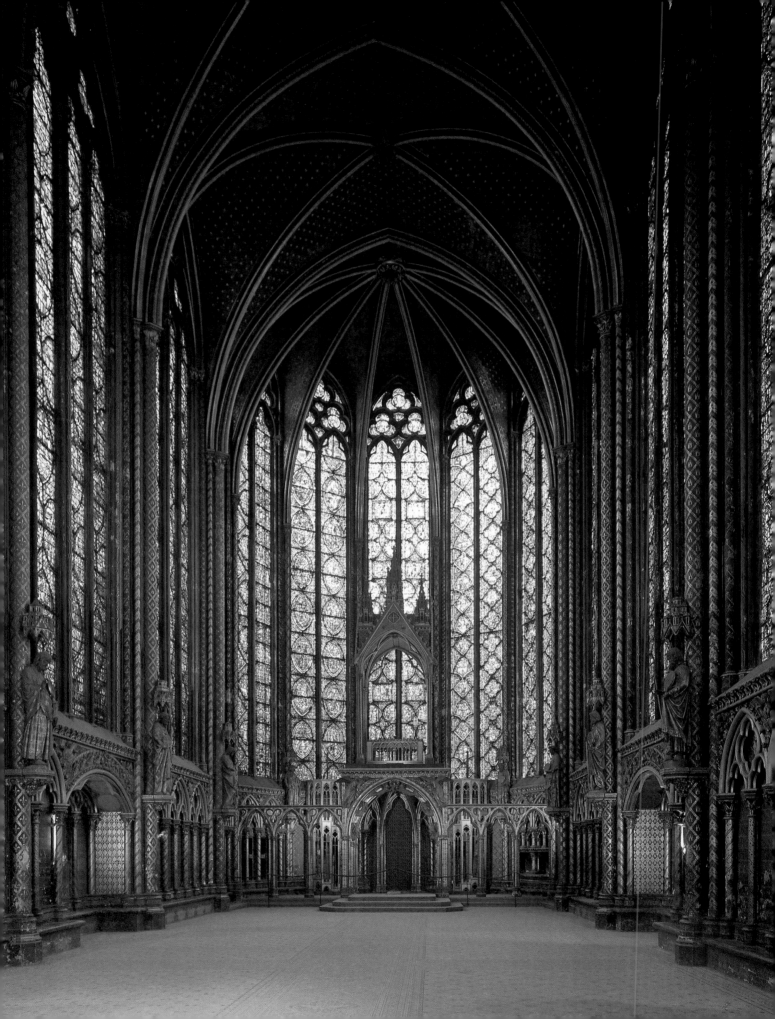

◄ 3.29 Interior view of the Upper Chapel of La Sainte-Chapelle, Paris, 1243–1248

■ 3.30 Notre Dame de Belle Verriere
Interior detail from Chartres Cathedral, France, early 13th century

■ 3.31 The Initial "B" from Psalm I
of the *Munich Psalter* c. 1200
10⅞×7⅜ in (27.4×18.8 cm)
Bayerische Staatsbibliothek, Munich

very limited motifs. The beauty of this work lies in how individual artists worked within the confines of these practical considerations.

In a Europe devastated by centuries of warring, the book was one of Western civilization's few links with the thoughts and deeds of the past (the Moors and Islamic scholars likewise kept libraries, but these were inaccessible to most Western eyes). The luxury of the printing press (movable type was not invented until 1447) was not available to the Europe of the Middle Ages, so each text had to be patiently recopied by hand. The process could, and often did, take years, and thus books became an extremely valuable item, housed in the security of monasteries and the dwellings of a few rich rulers, and accessible to very few. The importance of these texts (often works of philosophy and religious commentary) made them understandably precious, and thus they became predictable repositories for decoration and embellishment. The "illuminated manucript" provided artists with the opportunity to work in a labor-intensive and intimate manner—in a medium very different from the awkward materials of glass and stone. The result is work such as the illustrated initial "B" from Psalm One of the *Munich Psalter* (Fig. **3.31**), which illustrates the intricate patterning and painstaking detail that typify this form of art making.

The history of Christian art after the Midde Ages was to belong to the world of representation, as the faithful began to investigate the relationship between humans and their physical world. As Chapter Four will·point out, developments such as perspective and illusionistic rendering began to obsess Christian artists by 1400, ushering in a new age in Western art referred to as the Renaissance. And that meant pattern—a form of art and a way of looking at the world that was very different from the aspirations of the Renaissance—was to find its greatest religious expression not in Christianity but in Islam.

▶ ISLAMIC ART

● In 622 an Arab prophet named Muhammad fled from his native Mecca to the northern city of Medina, and in doing so ushered in a new age and a new religion—Islam. Islam belongs to the tradition of monotheism first initiated in the Mediterranean basin by Judaism and then Christianity, and it shares some of the same history. But unlike the Judeo-Christian heritage, it relies exclusively on a book, the Koran, as the undisputed word of God, given to humans through the prophet Muhammad. This has certain repercussions for Islamic art, including the basic concept of the artist or creator, which one often takes for granted. As a religious community evolving out of a virtual vacuum of visual art activity, Islam provides a fascinating case study of how art develops around, and then reacts to, existing notions of beauty and decorum.

Like the ethnic Jews before them, the Bedouin (the native peoples of the Arab peninsula) were a nomadic society, with little practical interest in architecture or the cumbersome visual arts. What little they had was decorated simply, and for the most part the culture survived through oral and musical means. A good example of this lack of interest in visual arts in Bedouin society is the absence of actual words to define art forms. Since there was little practical use for such expressions, no linguistic equivalents for concepts such as painting or sculpture developed. Instead, the word "musawwir" (meaning fashioner) was used as a catch-all term for any visual expression.

It is significant that Islamic history begins with Muhammad's exile in Medina—in fact year one in the Islamic calendar coincides with 622 in the West, pointing to an outright dismissal of the era before (Muslims call this time the "jahiliyyah," meaning the time of ignorance). So central is the Koran to the faith that it quickly became both the source for later art and the law for its execution. Early Islamic scholars looked to the holy book for guidance with regard to the visual arts, but it is difficult to find any overt support or denial for the creation of images in the text. One story is the Koran's reference to Jesus fashioning a bird out of clay, and then breathing life into it and letting it free. This passage may suggest the awesome power of images and the creative act, but perhaps it also warns against such activities unless sanctioned by God.

The ambivalence of such passages gave early scholars little to go on, but certain pragmatic considerations helped clarify the status of art in Islam. One such reality was the fact that the Koran simply did not lend itself well to narrative illustration. It reads much more like the Psalms, Proverbs, the laws of Leviticus, and the Epistles of the Bible, which by their very format are difficult to translate visually. Thus the idea of representational art as a vehicle for narrative held little interest or practical merit for the faith.

The Hadith (traditions about the Prophet) was compiled some years after the death of Muhammad, and as a document it probably reflects the interests of another time and even other cultures. Unlike the Koran, it is explicit about the repercussions of indulging in representational art for the pious. One dramatic example from the text will suffice to illustrate this point: "Those who will be most severely punished on judgment day are the murderers of a prophet, one who leads men astray without knowledge, and the maker of pictures." This placing of blame on the artist as a blasphemous competitor with the creative powers of God is probably an early attempt at justifying iconoclasm. Logically, if God is the sole source of inspiration behind any creative act, then it follows that the artist's creation is simply an extension of God's will and thus his/her art a glowing example of God's magnificence. It is interesting to note that recent scholarship on this important text suggests that it was compiled for the most part outside Arabia in areas such as Persia and India (which had become part of the Islamic empire), where representational imagery was already present. One may speculate that such new adherents to the Koran desired an identifiable separation between their polytheistic pasts (and the images that surrounded such worship) and their new faith, much like the Jews before them.

Christian Byzantine culture was flourishing around the Mediterranean Basin during the rise of Islamic culture, and as the Muslim community aggressively flexed its military and political muscle, it quickly assimilated many of these towns and subsequently their Byzantine heritage. Though by most accounts it appears that Muslims began by appreciating, and in some cases even emulating, Byzantine art, as the fight-

ing continued, admiration was quickly consumed by hatred and suspicion and Christian art forms fell out of favor. The Islamic community saw Byzantine icons and mosaic works as idolatrous, and in retrospect this is certainly understandable, considering the Christian community's own inability to come to a consensus on their value and legitimacy (remember John of Damascus's eloquent defense). This had a recognizable effect on the developing art of Islam, as they consciously avoided the blasphemies of their enemies.

CALLIGRAPHY AND ARABESQUE DESIGN

Shortly after the initial conquests of Christian territory, Islamic culture began to develop an art program based almost exclusively on decoration, as artists desired a symbolic language different from that of other cultures, and a unique expression of the faith. An interesting way to study this development is by examining early coinage from the period. Once Islam occupied the so-called "fertile crescent" and began expanding to cover most of the territory between eastern Europe and the Sinai, there came the need for an all-inclusive monetary system. They began by removing Christian symbols from the existing coinage, which was then followed by the removal of typical Greek-style portrait busts (similar in design to our coins). In 699 a decree insisted on Islamic coinage with no links to other cultures. This was obviously not an easy undertaking. The most unique aspect of Islam is, of course, the centrality of the Koran as the undisputed word of God in written form. This meant that the script of the Koran (written in the

■ 3.32 (above) Dirham or drahm minted in Basra 694–95 AD (below) Dirham minted in Abarqubedh, Iraq, 702–03 AD
The American Numismatic Society, New York
(1975, 270.1) (1949, 163.946)

■ 3.33 Details of tile work from the Lotfollah Mosque, Isfahan

miraculous gift of Arabic) was in some way a visual artifact of God's communiqué to the world. The miracle of script in a community that relied exclusively on oral traditions made Arabic at once a central and important part of the Islamic culture. When the written language of the Koran was accepted as a legitimate symbol of the faith, then calligraphy, the art of drawing language, quickly became the most important visual document of the culture. By 750 the motif had found its way onto coinage (Fig. **3.32**).

By the eighth century, Arab Islam was for the most part free of representational imagery (many of the conquered areas such as Persia and India still embraced figurative images, most likely because of their strong pictorial traditions). Abstract patterning, then, was one of the few available outlets for visual explorations. The term "arabesque" is often used to describe the great abstract designs initiated by these Islamic artists, and it refers specifically to the combination of calligraphy and intricate, mathematically precise compositions. This art form breaks down into two basic areas of design: vegetal and geometric. Vegetal design was considered an appropriate symbol of growth, change, and movement—the basic vocabulary of life. The ivy plant and the grape vine are typical of these organic motifs, their wandering, cursive branches good examples of abstract design in nature. These patterns probably originated in Persia, and with the conquests they quickly became popular throughout the Islamic world as eloquent reminders of life's flow and unpredictability (see Fig. **3.33**). Geometric design has its origins in Arabia and the great developments in the field of

■ 3.34 Geometric designs from the Dome of the Rock, Jerusalem,
late 7th century AD

mathematics that surfaced during the eighth century. Appearing visually predictable, angular and hard-edged, it came to represent the static, fixed, and stable ideas of the faith. It also had the added bonus of providing clarity and balance to any visual composition (see Fig. **3.34**). When combined, the vegetal and the geometric motifs were understood to represent life and growth within the framework of order—the sensitive pictorial equivalent of the Islamic faith (see Fig. **3.35**).

Calligraphy is arguably Islam's greatest visual expression. To the faithful, Arabic was a language designed and instituted by God himself through his mouthpiece Muhammad, and calligraphy its human expression. Scholars note that before the birth of Islam, there was no accepted written script among the nomadic Bedouin community, most likely because of the long tradition of

■ **3.35 Exterior mosaics from the Great Mosque of Damascus** c. 715 AD

oral histories and the practical consideration of traveling light. With the arrival of God's word in its final form, there came a need for more permanent documentation, since the proliferation of such truth relied on a fixed and unchanging source. As a consequence, the vitality of God's transmission through Muhammad quickly became inextricably linked with the development of script, to the point of becoming a logical extension of God's gift to the world—hence the popular phrase "the miraculous gift of Arabic." And though it started out with only the most utilitarian of motives, script soon took on important ramifications for art. Note that Kufic script has many of the same qualities as vegetal patterning, yet the unpredictability of the lines separates it from more all-over and static patterns with which it is often associated (see Fig. **3.36**).

◄ 3.36 Glass Mosque Lamp
inscribed with quotes from the Koran
Syrian, 14th century
Early glass painted in enamel colors
Height 11⅜ in (28.5 cm)
Diameter 10 in (25.5 cm)

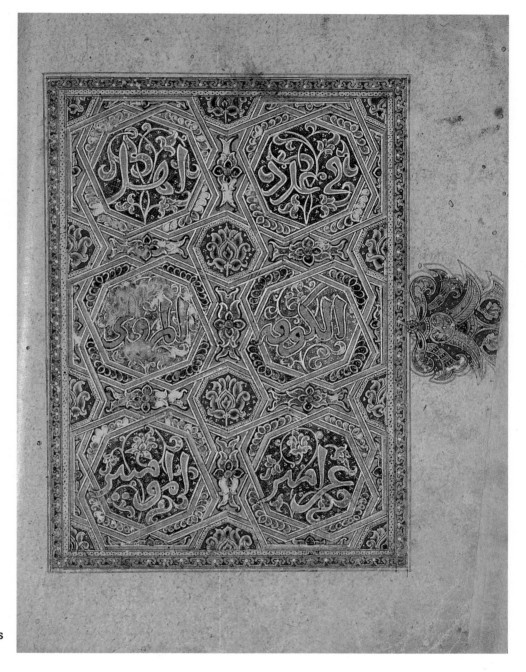

■ 3.37 Leaf from a manuscript
of the Koran c. 1000 AD
Probably by Ali-ibn-Hilal, Baghdad
7×5¼ in (17.7×13.5 cm)
Reproduced by courtesy of the Trustees
of the Chester Beatty Library, Dublin

One of the most striking examples of design on a flat plane is the combination of arabesque elements infused with script (see Fig. **3.37**). In these compositions, one can come to appreciate the considerable visual force of some of the most simple principles of design —principles that continue to inspire designers to this day. For instance, straight lines of predictable and consistent thickness and tone immediately evoke static and rational qualities on the picture plane. This visual framework provides a field on which other activities (scribbles, forms, etc.) can be measured and stabilized. A good example of this type of design is the grid, which breaks down the plane into smaller, often identical, compartments. Once the grid is in place, any mark or scribble placed on top of it will set up an interesting discord, and the structure of the grid attempts to stabilize the activity of the gesture. The Islamic vegetal design undulates in and out of the predictable geo-

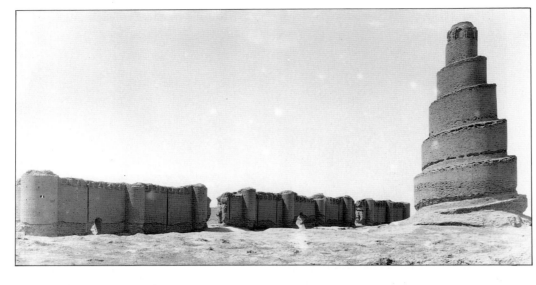

■ 3.38 The Great Mosque and minaret of al-Mutawakkil, Samarra, Iraq, 847–48 AD

■ 3.39 Floor plan of the Great Mosque and minaret of al-Mutawakkil, Samarra

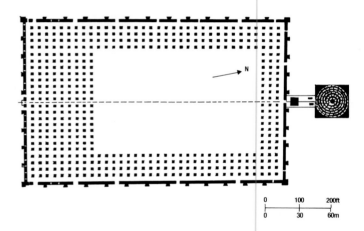

metric framework much as our lives pass through time, and in this way the overall design reminds us of our own relationship to the static realities of life, death, and the need for faith.

The most dynamic gesture to grace these intricate designs is that of calligraphy, the word of God made visible through script. These sporadic, sensual lines dance through the field of vegetal and geometric patterns, providing the viewer with an obvious counterpoint. On the most basic visual level, the marks demand attention because they are different from the pattern on which they exist; we acknowledge them as a different form of "language" from the arabesque design. In the case of Islam, it is a profound difference because it refers directly to the Koran, which in turn refers directly back to God. Perhaps one may go so far as to claim that if arabesque design is a visual equivalent to life's harmonious balance, then the dynamic visual quality of script connotes our own persistent need for faith. In any event, arabesque design and calligraphy remain Islam's most profound visual expressions —ones that remain virtually unchanged to this day. If great religious art can be said to perform as a contemplative act and an expression of one's relationship to the unknown, then in Islam abstract design has consistently satisfied artists and viewers on both levels.

● Traditional Islamic architecture presents the viewer with similar visual suggestions. The format of most mosques (from *masgid* or *masjid*, meaning roughly worship or place of worship) is based on a relatively simple rectangle, oriented in such a manner as to lie directionally in line with the holy city of Mecca. Mosques usually consist of three sections: a courtyard or atrium, a covered sanctuary, and a tower, or "minaret," from which the "muezzin" (crier) calls the community to worship. In order to facilitate the Islamic worshipper's ritual prayers, which are to be performed while facing Mecca, the "qibla" (the direction faced by the faithful) wall at the end of the sanctuary always faces east. In the center of the qibla the "mihrab," or sacred niche, is located.

One of the earliest examples of this simple, though by no means simplistic architecture, is the Great Mosque and Minaret of Samarra (Fig. **3.38**), which was constructed between 847 and 848. Though now only a shadow of its former glory (excavations suggest that the inner walls were once covered with golden mosaics),

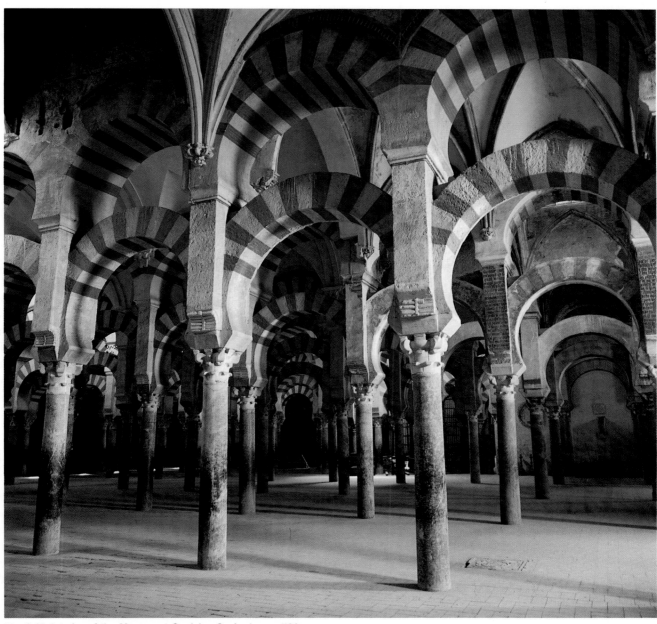

■ 3.40 Interior of the Mosque at Cordoba, Spain, begun 786 AD

the structure is a clear example of period architectural philosophy, and remains the largest of its kind in the Islamic world. The floor plan (Fig. **3.39**) adequately demonstrates the predictable, symmetrical character, suggesting such psychological equivalents as stability, clarity, anchoring, and perhaps the eternal character of God's law.

Encompassed within this complex lie row upon row of columns, dispersed throughout the sanctuary in seemingly endless succession. Like most architectural developments, these posts were first and foremost the products of functional need—they held a roof over the sanctuary to protect the worshippers from the intense sun. But their striking visual character was not over-looked by either architect or theologian; the array of columns, with their curved vaulting, provided a fitting counterpoint to the rigid format of the predictable rectangular skeleton. An interior scene from the Mosque at Cordoba (Fig. **3.40**) adequately illustrates the visual impact such a repeated motif has on one's perception of space within the confines of the rec-tangle. Like arabesque patterning and Kufic script, the interest in repeated gestures or pattern within the defining boundaries of a strict, easily understood geo-metric form such as a rectangle, makes these excursions into architecture visually satisfying, while remaining meaningful as a vivid reminder of God's eternal order in a world of seemingly endless possibilities.

▶ HINDUISM AND THE CULT OF IMAGES

● It has been said that nearly all Indian art can be considered religious in one way or another, and the practise of art making a spiritual endeavor. Thus it is understandable that historians have up until very recently found it difficult to distinguish between art and religion in traditional Indian culture. As the principal religion of India, Hinduism stands out as both the oldest continuous religious tradition in the modern world (dating as far back as 2500 BC) and the most devoted to visual forms. As a faith, Hinduism emphasizes the centrality of a single god who, unlike the God of Israel, exposes itself through myriad manifestations, including male, female, and animal forms. The primary focus of Hinduism is on the cycle of reincarnation, where right conduct may lead to a better situation in the next life. This emphasis on birth, death, and rebirth is both the crux of Hindu social and moral codes and a viable explanation for the abundance of fertility images in its visual culture, and it points to a faith obsessed with notions of transience and transition—important features in its art.

The polytheistic nature of the faith has made representational imagery a necessary and rich part of ceremonies and rituals. Many gods means many identities, all of which are differentiated in worship by an image. And unlike the traditions of Judaism and Islam, which place emphasis on the transcendent nature of the deity and thus its incompatability with pictorial representation, Hinduism's emphasis on the multiple manifestations of the ''Supreme Being'' allow for a great many representations.

The history of Hinduism is, then, the history of image making in Indian culture, and in this way it provides some interesting parallels to Christian art.

In general, Hindu art theory emphasizes the role of art as embellishment or idealization. There are texts that outline proper procedures for the rendering of forms; these coincide with the ideal nature of the deities in question. In this context, poor art is that which deviates from the prescribed forms, or art that emphasizes the particular over the universal. This is reminiscent of two traditions already discussed: the idealism of Classical Greece and the rigid pictorial structure of Christian icon painting. The relationship between Hindu and Greek culture is not an incidental one, for conquests by Alexander the Great brought the Indus valley into direct contact with Classical models as early as 327 BC. The idealized form recurs with regularity throughout the history of art, and its cross-cultural significance should give some indication of the ability of art to tackle such abstract concepts. The relationship between Hindu art theory and early Christian thought is perhaps less obvious but still intelligible. The sanctioning of specific forms of representation by the Christian Church gave Western artists little room for expression. In these restrictive confines, the test of great art is its ability to transcend the dictates of decorum. In this way, Hindu and Early Christian artists engage in a similar type of artistic activity, where meaning is found in the meditation on established codes rather than in innovation.

HINDU TEMPLES: KANDARIYA AND SHRI RANGANATHA

A tremendous amount of Hindu iconography centers around three manifestations of the central power: Shiva, Vishnu, and Vishnu's subsequent manifestation in the form of Krishna. Since each god is present in both the heavenly and material (earthly) realm, places such as temples hold special significance for Hindus as dwellings of the deities. In temple architecture one can learn much about how Hindu artists have viewed the relationship between art and religion, and to do this we will examine two specific Hindu temples: the Kandariya Temple (Fig. **3.41**) at Khajuraho in Northern India, and the Shri Ranganatha Temple (Fig. **3.42**) (located near Madras), which is a typical southern building.

The Kandariya Temple was built around 1000 as a shrine to Shiva, a god of tremendous creative and destructive power, paralleling the cycle of birth and death implicit within the Hindu faith. In this case, Shiva is symbolized in the form of a lingam, or stylized phallus, and the great stone image of primal force is the central focus of the temple construction. The temple complex is built to emphasize the vertical thrust of the lingam, and the participant's journey through the temple interior is a psychological ascent to the embodiment of Shiva. Viewed from the exterior, the roofs of the three inner halls rise in ascending order towards the

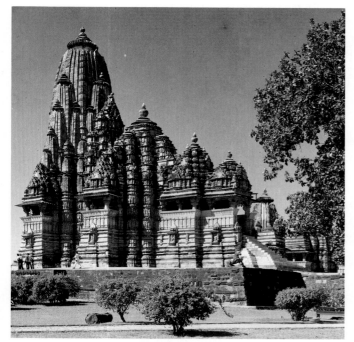

■ **3.41 Kandariya Mahadeva temple**
Khajuraho, Northern India, c. 1000 AD

■ **3.42 Plan of the Shri Ranganatha temple, South India,**
5th century AD

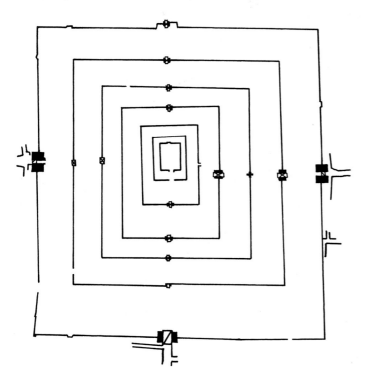

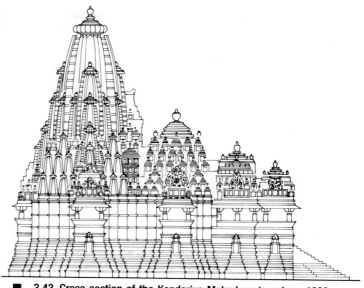

■ **3.43 Cross-section of the Kandariya Mahadeva temple c. 1000 AD**

"shikhara" or inner chamber, where the phallus is kept. The immediate impression is one of verticality, and the diagonal movement of the roofs helps focus attention on the primacy of the shikhara (see Fig. **3.43**). This is reiterated by the height of the platform on which the temple is constructed, reinforcing the already obvious heavenward thrust of the complex. There is also the impression that one is viewing some form of an ideal or heavenly mountain, devoid of the imperfections of nature. One then enters the mountain by way of the cave, finding the center of the lingam deep within the "womb" of the earth (the actual room which houses the lingam is called the "garbha-griha" or womb room). The allusions to both mountain and sexual union are appropriate in this case, and are accentuated by over 850 individual sculptures, many of which are in erotic poses. The Kandariya Temple is a wonderful example of how intelligent design can evoke very convincing bodily associations in the minds of the faithful. Here the primal creative power of Shiva is successfully integrated into the structure of the temple design, and the result is a very pleasing union of religion and art.

The Shri Ranganatha Temple is devoted to the ancient god Vishnu (the great heavenly king who descends to earth periodically in a number of guises to maintain cosmic stability), and today it stands as the practical result of centuries of change and rebuilding, though the original design is said to date back to the

■ 3.44 *Krishna and Radha in a Grove* c. 1780
from the *Gita Govinda*
Gouache on paper
4¾×6¾ in (12×17 cm)
Courtesy of the Trustees of the Victoria and Albert Museum, London

fifth century. The temple covers an immense 156 acres (385 ha) and includes seven rectangular walls arranged concentrically around the garbha-griha, which houses the image of Vishnu. It holds approximately 42,000 permanent residents, most of whom reside inside the first wall. As one continues toward the center, the hustle and bustle of daily life give way to fewer and fewer distractions. The overall design reminds one of a maze, with its center hidden from view. The worshipper is required to follow a series of alleyways to get to the inner sanctum, supporting the impression that Vishnu appears only to those who specifically seek him out. Here the experience is one of descent rather than ascent (as in the case of the Kandariya Temple), as the worshipper peels off layers of the outer world to find the sanctum and union with the god. Again, the obvious analogy to the body and the revealing of self through a carefully orchestrated journey is evident, and it only further reiterates the rather impressive abilities of architecture to embellish a religious experience.

● The god Krishna, an incarnation of Vishnu, is one of the most popular deities in the Hindu pantheon. His playful character has made him a favorite of Hindu artists, and the great narratives from which they draw inspiration are ideally suited to the demands of painting. Some of the most beautiful of these Krishna narratives were produced by an eighteenth-century artist named Manaku, whose illustrations to the *Gita Govinda* were to form the basis for later Indian painting. A good example of Manaku's virtuosity is the image of Krishna and Radha from the *Gita Govinda* (Fig. **3.44**). Consistent with Hindu art theory, the figures and the environment are both idealized, and the graceful handling of the forms is indicative of the lushness and sensuality often associated with Indian manuscript painting. In the ideal world, it is always spring, and thus the paintings typically exude the brilliant colors of the most perfect of seasons, including the symbolic blue of Krishna himself. This is paradise, a place where gods and humans live in intimacy, and here art can provide a vehicle for flights of religious fancy. This is not representation but a highly developed tradition of abstraction, where art can become the springboard for meditation and rapture. And in Hindu art, this is the very essence of quality.

▶ ASPECTS OF THE BUDDHIST ART TRADITION

● One of the most fascinating and dynamic religious art traditions is that of Buddhism. As it encapsulates a tremendous degree of stylistic inventions and philosophical viewpoints, this survey will unfortunately have to concentrate on only a few fundamentals, for the sake of brevity.

Buddhism centers around the teachings of Gautama, a fifth-century BC Indian prince and sage who achieved profound wisdom and complete enlightenment by finding the "middle path" between excess and denial. Traditional Buddhism teaches of a world in flux, where truth is achieved through a process of extinguishing one's ego or soul, which is the root of all suffering. When Buddhists speak of enlightenment, they are describing such as a dismissal of self. This traditional form of Buddhism is described as extra-bodily, in that it attempts to move beyond the everyday. This is, of course, very different from most Western religions, where the shocking reality of daily existence, and its manifestation in guilt and faith, sustain the sinner. In Buddhism, this endless cycle of birth, death, and rebirth is ended only through the realization of "nirvana," and a letting-go of world.

BUDDHIST FIGURATIVE ART

Buddhist figurative art did not surface until after the first century AD, and its rise coincides with the beginnings of the veneration of Gautama as a deity. Early on Orthodox Buddhism saw the Buddha as embodied in his message—to understand him was to see him. Another problem for early Buddhist art was the

admission that when the Buddha died, he achieved complete extinction in nirvana, and thus could not be legitimately endowed by art with any likeness of a body. This accepted truth denied figurative representation, but it did allow for the establishment of a system of symbols which claimed no likeness, but instead simply evoked an idea. As early as 450 BC, symbols such as the wheel (the "dharma chakra") became an established part of Buddhist meditation, conjuring ideas of both the cyclical nature of existence and the veneration of the Buddha through his teaching. Another famous symbol is that of the footprint, which is associated with the Buddha's missionary journeying and his presence in nature. The lotus is the most complex and prevalent of the major symbolic representations of Gautama's teaching, and depending on one's orientation to the object or image, its meaning alters. Viewed from above, its rounded shape and circular heart represent the "essense of all," and when seen from the side above the water line, it is a vivid reminder of spiritual rebirth. By about 100 BC, artists had begun combining such symbols to imply the presence of the Buddha (see Fig. **3.45**). Thus from the footprint, lotus form, and the wheel one soon inferred the presence of the Buddha, rather than simply seeing separate symbols. Slowly, artists had found a way of describing the body of the Buddha through symbolism, signaling a shift toward a more indepth description of his bodily form.

The emergence of figurative art in Buddhism coincides with the beginnings of the veneration and worship of the Buddha as an object of devotion. Early Buddhism stressed austerity and discipline, and its inflexibility to everyday demands gave little incentive to the average person to follow its noble path. The teaching of the law (or dharma) slowly gave way to "bhakti" or devotion, and with it came the emergence of Mahayana Buddhism between the years 100 BC and AD 100. With a new emphasis on love and adoration not found in earlier Orthodox Buddhism, objects of veneration quickly became an important part of worship. Here, Buddhist art makes a conceptual move back into the context of the older Hindu tradition from which it first emerged—a process of conventionalizing the teachings into a complex iconography. This development of figurative art in Buddhism also coincides with two other historical events of some note. One was the development of the cult of Krishna in Indian Hinduism, with its emphasis on love and devotion and its popular use of imagery. The other was the effect of Alexander the Great and Greek culture on India and Central Asia. The Greeks brought with them a figurative tradition already well entrenched in religious ceremony, and the influence of Western sources is very evident in early Buddhist statuary (see Fig. **3.46**).

■ **3.45** *Central Lotus Form* **6th century** AD **from Lotus Blossom Cave, Lung Men**

■ 3.46 *Seated Buddha* from
Gandhara, Pakistan,
2nd–3rd century AD
Dark grey schist
36×22½ in (91.4×57.1 cm)
Seattle Art Museum
Eugene Fuller Memorial Collection

■ **3.47** *Colossal Buddha with Attendant Buddha* **Yung Kan, China c. 460–470** AD

The combination of these influences and events, along with an increased desire to make the teachings of the Buddha more accessible and meaningful to the populace, led to the emergence of visual images of the Buddha by about AD 100. Let us consider the seated Buddha image, a format that was to remain virtually intact for the next two millennia, for a brief moment. Upon first observation, one is immediately struck by the symmetrical posture of the figure. Its stability and balance are attributes of the Buddha's harmony, perfection, and ideal character at enlightenment. Its posture, the ancient Indian yogic "lotus position," suggests discipline and strength. Such figures also retained much of the earlier Buddhist interest in symbolism, using such devices as hand gestures or special decorative marks to evoke specific ideas. One such gesture (or "mudras") is the commonly depicted outstretched right hand with the palm up, which symbolizes blessing and reassurance. In the case of the Gandhara *Seated Buddha*, it is the "dhyana-mudra" with upturned hands held in the lap, designating meditation and serenity, that is depicted. An even more striking example of symbolic suggestion is the "ushnisha" or extra lump on the Buddha's cranium, referring to an auxiliary brain which accommodates his supreme wisdom. In much of later Buddhist statuary, the evolution of this symbolic gesture results in the head becoming highly abstracted, and it gives a good indication of how representation is itself nothing more than a set of conventions agreed upon by a community (see Fig. **3.47**).

As Buddhist figurative art became more popular and widespread, the image of the Buddha changed from a lifelike Greek-style statue, to a more abstract, frontal, and schematic form. Note that this development echoes a similar process of abstraction in Christian art during the Byzantine era, as artists attempted to discover a clear and transcendent language for the description of forms. And like Orthodox Christianity, Buddhists soon developed a canon, or fixed standards, for the production of religious imagery. The *Kama Sutra* was one such text, outlining such important considerations as proportion, which would allow art work to transcend the imperfections of this world. These proportions have little to do with naturalistic human anatomy, so in this respect the figures do not aspire to represent the physical Buddha, but instead stand as representations of ideas.

■ **3.48** *Tathagata Buddha*
Tibet, 13th–14th century
Opaque watercolors on cloth
36¼×26⅞ in (92×68 cm)
Los Angeles County Museum of Art
Nasli and Alice Heeramaneck Collection
Museum Associates Purchase

Buddhist art is not, however, restricted to simple three-dimensional concerns. In areas such as Nepal and Tibet, banner illustration became a popular format for figurative motifs. Since monastic orders often migrated on a seasonal basis to avoid the biting cold, the cumbersome nature of three-dimensional work made it impractical. The banner, on the other hand, was both convenient and portable, and quickly took on the form of a visual record of the Order. Though ''thangkas'' (banners) have religious significance, they were for the most part painted by lay people, many of whom spent years working on single pieces. As the banners became increasingly complex, they took on greater meditative value to the monks, who often used the illustrations as part of the process of refining their spiritual vision, and became permanent parts of the monastery (Fig. **3.48**).

BUDDHIST PAINTING IN CHINA AND JAPAN

By AD 100 Buddhism had reached China, coming into contact with other sophisticated religious traditions, the most prominent being Taoism and Confucianism. The "Tao" (Way) placed primary importance on the naturalness of action ("wu wei") and the harmonious relationship between humans and the universe. Therefore, the virtues of intuition and spontaneity anchor Taoist philosophy. Ch'an Buddhism (the most popular form of Buddhism in China) was deeply influenced by this concept, and it changed the way artists viewed both traditional techniques and the tools for making religious art. Confucianism had less direct influence with regard to Buddhist art than its Taoist counterpart, but it did provide artists with an important convention that was to be essential to later Buddhist art: poetry. As a socially constructed religious philosophy, Confucianism supported the idea of filial piety and loyalty through the writing and exchanging of verse, sometimes on a daily basis. As the custom developed, this essentially social activity soon took on deeper significance, prompting many observers to believe that

■ 3.49 Jun Dish, China
12th century
Ceramic
Diameter 6¾ in (17.1 cm)
Ashmolean Museum, Oxford

■ 3.50 Emperor Hui Tsung
The Five-Colored Parakeet
Handscroll, ink and
colors on silk
21×49½ in (53.3×125.1 cm)
The Museum of Fine Arts,
Boston
Maria Antionette Evans Fund

poetry was an intuitive and natural outpouring, and capable of leading to enlightenment. Such greetings were often combined with small drawings or a simple painting, and as the reputation of poetry grew, so too did that of illustration. Art, like poetry, was granted special status as a form of revelation about human nature. Here, the secular arts of calligraphy and drawing took on religious significance, and placed increased emphasis on the meditative value of the actual activity of painting (see Fig. **3.49**).

Another concept worthy of note is the Eastern view of nature during this period. In Western society, it is popular to see nature as something to shape, fashion, or beat down if need be. In this view, the world is the supreme embodiment of intellect (i.e. God) and thus can be ordered and manipulated according to certain rules. In traditional Eastern thought, nature is cruel, dispassionate, and unconquerable. Unlike their Western counterparts, Eastern artists felt a certain degree of religious awe toward their environment —devoid of intellect. Thus in the Eastern view, the very best and most truthful art is that which attempts to assimilate itself into the workings of nature rather than be its opposition. In Chinese Ch'an Buddhism, a landscape painting is an embodiment of Gautama's teaching, and the artwork, like nature itself, a manifestation of the eternal truths (see Fig. **3.50**).

When Buddhism arrived in Japan around the sixth century, the Ch'an view of nature became established in the Japanese monasteries. Zen Buddhism (the Japanese equivalent to Ch'an) is the most intuitive of all forms of Buddhist art, placing the naturalness of the act above all else. In an enlightened state, a Zen practitioner successfully unifies subject, content, and form into one absolute harmony—all of which is brought about by an intuitive response to environment. Alan Watts, one of the first Westerners to explore Zen Buddhism, summed up Zen painting when he stated: "The painting itself is a work of nature. . . using controlled accidents, paintings are formed as naturally as the rocks they depict." (A. Watts, *The Way of Zen*, Vintage Press, 1957, p. 174.) Here art is as much a work of nature as it is a representation of it (see Fig. **3.51**).

To understand fully this important concept (one which will concern us again in our discussion of modern art) it is necessary to understand what is commonly called a "non-dual" experience. The age-old Chinese symbol of "yin" and "yang" (see Fig. **3.52**) is perhaps the best way to describe the idea. Shown as

■ 3.51 Hakuin Zenji
Bodhidharma
Ink on paper
Private Collection

■ **3.52** *Yin and Yang*

opposites, these shapes nevertheless combine to create a perfect harmonious whole—the decline of one is supported by the rise of the other. This image can be applied to a variety of situations, but the most common is that of intuition versus rationality. According to the symbol, we attain harmony when we find the perfect equilibrium between these two extremes. The artistic ideal, then, would be the combination of naturalness and human thought, and in Zen painting that quality is achieved through the relationship between artist, materials, rational conception, and the accidents of nature.

What exactly did the Zen artists mean by the idea of harmony? First, consider the rational processes inherent in the making of art: one sits down, determines what one wants to paint, and then attempts to execute this design with the available materials. The tools will determine to what extent the artist can control the marks on the paper, and it is in these simple materials that the essence of Zen harmony is achieved. Take, for instance, a typical tapered bristle brush used in ink painting. Unlike a Western brush, which is often shaped to provide its user with the maximum degree of precision and predictability, the brush of the Zen artist is shaped to hold ink, as well as being extremely sensitive to pressure—which gives the line an unpredictable quality (Fig. **3.53**). If it is worked in a hesitant or unsure manner, such a brush blots or empties its ink, hence it is a tool shaped specifically for spontaneity and confidence. Even the handmade paper on which such marks are made is an extension of the natural world, since it reacts differently with each application. Together, these simple materials become the messen-

gers or embodiments of the intuitive truth that the Zen artist hopes to capture. When these features are combined with the polarity of black marks on white paper, the stage is set for the profound gesture. Briefly, then, in Zen painting the non-duality of existence is realized through a very sophisticated relationship between chance (the materials) and choice (the hand).

The most deliberate and perhaps quintessential symbol of Zen Buddhist art is the circle or "marvelous void" (Fig. **3.54**). Here the image of wholeness and connectedness is painted with great authority, only to find its path mediated by the "happy accidents" of the tools. Rationality and intuition, nature and nurture, universe and self, or whatever else you may choose to call this harmony, this is one of the great expressions of balance and humanness in the history of civilization. Though many were to attempt such an integration between their lives and the mysterious world around them, few were able to achieve anything quite so profound and so sparse as the Zen circle.

■ **3.54** Gyokusei Jikhara
Circle (Void)
Brush and ink on paper

■ **3.53 Calligraphic ox hair brush and Western bristle brush**

▶ SUMMARY

● It is fitting that this short discussion of religious art should end with the circle painting, for embodied in its simple gesture is the wrestling between the known and unknown that forms religious art. Though the diversity of approaches and theories has changed dramatically from religion to religion, there remains a constant: the desire for an art that can eloquently speak the truth while simultaneously manufacturing it. Perhaps that is the real motivation behind iconoclasm, but it is also what has historically given art its authority. And if harmony can be achieved through spirit and mind, then in the next chapter on the Renaissance, we will see how Western society created its own equivalent to the Zen circle—Michelangelo's *David* (Fig. **4.35**).

If religion can generally be understood as the human community's attempt at constructing some greater truth or rationale for existence in an often dispassionate and cruel world, then art, as a vivid expression of our cultural needs and thoughts, perhaps most clearly illustrates this important relationship. Through the examination of five of the world's most important religions, it has become apparent that each community fashions its images around certain basic assumptions with regard to its personal and communal relationship with God. In some cases, such as Islam and Judaism, the very act of producing likenesses was/is seen as a blasphemous attempt at competing with God's power to create and destroy; in others, images appear as a fundamental component of the faith and the process of worship. It appears that the suspicion of images is determined very much by the nature of the faith, particularly its monotheistic or polytheistic character. Yet in all faiths there is an undeniable attempt to make an art which acts as both an inducement to worship and meditation, and an accurate suggestion of God's will and order in the world. In this way, the religious arts remain perhaps the clearest indications of how we as humans have historically contemplated the mind of God.

Suggested Reading

Some of the best texts on religious art are books on the history of religion, since they place artists and their visual expressions within the context of faith. However, there are also some excellent surveys which specialize on religious art. This short list is but a sampling: Michael Gough, *The Origins of Christian Art* (London: Thames and Hudson, 1973), O. Grabar, *The Formation of Islamic Art* (New Haven: Yale University Press, 1973), A. C. Moore, *Iconography of Religions* (London: SCM Press, 1977), and B. Rowland, *The Evolution of the Buddha Image* (New York: Abrams, 1963).

Glossary

arabesque (*page 129*) Meaning "Arab-like," it is commonly used to describe Islamic ornamental work, which combines both vegetal and geometric configurations into a unified composition.

basilica (*page 108*) An early form of Christian church architecture based on Roman secular designs, which would set precedents for later Christian building projects. It typically consisted of an "atrium" or outer courtyard and a closed colonnaded hall.

calligraphy (*page 131*) Literally the art of writing, it is the written word or words as a visual document.

flying buttress (*page 123*) A supporting armature used on Gothic cathedrals to take the strain of the vast vaulted ceilings. The buttress distributed the mass of the building away from the walls to the area around the foundation, allowing architects to build higher and more structurally sound churches, with more window space and thus greater light in the interior.

iconoclasm (*page 101*) The practice of denying representational imagery, often on moral or religious grounds.

mosaic (*page 114*) The art of creating images using colored pieces of stone, terracotta, and glass "tesserae." This art form was originally used to decorate the floors and walls of buildings.

yin and yang (*page 146*) Described as the unity of opposites and popular in Taoism and Buddhism, this circle symbol combines its halves to create a perfect harmonious whole—the decline of one is supported by the rise of the other.

4

ISSUES AND IDEAS IN RENAISSANCE ART

Painting is not only a science, it is even a divinity,
because it transforms the painter's mind into something
similar to the mind of God.

LEONARDO DA VINCI

In 1860 the Swiss historian Jakob Burkhardt wrote his influential text *The Civilization of the Renaissance in Italy.* He argued that European culture was "reborn" in the late fourteenth century after having lain dormant for almost 1,000 years (since the fall of the Roman Empire). Such a rebirth, or "renaissance," signaled a new emphasis on individuality and social reform, and a recentering of culture around humanistic interests rather than devotion to God. This marked a dramatic shift in European civilization after the dominance of religious ideals of self-denial of the medieval period, and left a legacy of learning and Humanism, of which the visual arts are perhaps its greatest manifestation.

And though violently debated since its origin in Burkhardt's text, the term Renaissance is now one commonly associated with European culture from 1400 to 1600.

If it is at all possible to localize the hopes and aspirations of an entire era around one specific locale, then in the early Renaissance that locale was Florence. The city was something of an anomaly during the late 1300s, with a strong economy and one of the most progressive political systems of its age, moving from its previous medieval feudal system to a burgher oligarchy or "Signoria." Located on the road between Rome and the northern centers of commerce, it was ideally situated

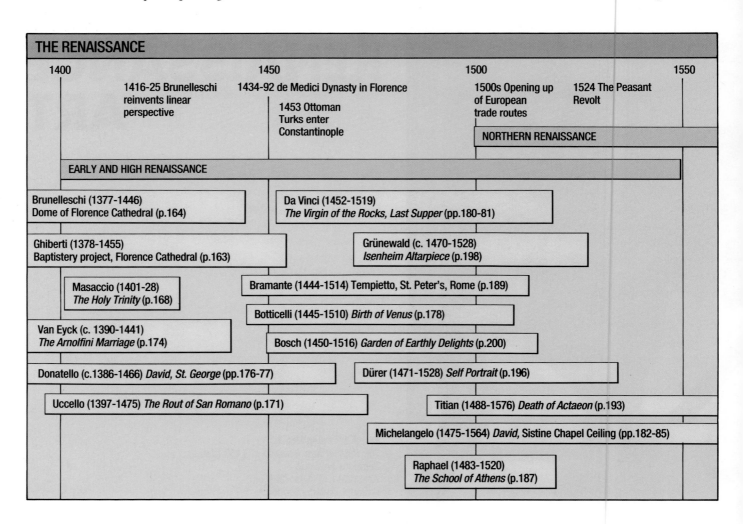

THE RENAISSANCE

1400	1450	1500	1550	
	1416-25 Brunelleschi reinvents linear perspective	1434-92 de Medici Dynasty in Florence	1500s Opening up of European trade routes	1524 The Peasant Revolt

1453 Ottoman Turks enter Constantinople

NORTHERN RENAISSANCE

EARLY AND HIGH RENAISSANCE

Brunelleschi (1377-1446)
Dome of Florence Cathedral (p.164)

Da Vinci (1452-1519)
The Virgin of the Rocks, Last Supper (pp.180-81)

Ghiberti (1378-1455)
Baptistery project, Florence Cathedral (p.163)

Grünewald (c. 1470-1528)
Isenheim Altarpiece (p.198)

Masaccio (1401-28)
The Holy Trinity (p.168)

Bramante (1444-1514) Tempietto, St. Peter's, Rome (p.189)

Botticelli (1445-1510) *Birth of Venus* (p.178)

Van Eyck (c. 1390-1441)
The Arnolfini Marriage (p.174)

Bosch (1450-1516) *Garden of Earthly Delights* (p.200)

Donatello (c.1386-1466) *David, St. George* (pp.176-77)

Dürer (1471-1528) *Self Portrait* (p.196)

Uccello (1397-1475) *The Rout of San Romano* (p.171)

Titian (1488-1576) *Death of Actaeon* (p.193)

Michelangelo (1475-1564) *David*, Sistine Chapel Ceiling (pp.182-85)

Raphael (1483-1520)
The School of Athens (p.187)

for the development of trade, and it soon became an enticing center for many of the Western world's most powerful financial institutions. Recognizing the importance of the city's trade guilds to the well-being of all its citizens, elected officials from each of the seven most economically influential guilds formed a "representative" government for the whole of Florence. This insured the continued prosperity of the city-state, and kept the affairs of government directly related to economic policy. The result was an efficient and energetic community which had both the resources and the intellectual aspirations to become the new center of Western culture.

Florence's prosperity coincided with a significant shift in attitude toward education and intellectual curiosity. One notable result was the re-emergence of philosophy and the Classical languages of Greek and Latin in daily study after centuries of neglect. Influential Florentines were exposed to many of the great Classical thinkers, whose works were not readily available in the medieval period. This in turn created a whole new generation of enlightened citizens.

 # THE RISE OF LEARNING

● There is no shortage of frustration for a historian studying the origins of the Renaissance. It is, obviously, impossible to pinpoint any one specific social or technical condition as the impetus for the Renaissance. Rather, it is sensible to see the rise of Renaissance culture as an outgrowth of an assortment of disparate events and ideas surfacing during the end of the fourteenth and beginning of the fifteenth centuries. To understand clearly the singular dynamic that permeated Florentine culture around 1400, it is necessary to briefly digress into some of the contemporary historical issues and consider some precedents that anchored such activity.

On 29 May 1453, the Ottoman Turks entered the golden city of Constantinople, signaling the end of Christian Byzantine culture. Like most collapses, the process of moral and intellectual decay within the walls of the city had been slow but steady in the years leading up to the fall, and by the beginning of the fifteenth century, the scholarly community (traditionally an avid supporter of the Court) had begun a steady migration toward the West, finding sanctuary in the numerous universities that had sprung up in Europe over the previous two centuries. One such center was Florence, which happened to have the good fortune of hosting the latter half of the Ecumenical Council of 1438–9 (which originated in Ferrara), which once again attempted a reconciliation between the Eastern Orthodoxy (centered in Constantinople) and Western Catholicism. Many of the Eastern dignitaries and intellectuals were to remain in the city after the meetings, including the celebrated Genisthos Plethon (c. 1389–1464), sometimes called Gemistos, who tutored the Florentine leader and patron Cosimo de' Medici.

This migration of scholars was indeed significant, for it reintroduced certain Classical thinkers into Western culture. In particular, the rekindling of interest in Plato made popular once again the notion of ideals and "idealism," as opposed to an earlier medieval interest in "empiricism" (which emphasized observation of natural phenomena over abstract speculation and devotional mysticism). One consequence of this shift was a dramatic reconsideration of the structures of society and culture—events that would form the foundation of a Renaissance art.

Now, it is one thing to be able to lecture to a small, interested, and typically affluent audience on a topic such as Plato, yet it is an entirely different story making such information available and digestible to the greater populace. Throughout the medieval age, the written tradition (including such works as the Bible, a few commentaries, and some authorized works of philosophy) had been kept alive through scribes and calligraphers who patiently recopied by hand the texts in various monastery libraries. In one sense, the monks were perhaps the only continuous link between that age and the great thoughts of the past. However, such projects were extremely labor-intensive, making these documents highly prized and rarely available for study.

In 1457 the German Johann Fust printed the first

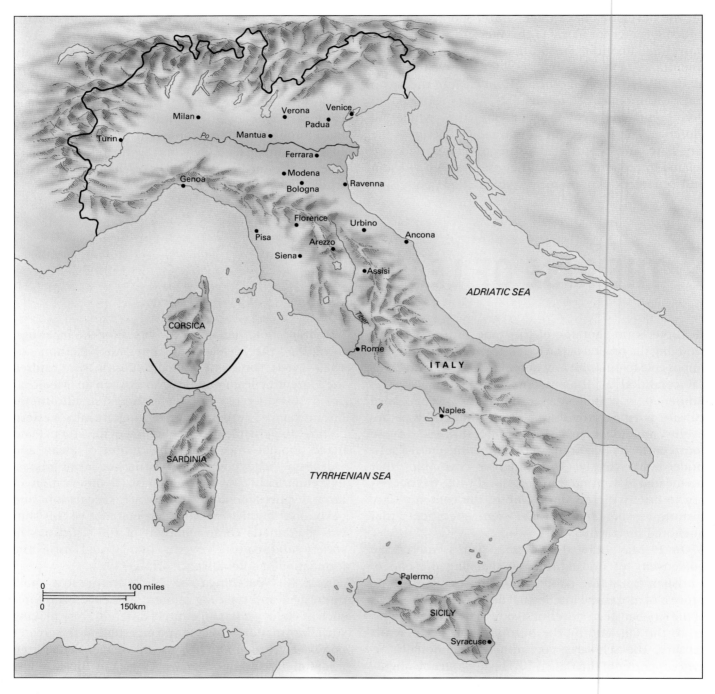

■ 4.2 Renaissance Italy

surviving dated book, a Latin edition of the Psalms. Using the then recently invented movable-type process discovered by his father-in-law, Johann Gutenberg, he successfully distributed and popularized a text which had up until then been in the hands of only a very few.

By 1500 over half a million printed books were available across Europe (such as *Jonah and the Whale*, Fig. **4.3**), which helped spread new intellectual ideas throughout the continent.

By the fifteenth century the world was also becoming

■ **4.3** *Jonah and the Whale*
Illustration from "Speculum humanae salvationis"
German, 15th century
Woodcut
The Metropolitan Museum of Art
Harris Brisbane Dick Fund, 1923 (23.26.2)

a considerably smaller place. The invention of navigational tools such as the stern rudder and the astrolabe made travel easier and more reliable, particularly in the case of Europe, where the North Atlantic was now opened as a trade route, linking the British Isles and Scandinavia to the other large commercial centers in the South. And like the printed text, this dramatic increase in communications between nations also enabled the quick proliferation of ideas and art work across Europe and into the New World.

▶ INDIVIDUALITY AND HUMANISM

● Perhaps the most important concept to come out of all the innovative developments and economic factors of the late fourteenth century was a renewed belief in the power and the majesty of the human being. The nineteenth-century historian Burkhardt claimed that it was an interest in individuality that separated the Renaissance from the medieval period, where God was the center and the axis of all power and dignity. The human, created in perfection but fatally flawed by desire (as evidenced in the story of Adam and Eve, Figs **4.4** and **4.5**) lived in the not-so-wonderful shadow of God through the sacrifice of his son Jesus Christ. The result was a world view deeply entrenched in guilt and obedience, and one where individuality was seen as a gross indulgence of vanity for all except kings and princes, who remained to all intents and purposes above the strict precepts of the Church.

The Renaissance seems to have liberated many of the pious from much of the restrictive dogma of the medieval period, thanks in part to economic considerations. With the various technical innovations in place, trade and commerce throughout the continent increased significantly, which in turn brought about the slow development of the competitive marketplace. Earlier teachings had made the acquisition of wealth appear a hindrance to salvation, and in its place put poverty and humility as attainable goals. Yet the success of commerce and the trade guilds in many of the more developed communities afforded a better standard of living for some and a more humane organization of society,

■ 4.4 *Adam and Eve Reproached by the Lord*
Relief from the bronze doors of Hildesheim Cathedral c. 1015 AD
Approx. 23×43 in (58.4×109.2 cm)

■ 4.5 Bronze doors with scenes from the Old and New Testaments,
c. 1015 AD
Hildesheim Cathedral, Germany
Bronze
Height 16 ft 6 in (5.03 m)

■ 4.6 *The Bank's Counting House*
Manuscript illustration
Courtesy of the Trustees of the British Library, London

all of which in turn helped justify such a system on solid
moral grounds (Fig. **4.6**). As well, it was the rich who
could afford to engage in a variety of guilt assuaging
charities and cultural activities. The art patron is an
excellent example of such supposedly philanthropic
activity; it was through the donations of the rich that
many a cathedral obtained its art.

THE BODY

The human figure was to embody many of the traits implicit within this new social order. For instance, the human nude makes an undeniable resurgence in the fifteenth and sixteenth centuries, after being absent from Western art since antiquity. The reasons for this seem clear: the human body was intrinsically connected with pleasure during the medieval age. According to dominant religious doctrines of the medieval period, bodily pleasures were to be avoided as a way of atoning for the guilt of the original sin of Adam and Eve. By the middle of the fifteenth century, this chaste outlook began to give way to a more natural and perhaps more realistic point of view, in keeping with the freedoms being exercised in the areas of economics and social matters. Subsequently, the issue of the body as a symbol of sexuality became equated not so much with sin as with nature, and it assumed the visual role as a reminder of the majesty and centrality of human form as God's creation (see Fig. **4.7**).

■ **4.7** Antonio del Pollaiuolo
Battle of Ten Naked Men c. 1465–70
Engraving
15½×23¼ in (38.4×59 cm)
The Metropolitan Museum of Art
Joseph Pulitzer Bequest, Purchase 1917 (17.50.99)

GIOTTO AND THE LIBERATION OF THE FIGURE

Giotto di Bondone (*c.* 1266–1337) is always cited as the artist who initiated the decisive pictorial break that was to culminate in the so-called "rebirth" in the visual arts. He is best known for his monumental frescoes in the Arena Chapel, Padua, which illustrate the lives of Christ and the Virgin. Perhaps the most memorable of the various scenes is the *Lamentation* (Figs **4.8** and **4.9**) of *c.* 1305, in which the dead Christ is presented to the faithful. Viewed alone and out of its historical context, it is difficult to see why this work was so radical, yet at the time it marked a significant shift in the way art was produced. To get a better idea of the nature of Giotto's achievement and its repercussions on later art, it is useful to compare his work with contemporary representations of the same theme—take, for example, the *Madonna Enthroned*.

First consider the *Madonna Enthroned* (Fig. **4.10**) by Cimabue (*c.* 1240–1302?) painted between 1280 and 1290. In this painting, there is an obvious adherence to the Byzantine tradition of figurative abstraction and the flattening out of space (which, you will remember from earlier discussions, allows for a clearer reading of the image). However, unlike Cimabue's predecessors, there are some marked departures. Though the space is shallow and not particularly convincing, the painting

■ 4.8 Giotto di Bondone
The Lamentation c. 1305–6
Fresco
7 ft 7 in × 6 ft 7½ in (2.31×2.02 m)
Arena Chapel, Padua

■ 4.9 The Arena Chapel, Padua, showing frescoes in situ

■ 4.10 Cimabue
Madonna Enthroned 1280–90
Tempera on panel
Approx. 12 ft 7 in × 7 ft 4 in (3.84×2.24 m)
Uffizi Gallery, Florence

nonetheless attempts to situate its figures within a constructed depth of field. This illusion of three-dimensional space is further accentuated in the drapery that wraps the body of the Virgin; unlike in previous images it corresponds to the implied roundness and volume of the figure. As well, the scale of the piece is an unprecedented 12 ft 7 in by 7 ft 4 in (3.84 m x 2.24 m) —much larger than most Byzantine images. As a result, the painting functions on a very different level

with its audience; it reflects an heroic affirmation of faith and the power of the Church, rather than an intimate personal correspondence between the viewers and their faith. The result is noteworthy, and it leads to the work of Cimabue's younger contemporary, the Sienese artist Duccio di Buoninsegna (*c.* 1255–*c.* 1318), who between 1308 and 1311 painted his own version of the *Madonna Enthroned* (Fig. **4.11**) for the altar of Siena Cathedral.

Duccio's painting shows many of the Byzantine mannerisms evident in the work of Cimabue. There is

▶ 4.12 Giotto di Bondone
Madonna Enthroned c. 1310
Tempera on panel
10 ft 8 in × 6 ft 8 in (3.25×2 m)
Uffizi Gallery, Florence

■ 4.11 Duccio
Madonna Enthroned c. 1308–11
Tempera on panel
Height 6 ft 10 in (2 m)
Cathedral Museum, Siena

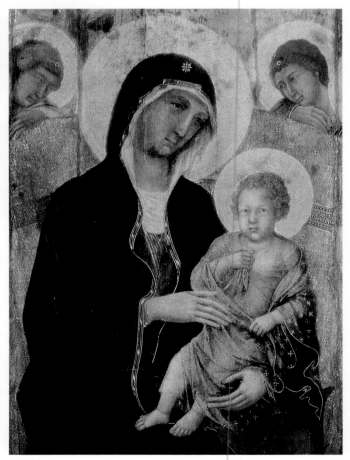

still little variation in scale between figures (which implies that all of the figures exist on the same plane, which in turn flattens out the painting), and there remains a certain degree of abstraction and schematic design in the scene. There is, however, a notable departure in the rendering of volume in the work, and further, a concentration on facial expressions which produces an engaging sense of emotion and tenderness. In the soft folds of the drapery and the contemplative expression of the Virgin, we are privy to the emergence of a new type of figure—the emotional counterpart to the compositional innovations of Giotto. In other words, with the Duccio painting one senses not only the liberation of the figure from the flatness of the panel but also an increased awareness of the personality of the subject—both of which seem to imply a more general acceptance of the idea of individuality.

It is not unusual for texts on the history of art to take the work of Giotto as a turning point in Western art. Indeed, many of the most important attributes of Renaissance culture are inextricably linked to the artist's attempts at constructing a more convincing sense of space on a painted surface. But why was it so important and revolutionary for an artist to create a convincing illusion of depth in painting? And further, what does this development tell us about Giotto's historical circumstances? Consider the artist's version of the *Madonna Enthroned* (Fig. **4.12**), which is contemporary to Duccio's version. The painter has placed much greater emphasis on the description of mass and volume in the work—illusionistic elements only mildly suggested in the previous examples. The most common way to produce an illusion of volume is to convince the viewer that elements within the scene exist in light and shadow. Giotto's successful use of light as a tool in the modeling of items enabled the inner space of the painting effectively to recede, liberating the figures from the surface. The term "liberation" is indeed appropriate here, for it asserts the freedom of the figure from the Byzantine insistence on flat, embedded design—a pictorial concept with parallels to the increasing sense of individuality in fourteenth-century Italy. For the first time in almost 1,000 years, both artists and their painted figures became individuals in the most basic sense of the term, liberated from the flattening dictates of previous "good taste." An example of this is the issue of authorship or "attribution" that suddenly surfaced for the first time in Western art since the Classical age. Today we know the names of these important figures; Cimabue, Duccio, and Giotto are recognized as "individuals" of achievement rather than anonymous contributors to the greater glory of the Church (which was previously the fashion in a world centered around concepts of piety and humility).

THE FLORENCE CATHEDRAL COMPLEX AND THE AIMS OF ART IN 1400

As the work of Giotto demonstrates, something new was "in the air" by the fourteenth century, and it was making its way into the cultural arena. Yet the decades after the death of the artist provided little conclusive evidence that a rebirth had indeed taken place. The century had seen its share of misery with war and religious intolerance, but perhaps the most devastating event to darken the period was the terrible Black Death, which made its way across Europe from Sicily in 1348, ending in Scandinavia in 1350. In that period of two years, it is estimated that the European continent lost 40 percent of its population. One Sienese writer perhaps summed up the agony and destruction of the day when he stated, "No one wept for the dead, because everyone expected death himself." But if it is possible to set aside the huge cost of human suffering brought about by the plague, there is evidence to suggest that the drastic decline in population had some beneficial effects on the economy and the standards of living in the late fourteenth and early fifteenth centuries. Less people meant more jobs, more food, and better wages for the workforce, and a greater share of what the land produced was now going back into the pockets of the survivors. Though one may argue that the actual records do not indicate any significant resurgence in gross economic product, the alteration in per capita affluence shows that the plague indeed contributed in an odd way to the success of the Renaissance.

It was not until 1400 that the cathedral authorities decided to continue work on their beloved Duomo (Italian for cathedral). The first of many projects to be initiated was a competition for a pair of bronze doors for the Baptistery started in 1401. This was to be one of the great competitions of the age, and it pitted two of Florence's most talented young artists against each other: Filippo Brunelleschi (1377–1446) and Lorenzo Ghiberti (1378–1455). The competition asked each artist to submit a design of cast bronze around the subject of the sacrifice of Isaac. Brunelleschi lost the bid, but the

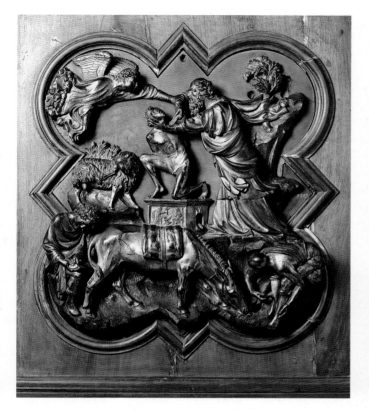

■ 4.13 Filippo Brunelleschi
Sacrifice of Isaac 1401
Gilt bronze
21×17½ in (53.3×44.4 cm)
Museo Nazionale del Bargello, Florence

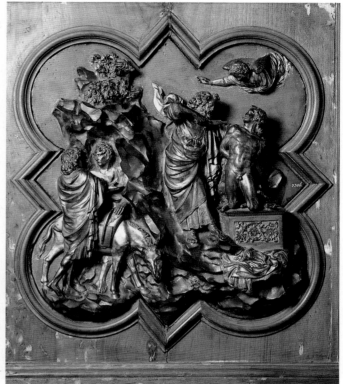

■ 4.14 Lorenzo Ghiberti
Sacrifice of Isaac 1401
Gilt bronze
21×17½ in (53.3×44.4 cm)
Museo Nazionale del Bargello, Florence

decision of the jury can tell us much about the new "look" that was capturing the imagination of the era.

Brunelleschi's *Sacrifice of Isaac* 1401 (Fig. **4.13**) is a dynamic and busy composition. Though the artist makes some attempts to produce an illusion of depth in the relief, there is a notable insistence on the foreground plane, which gives the impression of a frieze rather than a convincing spatial arrangement. If one compares this with Ghiberti's winning entry, it is possible to speculate on the criteria the jury deemed important, and further, on what they aspired towards. Though Ghiberti's *Sacrifice of Isaac* (Fig. **4.14**) conforms to the same design requirements as Brunelleschi's entry (stipulated in the competition guidelines), the results are somewhat different. Instead of the tight grid format utilized by his most formidable competitor, Ghiberti implemented a dramatic diagonal thrust across the middle section of the relief, resulting in a more startling depiction of space and depth within the work. Such a

recession of space also gave the artist the opportunity to manipulate sharply the various sizes of his figures with regard to their relative positions in relation to the viewer. Such "foreshortening" is best seen in Ghiberti's handling of the figure of the Angel, which pierces the foreground plane from its origin in the background. This more natural approach to the positioning of figures must have found greater favour with the jury than Brunelleschi's more stable composition. Ghiberti's commission—creating the north and then the east doors of the Baptistery—was to last him the rest of his life.

It took Ghiberti almost twenty-five years to complete the first commission for the north doors of the Baptistery, only to be then offered the job of creating another set of bronze panels to adorn the east doors. The two works cover some forty years of cultural flux, and the change of attitude on the part of the community (and subsequently the artist as a member of

that community) can be witnessed by comparing the two projects. First, the east doors are much more regular in styling and lack the medieval quatrefoil frames that graced the surface of the north doors —which results in a more refined and somewhat restrained series of works. The recent rediscovery of linear perspective also found its way into Ghiberti's late work—a technical innovation for the systematic design of illusionistic space that was ironically initiated by his one-time competitor Brunelleschi. The result is a series of works that exhibits a much more airy and expansive inner space than the earlier panels from the north doors. A good example of this increased sense of depth can be seen in *The Story of Jacob and Esau* (Fig. **4.15**) of *c.* 1435 from the east doors (Fig. **4.16**)—which the young Michelangelo once aptly called "the Gates of Paradise." In the new work, Ghiberti allows for the figures to integrate into the deep illusionistic space of the relief, creating a much more relaxed and naturalistic portrayal of the subject. The attempts at rendering architectural motifs in space further refine the illusionistic quality of the piece. What is more, the earlier

■ 4.15 Lorenzo Ghiberti
The Story of Jacob and Esau c. 1435
from the "Gates of Paradise", Baptistery of Florence Cathedral

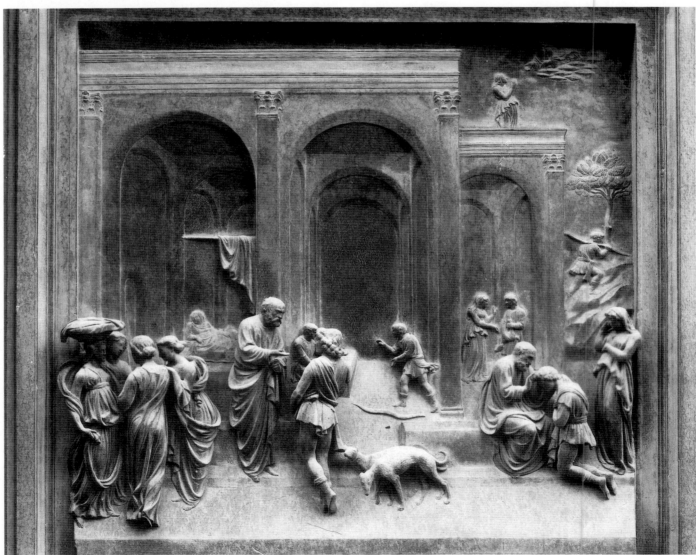

■ 4.16 Lorenzo Ghiberti
The "Gates of Paradise" c. 1425–52, Baptistery of Florence Cathedral

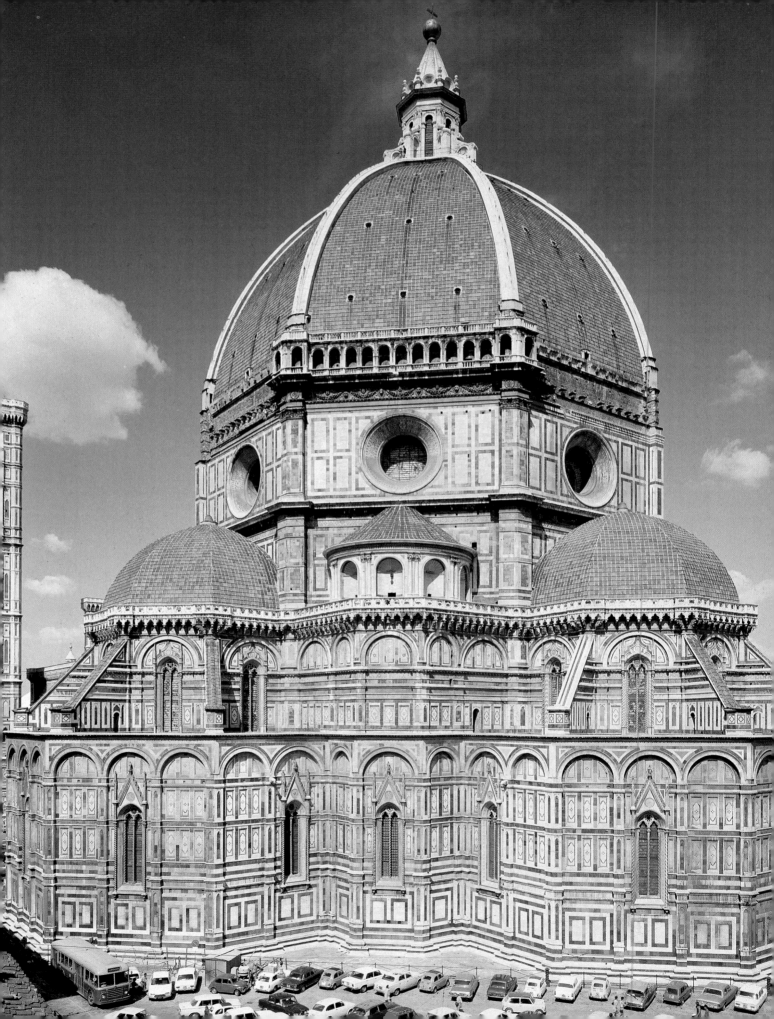

compositional exuberance of the sweeping diagonal (witnessed in the *Sacrifice of Isaac*) gives way to a more harmonious and subtle design. This marriage of architectural motifs and closely observed figure modeling was to become an increasing preoccupation with many of the artists following in Ghiberti's footsteps, and it set the stage for some of the most prominent innovations of the latter part of the fifteenth century.

The unsuccessful bid for the Baptistery doors commission was not the end of Brunelleschi's relationship with Florence, and perhaps his initial loss was the Renaissance's gain, in that his later discoveries in architecture were to prove even more revolutionary. At the time of the competition of 1401, the cathedral proper was still unfinished. The problem was how to successfully bridge the enormous area of the central tower of di Cambio's original design without the use of flying buttresses, which were out of the question because of their obvious incompatibility with the beautiful Romanesque marble exterior. Between the years 1417 and 1420 Brunelleschi studied many of the ancient building projects in Rome (such as the Pantheon, Fig. **2.40**) and suggested that a dome could in fact be built without the visual distraction created by buttressing. His answer was the implementation of classical vaulting techniques, and a project that would take another sixteen years to complete (see Fig. **4.17**).

Brunelleschi's innovative design provides further evidence of the new sensibility in Florence around 1420. It succeeds in addressing the needs of both art and technical interests through a clear understanding of not only Classical but also medieval building techniques, creating a sense of harmony rather than the typical discord that often follows such mergers. Brunelleschi understood that the principles of buttressing were useful in spreading the enormous weight of a dome over a greater expanse—thereby alleviating much of the stress on the walls and foundations of the structure. He thus concluded that the tall supporting walls of the dome had to be constructed with "tribunes" (small offshooting extensions from the original walls), which would act, like the buttress, to disperse weight over a wider area. In this way, Brunelleschi manipulated the basic tenets of medieval

◄ 4.17 Filippo Brunelleschi
The Dome of Florence Cathedral 1420–36
Height of dome 367 ft (111.86 m)

cathedral construction to better serve the interests of the new church.

Clearly, however, it was the dome itself that created such awe in the community. No structure like it had been attempted in Europe since antiquity, and never before on such an immense scale. Brunelleschi's solution was to create a dome within a dome, which would further support the exterior weight effectively while removing the need for interior armatures or any other superfluous accessories that would distract from the simplicity of the construction. The outer dome was thus constructed as a light skin or cover, exhibiting great visual authority over the Florence skyline while resting almost exclusively on the smaller interior skeleton. The result was a resurgence in dome architecture, since now architects possessed both the skill and technical know-how to attempt structures which had only years before been thought impossible.

What may one conclude from Brunelleschi's technical breakthrough in the light of the previous discussion on the Renaissance? First, it must be remembered that had it not been for a renewed interest in Classical thought and culture, it is doubtful that artists like Brunelleschi would have sought inspiration from Roman architecture such as the Pantheon. It was not that artists and architects had not been interested in such building solutions before this period, but simply that most looked toward a more "spiritually sound" influence. The dome is by design a stable and symmetrical structure—attributes which visually mimic the emerging Renaissance ideals of harmony and equilibrium over the obedience and superstition that had marked the previous age. In this way, the innovative dome construction situates itself as a vivid reminder of the greater influences and aspirations of the day.

LINEAR PERSPECTIVE

The word perspective comes from the Latin verb *"perspicio,"* meaning to see clearly or look through. Today the term is commonly used to describe a geometric system for depicting depth on a two-dimensional plane (called linear perspective), but its original meaning put a more general emphasis on the "lifelikeness" of a given representation. In aspiring to lifelikeness, there is an underlying assumption of a certain truthfulness implicit to this system—an idea which should be put in context at the very outset of this

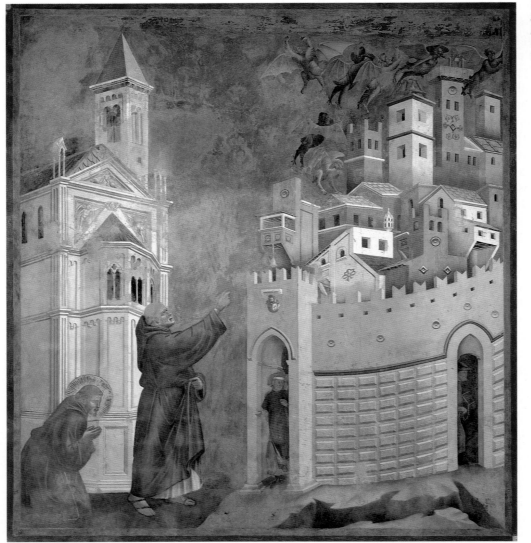

■ 4.18 Giotto di Bondone
St. Francis drives away the Demons from Arezzo
Instituto Italiano d'Arti Grafiche, Bergamo

discussion. The depiction of space on a two-dimensional plane is not truth but convention; its validity as a method of interpreting our visual experience is not absolute. But the notable popularity of the system from the Renaissance through the nineteenth century makes it an interesting example of the interrelationships between art and convention.

According to the Renaissance writer and critic Giorgio Vasari (1511–74), linear perspective re-emerged in Europe around the end of the thirteenth century in the work of Giotto. It was he who first attempted the device of "foreshortening" to produce an illusionistic space within the plane of the painting (foreshortening simply meaning the manipulation of scale to produce depth).

An example from Giotto's work will certainly help in clarifying this concept. In *St. Francis drives away the Demons from Arezzo* (Fig. **4.18**) the artist positions two figures in the immediate foreground of the scene and other characters in the middle or background. Note that the distribution of figures in space appears convincing due to Giotto's willingness to "shrink" elements as they recede in depth. This technique mimics everyday perception, as things closest to us appear larger than those in the distance.

The reception such revolutionary depictions received during their day is an interesting example of how the seemingly natural act of perception is tied to certain preconceptions about reality which are themselves

based in convention. The early Renaissance writer Giovanni Boccaccio (1313–75), in discussing the merits of Giotto's painting in his famous literary work *The Decameron*, stated: ". . . many times the visual sense of men was misled by the things he made, believing to be true what was only painted." Now perhaps the idea of being misled by the rather shallow and often illogical space of a work such as *St. Francis* seems an absurdity in our age of ultimate illusionism (such as 3-D movies and compact discs), but at the time such images appear to have been quite deceptive. Ideas about why this phenomenon occurred vary, but one of the soundest is a theory developed by twentieth-century psychologist Rudolf Arnheim, whose intense studies of composition have led to a new understanding of the relationship between art and the science of perception. Arnheim claims that any progress in pictorial lifelikeness creates an illusion of life itself. He takes the example of how the public first reacted to the technique of moving pictures in the 1890s, when it was quite common for viewers to scream at a moving image of a locomotive coming toward the foreground of the screen. Since the resultant image from this new medium appeared as a revolutionary departure from earlier images of its kind, the initial response of the public was to perceive it as "more real" and act accordingly. If a moving picture got this kind of reception, then Giotto's simple fore-shortening might well have given his audience a similar visual thrill.

After Giotto's preliminary excursions into the field of illusionistic space, many competent artists began to utilize the techniques with greater freedom and skill. Within a few short years of Giotto, Ambrogio Lorenzetti (1280–1348) had already far advanced the basic skills of his predecessor (such as in his *Scenes from the Legend of St. Nicholas*, Fig. **4.19**). His complex renditions of cityscapes and intricate building items such as staircases allow for a much more convincing (if somewhat inconsistent) space within the confines of the painting.

Vasari claims that the system of linear perspective was reinvented by the painter-sculptor-architect Brunelleschi. His discoveries placed an increased emphasis on the viewer's gaze, and it set in motion a codified system by which to render space. Between 1416 and 1425 the artist produced two perfect examples of his discovery, which operated much like public peep-shows. In these demonstration pieces, he painted an accurate depiction of San Giovanni in Florence,

■ 4.19 Ambrogio Lorenzetti
Scenes from the Legend of St. Nicholas
Panel
Uffizi Gallery, Florence

■ 4.21 *The Holy Trinity with the Virgin and St. John* 1428 showing perspective lines

◄ 4.20 Masaccio
The Holy Trinity with the Virgin and St. John 1428
Fresco
21 ft 10½ in × 10 ft 5 in (6.66×3.19 m)
Santa Maria Novella, Florence

which was separated from the viewer by a partition with a small peep-hole cut out in the middle. Directly across from this hole was a mirror, in which was reflected the painted scene, which rested on the back of the partition. The result was an image that seemed to recede into space. By aligning the viewer's vision with his own centralized convergence of lines (thanks to the small peep-hole), it is said that the artist found the all-important "vanishing point" (the point where lines receding back into space converge) that had been lost for over 1,000 years. Though neither of the two show-pieces survives to this day, their reputation was well known to many of the leading artists in Florence at the time. Painters such as Masaccio, Piero della Francesca (died 1492), Bellini (*c.* 1431–1516) and Mantegna (1431–1506) all claim to have followed the discoveries of Brunelleschi during the period, and many went on to produce even more spectacular results.

One of the results of perspectival rendering was the further development of volume in painting. One of the early masters who capably assimilated the complementary notions of volume and perspective was Tommaso d. Giovanni di Simone Guidi, better known as Masaccio (1401–28). In his short life he produced some of the most important paintings of the early Renaissance. He is perhaps best known for his fresco of *The Holy Trinity* (Fig. **4.20**) of 1428, the year of his death. In this work the important innovations of Giotto are assimilated into a more rigorous and rational depiction of space, clarified through a steadfast insistence on symmetrical composition (see Fig. **4.21**). Here symmetry and balance become the visual equivalents of the principles of harmony and moderation—precepts very much in keeping with an era and a people bent on reconciling body and soul after the piety of the medieval period.

The merging of volume and perspective was of course inevitable, particularly since each technique often had to rely on the other to produce a convincing representation of space. Masaccio was one of the first to understand this relationship, and his painting of Christ in *The Holy Trinity* is one notable result. The artist's use of linear perspective in rendering the surrounding architectural framework effectively creates a deep central space, suggesting area both in front and behind the Christ figure. Masaccio then reasserts this space by modeling his figure in light and shadow, which reaffirms the viewer's anticipation of space in the work. This is a reciprocal relationship, since each device relies on the other to produce a convincing illusion; in other

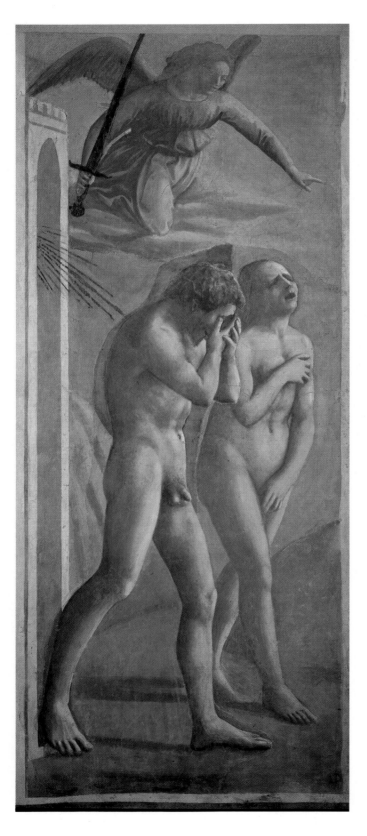

words, flat figures in a perspectival scene, or figures with volume on a flat background will not succeed in convincing the viewer.

The compositional rigor of Masaccio was not the only significant characteristic of his painting. He had likewise learned his lessons from the earlier Duccio, and successfully integrated emotional content into the sometimes too predictable demands of balance and symmetry. The results are paintings such as *The Expulsion from Eden* (Fig. **4.22**) of 1427. The sense of deep shame is very present in these nudes, and they suggest a naturalism unparalleled at the time. Together, these two attributes, idealism (embodied in mathematical constructs such as perspective) and naturalism (the artist's eye for detail and expression), were to form the basis of much of later Renaissance art theory, where quality distinguished itself through a harmonious interchange between observation from nature and contemplation of perfection and beauty. Masaccio was a student of nature, and his works exhibit a much closer observation of shadows, anatomy, and emotional gestures than any of those of his Italian predecessors. But once observed, these figures were nonetheless assimilated into ''higher'' or loftier considerations. The dominating concern of pictorial balance is but one of the many reliances on idealism over naturalism. In harmony, a great painting could glorify both God and the cultural aspirations of the day; in discord it became either a static academic exercise or an unintelligent arrangement of imperfect objects. In Masaccio there is at least the attempt to integrate one aspect into the other, and the result would eventually lead to the theories and works of Leonardo da Vinci and Michelangelo.

Another contemporary of Brunelleschi was the artist Paolo Uccello (1397–1475). He too was obsessed by the possibilities of linear perspective. In his *The Rout of San Romano* (Fig. **4.23**) of *c.* 1450, the results of his investigations seem completely absorbed, though perhaps overly contrived. Note how the broken shafts of the various lances and other weapons that litter the foreground fall neatly to the vanishing point of the painting, and how the tidy positioning of the fallen

■ **4.22 Masaccio**
The Expulsion from Eden c. 1427
Fresco (after restoration 1989)
Brancacci Chapel, S Maria del Carmine, Florence

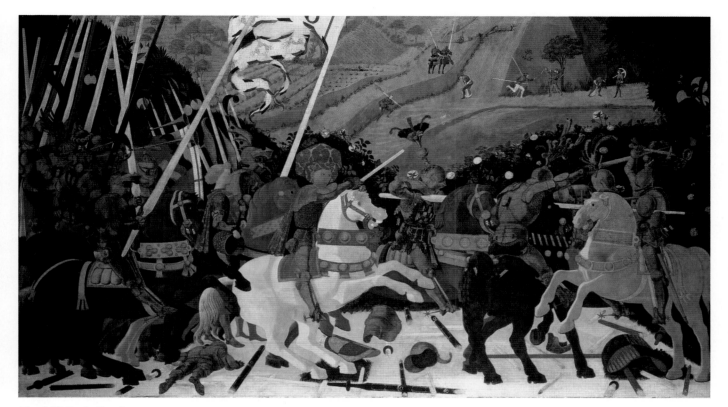

■ 4.23 Paulo Uccello
The Rout of San Romano c. 1450
Tempera on wood
72×125¼ in (180×320 cm)
National Gallery, London

soldier again draws our eye back to a predictable central focus. The result is a clear depiction of space receding from the immediate foreground, but its less than subtle manipulation of our viewpoint makes it a somewhat obvious solution to the problem of "lifelikeness," and thus in the end less satisfying.

In the year 1500 another great craftsman of the Renaissance, Leonardo da Vinci (1452–1519), began a treatise on art that remained unfinished at his death, and was not circulated until 1542. In it the artist-scientist attempted to define and discuss many facets of the art-making process, of which perspective was given special consideration. One of the famous discussions on perspective centered around what became known as "Leonardo's window," a device which enabled the painter to see and then translate elements from life onto a flat surface. The idea itself wasn't really new; the art theorist Leon Baptista Alberti (*c.* 1404–72) had used a similar device called a veil, whose transparent grid of

string bound on a frame enabled the artist to transcribe a given scene, as Figs **4.24** and **4.25**, contemporary woodcuts, illustrate. However, it was Leonardo who first attempted a codified statement on the subject. He wrote: "Perspective is nothing else than seeing a place or objects behind a pane of glass, quite transparent, on the surface of which the objects that lie behind the glass can be drawn. These can be traced in pyramids to the point in the eye, and these pyramids are intersected by the glass pane." Fig. **4.26**, from a nineteenth-century text on perspective, shows how this set-up might have looked to Leonardo.

Through the ongoing research initiated by artists of the early Renaissance era, there continued to be dramatic jumps in the rendering of illusionistic space on the two-dimensional plane. By far the most significant result of the years of patient research was the general implementation of both one- and multiple-point perspectives as convenient "rules" from which to

■ 4.24 Albrecht Dürer
Alberti's Veil 1525
Woodcut from Dürer's *Perspective and Proportion* 1525

■ 4.25 Albrecht Dürer
A Variation on Alberti's Veil 1525
Woodcut from Dürer's *Perspective and Proportion* 1525

■ 4.26 Brook Taylor
Leonardo's Window
From *New Principles of Linear Perspective*, published 1811
British Library, London

develop depth. So convinced were artists that linear perspective was the correct and accurate method for depicting nature that it wasn't until the late nineteenth century that the idea was really challenged.

However, by the early sixteenth century the ingenious Leonardo had already noticed faults in the system, and mathematical paradoxes implicit within its method. Though the results of his complex investigations need not concern us here, suffice to say that even its supposed infallibility was an illusion. But all the same, the feat of creating a logical space on a two-dimensional plane remains a remarkable achievement, particularly when one takes into account the amazingly short period of time it took Renaissance artists to rediscover what had been lost for over a millennium in Europe.

THE NATURALISM OF VAN EYCK

If the paintings of Masaccio and the architecture of Brunelleschi can be said to have epitomized the goals and aspirations of early fifteenth-century Florentine society, then it can be claimed that the painter Jan Van Eyck (c. 1390–1441) likewise captured the spirit of northern Europe during the period—with very different results. Consider one such image, his famous *The Arnolfini Marriage* (Fig. **4.27**) painted in 1434, roughly contemporary with Masaccio's paintings. From this example, it is obvious that very different artistic conditions prevailed in the northern centers that had little obvious reference to the aspirations of the South. Unlike Masaccio's idealization of form and composition, evident in his *Holy Trinity* (Fig. **4.20**), Van Eyck's painting gives paramount emphasis to minute observation. Van Eyck studiously described the natural world with a precision unparalleled during the age. Art historians such as E. H. Gombrich have claimed that Van Eyck saw art as a mirror of nature, where faithful reproduction of all its intricacies was necessary to capture the wonder of creation. In the painting of the wedding portrait of the Arnolfini (Arnolfini was an Italian merchant attached to the Medici Bank in the Netherlands during the time, which gives an idea of the prominence of Florentine banks throughout the continent) Van Eyck most certainly reflects this interpretation of northern art as a mimic of the natural world. Everything from the fur trim of the cloaks to the wood paneling speaks of close observation. Though different in approach from the rigid compositional harmonies of

Masaccio's *Holy Trinity*, it nonetheless marks a departure from the earlier Gothic stylings that were at the time still prevalent in the North. Van Eyck's delicate manner of observing and then transcribing the most seemingly insignificant features of clothing and ornament should lead one to believe that there were specific reasons why he and other northern European artists adopted such a manner of painting, and this was the case.

In the thirteenth century, the establishment of universities meant that texts once hidden away in monasteries were circulating to a wider public. This led to an increased interest in not only ancient scientists and philosophers but also the form of illustration that ornamented these texts. The result was the emergence of a pictorial style very similar to the aims of the monastic artists of the past: intricate, complex arrangements with an eye for detail and a delightful vibrancy of color—all of which had a tremendous effect on the artists of the day. Unlike their contemporaries in the South in areas such as Florence, ideal forms (which, you will remember, were based on Platonic scholarship) took a back seat to other considerations, such as ornamentation and empiricism.

It would be premature to end this discussion of Van Eyck without briefly mentioning one very significant contribution he made to the history of painting: the invention of oil paint. Though still hotly debated, many scholars credit Van Eyck as the first documented painter to use oil as a binder for his pigments. Before this time, artists ground their colors (usually derived from various stones or roots) and then added a liquid substance to bind the mess together and create a fluid material. The choice binder of the time was egg yolk, which made the paint opaque and was quick drying. This meant that subtle blendings and glazes of color were for all intents and purposes impossible; instead, tempera was usually applied in a series of linear cross-hatchings, one color sitting on top of another (Fig. **4.28**). The result was that work, while brilliant in color, often lacked subtlety. However, Van Eyck must have been dissatisfied by the speed of the drying process—perhaps because it didn't allow an artist the time to blend colors successfully or create luminous effects. The solution was not particularly earthshattering: he simply replaced the egg yolk with a binder that had a slower drying time, which enabled the artist to work over an area for days instead of minutes. The suspension of the ground pigment in the translucent oil

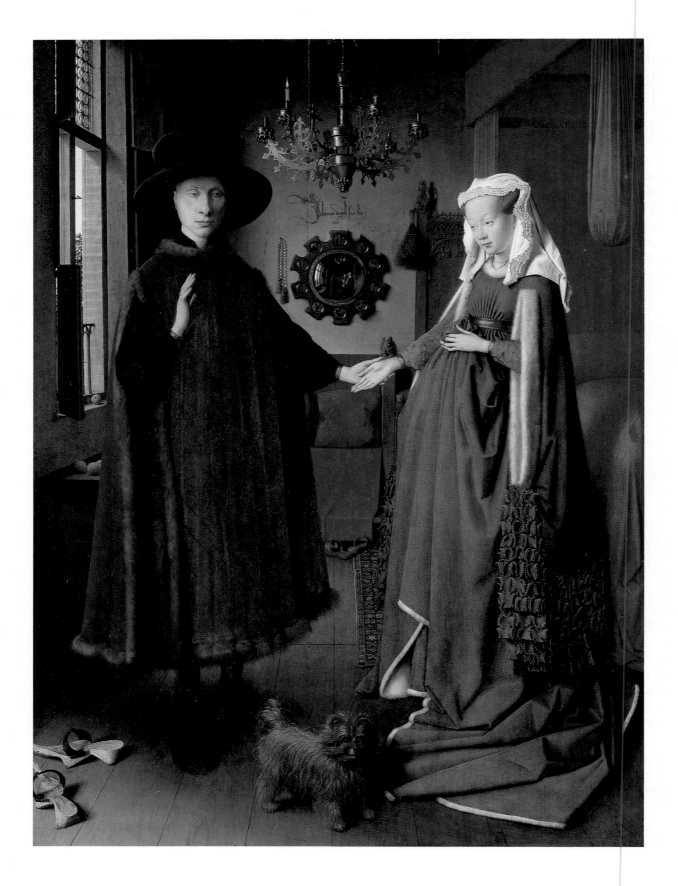

■ 4.28 Detail of Cimabue's *Madonna Enthroned* 1280–90 showing handling of tempera paint

■ 4.29 Detail of Van Eyck's *The Arnolfini Marriage* 1434 showing oil paint technique

◄ 4.27 Jan Van Eyck
The Arnolfini Marriage (Giovanni Arnolfini and His Bride) 1434
Oil on panel
32¼×23½ in (81.9×59.7 cm)
National Gallery, London

medium further increased the intensity of the colors, in that it allowed light to penetrate the surface and reflect the various underlayers of paint. The result was work that possessed a closer perceptual intensity to one's experience of nature, and painting that could now embrace a mind-boggling array of subtle differences and fluctuations (Fig. **4.29**).

▶ ART PATRONAGE

● The rise of individual wealth throughout Europe during the fifteenth century had an important influence on the course of art making in the Renaissance. After centuries of artists working directly with the Church or state, now private citizens began to commission art projects as a way of solidifying their social, and sometimes even moral position in the community. Often such families also possessed enormous political influence, and as a result much of the patronage granted to many of the Renaissance's most influential artists was tied in some way to the success of such figures in the marketplace and in government. One such family was the de' Medici, who between the years 1434 and 1492 controlled the city-state of Florence through a combination of political know-how and financial clout, thanks to their highly profitable banking company.

The first member of the family to rise to prominence was Cosimo de' Medici (1389–1464), who held power from 1434 to 1464. Cosimo reaped the significant benefits of a prosperous banking enterprise, and was able to secure for himself the very best scholars and teachers to cultivate his interests in the humanities. Of the many studies pursued during the period, one in particular was to play a decisive role in later events —Classical philosophy and in particular the neglected works of Plato. Finding Platonic scholarship almost non-existent in the city at the time, Cosimo enticed some of Constantinople's most brilliant scholars to come to Florence with offers of good pay, decent lodgings, and a safe haven from the dangers of the East. He funded a new Chair in Greek at Florence's "Stadium" (university). Thanks to this all-important economic boost, Platonism became a dominant artistic and philosophical force amongst the city's élite—an influence that would determine the path of much of future art theory.

The de' Medicis are perhaps best known for their patronage of the arts. Cosimo was the first of the de' Medici rulers to fund elaborate commissions, the results of which both beautified the city and possibly assuaged some of the guilt associated with making money (remember how Christ kicked the money lenders out of the temple). Cosimo had a particular fondness for sculptural projects and the result was a

■ 4.30 Donatello
St. George c. 1415–17
Marble
Height approx. 6 ft 10 in (2 m)
Orsanmichele, Florence

long and profitable relationship with one of the great sculptors of the age, Donato di Niccoloi Betto Bardi, better known to us as Donatello (*c.* 1386–1466).

Donatello was a prolific sculptor, and his work allows us an insight into the state of sculpture in the middle of the fifteenth century. Though art in the round posed very different problems from two-dimensional images, there were all the same certain unmistakable parallels in sensibility beginning to emerge between the two forms. During the medieval age, sculptural projects were often seen as simple extensions of architecture, and like much of the painting at the time, emphasis was placed on legibility and decoration over naturalism —which was seen as a vain attempt to duplicate the perfections of God. But with the rekindled interest in the idea of universal laws which govern the natural world (a popular preoccupation with many in the increasingly Platonic Florentine intelligentsia), sculpture began to move back toward a more naturalistic, three-dimensional format. One of Donatello's earliest attempts to integrate such ideas into carved stone is his *St. George* (Fig. **4.30**) of 1415–17. Conceived as a niche sculpture, it was probably never intended to be viewed from all sides, thus the frontal nature of the work can be attributed more to the specifics of the commission than any omission on the artist's part. Yet note the monumental sense of volume and mass the figure possesses. Further, the proportions of the figure suggest a keen observation of nature and anatomy rather than a reliance on traditional graphic equivalents, which tended to schematize the figure for the demands of legibility. In essence, Donatello has effectively produced a work that unifies Christian subject matter with the sculptural traditions of antiquity—a reasonable aspiration for such an avid participant in the weekly discussions on Classical thought, initiated by his patron, Cosimo de' Medici, during the early years of his rule.

Many historians consider the bronze sculpture of *David* (Fig. **4.31**) of *c.* 1432 to be Donatello's most important work. Created with the intention of being seen from all sides, this figure, like Giotto's painted equivalents, is liberated from the confines of past decorum. In this work, the gesture itself is a dramatic departure of some historical note. The swinging of the hip—the so-called "contrapposto" pose we first encountered with the *Doryphorus* (Fig. **2.25**)—engages one leg while resting the other, and it gives the impression of deliberate confidence and grace. There is

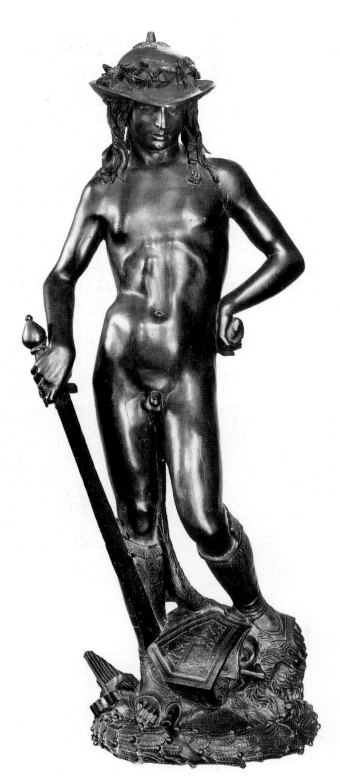

■ **4.31** Donatello
David c. 1432
Bronze
Height 5 ft 2½ in (1.58 m)
Museo Nazionale del Bargello, Florence

an undeniable celebration of the human figure implicit within this work; its convincing gesture and sensuous modeling produce a dynamic image of young virility and heroic defiance. It is also difficult to miss the rather provocative sexuality in this piece; it neatly parallels the steady decline of medieval prudery in favor of the body as the center of consciousness—and the attainment of pleasure as a worthwhile pursuit. There is little in the history of Christian art before this period to compare with the ease and sensuousness of Donatello's *David*, and it points to a crossroads in a religion which would by the end of the Renaissance find itself severely compromised by its importation of other popular views.

Cosimo de' Medici died in August 1464, leaving the leadership of the city in the hands of his son Piero, who himself lived only another five years. The short period of Piero's rule was beset by a number of political tensions, and thus emphasis was placed more on the de' Medici family's survival than on celebrating a city and a culture through its often generous art patronage. There was, however, one artist of some considerable note to come to prominence during Piero's term in office—the painter Sandro Botticelli (1445–1510).

Botticelli's reputation flourished under the patronage of Piero's successor, Lorenzo the Magnificent (1449–92), after the former's early death in 1469. The reign of Lorenzo has come to be known as the golden age of Florentine culture, and his death signaled the decline of Florence as the center of the Renaissance. A pragmatic politician and a cultivated follower of the arts, Lorenzo initiated some of the most impressive commissions of any age. This period of intelligent and sympathetic patronage also corresponded with a

■ **4.32 Sandro Botticelli**
Birth of Venus c. 1482
Tempera on canvas
68⅞×109½ in (175×278 cm)
Uffizi Gallery, Florence

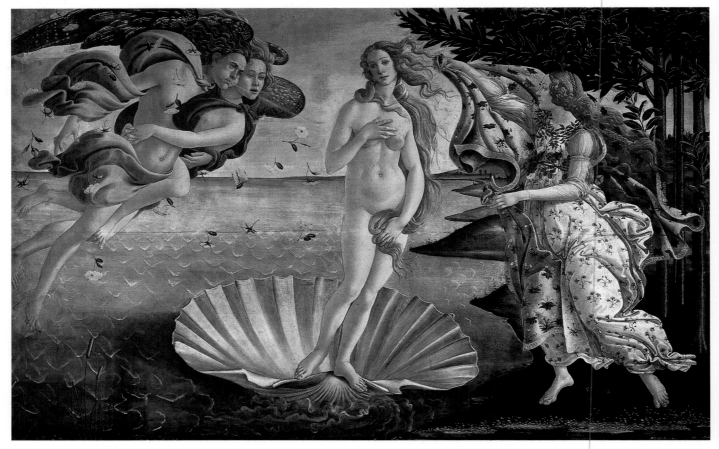

tremendous amount of artistic activity within the city walls. The result was spectacular. One of the important works to come out of this invigorating environment was Botticelli's *Birth of Venus* (Fig. **4.32**) of *c*. 1482. The choice of subject matter was unprecedented in its embrace of Classicism. If you look back over the past few pages, you will note that though artists of the period were interested in Classical thought, their subject matter remained in the domain of traditional Christianity. However, regardless of the less than religious implications such a painting might have, Botticelli's Venus possesses many of the same pictorial qualities as its contemporary religious works. The reason for this is straightforward: by the late fifteenth century, the interest in nature had led many to believe that the Classical myths possessed the same extraordinary wisdom as their great philosophies. Venus, traditionally the bearer of divine beauty to an imperfect world, took on obvious symbolic associations with the Virgin. Though Church decorum could not easily accept the portrayal of the Virgin as a nude, the use of Classical myths provided a convenient opportunity to further the growing relationship between Classical idealism and Christian morality. The result is a work that has come to embody the harmonious marriage of Christianity and Classicism, mystery and reason, the sacred and the profane, in the graceful emergence of Venus from the ocean. Botticelli would continue to produce these allegories throughout his career, but none equaled the Venus in its ability to embody the dynamic of the age.

Botticelli was but one of many artists of note to benefit from Lorenzo's patronage during the late fifteenth century. Two others who enjoyed similar support were Leonardo da Vinci (1452–1519) and Michelangelo Buonarroti (1475–1564), both of whom lived in Florence during the rule of Lorenzo. Together, their works have come to epitomize the Renaissance sensibility in its grandest and most inspired form, and it is in their creations that the era finds its greatest expression.

LEONARDO DA VINCI

Leonardo moved to Florence as a young man, and stayed there until 1483, when appointed to the court of Milan. Leaving Florence as he did at only thirty years of age, little of his great work had yet been executed, but it remains significant that Leonardo passed through the city of Florence when he did, and his work retains many of the interests and pictorial devices then popular in the city. Perhaps the most noteworthy development to come out of Leonardo's early stay in Florence was an interest in linear perspective, which had, by the late fifteenth century, become a predominant concern with many painters. Another important influence in the early development of Leonardo was the centrality of Platonic scholarship, which appears to have deeply affected the subsequent course of the artist's thinking. Together they provided the necessary impetus for many of the later discoveries and theories that were to secure his reputation forever as one of the most truly remarkable people of any age.

One of the most striking of all Leonardo's paintings is *The Virgin of the Rocks* (Fig. **4.33**) of *c*. 1484. Almost immediately, one is struck by the developed sense of illusionism within the confines of the picture plane. The organic landscape and naturalistic interior combine to give the piece a deep, mysterious space without the static and often awkward reliance on perspective lines (as noted in Uccello's *Rout of San Romano*, Fig. **4.23**). Through keen observation, Leonardo was able to note such perceptual subtleties as how objects move toward a more neutral blue-gray as they recede in space, and further how images become less clear in the distance. This portrayal of space with regard to these rather elementary observations is called "atmospheric perspective," and though now commonplace, only a few artists had yet broken away from the mannerisms of earlier traditions and attempted to harness such findings to their own paintings. Leonardo considered these observations from nature as fundamental to knowledge, and their implementation into art a decisive move toward a more ideal vision. For many, observation provided little of interest outside the most fundamental necessities such as proportion, but for Leonardo the natural world provided the underlying blueprint for the workings of the universe. Since painting had the ability to transform a viewer's experience of the world, the artist was afforded the possibility of contemplating ideals. In other words, since artists did not have to rely exclusively on the visual experience of nature to produce their images, their choice of subject and its presentation grant the viewer special access to a world perhaps closer to a universal truth than that in which they ordinarily exist. For Leonardo, the power of art lay very much in the basic premise that the artist possessed a privileged and necessary position in the

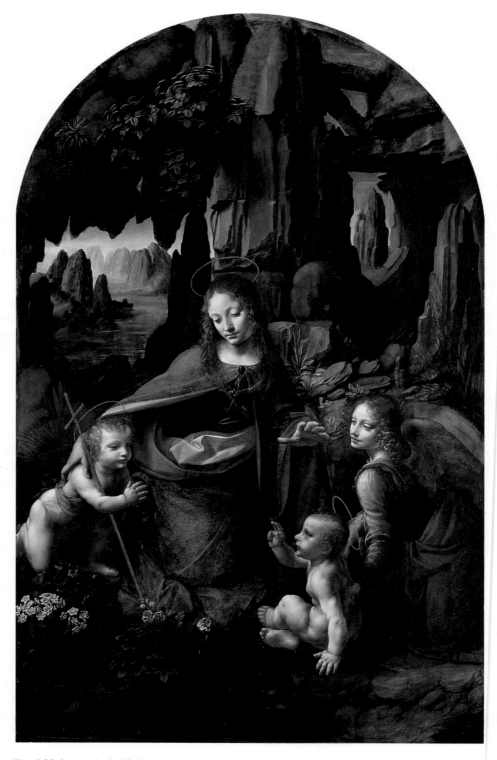

■ 4.33 Leonardo da Vinci
The Virgin of the Rocks c. 1484
Panel
78½×48 in (199.3×121.9 cm)
National Gallery, London

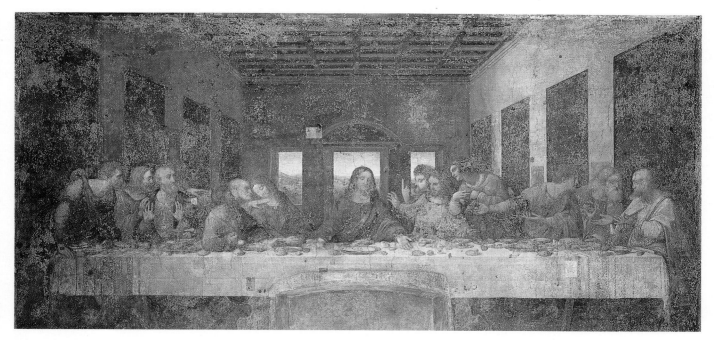

■ 4.34 Leonardo da Vinci
The Last Supper c. 1495–8
Mural painting
14 ft × 28 ft 10½ in (4.26×8.8 m)
Refractory, S Maria delle Grazie, Milan

community. This did not necessarily mean that the artist's imagination was in itself authoritative; Leonardo, like many of his contemporaries, abhorred such indulgences as gross vanity. Instead, he placed importance on a correct experiencing of phenomena, from which the viewer could then access the implicit connections and workings of the natural world. The balance between natural observation and artistic license was thus paramount, and in Leonardo's work it finds some of its greatest expressions.

This all-important construction of a painting is perhaps best envisioned in Leonardo's famous *Last Supper* (Fig. **4.34**) of 1495–8. Though the painting stands in a horrid state of disrepair due to dampness and Leonardo's own disposition for experimenting with painting media, the composition remains clear. The scene portrays Christ's presentation of the sacraments and the acknowledgment of his later betrayal at the hands of Judas. The group that congregates around the back of the table part from the central figure at the news, creating a heightened focus on Christ. The various figures are richly modeled, and show a keen observation of facial expressions and bodily gestures.

But, ultimately, this painting's success rests on the pivotal figure of Christ—a compositional arrangement that embodies Leonardo's theoretical standards.

Leonardo positions Christ as the central figure in this work, in keeping with his divine status and importance to the subject matter. His presentation in the center of the table also corresponds with the central vanishing point for the receding perspective lines that enclose him. A simple experiment will perhaps clarify this concept. Take a straight edge, and place it on either of the diagonal lines that are created by the meeting of the side walls with the ceiling. Now draw a line across the image, and then do likewise with the other side, forming an *X* on the painting. You may also do likewise by connecting the lines formed by following the receding diagonals of the top of the various doorways on either side of the table. The axis perspective lines meet at the head of Christ, the vanishing point, the personification of God, the implied universal truth; Jesus thus becomes the origin and center of world. Leonardo, by utilizing such a mathematical system with consummate skill, has successfully painted an image of harmony and idealism within Christian dogma.

MICHELANGELO'S FIGURATIVE IDEAL

Michelangelo Buonarroti was an artist of remarkable versatility, and his accomplishments span the disciplines of painting, sculpture, architecture, and poetry. Though most of his important work was executed in Rome after 1505, there were pieces of considerable note produced while he was still in Florence. By far the most influential of all his early work is his heroic depiction of the Old Testament figure *David* (Fig. **4.35**), created between the years 1501 and 1504.

Michelangelo's *David* has long been considered one of the great depictions of ideal beauty. It stands at over three times life size, and was carved from a single piece of Carrara marble that had lain unused behind Florence Cathedral for over a century. The clarity of anatomical observation and the grandeur of the pose make clear that Michelangelo was no simple imitator of the earlier Donatello but possessed tremendous skills and sensitive insights into both sculpture and the human condition—issues embodied in the massive stone figure.

The polarities or "dialectic" of existence were a constant point of interest for Renaissance artists and scholars, who attempted to find a single, unified vision that could engage both the Classical and Christian traditions. In the previous works of Leonardo, this uneasy balance found its parallels in the delicate harmony between naturalism and systems of reason, in keeping with the struggle between experience and faith. The unification of apparent opposites has of course been a part of almost every cultural tradition in the world, witnessed in societies as diverse as those of Taoist Asia (with their symbol of yin and yang) and the Western tradition of the unity of body and soul. Michelangelo's *David* is one such art work that attempts, within the confines of a single body, to find perfect harmony and equilibrium. Scholars often talk of the split nature of *David*—his body consciously separated into the "*vita activa*" and the "*vita contemplativa*," the active and the contemplative life. This can be seen by running a vertical line up the middle of the figure, which splits the sculpture into two seemingly separate personas. The right half of the body is the side of action. His strong, outstretched right arm cradles the rock which will kill his enemy Goliath, and make the young warrior king of Israel. His right leg, engaged and holding the considerable physical and psychological weight of his entire body, again echoes the necessity of brute action. The right side is the foundation of David's

■ 4.35 Michelangelo Buonarroti
David 1501–4
Marble
14 ft 3 in (4.34 m)
Galleria dell'Accademia, Florence

existence, as it visually supports his upright, living posture. The left side does much the opposite. The left arm gently holds the sling over his shoulder, relaxing the very instrument of action (and in this case of death) in that eternal moment of thought. The left leg, free of the weight of activity that bears down so heavily upon the "*vita activa*," is left forever weightless. The result is a vivid personification of an era, and its "contrapposto" gesture would subsequently come to symbolize the body in perfect harmony.

▶ THE "HIGH" RENAISSANCE IN ROME

● During the fifteenth century, the Vatican had been able to consolidate its religious authority after surviving nearly two centuries of rather shaky existence, and by the turn of the century, it again possessed the resources to commission large, expensive art projects. These works were seen as glorious reassertions of the Church's dignity and authority over its people, and its importance demanded the attention of only the best artists. With his reputation already established, the young Michelangelo was summoned to Rome from his Florentine home in 1505 for the greater glory of the Church.

Pope Julius II, concerned with his rapidly declining health and further convinced that he deserved a magnificent tomb, commissioned Michelangelo to produce a lavish future resting place for his bones. The project was never completed, but the offer of working on such an elaborate sculptural commission was enough to entice the artist to the Holy City. Little did he know at the time that the bulk of his days were to be spent on major painting projects that he neither liked nor wanted. It was with this disposition that the sculptor was virtually commanded to begin his most famous work—the ceiling of the Sistine Chapel (Fig. **4.36**).

It is claimed that when Michelangelo caught word that he was being ordered to spend the next four years of his life painting a ceiling, he immediately fled Rome, only to be brought back by a papal edict. He miraculously finished the entire 131 x 41 ft (39.9 x 12.5 m) ceiling in less than four years—with virtually no assistance. Throughout this text we have tried to be conscious of how social, economic, and political circumstances help to shape and even determine the standards of quality on which a particular work is judged. But in approaching the work of the Sistine Chapel ceiling, even the most skeptical of social historians cannot help but be reminded of the will and determination of the human spirit that seems to stand apart from the most considered of theories and explanations. The Sistine ceiling is a monument to the artist's tenacity and perseverance, and it is a reminder of the intangibles that so modestly inspire important and influential works.

The art historical problems surrounding the Sistine ceiling are perhaps too numerous to be of much use in such a brief discussion, but its iconography does help illuminate the artist's disposition toward his subject matter. Though extremely difficult to describe, the basis of the iconography of the work is threefold: the ancestry of Christ, Old Testament and pagan prophecies of Christ's coming, and scenes from the creation of Man and other stories from Genesis. The figures are the rough two-dimensional equivalents of his earlier *David*, but his obvious exaggeration of much of the anatomy is not altogether incompatible with his sculptural work (see Fig. **4.37**). Instead, such abstractions were probably Michelangelo's way of compensating for the height and awkward character of the ceiling surface, which called for more dramatic and legible figure-types. In any case, the overall effect is one of heroic grandeur and herculean will. The most famous of these images is most certainly the *Creation of Adam* (Fig. **4.38**), which occupies the central position in the intricate composition. The concentration of the entire composition upon a single, energized space that weaves between the outstretched fingers of God and Adam is without doubt one of the most poignant and dramatic "pauses" in all of art.

■ 4.36 Michelangelo Buonarroti
The Sistine Chapel ceiling 1508–12
Fresco
Total 131 ft × 41 ft (39.9×12.5 m)
The Vatican, Rome

1 Ezekiel
2 Creation of Eve
3 Cumaean Sibyl
4 Creation of Adam
5 Persian Sibyl
6 God Separates the Water and Earth and Blesses his Work
7 Daniel
8 God Creates the Sun and the Moon and Plants on Earth
9 Jeremiah
10 God Separates Light and Darkness
11 Libyan Sibyl
a Lunettes above the windows with portraits of the ancestors of Christ and scenes from the Old Testament

■ 4.37 Michelangelo Buonarroti
Detail of lunette after restoration
The Sistine Chapel ceiling 1508–12
The Vatican, Rome

■ 4.38 Michelangelo Buonarroti
The Creation of Adam
Detail from the Sistine Chapel ceiling 1508–12
The Vatican, Rome

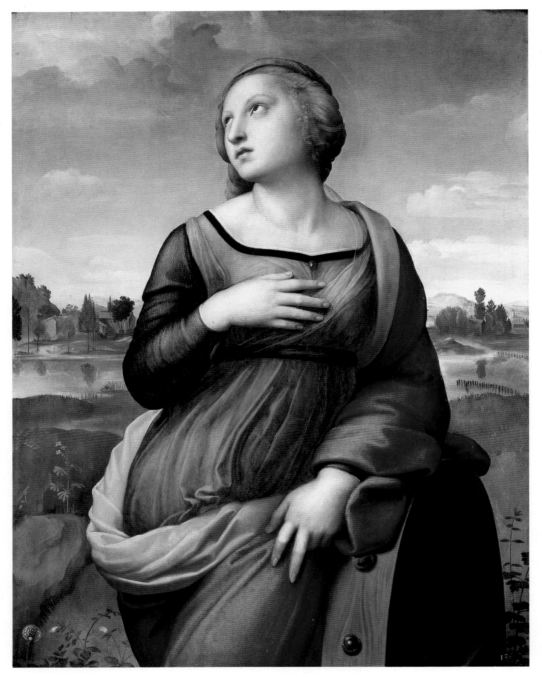

■ 4.39 Raphael
Saint Catherine of Alexandria
c. 1507
Oil on panel
National Gallery, London

RAPHAEL

While the melancholic genius of Michelangelo wrestled away the years between 1508 and 1512 suspended many feet above the Sistine Chapel, there was another artist in the same Vatican complex whose name was to become synonymous with great painting. Raffaello Sanzio (called Raphael) (1483–1520) was born in Urbino, and trained at the court of the Duke of Urbino before moving on to Florence in 1505. There he produced a number of accomplished pictures of the Madonna and other saints, such as his early *Saint Catherine of Alexandria* (Fig. **4.39**) of 1507. Though there is an indebtedness to Leonardo in Raphael's description

■ 4.40 Raphael
The School of Athens 1508
Fresco
26×18 ft (7.92×5.49 m)
Stanza della Segnatura, Rome

of the landscape background, the work extolls an emotional sensitivity and quiet tenderness all his own. In Raphael's work even at this early point, the ideal has become a psychological embodiment, where subjects possess not only the physical attributes of beauty but also the emotional characteristics of an inner harmony. It is this remarkable depiction of solemnity and dignity that has endeared Raphael to so many viewers for nearly five centuries.

Raphael moved to Rome in 1508, where he soon found favor in the papal court of Julius II. He was commissioned to produce a number of works for various rooms in the Vatican; he is best known for the library. *The School of Athens* (Fig. **4.40**) of 1508 is one of four frescoes that decorate the walls of the Stanza della Segnatura (where important documents were signed), and it stands alongside other depictions of the great passions of the age: law, poetry, and theology. It is a homage to the great Classical philosophical tradition, anchored by the towering figures of Plato and Aristotle, who stand together in the center of the composition. Plato (on the left) strides forward while pointing to the

heavens—a reference to his belief in ideal forms. He is flanked by Aristotle, whose downward-pointing hand is a visual reminder of his steadfast belief that all knowledge is based in observation (empiricism). Both the environment and its figures are heroic, and the work demonstrates the breadth of Raphael's skill both as a draftsperson and an imaginative thinker. It is also one of the most convincing and seemingly natural depictions of space using one-point perspective to emerge during the period, a feat of technical brilliance which further concentrates the viewer's attention on the deep space in which these figures interact.

FRESCO

The term fresco has been used throughout much of this chapter in reference to painting—a material process by which the likes of Giotto, Michelangelo, and Raphael produced their most important work. But what exactly is fresco? And how does it differ from other forms of painting? It is the process of painting water-immersed pigments onto wet, freshly prepared lime plaster. Though it is common to think specifically of the Renaissance when discussing this practise, the actual technique had been known to artists of different cultures for many years. Originally thought to have evolved from processes used in Byzantine mosaic work, recent archeological evidence from India now verifies that the painting of pigments onto wet plaster is well over 3,000 years old.

For a number of reasons, fresco painting has long been well regarded as a technique by painters. First, the drying of the colored pigments into the plaster makes for an extremely solid bond, literally embedding color into the ceiling or wall and drying rockhard. A second practical consideration is the matt finish of the dry colored plaster, which allows for a surface free of the glare and reflection commonly associated with oil painting. This is particularly handy when producing an image on a wall or a ceiling that will be viewed from a number of angles, where different light sources often pose reflection problems. Another handy feature of the technique is that once dry, the image is part of the wall rather than a painting on its surface, and can be washed without losing much of its initial impact. There is, however, a downside to this attribute: such large painting surfaces usually come into contact with all sorts of atmospheric pollutants, from candlesmoke to car

exhaust, all of which significantly deteriorate the fresco surface.

Both Raphael and Michelangelo used fresco in a manner typical of most artists. The seams of each day's plaster application are still visible in these works, and they give interesting insights into the remarkable proficiency of these artists in producing such stunning details and luminous color effects over a very short period of time. Unlike an oil painter, who has the leisure of reconsidering and reworking ideas over a period of days or even months, the true fresco painter has only a few short hours. And once the color is in the plaster, it is there for good (short of chiseling the initial painting off the ceiling or wall). There were, however, in use two adaptations of the traditional practise of fresco painting that became increasingly popular during the period: "lime-water" and "secco." Lime water is a clear water mixed with a very small amount of plaster. This solution is then mixed with the pigment to produce a more chalky or pastel-like color. By varying the palette between lime-water and clear water, the artist is able to achieve a greater degree of subtlety than in traditional fresco. The other technique, secco, refers to the application of color on dry plaster. Though Michelangelo used this additional aid sparingly, it allowed for the intensification of a color area after the initial plaster had taken hold. It takes a confident painter to execute imaginative and inventive work in fresco, and these artists' skill in producing such lively work under such decidedly harsh conditions only reiterates the notion of a sizable talent.

ARCHITECTURE

There was a spirit of expansion and grandeur in the Rome of the early sixteenth century that did not end in painting. Other commissions also attracted considerable interest, but perhaps none more so than the scheduled rebuilding of St. Peter's. The Old St. Peter's Basilica, originally built during Constantine's rule, had, by the late fifteenth century fallen into poor repair. Centuries of neglect had diminished the beauty of the structure, and it became apparent that a new basilica was desperately needed to restore the image of the Church. In 1506 the architect Donato Bramante (1444–1514) was awarded the prestigious commission, only to die many years before the final, compromised completion of the project.

Bramante envisioned the Holy Church of

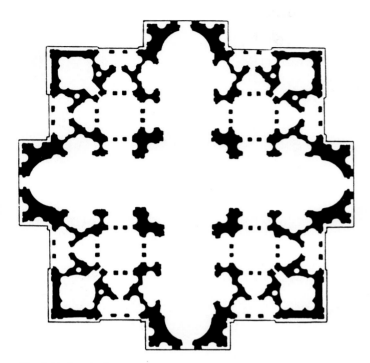

■ 4.41 Donato Bramante
Floor plan for the new St. Peter's Basilica, 1506

in the Classically derived, domed structure. The building is of some art historical significance in that it is one of the first such structures to be designed and carried out with strict regard to Classical building principles. It likewise exhibits the characteristic Renaissance qualities of symmetry, balance, simple design, and a harmonious interplay between parts. If Michelangelo and Raphael can be said to have embodied the Renaissance spirit in painting and sculpture, then it is to Bramante one must turn when considering architecture.

Almost as soon as Bramante was dead his basic central design for St. Peter's was altered. A number of important artists were assigned to the project over the next years, including Raphael and a talented designer named Giuliano da Sangallo (1443–1516), who added a long nave and some side aisles to Bramante's plan. The result was a break with his centralized Greek cross foundation, relying on a more traditional Latin cross design.

■ 4.42 Donato Bramante
The Tempietto 1504
San Pietro in Montorio, Rome

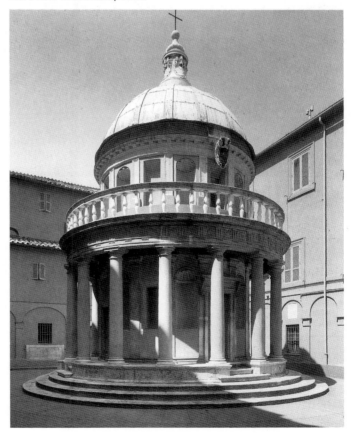

Christendom as having a domed central plan (Fig. 4.41). Such a form paid visual homage to the great building projects of antiquity, and Bramante was particularly inspired by the famous Pantheon (Fig. 2.40); furthermore, its proximity to the Vatican allowed for such vivid comparisons. The architect also had the good fortune of learning from Brunelleschi's important engineering breakthroughs in dome construction that had enabled the earlier completion of Florence Cathedral. The overall impression was one of a deliberate evocation of the antique within the context of the new humanistic Church. In fact, the only "leftover" from earlier Romanesque and medieval structural plans was the stabilizing Greek cross floor plan—a form which suggests that the institution of the Church (the building proper) rests squarely on the foundations of faith (the cruciform foundation).

We now know of Bramante's intentions only through drawings, since the actual building was never completed as designed. But his vision of a harmonious and fully integrated architecture does live down to this day through his engaging Tempietto (Fig. 4.42) or "Little Temple" authorized in 1502, and completed after 1511. Here, many of the same issues are reiterated

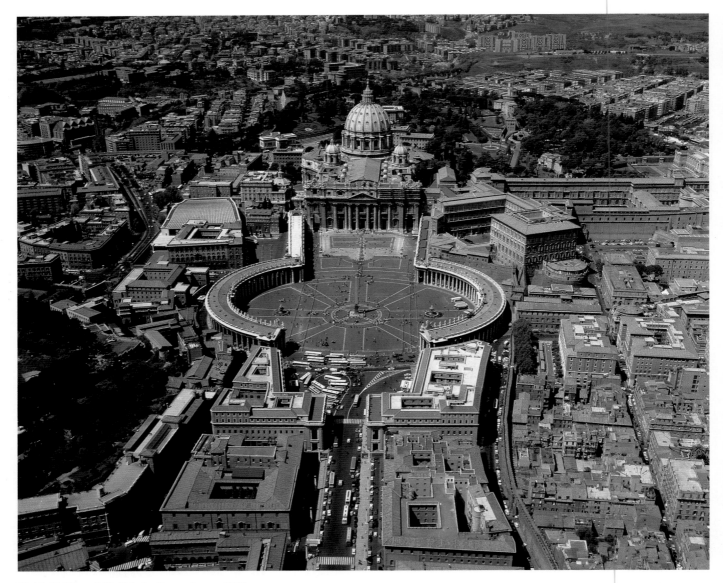

■ 4.43 View of St. Peter's, Rome, begun 1546

In 1546 Michelangelo assumed control of the project. He found Sangallo's additions intolerable, and was given permission to rework the plans. He returned to Bramante's centralized basilica design, which indicates that even late in his life Michelangelo still had a strong affection for the virtues of symmetry and balance. His greatest contribution to the project is the dome (Fig. **4.43**)—an immense structure he lived to see completed (something unknown in previous centuries, where a lack of engineering techniques made such projects span many lifetimes). St. Peter's was to undergo a series of other design alterations, including Maderna's construction of a long nave and elaborate entrance in 1606, and finally the execution of the piazza by Gianlorenzo Bernini (1598–1680) in 1663 (see Fig. **5.22**). The result is a structure that embodies not one but a number of sensibilities and period interests. Though the simple design first initiated by Bramante is all but lost in the trappings of other ages, the Basilica proper remains a monument to the marriage of Humanism and Christianity, and an era's quest for harmony and equilibrium.

▶ PAINTING IN VENICE IN THE 1500s

● Rome was not the only Italian city to enjoy prosperity during the sixteenth century; the port republic of Venice had also flourished in the light of recent advances in shipping and trade. Venice was the gateway to the East, and it supplied much of inland Europe with an assortment of items from abroad. As well, improvements in rudder-steering techniques and navigational aids had enabled the Venetian merchant marine to travel to what were once thought impossible destinations. The result was tremendous economic and political growth, which in turn attracted many artists to Venice in search of patronage.

During the early sixteenth century, Venice was the richest, most productive, and most heavily populated city in Italy. There appears to have been an abundance of commissions available to artists during this period, and the art itself became highly influenced by the diverse historical background of the city. Venice had perhaps the closest relationship to the northern centers of commerce of any of the Italian cities, thanks predominantly to its trade connections. The city also saw an influx of Eastern artistic styles, including icon painting from Constantinople, which surfaced at its massive commercial port. The result of such diverse influences was a keen interest in color—an element in painting which had taken a back seat to the principles of linear perspective and compositional clarity in the courts of Florence and Rome. Both the medieval North and the Byzantine East had left a legacy of rich coloration in their art, and the city's proximity to such images had a significant influence on tastes in painting. This issue was pushed even further by the overwhelming use of the new medium of oil by prominent Venetian painters.

Oil paint, a technical development out of early fifteenth-century Flanders, had made its way via the trade routes to Venice by the middle of the century. This new material was ideally suited to the needs of the Venetians, who had great difficulty in maintaining fresco paintings because of the damp conditions that prevailed in their "Floating City." The plaster content in fresco did not dry effectively in such conditions, and the results were paintings of little quality and almost no longevity. Oil paint, on the other hand, could withstand damp conditions without much damage. When this practical consideration was combined with a historical disposition toward highly saturated color, the result was the emergence of a particular brand of painting quite unlike that of either Florence or Rome.

TITIAN

Tiziano Vecellio (c. 1488–1576), known as Titian, was by far the most prolific and traveled of the port city's painters, and his work capably embodies the Venetian style. He is best known for his sparkling use of light and color, attributes very much in evidence in his *Le Concert Champêtre* (Fig. **4.44**) *c.* 1508. There is an undeniable subjectivity in this work that is very different from the paintings of, say, Raphael, and it speaks of a view of individuality rooted in the North. The term "sensuous" has often been used to describe Titian's, and other Venetian artists', painting, and it refers to the dynamic play of light and color on the surfaces of observed objects. Many have speculated that this textural interest in light derives from Venice's proximity to the sea and the unpredictable effects of reflections on colored surfaces that often illuminated the city. This may indeed have had an unconscious effect on Titian's painting.

Though light had played a part in the modeling of forms in both Roman and Florentine painting, it was held to be of less significance than clear linear design and ideal proportion. The evolution of the liberated figure from its flat surface has interesting parallels with the elevation of individuality during the rise of the Renaissance—ideas which germinated alongside the idealist philosophy. Yet Venice's interest in such matters was always tempered by a more northern preoccupation with the minute observation of nature derived initially from a medieval fascination with the empiricism of Aristotle. This led to an interest in details such as texture and bold color that were perhaps too harsh or discordant for those not used to such a Venetian sensibility. It is within this context that Titian makes his break with past interests, using light to interject a degree of subjectivity in the observable world.

To clarify matters somewhat, consider Titian's *The Death of Actaeon* (Fig. **4.45**), painted late in his career.

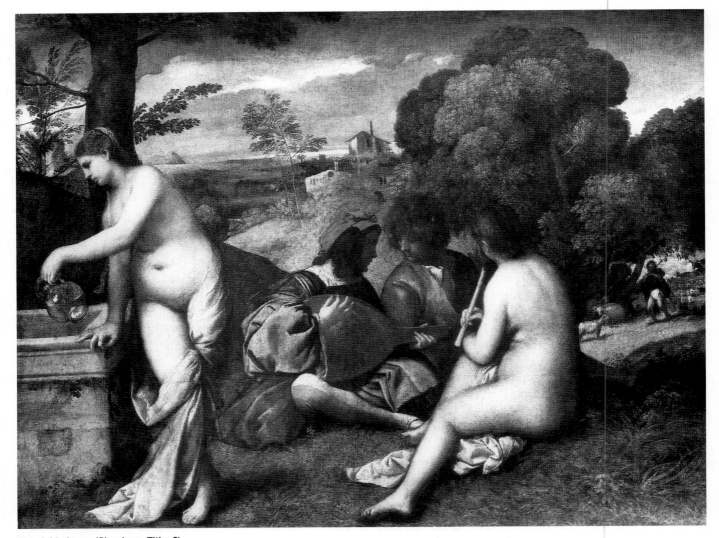

■ 4.44 Anon. (Giorgione–Titian?)
Le Concert Champêtre c. 1508
Oil on canvas
Approx. 43×54 in (109.2×137.2 cm)
Louvre, Paris

Initially, it appears quite unlike other paintings of the age. The coloration is subtle yet saturated, and the figures are rendered with more consideration to their immediate environment than to any specific convention such as proportion. Perhaps most importantly, there is a tangible playfulness and lyricism to the work; the painting is firmly committed to the interrelationships between paint handling, color, and the dramatic effects of light upon objects. Few painters during the era handled paint with the freedom and spontaneity exhibited by Titian, and the result was a degree of unity between the medium (oil paint) and the personality of natural daylight—both could caress surfaces while breaking down the materiality of other objects by their sheer intensity. (If you need proof of this, place an item of your choosing in front of the sun and attempt to study its outline. You will quickly note how the rays of the sun affect your ability to perceive the object—a phenomenon commonly referred to as halation.) *The Death of Actaeon* is a good example of this warm bathing light, a light that is transformed into an almost physical entity by Titian's paint.

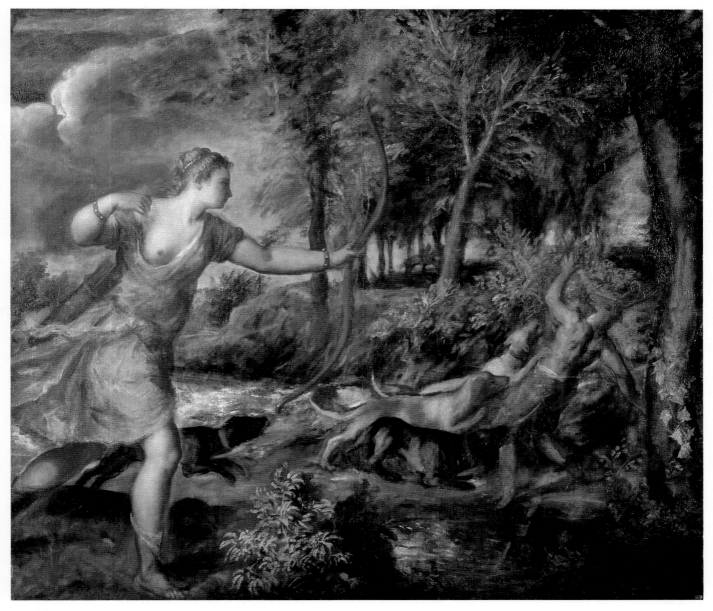

■ **4.45 Titian**
The Death of Actaeon c. 1560
Oil on canvas
70¼×78 in (178.4×198.1)
National Gallery, London

▶ NORTH EUROPEAN PAINTING

● Though the Renaissance ideals of harmony, individuality, and Humanism seemed a perfect fit with the aspirations and interests of the Italian states of the fifteenth and sixteenth centuries, sometimes dramatic cultural differences prevented the northern European centers from embracing such issues wholesale. Instead, the so-called Renaissance "ideals" were tempered by a long northern tradition of piety, restraint, and suspicion—developed through the severity of the medieval age. By the end of the fifteenth century, political and religious dissent were already beginning to make possible a very different artistic path for the North.

Throughout the Renaissance, the northern centers (those to the north of the Alps) provided a sympathetic intellectual climate for some of the more important scientific studies of the age—a climate which would in turn embody such attitudes in its art. As we have seen with the Venetian character of Titian's art, the North's passionate interest in the sciences can be traced back to a general respect for Aristotle's empirical methods, popular in the monasteries and universities of the medieval age. Fundamental to such a doctrine was the belief that all inquiry and learning were to be based on valid observations of nature, and the practical application and testing of hypotheses through experiments. Thus throughout the medieval age, many an artist and scientist were drawn to observed experience, and such fundamental attitudes were inevitably reflected in their activities.

DÜRER

It is difficult to find a survey of Renaissance art that does not spend a considerable amount of time discussing the accomplishments of the German artist Albrecht Dürer (1471–1528). An artist of tremendous range and technical skill, Dürer's body of work reflects a competence in both painting and printmaking.

Trained as a wood engraver, Dürer found himself very much at ease with the often limiting constraints of that form of printmaking. Wood engraving, unlike metal engraving, is a relief printing process, whereby the highest areas on the wood are coated when ink is uniformly rolled onto its surface (this means that areas

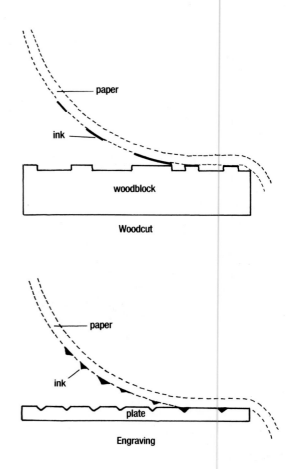

■ 4.46 Diagrams of woodcut and metal engraving techniques

that are to remain unprinted are carefully carved out). Next, a piece of paper is placed on top, and then, when pressure is applied across its surface, the image is transferred (Fig. 4.46). Now, considering the tedious labor and obvious limits imposed by such a primitive process, Dürer's *Christ Bearing the Cross* (Fig. 4.47) is a remarkable feat. With works such as this, Dürer revolutionized printmaking to the point where it too possessed a strength of vision usually confined to painting. Further, the artist's use of a reproducible process for the generation of images (in effect making multiples of what was once a unique image) enabled his works to travel freely throughout Europe, quickly establishing his reputation as a master draftsperson.

The rise of printing processes in the fifteenth century

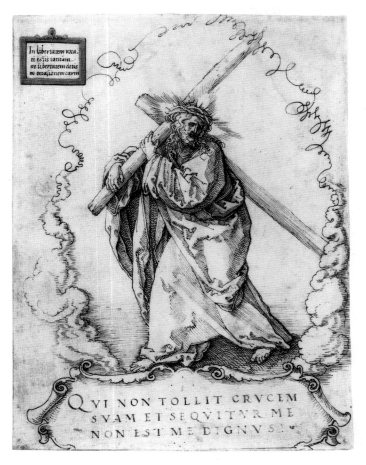

In libertatem voca..
ti estis tantum
ne libertatem detis
in occasionem carni

QVI NON TOLLIT CRVCEM
SVAM ET SEQVITVR ME
NON EST ME DIGNVS.

■ 4.47 Albrecht Dürer
Christ Bearing the Cross 1498–9
Woodcut
British Museum, London

also coincided with a growing religious and social unrest in the North that was to culminate in the Reformation. It is notable that Dürer's prints were popular among many of the same northern clergy who would within a few short decades find themselves forever severed from the Catholic Church. The print had a wonderfully democratic side, as images could be easily read, interpreted, and even discussed by groups with little or no access to great art. In this regard, Luther's written texts and Dürer's prints can be seen as parallel visions in bringing doctrine to the masses.

Dürer's paintings from around the turn of the century share many of the same painstaking qualities as his printed works, but the greater subtleties and color afforded by the oil paint allow for depictions of even greater psychological depth. The result are works such

as the provocative *Self-Portrait* (Fig. **4.48**) of 1500, which immediately resonates as a rather striking resemblance to Christ. This parallel was obviously intentional, for Dürer has gone to great lengths to depict himself in a typically Christ-like frontal pose with solemn gaze—features usually associated with the mystery of Jesus's sacrifice. This may give some indication of Dürer's faith in the sacredness of the art activity; like many in the Renaissance, he believed in the power of images as a source of contemplation and greater truth, and as a result, he too embraced the special character of the artist. But the German artist also grew up in a cultural environment which envisioned artists as faithful and humble reproducers of God's world and his abundant creations. The merging of these contradictory positions explains the strange transformation of personality which takes place in the portrait—the genius of artistic creation tempered by a will to servility. Given this dynamic, it is understandable to view Dürer's art as exuberance tempered by a lonely relationship to faith; a character-type that found many a kindred spirit in the Renaissance in the North.

Dürer was one of a number of northern artists who took an interest in the artistic developments in Italy. He traveled to Venice between 1505 and 1507, where it appears he was involved in many a lively debate on aspects of contemporary art theory and the technical subtleties of perspective. Though Dürer was understandably impressed with Venetian painting, he later returned home to concentrate more fully on his printed works. Perhaps the greatest of his late works is the engraving *The Knight, Death, and the Devil* (Fig. **4.49**) of 1513. Here the considerable technical prowess of the artist reaches full maturity in the subtle transitions of tone from deep black through the lightest grays, giving the print a sense of depth and volume usually associated with painting. In metal engraving, Dürer did not have the benefit of drawing directly on the surface of the plate and then carving away the waste (as in woodcut or wood engraving). Instead, he relied solely on his vision, creating the composition in reverse (so that it would print the right way round), using nothing but an awkward engraver's tool called a burin to carve into the surface (see Chapter Five for a discussion in greater depth on engraving). Yet despite the rather formidable odds against achieving such subtleties, Dürer arrived at one of the great depictions of the triumph of will over temptation—the calling card of a new age and a new attitude.

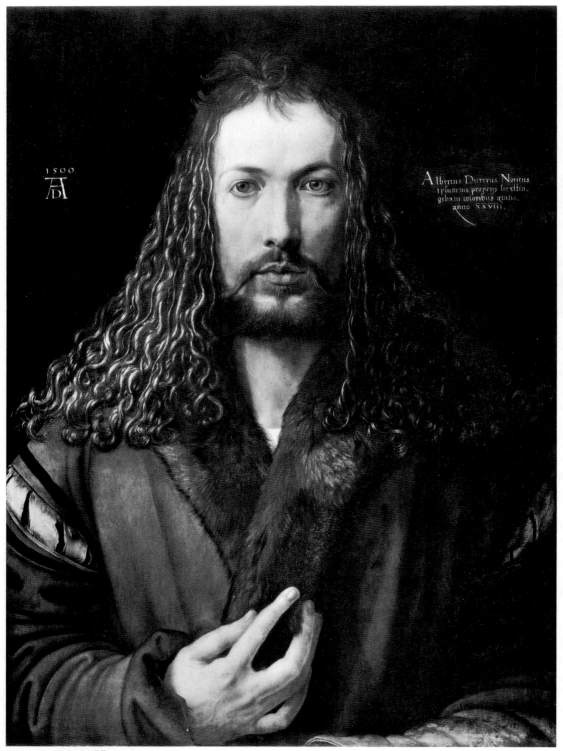

■ 4.48 Albrecht Dürer
Self-Portrait 1500
Oil on panel
25⅞ × 18⅞ in (65.5 × 47.8 cm)
Alte Pinakothek, Munich

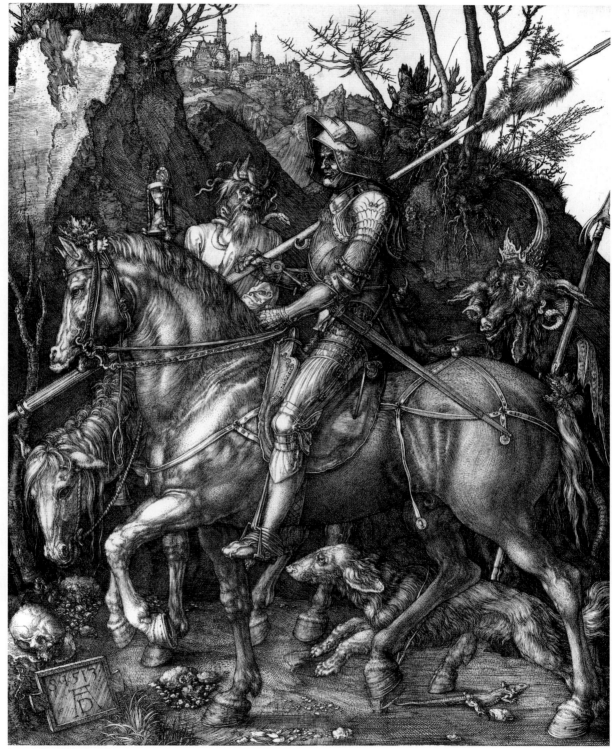

■ 4.49 Albrecht Dürer
The Knight, Death and the Devil 1513
Engraving
9⅝×7½ in (24.4×19 cm)
The Metropolitan Museum of Art, Harris Brisbane Dick Fund, 1943

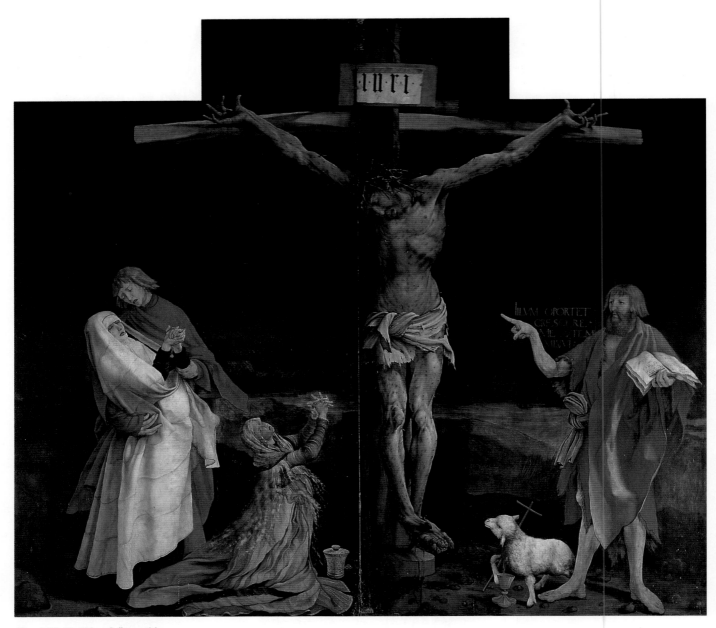

■ 4.50 Matthias Grünewald
Isenheim Altarpiece, central panel with Crucifixion c. 1510–15
Oil on panel
Center panel 8 ft × 10 ft (2.4×3 m)
Musée Unterlinden, Colmar

GRÜNEWALD

If Dürer can be said to have personified the uneasy balance of sensibilities between northern self-consciousness and Italian Humanism, the paintings of the artist known as Grünewald (*c.* 1470/80–1528) are firmly entrenched in the traditions of the North. Little is known about him—his name is thought to have been Mathis Neithardt-Gothardt, and few of his works survive, but his masterpiece, the *Isenheim Altarpiece* (Fig. **4.50**) of *c.* 1510–15, remains one of the most captivating and emotional portrayals of the crucifixion in Western art.

The lack of historical documentation on the artist says much about Grünewald's character. Unlike Dürer, whose whole life is known to us through his various writings, diaries, and numerous works, Grünewald wrote little or perhaps nothing, and produced only a few works before abandoning painting to fight in the 1525 Peasants' War in Germany (it is even possible that he stopped producing religious art altogether in his later years, since he sided with a fanatical Protestant sect in the war against the Catholic Court). Grünewald's work shows little interest or desire to revolutionize art. In the *Isenheim Altarpiece*, the haunting disposition of an earlier Europe is rediscovered in an only vaguely familiar Renaissance guise—its voice punctuated by thoughts of death and forgiveness rather than by the perfections of beauty and harmony. It is the work of an artist who chose freely from current technical innovations but whose intent lies squarely on the shoulders of medieval piety.

A detail from this work (Fig. **4.51**) gives even greater insight into Grünewald's punctuated vision. Here the naturalism of the North is pushed to its logical limits; the green body and the festering wounds speak of death as both awesome and awful. This is certainly not the Renaissance ideal of Michelangelo or Raphael; instead, the body's disintegration provides an interesting counterpoint. From his figures, it is apparent that Grünewald was familiar with both linear perspective and the rendering of volume, but he uses them only in so much as they grant him greater emotional clarity. The result is a degree of representation very different from the idealism of Florence and Rome. The centralized Christ is almost twice the scale of the other figures in the scene, and the emphasis on particular body parts as flashpoints of agony is apparent when one compares the hands and feet of Christ with those of

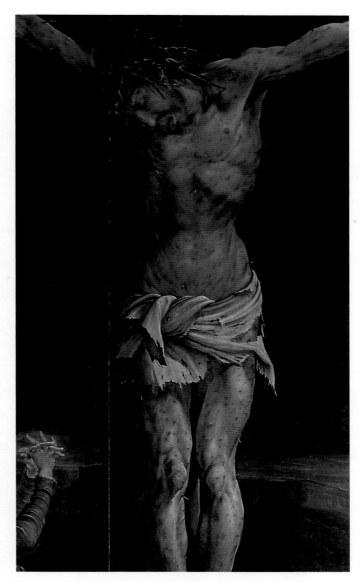

■ 4.51 Detail from the *Isenheim Altarpiece* c. 1510–15 showing the body and wounds of Christ

Mary. This abstraction of features for expressive ends, and the reworking of the body to fit the interests of art, were of course no less arbitrary or natural than the idealizations of Michelangelo—the cultural mindset was simply different. This form of abstraction drew much of its psychological power from the conventions of earlier medieval art, but the adept modeling and manipulation of light (Renaissance conventions anchored in the liberation of the figure) enabled a far more convincing depiction of suffering and resurrection to be produced.

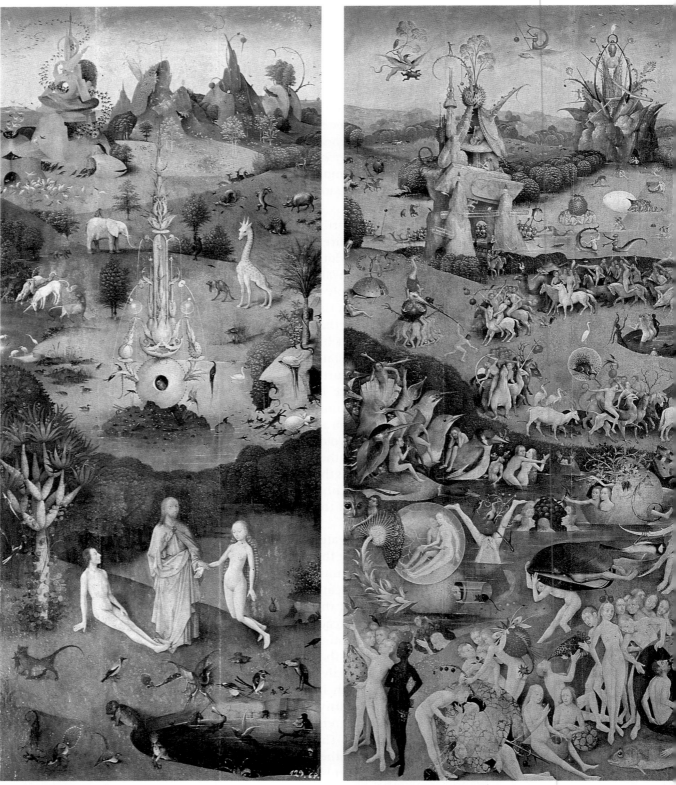

■ 4.52 Hieronymus Bosch
The Garden of Earthly Delights triptych 1505–10
Prado Madrid
Left panel: *Garden of Eden*, 86×36 in (218.5×91.5 cm)

Center panel: *The World before the Flood*
86×76 in (218.5×195 cm)

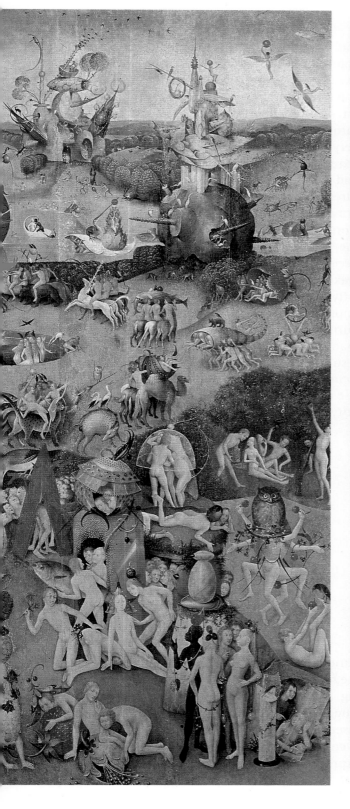

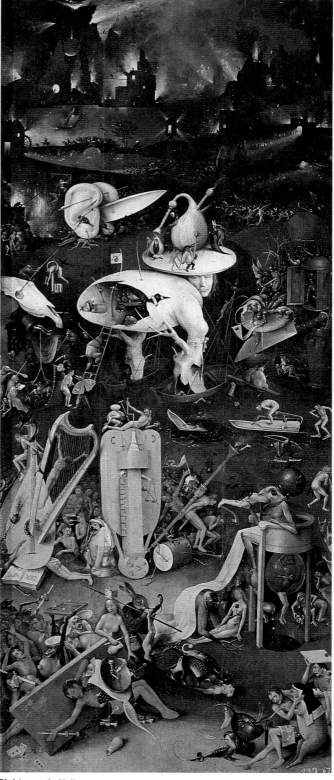

Right panel: *Hell*
86×36 in (218.5×91.5 cm)

BOSCH

Another artist of considerable imagination and insight during the first years of the sixteenth century was the enigmatic Dutch painter Hieronymus Bosch (c. 1450–1516), whose outlandish depictions of sin and the afterlife remain some of the oddest and most private visions ever produced. His *Garden of Earthly Delights* (Fig. **4.52**) of between 1505 and 1510 is a highly intricate and compulsive description of the sins of the flesh. Like Grünewald, Bosch used naturalism as a base from which to embark on visions both bizarre and moralizing. The distortions of the figure types and the various metamorphoses of human to animal to inanimate object are both celebrations of observation and imaginative departures from tradition. Little was written about his work during the period, and one can only speculate as to the intention of his complex symbolism. But as with the works of his contemporary Grünewald, the strong moralizing character of these works plants them firmly in a Europe far removed from the idealist visions of the South. The degree of religious fervor embodied in the works of Grünewald and Bosch anticipates the religious turmoil and conservatism that would find their voice in the Reformation. In this light the *Garden of Earthly Delights* may be read as an appropriate northern response to what was seen as the excesses of the Italian Renaissance.

It is perhaps fitting that this discussion of Renaissance art should end with the northern artists, for it is through their work that we witness the emergence of a very different sensibility arising by the middle of the sixteenth century. Their reservations about Italian art and its reliance on antiquity rather than on the Scriptures were to parallel a growing distrust of papal authority in Rome and a growing sense of nationalism in the North. The result was to be a revolution that would lay the foundations for modern Europe—creating a decidedly different role for the artist in society. In its wake, the period called the Renaissance, with all of its lofty hopes and aspirations, appeared awkwardly impractical. By 1630, the period had to all intents and purposes lost its initial edge and rigor, settling on mannerisms more predictable than invigorating. The resultant religious, political, and economic turmoil was to mark a new Western order, one that would see the rise of nation states and the slow decline of the authority of the Church—an era called the Baroque.

▶ SUMMARY

● The Renaissance has historically held a prominent position in texts on Western art. For many, the period between the mid-fourteenth and mid-sixteenth centuries is viewed as the culmination of a general "rebirth" of humanistic pursuits and a freeing of the artist from the restrictive dogma of the medieval Church. The status of art, and indeed the artist, shifted significantly, and our contemporary views on both are based very much on certain assumptions about the role and rationale of art in culture that were first developed during the Renaissance. It was in the Renaissance that the role of the artist went from simple maker (suggesting an anonymous craftsperson) to that of creator (suggesting individual genius)—an appellation once reserved only for God. As a consequence, art took on even greater significance, becoming not only an expression of its age and its means of production but also the very embodiment of genius. In this way, the Renaissance has played a fundamental role in shaping the way we think about art.

Glossary

atmospheric perspective (*page 179*) A convention for developing depth within a painting by making objects appear less defined as they recede in space.

contrapposto (*page 177*) A figure pose first developed by Polyclitus with his *Doryphorus* model in Classical Greece, it combines a "fixed" or "engaged" leg with a "free" leg—a motion which creates a sway in the hips and is subsequently counterbalanced by the upper torso.

empiricism (*page 151*) A philosophical position holding that one can gain knowledge and insights into existence through the close observation of nature. Originating in the writings of Aristotle, it had sweeping implications for the study of science in the medieval period.

fresco (*page 188*) A painting method by which colored pigments immersed in water are applied to fresh plaster, which absorbs the paint and dries rockhard. This method was particularly popular for decorating interior spaces during the Renaissance.

linear perspective (*page 165*) A geometric system for defining items in space. It implies that all lines receding back into space have their point of origin at a central vanishing point or points, depending on the circumstances.

Renaissance (*page 150*) Meaning "rebirth" it is generally used to define the period in European culture between 1400 and 1600 when there was a renewed interest in Classical scholarship and art.

symmetry (*page 169*) A compositional device to produce balance between parts through offsetting items on either side of the center.

wood engraving (*page 194*) A relief printmaking method whereby areas not to be printed are carved out of a flat wood surface, leaving the intended image raised to take ink.

Suggested Reading

The Renaissance has long been a favorite with art scholars and so there is no shortage of texts on the subject. The following is a short list of some of the more recent, convincing, and perhaps less stuffy: M. Baxandall, *Painting and Experience in Fifteenth Century Italy* (London/New York: Oxford University Press, 2nd edn, 1988), A. Chastel, *A Chronicle of Italian Renaissance Painting* (Ithaca: Cornell University Press, 1983), S. J. Freedberg, *Painting in Italy 1500–1600* (Harmondsworth/New York: Penguin Books, 1971; revisions 1979), and J. Snyder, *Northern Renaissance Art* (New York: Abrams, 1985). For an informative look at the history of perspective, Lawrence Wright's *Perspective in Perspective* (London: Routledge and Kegan Paul, 1983) is highly recommended.

ART,
ISSUES, AND
INNOVATIONS
IN THE
BAROQUE ERA

■ 5.1 Annibale Carracci
The Triumph of Bacchus and Ariadne (detail) 1597–1600
Farnese Gallery ceiling, Rome

Beginning reform is beginning revolution.

THE DUKE OF WELLINGTON

The origins of the word "Baroque," as the era of European art after the Renaissance is known, are not clear, and today one can only speculate as to the original intention of the title. It may have come from the Italian "*baroco*," meaning a complex problem, or even the Portuguese "*barroco*," meaning an irregularly shaped pearl, but what both roots imply is an interest in decoration or complex configurations—something very different from the harmonious mindset commonly associated with the art of the Renaissance. It is however clear that the title was given to the period sometime later, likely as a dubious descriptive term.

The seventeenth and early eighteenth centuries saw an unprecedented degree of nationalism and commercial venture develop in the major centers of Europe. In this relatively short period, the ideals and religious preoccupations of the West expanded past the boundaries of Europe and began to envelop the Americas and the Far East. It was the period of merchant forces and diplomacy, and in its subsequent flourish it planted the seeds of revolt that would forever change the face of politics as it was then known. In such a climate, it was art that became perhaps the ultimate expression of individuality—this was the era of Rembrandt and Rubens, of Velázquez and Poussin, and Bernini, and with them came some of the most admired masterworks the Western world has known.

Like the enraptured Renaissance, the Baroque was a period of tremendous artistic activity, though with decidedly different aspirations. The reasons for this are complex, and in approaching the art of the age within the context of the massive social, political, and philosophical upheavals of the time, the subtle pressures that influenced the nature of art and art making will become clear. To get an idea of the historical background, we will start by examining a discussion that preoccupied much of Rome back in the year 1541—the year Michelangelo finished his fresco of *The Last Judgment* (Fig. **5.2**).

▶ "THE LAST JUDGMENT" AND ROME IN 1541

● On 31 October 1541, Pope Paul III unveiled Michelangelo's recently completed *The Last Judgment* in the Sistine Chapel—twenty-nine years after the completion of his masterly ceiling (Fig. **4.36**). The new work had taken seven years to complete and, once viewed by the public, it initiated a furious debate that was to last another twenty. At the center of the debate was the question of "decorum"—in other words, the appropriateness of Michelangelo's choice of figures for the needs of the Chapel. The significance of the argument was that it saw a questioning of the validity of figuration and the role of images in the Church for the first time since the medieval age. This sudden readdressing of decorum, in an age that had witnessed unprecented freedoms for intellectual and artistic curiosity, signaled the emergence of a very different attitude in Europe. In a letter dated November 1541 (shortly after the unveiling of the aforementioned fresco), Nicolo Sernini wrote to Cardinal Gonzaga with regard to the reception afforded *The Last Judgment*: "The theatine fathers are the first to say that it is not good to have nudes displaying themselves in such a place . . . others say that he has made Christ beardless and too young, and that He does not have the majesty which is suitable for Him, and so there is no lack of talk."

A cool breeze of restraint and suspicion had swept over a once exuberant Church and its art, and behind it was a man named Martin Luther.

■ 5.2 Michelangelo Buonarroti
The Last Judgment 1534–41
Fresco, altar wall of the Sistine Chapel, Rome
48×44 ft (14.6×13.4 m)
The Vatican, Rome

THE REFORMATION

On 3 January 1521, the German Augustinian friar Martin Luther was officially excommunicated from the Catholic Church for heretical teachings (see Fig. **5.3**). The severe condemnation of Luther's activities was the result of a series of highly critical observations launched against the Catholic Church in 1517 in the form of ninety-five propositions, now known as the 95 Theses. Tacked to the door of Wittenberg Cathedral, these complaints called for an end to the corruption which was by this time increasingly common in the Church. The protest was a culmination of many years of frustration for northern European Catholics, who saw the Church enjoying increased revenues, while remaining unmoved by the plight of its "flock;" a situation further complicated by an administration riddled with corruption and hypocrisy. The religious revolt led by Luther would come to be known as "Protestantism" (as its followers were protesting), and the subsequent Reformation would dramatically alter the face of European culture, including its art.

Luther's teachings had enormous cultural repercussions, ranging from public education to music and art. Perhaps his greatest achievement, apart from his religious reforms, was his push for greater literacy among all classes. The Lutheran emphasis on the "word" of God as translated through the Bible made it imperative for all Christians to have access to the written text. Luther's translation of the Bible into his native German

■ 5.3 Hans Holbein the Younger
Hercules Germanicus 1520
Colored woodcut
Zentralbibliothek, Zürich

■ 5.4 Simon Guillain (after Annibale Carracci)
Paintings for Sale 1646
Etching

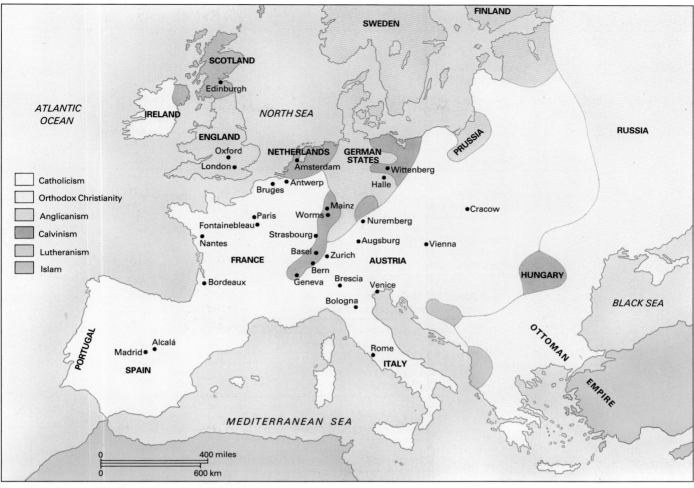

■ 5.5 Religious affiliations in Europe c. 1600

Catholicism
Orthodox Christianity
Anglicanism
Calvinism
Lutheranism
Islam

is thus of significance in that it was an attempt to give back the responsibility of faith to the individual, rather than see it arbitrated through an elaborate construction of ceremonies conducted by the Church. This democratization of faith led to other reforms, such as access to education—an idea with huge moral implications. In a similar vein, many Protestant congregations found it appropriate to use music to instruct the common people. Luther's emphasis on music as a vehicle for both celebration and teaching led to his writing of hymns—a genre which finds its greatest expression in the works of the German Lutheran Johann Sebastian Bach (1685–1750).

One area where the doctrines of Protestantism allowed for little tolerance was in the field of visual arts. The militant iconoclasm of Protestantism was a reaction to what it perceived as the Catholic Church's reliance on mystery and symbolism that were often unintelligible to the general public. However, this denial of imagery within the sanctuary of the Church had other, more positive, side effects for the development of art. The slow but steady drying up of commis-

sions from the once reliable patronage of the Catholic Church in the Protestant North helped to contribute to the emergence of art in the commercial marketplace, where it could be sold, as a commodity, to a rising middle class (see Fig. **5.4**).

Between the years 1517 and 1520, Luther's published writings sold an amazing 300,000 copies—and this in a Europe where very few could read. The recent discovery of movable typeface and printing techniques enabled information to be disseminated over large areas in a relatively short period of time, and by the middle of the sixteenth century, a considerable amount of Europe had come under the influence of the Reformation spirit. From this point on, the religious boundaries that divided the various Protestant denominations from their Catholic heritage have remained relatively unchanged in Europe. Britain, much of Germany, the northern Netherlands, most of Switzerland, and all of Scandinavia became Protestant states, while France, Spain and Portugal, Italy, southern Germany and Austria maintained their allegiance to the Pope (Fig. **5.5**) for both religious and

THE BAROQUE ERA

1550		1600		1650		1700

1534 Founding of Jesuit Order

1566 Iconoclastic destruction in Netherlands

1643 Louis XIV ascends French throne

1545-63 Council of Trent

1581 Dutch Independence Proclamation

1648 Peace of Münster

1663 Reorganization of French Academy

NORTHERN RENAISSANCE	MANNERISM	BAROQUE	

1672 *Lives of the Modern Artists* – Bellori

Carracci (1560-1609) Farnese commission (p.214)

Caravaggio (1571-1610) *The Martyrdom of St. Matthew* (p.216)

Rubens (1577-1640) *The Descent from the Cross, Marie de'Medici cycle* (pp.238-40)

Hals (1581-1666) *Laughing Cavalier* (p.251)

Van Honthorst (1590-1656) *The Merry Company* (p.242)

Ribera (1591-1652) *The Martyrdom of St. Bartholomew* (p.234)

Poussin (1593-1665) *Rape of the Sabine Women* (p.232)

Gentileschi (1597-1652/3) *The Penitent Magdalene* (p.230)

Bernini (1598-1680) *The Ecstasy of St. Theresa* (p.225)

Van Dyck (1599-1641) *Charles I of England* (p.252)

Velasquez (1599-1660) *Pope Innocent X* (p.235)

Borromini (1599-1667) San Carlo alle Quatro Fontane (p.227)

Rembrandt (1606-69) *The Descent from the Cross, Side of Beef* (pp.243-45)

Le Brun (1619-90) *Louis XIV Adoring the Risen Christ* (p.233)

Van Ruisdael (1628-82) *View of Haarlem from the Dunes at Overveen* (p.255)

Vermeer (1632-75) *Interior with a Woman Reading a Letter* (p.253)

decidedly political reasons. These geographic divisions also contributed to the pictorial and cultural variety that marked Baroque art, making it one of the richest periods in the history of the visual arts.

This diversity of styles and concepts between the years 1600 and 1750 was the result not so much of the Reformation as of the defensive posture of the Catholic Church after suffering this onslaught of harsh and militant criticism. It was through the Council of Trent, which met intermittently between 1545 and 1563, that Catholicism began its purge of in-house corruption, and in its wake there emerged a revitalized Church. The most obvious result of this new celebration of papal authority was the launching of large and elaborate commissions—items that were to set the standards for Baroque art.

THE COUNTER-REFORMATION

The sack of Rome by northern Protestants in 1527 is an appropriate date from which to begin a discussion of the Catholic resurgence. As the name implies, the Counter-Reformation was an attempt to fight back against the militancy of the Protestant North (see Fig. **5.6**). The Church began to rely heavily on missionary service to expand both its pocket and its authority, and the subsequent founding of the Jesuit Order in 1534 was the first of a number of decisive steps taken to counter the recent inroads of the radicals. Emphasis was now to be placed not on esoteric symbolism and unintelligible ceremony but on a directness and clarity of teaching, so that even the humblest could come to understand the chief tenets of the faith.

For the Church of the Counter-Reformation, art worked on two levels: it was didactic and it served as propaganda. One of Luther's complaints was that Christian worship had become inaccessible and mysterious to the common people. Ceremonies had become nothing more than a grand theatrical production with little substance and even less relation to the Scriptures. The Council of Trent attempted to rectify this obvious inconsistency between the commissioned art of the time and its public, by placing greater emphasis on more direct and intelligible works—governed first by moral standards and then by esthetic interest. The result was a series of debates that ended with a specific decree issued at the last meeting of the Council in December 1563. It explicitly stated: "By means of the stories of the mysteries of our Redemption

■ 5.6 Anon. *Luther as the Wolf in the Fold* c. 1525
Woodcut
Print Collection; Miriam and Ira O. Wallach
Division of Art, Prints and Photographs
The New York Public Library; Astor, Lennox and Tildes Foundations

portrayed by paintings or other representations, the people [should] be instructed and confirmed in the habit of remembering, and continually resolving in mind the articles of faith." By viewing art that surrounded them in worship, the pious could gain greater insight into the articles of faith, and in this way art functioned as a teaching device—very much in keeping with Luther's objective in writing hymns.

It is perhaps important at this point to place such criticisms within the context of the work itself. Artists working under the patronage of the Catholic Church during the early 1500s were heirs to an abundance of

■ 5.7 Parmigianino, *Madonna with the Long Neck* c. 1534
Oil on panel, 7 ft 1 in × 4 ft 4 in (2.15×1.32 m), Uffizi Gallery, Florence

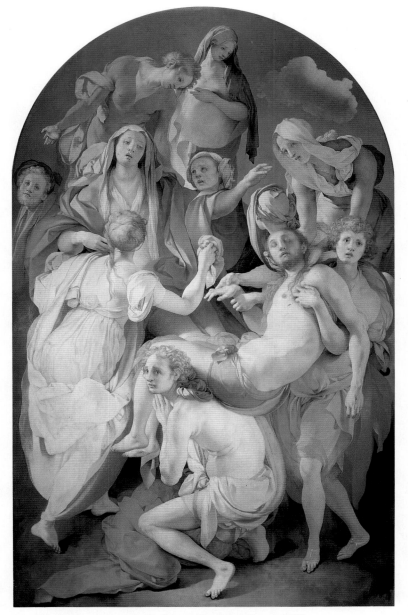

■ 5.8 Jacopo Carucci da Pontormo, *The Deposition* c. 1528
Oil on panel, 11 ft × 6 ft 6 in (3.35×1.98 m)
Capponi chapel, Santa Felicita, Florence

visual conventions developed over the previous century. As a result, technical formulas such as perspective and ideal proportion soon became the focus of further manipulation at the hands of artists who desired a more personal, if somewhat idiosyncratic, form of representation. The unfortunate label "Mannerism" has often been applied to the art of this transitional period, and it refers to an emphasis on stylistic virtuosity and complex design over the principles of restraint, idealism, and equilibrium—the catchwords of the previous generation. A clear example of this exaggeration comes in the work of Parmigianino (1503–1540), whose so-called *Madonna with the Long Neck* (Fig. **5.7**) shows the

elongation of both body parts and perspective so in keeping with the changing spirit of the era. The impossible proportions and exaggerated perspective (note the tiny figure in the bottom right corner which is supposed to infer background) posit theatricality over naturalism, and the result is an oddly lyrical, even erotic, rendering of the Virgin and Child.

Another aspect of painting to come under consideration was color. One of the most striking departures from the early Renaissance norm of color harmony is a work by Jacopo da Pontormo (1494–1556), *The Deposition* (Fig. **5.8**) of *c.* 1528, where exaggerated figure types and highly active color (consisting of bright pinks, light

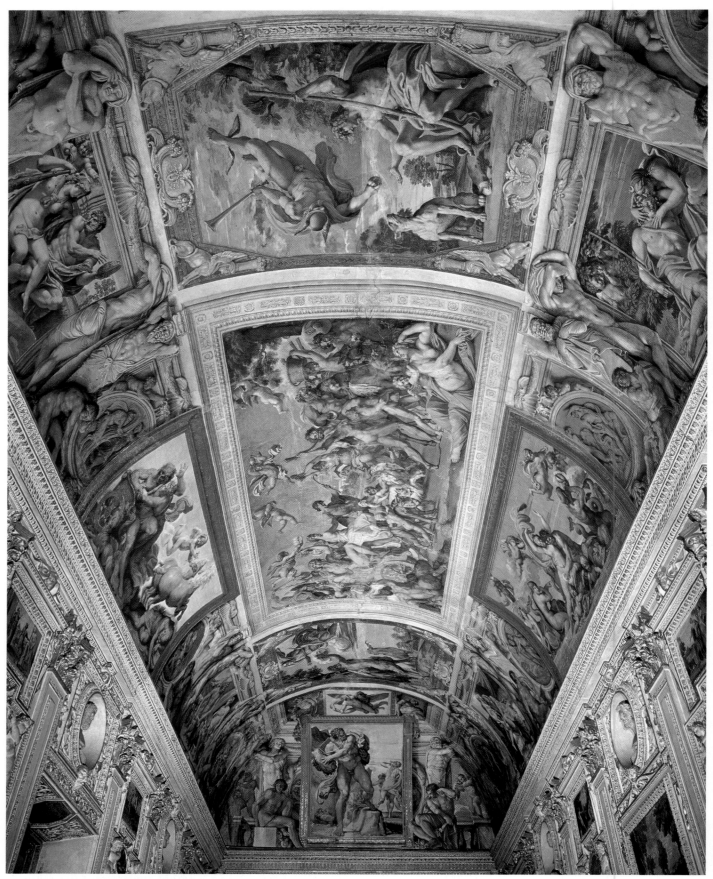

■ 5.9 Annibale Carracci, Ceiling, Farnese Gallery 1597–1604
Fresco, 67 ft × 20 ft (20.42×6.09 m); Farnese Palace, Rome

blues, and acid yellow-greens) resonate with a blatant, and often disquieting, contrast.

It was within this artistic climate that critics placed Michelangelo's *Last Judgment* (Fig. **5.2**), with its almost supernatural rendering of space, and its demanding, disjointed, and psychologically challenging composition. Moreover, the unabashed nudity of the figures spoke as much of eroticism as it did of idealism. These

were works ripe with the stylistic ingredients considered so insidious to Luther and his followers, and their exotic character and obscure subject matter only further corroborated the Protestant insistence that art served its own god, rather than Christ. Soon the Catholic Church too felt the pressure, and between 1559 and 1565 drapery was added to many of the figures in *The Last Judgment*.

▶ CLASSICISM VERSUS NATURALISM

● Two distinct currents were to emerge in the late sixteenth century that would determine the direction for much of the Baroque era: a Classicism derived from the antique, and an invigorated naturalism that found at least its inspiration in the edicts of the Council of Trent. Both were to start in the Rome of the Counter-Reformation, and though each was in keeping with the spirit of the reformed Catholic Church, their sensibilities were very much in conflict. That these two contradictory attitudes arose simultaneously is not surprising, particularly in the light of the continued interest in the antique throughout the 1500s, and the ongoing developments in the description of space and volume in both painting and sculpture. What is interesting is how each of the early practitioners attempted to reconcile these inclinations with the "new spirit" of the Church.

Much of the impetus for developments in the Baroque can be traced back to two contemporaries whose contrasting works set precedents that were to continue well into the nineteenth century. Thus in comparing the work of classicist Annibale Carracci (1560–1609) and naturalist Michelangelo Merisi da Caravaggio (1571–1610), the various mutations of the Baroque esthetic will begin to emerge.

In 1597 Annibale Carracci was awarded the commission for decorating the reception hall of the Farnese Palace (Fig. **5.9**). The commission took almost seven years to complete—the same amount of time it took Caravaggio in Rome to complete a series of paintings for the Contarelli Chapel (Fig. **5.10**). The results could not have been more different. The strong contrasts of light and shade and the violent directness of the composition made Caravaggio's paintings at once controversial; in

contrast, Carracci's steadfast reliance on antique sources and Classical modeling appears a direct recapitulation of High Renaissance ideals. However, what both artists have in common is a desire to push their art to a higher level of emotional content; their images possess an unprecedented directness and clarity, signaling the rise of a new sensibility in Counter-Reformation art.

The personalities of the two artists were diametrically opposed: Carracci was withdrawn and brooding, his younger competitor dramatic and violent. The story of Caravaggio's life is almost as exciting and theatrical as his paintings, and his violent existence no doubt had some effect on his work. Shortly after the Contarelli Chapel commission was finished, Caravaggio murdered a fellow citizen, having argued over a game of racquets. He fled to Malta, where he enjoyed prestige as a court painter until a fight with a police officer landed him in jail. He subsequently escaped, only to run into more trouble in Naples, where yet another quarrel left him seriously wounded. He died of fever on his way back to Rome in 1610. This story has all the intrigue of an adventure novel, but it also points to an artist of violent emotions with little interest in the accepted etiquette of his day—personality traits that found their resolution in the striking innovations of his work.

Through the Council of Trent, it was made clear that Church art was to follow the path of clarity and directness, making intelligible the various biblical stories and parables that were so often the subjects of great commissions. Caravaggio's answer to this demand was a critical reworking of the traditional techniques of rendering volume through the deliberate manipulation of light and shade, known as "chiaroscuro."

Chiaroscuro (Italian for "light and shade") is a term used in painting and drawing to describe the convention of using light to enhance the volume of objects. As a picture-making device, chiaroscuro mimics our visual world; light and shade are, of course, fundamental to our perception of space, and shadows and highlights help us determine surfaces and indicate volume.

Consider this example. Place an item on the desk next to your reading light; note how the beam of light falls on the nearest surface of the object facing the light (creating a highlight), and shadows on the planes that face away. By manipulating the lamp head, it becomes apparent that the contrasts between highlights and shadows are particularly acute when the light source is both strong and directed, making such a situation ideal for dramatic effects. Now, if it is possible to appreciate

◄ 5.10 Caravaggio
The Martyrdom of St. Matthew
c. 1602
Oil on canvas
10 ft 9 in × 11 ft 6 in
(3.23×3.5 m)
Contarelli Chapel,
San Luigi dei Francesi, Rome

■ 5.11 Caravaggio
The Conversion of St. Paul
1600–02
Oil on canvas
7 ft 6½ in × 5 ft 9 in
(1.2×1.4 m)
Cerasi Chapel,
S Maria del Popolo, Rome

the visual theatricality of such a light source from this example, then consider the ramifications for painting.

Caravaggio's *The Conversion of St. Paul* (Fig. **5.11**) of 1600–02 is one such breathtaking study in the dynamic character of light. The once implicit heavenly light that softly shone in Leonardo's painting has become in Caravaggio's work an explicit reminder of God's presence. Like a flash of lightning, the artist has suggested the very moment of St. Paul's conversion, focusing physical and psychological attention on the central figure by the erratic nature of the gesture and enveloping him in a shroud of darkness like an actor on stage. The result is a work that appears unapologetically dramatic, high keyed, and penetrating—attributes in keeping with the new spirit of renewal and accessibility sweeping over the Catholic Church.

■ 5.12 Caravaggio, *The Death of the Virgin* 1605–6
Oil on canvas, 12 ft 1 in × 8 ft ½ in (36.9×2.45 m), Louvre, Paris

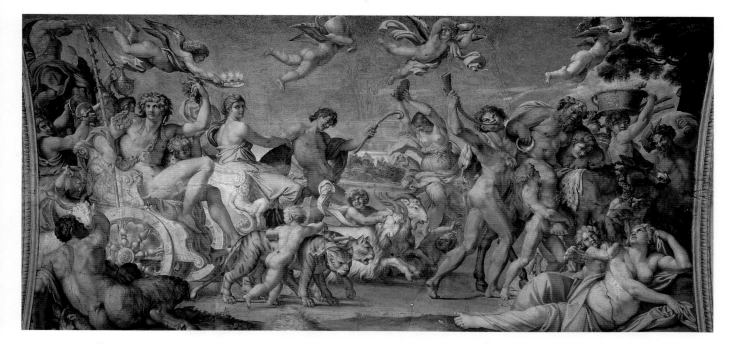

■ 5.13 Annibale Carracci
The Triumph of Bacchus and Ariadne 1597–1600
Detail from the Farnese Gallery ceiling, Rome

But if the chiaroscuro modeling could claim some implicit sympathy with the "new" Church, Caravaggio's unorthodox use of models and interest in minute details often brought him into contact with the tightening noose of decorum. In attempting to produce authentic representations of biblical figures (who were themselves often peasants and laborers) the artist went to painstaking lengths to describe every aspect of their physiognomy. The results were representations of martyrs and disciples with dirt on their feet, and Virgin Marys who resembled not the idealized figures of Raphael but those of simple, poor Roman mothers. One particularly enlightening altercation of this sort surrounded Caravaggio's painting of *The Death of the Virgin* (Fig. **5.12**), in which the figure of the Virgin was derived from the body of a drowned prostitute (apparently to get the authentic look of a dead body). Predictably, this offended the sensibilities of many of the Church officials, who considered such depictions blasphemous and lacking in true devotion.

Comparisons between the life and work of Caravaggio and his rival Carracci could not be more extreme. Carracci, thirteen years older than Caravaggio, lived a relatively secure life and enjoyed a considerable reputation as a painter. Historians typically point to him as a major, and perhaps even the primary, figure in the re-establishment of Classical virtues in painting. Up until the nineteenth century, his famous Farnese Gallery fresco cycle (Fig. **5.9**) was considered, along with

Michelangelo's Sistine Chapel (Fig. **4.36**) and Raphael's Stanza della Segnatura (Fig. **4.40**), as one of the truly great works in the whole history of art.

Carracci had formidable talents as a technician, and his thorough knowledge of principles of drawing, combined with an observant eye for Classical proportions, gave him the singular advantage of recognizing the subtleties of the antique often overlooked by other contemporaries. The result was a body of work that injected a strong dose of Classical refinement, and a lively, celebratory character to what had only decades before been a monotony of lofty and sometimes uninviting compositions. His unique ability to combine Classical picture-making devices and motifs with a clarity and exuberance befitting the new spirit of the Counter-Reformation makes Carracci's achievement as dramatic in stature as Caravaggio's chiaroscuro. He became the other half of the era's equation—a second possibility afforded to the artist in the age of reform.

You will remember that Caravaggio's naturalism faced a major obstacle in the form of the doctrine of decorum. In keeping with such concerns, it may appear odd that the Farnese Gallery (Fig. **5.13**) did not suffer the same criticisms for its less than subtle joviality. Yet in pondering the overwhelming acceptance of this work during an era of reform, it may be helpful to consider two other points: the discrepancy between public and private commissions, and the difference

■ 5.14 Annibale Carracci
The Assumption of the Virgin
1601
Cerasi Chapel,
S Maria del Popolo, Rome

between the grand tradition of fresco and the emergence of oil painting. The Farnese Gallery, part of a magnificent mansion built by Cardinal Odoardo Farnese, was of course a private building, and not necessarily bound to the decrees of decorum issued by the Church. The subject matter, full of popular myths then familiar to most guests, could be justified as serving a double purpose—celebrating the wonder of life and love, and at the same time allowing for a degree of moralizing through symbolic associations with the Bible (circumstances reminiscent of the early Church during its years of persecution). Though such subject matter exhibits at least a mild affinity to the elaborate narratives so harshly criticized in the Mannerist era, its uncompromising use of Classical sources (many of these poses are direct copies of Classical sculpture) made it appear ultimately controled and thus acceptable.

Another recognizable difference between the Contarelli Chapel and the Farnese Gallery is the consideration of materials. It is certain that both artists had a working knowledge of the materials and techniques of the age. However, Caravaggio worked almost exclusively in oil on canvas, while Carracci is perhaps best known for his fresco painting. The issue of materials may on the surface appear relatively inconsequential when compared to many of the other variations that separate the artists' images, but it is nevertheless illuminating in any consideration of the reception their work received. Since the early Italian Renaissance, fresco had enjoyed a reputation as the medium of the grand commission, since it was most flexible to the decorative demands of interior Church architecture. The most noted artists—ones capable of winning prestigious competitions—were thus forced to use the rather awkward medium. The ability to produce quality results under often extreme conditions (such as lying on one's back or straining the neck for ceiling work) was considered the mark of a true master, and subsequently fresco developed a strong mystique as the medium of the great artists. In contrast, the relatively new medium of oil painting, capable of much more dramatic shifts in color and texture, and able to sustain repeated workings, was considered the poor cousin to the fresco. The canvas stretcher frame, which was transportable and thus could be bought and sold like any other object, tended to be looked upon as technically less demanding—though few would quarrel with the view that it gave the painter greater

freedom. It would be difficult to visualize Caravaggio's theatrical lighting and deep chiaroscuro in terms of fresco; we understand his "form" (oil on canvas) and "content" (the dramatic spaces and violent gestures) as inextricably linked. However, this did not stop many critics of the day from ranking him behind Carracci, who produced admirably in the difficult medium of fresco. When Carracci did paint in oil, his work shows an awareness of the dramatic effects produced by an extended tonal range missing in his fresco work, and the result is a deeper, more volumetric series of forms (see Fig. **5.14**).

THE ART CRITICISM OF BELLORI

Giovanni Pietro Bellori, born in Rome in 1613, wrote many years after the deaths of both Carracci and Caravaggio, yet his critical work reflects an enthusiasm for idealism rather than the naturalism so popular in the Italian Baroque. Bellori was one of the leading scholars of the time, holding the position of Commissioner of Antiquities in Rome from 1670 to 1695, and this no doubt influenced his opinions. He is perhaps best known for his *Lives of the Modern Artists*, published in 1672. Here he not only describes some of the leading figures of the day but also gives a series of critical observations on the then current state of art.

In his preface he presents a brief but influential treatise on the nature of art. Though not particularly original, the short text quickly became a model for art criticism during the Baroque, and is enlightening as a justification of Classicism in art. Bellori's concept of art shows a clear sympathy for ideal forms, and in the works of Carracci as well as the earlier Raphael he finds perfection. He begins his treatise by describing a world where the earth is still positioned at the center of all things. Writing almost fifty years after Galileo's revolutionary observations had displaced the Ptolemaic conception of the universe, Bellori implicitly adhered to the earlier astronomer's views. This apparently reactionary stance had important ramifications for Bellori's theory. Regarding the universe beyond our atmosphere as a place untainted by decay or time, certain "ideas" (prototypes for each thing in the universe, created by God) found their true reflection only in the realm of the heavens. The flipside of this abstract world of perfection is life on earth, where time and decay corrupt such true reflections, leaving only vulgar facsimiles (a view derived from Plato). Enter the artist. It is

the artist's role to form an example of superior beauty, and then use that prototype to beautify his/her depictions of earthly objects. By effectively implementing such a concept of divine or heavenly beauty, the artist had the ability to improve on the corrupt images of nature, and provide a window to heaven.

The critic uses a then popular Renaissance story from Pliny to illustrate his point. He writes of how the ancient Greek painter Zeuxis, hoping to depict the legendary beauty of Helen of Troy, sought out the five most beautiful maidens in the city of Croton, and then copied the best parts of each model. In this way he was able to assemble a human form more beautiful than any that existed in nature (remember that in Bellori's theory, the natural world is plagued by imperfection and decay). As a rather outrageous addition to the myth, Bellori further claimed that the famous Trojan War was fought not over the real Helen but the sculpture depicting the idea of her beauty. Seeing the idealized art of the Greeks as an expression of acute selection and synthesis, Bellori believed it was a treasure chest of valuable lessons for the artists of his era. For this reason, he is categorized as a devout Classicist.

Given Bellori's blatant sympathy toward Classical design, it should come as little surprise to find him an avid supporter of artists such as Carracci, whose idealization of form and heavy reliance on Classical imagery pleased him. In Carracci, Bellori saw an artist who exemplified the Classical tradition of synthesizing disparate parts of imperfect ideals (namely the human body as it presents itself to us) to produce a more profound and eternal beauty. The emphasis was to be placed not on direct observation of an imperfect world and its corrupt reflections, but on assimilating parts of this imperfection into a higher conception of the idea. As a result, although the critic was moved by the work of Caravaggio, he saw such painting as of less sophistication and merit. Bellori believed that Caravaggio had erred by taking the natural world as a true reflection of the idea rather than something that was aspiring to real beauty. Caravaggio saw true spirituality (perhaps, he would even claim, the idea) in the images of daily life, and he took great pains to depict these events in even the most religious of pictures. Bellori saw only imperfection and corruption in the dirty feet and tattered clothing of the naturalist painting of the Italian Baroque. To him, it was the artist's duty to reach toward ideals that spoke of God and the eternal, rather than depicting the common and the defective.

■ 5.15 Gianlorenzo Bernini
David 1623–4
Marble
Height 5 ft 6¼ in (1.7 m)
Borghese Gallery, Rome

BERNINI

If Caravaggio and Carracci can be said to have contributed to the arguments between naturalism and classicism that were to preoccupy much of the Baroque age, then perhaps the most successful integration of these ideas came in the work of the sculptor-architect Gianlorenzo Bernini (1598–1680). No other artist during the Baroque era so completely dominated his/her discipline as did this virtuoso, whose sculpted figure

■ 5.16 Donatello
David c. 1430–32
Bronze
Height 5ft 2½ in (1.58 m)
Museo Nazionale del Bargello, Florence

■ 5.17 Michelangelo Buonarroti
David 1501–4
Marble
Height 14 ft 3 in (4.34 m)
Galleria dell'Accademia, Florence

works came to personify the very spirit of the Counter-Reformation.

Born in Naples, from an early age he possessed tremendous technical skill in modeling. His *David* (Fig. **5.15**), of 1623–4, sculpted between the ages of twenty-five and twenty-six, evokes comparisons with the *David*s of Donatello and Michelangelo. Each work encapsulates the ideals and aspirations of its day. The sinuous body and graceful gesture of Donatello's bronze (Fig. **5.16**) speak of the break with the stiffness

and grim determinism of the medieval age. Michelangelo's *David* (Fig. **5.17**) is quintessentially heroic, his gigantic body and sensuous musculature the very idiom of human self-confidence in the High Renaissance. By comparison, Bernini's sculpture, neither complacent nor particularly grand, takes on a combativeness and an offensive posture; here the body appears poised to attack and defeat. This suggested dynamism points directly to the upbeat social and political climate inside Counter-Reformation Rome.

The clarity of vision and directness of the figure in its engagement of surrounding space are reminiscent of the naturalist Caravaggio. One could easily imagine confronting this *David* and feeling the need to duck out of the way of the stones about to come from his sling. This agitation of the area around the figure was in fact very new to sculpture, and its provocative engagement of the space amplified the viewer's relationship to the art. This was the very essence of the Baroque.

Bernini's technical skill is also worthy of consideration, for here we can see the influence of Caravaggio. His captivating use of light and shade through the technique of "undercutting" gave his cold marble figures an emotional vitality on a par with the very best chiaroscuro in painting. And to appreciate fully such an advance in sculpture, it is necessary to consider in greater depth stone carving as it was practised in the seventeenth century.

Stone carvers use relatively simple tools to execute their art. The process is a subtractive one, which means that pieces of material are removed from the original form to produce an end result (clay or wax modeling is thus usually considered an additive process, since one builds up a form). By hammering stone chisels of various shapes and sizes into the quarried stone, the artist can often produce quite astounding representations of other materials. For many centuries and in many cultures, the stone of choice for delicate carving has often been marble, since its cleavage and molecular structure allow for a relatively soft yet stable material capable of withstanding heavy blows. It can also be highly polished, which made marble particularly good for interior work, where there was often a demand for greater finish.

Marble sculpture made a marked resurgence into European art during the Italian Renaissance, having been absent for a number of centuries. Medieval artists had worked predominantly gray limestones, granites, shales, or cement to complement the materials chosen for cathedrals and other buildings. As well, the stone's exposure to severe environmental conditions did not facilitate the use of an expensive material most noted for its polish. This set of circumstances changed dramatically in the Renaissance with the opening up of large interior commissions, which in turn precipitated the reintroduction of fine marble (quarried in great abundance in Italy) on a much greater scale. However, there was as well a decidedly conceptual side to this argument; the historical connotations of marble were

very much in keeping with the popular aspirations of the day. Observing marble as the preferred stone among ancient Greek and Roman stone carvers (the ruins of their work littered the Roman landscape), many sculptors began to emulate not only the images but also the materials of the past, in the hope of evoking a similar sensibility.

Michelangelo likened carving to liberating a figure from its stone captivity. If this was indeed a feeling shared by sculptors of the day, then perhaps it could be said that Bernini's figures leapt from their prisons. The emotional gestures and agitated surfaces give one the impression that the figures are indeed flesh and blood. The drama of the scene is caught entirely by the convincing portrayal of movement, produced by a series of deep cuts into the marble surface that catch and reflect light. These deep spaces of shadow are produced by a technique called "undercutting"—a method of manipulating the descriptive character of light on stone.

Undercutting is a technique of creating deep cuts in stone which produce shadow; the result suggests movement and dynamism, as the surface is transformed by light and shade capable of expressing the most dramatic of gestures (Fig. **5.18**). In Bernini's

■ **5.18 Diagram of undercutting**

A cross-section of a typical sculptured surface which shows undercuts at different places.

A cross-section of a typical sculptured surface which shows how the sculptor avoids creating unwanted shadows by carving surfaces at nearly right angles to allow light to strike both sides of the form.

■ 5.19 Gianlorenzo Bernini, *The Ecstasy of St. Teresa* 1645–52
Marble, height approx. 11 ft 6 in (3.5 m)
Cornaro Chapel, S Maria della Vittoria, Rome

■ 5.20 *The Ecstasy of St. Teresa*, in situ, 1645–52

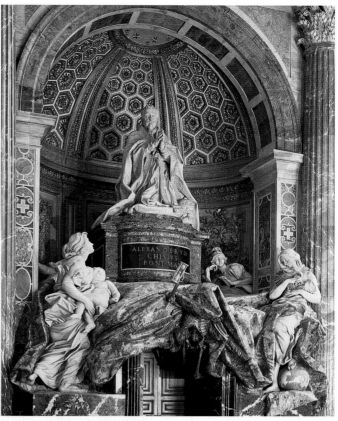

■ 5.21 Gianlorenzo Bernini
The Tomb of Alexander VII 1671–8
Marble and cast bronze
The Vatican, Rome

remarkable *The Ecstasy of St. Teresa* (Figs **5.19** and **5.20**) we are witness to the dramatic potential of such a development. Note how the draperies of the enraptured saint take on the lightness of cloth, and how the scene itself is wrapped within a turmoil of lines created through the inventive use of shadow. Bernini was also well aware of the coloristic possibilities afforded by marble, and used striking variations of the pink, white, green, and black varieties to produce spectacular results. One such example is his execution of the *Tomb of Alexander VII* (Fig. **5.21**) of 1671–8, where traditional white marble figures are juxtaposed against colored marble drapery, striking black pedestals, and the ever-present symbol of Death—the skeleton. This is the Baroque sensibility in all its glory; the newly rediscovered confidence of the reformed Church finding its visual manifestation in what was once a crude block of quarried stone.

Considering Bernini's rather formidable skill in engaging space and working materials, it was perhaps inevitable that he would from time to time embrace architecture as well. The most notable of these excur-

■ 5.22 Gianlorenzo Bernini
The Piazza of St. Peter's begun 1663
Height of facade 147 ft (44.81 m)
Width 374 ft (114 m)

sions was his design for the piazza of St. Peter's in Rome (Fig. **5.22**). The monumental project saw the passing of three popes before its final completion, by which time there had been a total reworking of the ceremonial entrance. Relying on many of the techniques and innovations of Renaissance architects, Bernini nevertheless allowed his engaging sense of novelty to guide him. As a result, the unorthodox combination of Doric and Ionic orders and the dramatic sweep of the colonnade (which psychologically heightens the pilgrim's anticipation of the Church) appear very much in keeping with his quintessentially Baroque sensibility. It is in the artist's decidedly different response to the problem of activating space that we see a departure from previous Renaissance norms. Here, space is arranged for what can be described only as kinesthetic (sensation on a nervous or muscular level) ends; Bernini's deliberate manipulation of the viewers' sense of rhythm and motion as they progress toward the steps of St. Peter's is thus a logical extension of his sculptural strategy—space as a psychological tool. It is this notable departure in the construction of space from the relative stasis of Renaissance models that perhaps epitomizes the rise of a specifically Baroque architecture.

BORROMINI

Though Bernini had virtually no contemporaries to rival his work in sculpture, there were architects who matched his abilities in designing buildings. The most famous of these was Francesco Borromini (1599–1667), whose work may rightly be described as ''Baroque.'' The excessive detailing and intricate patterning of his façade designs show yet another vein of Baroque decoration, and one whose popularity would only increase during the next two centuries. A fine example of this incessant desire for greater complexity is Borromini's façade of San Carlo alle Quattro Fontane (Figs **5.23** and **5.24**), finished in 1667. This structure marks a notable departure from the building conventions that had preoccupied the Renaissance imagination (symmetrical composition, balance, clear quotation from Classical sources). With Borromini, the

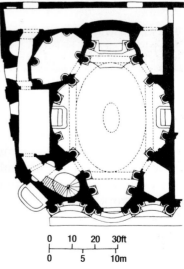

■ 5.23 Francesco Borromini
San Carlo alle Quattro Fontane, Rome
Begun 1638, façade finished 1667
Width of facade 38 ft (11.58 m)

0 10 20 30ft
0 5 10m

■ 5.24 Plan of San Carlo alle
Quattro Fontane, begun 1638

■ 5.25 Francesco Borromini
Detail of Dome from interior of
San Carlo alle Quattro Fontane

undulating surfaces and dramatic play of light and shade within the façade of San Carlo point to an architect with sympathies for issues that appear to have preoccupied Bernini in his sculptural work. In fact, one may even go so far as to claim that Borromini's architectural work has more in common with Bernini's sculptural interests than do Bernini's own architectural designs.

The interior dome of San Carlo (Fig. **5.25**) further confirms Borromini's singular abilities in the designing of dynamic space. The oval form of the dome is a dramatic departure from the typical circular motif; its suggestive compression and the speed of its end curves create an almost uncanny pulsing sensation. And yet despite the compression, the dome remains light—almost floating—due to the architect's inclusion of a row of hidden windows at the base. The interlocking of cross and circle forms, which illusionistically decrease in scale as they rise up from the base, accentuates the otherworldly quality of the design. Though later architects would take further the emotional possibilities afforded by such conventions, few ever achieved the convincing coupling of energy and harmony that is displayed in San Carlo.

▶ THE INFLUENCE OF ROME

● Throughout history, certain venues have fallen in and out of favor as meeting places for artists and artistic ideas; at different points in the history of Western art, Athens, Constantinople, Florence, Paris, and New York have all taken on this role. In the early 1600s, Rome was the cultural focus. The great demand for artists to work on the numerous major commissions centered around the regenerated Church led to many an artist's pilgrimage to Rome. With the possible exception of artists from the Protestant North, most artists spent a part of their formal training in the ancient city. Here, many of them were brought into contact with the works and ideas of both Caravaggio and Carracci, as well as other distinguished artists from outside Italy,

■ 5.26 Artemisia Gentileschi
The Penitent Magdalene 1619–20
Oil on canvas
Pitti Palace, Florence

■ 5.27 Georges de la Tour
Joseph the Carpenter c. 1645
Oil on canvas
58⅛×39¾ in (130×100 cm)
Louvre, Paris

and these encounters inevitably led to artistic debates that were to continue outside the city—particularly in Spain and France—up until the mid-eighteenth century.

If Caravaggio's rigorous naturalism did not always serve him well with his patrons, it did leave an indelible mark on many of the artists of the age. A group of artists, sometimes referred to as the Caravaggisti after their reliance on the pictorial devices of the master, used the technique of strong contrast chiaroscuro with

varying degrees of skill and innovation. One such artist was Artemisia Gentileschi (1597–1652/3), whose *The Penitent Magdalene* (Fig. **5.26**) of *c.* 1620 embraces the dramatic potential of deep chiaroscuro with somewhat more reserve.

Perhaps the most noted practitioner of dramatic light and shade was the French artist Georges de la Tour (1593–1652). The calm that permeates his paintings is an emotional departure from the sometimes violent gestures of Caravaggio, but his use of candlelight is an

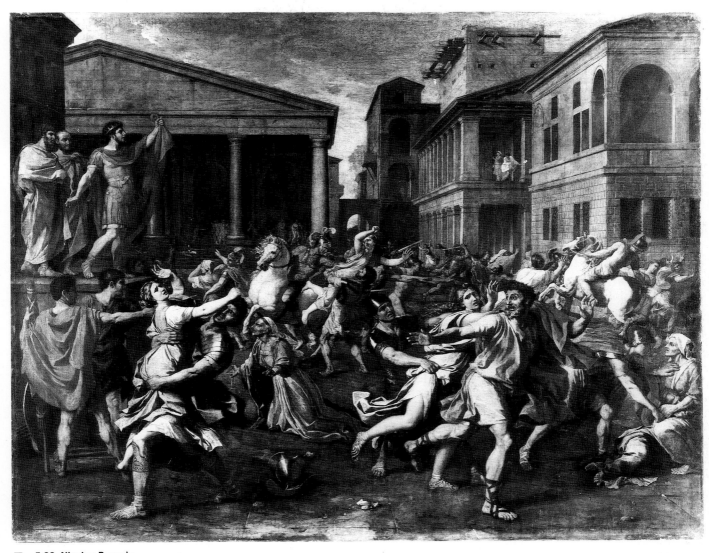

■ 5.28 Nicolas Poussin
Rape of the Sabine Women 1636–7
Oil on canvas
60⅞×82⅝ in (154.4×209.8 cm)
The Metropolitan Museum of Art
Harris Brisbane Dick Fund, 1946

innovative progression from the raking light evident in his predecessor's work. The results are often breathtaking, as his *Joseph the Carpenter* (Fig. **5.27**) of *c.* 1645 attests.

Another French artist greatly influenced by the art of Rome was Nicolas Poussin (1593–1665), who chose a very different path to de la Tour. If de la Tour was a Caravaggisti, then it is clear that Poussin's sympathies lay with Carracci and his Classicism. To Poussin, much of Baroque art was decadent and excessive, and

throughout his life he aspired to a harmony and Classicism even more stringent than Carracci's. The results are illuminating. In his *Rape of the Sabine Women* (Fig. **5.28**), the ancient story of the violent struggle between Roman soldiers and their desperate opponents is captured as a frozen, motionless frieze. The demand for absolute control and clarity may indeed give the painting an air of contrivance, but the splendid rendering of the figures and the complexity of the composition make it at once an engaging image. Note that this work makes

few pretensions toward naturalism; instead it aspires to an image of perfect solidity, control, and restraint —ideas anchored in the belief that art is about timeless ideals. Further, this work acts as a strong critique of the emotionalism of Poussin's contemporaries such as Artemisia Gentileschi and other Caravaggisti, making clear his sympathy for the cool detachment he saw epitomized in the antique.

ART THEORY AND THE REORGANIZATION OF THE FRENCH ACADEMY

Poussin's steadfast order and clarity were not only calling cards of Baroque Classicism; they further came to embody a nation's entire art program. The story of the development of the French Academy and its relationship to the reign of Louis XIV is perhaps one of the clearest examples of the manipulation of artistic enterprise in the name of political expedience. The implicit control of artists and their work by the state calls into question the role of patronage as it pertains to art making, and is thus worthy of some consideration here. At the height of its influence the French Academy had the ability not only to dictate commissions and schooling but also to determine the very concept of art through its teaching of theory. In exposing the reality that even art theory is not immune to the overriding concerns of power and political convenience, the French Academy is an illuminating microcosm of the subtle relationship between art and society.

The death of Cardinal Mazarin, first minister to the young Louis XIV, in 1661 ushered in a dramatic new era in the history of France. By declining to replace Mazarin with another first minister, the king took complete control over the governing of the nation. Astute enough to recognize the limits of his own capabilities, he then appointed Mazarin's assistant, Jean Baptiste Colbert (1619–83), as chief adviser—a post he would hold for some twenty years. Though most noted for his economic reforms and Machiavellian politics, Colbert also managed to change the course of the visual arts in his country for the next half-century. Under his critical eye, the artist in France became yet another cog in the large propaganda machine that helped establish and glorify the rule of the so-called "Sun King."

Colbert fully believed that the arts should follow the goals of national unity and power, serving to propagate these ideas as a state cultural industry. To carry out this program, he appointed the French artist Charles Le Brun (1619–90) to oversee the Academy during its reorganization in the year 1663. Together they dictated the interests of French art, and by way of their distinguished positions were able to direct virtually every important commission. In a country now centrally governed, all money for art programs affiliated with building projects or important portraiture could be given to artists and works in sympathy with the political aims of the king. The result was an era of homogeneity in the field of virtually all French arts (except literature)—and perhaps nowhere so obviously as in the visual arts, where patronage was a necessity for survival.

To establish such steadfast rules for artists, both Le Brun and Colbert recognized the importance of providing training for those who aspired to paint, sculpt, or be architects. The Academy filled this essential role as "bearer of truths," espousing the virtues of correct craft and correct intent. One of the major influences on this theoretical stance was Rationalism, perhaps best known to us through the work of the great French thinker René Descartes. Art, according to the Academy, could be learned through the application of certain rational principles, which could be expressed in words and would thus be intelligible to anyone. What were these principles? These new principles can be summarized as an adherence to certain characteristics of Classical art, such as the reliance on rational processes and systems such as ideal proportion, linear perspective, and deliberate execution. What the Academy rejected was the emotional inclinations and the dramatic postures of the Italian Baroque, and in particular that of Caravaggio and his followers.

There are many ways to justify the emergence of such sympathies on behalf of the Academy. Some historians point to the French disposition for the principles of Rationalism, and their interest in the relationship between art and science. A more telling reason may be Louis XIV's own feeling that such art had an intrinsic relationship with the religious aims of the Counter-Reformation, and thus was not suitable for secular projects such as his palace of Versailles. By the time of Le Brun's appointment to the Academy of St. Luke in Rome in 1675 (pointing to the increasing influence of French art throughout Europe), this agenda had become the accepted orthodoxy of French art.

With respect to some of the finer features of the theory of art taught within the Academy, many of the

ideas were not new. The Academy generated a view of art that was primarily for the mind and not for the eye. Art was to be considered an intellectual pursuit, to be followed and understood by educated people. This position was in keeping with many earlier claims that painting is essentially imitation but is different in that through intelligently choosing subjects from the dis-order of nature, and reorganizing its most beautiful parts (*à la* Bellori), the artist could establish new images of greater understanding and perfection. The Academy warned against an overzealous regard for color, which was of interest to the eye and not the mind. The artist should keep instead to issues such as form and outline, which were constants and could be rationally analyzed.

The order of merit within this system is indeed telling. The noted twentieth-century expert on French Baroque Sir Anthony Blunt described the hierarchy as follows: first, the artists of Classical Greece and Rome; second, Raphael and his followers; third, Poussin; then, at the other end of the scale, were Titian and the Venetian painters (whose interest in color apparently led them to frivolous painting without substance); and finally, the Dutch, whom the Academy considered little more than direct imitators of an unordered and chaotic world—their indiscriminate portrayal of the irrational and the unbeautiful showed, like that of the Venetians, a lack of understanding of the rational principles evident to those of sound intelligence.

What can one learn about art from such an historical situation? Certainly this development illustrates the relationship that necessarily exists between a patron and an artist. In a period such as seventeenth-century France, the granting of lucrative commissions became an expedient way of developing a virtual dictatorship of taste. Art, sustained and somewhat dependent on large commissions, faced compliance with the interests of the Academy or risked falling into disrepute. In this manner, art quickly became assimilated into the power structure of its patron; both its technical aims (form) and its subject matter (content) rightfully became the psychological property of the state. The Classical sen-sibility so adhered to by the Academy was thus as much a political device as it was an esthetic concern, in that it theoretically proposed a form of stability, rationality, and heroic proportion in keeping with the aspirations of those in power. Here, then, the supposedly neutral theories of an art academy take a decidedly political twist, and the work becomes yet another form of cleverly disguised propaganda.

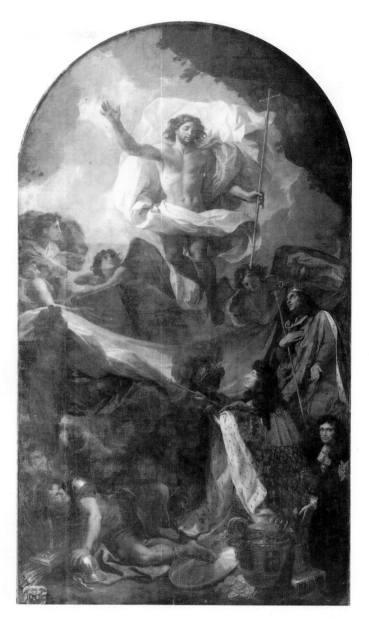

■ 5.29 Charles Le Brun
Louis XIV Adoring the Risen Christ 1674
Oil on canvas
Musée des Beaux-Arts de Lyon

What did such art look like? A wonderful example of the Academy in action is director Le Brun's painting of *Louis XIV Adoring the Risen Christ* (Fig. **5.29**) of 1674. Here the lofty standards of the Academy come to fruition in a technically superb and politically correct rendering of the artist's three masters: Christ, the Sun King, and Colbert (lower right).

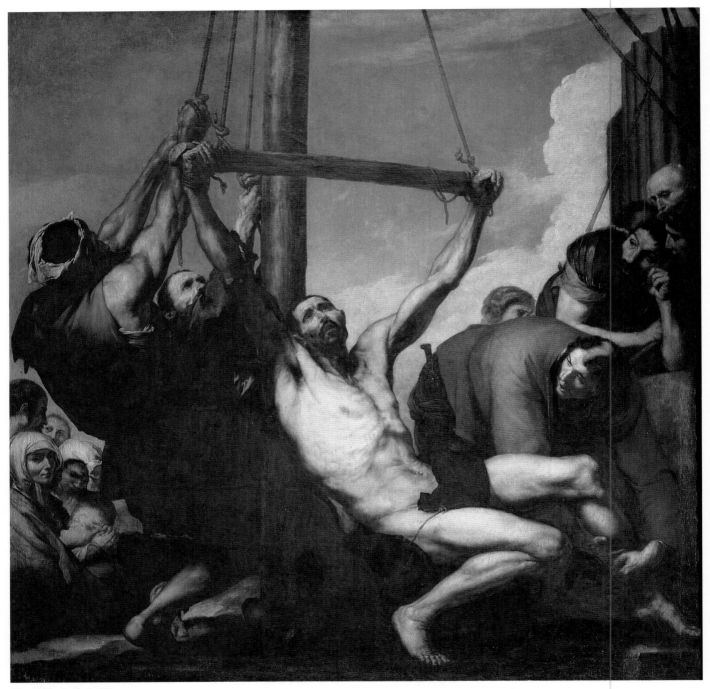

■ 5.30 José de Ribera
The Martyrdom of St. Bartholomew c. 1639
Oil on canvas
6 ft × 6 ft 6 in (1.83×1.98 m)
Prado, Madrid

SPANISH CARAVAGGISTI

Another country deeply influenced by the art of Rome was Spain, which was noted for its Baroque painting. José de Ribera (1591–1652) was yet another in a series of artists interested in the dramatic intensity of Caravaggio's painting, and like him he too painted religious figures in sometimes startling detail (Fig. **5.30**). To this brew of contrasting light and shade, Ribera added his own characteristically Spanish disposition for strong emotion in art, a combination which produced a body of work that parallels the psychological intentions of Caravaggio as closely as that of anyone during the age.

However, the most dominant figure in Spanish art during the height of the Baroque was the more subtle Diego Velázquez (1599–1660), whose scenes of court life provide a strong counter to the brutal naturalism of Ribera. No doubt the artist's eye for detail and his incessant observation of character evolved from Caravaggio, but here the results are very different. One reason for this divergence was Velázquez's singular use of color, a sensitivity derived more from Titian than from any of the popular naturalist painters (who continued to shroud their paintings in dark shadow). In his portrait of *Pope Innocent X* (Fig. **5.31**) of 1650, we witness the results of this happy marriage in the shimmering velvet garment and striking color combinations that fill the picture plane. In Velázquez's portraits, Venetian color finds its rightful place alongside the steady observation of a Caravaggio, producing work uncompromising in its naturalism and subtle in its palette.

■ **5.31 Diego Velázquez**
Pope Innocent X 1650
Oil on canvas
55 × 45¼ in (139.7 × 114.9 cm)
Galleria Doria Pamphill, Rome

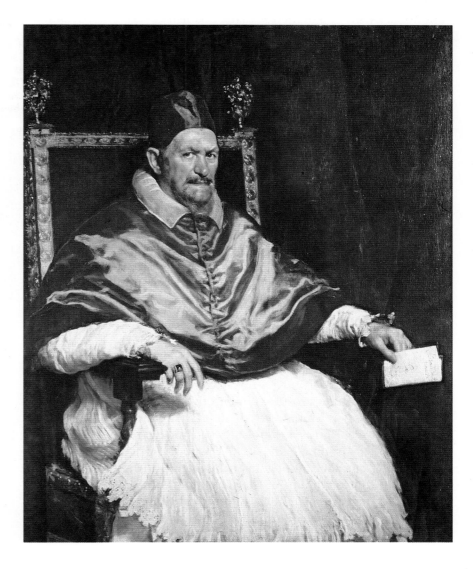

▶ DUTCH AND FLEMISH ART

● While the Counter-Reformation can be said to have provided the impetus for the dynamism of the Italian Baroque, the Reformation was equally influential, changing forever the way people thought about art. The breaking away of the Low Countries (what today is Belgium and the Netherlands) from Spanish control between 1573 and the Peace of Münster in 1648 provided the necessary context for a drastic reorientation of art and patronage, and it created in its wake the foundations of our current art market.

In the sixteenth century, the Low Countries were ruled by the Spanish, who felt justified in tapping into the area's sizable tax base to help finance their overseas conquests. By the end of the 1500s the Spanish government's excessive taxation of areas such as the Netherlands inevitably led to increased tensions. The small piece of lowland country was the site of many industrious ports and was blessed with a practical geographic position, close to Britain, France, Scandinavia, and the Atlantic Ocean. Though relatively small in population, the Dutch had shown themselves to be extremely capable in commerce and seamanship, occupations which afforded them the opportunity to develop an affluent middle class without the bloodshed that is so often a part of economic self-determination.

Another economic phenomenon which contributed to Dutch prosperity was the influence of the marketplace—an idea based upon the free exchange of goods produced by individuals or groups bartered in a forum. Yet economics was not the only bone of contention between the Dutch and Spanish; another was religion. By the late sixteenth century, the Protestant Reformation had reached the northern provinces of the Netherlands in the form of Calvinism.

Earlier in this chapter, the relationship of Protestantism to the concept of iconoclasm was considered. This dynamic was perhaps most extreme in the case of the Calvinists, who had a great deal of popular support in northern Europe. Known for their severity and dogmatism, the Calvinists forbade the use of imagery in places of worship, considering it idolatrous, and further evidence of the corruption of the Catholic Church. A popular preoccupation of Calvinists during the militant sixteenth century was to tear down and burn art from nearby cathedrals, leaving once magnificent interiors whitewashed and spartan. The most famous of these purges was the iconoclastic destruction of 1566, which destroyed a considerable amount of liturgical art in the major Dutch centers (the result of which can be witnessed in a work by Pieter Saenredam [1597–1665], *The Interior of St. Bavo, Haarlem*, Fig. **5.32**, of 1637). Soon thereafter, the Dutch Church collapsed as a reliable source of patronage for the arts, and artists were forced to turn elsewhere to make a living.

The answer lay in the hands of the affluent middle class, who desired small paintings to hang in their homes. Soon artists found themselves developing pictorial strategies in keeping with the demands of their customers, and concentrated on depicting scenes of

■ 5.32 Pieter Saenredam
Interior of the Choir of St. Bavo's, Haarlem 1637
Oil on oak panel
27⅜×21½ in (70.4×54.8 cm)
Copyright Worcester Art Museum, Massachusetts
Charlotte E. W. Buffington Fund

■ 5.33 Gerard Terborch
Boy Removing Fleas from his Dog c. 1658
Oil on canvas
13½×10⅝ in (34.4×27.1 cm)
Alte Pinakothek, Munich

domestic life rather than the immense heroic subjects often familiarly associated with southern Baroque painters (compare a work by Gerard Terborch [1617–81], *Boy Removing Fleas from his Dog*, Fig. **5.33**, of *c.* 1658 with Annibale Carracci's work from the Farnese Gallery, Fig. **5.9**). These circumstances also had a notable effect on subject matter, as grand religious works slowly gave way to more modest still life, landscape, group portrait, and everyday life or "genre" paintings, in keeping with the interests of the clientele. Artists were now content to find art and spirituality in the everyday, rather than relying exclusively on grand mythological themes and biblical stories.

The marketplace provided the perfect setting for the selling of art—paintings in particular. In entering the marketplace, art took on a number of practical features that changed both the criteria and the context of the work. It was a move away from the large-scale commissions of Caravaggio and Carracci toward a more intimate and practical art in keeping with the modest quarters of the purchasers. However, if the marketplace environment was influential in bringing about such dramatic changes, it required the added vehemence of early Calvinism to grant it moral justification.

The political upheaval created by the excessive tax-ing of the Netherlands, and the Spanish government's strong links to the Catholic Church, provided a suitable setting for a revolt between the North, with its dominant middle class and Calvinist religious sympathies, and their faraway landlords. The northern provinces' quest for self-determination led to their secession in 1609 after a truce with Spain. The sub-

sequent collapsing of excise tax in the northern six provinces (Holland being the most prosperous) allowed for a tremendous period of growth in the area, and it is to this period of Dutch art that historians assign the title "Golden Age." After 1609, many Catholics, fearing religious persecution in the North, migrated south into Flemish provinces still held by Spain, and were thus able to practise Catholicism without interference. The

■ 5.34 Peter Paul Rubens
The Descent from the Cross
(central panel) 1611–14
Oil on canvas
13 ft 9⅜ in × 11 ft 9¾ in
(4.2×3.6 m)
Copyright Provincial Government
of Antwerp

subsequent split in the Spanish Netherlands thus falls almost directly along religious and economic lines, and it provides an ideal context from which to study the relationship between art and ideology.

RUBENS AND REMBRANDT PAINT "THE DESCENT FROM THE CROSS"

Flemish artist Peter Paul Rubens (1577–1640) and Dutch artist Rembrandt van Rijn (1606–69) have come to personify the legacy of Baroque art, and in many respects each artist embodies the particular sensibilities of the fractured Spanish Netherlands. Rubens, who distinguished himself as not only an artist but also a diplomat and scholar, is best known for his grand commissions, such as the altarpieces for Antwerp Cathedral and the massive Marie de' Medici cycle (Fig. **5.36**) of 1622–5. Rembrandt, who also enjoyed considerable praise and attention from contemporaries, never traveled and had few close associates. Even their manner of work and choice of subject offer striking comparisons. Only once did the two artists attempt a similar composition, and in their contrast these paintings have come to embody the artistic ideas generated by and through each artist's complex historical situation.

Rubens painted his *The Descent from the Cross* (Fig. **5.34**) between the years 1611 and 1614, shortly after completing a massive and complex commission for another altarpiece, called *The Raising of the Cross*. The thirty-one-year-old artist was called back to his native Antwerp to execute the commission, which forced him to abandon his studies in Rome, where he had already developed a considerable reputation for his capable modeling of forms. Once in Antwerp, he set up, like most artists engaged on large-scale commissions, an atelier (studio with assistants)—an enterprise that would soon see its products shipped to clients across the continent as Rubens's reputation flourished.

Rubens's *The Descent from the Cross* is a vast painting, and its sheer scale and massive figure types give the work a dramatic sense of presence and strength. In this piece, Rubens openly acknowledges his debts to other artists with whom he most certainly came in contact during his time in Italy. The massive figures call to mind the Classical borrowings of Carracci, the sensuous paint handling pays direct reference to Venetian art, and the theatrical light source shows a thorough understanding of chiaroscuro. Yet the allusions go further than simple

■ **5.35 Hagesandros, Athenodoros and Polydorus** *Laocoön and His Two Sons* 1st century AD
Marble
Height 96 in (243.8 cm)
Vatican Museums, Rome

stylistic conventions. The main figure of Christ—gestural and outstretched—is derived from the central figure of the famous *Laocoön* (Fig. **5.35**), only in reverse. Discovered in 1506 and an exquisitely preserved example of antique sculpture, the *Laocoön* was admired by the early seventeenth-century audience as a supreme representation of suffering and pathos in a visual form. Rubens, by directly alluding to famous Greek sculpture, was thus able to further the tragic and heroic nature of the crucifixion—a point that would not be lost to most of his patrons, who had come to know the Classical sculpture through circulated engravings popular during the period. The frieze-like placement of figures on the immediate foreground only serves to reiterate this Classical orientation, and when combined with the striking prototype for his dead Christ, the altarpiece became a champion of Counter-Reformation dogma. This mix of Christian and Classical iconography (complementing contemporary Neo-Platonism) situates Rubens's choice of subject firmly

■ 5.36 Peter Paul Rubens
Triumph of Juliers
from the *Marie de' Medici* cycle c. 1622–25
Oil on canvas
14 ft 11 in × 9 ft 6 in (3.94×2.95 m)
Louvre, Paris

within the new spirit of the Church. Further, when one considers the greater role of the Catholic Church in Flanders as a focus of nationality (the northern provinces being, of course, predominantly Protestant), it is understandable that such activity would become invested with a degree of social and cultural relevance beyond its subject matter.

Like most artists of his era, Rubens did his share of private portraits and smaller commissions, yet his most noteworthy achievements remain in the form of large-scale commissions. One of the most famous of these is the Marie de' Medici cycle (Fig. **5.36**), which contained twenty-one paintings once completed. Painted between the years 1622 and 1625, there is a notable departure from Rubens's previous work into a more graceful, sensuous, and painterly manner. Gone are most of the Classical allusions, and the figure types now resemble the living nude rather than age-old marble. These are not portraits in a conventional sense but represent their subject as dominating a mythological

world of gods, nymphs and obedient peasants. The world of the painting with its complex allegory is arranged according to principles of power and privilege and is thus intensely political, setting out an ideal which the original owner of the painting wished the real world to aspire to. These expansive commissions—difficult to paint and labor-intensive—were within the grasp of only the very rich, who in turn used such images to establish and secure an aura of privilege.

Since his death, Rubens's reputation in art circles has enjoyed the highest of acclaim, as well as meriting the most deliberate of criticism. Today his prestige as the quintessential Baroque painter appears to be in decline. Some speculate that this may have much to do with our more middle-class tastes, which typically embrace art produced within similar circumstances (such as the Dutch Baroque, see pages 250–55). Perhaps Rubens's work embraces a lifestyle and an aura of privilege no longer fashionable, and as a result his work is viewed as decadent (note once again that it is our own set of socially defined values that determines the worth of a piece of art). The most common complaint about his work is also one of its most illuminating features. The figures, which play an increasing role in Rubens's paintings, are often considered unsightly as body types. Today the term "Rubenesque" refers more to a plump and fleshy figure than it does to any other stylistic convention. In one respect, Rubens's refusal to conform to classical female prototypes can be taken as a reassertion of a northern inclination toward naturalism. On the other hand, portraiture of this period clearly indicates that the majority of women did not possess the figurative attributes of Rubens's nudes. Is Rubens, then, viewing his female figure-types as embodiments of sensuality and nature, or do they indeed derive from another source? These are provocative questions, and ones not easily answered, yet they reflect in a great way our appreciation of these figures today. At least one thing is clear, and that is the simple truth that Rubens was unparalleled in his free and unencumbered use of the oil-paint medium. No artist had ever given flesh such an organic reality, and handled complex compositional problems with such apparent ease.

Rembrandt knew of Rubens's *Descent from the Cross* by way of the engraving by Lucas Vorsterman, whose faithful reproduction was widely known throughout Europe. By 1630 the Flemish master had not only established a considerable reputation in his own country but was also revered in the Dutch provinces to the north. The Dutch writer and critic Constanin Huygens considered Rubens "the greatest painter in all the Netherlands" and claimed that his influence was recognizable in the works of many of the artists of the North. Rembrandt was one such artist. Thirty years younger than Rubens, he entered into an art world where the achievements of the Italian Baroque were now fully understood, and its conventions commonplace in most of the European art centers. The tradition of chiaroscuro, carried on by the followers of Caravaggio, was particularly popular in the northern Netherlands at the time of Rembrandt's emergence as an artist. By the 1630s, the city of Utrecht had become known for its community of Caravaggisti—the most prominent artists being Gerrit van Honthorst (1590–1656), Dirck van Baburen (c. 1595–1624), and Hendrick Terbrugghen (1588–1629) (see Fig. **5.37**). In particular, the Utrecht

■ 5.37 Hendrick Terbrugghen
St. Sebastian Attended by St. Irene 1625
Oil on canvas
58¹⁵⁄₁₆ × 46¼ in (149.5 × 120 cm)
Allen Art Museum, Ohio; R. T. Miller, Jr. Fund, 1953, 53.256

■ 5.38 Gerrit van Honthorst
The Merry Company (*The Prodigal Son in the Brothel*) 1620
Oil on canvas
54 × 84 in (137×213 cm)
Uffizi Gallery, Florence

Caravaggisti contributed a specific convention to Dutch painting that was to become essential to the young Rembrandt: the use of the "repoussoir" figure—one or more silhouetted figures situated in the immediate foreground facing away from the viewer; this creates a more convincing sense of space in the middleground area. This convention also gave the work an increased sense of intimacy; the viewer was now an implied bystander to the activities within the painting, behind other deliberately positioned spectators. A good example of this convention can be seen in Honthorst's *The Merry Company* (Fig. **5.38**) of 1620, in which the dark figure on the left side acts as a gauge of space on the foreground plane, projecting an impression that the light source and the other players rest in the middleground. This dramatic device was to find its maturity in the work of Rembrandt, who by 1633 had started to work on a series of Passion pictures for the Prince of Orange.

Viewing the paintings of Rubens and Rembrandt side by side, there appear marked differences between the artists in both stylistic approach and emotional sensibility. Though Rembrandt pays explicit homage to the work of the Flemish painter through his allusion to the Christ gesture, his painting is not only a reworking of the Rubens altarpiece but also a complete transformation of the subject matter. Gone are the Classical heroics of the Rubens work, and in its place we witness a quiet, solemn, and intimate portrayal of the descent of the dead Christ. The extreme musculature of the Jesus

■ **5.39 Rembrandt van Rijn**
The Descent from the Cross c. 1633
Oil on canvas
36¼×27½ in (92×69.2 cm)
Alte Pinakothek, Munich

on the Rubens altarpiece—so much in keeping with the revival of the Church—finds its opposite in the pitiful figure in Rembrandt's *The Descent from the Cross* (Fig. **5.39**). This, like the Christs of Grünewald, is a portrayal of a limp and lifeless corpse, a figure of sacrifice rather than of Classical heroics. The extreme pathos is further intensified by the illumination of the middleground; it situates the scene not in the immediate and confron-

tational foreground (as in Rubens's painting) but to the back, not immediately accessible to the viewer. This scene does not celebrate or confront with large figures and explosive gestures; instead it patiently embraces the spectator. Even the color is subdued, leaving the scene to quiet contemplation rather than imposing itself on the public. This is Rembrandt's private searching made public, and in both its quiet resignation and its

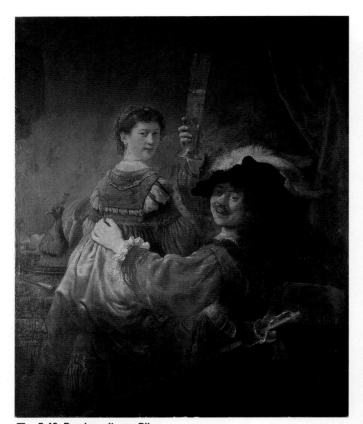

■ 5.40 Rembrandt van Rijn
Self-Portrait with Saskia on his lap c. 1635
Oil on canvas
68⅜×51½ in (101×131 cm)
Gemäldegalerie, Dresden

haunting mood, it anticipates many of his later great paintings.

Rembrandt's level of inquiry is perhaps best felt in his engaging series of self-portraits, executed from the 1620s through to his death in 1669. They are fascinating documents of an artist as both subject and object of contemplation, and in their extreme intimacy, they provide the viewer with singular insights into the dynamic psychological potential of painting. Rembrandt's close and unrelenting observation of the aging process—both in physical and emotional terms—is comparable in its riveting honesty only to the self-portraiture of fellow countryman Vincent Van Gogh over two centuries later. Two examples, taken from very different periods in the painter's life, exhibit this move toward greater introspection. The *Self-Portrait with Saskia on his lap* (Fig. **5.40**) of c. 1635 is one of the truly engaging portraits of the young artist during his

early successes, as Rembrandt poses with his bride Saskia in an uncharacteristic scene of celebration and joviality. Though the smile on the artist's face seems slightly awkward, the scene is one of the all too few examples of Rembrandt's charm as a genre painter (a painter of scenes of everyday life). In comparison, the *Self-Portrait* (Fig. **5.41**) of the late 1650s exhibits a very different sensibility; charm has given way to a more complete and penetrating portrayal of endurance and perseverance in the face of time.

Popular mythology has embraced Rembrandt as a brooding, intense individual—the perfect stereotype of the romantic artist. Little of this has any basis in fact, but his paintings, and indeed paint handling, have often been used to support these claims. Paint handling (the application of paint onto the canvas or panel) was often ignored by period artists who saw any reliance on materials as a distraction from the so-called "higher

■ 5.41 Rembrandt van Rijn
Self-Portrait c. 1659
Oil on canvas
33¼×26 in (84.4×66 cm)
National Gallery of Art, Washington, D.C.

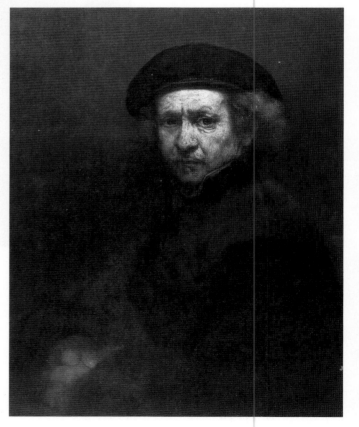

■ 5.42 Rembrandt van Rijn
Side of Beef 1655
Oil on canvas
37×27⅛ in (94×69 cm)
Louvre, Paris

■ 5.43 Detail of *Side of Beef* showing the
build up of paint

principles'' of composition and rendering. In Rem-
brandt's work, the method of applying material is
inseparable from the subject matter—and thus the
meaning of the painting. The famous *Side of Beef* (Fig.
5.42) of 1655 is an excellent example of Rembrandt's
skill in integrating the paint into the very subject of the
work; the often thick and textured paint makes
demands on the viewer's attention. One possible
explanation for Rembrandt's desire to put such
amounts of paint on his canvas is perhaps the way it
molds and models the carcass; the paint then becomes a
metaphor for meat, and its sinewy application reaffirms

the texture and structure of the animal. Whatever the
initial reasons may have been for constructing this
painting in such a manner, the use of the paint never-
theless gives the viewer an intimate chance to retrace
the work process of the artist. When paint is applied in
such a way, the gestures of the brush or knife are often
very visible. By examining such traces, one is then
equally conscious of both the work process and its
eventual result (Fig. **5.43**). In many areas of the paint-
ing, we as viewers are privy to Rembrandt's gestures
with the brush, and through them come to a further
appreciation of the artist's relationship to the work.

REMBRANDT AND THE ART OF ETCHING

Though Rembrandt is best known as a painter, he was also an extremely accomplished etcher, with a lively and lucid line quality that culminated in a series of moving and intimate prints. His etchings are perhaps unparalleled in their marriage of technical skill and emotional insight, and are interesting both for their inventiveness and their sheer visual energy. It is true that the use of etching as a technical process did not begin with Rembrandt, but in his adept hands it arguably found its greatest expression.

Etching (which comes from either the old High German word *"azzen"* or the Dutch word *"etsen,"* both meaning to bite, hence to eat) was first practically applied to printmaking in the early sixteenth century, when techniques borrowed from armor decorators enabled artists such as Dürer to begin producing a new type of printed image. As a technique, etching involves many of the same principles as engraving, such as the wiping of the plate, the embedding of ink below the surface of the metal, and the printing of the image in a press. However, with etching the artist engages in a further chemical process that alleviates many of the frustrating difficulties inherent in engraving.

The process initially began by covering an iron plate with a thin layer of melted wax which served as a resist, keeping the plate surface protected from its later immersion in an acid bath. Having prepared the plate, the artist would lightly scratch into the soft wax surface, removing its thin skin and exposing the metal base. The plate was then soaked in a bath of diluted acid, which reacted to the exposed iron and created a trough—the longer the plate's exposure to the acid, the deeper the "bite." The final step in this process was the removal of the resist (the wax skin), leaving behind an "etched" design on the metal surface. At this point, the plate would be inked and fed into the press like an engraving (see Fig. **5.44**).

A key player in the development of etching was the French artist Jacques Callot (1592/3–1635). Most noted for his strikingly impartial depictions of the atrocities of war, he was also a master craftsperson who extended the then restrictive boundaries of etching through the use of some inventive new techniques. One of his first important works is *The Great Fair at Imprunita* (Fig. **5.45**), in which he carefully depicted over 1,100 figures (yes, someone has actually counted them) in a neatly constructed composition. In develop-

A cross-section of a plate which shows all surfaces coated with an acid-resistant resin.

The coating is then scratched with a steel burin to form the lines of the design.

The plate is then immersed in acid and the scratched lines (unprotected by the resin) become etched into the metal surface.

The resin coating is then removed and the plate is wiped with ink. This ink fills the lines of the design and these lines are forced from the plate onto paper under pressure in a printing press.

■ 5.44 Diagram of a contemporary etching plate process

ing such a scene, Callot introduced two innovative technical devices to the etching process: a change of ground to resist the acid and a new scratching tool. Frustrated, like his predecessors, by the traditional wax ground that gave an uneven bite and was too soft to allow for detailed work, the artist substituted a harder varnish (then used in the making of musical instruments) in its place. This change of material allowed artists to generate a more subtle line quality, and an easier reproduction of the intended image. When this innovation was combined with the introduction of the "echoppe" (a cylindrical drawing tool with one end cut to produce a rounded point like an engraving tool), the result was a freer and more workable medium, capable of both tremendous accuracy and spontaneity.

With these technical innovations already in place by Rembrandt's birth, the Dutch artist was able to manipulate and develop further the young medium—in his hands, etching was more than a tech-

■ 5.45 Jacques Callot
The Great Fair at Imprunita 1620
Intaglio
16¹⁵⁄₁₆×26¼ in (43×66.7 cm)
The Metropolitan Museum of Art
Harris Brisbane Dick Fund, 1917 (17.3.2645)

▶ 5.46 Rembrandt van Rijn
Self-Portrait by Candlelight 1630
Etching
Staatliches Museum, Berlin

nique for reproducing images; it was a valid basis and starting point for the making of art. The result is nothing short of breathtaking. Introduced to the various printmaking processes while still in his twenties, Rembrandt took to etching immediately. The quality of line afforded by the acid-biting technique enabled the young Rembrandt to produce a wide assortment of expressive marks, using such varied instruments as nails and spikes to make drawings in the resist. His earliest attempts (such as his *Self-Portrait by Candlelight*, Fig. **5.46**) already exhibit the strength and emotional vibrance of an artist set on expanding the boundaries of etching.

■ 5.47 Rembrandt van Rijn, *Christ Presented to the People* 1655, etching (first state)
The Metropolitan Museum of Art, Gift of Felix M. Warburg and His Family, 1941 (41.1.34)

By the time Rembrandt reached Amsterdam in 1631, he had begun experimenting with "state prints" and "selective wiping," both of which grant the viewer privileged access to the artist's work process. The term state print refers to the initial printing and subsequent changing of an etched plate—a process which demonstrates the movement of an artist's idea over a period of time. By printing the plate at different times in the working out of a pictorial problem, the artist has the opportunity better to consider a decision without the inevitable loss of the original image. A clear example of Rembrandt's use of the state print can be seen in his *Christ Presented to the People* of 1655. The first state of this print (Fig. **5.47**) depicts the silent Christ as he is brought before the people of Jerusalem. Below him are gathered the vengeful crowds, who stand to judge him. Though we appreciate the skill of the drawing and the lightness of touch present in the artist's portrayal of

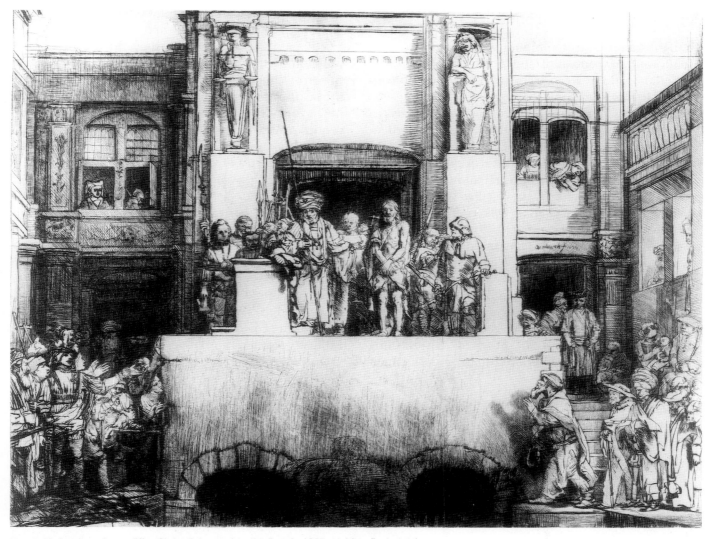

■ 5.48 Rembrandt van Rijn, *Christ Presented to the People* 1655, etching (last state)
Reproduced by Courtesy of the Trustees of the British Museum, London

these figures, Rembrandt obviously felt them a distraction to the viewer. In attempting to clarify the composition and complement the subject matter, the artist removed the centralized crowd, opting instead for the deep cavernous hollow that better focuses attention on the Christ figure. By scraping back into the copper plate (which had by this time replaced iron) and slowly burnishing down the etched lines, Rembrandt was able to remove almost all trace of those original figures—leaving only "ghosts" as a reminder of their presence (Fig. **5.48**). By executing the print in this manner, the viewer is granted intimate access to the private world of a great artist at work.

When the final state was ready to print, Rembrandt would then manipulate the ink spread on the plate, allowing for an uneven wiping of the surface to give each printed image a particular character of its own. The result was a sometimes hazy clouding of the image, in keeping with the artist's use of chiaroscuro.

Rembrandt's prints are among the great treasures of the period, and today they still attract attention as works of consummate skill and feeling. In assimilating the technical innovations of his time and combining it with the insights and vision of a great artist, Rembrandt produced printed works for which there is little comparison. And though we may think of him as a great painter, his skills as a printmaker are equally admirable and revolutionary.

PORTRAITURE AND OTHER GENRES

Though Rubens and Rembrandt were by far the most prolific and esteemed of the artists of the divided Netherlands, there were others of note who also contributed to this so-called "Golden Age" of painting. One of the most famous of these was Frans Hals (c. 1581–1666), whose vibrant brushwork was particularly revered by nineteenth-century artists.

Hals was a portrait artist, and his work runs the social gamut, from images of the unusual and the downcast, to vast group portraits of the well-to-do. One such portrait was *The Banquet of the Officers of the St. George Militia Company of Haarlem* (Fig. **5.49**) of 1616, a men's social club cleverly disguised as a militia brigade. Hals's talent at organizing space and creating ambience and sparkling color are very much in evidence in this work—qualities in considerable demand during the period. Perhaps a more dramatic example of his enormous skill as a painter can be seen in his so-called *Laughing Cavalier* (Fig. **5.50**) of 1624. His slashing strokes that seem to suggest rather than model comple-

ment the dramatic contrasts of color and tone in his painting. The result is a body of works that embrace the act of painting as much as they do the descriptive function of the portrait. With Hals one may rightly use the term "impression-like," because his work glorifies the beauty of the passing moment and the charm of the little event—the very pictorial qualities the nineteenth-century Impressionists would embrace.

On the other side of the Flemish–Dutch border emerged an artist of very different sensibilities, portrait painter Anthony Van Dyck (1599–1641), who worked with a clientele slightly more inclined to the grand commissioned portraiture of old than the seemingly spontaneous outpourings of Hals. Implicit within this assumption (that a particular style or manifestation of painting can correspond with the needs or aspirations of a given class or clientele) is the idea that art carries a series of subtle value considerations often left unacknowledged. At least in this respect, Hals and Van Dyck each provide a fascinating looking glass into the explicitly social nature of portraiture.

One of Van Dyck's most interesting works is the 1635

■ 5.49 Frans Hals, *The Banquet of the Officers of the St. George Militia Company of Haarlem* 1616
Oil on canvas, 68⅞×137½ in (175.5×350.5 cm)
Frans HalsMuseum, Haarlem

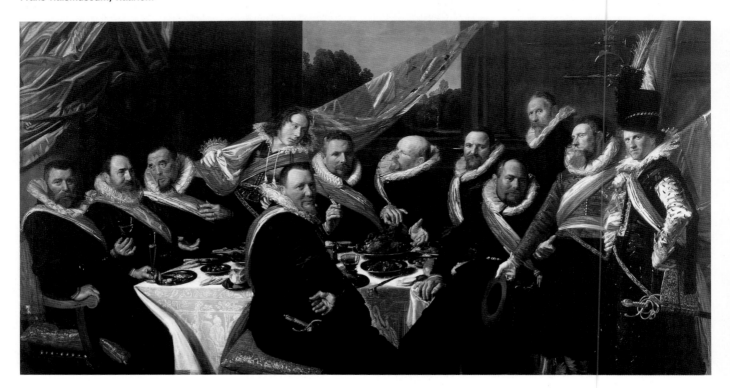

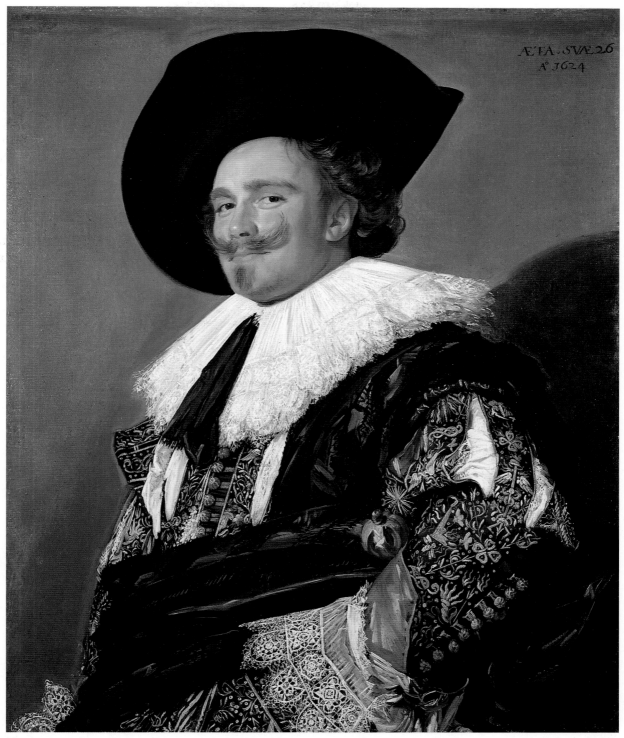

■ 5.50 Frans Hals
The Laughing Cavalier 1624
Oil on canvas
33¾×27 in (86×69 cm)
Reproduced by permission of the Trustees, The Wallace Collection,
London

portrait of *Charles I of England* (Fig. **5.51**). Van Dyck's ability to imbue grace and esteem on the personality of his sitter is truly remarkable. Unlike his master Rubens (in whose studio he had briefly worked during the years 1618–20), Van Dyck situates his figure not in some grand allegorical composition but in a moment of quiet pleasure, as befitting his stature as ruler over the landscape he surveys. Whereas Hals's excited brushwork created a slightly shifting and dynamic image,

Van Dyck's refined and delicate manner only heightens the already present aura of dignity and infallibility. Here, the relationships between material handling, composition, and subject matter combine to produce a package suitable for the social and political needs of the sitter. Thus Van Dyck's paintings, like those of his contemporaries Rubens, Rembrandt, and Hals, enter into the larger context of issues and class distinctions that were already beginning to surface—finding their

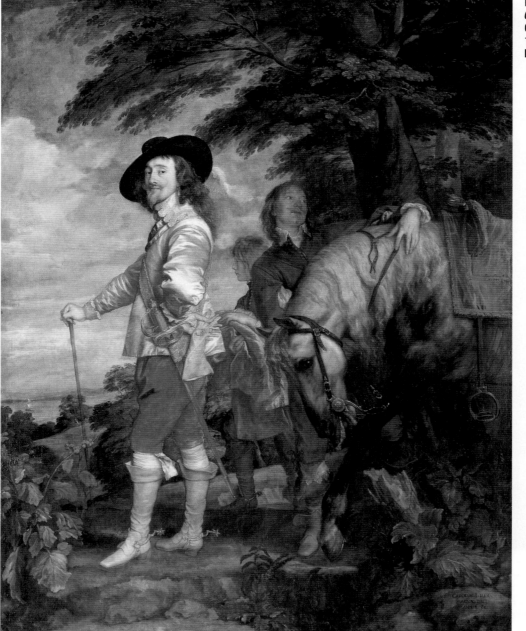

■ **5.51** Anthony van Dyck
Charles I of England 1635
Oil on canvas
104¾×81½ in (266×207 cm)
Louvre, Paris

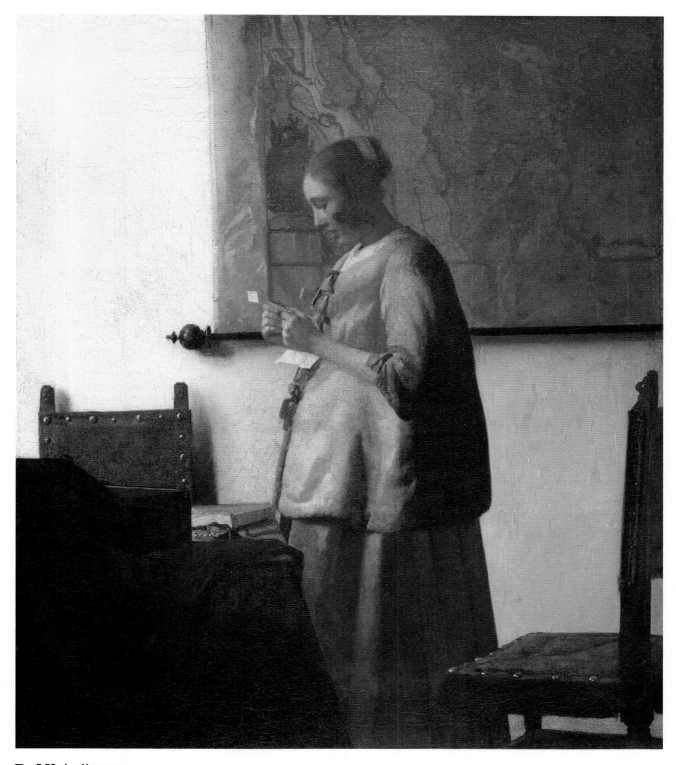

■ 5.52 Jan Vermeer
Interior with a Woman Reading a Letter c. 1662–64
Oil on canvas
18⅓×15⅓ in (46.5×39 cm)
Rijksmuseum, Amsterdam

culmination in the bloodbaths of the eighteenth century's revolutions. Van Dyck's creation of an imagery of royalty and dignity operates as effective propaganda. However, such dignity, maintained by the portrait, was insufficient to prevent Charles's execution in 1649 during the English Civil War. So in the end, Van Dyck perhaps did more for his sitters than the history books could, presenting them as civil and dignified human beings at a moment in time.

Today, one of the most popular of the Dutch Baroque painters is Johannes (Jan) Vermeer (1632–75), whose reputation was saved from obscurity in the nineteenth century after almost 200 years of neglect. Few artists have captured the quiet moments of domestic tranquillity better than he, and his meticulous rendering of the effects of the cold northern light of morning is utterly convincing. Vermeer turned his attention predominantly to "genre" scenes—concentrating on everyday activities rather than formal portraiture. Since these scenes were not person specific, they appealed to a number of prospective buyers—in keeping with the strictures of the market, in which the Dutch artist had to compete. His *Interior with a Woman Reading a Letter* (Fig. **5.52**) of *c.* 1662–4 is one such intimate portrayal. The cool colors of the scene—a variety of muted blues and yellows—are somewhat typical in Vermeer's work. Behind the woman there hangs a large map—a reminder of the might and prestige of the Dutch merchant fleet—which acts both as a development of subject matter (perhaps she is reading a letter from a loved one far away) and as a deliberate use of geometric form to strengthen the composition. Some 250 years later, another Dutch artist, Piet Mondrian (1872–1944), was to cite Vermeer as an influence in his development of geometric abstraction.

Little is known about Vermeer's life, and from the very small body of work that survives it appears that he was not particularly prolific. Yet these scenes of domestic, middle-class living have endeared him to today's public, who perhaps see in these quiet works a kind of solitude and tranquillity from the pressures and turmoils that engulf our contemporary society. Vermeer's paintings have been successfully assimilated into the tastes of the late twentieth century, and in that way they too document some of the thoughts and aspirations of our own age. Fifty years ago, Rubens was the most prized and respected of the Baroque artists, yet today many find him excessive. And though it is probable that Vermeer's reputation will decline over

■ 5.53 Rachel Ruysch
Flowers in a Vase 1698
Canvas
23×17½ in (58.5×44.5 cm)
Städelsches Institut, Frankfurt

the next decades, the necessary re-evaluation of his work in the late nineteenth century has left our world a little more at peace with itself.

The Dutch art community distinguished itself in a vast array of subjects. There were flower painters such as Willeboirts Bosschaert, Jan de Heem (1606–83/4) and Rachel Ruysch (1664–1750) (see Fig. **5.53**), still-life artists such as Willem Heda (1594–1860) and Pieter Claesz (1597/8–1661), landscape painters such as Aelbert Cuyp (1620–91) and Jacob van Ruisdael (*c.* 1628–82) (see Fig. **5.54**) and even those who specialized in farm animal paintings such as Paulus Potter (1625–54). This subject specialization was to become very popular with artists over the next generations, as developing a sound reputation in one area of expertise was essential to their survival in a competitive marketplace (mimicking the specialization of labor going on in all sectors of society). Few were to venture into such

■ 5.54 Jacob van Ruisdael
View of Haarlem from the Dunes at Overveen c. 1670
Oil on canvas
22×25 in (55.8×63.5 cm)
Mauritshuis, The Hague

dramatically different avenues as Rembrandt, but then again, few had his great skills. Yet this short era in the history of Western art (approximately 1600–1680) produced some of its greatest paintings, cultivated in an economic and political climate very different from that of the previous era. The Dutch "experiment" is one of the great examples of the interplay between social and economic realities, and the culture that derives from its body. In its breadth and foresight, the Dutch Baroque set the stage for the modern idea of art.

▶ THE DECLINE OF THE BAROQUE

● In 1689 Dutch Stadholder William III of Orange married Mary Stuart, thus becoming King of England. This political shift came at the end of the so-called Golden Age of the Dutch. The exhaustion of the Dutch economy caused by years of warfare against Louis XIV's French armies coincided with a more general retreat from the aggressive expansion of trade and commerce which had marked the Golden Age. Competition from England, France and the Baltic states challenged Dutch supremacy on the seas, and more conservative schemes came to replace the lively speculative investment which had been a feature of the Amsterdam financial world. Stylistic innovation in the arts also slowed with the stagnation of the economy, signalling the end of the

Golden Age of Dutch painting.

A decline of energy which marked the end of the Baroque era affected the arts as well as the political aspirations of the dominant groups in each European nation. The period is characterized by contradiction rather than unity; Reformation versus Counter-Reformation, aristocratic patronage versus the bourgeois marketplace, and the grand-scale decorative program versus the bawdy genre scene (Fig. **5.55**). Yet the sheer output and energy of this period remain one of the most decisive and unifying characteristics of the seventeenth century.

Louis XIV, the Sun King, built his great palace of Versailles in 1661. This was to be the clearest expres-

■ 5.55 Jan Steen
The Dissolute Household
c. 1660–1670
Oil on canvas
30×32¼ in (76×82 cm)
Victoria and Albert
Museum, London

sion of the Baroque age in its scale, grandeur, and excess. It was also to be the ultimate symbol of power befitting the stature of its owner. On his deathbed, he left his son, Louis XV, with a prophetic indictment of both the excesses of his patronage and the art it pro- duced. It is perhaps fitting that we should end this chapter and open the next with his chilling words: "My child, do not imitate me in my taste for building; it spells the ruin of the people."

▶ SUMMARY

● There are few periods in the history of Western art to compare with the Baroque for vitality and sheer output. A century and a half of political and religious turmoil had a profound effect on the larger community's view of the role of art in society, and helped set the stage for our modern conceptions of the art market and the autonomous creator. With the significant shift in patronage that began to occur during the period, art, which once reflected almost exclusively the desires of the Church, now began to cater for a more broadly based market. In this way, the art of the Baroque was to set an early but important precedent for the slow release of culture into the growing middle class.

Glossary

Baroque (*page 206*) A term used to identify the period in Western art from 1600 to 1750. Its linguistic origins indicate something complex, intricate or irregular, and it most likely refers to the increase in emotional content and exuberant composition over the restraint of the Renaissance.

chiaroscuro (*page 216*) From the Italian "light and shade," it is a technique for suggesting three dimensions by modeling figures in highlight and shadow.

etching (*page 246*) Derived from the Old High German word "*azzen*" or the Dutch "*etsen*,' to eat, it is a printmaking process which involves the drawing of lines into a resist already painted on a metal plate. Drawing removes the resist, exposing the metal, which is then submerged in acid (called "biting"). The exposed metal is then eaten into, leaving a series of lines "etched" in the metal. When the plate is inked printing will faithfully reproduce the original lines.

naturalism (*page 215*) Art which draws from the world as it exists in perception, without idealization (often opposed to the precepts of Classicism, which forms ideals from natural phenomena).

repoussoir figure (*page 242*) An object or figure placed in the immediate foreground of a composition whose purpose is to direct the viewer's eye into the picture.

Suggested Reading

The Pelican History of Art Series offers some of its finest selections of survey art history in the area of Baroque studies, written by some of the most important scholars in the field. J. Rosenberg, S. Slive and E. H. ter Kuile's *Dutch Art and Architecture 1600–1800*, Anthony Blunt's *Art and Architecture in France 1500–1700*, and Wittkower's *Art and Architecture in Italy 1600–1750* (all Harmondsworth and New York: Penguin Books) are highly recommended. If you are interested in reading original documents from the era, including artists' statements and critical writings, R. Enggass and J. Brown, *Italy and Spain 1600–1750: Sources and Documents* (Englewood Cliffs, NJ: Prentice-Hall, 1970) is a good source. For more information on technical aspects of the Baroque, such as stone carving, try J. C. Rich, *The Materials and Methods of Sculpture* (New York: Oxford University Press, 1947; reprinted New York, Dover Books, 1975). For information on etching or engraving see A. Hyatt Mayor, *Prints and People* (Princeton: Princeton University Press, 1971) and D. Saff and D. Sacilotto, *Printmaking: History and Process* (New York: Holt, Rinehart and Winston, 1978)—both are informative and well written.

REASON AND REVOLUTION

Eighteenth- and Early
Nineteenth-Century
Art in Europe

■ 6.1 Jacques Louis David
The Oath of the Tennis Court (June 20, 1789)
Museum Carnavalet, Paris

With terrors round, can reason hold her throne,
Despise the known, nor tremble at the unknown?
Survey both worlds, intrepid and desire,
In spite of witches, devils, dreams and fire.

ALEXANDER POPE

"My child, do not imitate me in my taste for building; it spells the ruin of the people." With those prophetic words, the dying King Louis XIV of France ushered in an age of doubt and conflict that would signal the slow but steady demise of the Baroque era. He was talking, of course, about the Palace of Versailles (Fig. **6.2**), that example of aristocratic indulgence and deified power that was to preoccupy the French imagination during its sixteen years of construction and subsequent decades of debt. At its height, Versailles housed almost 4,000 servants and encompassed thousands of acres of carefully groomed "nature." Today it stands as one of the most exquisite examples of Baroque sensibility in architectural form, and in retrospect perhaps the most inane. And though the bloodbath we have come to call the French Revolution was still a long century away, the image and aura of Versailles planted a symbolic seed in the hearts of the masses—revolution.

■ 6.2 Louis le Vau and Jules Hardouin-Mansart
Palace of Versailles 1669–85
Garden Façade

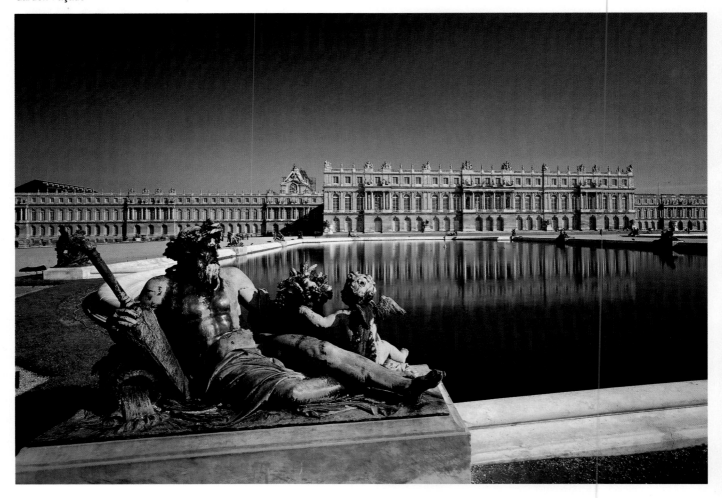

▶ VERSAILLES AND THE DECLINE OF BAROQUE

● As a building, Versailles (built 1669–85) is quintessentially Baroque, with a fittingly French accent. As exteriors go, the palace stands as a monument to the lasting virtues of symmetry, order, and restraint—the very principles Louis XIV admired in artists such as Poussin, on whom he was to model his French Academy. The façade extends for almost half a mile and the dominant horizontality of the design is interrupted only by the inclusion of several small pavilions arti-culated with standing columns that jut out slightly from the face of the structure. It is in essence a monument to Classical design. However, on the inside, opulence reigned (see Fig. **6.3**). The analogy to a body is both fitting and appropriate here, and it says much about the subsequent decline of the Baroque era in Europe. By the middle of the seventeenth century, the initial inroads of the Counter-Reformation spirit (in which art was certainly an influential player) had begun to level

■ **6.3** Jules Hardouin-Mansart and Charles le Brun
The Hall of Mirrors
Interior of Palace of Versailles, begun 1678

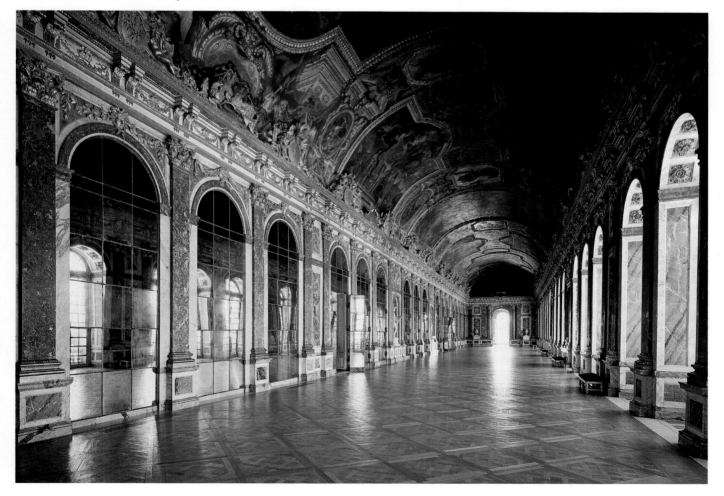

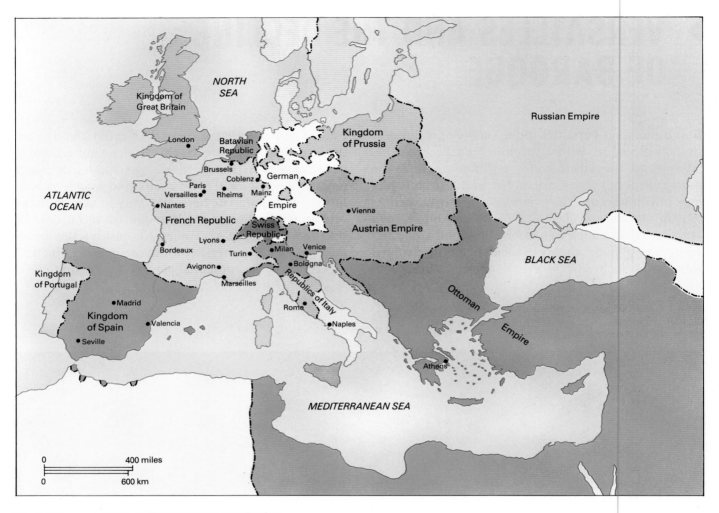

NORTH SEA

Kingdom of Great Britain

London

Batavian Republic

Brussels

Coblenz

Paris

Versailles

Rheims

Mainz

German

Nantes

Empire

French Republic

ATLANTIC OCEAN

Swiss Republic

Lyons

Bordeaux

Turin

Milan

Venice

Avignon

Bologna

Marseilles

Republics of Italy

Kingdom of Portugal

Madrid

Rome

Kingdom of Spain

Valencia

Naples

Seville

Kingdom of Prussia

Russian Empire

Vienna

Austrian Empire

BLACK SEA

Ottoman

Empire

Athens

MEDITERRANEAN SEA

0 400 miles
0 600 km

■ 6.4 Europe c. 1800 showing Kingdoms and Empires

out, and as a result art production turned increasingly away from the patronage of the Church. The demise of the Church's moral authority in an increasingly rational world coincided with the rise, and subsequent wealth and autonomy, of the European nation states and their colonies. By the end of the seventeenth century, authority rested not in the will of God but with the might of armies and the whims of royalty. And though the world might not have looked different, power now rested in more pragmatic hands.

In our discussion of ancient Egyptian art, we saw how monuments existed as visual demonstrations of the status quo. This concept doesn't take much explanation. In order to produce a monument, one requires funding, land, and laborers. So, the people in a position to acquire all of these can, and often do,

produce visual objects and images that reflect their interests (if you need proof of this, consider the absence of monuments to people of color and women throughout the history of American art). The larger the project, the greater the funding, and thus many of the most elaborate structures in history are reflections of the interests and ideas of those in positions of power. Cathedrals work in a similar way and with similar psychological intent. But religious buildings have had the added benefit of a supposedly moral underpinning, which effectively diverts criticism away from the less savory issues of excess and onto the questionable moral character of the critic. In nation states, such forms of criticism were often considered treasonous—affronts to the authority of those in power. It was within this context that one individual began to examine the tricky

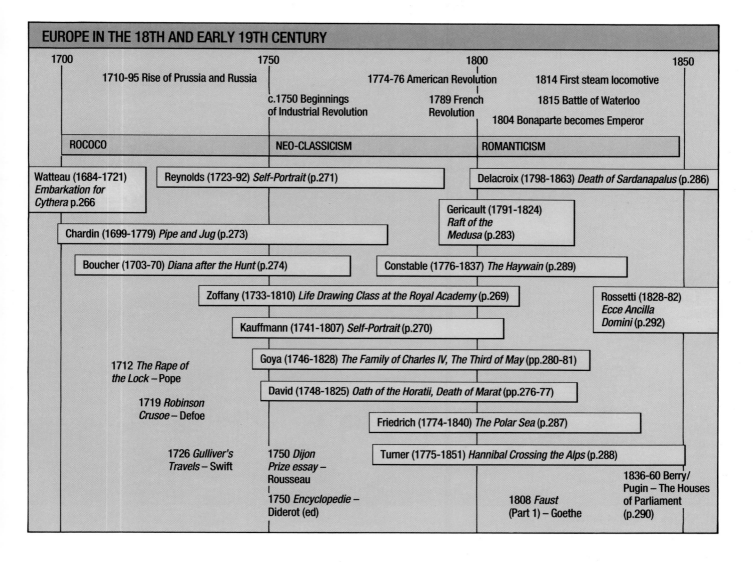

EUROPE IN THE 18TH AND EARLY 19TH CENTURY

1700	1750	1800	1850

1710-95 Rise of Prussia and Russia

1774-76 American Revolution

1814 First steam locomotive

c.1750 Beginnings of Industrial Revolution

1789 French Revolution

1815 Battle of Waterloo

1804 Bonaparte becomes Emperor

ROCOCO NEO-CLASSICISM ROMANTICISM

Watteau (1684-1721) *Embarkation for Cythera* p.266

Reynolds (1723-92) *Self-Portrait* (p.271)

Delacroix (1798-1863) *Death of Sardanapalus* (p.286)

Gericault (1791-1824) *Raft of the Medusa* (p.283)

Chardin (1699-1779) *Pipe and Jug* (p.273)

Boucher (1703-70) *Diana after the Hunt* (p.274)

Constable (1776-1837) *The Haywain* (p.289)

Zoffany (1733-1810) *Life Drawing Class at the Royal Academy* (p.269)

Rossetti (1828-82) *Ecce Ancilla Domini* (p.292)

Kauffmann (1741-1807) *Self-Portrait* (p.270)

1712 *The Rape of the Lock* – Pope

Goya (1746-1828) *The Family of Charles IV, The Third of May* (pp.280-81)

David (1748-1825) *Oath of the Horatii, Death of Marat* (pp.276-77)

1719 *Robinson Crusoe* – Defoe

Friedrich (1774-1840) *The Polar Sea* (p.287)

1726 *Gulliver's Travels* – Swift

1750 *Dijon Prize essay* – Rousseau

Turner (1775-1851) *Hannibal Crossing the Alps* (p.288)

1836-60 Berry/Pugin – The Houses of Parliament (p.290)

1750 *Encyclopedie* – Diderot (ed)

1808 *Faust* (Part 1) – Goethe

relationship between art and power—a course that would set important precedents for later art criticism. His name was Jean-Jacques Rousseau, and his target was Versailles.

ROUSSEAU

Rousseau (1712–78) is best known for his idea of the "noble savage"—an individual living free of the corrupting influences of society and education. This ideal follows the premise that individuals are by nature good and it is social constructs that inevitably corrupt. Living as he did in a country where virtually every aspect of "high" culture was overseen by the crown, Rousseau understood implicitly the need of the aristocracy to maintain a cultural status quo (consider the discussion

in the previous chapter on the intentions of the French court in the reorganization of the French Academy in 1663). Rousseau saw this arrangement as a microcosm of the world's problems; the dominating influence of sanctioned culture further alienated individuals, replacing "natural" feelings with "correct" feelings, given to the people by those in power. In 1750 Rousseau gave substance to these thoughts in an essay on Versailles which remains one of the most insightful readings of the structure ever written.

Rousseau's use of the "forbidden" topic of Versailles (the government censors were understandably uneasy with any critical discussion on the subject), and in particular the gardens (Fig. **6.5**), is an indictment not only of aristocratic power but also of the human desire to ever increasingly control the world. Rousseau

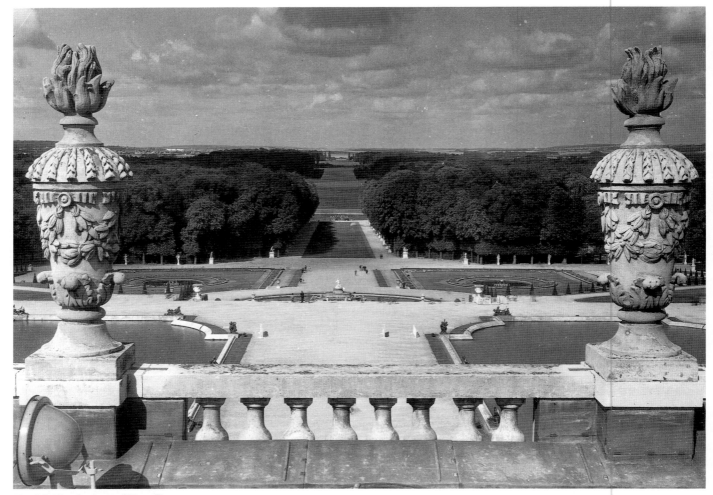

■ 6.5 The Gardens of Versailles
planned 1661–68, executed 1662–90

understood the connection between the control of nature and the control of individuals, and set about within the context of the Versailles gardens to draw on such parallels (see Fig. **6.6**). In his Dijon Prize essay of 1750, he wrote:

> *A stroll through the gardens of Versailles represents a direct challenge to man's impulse toward virtue and an invitation to join in collective corruption. . . A society which can ordain such a travesty of nature must by definition be corrupt. Our gardens are adorned by statues and our galleries by paintings. What would you expect to be shown from these masterpieces of art, exposed to the admiration of the masses? Great men who have defended their country or those still greater who have enriched it with virtue? No, these are all images of the aberrations of the heart and mind, carefully selected from mythology in order to have models of misconduct . . . this is the work of the arts that secretly exert their influence in the governmental chambers.*

What is one to make of such a tirade? It appears that Rousseau understood art as both a tool of corruption and an unconscious representation of the larger corruptions of the age. This is indeed an insightful interpretation, as art is viewed in this critical model as both manipulating and manipulated. Yet consider a more positive extension of such a theory. If, as Rousseau claims, art has the capacity to corrupt, then it must by extension have the ability to inspire, and it was this very dynamic that was to perplex and captivate both artists and critics for the next 200 years.

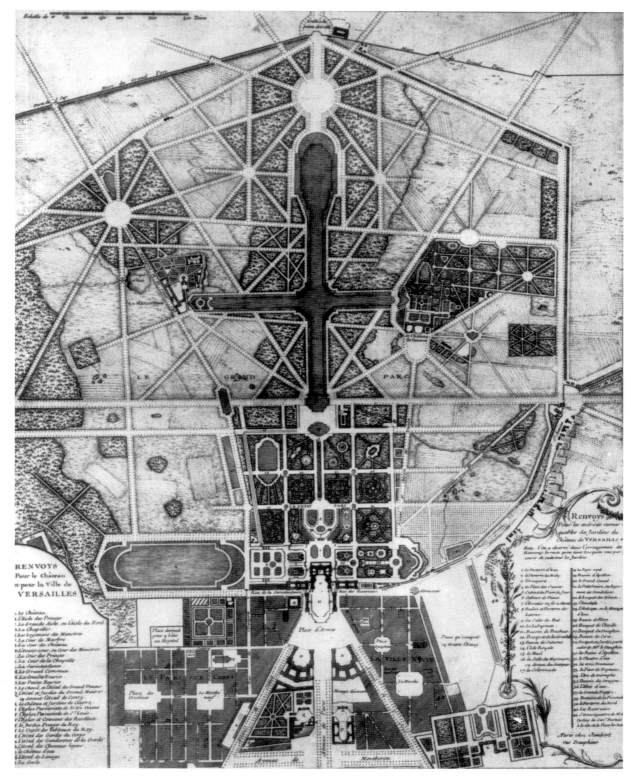

■ 6.6 Andre Le Nôtre
Plan of the Gardens and Park of Versailles
17th century engraving

▶ WATTEAU AND THE ROCOCO

● Few periods in art history continue to bring out such violent reactions from modern eyes as that which spanned most of the eighteenth century up to the French Revolution—a period commonly referred to as the Rococo. The term, once again dating from a later period, derives from a negative value judgment. It derives from the word "*rocaille*"—a delicate and ornate form of shell and rock work used to decorate walls and floors thus denying anything more profound than a trivial and decorative character to the art of the period. In our current vocabulary, rococo has come to mean tasteless, gaudy, and contentless decoration, and subsequently few are willing to admit to a liking for such fancies. As with Versailles, Rococo art embodies an age

and a sensibility perhaps too far removed from our own, but it nonetheless set in motion a precedent for the explicit and the pleasurable that has survived in some facets of art to this day.

One of the great masters of this period was Jean Antoine Watteau (1684–1721), whose *Embarkation for Cythera* (Fig. **6.7**) of 1717 embodies some of the complex concerns of the late Baroque age. The *Cythera* painting is loosely about a pilgrimage to the shrine of Venus on the island of Cythera, where the reward is love without any restraints. The subject might be considered too trite and gratuitous in our cynical age, but for Watteau the concept of profane love was inextricably intertwined with other issues of the period—the

■ 6.7 Antoine Watteau *Embarkation for Cythera* 1717
Oil on canvas, 50¾×74¾ in (128.9×189.9 cm), Louvre, Paris

ideas of freedom and human nature. Remember that up until this time, the conventions of Western art had strictly excluded the explicit presentation of passion and eroticism. The declining influence of the Church and the creation by Louis XIV and his successors of a large court with dwindling political and executive roles led to an increasingly elaborate and luxurious court culture. While philosophers examined the possibilities of rational argument, artists like their courtly patrons concentrated on exploring the possibilities of human relationships and feelings, especially courtship and love.

One of the most popular complaints about a painting such as *Embarkation for Cythera* is its apparent delicacy—a technical exuberance considered by some as inherently "feminine" in sensibility (or so said the eighteenth-century critic Diderot). As early as 1713, the English critic the third Earl of Shaftesbury claimed that looking at a Rococo painting was much like looking at a woman's dress, which, he said, would "make effeminate our Tastes, and utterly set wrong as to all Judgment and Knowledge in the kind." One can surmise from this claim that high or good art is supposedly about rational, sturdy, moral (read masculine) virtues—the virtues of the academies and of the governments that supported them—and not about profane love. This implicit male/female polemic would continue to taint art language for the next 200 years, and today it is still disturbingly common to understand ideas of delicacy and momentary rapture as inherently feminine insights in art. Watteau wanted to create an image of love embodied in a relationship between a couple, a bond that the world could not disturb. His paintings are about freedom and insight, the psychological moment and the electricity that is desire. It is in essence about being human, and in creating such paintings he wrested art from the constraints of decorum to produce an effective image of the age. It is ironic that Watteau of all people was to let loose some of Rousseau's noble savage in his intimate portrayals of love, particularly since Rousseau had little faith in the powers of art to act as an instrument for truth. But in another respect, it places both characters within the context of an age increasingly enchanted by issues of freedom and nature, and their works are necessarily extensions of those issues.

Watteau's intimate portrayals of frail and sometimes buffoon-like harlequins suggest the characteristic atmosphere of the Rococo period. The idea of the

masquerade and the individual as an actor playing a role is never far from the heart of Watteau's paintings. The artist's choice of the actor as subject had a long and established literary tradition by the eighteenth century. The actor existed in two realms, had two lives, had two distinct natures—one free of set conventions (life on stage, life in masquerade), the other within society's codes. In Watteau's paintings, such a masquerade becomes an analogy to duality—the relationship betwen self and world, discipline and desire, and all the other opposites. Watteau's embodiment of this predicament is the Harlequin—the comedian lover. His painting *Gilles* (Fig. **6.8**) demonstrates the melancholy which is conventionally supposed to afflict the lover, and it gives some indication that these supposedly frivolous works are perhaps more insightful than one might have originally assumed. In any case, with Watteau the psychology of profane love—of what it means to be and feel human—enters into the realm of appropriate art.

■ **6.8 Antoine Watteau**
Gilles (undated)
Oil on canvas
72⅝×58¾ in (184.4×149.2 cm)
Louvre, Paris

▶ MORALIZING TONES: REYNOLDS AND DIDEROT ON ART

● Rousseau was not the only scholar to have problems with the cultural status quo during the late eighteenth century. Throughout Europe individuals began a dramatic re-evaluation of artistic practise, and in the process provided the community with a much needed dialogue on artistic responsibility. Two of the most outspoken critics of the age were the Englishman Sir Joshua Reynolds (1723–92) and his French counterpart Denis Diderot (1713–84), whose discourses on art provide an important context for the development of nineteenth- and twentieth-century critical thinking.

REYNOLDS

It is difficult to separate Joshua Reynolds from the institution of the Royal Academy, of which he was president from its inception in 1768 until his retirement in 1790. Unlike the French Academy, set up and operated within an arm's length of the court, the Royal Academy was somewhat more autonomous, if less influential (see Fig. **6.9**). Like virtually all academies then, the Royal Academy's membership and attitudes reflected the values of the time. A fascinating group

■ 6.9 *George III and his Family Viewing the Royal Academy Exhibition at Somerset Place* 1788 Engraving, Guildhall Library, London

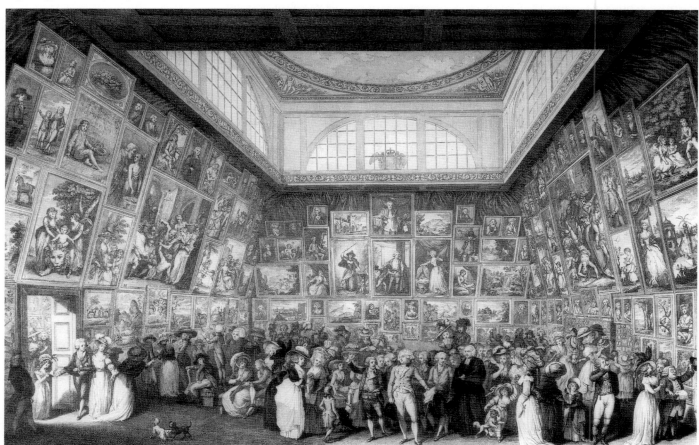

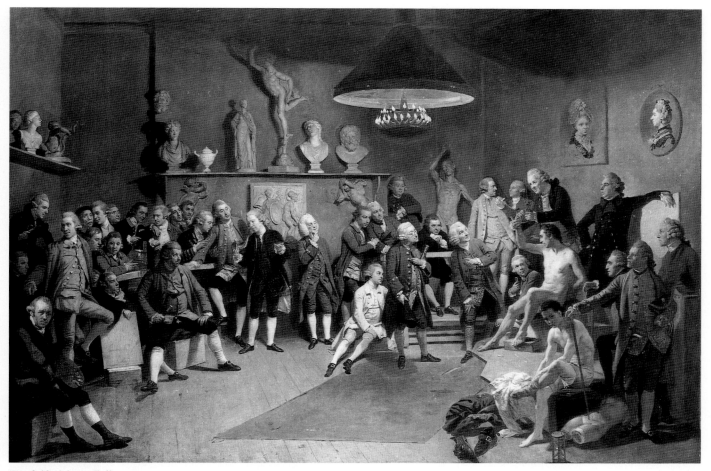

■ 6.10 Johann Zoffany
The Life Drawing Class at the Royal Academy 1772
Oil on canvas
40×58 in (101.6×147.3 cm)
Copyright Her Majesty the Queen,
Windsor Castle

portrait of the members (Fig. **6.10**) by one of their number, Johann Zoffany (1733–1810), shows them during a discussion of the nude. Noticeably absent from the proceedings are the two women members of the Academy, Angelica Kauffmann (1741–1807) and Mary Moser, whose portraits hang above on the right, since women were not then allowed to draw from the nude (this point will be taken up in greater length in the Epilogue). As president, Reynolds initiated the tradition of delivering an annual address to the students and members of the Royal Academy—a tradition that resulted in a series of fifteen discourses, which survive as one of the most significant statements on art in the late eighteenth century.

Two parallel issues preoccupied Reynolds throughout his discourses, and they show clearly how the Academy mirrored the concerns of the period. The first is art education—the idea that art could be effectively taught. Now, if this appears a rather moot point (nestled, as you are, with your art text in hand), then consider that even today the liberal education of the artist is not without its critics. Reynolds steadfastly believed that art was a matter of applying certain principles (rules) to the observation of nature, and that these principles were acquired through a disciplined study of the great masters. Sound familiar? The discourses on art became the first authoritative system for the academic training of the artist in the English

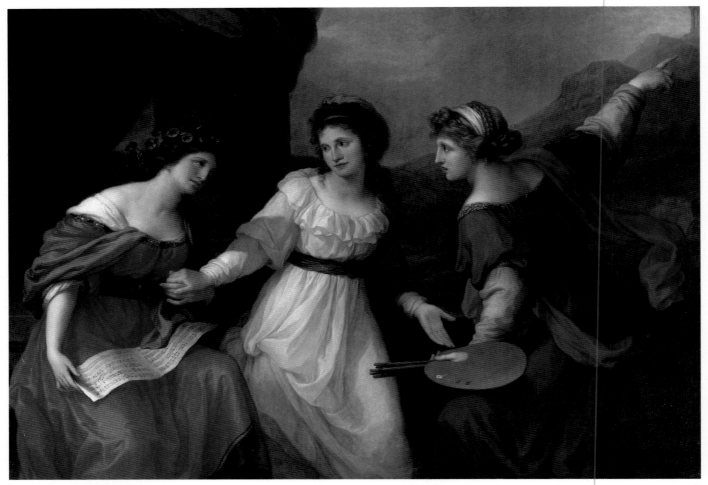

■ 6.11 Angelica Kauffmann
Self Portrait Hesitating between the Arts of Music and Painting 1794
Oil on canvas
58×86 in (147.3×218.4 cm)
Nostell Priory, Yorkshire

language, and even today the concept and structure of the art school are in many ways a reflection of these influential lectures. The belief that art is a problem-solving, intellectual exercise is very much an eighteenth-century idea, and it derives from a popular love affair with the scientific method that appeared to make the whole world knowable. To be of sound merit, art had to be guided by the same principles as all other disciplines—the pursuit of truth through reason, hence an investigation of nature through study. Royal Academy training thus involved more than basic studio exercises; it encompassed a variety of literary and philosophical considerations. If the early results of this kind of training were sometimes dubious, it is perhaps because the Academy was unable to understand artistic

practise as a sensitive barometer of cultural pressures, and not simply its secretary.

Reynolds also believed that it was the artist's role to capture nature's "timeless forms" from the everyday, and then, through exposing truth, educate and enlighten the viewer. This is, of course, Classicism at its height, and shows how little opinions had changed since the time of Bellori. Reynolds warned against the evils of simple imitation (needless to say, the Dutch masters of the early Baroque took a real beating in his books), and called instead on artists to delve deeper into the true "nature" of things. How does one do this? Simply learn how to decipher nature's code, which comes through patient deliberation and study. If only life were so simple! Here the discussion has come full

circle; nature's essential characteristics are available only to those who have studied its principles, and thus education becomes an essential part of being an artist.

One artist to train under the Academy was Angelica Kauffmann, one of only two women originally allowed membership under the strict gender quota that existed. Her work openly embraces many of Reynolds's and the Academy's theories, such as a timeless (though some would claim overly artificial) quality, being enhanced by such devices as symmetry, a correct understanding of the human form, and the elevation of both subject and concept (see Fig. **6.11**).

Reynolds's discourses were intended as a manifesto for his new Academy, claiming for British painting and artistic theory equal status with the French and Italian classical schools. The ultimate inappropriacy and perhaps even unattractiveness of Reynolds's theories to British artists are evidenced by the very small number of classically conceived history paintings at the Academy's own exhibitions. Sir Joshua's own painting was far less portentous than his *discourses*, and the results, especially in portraiture, if less dramatic, were far livelier and more captivating in the long run (see Fig. **6.12**).

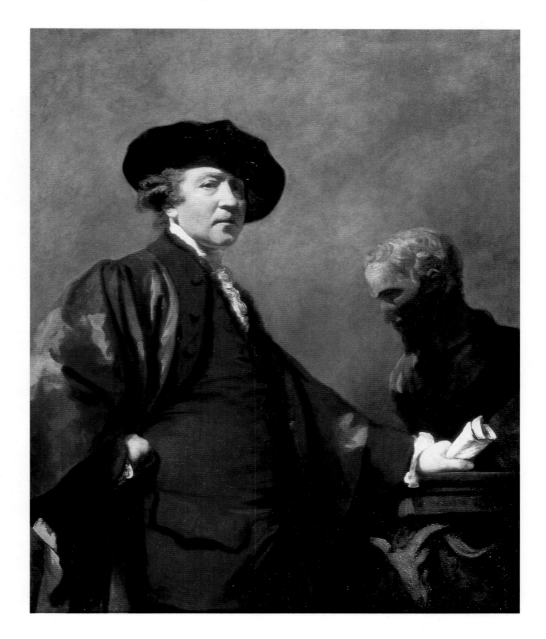

■ **6.12 Sir Joshua Reynolds**
Portrait of the Artist 1773
Oil on canvas
50×40 in (127×101.6 cm)
Royal Academy of Arts, London

DIDEROT

Denis Diderot has long been considered the father of journalistic art criticism, and his brisk essays on the artists of his age point to an individual with a shrewd eye and a moralizing point of view. Diderot's writing is full of what might be called "secular morality," which placed high value on art that was instructive, socially useful, and elevating. Given these parameters, it seems only right that Diderot should have moved to a more popular and accessible form of criticism (a journalistic style) later in his life, producing, among other pieces, nine outstanding reviews of the Paris Biennial Salons between 1759 and 1781.

Diderot's criticism seems to blur distinctions between ethics and esthetics, and in this respect he was very much a man of his time. Diderot understood truth in art as not merely the resemblance of nature, but a position of moral rightness. Subsequently, he spent most of his time developing critiques of storylines and arrangements, paralleling in sensitivity the Rousseau-inspired paintings of his contemporary, Greuze (1726–1806), whose moralizing narratives were an affront to the Rococo *joie de vivre* (see Fig. **6.13**). What did such criticism sound like? Consider these extracts from Diderot's *Pensées détachées* (meditations) which illuminate his bias: "Every work of sculpture or painting must be the expression of a great principle, a lesson for

■ 6.13 Jean Baptiste Greuze, *The Village Bride* 1761
Oil on canvas, 36×46½ in (91.4×118.1 cm), Louvre, Paris

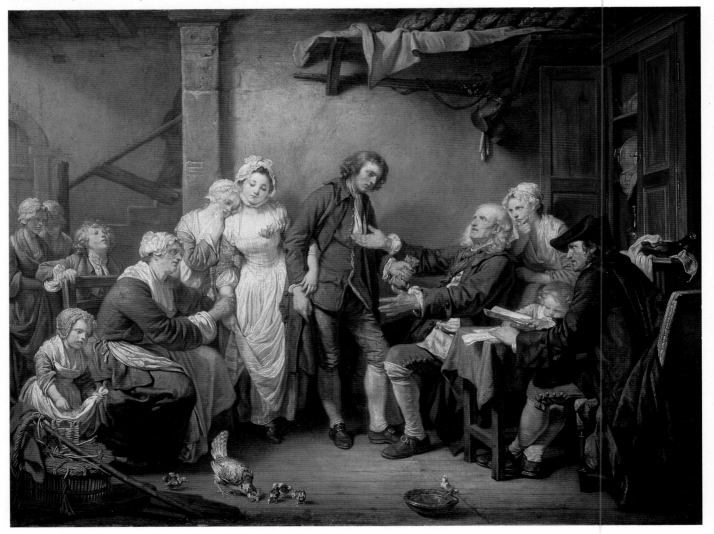

■ **6.14** Jean-Baptiste-Siméon
Chardin *Pipe and Jug* (undated)
Oil on canvas
12½×16½ in (31.7×41.9 cm)
Louvre, Paris

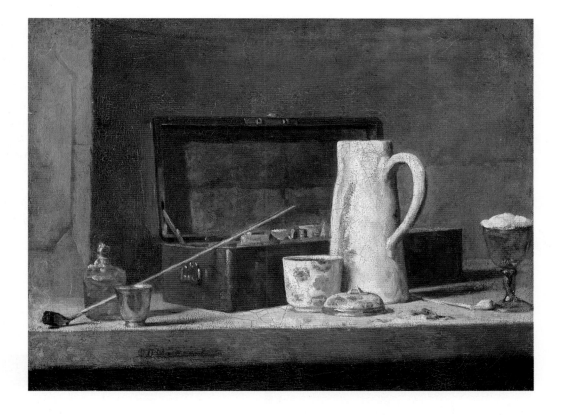

the spectator—otherwise it remains mute;'' or, ''A question which is not as ridiculous as it may seem: is it possible to have pure taste, when one's heart is corrupt?'' Today, it is hard to find a critic overly concerned with an artist's purity of heart; indeed, most would agree that moral intention does not always lead to great art. But in the period directly preceding the French Revolution, the question of intention on the behalf of artists was tied into the greater question of the morality of the cultural machine itself. Needless to say, Diderot saw little good coming out of the playful Rococo stylings so popular in the French court.

Who, then, did Diderot champion? For him, the French painter Jean-Baptiste Siméon Chardin (1699–1779), whose scenes of the pious middle class and their various accoutrements (he was most noted for his still lifes) exuded virtue and vitality (see Fig. **6.14**). Diderot writes, ''Here is the man who truly understands the harmony of color and reflections. Oh, Chardin! What you mix on your palette is not white, red or black pigment, but the very substance of things.'' Here truth to experience is seen as truth to oneself and thus truth to the viewer; in one sweeping gesture, the critic has given moral authority to a painting of

inanimate objects! Diderot's use of the word ''understand'' with regard to Chardin's vision is yet another ·indication that the artist's vision is part of a deeper and more truthful view of the world. Given this point of view, it is understandable that a moralist such as Diderot would find Watteau's contemplations on the nature of love trivial, if not immoral. What the critic fails to realize is that morality often confuses our impressions of true ''nature,'' and that ethics are a social construct. In other words, truth to nature is not always morally uplifting, and sincerity to truth is often a difficult thing to swallow (just ask anyone who has lived through a war).

Both Reynolds and Diderot point to a sensibility far removed from our own age, and if both seem a little too optimistic and moralizing in their appraisals of art, then perhaps it is because they (like most of their contemporaries) believed that the adherence of all to rational principles was an attainable ideal, which would result in the development of a code of ethical conduct. The tranquil certainties of Diderot, Reynolds and their contemporaries was to be dramatically displaced by a series of violent and uncontainable revolutions.

▶ THE NEO-CLASSICAL ARTIST

● Asked to justify the tastes and aspirations of her age, a mid-eighteenth-century aristocrat, one Madame du Châtelet, was quoted as saying: ''We must begin by saying to ourselves that we have nothing else to do in the world but seek pleasant sensations and feelings.'' It appears that artists such as Watteau, Jean Honoré Fragonard (1732–1806), and François Boucher (1703–70) (see Fig. **6.15**) were sympathetic to such a world view, and consequently their life's work oozes with the playfulness of a secure society. There were,

however, others who believed art could and should deliver more than just gratuitous imagery, and it is from this simple premise that some of the rhetoric of Modernism begins to flourish.

Let us consider the issue of art's role in society a little more carefully. Despite some modest efforts to explain the significance of an artist such as Watteau, it is doubtful that this text has converted even a few readers to the merits of Rococo art. Surely art is supposed to be something much more serious and profound than all

■ 6.15 Francois Boucher
Diana after the Hunt c. 1750
Oil on canvas
37×52 in (94×132 cm)
Musée Cognacq-Jay, Paris

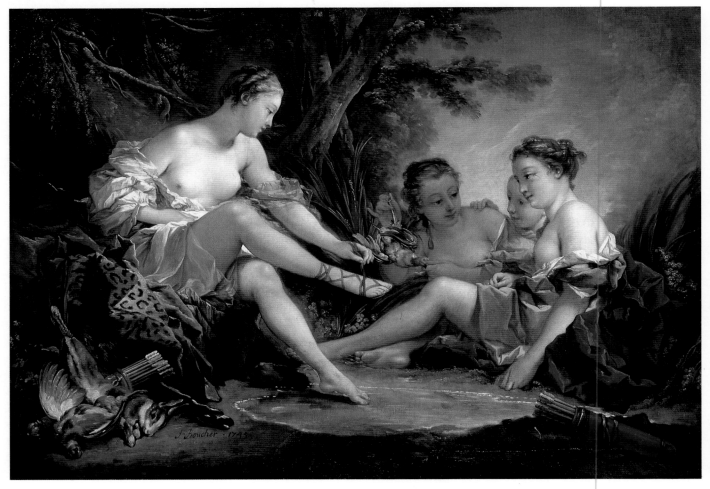

that fluff, isn't it? But why so? Perhaps the legacy of religious art has made the average viewer particularly sensitive to the vitality and contemplative power of visual images, or maybe we (as a society) are deeply comitted to the belief that art and artists provide an important window onto the complexities of the world. These are both valid points, but within this framework is an underlying assumption that there is a moral purpose to art making—that art provides some beneficial and necessary function in and to our world, and the Rococo artists simply missed the boat. It is this "moral mission" of art that forms an important part in the foundations of Modernism, and in the Neo-Classical movement of the late eighteenth century those seeds were sown.

To many an observer, Classical society had been the crowning achievement of Western civilization—or so thought a considerable proportion of artists and thinkers along the way. The art of the antique supposedly epitomized the perfect equilibrium of freedom and responsibility, rational insight and considered cause, honor and virtue. If one were to catalogue the various instances when the longing for a Classical past was most popular, it would invariably correspond with a significant crisis in the art and art making of the era (and thus with the culture generally). It seems that the cool, analytic character of the Classical period appealed (and still appeals) to those who saw restraint and sacrifice as admirable virtues in a world plunging head-first into certain chaos. The late eighteenth century was one such period, and as the aristocracy clung to power, so too did its art embrace the challenging rigor of a new regime: Neo-Classicism.

There are two ways in which one can resurrect Classical ideals in art: first, through a consideration of the formal characteristics of the past (what the art looked like), and second, by way of a deliberate use of Classical subject matter. Throughout this book, we have pointed to a number of artists who reworked Classical formal considerations (a small feat in itself, since they relied almost exclusively on Roman copies of Greek statues), most notably Poussin and Carracci. In both these cases, an emphasis on proportion and symmetry helped perpetuate an ideal world of restraint and clarity; here formal constraints are effectively used to parallel similar virtues in the individual. Often, this strength of pictorial vision outweighed considerations of subject matter, which was often left within the confines of the popularized myths (for example,

creation, beauty, sacred versus profane love). What is noticeably absent from these earlier images is the use of legends and narratives from the communities of Sparta and Republican Rome—arguably equal partners with Athens in the history of the Classical world, yet rarely the subject of Western painting. This is not a case of mere oversight. If one stops and considers the strikingly different attitudes toward issues of, for example, morality and power held by such societies, such models of behavior would have likely made many a prospective patron uncomfortable—particularly those in power, who had the resources to initiate such lavish commissions in the first place. Both Sparta and Republican Rome prided themselves on their military prowess and their discipline, and understood absolute sacrifice as the most profound expression of morality. This type of defiant righteousness made many squeamish, as it set precedents for undermining the general air of peacefulness, and provided an unhealthy influence on the masses. Better for them to think of the kinder virtues than to be uprooted by revolutionary thoughts. But by the late eighteenth century, the foundations of aristocratic rule were beginning to falter under the strain, and the time was right for one artist to make important connections between the formal construction of his art and the ramifications of his subject matter. His name was Jacques-Louis David, and his work might rightfully claim to be the first academic art to posit social and political revolt—very modern ideas indeed.

DAVID

David (1748–1825) lived in a France of extremes, where abject poverty and unbelievable affluence coexisted in a constant state of social and economic inequality. Brought up as a painter through the ranks of the French Academy and winner of the prestigious Prix de Rome, David was one of the lucky few to reap the considerable rewards of the sanctioned cultural machine. Yet given such benefits, the artist was also in a position to comprehend the further implications of art as propaganda—the way such high art only perpetuated certain preconceptions about authority and the role of the individual. The fact that in the end David would prove himself as susceptible as the rest of us to hypocrisy should only heighten one's appreciation of the fragility of his vision, since within his art lies a moral authority as vibrant and ultimately as destructive as

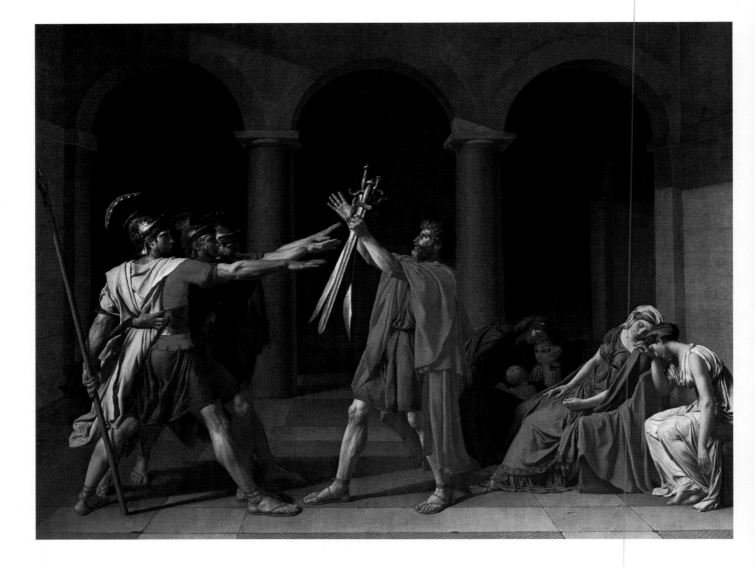

that which came before. The result of this dynamic is a fascinating example of an artist whose works seem to encapsulate the most significant ideological shifts to occur during his lifetime—in simpler terms, his works record what it may have meant to be an educated person at this particular point in the history of the world.

One of David's most notable compositions is the *Oath of the Horatii* (Fig. **6.16**) of 1784–5, completed four years before the beginning of the French Revolution. The subject matter is anchored in Republican legend, and it alludes to a series of deaths "through duty," including the Roman virtue of brother killing sister for her love of a member of the enemy. Here the loose philosophizing and lofty aspirations of a Classicist such as Poussin give

way to a straightforward story, portrayed in a shockingly straightforward manner. Despite its obvious technical homage to painters such as Poussin and Caravaggio, *The Horatii* remains a very different type of history painting from those previously discussed. There is an arresting clarity about David's composition, and the pivotal gathering of the gleaming swords becomes an almost hallucinatory focus—absolute resolution through absolute sacrifice. There is a certain agreeable severity about this picture; here the Republican virtues that resonate through the storyline find their compositional equivalent in the equally harsh and disciplined execution of the painting. Like the Rococo artist before him, David had found an adequate formal language for his subject, which resulted in a fundamental internal

◄ 6.16 Jacques-Louis David
Oath of the Horatii 1784–85
Oil on canvas
Approx. 14×11 ft (4.27×3.35 m)
Louvre, Paris

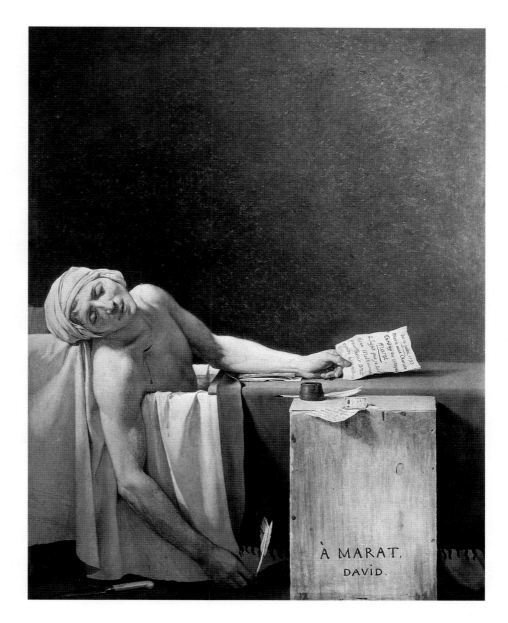

■ 6.17 Jacques-Louis David
Death of Marat 1793
Oil on canvas
65×50½ in (165.1×128.3 cm)
Musées Royaux, Brussels

harmony. Here, "form" and "content" complement and reinforce each other; we not only comprehend the subject but are also forced to feel it. The composition shows an uncanny intelligence. The tripartite (three-section) arrangement of the picture plane, made plain through the use of the background arch motif, gives an almost religious authority to the piece. On the left stand the proud Horatii, whose gestures to the gathered swords are reminiscent of the awe and reverence that a worshipper might pay to an içon. In the middle stand the swords, an extension of the father figure on which all loyalty rests. Last (and in David's case certainly

least), on the right side lie the swooning women (the virtues of compromise and love once embodied in the Rococo persona), envisioned as little more than a weak, piteous huddle. The composition is both brilliant and unsettling, and it bears witness to the changing and violent attitudes that would follow in its wake.

In 1790 the season's color of choice around French fashion circles was red, blood red. The aristocracy had finally fallen and with it centuries of persecution and humiliation—only to be replaced with chaos and violence. David's *Death of Marat* (Fig. **6.17**) of 1793 is a keen indictment of the various intrigues and assassina-

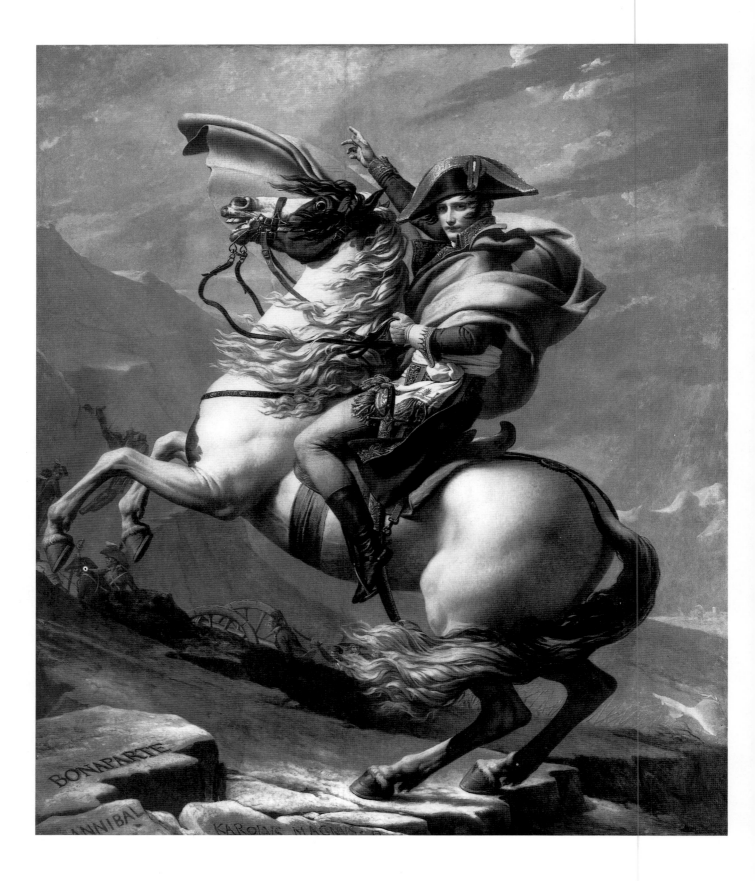

tions that followed in the wake of the revolution. Here, the patriot Marat, one of the heroes of the cause, lies stabbed in a bath of deep red; the symbolic sword of the Horatii had indeed found a home, but the final resolution was anything but virtuous. The starkness of the scene and the forceful placement of the figure on the immediate foreground plane suggest the Baroque theatricality of Caravaggio, and it points to an uncompromising design and vigilance of execution commonplace in both art and political circles during those early revolutionary years. Unfortunately for the ever-inflammatory David, the tired analogy of when one plays with fire, one eventually gets burnt, came true; the artist soon found himself out of favor with those in power and gamely retreated from the scene. But ever the pragmatist, it was not long before the same David locked into something new and something big in French political circles—a man named Napoleon Bonaparte. With David's triumphant *Napoleon Crossing the Alps* (Fig. **6.18**) of 1800, one witnesses the ironic end to a fervent revolutionary—the artist agreeably painting yet another manifestation of coming élite rule. The king is dead, long live the king.

Classical motifs were by no means confined to painting. We might remind ourselves at this point that communities often recycle history to suit their specific needs, and in the case of Europe at the turn of the century, popular nostalgia for a more harmonious, democratic, and egalitarian time led many to see Classical society as something reasonable to aspire to. The result was a proliferation of Classical references throughout almost all the arts during the period, but particularly so in revolutionary France and the young United States. Sometimes, as in the case of David, form and content worked in unison, producing powerful evocations of the Classical aura. At other times the result was more humorous than inspiring; one such example is the notorious statue of George Washington (Fig. **6.19**) produced by Horatio Greenough. In a style reminiscent of Roman portraiture, the artist placed a bust of the first President of the United States on a rather imposing and idealized figure—the Olympian God Zeus to be exact! The discrepancy between portrait

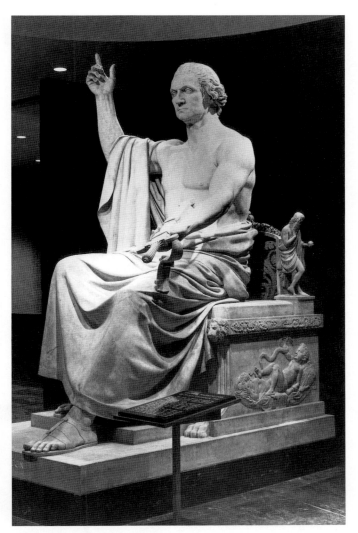

■ **6.19 Horatio Greenough**
George Washington 1832–41
Marble
138×102×82 in (345.4×259.1×209.6 cm)
National Museum of American Art, Smithsonian Institute

◄ **6.18 Jacques-Louis David**
Napoleon Crossing the Alps 1800
Oil on canvas
96×91 in (243.8×231.1 cm)
Musée de Versailles

(individual) and ideal (universal) is at once obvious, and the unfortunate result is little more than grand-scale heroic propaganda with little insight into the nature of the sitter. Here the once grand aspirations of the Neo-Classical revival are trivialized to the point of virtual insignificance, signaling the eventual exhaustion of a period and its original lofty aspirations. One can speculate that individuals simply tired of "politician-turned-god" imagery, and cynically came to see ideas like symmetry and proportion as just one more way of supporting other, more pragmatic agendas.

▶ GOYA AND MAN'S INHUMANITY TO MAN

● By now, you may have received the distinct impression that being an artist was not a particularly easy task at the end of the eighteenth and beginning of the nineteenth centuries. One by one the traditional ruling groups were forcibly dislodged: and once the "ancien régime" had ended the problems of governing fell on inexperienced successors, who were themselves subject to the disapproval of the populace which had displaced the aristocracy. The transition of power often led to tragic extremes, and the resultant chaos and bloodshed poignantly illustrated the seemingly limitless human capacity for cruelty and vindictiveness. Was this essentially human nature? Was this the "noble savage" who lay in the hearts of all humans? Or was this a glimpse of the world of instinct—our darker side

finally exposed? Among the noise, revelry, and violence of the era, there stood one individual who dared to look beyond the accepted façade of progress. His name was Francisco de Goya, and his visions remain some of the most unsettling in all of art.

In retrospect, it seems rather appropriate that Goya trained and worked under the patronage of an aristocratic court. The life of Francisco de Goya (1746–1828) is a microcosm of the social pressures in which he lived and prospered. He grew up as one of the lucky few who gained the favor of the court through skill and he commenced a career as court portrait painter in his native Spain. He lived in a country with an unmistakable propensity for Rococo stylings, and his early pictures pay homage to those influences. Yet a painting

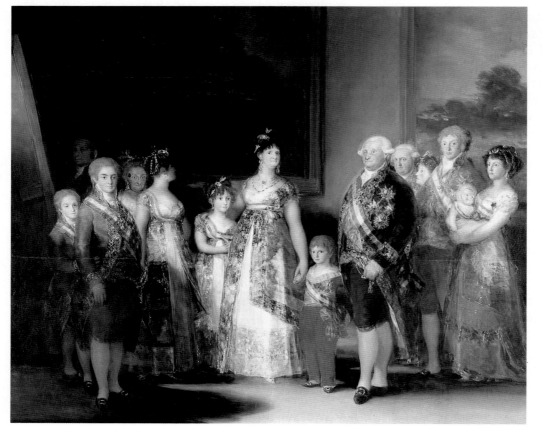

■ 6.20 Francisco de Goya
The Family of Charles IV 1800
Oil on canvas
110¼×132¼ in (280×335.9 cm)
Prado, Madrid

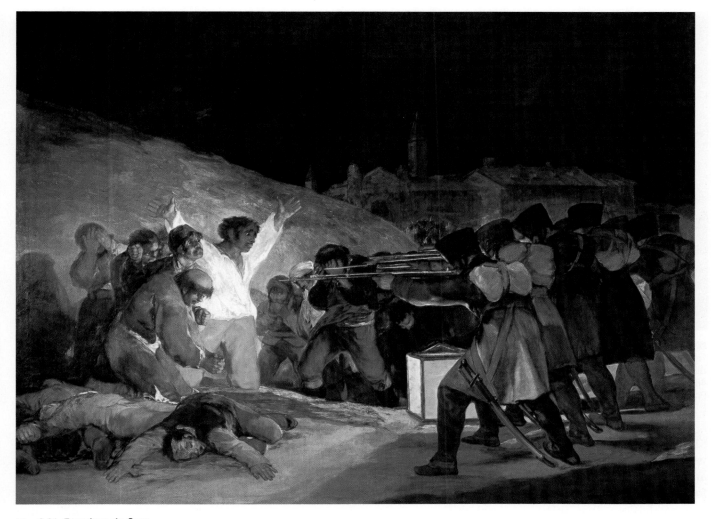

■ 6.21 Francisco de Goya
The Third of May 1808 1814
Oil on canvas, 104¾×136 in (266×345.4 cm)
Prado, Madrid

■ 6.22 Detail of *The Third of May* 1808 showing raised arms

such as *The Family of Charles IV* (Fig. **6.20**) of 1800 is indicative of his increasingly dispassionate eye for personality and humanness. The work is neither a Rococo glorification of the aristocracy nor a stiff Davidian political rendering; it is instead a painting of a family, and despite their formal attire, the group remains a curious, if not humorous, assemblage. This was to be the last gasp of naturalism as the eighteenth century defined it; something less passionately inspired than a Watteau, and more frail and believable than a David.

However, naturalism requires more than simple, penetrating observation to have meaning; there must also be an implicit awareness of the fragility of life.

■ 6.23 Francisco de Goya
Fight with Clubs (undated)
Oil on canvas
48½×104¾ in (123×266 cm)
Prado, Madrid

Shortly after the turn of the century, Spain was to witness this folly first hand, as an insatiable Napoleon and his French Republic marched on Madrid. What followed in its wake was a series of brutal insurrections and retaliations that were to signal the end of the Spanish Enlightenment—a world to which Goya was inextricably bound. Out of this all too familiar blood-bath came one of the most devastating depictions of humanity ever to grace canvas; eighteenth-century rationalism stripped bare in the anguished scream of Goya's victim in *The Third of May 1808* (Fig. **6.21**). Here the insights of a keen observer are let loose on human-ity in general, and the view from the edge is none too pretty. There is no blind heroism in this painting, and no discrete symbolic language to be followed. It is neither propaganda nor compassion—it is an insight into Alexander Pope's world of witches and demons that the eighteenth century tried so hard to ignore. Humans are let loose on humans, and the result is death and annihilation. The forces of evil (the soldiers) are faceless and thus universal, and the individual is shrunk to the level of puppet, his arms held outstretched and embracing (see Fig. **6.22**). What a

distance we have traveled from Madame de Châtelet's world of pleasure and indulgence.

As Goya grew old, he began a series of highly per-sonal paintings that vividly illustrate the depths of the artist's insight. It is significant that Goya was deaf when the so-called "black paintings" were executed; the images show a focus and concentration that one might imagine only from an individual whose life had become increasingly enclosed. The massive *Fight with Clubs* (Fig. **6.23**) is one of his most powerful and awful depictions of the self-destructive tendencies implicit within all humans; it is Goya's answer to the "might is right" argument which allows humanity to beat itself sense-less. This is "truth to nature" in its extreme, and it is a long way from Diderot's favored Chardin. Yet its poignancy is both uncanny and chilling, and it makes one wonder if nature is found not in observation but in introspection. Few were to realize the implications of Goya's late work at the time, and it wasn't until the twentieth century that these pieces were given their due. Thus while an old and disenchanted Goya dared to view nature from the inside, a heroic façade was being developed by a new group, the Romantics.

▶ ART AND THE HEROIC: ROMANTICISM

● Goya's haunting vision of a world of perpetual gloom and unfulfilled desire was by no means an isolated attitude by the second decade of the nineteenth century. It appears that Neo-Classicism had run its course; the need to order and aggrandize the world through art had, by the fall of Napoleon, created a rather rigid and uncompromising monster. Analytic clarity and heroic subjects had simply become tired motifs, and many saw the restrictive conventions of Classicism as no longer appropriate in an age of dynamism and chaos. What was needed instead was a method for expressing all of the intangibles that one feels but never knows. In short, it required gifted visionaries whose sensitivity to such nuances granted them privileged status—a position artists were quick to pick up on.

This declaration on behalf of artists was not quite as gracious and humanitarian as might at first appear. The world of the artist had been turned upside down by the swift changes of revolution. Within a thirty-year span, the single most important source of patronage for the artist through the eighteenth century—the aristocracy—had been all but effectively dismantled in most parts of Europe and artists soon found themselves without a reliable source of patronage. This absence forced artists to redefine their role in society: to find new patrons and to compete for status in the free-for-all of post-revolutionary culture. The Romantic attitude fits perfectly in this respect, because it placed enormous emphasis on the subjective experience of the individual in the face of an overwhelming world. This shift of sensibility also coincided with a popular mistrust of the rationalism of the previous century, which was now seen as restricting and dogmatic. In the face of such dynamics, the artist became the intermediary between the awesomeness of "nature" (to reuse the eighteenth-century definition) and the fragility of humankind.

GÉRICAULT, DELACROIX AND FRIEDRICH

A rather instructive example of the emerging Romantic sensibility is a work by Théodore Géricault (1791–1824), *Raft of the Medusa* (Figs **6.24** and **6.25**), of 1818. The painting is based on the tragic voyage of the

■ **6.24 Theodore Géricault**
Sketch for the *Raft of the Medusa*
1818
Pen and ink
16⅛×23 in (41×58.4 cm)
Gemente Museen, Amsterdam

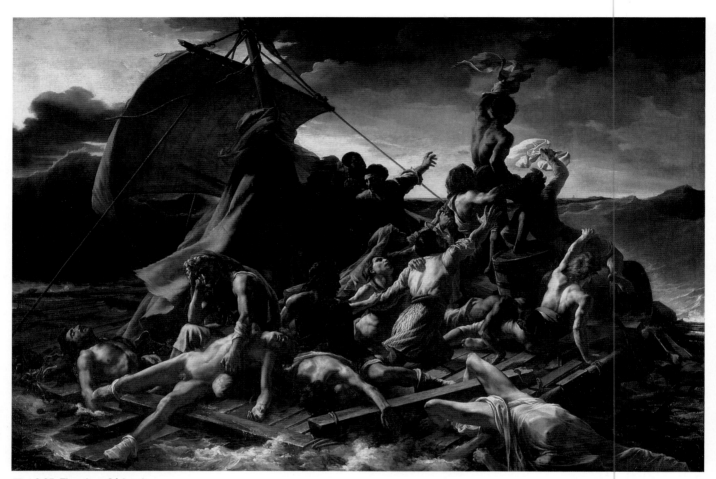

■ 6.25 Theodore Géricault
Raft of the Medusa 1818
Oil on canvas
16 ft 1 in × 23 ft 6 in (4.8×7 m)
Louvre, Paris

French ship *Medusa*, which in 1816 through incompetent handling fell into the hands of a negligent sea captain (appointed by friends in the government), who sailed headfirst into a storm. The result was a single raft set adrift on the open seas, crowded with individuals deemed unworthy of lifeboats. The story created a sensation in Paris, with images of parching thirst, unbearable heat, and even rumors of cannibalism prevailing. In this day and age of billboards and docu-dramas, it may seem obvious for Géricault to have chosen a monumental scale, 16 feet 1 in by 23 feet 6 in (4.8 m x 7 m) for such a controversial subject, but at the time of its execution, this was considered an affront to prevailing Classical decorum. For here a contempor-

ary event was given a level of dignity and importance once reserved for only the most profound myths, and in this regard Géricault's monumental work also acts as a deliberate critique of the self-proclaimed righteousness of the Classicists. Yet in spite of its radicalness, the painting remains indebted to Classical standards of formal composition. The sweeping diagonals that permeate the scene are at once dynamic and yet balanced, and despite the rough seas and intense lighting, the composition retains absolute harmony of parts. However, Géricault is not simply a passive practitioner of these devices; his considerable formal skills are used for ultimately dramatic ends, as the sweeping thrust of the design accentuates the decisive gesture of the inde-

■ 6.26 Detail from the *Raft of the Medusa* 1818 showing the sailor waving

fatigable sailor and the approaching vessel (see Fig. **6.26**). It is indeed unfortunate that Géricault died so tragically young, aged only thirty-three, for his ability to evoke a certain consciousness of the human condition through paint is indeed singular.

Perhaps the most painterly of the Romantic artists

was Eugène Delacroix (1798–1863). Delacroix combined a typical Romantic interest in the exotic with a liberated handling of materials and color to produce some of the most captivating images of his era. A good example of his propensity for intense color and gestural paint activity can be seen in *The Death of Sardanapalus* (Fig. **6.27**) of 1826, where the artist's handling of materials and the wildly organic forms seem to reiterate the intense violence and passion of the scene. Here, as in all great art, a direct connection between form and content is developed, and the result is a painting that not only describes the horror of a slaughter in the name of vanity but in some ways mimics its very energy.

It is interesting to note how society's relationship with the environment changed with the Romantics. Gone were the confident, restrictive renderings of Poussin and David. Instead, the world was portrayed as vindictive, threatening, and sublime; nature had now become not the product of human intellect but an allegory to the troubled, tumultuous world of the

■ **6.27 Eugène Delacroix**
The Death of Sardanapalus 1826
Oil on canvas
12 ft 1 in × 16 ft 3 in (3.68×4.95 m)
Louvre, Paris

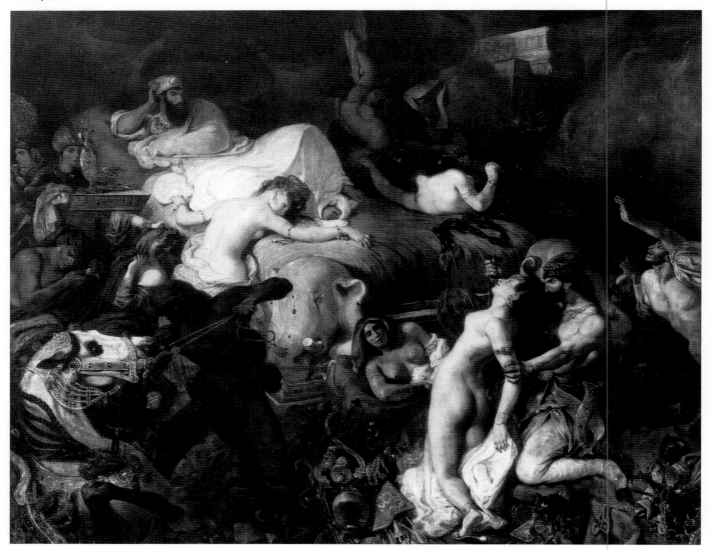

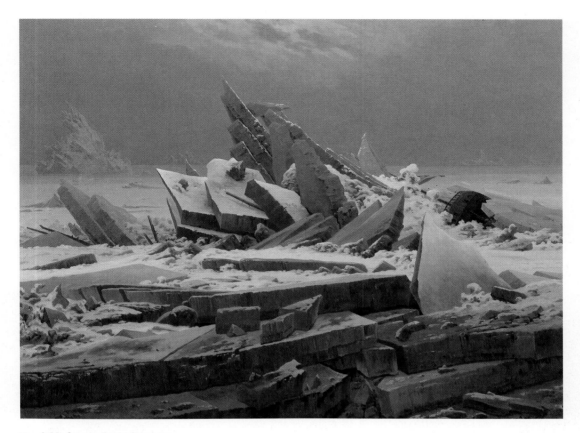

■ 6.28 Caspar David Friedrich
The Polar Sea 1824
Oil on canvas
38½×50½ in (97.8×128.3 cm)
Kunsthalle, Hamburg

human psyche. As revolution and social upheaval captivated the imagination of whole communities and set minds adrift in a seemingly endless sea of possibilities, nature became a reminder of the relative insignificance of existence in the face of an overwhelming and amoral universe. One of the truly superb depictions of the sublimity of nature is a work by Caspar David Friedrich (1774–1840), *The Polar Sea* (Fig. **6.28**), of 1824. Here the individual (and all of humanity for that matter) reads as little more than a footnote in the violent convulsions of nature. The ship, once a mighty symbol of conquest, lies crushed by the sheer weight of an ice pack. In the face of such a scene, even David's heroic Horatii could do little to save the day. There is no heroism here and no morality play—just the ambivalent work of a world both grand and ultimately unmerciful. Nature, it seems, was the great equalizer in many an artist's eyes, and in this regard the landscape took on its own sense of urgency.

■ 6.29 J. M. W. Turner
*Snow Storm: Hannibal and his Army
Crossing the Alps* 1812
Oil on canvas
57×93 in (144.8×236.2 cm)
Tate Gallery, London

■ 6.30 John Constable
Hampstead Heath 1821
Oil, sketch
10×12 in (25.4×30.5 cm)
City Art Galleries, Manchester

TURNER AND CONSTABLE

Two other artists are worthy of mention with regard to the new attitude toward nature: Englishmen J. M. W. Turner (1775–1851) and John Constable (1776–1837). Like Friedrich, Turner's conception of nature can be best understood with the aid of two Romantic critical terms—the "sublime" and the "picturesque." Both artists and authors responded to the "sublimity" of all that was awesome in landscape: the grandeur of mountains and storms or the emptiness of the plains. The "picturesque" was homelier, a landscape of cultivation with brightly clad rural laborers and abundant vegetation set against a backdrop of rolling hills. These two modes were dominant in the output of Turner and contemporary landscape painters all over Europe. Yet Turner also used the expressive freedom gained in his landscapes of the sublime to dramatize grand subjects of the past. As a result, the mix reflects a view of the landscape both heroic and often merciless (see Fig. **6.29**). Perhaps more than any other feature, it is the searing, almost material presence of light that makes Turner's paintings so tangibly different from those of his contemporaries. Here light is seen as nature's divine instrument—a force which decomposes or solidifies forms at will, and is as wild and unharnessed as the environment it illuminates.

Constable, on the other hand, was the quintessential empiricist, believing all landscape painting to be the patient result of observing facts. To this end, he

■ **6.31 John Constable**
The Haywain 1821
Oil on canvas
51¼×73 in (130.2×185.4 cm)
National Gallery, London

■ 6.32 Charles Berry and A. W. N. Pugin
The Houses of Parliament, London, 1836–60
Length 940 ft (286.51 m)

produced countless works which examined transient moments—the effect of light through clouds, breezes through trees, etc. To him, the sky was also the key, but he applied a meteorologist's precision to the recording of phenomena, believing that the wonder of nature did not require the dramatic embellishments so glorified in the work of Turner. Constable's *Hampstead Heath* (Fig. **6.30**) and *The Haywain* (Fig. **6.31**) of 1821 exemplify such patient observation, and the result, while perhaps less dramatic than the work of his English contemporary, eloquently captures a similar devotional attitude toward the world that is typically early nineteenth-century.

Romantics too had specific historical precedents in mind for giving credence to their aims. As a reaction to the Classicism of the academies, it should come as little surprise that Romantic artists dismissed the conven-tions of the Renaissance; instead they turned their attention to less refined and more expressive art. Early Christian art, and in particular the medieval period, became an important source for imaginative wanderings. Soon, like the Neo-Classicists before them, many Romantic artists began to reconstruct works from the past to express the conditions of their own age. The British seemed particularly fond of the idiosyncrasies of the Gothic era. A building project which made this connection quite clear was the formidable Houses of Parliament in London (Figs **6.32** and **6.33**), with their direct associations with medieval forms. Then there was the Pre-Raphaelite movement, which, as the name implies, desired an art in keeping with the spiritual aims of the pre-High Renaissance era. To this end, the Pre-Raphaelites abandoned the techniques they had received in training at the Royal Academy, where the

■ 6.33 Interior view of The Houses of Parliament, London, 1836–60

■ 6.34 Dante Gabriel Rossetti
Ecce Ancilla Domini 1850
Oil on canvas
28½×16½ in (72.4×41.9 cm)
Tate Gallery, London

precepts laid down in Reynolds's *Discourses* were still observed. Instead the young Pre-Raphaelites developed a style of painting with vivid colors applied onto a canvas prepared with brilliant white underpainting. The result was a jewel-like intensity which, while not imitating the methods of the early Italians (the one Pre-Raphaelite attempt at mural painting was a technical disaster), seemed to return to the directness and supposed honesty of early Italian art. The group favored subjects from medieval mythology and from Shakespeare, as well as attempting to revitalize religious painting. Dante Gabriel Rossetti's (1828–82) *Ecce Ancilla Domini* (Fig. **6.34**) of 1850 provides a challenge to pictorial convention with its deliberately distorted perspective and creamy fresco-like coloration. But there is more to Rossetti's version of the Annunciation than imitation of art before Raphael: in the expression of the young Virgin Mary we find not an idealized type but a vivid and thoroughly modern portrayal of a deeply troubled young adolescent girl.

● The world had seen much, perhaps too much, in the short century and a half between Watteau and Friedrich. It had gone from aristocratic pleasure to Classical restraint to fear and trembling, and art was its quivering voice in the chaos. The artists had lost patronage but gained autonomy, and now they faced their biggest challenge: to find a voice as loud and overwhelming as the industrial age. This was going to require a strategy—or even better, a whole new way of looking at the role of art. This was to be the beginnings of Modernism, which is the subject of our next chapter.

▶ SUMMARY

● The eighteenth and early nineteenth centuries were a period of unprecedented political and social upheaval throughout the Western world. As the decadence of the ruling aristocracies gave way to equally convulsive revolutionary excesses, so too did artists find themselves reconsidering their traditional role in the greater cultural arena. As art production shifted from large decorative projects and commissioned portraiture to the more personal interests of the artists involved, there was likewise a significant reappraisal of the meaning/s of art as a potent esthetic, emotional, and even political catalyst. The issue of nature, both that of human consciousness and the environment in which we function, also came under the increased scrutiny of thinkers and artists alike, as the rationalism of the previous era gave way to a more personal, speculative mode of thought. It was during this necessary re-evaluation that the modern notion of the artist as a distinct, autonomous voice within culture began to arise—a voice that will, as we continue our discussion in the next chapter, form more fully into the concept of an avant-garde.

Glossary

Journalistic art criticism (*page 272*) A form of writing on art based primarily on direct observation, deliberation and brief critique, rather than using works as the basis of a more complex theoretical argument. The mainstay of most art critics today, the style was first used by Denis Diderot in his reviews of the Paris Biennials between 1759 and 1781.

Neo-Classicism (*page 275*) The term used to describe the revival of Classical conventions such as symmetry, a reliance on draftsmanship over color (in painting), and the evocation of a determined and disciplined order to the world.

Rococo (*page 266*) Deriving from "*rocaille*," a delicate and ornate form of shell and rock work used to decorate walls and floors, the term refers to a period in European art *c.* 1700 when technical exuberance and pleasurable sensations were popular, signaling a shift away from the rigid formulas of the Baroque Classicists.

Romanticism (*page 283*) A movement in early nineteenth-century culture against earlier rationalism, Classicism and mechanism. It sought to elevate the fantastic, the sublime and the pleasurable. It asserts the primacy of the individual's experience and the self-conscious isolation of the artist after the fall of patronage.

Suggested Reading

The period between 1700 and 1830 is rich with biographers and contemporary historians, and these documents provide singular insights into the processes by and conditions under which the art was produced. One particularly good collection of material is Lorenz Eitner, *Neoclassicism and Romanticism 1750–1850, Sources and Documents. Volume One: Enlightenment/Revolution* (Englewood Cliffs, NJ: Prentice-Hall, 1970). Two recommended surveys of the period are Julius S. Held and Donald Posner, *17th and 18th Century Art* (Englewood Cliffs, NJ, and New York: Prentice-Hall and Abrams) and Michael Levey, *Rococo to Revolution: Major Trends in Eighteenth-Century Painting* (London, New York and Toronto: Oxford University Press, 1977). Finally, for a thorough and enlightening introduction to the modern world and its particular artistic sensibility in the early nineteenth century, William Vaughan's *Romantic Art* (London, New York and Toronto: Oxford University Press, 1978) is highly recommended.

7

THE MODERN
WORLD AND
ITS ART

■ 7.1 Claude Monet
Regatta at Argenteuil (detail) 1872
Oil on canvas
19×29½ in (48×75 cm)
Musée d'Orsay, Paris

Art never expresses anything but itself.
OSCAR WILDE, *The Critic as Artist*

Throughout this book, it has become clear that an individual's most fundamental appreciation of art is always contingent upon a series of value judgments (the tools one uses to assess the merit of a work). These value judgments are in turn inextricably linked to a wide range of interests and social conditions (one's "historical condition"), and thus any evaluation of art is itself an expression of its age. This cycle helps explain the subtle differences in taste and values between generations and cultures, since each sector develops around a particular set of conditions unique to its age. In earlier discussions, much time has been spent sorting out the wide variety of historical factors that have contributed to our common understanding and appreciation of art, and by placing art and art practise within the context of its contemporary value system, it has become apparent that art often carries implicit notions about the state of being human during its time. Since artists have traditionally produced work for a specific audience (Church, state, aristocracy, or the marketplace), it seems only logical that art in some way should reflect the interests of its clients, who were in turn significant players in the daily events and dominant interests of the age.

But suppose artists were to sever their direct links to this patronage system. Would art still be an accurate gauge of the human community, or would it simply become the irrelevant play toy of each artist, without direct association with or responsibility to its age. One might also inquire as to why artists would want to divorce themselves from society in the first place, particularly since they often receive a considerable amount of prestige and financial reward for their work. Further, if the artist no longer produces work for a specific patron, the issue of subject matter becomes at once essential; what does one create when one is working only for oneself? These basic questions about the nature of artistic practise outside the realm of traditional patronage are the legacy of Modernism, and if they can be answered, the importance of Modernism to our contemporary appreciation of art will become clear.

▶ THE IDEOLOGICAL FERMENT

● To appreciate the significance of the decline of patronage and the rise of the modern artist, it is necessary to consider how radically the world changed between the French Revolution and the mid-nineteenth century. The invention of various mechanized techniques for the production of goods enabled massive industrial expansion to take place in western Europe and America. Items that once took weeks, even months, to produce were now assembled in hours, replacing traditional cottage industries and old-fashioned craft guilds with factories and an increasingly urban labor force. What a miracle was the machine! Not only did it produce goods at an extraordinary rate; it also helped establish a vital middle class, who prospered in this new spirit of optimism and unprecedented freedom. The world was full of hope, and progress was in the air.

Artists were quick to pick up on this spirit of progress. The revolutions and social upheavals of the previous century had left many an artist without traditional sources of patronage (and thus livelihood). This in turn forced many artists to reconsider their function in society—a position now up for heated debate as society moved ever further from the traditions of Church and Crown, and the call for grand decorative programs shrank. What, then, was the role of the artist in society? And further, did the artist have any mission or specific voice to offer the public? The answer, as far as artists were concerned, was a resounding yes, and this paved the way for the rise of the "avant-garde."

Avant-garde simply means "before the rest," and it implies the role of explorer or adventurer, blazing a trail for others to follow. Yet how was it that artists came to view themselves and their activity in such an exalted light? The answer lies in the popular thought of the early nineteenth century, which took as its premise the

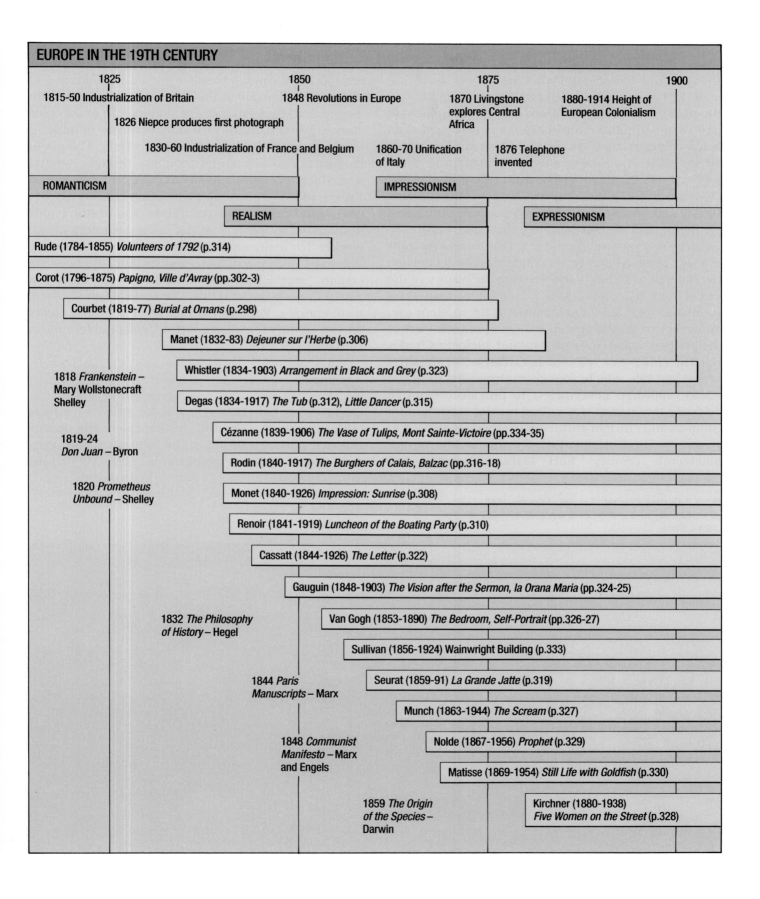

EUROPE IN THE 19TH CENTURY

1825 1850 1875 1900

1815-50 Industrialization of Britain

1826 Niepce produces first photograph

1830-60 Industrialization of France and Belgium

1848 Revolutions in Europe

1860-70 Unification of Italy

1870 Livingstone explores Central Africa

1876 Telephone invented

1880-1914 Height of European Colonialism

ROMANTICISM

IMPRESSIONISM

REALISM

EXPRESSIONISM

Rude (1784-1855) *Volunteers of 1792* (p.314)

Corot (1796-1875) *Papigno, Ville d'Avray* (pp.302-3)

Courbet (1819-77) *Burial at Ornans* (p.298)

Manet (1832-83) *Dejeuner sur l'Herbe* (p.306)

Whistler (1834-1903) *Arrangement in Black and Grey* (p.323)

Degas (1834-1917) *The Tub* (p.312), *Little Dancer* (p.315)

Cézanne (1839-1906) *The Vase of Tulips, Mont Sainte-Victoire* (pp.334-35)

Rodin (1840-1917) *The Burghers of Calais, Balzac* (pp.316-18)

Monet (1840-1926) *Impression: Sunrise* (p.308)

Renoir (1841-1919) *Luncheon of the Boating Party* (p.310)

Cassatt (1844-1926) *The Letter* (p.322)

Gauguin (1848-1903) *The Vision after the Sermon, Ia Orana Maria* (pp.324-25)

Van Gogh (1853-1890) *The Bedroom, Self-Portrait* (pp.326-27)

Sullivan (1856-1924) Wainwright Building (p.333)

Seurat (1859-91) *La Grande Jatte* (p.319)

Munch (1863-1944) *The Scream* (p.327)

Nolde (1867-1956) *Prophet* (p.329)

Matisse (1869-1954) *Still Life with Goldfish* (p.330)

Kirchner (1880-1938) *Five Women on the Street* (p.328)

1818 *Frankenstein* – Mary Wollstonecraft Shelley

1819-24 *Don Juan* – Byron

1820 *Prometheus Unbound* – Shelley

1832 *The Philosophy of History* – Hegel

1844 *Paris Manuscripts* – Marx

1848 *Communist Manifesto* – Marx and Engels

1859 *The Origin of the Species* – Darwin

notion that the world was on a course toward a future utopia (heaven-like place) thanks to the evolution of thought and living standards. Sure, there were still wars, and people were still starving in some regions, but the plight of the average citizen had indeed improved, and with work and enthusiasm, most predicted even better things to come (an ideal to which most individuals still adhere). In the nineteenth century, the philosopher G. F. W. Hegel (1770–1831) gave intellectual credence to this view with his theory of the dialectic (thesis and antithesis combine to produce a dynamic synthesis, which then becomes the new thesis)—an underlying structure of existence that inevitably leads to more resolved and better conditions. Hegel applied his dialectic to history itself, viewing the history of the world very schematically as the spirit of mankind's coming to total self-consciousness in the modern age. To lend even greater credence to an optimistic view of the progress and destiny of mankind, biologist Charles Darwin (1809–82) released his treatise *The Origin of Species* in 1859, which, though controversial from the outset, appeared nevertheless to provide conclusive evidence that nature was indeed moving toward more complex and efficient entities. Such theories also led to greater political speculation. By the middle of the nineteenth century, Karl Marx (1818–83) and

Friedrich Engels (1820–95) had formulated a radical criticism of Hegel's earlier theory. Rather than an abstract spirit coming to self-consciousness, Marx and Engels saw changes in the material reality of the life experienced by mankind. The domination of different classes, rather than the proximity of theory to spiritual ideals became the key to their analysis. Using the language of contemporary economic thought, known as political economy, Marx and Engels developed a theory called "historical materialism" in which the goal, rather than Hegel's realization of an abstract spirit of mankind in the real world, is the liberation of the worker. For many artists, the heroic and revolutionary nature of such speculation, and further, the need for certain "world historical individuals" (to borrow a phrase from Hegel) to drive the mechanism forward, were enticing. Perhaps the first artist in whose works we can identify the effects of this ideological ferment is Gustave Courbet.

COURBET

Gustave Courbet (1819–77) is today known (perhaps misleadingly) as a "realist" for his essentially unsentimental portrayal of life in the mid-nineteenth century. One of the most famous of his early works is his

■ 7.2 Gustave Courbet, *A Burial at Ornans* 1849
Oil on canvas, 10 ft 3 in × 21 ft 8¾ in (3.12×6.62 m)
Louvre, Paris

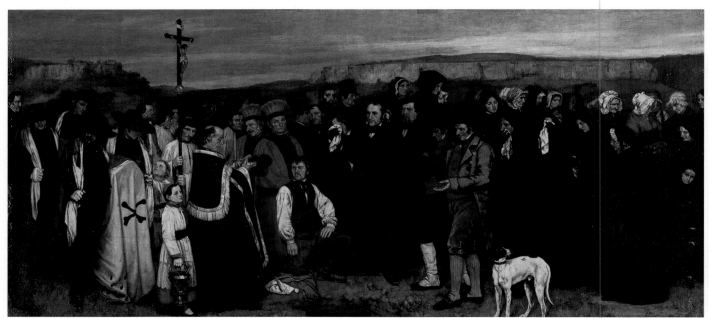

■ 7.3 Gustave Courbet, *The Stone Breakers* 1849
Oil on canvas, 5 ft 3 in × 8 ft 6 in (1.60×2.59 m)
Formerly Gemäldegalerie, Dresden (Destroyed 1945)

vast *A Burial at Ornans* (Fig. **7.2**) of 1849. Its acute description of this simple yet profound ceremony seems to have provoked very specific, sometimes vehement, responses in the years immediately after its unveiling, and as a result the realism was thought to be motivated by little more than socialist concerns. The negative reaction to this subject matter should not come as a surprise, as throughout the history of Western art few artists had ever considered the plight and devotion of the peasant as a topic worthy of serious attention—other than for overtly sentimental or moralizing reasons. But it would be misleading to view Courbet as principally a politically motivated painter; instead, his work asserts a very modern notion that an artist is first and foremost a social barometer of the age and context. In 1861, Courbet wrote: "An epoch can be reproduced only by its own artists. I mean artists who have lived in it. I hold that the artists of one century are fundamentally incompetent to represent the things of a

past or future century. . . It is in this sense that I deny the existence of an historical art applied to the past." This was, of course, an affront to the academic standards of Neo-Classicism, but it also was an artistic call to arms for expression tied directly to the events, traumas, and psychology of the age—art as a dynamic if sometimes uncertain voice within culture, rather than a decorative or didactic tool. This opinion did not go over very well in critical circles, since most influential writers and "taste-makers" still viewed art as a tool for moral elevation and profound teaching, and consequently saw everyday events as simplistic and unworthy subject matter. As a result, *Burial at Ornans* was rejected at the Universal Exposition of 1855. Courbet responded by setting up his own show in a tent next to the official exhibition. In the process, the always flamboyant Courbet sealed his reputation as a master of self-promotion (again a posture considered unworthy of an artist in earlier times) and a politically astute artist.

How does such a dramatically different view of art alter the way in which the artist, and thus the viewer, come to appreciate an artwork's meaning? Here, a simple comparison might prove useful. We have talked at great length about the important reciprocal relationship between contemporary ideas in other fields of human inquiry and those in the visual arts. If one compares Courbet's *The Stone Breakers* (Fig. **7.3**) of 1849 with Jacques-Louis David's *Oath of the Horatii* (Fig. **6.16**), it seems quite apparent that the artists in question constructed their paintings with very different intentions. David demands that his composition evoke the same characteristic sensibility as the tale he tells. Thus the rigid geometry and severe handling of forms further accentuate the impression of ultimate sacrifice. In short, form (the stark, angular composition, and its reserved handling) and content (a tale of heroic denial and stoic discipline) merge into a unified and consistent whole. This relationship between form and content is no less important to Courbet, but his choice of conven-tions to accentuate his message is telling. Though Courbet understood and even utilized a number of traditional compositional devices in his execution of work (notice how the implied diagonals created by the picks counter the opposing sloping diagonal of the background), the seemingly natural gestures of the figures give the impression of an authentic and perhaps more "natural" space. Rather than developing an architectural framework or other mathematically derived pictorial structure, Courbet's painting enables the viewer to enter into the scene with few external or otherwise presumed considerations other than the labors of the two men. As a result, one's concentration is thrust upon these two solitary figures and their brute activity; if there is any heroism present, it must rest with the travails of the workers, and the elevation of the here and now. Painted only a year after the 1848 revolt in France, it speaks of an art for the masses and a creative process intimately linked to the stresses of the street. This is what "realism" meant to Courbet.

▶ PHOTOGRAPHY AND PAINTING

● One of the traditional functions of art in Western society is to suggest or re-create aspects of the world one normally perceives—to provide a window onto the world, or at least imply that what is seen in art abides by most of the rules of everyday perception. Despite often dramatic changes in philosophy, subject matter, and even taste since the Renaissance, there had always been a consistent and underlying assumption in the West that art functioned within the confines of representing forms. But suppose someone was to invent a machine that could not only document the world around him/her effectively but do it better and more accurately than any human. Would this dis-covery diminish the importance and status of art in culture, or would it force artists to reconsider the nature of art in an increasingly industrial and mechanized age? By the middle of the nineteenth century, the advent of the camera signaled a new era for art, and it forever changed the way artists and viewers were to look at the world through images.

The working premise behind photography (from the Greek to write or describe with light) had in fact existed for a number of centuries before it was finally fixed on paper. Initiated during the Renaissance and further developed through the Baroque period, a device called a "camera obscura" (Fig. **7.4**) was used in the study of

■ **7.4 Camera Obscura in cutaway view 1646, engraving**
Museum of Photography at George Eastman House
Rochester, New York

■ 7.5 Julia Margaret Cameron
Alfred Lord Tennyson 1865
Silver print
10×8 in (25.4×20.3 cm)
The Royal Photographic Society, Bath

when applied to a surface could reproduce the projection as a static image. In 1826, thanks in part to the huge strides in the field of chemistry during the late eighteenth and early nineteenth centuries, Nicéphore Niépce produced the first photograph. And though the exposure time was a lengthy eight hours, it set off a wave of pioneering developments that forever changed the way we view the world.

In 1837, Niépce's associate Louis Daguerre invented the "daguerreotype," which was a chemically derived silver-plated copper sheet—an invention that produced a clearer image in far less exposure time. Before long, the exposure time had lessened to such a significant degree that it was possible to document people clearly in these silver plates (the natural movements of a human and the long exposure time made it almost impossible to photograph individuals before this point). A fine example of such portraiture is Julia Margaret Cameron's photograph of *Alfred Lord Tennyson* (Fig. **7.5**) of 1865.

The refinement of the photographic image through the middle years of the nineteenth century sent shock waves through the art community. The repercussions of such accessible, accurate "do-it-yourself machines" for the art world, which prided itself on the craft of representation, were predictably significant. The issue of craft, where an artist painstakingly studies nature and learns to represent it (consider Reynolds's discourses on art, Chapter Six, pages 268–71), was now in jeopardy, since this new technology could do it better, more economically, and in less time than the painter.

perspective. It was made of a simple enclosed box with a tiny hole in one end, which allowed external light to pass through and project an image onto the interior wall. The inverted image was then traced by artists, who used the projected image to obtain a more "lifelike" representation of the world. The problem was how to fix this image in a permanent state. The answer came in the form of light-sensitive silver salts, which

■ 7.6 Oscar Rejlander
The Two Ways of Life 1857
Combination albumen print
16×31 in (40.6×78.7 cm)
The Royal Photographic
Society, Bath

There were those who attempted to mimic "high art" subjects and composition through the photographic medium, such as Oscar Rejlander with his *The Two Ways of Life* (Fig. **7.6**) in 1857. Often, as in the case of this image, the result lacked the consistent internal harmony we have come to expect from a painting. But the effects of photography were soon to influence even the most traditionally minded artists.

COROT

Jean-Baptiste Camille Corot (1796–1875) is an excellent example of a painter who "resaw" his subject in terms of the photograph. The artist's early works reflect an interest in capturing a specific place and time—a contemporary idea that would find its greatest expression in the later Impressionists. A painting such as *Papigno* (Fig. **7.7**) of 1826 is indicative of Corot's desire to order and solidify his experience of a dynamic environment into a well-orchestrated painting. What is particularly notable about these early works is the uncanny stillness of the landscape (reminiscent of Poussin) that seems more in line with still-life painting than the natural world. Nevertheless, the combination of rigorous visual observation and an uncanny sensitivity to natural light makes these simple scenes arresting to the eye.

Like his predecessor Poussin, Corot spent much of his time in Italy, but he returned home to the outskirts of Paris toward the end of his life. There he came into

■ **7.7 Camille Corot**
Papigno 1826
Oil on canvas, 13×15¼ in (33×38.7 cm)
Fritz Nathan Collection, Zürich

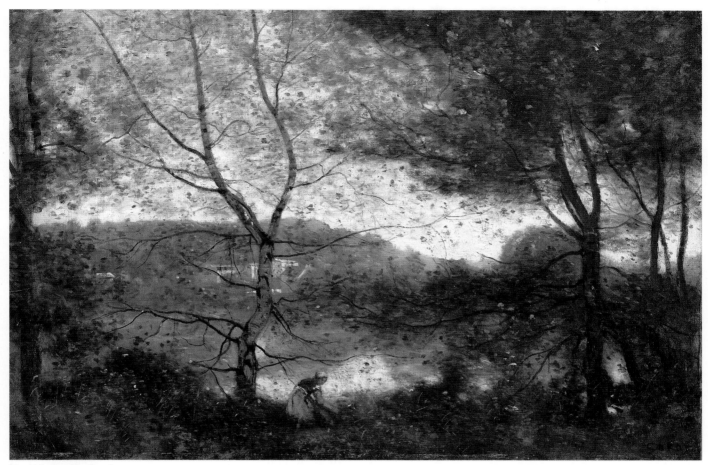

■ **7.8 Camille Corot**
Ville d'Avray **1870**
Oil on canvas
21⅝×31½ in (55×80 cm)
The Metropolitan Museum of Art
Bequest of Catherine Lorillard Wolfe, 1887

contact with a group of inventive photographers who too were captivated by the landscape. By the 1860s the exposure time for a photograph had dwindled down to mere seconds, which made it workable for documenting human subjects. However, even one second of exposure time became an issue for those souls interested in photographing the natural world. A simple phenomenon such as wind or the passage of light through leaves changed the position of objects constantly, and the result was a photograph with three notable characteristics: first, blurred areas, caused by the movement of forms during exposure; second, the disintegration of some forms due to strong sunlight, which breaks down solid forms and creates a feathery appearance throughout called "halation;" and third,

the combination of blurring and halation which creates an integration of all areas of the field, in turn unifying the plane. The concept of blurring should come as little surprise to those of you familiar with even the simplest of cameras, and anyone who has walked through a light forest on a sunny day will understand the concept of halation; but it was the combination of these two phenomena that provided Corot and other artists with a new set of conventions for describing the natural world. Corot's *Ville d'Avray* (Fig. **7.8**) of 1870 is an excellent example of such an assimilation of photographic devices into traditional painting, and it paves the way for an even more revolutionary departure from convention—with the group we have come to call the Impressionists.

▶ THE ARTIST AT MID-CENTURY

● Photography was by no means the only innovation to find its way into the realms of art. During the early nineteenth century the fields of physics and optics also paved the way for breakthroughs in the understanding of color. In 1839 the French thinker Eugène Chevreul published his *Principles of Harmonies and Contrasts of Color and Their Application to the Arts*, a text that was to influence a whole generation of artists (both Monet and Seurat had firsthand knowledge of this work). In his treatise, Chevreul claimed that colors in proximity to one another influence and modify how each is perceived. This means that we as viewers see color only in relation to its environment, as each sensation of color is directly related to its position among other colors. Chevreul also stated that any color seen alone appears to be surrounded by a specific complementary color, somewhat like a faint halo. (Try staring at a red dot for a minute, and then quickly look away. Notice how you now observe a green or opposite color ghost in its place.) To see what this meant to artists at the time, a brief look at a color wheel (Fig. 7.9) will be helpful.

According to then contemporary color theory, the

relationship between colors was explained in terms of a schematic wheel, with the colors blue, red, and yellow providing the backbone for all other combinations; because of the necessity of using these three colors in the mixing of all other colors, we call them "primary." You will note that half-way between red and yellow on our wheel is the color orange, which is produced by mixing equal portions of the primaries on either side. Given this configuration, the colors closest to each primary will then have a greater saturation of that color in their mix (red-orange, red-violet). Now, if we examine the color that lies directly opposite any "hue" (the property which gives a color its name) on this wheel, it will become apparent that this complementary possesses none of the color traits of its opposite. Take the color red, for instance. According to the wheel, its complementary or opposite is green, which is made up of equal parts of yellow and blue—and no red. Now consider this phenomenon in the light of Chevreul's claim that each color possesses a faint halo of its complementary when isolated. One obvious (though mind-boggling) corollary is that each color we perceive has implicit characteristics of every other hue in its makeup.

Interesting though all this might be, such treatises are only of value to artists when they can be practically applied. One implication drawn from the findings was that artists could use colors (usually referred to as "chroma," with regard to the purity of the colors and the amount of their saturation in the paint) that were dramatically more intense in close proximity. When such high chroma color applications were allowed a degree of breathing space between them, the result was an intensified experience of each; when placed in closer proximity, the vivid colors neutralized each other. A good example of this idea in pictorial form is a work by Pierre Auguste Renoir (1841–1919), *Railway Bridge at Chatou* (Fig. **7.10**) of 1881, where a variety of intense colors are used to create a dazzling yet still remarkably harmonious painting.

One other, often forgotten innovation is worthy of mention before discussing in earnest how Impressionist painting has shaped our contemporary view of art: the tube for holding paints. Before the mid-nineteenth century, an artist was to all intents and purposes con-

■ **7.9 Color wheel**

■ 7.10 Pierre Auguste Renoir
Railway Bridge at Chatou 1881
Oil on canvas
51×68 in (129.5×173 cm)
The Phillips Collection, Washington D.C.

fined to the studio, since each color had to be carefully prepared, the pigment ground, and mixed with safflower or some other available oil. This put obvious restrictions on any artists interested in natural light; they would have to make sketches in watercolor—or have a very good memory! The production of the squeezable tin tube, which was sealed at one end, filled with paint, and then capped at the other, gave artists unprecedented freedom to execute work in virtually any locale.

MANET

The transition from artists like Courbet and Corot to the Impressionists appears, in retrospect, very predictable. A key figure was Édouard Manet (1832–83), whose monumental and controversial *Le déjeuner sur l'herbe* (*The Luncheon on the Grass*) (Fig. **7.11**) of 1863 suggests a new attitude toward the problem of making an image. At first glance, this work appears to have much in common with the history of Western painting already discussed, yet there are some noteworthy departures. The first and perhaps most apparent difference between this image and its predecessors is the purposeful disregard of volume in the painting. Since the Renaissance,

Western artists had been concerned with rendering three-dimensional forms on a two-dimensional surface, and thus they utilized a series of conventions to give the illusion of forms in space (chiaroscuro, perspective). Though it is certainly true that Manet still implies space within the confines of the picture plane, the figures are now handled with broad, sweeping areas of undifferentiated color, denying the traditional modeling that would grant these figures volume.

The subject matter of *Le déjeuner sur l'herbe* remains one of the most enigmatic, if captivating aspects of the work. The forthright glance of the central female nude seems specifically designed to draw the viewer into the scene, yet the relationship between figures and specifically the context of the nude in relation to the two decidedly dressed men created a stir from its inception. Even at the Salon des Refusés (where images not chosen in the Paris Biennials could be viewed) the work was viewed as scandalous, and today its iconography is still not without its critics. One contemporary wrote of it: ''A commonplace woman . . . as naked as can be, shamelessly lolls between two dandies dressed to the teeth. These latter look like schoolboys on a holiday, perpetrating an outrage to play the man, and I search in vain for the meaning of this unbecoming rebus. . . This

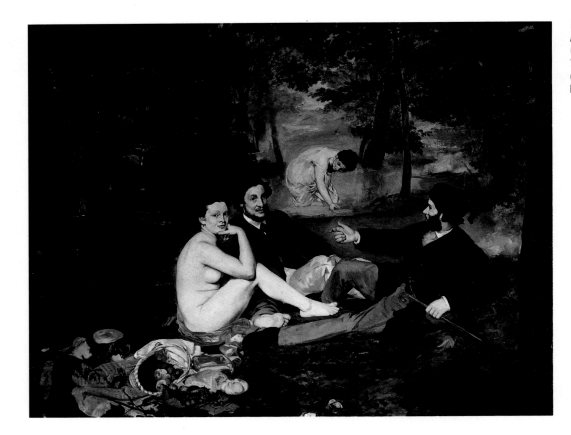

■ 7.11 Edouard Manet
Le déjeuner sur l'herbe 1863
Oil on canvas
7 ft ¾ in × 8 ft 10⅜ in
(2.15×2.7 m)
Louvre, Paris

is a young man's practical joke, a shameful open sore." Is this a commentary on the preoccupations and leisure activities of the middle-class, a mildly erotic picture of two couples caught in a private moment, or simply some artists and their models? In any event, this is a very modern picture, focused in the present, and involved with subjects that would come to personify the Modern attitude.

From reports, it appears that Manet was certainly conscious of the radicality of the piece, yet he remained convinced that its importance lay not in its subject matter but in its painting. Indeed, the unconventional array and placement of figures only reiterate the notion that this is first and foremost a painting about painting.

Perhaps this needs explaining. Today, the notion of an art piece's formal arrangement acting in part as a type of inner or self-critique is quite common, since after all it is through art's conventional language that we come to access its information. Manet's painting is an early example of this very modern approach to art making. Take, for instance, the unorthodox relationships set up between the viewer and the painting. First, there is an undeniable debt to traditional allegorical

painting in the choice of figures and setting, yet the title of the work posits little more than the acceptance of its contemporaneity, its here and now, and certainly not any of the higher or finer virtues associated with the earlier allegories of a Titian or a Watteau. Yet the formal poses of the figures contradict any suggestion of this being a simple representation of middle-class Parisians out on a jaunt in the woods. Indeed, the clash between the clothed and the unclothed, the dramatic warmth of the flesh offsetting the cool lushness of the landscape and drapery, the polarity of title and its historical debt, all point to the implausibility of this as either an allegory or an accurate representation of everyday life. Instead, we are left with a sense of the artist's freedom to pick and choose at will—for the sake of the picture, for its esthetic effect, for the sake of art. Here Manet positions himself as one of the first "pure painters" of the Modern period, where once sacred aspects of subject matter and symbolic content take a back seat to the act of painting and a regard for the material properties of the medium.

Manet was adept at recontextualizing the subject matter and compositions of other artists. A particular

preoccupation was Goya, and in Manet's reconstitution of the Spaniard's work the revolutionary character of the artist's painting becomes apparent. A good example of Manet's decisive contribution to "the new art" can be seen by comparing *The Balcony* (Fig. **7.12**) of 1869 with Goya's *Majas on the Balcony* (Fig. **7.13**) of 1810–15. Immediately, one is taken by the apparent flatness of Manet's painting, particularly when compared to the atmospheric handling of space so evident in the Goya. Manet's heightened color scheme and rigid positive–negative space design (positive referring to the shapes of forms representing the subject matter, negative to the open spaces surrounding them, often called the background) contradict many of the traditional notions of space "in" the painting—which is another way of saying that the composition reasserts the surface, rather than actively trying to deny it (as was previously popular). Manet's figures are not easily

■ **7.12 Edouard Manet,** *The Balcony* **1868–69**
Oil on canvas, 67×49 in (170×124.5 cm)
Musée d'Orsay, Paris

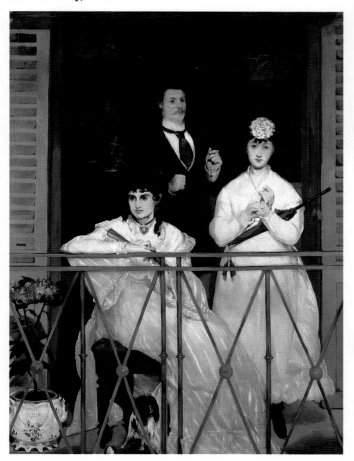

■ **7.13 Francisco de Goya**
Majas on the Balcony **1810–15**
Oil on canvas, 76¾×49½ in (1.95×1.26 m)
The Metropolitan Museum of Art

assimilated into the depths of the painting; they operate as much as flat forms of color as they do protagonists in some social affair. This does not mean that Manet was unconcerned about the content of his work—the penetrating glances and preoccupied dispositions of his subjects prove that he most certainly was. Rather, we can perhaps understand Manet best as an artist of his time, rethinking the nature of painting in an era of unsurpassed expansion. When Courbet remarked that Manet's paintings were "as flat as playing cards," he could never have imagined how prophetic those words would come to be.

▶ IMPRESSIONISM

● There are few movements in art that so exquisitely parallel the developments of their time as Impressionism. The term Impressonism is something of a misnomer, and it derives from one specific painting —Claude Monet's *Impression: Sunrise* (Fig. **7.14**) of 1872. It was in the adept hands of Monet (1840–1926) that the vision of a world created by light and color found perhaps its greatest expression. To appreciate fully the radical nature of Monet's and his fellow Impressionists' work, it is necessary once again to consider the artists within the context of traditional Western two-dimensional visual culture. Since Giotto's "re-engagement" of Classical conventions for the depiction of space and volume on a flat plane, painting was predominantly interested with naturalism as applied to form, rather than to the quality of light and color. The reasons for such a bias in the Western tradition are themselves rooted in a number of assumptions about the nature of art and existence in which painting was seen as the masterful illusion of three dimensions in two. The problem with any serious consideration of the naturalistic effects of color and

■ **7.14 Claude Monet**
Impression: Sunrise 1872
Oil on canvas
19½×24½ in (49.5×62.2 cm)
Musée Marmottan, Paris

light is that both phenomena tend to destroy the perception of depth and disintegrate form, which results in flat painting. Though such a depiction of form through the experience of light and color might seem more truthful to perception, for almost five centuries painting was preoccupied with a different kind of truth. In a world where humans saw the intellect as living proof of God's divine order, it should come as little surprise that rationally deduced conventions such as perspective and symmetrical composition found greater favor with artists. But by the middle of the nineteenth century, the world had changed, and so too had its perception of naturalism.

MONET

Monet's *Impression: Sunrise* is a very different kind of painting to those Western culture had experienced. Gone is the concrete form carefully executed to give the suggestion that it exists in a defined and measurable space. Instead, the work appears as a series of "color events" taking place on the surface of the canvas, where forms are articulated through their response to light (see Fig. **7.15**). Here, the simple recognition of halation as a perceptual reality opens the door to a revolutionary new way of looking. Impressionism had two distinct effects on painting: it elevated color to the status of subject matter, and it reasserted painting's relationship to the flat surface. But perhaps what is most interesting about these departures is how they followed a predictable evolution toward self-critique and the questioning of perception inherent in painting that had been ongoing since the Renaissance; in other words, Impressionism is at once the heir to a tradition and a departure from it.

Monet was one of the first artists to work almost exclusively out of doors. With a tube of paint in his hand, Monet was liberated from the confines of the studio, and set to work at understanding the one natural phenomenon still virgin territory in the nineteenth century—the effect of natural light on forms. Light in fact meant color, since one only perceives light through its effects on color, and color in turn was one area that the new upshot photographic medium could not in the late 1800s yet restore. So vital was the proper understanding of color to artists such as Monet that they forbade the use of black in their paintings—since black corresponded in scientific terms to the absence of color, and thus did not exist in nature.

■ 7.15 Detail of *Impression: Sunrise* 1872 showing application of the paint in the reflection

There is also a degree of self-imposed naïveté implicit within Impressionist art. The history of Western painting up until Monet had been predominantly about what one knew, rather than what one saw. Artists used pictorial conventions with the aim of producing a very particular kind of experience—one where viewers became God, and the world was organized around their gaze. Of course, the world never actually appeared this way to an individual in everyday experience, and thus it is fair to claim that painting was as much about a culture's projection of ideas onto their world as it was about an authentic, disinterested representation. Impressionism sought to bring painting in line with

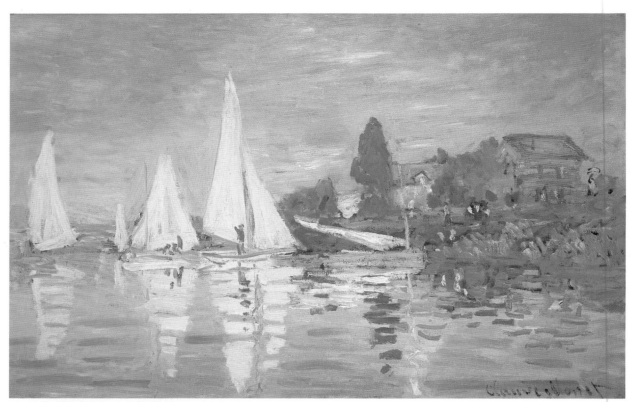

■ 7.16 Claude Monet, *Regatta at Argenteuil* 1872
Oil on canvas, 19×29½ in (48×75 cm), Musée d'Orsay, Paris

■ 7.17 Pierre Auguste Renoir, *Luncheon of the Boating Party* 1881
Oil on canvas, 51×68 ins (129.5×172.2 cm), Phillips Collection, Washington, D.C.

commonsense visual experience, and as a result, traditional conventions were replaced with a more spontaneous depiction of nature's dynamics in oil paint. In short, construction gives way to impression.

Monet's *Regatta at Argenteuil* (Fig. **7.16**) of 1872 was executed the same year as *Impression: Sunrise*, and is a good example of the radical strides the artist was making from one painting to the next. What is perhaps most captivating about this work is his commitment to showing the process of painting. Take, for instance, the vibrant array of color found in the reflection on the water's surface: rather than subtly blending his color through a series of glazes (as was traditionally done), Monet let each sensation of light have a physical, painterly correspondent. As a result, we as viewers are more aware of the artist's efforts to describe a sensation than we are of the image itself. This is called "mark making," and it takes as its premise the fact that the gestures, scribbles, and gouges produced by an artist during the execution of a work are part of the work's subject matter. The implication of such an obvious work method is that now, instead of simply looking through a window onto the world, one is forced to look at the world through the artist's physical experience of his/her subject. Paint is a wonderful carrier of messages when allowed to exist undiluted; its paste-like consistency takes brush marks and other gestures and transforms them into intimate suggestions of the artist's method of work. Thus in Impressionist painting the viewer is privy not only to the artist's sensation of the natural world but also to the very experience of painting that sensation. There is, however, a degree of irony in all of this, for in attempting to view the world in a more objective, truthful, and less "conventional" manner, artists such as Monet seemed to produce decidedly more intimate, subjective, and egocentric views of the world. Yet this is also what makes their work definitively modern, and makes their efforts all the more engaging.

● In 1874 a group of artists spearheaded by Monet organized a show of work at the Café Guerbois in Paris, after being denied entry to the fashionable Salons because of their unconventional approach to painting. *Impression: Sunrise* seems to have provoked the most vehement of outcries from critics, who labeled the entire group "Impressionists" (by no means a compliment at the time), and despite sometimes overt differences in attitudes between artists who took part in

■ 7.18 Pierre Auguste Renoir
Nude in the Sunlight 1876
Oil on canvas, 32×25 in (81×63.5 cm)
Musée d'Orsay, Paris

the initial and subsequent "Impressionist" exhibitions, the label stuck.

Pierre Auguste Renoir shared Monet's enthusiasm for the effects of light and freedom of paint handling, but was much more conservative in his tastes. Renoir is one of those rare characters in art who seemed genuinely content to explore and elevate the status of everyday joy and harmony without moralizing baggage. A painting such as his *Luncheon of the Boating Party* (Fig. **7.17**) of 1881 is a delightful depiction of *joie de vivre* in those seemingly endless forty years of peace and prosperity between the Franco-Prussian War and the First World War. But it is in a painting such as *Nude in the Sunlight* (Fig. **7.18**) of 1876 that Renoir's unparalleled ability to unleash the sensual potential of light becomes apparent. The skirting and flickering of light on translucent skin are heightened by the liberated handling of the paint, which gives the entire painting a hazy and diffused ambience.

The idea of an "impressionistic glance" not only lay in the liberation of color and an increased emphasis on the artist's response to his/her environment, but also had repercussions in the way artists composed. One such individual convinced that painting could be manipulated to suit the "natural view" was Edgar Degas (1834–1917). Some of his most captivating work was done in chalk pastel—a medium that effectively combines a variety of mark-making devices usually associated with drawing and dramatically intense color. *The Tub* (Fig. **7.19**) of 1886 exhibits Degas's formidable drawing skills and keen eye for essentials. However, what is perhaps most intriguing about this image is its rather unorthodox perspectival composition. The very

fact that one perceives the viewpoint as an oddity is in itself illuminating; the naturalness of such a view (one gets the distinct impression that we have opened a closed door and caught this woman in the midst of a bath) is an open critique of the traditional notion that the viewers hold a privileged position in the world as described in art. There is more than just a hint of the influence of photography in such work as well; Degas's disposition toward cropping elements around the extremities of his scenes reminds us more of snapshots than the ordered world of traditional painting. In *The Tub* we are privy to this scene only as passers-by—we are given a glimpse into a world without a predetermined storyline. Here, the innocent glance

■ 7.19 Edgar Degas
The Tub 1886
Pastel on paper
27½×27½ in (70×70 cm)
Louvre, Paris

■ 7.20 Mary Cassatt
Mother and Child 1889
Oil on canvas
29×23½ in (73.7×59.7 cm)
Cincinnati Art Museum
John J. Emery Endowment 1928

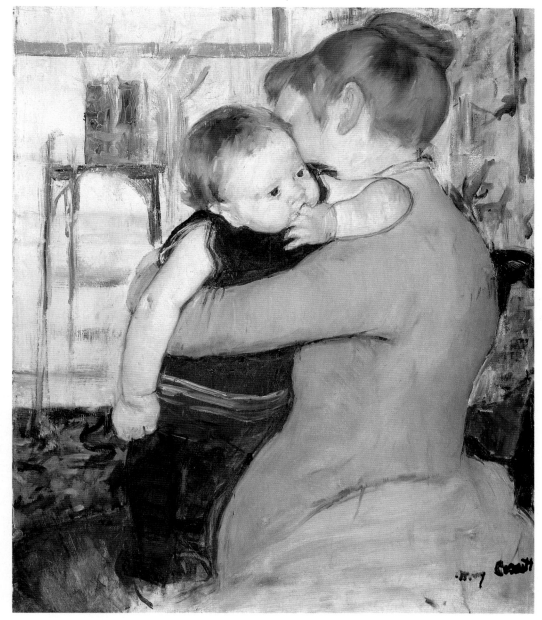

produces an impression as powerful as any specific truth to stimuli.

The American Mary Cassatt (1844–1926) was closely associated with Degas, and her work combines the often contradictory sensibilities of drawing and color with singular insight. *Mother and Child* (Fig. **7.20**) of 1889 is typical of Cassatt's work, which drew heavily on the everyday relations between mothers and their children. Here Cassatt takes Manet's initial experiments in presenting large areas of undifferentiated color to new heights; now volume is implied almost exclusively through the sensitive handling of line that forms the shapes (such as under the woman's arm or the child's wrist). Even the simple background is articulated almost exclusively through line, but these lines retain a certain unpredictable and organic quality that we have come to associate with Impressionist painting. The end result is an interesting merging of Monet's light and mark making with Manet's flattening of forms, in a satisfying and sensitive portrayal of domestic life.

▶ RODIN AND NINETEENTH-CENTURY SCULPTURE

● As was previously discussed in connection with Impressionism, the necessary and predictable path toward a revolutionary new form of art making seems to lie in the questioning of previously established conventions. Painting questioned the idea of illusion, and the discrepancy between what one saw and what one thought one saw. In this way, the concerns of nineteenth-century sculptors paralleled attitudes in the two-dimensional arts, but sculpture's established set of conventions forced it in other directions.

A work by François Rude (1784–1855), *Volunteers of 1792* (known as *La Marseillaise*) from the Arc de Triomphe (Fig. **7.21**) of 1833–6, is indicative of the prevailing interests in sculptural art mid-century. The emotional and exuberant subject matter is most certainly Romantic in attitude, yet compared to much of the painting of the period, it pales in comparison (compare it to Géricault's *Raft of the Medusa*, Fig. **6.25**). The reasons for this are as much embedded in the nature of sculpture as it was understood in the nineteenth century as they are an indictment of Rude's work, and they say a lot about the accepted sculptural conventions of the time. Despite a move toward greater naturalism in the painting of the period, it is interesting to note how derivative *La Marseillaise* appears. The reasons for this often frustrating recapitulation of supposedly "eternal" standards in sculpture between Bernini and the late nineteenth century can be directly tied to a number of practical considerations. One of the most immediate determining factors behind the execution of a sculptural project is the market—sculpture has been traditionally tied to large-scale commission work. Figurative sculpture is unlike painting in that it requires a substantial amount of room to be displayed; this places the work economically within the range of a very select group (such as the Church or state) with the resources to buy and house it. Even the cost of basic materials and labor could be so great that few artists had the capability to produce work or experiment on their own accord—they were financially bound to commission work, even as late as the 1830s.

A second factor of some significance in the development of a specific sculptural language was the necessary consideration of the work's architectural or environmental surroundings. Up until the nineteenth century, sculpture was often tied to architectural considerations. Rude's work is a direct heir to such a tradition, as relief sculpture is inextricably linked to the wall, and thus must be set within the confines of a greater architectural environment. This practical reality had a determining effect on the work produced, with everything from subject matter to scale needing to

■ 7.21 François Rude
Volunteers of 1792 (La Marseillaise) 1833–36
Stone
Approx. 42×62 ft (12.8×18.9 m)
Arc de Triomphe, Paris

be considered within the context of larger issues. This helps explain why Rude's figures continue the lineage of ideal form that dates back to Classical Greece: heroic figure modeling seems most appropriate within the realm of sanctioned heroes, which is the territory of Church and state.

Perhaps the most apparent, though often ignored, convention employed by sculptors during this period was the pedestal. It was the accepted standard for the display of sculpture as early as Archaic Greece, and was considered an inevitability in sculpture by the nineteenth century, not a convention to be challenged. A pedestal removes the object from the space and scale of the viewer; it elevates and sanctifies the object as "other," "different," and usually "heroic." Thus any appreciation of a sculptural form often came with the implicit acceptance of the majesty and sanctity of the figure, and as with perspective and chiaroscuro in painting, a seemingly arbitrary convention soon became an essential characteristic of the medium.

It is arguable that the first radical departure from such accepted norms in sculpture came, ironically, in the work of a painter—Edgar Degas's *Little Fourteen-Year-Old Dancer* (Fig. **7.22**) of 1881. It is the only sculpture Degas (1834–1917) ever exhibited, and though it exists in bronze reproduction at museums throughout the world, the original was of colored wax. The idea seems to have been to produce both a gesture and a coloration that were at once natural and convincing. Degas colored his wax to simulate the skin of a fourteen-year-old dance student, and the various accoutrements (the tutu is made from gauze and tulle, silk is wrapped around the figure as a bodice, and real hair has been attached to her head) accentuate the enormous gulf that had developed between the perception of naturalism and the nature of sculpture before this work. Degas's dancer possessed no pedestal as part of the object, so that the form is grounded on its base as a human would stand—again placing it within the context and even the psychological space of the viewer. It is also not idealized. Many critics were openly hostile to its appearance, and it seems that many writers, while willing to accept the realism of a Courbet, were not yet able to see such naturalism in the ideal world of sculptural forms.

Degas's *Little Dancer* was an affront to most of what sculpture had held dear since the Renaissance: it did not idealize, it used color rather than stone or bronze, it broke with the pedestal, and it was unapologetically

■ 7.22 Edgar Degas
Little Fourteen-Year-Old Dancer c. 1881
Wax, silk, satin ribbon, and hair
Height 39 in (99 cm)
Collection of Mr. and Mrs. Paul Mellon, Upperville, Virginia

■ 7.23 Auguste Rodin, *The Burghers of Calais* 1884–86, bronze
6 ft 10½ in × 7 ft 11 in × 6 ft 6 in (2.09×2.41×1.98 m)
Hirshhorn Museum and Sculpture Garden, Smithsonian Institute

naturalistic. But it was in the hands of a sculptor that the conventional language of sculpture was to undergo its greatest transition. Auguste Rodin (1840–1917) was perhaps the most gifted sculptor in Western art since Bernini, and his work spans six crucial decades in the development of modern art.

Rodin's *The Burghers of Calais* (Fig. **7.23**) of 1884–6 was commissioned by the port city of Calais to honor six of its citizens who, in 1347, willingly allowed themselves to be taken hostage by the invading English in the hopes that their city might be spared. Upon first impression, this sculpture has few of the qualities one

has come to expect from public monuments. Consider *The Burghers* in light of François Rude's *Monument to Marshal Ney* (Fig. **7.24**) of 1853 — a rather typical example of public sculpture then (and still) popular. Rodin's decidedly intense depiction of the human condition is at once a radical departure from the norm. The modeling of the figure responds as much to the materials in which the sculptor works as it does to any anatomical accuracy. In this way, Rodin parallels the Impressionist interest in developing a relationship between the materials one used and the image one hoped to capture, a tendency eloquently captured in the artist's drawings

■ 7.24 François Rude
Monument to Marshall Ney 1853
Bronze
Height 8 ft 9 in (2.67 m)
Place de L'Observatoire, Paris

■ 7.25 Auguste Rodin
Dancing Figure 1905
Graphite with orange wash
12⅞×9⅞ in (32.6×25 cm)
National Gallery of Art, Washington, D.C.
Gift of Mrs. John W. Simpson

(see Fig. **7.25**). Here, the sensitivity of the cast bronze replicates all of the imprints and the wrestlings with the original clay and plaster surfaces; the dialogue between the artist's creative activity and the seriousness of the subject matter creates a work of tremendous psychological penetration rather than generic glorification. Gone too is the lofty pedestal—the convention by which artists had traditionally distanced and monumentalized public figures. Instead, these figures engage one's space in a most personal and intimate manner, forcing the viewer to relate to this work on a fundamentally physical, even bodily, level. The result is a public sculpture that functions on an altogether different plane from its predecessors, as the public subject and the artistic gesture fuse into a demanding image of sacrifice.

■ 7.26 Auguste Rodin
Monument to Balzac 1897–98
Plaster
Height 9 ft 10 ins (2.99 m)
Musée Rodin, Paris

■ 7.27 Detail of *Monument to Balzac* 1897–98

One of the most celebrated sculptures produced by Rodin is his monument to the French writer Balzac (Figs. **7.26** and **7.27**) of 1897–8. Here, many of the sculptor's germinating ideas come to full maturity, and the result is a hauntingly enigmatic expression of genius. Perhaps more than any other work Rodin executed, this monolith pointed the way into the twentieth century for sculpture; a pivot between nineteenth-century representation and the need for modern artists to share some of themselves through the material process itself. The most obvious difference between this and *The Burghers* is the crudeness of its execution. It appears that Rodin was as much concerned with leaving evidence of his work methods (including chisel marks, soft modeling work, etc.) as he was interested in producing a likeness of the French novelist. Rodin hoped to create an object that did not simply reproduce the novelist in three-dimensional form but truly embodied his genius. Thus the rough-hewn look of the figure emerging out of his heavy cloak is more than a simple representation of an artist of incredible energy; it mimics such personality traits through the very work process itself. Here material, artist, and subject matter become one unified expression—a sensibility, it seems, whose time had come.

▶ THE LIBERATION OF COLOR

● As Chevreul's color theory became common knowledge in art circles and the photograph proved itself increasingly adept at representing reality on a two-dimensional plane, many painters began excursions into color as a means of unlocking the potential still believed to be manifest in painting. The debate about the nature of painting had been around as long as painting itself, but it was often fought in and around two prominent positions; in the days of the French Academy it was the "Poussinistes" versus the "Rubenistes"—or for simplicity's sake, drawing versus color.

Drawing has traditionally centered around a number of conventions used to delineate space and structure in a painting. Drawing helps create order in a work—an order many artists saw manifest in nature itself, via the grace of God through creation. The very thought of an untamed experience of the world, full of sense experience, was most probably unnerving to many an artist up until the nineteenth century. This helps explain why color often had a subsidiary role to drawing in painting. To many, color confused order and often dispersed space, and thus could be used only in moderation. But Monet had shown how one could

■ 7.28 Georges Seurat
A Sunday on La Grande Jatte—1884 1884–86
Oil on canvas
6 ft 9 in × 10 ft ⅜ in (2.06×3.08 m)
The Art Institute of Chicago
Helen Birch Bartlett Memorial Collection, 1926. 224

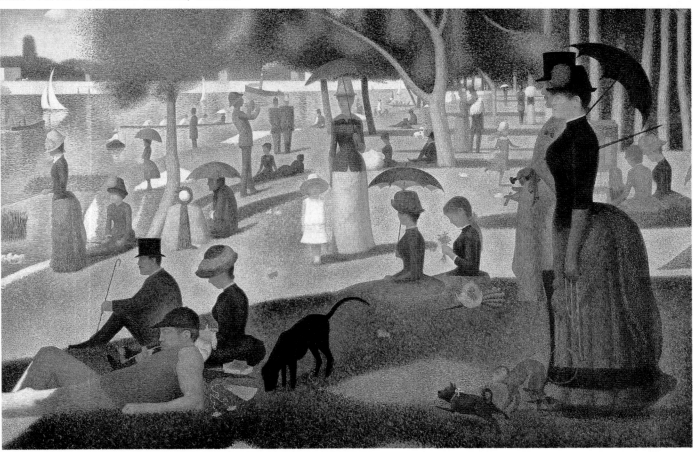

understand nature through an accurate and disinterested approach to color, and quickly other artists began similar investigations.

Color has two specific effects on a two-dimensional image: it can disperse volume, or if used in broader applications, it creates the impression of pattern. Both work in competition with drawing conventions such as perspective for the viewer's interest, and as a result often disturb one's appreciation of illusionistic space. One of the most interesting investigations into the relationship between color theory and painting came in the work of Georges Seurat (1859–91). Seurat perhaps most closely understood the repercussions of Chevreul's theories for artists, and his work stands out as the clearest expression of the influence of theory on art making in the late nineteenth century. His *A Sunday on La Grande Jatte* (Fig. **7.28**) of 1884–6 took almost two years to complete and is the most exhaustive example of his theory of "divisionism." Seurat applied his paint in small, carefully selected "dots" of chromatically intense color. He then applied Chevreul's method of neutralizing color by placing these dots in direct proximity to other colors, allowing their resonance to dissipate into a larger field; where Seurat wanted each color to retain its identity, he simply nullified most of the visual competition. The artist also effectively used Chevreul's notion of the "negative after-image," which he mimicked by placing his complementary

■ 7.29 Detail of *La Grande Jatte* 1884–86

pairs in direct conflict with one another (note the red interspersed among the field of green in the detail of *La Grand Jatte*, **7.29**). The result is a field of view that visually vibrates, much like the flickering of natural light. Here science and art merge in a truly nineteenth-century interpretation of the world.

It is hard to tell where the young Seurat might have gone with his great talent had he not died at the early age of thirty-two. But his method of applying contemporary theory to painting had its admirers almost immediately, and soon many artists had moved well beyond his initial discoveries. Yet color theory was by no means the only influence to take hold with colorists during the late years of the century; artists were looking to new sources for inspiration, and found them in the Japanese print.

THE INFLUENCE OF JAPANESE PRINTS

After centuries of self-imposed isolation from the rest of the world Japan, with its rich culture, was opened to the West in 1853, when Commodore Perry's "black ships" were granted then unprecedented docking privileges on the island. Before long, trade had brought an assortment of Japanese treasures to Western markets, including the highly sought-after Japanese porcelain. Such delicate merchandise required careful packing, and the Japanese traders used whatever was accessible—straw, wood chips, and old printed paper. Some of the first two-dimensional images from Japan to arrive in the West came through this rather unlikely route, but the timing could not have been better.

Traditional Japanese printmaking revolved predominantly around the woodblock technique, which was capable of producing a high-quality, clear image with very simple tools. The process involves the inking of cut-out wood forms, which are reassembled and through pressure then transferred onto paper. The woodblock method is also a relief form of printing, which means that only the raised areas of the block are printed. One repercussion of this technique is that images produced in print are often quite uniformly flat and strongly articulated as shapes. Take, for instance, Eisui's *The Courtesan Yasooi of Matsuba-ya with a camellia* (Fig. **7.30**), an image probably typical of those filtering into the West during the period. The degree of outline that articulates such forms and the repetition of pattern over large areas of space were understandably very new to Western eyes. In the Japanese print, artists such

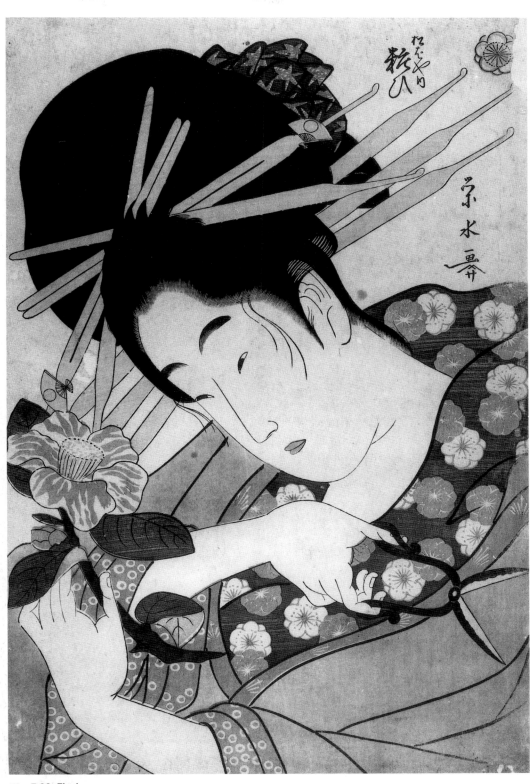

■ 7.30 Eisui
The courtesan Yasooi of Matsuba-ya with a camellia late 1790s
Oban color print. Tokyo, National Museum

■ 7.31 Mary Cassatt
The Letter 1891
Color print with dry paint, soft ground etching and aquatint
13⅝ in × 8¹⁵⁄₁₆ in (34.5×22.8 cm)
Philadelphia Museum of Art
Louis E. Stern Collection (63–181–22)

■ 7.32 James McNeill Whistler, *Arrangement in Black and Grey: The Artist's Mother* 1871
Oil on canvas, 57×64½ in (144.8×163.8 cm), Musée d'Orsay, Paris

as Manet, Cassatt (see Fig. **7.31**), and James McNeill Whistler (1834–1903) (see Fig. **7.32**) saw a degree of flatness, pattern, undifferentiated color, and internal design that was in sympathy with their own investigations. Further, the Japanese print showed a way of creating art on a two-dimensional surface without the tired conventions of perspective and atmospheric space that had been a part of Western painting since the Renaissance.

GAUGUIN

A number of artists were indebted to woodblock prints, some of whom copied directly from the images. Two of the most famous painters to pick up on the dramatic flattening of space and saturated areas of color were Vincent Van Gogh (1853–1890) and Paul Gauguin (1848–1903). However, each artist also brought to this new set of conventions a very specific attitude about

the nature of color and its psychological effect on the viewer. A painting such as Gauguin's *The Vision after the Sermon* (Fig. **7.33**) of 1888 is a striking example of his willingness to let color inform the viewer in less than traditional ways; here color is not a matter of simply transcribing natural events with a sensitive eye (as was the case with the Impressionists) but another way of generating subject matter. Gauguin, like many of his contemporaries after Impressionism, desired color that was liberated from its role as representation, and as a result functioned with a degree of symbolism and intent on the part of the artist (hence the rather loose term ''Post-Impressionist'' to describe those artists who consciously rejected the naturalism of the Impressionists). *The Vision* shows an obvious indebtedness to

Japanese sources with its flat areas of vibrant color and denial of perspectival motifs, but it is also a religious painting done by an inherently Western artist. Gauguin's use of the flat red field (at once a revolutionary departure from Impressionist naturalism) makes demands on the viewer that are not simply perceptual but decidedly psychological in nature. One understands ''red'' not only as the color of an apple, but as a suggestion of warmth, passion, carnality, and a host of other notions. As humans, we are no more capable of separating our feelings from our perception of color than we are able to have a truly objective thought. Gauguin understood this implicitly, and used painting as an arena for investigating our more private instincts.

Gauguin drew from other sources besides woodblock

◄ 7.33 Paul Gauguin
The Vision after the Sermon 1888
Oil on canvas
28¾×36½ in (73×92.7 cm)
National Gallery of Scotland, Edinburgh

■ 7.34 Paul Gauguin
Ia Orana Maria 1891
Oil on canvas
44¾×34½ in (113.6×87.6 cm)
The Metropolitan Museum of Art
Bequest of Samuel A. Lewisohn, 1951

prints; he actively collected works from non-Western (Polynesian, West Indian) and folk traditions (Brittany) in his attempt to find a symbolic language capable of transcending traditional Western painting. In these the artist saw a freshness of approach and a more forthright dissemination of ideas without the compromising conventions of the trained artist. Gauguin and his "Symbolist" colleagues saw the history of Western art from the Renaissance on as tragically flawed by its desire to work from observation—empiricism as applied to art. By demanding greater freedom from observation in his work, Gauguin also gives the viewer a degree of autonomy to suggest a more personal meaning—often unavailable in earlier art. A good example of Gauguin's desire to cross cultural and conventional barriers can be seen in his *Ia Orana Maria* (Fig. **7.34**) of 1891, where a traditional Madonna and Child subject is placed in a Polynesian scene, accentuated by an abundance of pattern and saturated, flat color. Here the viewer is an active participant in the creation of meaning, rather than a silent receiver, and the result is eminently more satisfying.

VAN GOGH AND MUNCH

The tragic life of Vincent Van Gogh is so well documented that it often obscures the revolutionary quality of his work. Like Gauguin, Van Gogh wished to release color in painting from empirical notions, but unlike his friend, he spent his life painting from observation. However, through Van Gogh's eyes the simplest, most commonplace scene is transformed into an enticing, if often hallucinatory, experience. Take, for instance, his *The Bedroom* (Fig. **7.35**) of 1888, where a subject with seemingly little pictorial merit is elevated to the status of self-portrait. His sources are at once apparent: the ambiguous space, the large areas of flat color, the heightened palette, and the strong character of outline all follow precedents in previously described woodblock prints. But to this pictorial strategy Van Gogh adds something specifically his own—an emotional application of paint. No longer is color applied in flat, sweeping gestures; instead it is understood first and foremost as oil paint, which has its own material qualities. Here the artist draws us even further away from

established conventions, heightening not the appreciation of nature in some supposedly objective form but the intrinsic personality of the artist wrestling with his subject. The result is an even greater shift toward the primacy of the artist's subjective experience in the vision of the painting.

The implications of such blatant subjectivity for later art can be seen by comparing a Van Gogh *Self-Portrait* (Fig. **7.36**) of 1886–7 with *The Scream* (Fig. **7.37**) of 1893 by Norwegian painter Edvard Munch (1863–1944). Van Gogh's paint handling does not simply describe through color; it physically forms his features. The chisel-like quality of his brushwork distorts the face into a mask of material, each stroke a convulsive attempt to address observed reality in terms of paint. In Munch's *The Scream*, perhaps the most angst-ridden image in the history of Western art, the viewer is granted only remnants of the natural world. Instead, the painting becomes a battleground for the pressures and anxieties of modern life that seem as natural and as omnipresent as the real world, and in desperate need of a visual equivalent not realized in a

■ **7.35** Vincent van Gogh
The Bedroom 1888
Oil on canvas
28¾×36 in (73.6×92.3 cm)
The Art Institute of Chicago
Helen Birch Bartlett Memorial
Collection

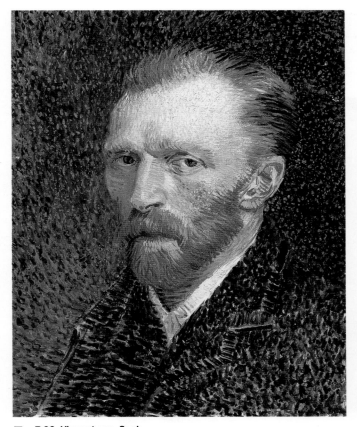

■ 7.36 Vincent van Gogh
Self-Portrait c. 1886–87
Oil on artist's board mounted on cradled panel
16½×13¼ in (41×32.5 cm)
The Art Institute of Chicago
The Joseph Winterbotham Collection, 1954. 326

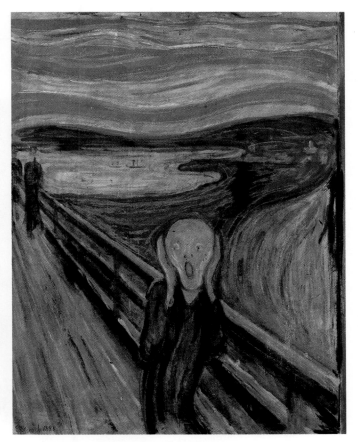

■ 7.37 Edvard Munch, *The Scream* 1893
Tempera and casein on cardboard, 36×29 in (91.4×73.7 cm)
National Museum, Oslo

■ 7.38 Edvard Munch, *The Kiss* 1902
Woodcut, printed in color, 18⅜×18⁵⁄₁₆ in (46.7×46.4 cm)
Collection The Museum of Modern Art, New York
Gift of Abby Aldrich Rockefeller

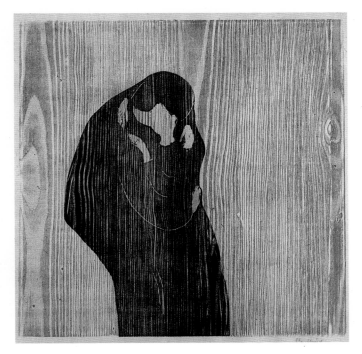

simple observation. Munch finds this vocabulary by exploring the conventions themselves: lines once used in painting to represent nature now actively break it down, and color is released from its function as a descriptive device to resonate with the sounds of the troubled mind (see Fig. **7.38**). This was to be the new naturalism of the late nineteenth century and a premonition of the twentieth, as many an individual found it increasingly difficult to divorce subjective experience from objective reality—a vivid signal of the growing dislocation of human consciousness from mechanized society. If Monet's work can be said to have grown out of an interest in natural observation, then Munch's *The Scream* attests to the increasing inability of artists to see anything outside the daily traumas associated with being human. It is interesting to note that it was during this period of peace and prosperity that Sigmund Freud developed his theory of repression and neurosis as both personal and social disorders—ideas with their pictorial equivalent in the work of artists such as Munch.

■ 7.39 Ernst Ludwig Kirchner, *Five Women in the Street* 1913–15
Oil on canvas, 47½×35½ in (120.6×90.2 cm)
Rheinischer Bildarchiv, Cologne Museum, Ludwig

■ 7.40 Ernst Ludwig Kirchner
Three Figures 1909
Woodcut
Albertina Graphische
Summlung,
Vienna

■ 7.41 Emil Nolde
Prophet 1912
Woodcut
12¾×8⅞ in (32.4×23 cm)
National Gallery of Art,
Washington, D.C.
Rosenwald Collection
© Nolde-Stiftung Seebüll

EXPRESSIONISM

The term "Expressionism" has been traditionally used
to describe artists whose work is involved not so much
with a description of nature (implicit within the terms
"Impression-ist," "Real-ist," etc.) but with the expres-
sion of less tangible and often psychological states
through images. Often such work maintains the
suggestion of a specific subject: for example, the work
by Ernst Ludwig Kirchner (1880–1938) *Five Women in
the Street* (Fig. **7.39**) of 1913–15. Through devices not
often associated with observation (aggressive paint
handling, bright unnatural color) artists were able to
produce images about the various states of being rather
than of the historically static, singular "being." They
even pirated less refined techniques such as the wood-
cut print, which they saw as raw, physical, and very
graphic. Like many an artist before them, Expression-
ists such as Kirchner (see Fig. **7.40**) and Emil Nolde
(1867–1956) (Fig. **7.41**) capitalized on the materials
and techniques of other cultures in an attempt to free
their images from the tired clichés of the Western
tradition. In appreciating non-Western and naïve
work, artists (often mistakenly) saw what they con-
sidered a more pure and less repressed expression, and
took from these cultures freely. In Expressionist art,
reality is understood as the production of each
individual, with all of the idiosyncrasies inherent in

◄ 7.42 Henri Matisse
Still Life with Goldfish 1911
Oil on canvas
58×38⅜ in (147.3×97.5 cm)
Pushkin Museum, Moscow
Succession H. Matisse

► 7.43 Henri Matisse
Harmony in Red 1909
Oil on canvas
71¼×96⅞ in (181×246 cm)
The Hermitage, Leningrad

being human. With vibrant color, disfiguring drawing, and sometimes violent applications of material, Expressionists championed the egocentric vision.

But there was also a contrary side to this revolution of color and material consciousness enticing painters at the turn of the century, and it would be a mistake to see such innovations as limited to the expression of anxiety and alienation. If color can emotionally harass, then it can also entice, and the most lyrical and subtle of the

colorists of the period was most certainly Henri Matisse (1869–1954), who seems light years apart from the moody pictures of a Munch or a Kirchner. A delightful example of Matisse's playfulness with established painting conventions is his *Still Life with Goldfish* (Fig. **7.42**) of 1911. Matisse wrote that painting was not about static truths (the kind he saw evident in the work of Seurat), nor a record of a passing sensation (the Impressionists), but about expressing a "nearly

religious feeling toward life.'' In an artist's statement published in *La Grande Revue*, Paris, December 1908, he wrote:

I am unable to distinguish between the feeling I have for life and my way of expressing it. . . Expression to my way of thinking does not consist of the passion mirrored upon a human face or betrayed by a violent gesture. The whole arrangement of my picture is expressive. . . Composition is the art of arranging in a decorative manner the various elements at the painter's disposal for the expression of his feelings.

Matisse saw the interrelationship of colors in composition as the fundamental problem for the contemporary painter, and his painstaking synthesis of color in his arrangements attests to his ability to bring harmony and tranquillity to a part of culture that was beginning to anticipate a series of major convulsions.

Matisse's unabashed use of large areas of color often gives the impression of an intricate pattern, where each element is sharply defined and articulated through bold outline—a method which forces the image to sit flush to the surface of the painting. *Harmony in Red (The Red Room)* (Fig. **7.43**) of 1909 is a good example of Matisse's unequaled ability to compose disparate objects in a coherent and seemingly effortless whole. Here, the large areas of red pattern (tablecloth and wall) are neatly offset by the strength of the green in the window (green, of course, is red's complementary color), and the figure (the white and deep blue falling on either side of the red in tone)—each of which helps balance one's perception of the scene. Further, the organic quality of the patterned wallpaper and tablecloth is carefully kept in check by the strong vertical–horizontal grid set up by the windowsill and chairs. What is truly remarkable about this sort of work is how deceptively facile it appears upon first glance; the technical problems are so convincingly solved that we feel only resolution and harmony, rather than struggle and self-consciousness. Here, Matisse is decidedly different from the Expressionists, working feverishly to avoid discord on any level.

▶ OF STEEL AND SKYSCRAPERS

● The visual arts were not the only aspects of the larger cultural machine to show signs of revolutionary change between 1850 and 1900. Architecture too was to undergo tremendous reconsideration at the hands of both engineers and architects. Perhaps the most noteworthy technical breakthrough to come about in the late nineteenth century was the development of structural steel, which enabled structures to be built higher and more safely than ever before. Up until the commercial manufacture of steel in the nineteenth century, architects had been forced to consider the tremendous weight of masonry walls when calculating the height of a building; the higher the building, the more the weight resting upon the lower walls, which resulted in the structural necessity of building thicker supporting walls at the foundation, which then ate up interior space. Even with the time-honored use of the buttressing system, it was difficult to fashion a tall structure with any sizable interior space. Steel changed all that. Arranged in a grid format around a series of reinforced columns, steel was both flexible and incredibly strong, which enabled it to carry an extraordinary amount of the building's load without the visual bulk associated with masonry—hence the term ''load-bearing steel

■ 7.44 Gustav Eiffel
Eiffel Tower, Paris, 1889
Wrought iron on a reinforced concrete base
Original height 984 ft (299.9 m)

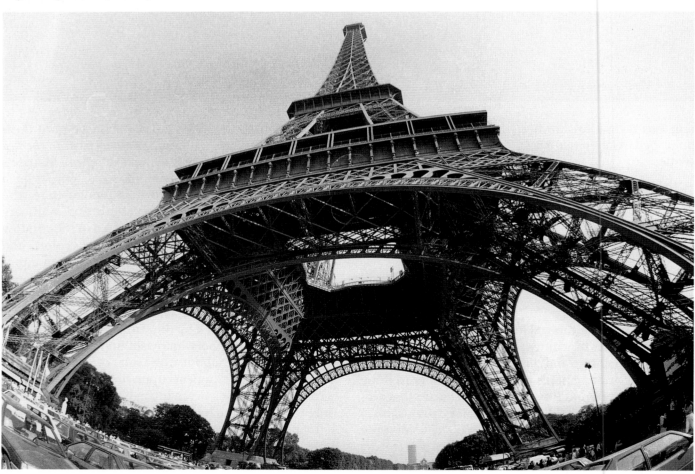

frame." As a result, storey after storey could be built upon a relatively streamlined foundation, which gave unity and uniformity to the structure as a whole.

One of the first important structures to use steel was the Eiffel Tower (Fig. **7.44**), built by engineer Gustav Eiffel for the World's Fair in Paris in 1889 (the 100th anniversary of the French Revolution). It remained the tallest structure in the world until 1932. Rather than being a functional building, the Eiffel Tower served purely as a monument and observation deck. It is important to remember that this structure predated both the skyscraper and the airplane, so a view of the world from 984 feet (300 m) up was unprecedented at the time. This must have had a profound effect on the average citizens, who now envisioned their world as an assemblage of lines and flat borders of color—the horizontalization of their known experience.

The birth of the modern skyscraper relied on yet another innovation, again tied to steel: reinforced concrete. Simply put, reinforced concrete is concrete poured into a steel rod skeleton welded together on site; this reinforces the strength and overall resiliency of the concrete. The combination of reinforced concrete and the load-bearing steel frame enabled architects such as Louis Sullivan (1856–1924) to create unified multi-storeyed buildings, fittingly called skyscrapers. His famous Wainwright Building (Fig. **7.45**) of 1890–91 in St Louis is a good example of the dramatic departures such technical innovations precipitated in architecture. Sullivan envisioned his buildings as analogous to the human body, the façade being the flesh or muscle stretching over the skeletal steel gridwork. Here, the façade reflects its internal construction rather than being self-sustaining in the manner of previous building designs. As an adherent to the "form follows function" argument (the belief that good or truthful design must follow a structure's utilitarian requirements), Sullivan built with obvious sympathy for the idea that images or objects must reflect their own structural or internal makeup—an idea popular among artists of the period. Yet, like most architecture, the skyscraper is also the tangible result of the effects of increased urbanization during the end of the last century. The concept came at the right time, as cities became increas-

■ 7.45 Louis Sullivan
The Wainwright Building, St. Louis, 1890–91

ingly crowded, real-estate costs soared, and old methods of building would have been virtually impossible to finance. The skyscraper enabled businesses to stay located in the city, employing more workers in less space than ever before. So in this regard, the form following function formula of Sullivan and his colleagues not only reflects esthetic but once again has decidedly social ramifications.

▶ NATURE IN FLUX

● Monet was perhaps the first artist seriously to question the value of traditional painting conventions based on systems rather than on actual observation. He attempted to see nature as a collection of visual stimuli of which light was the unifying and consistent feature. The result was a form of painting that more closely mimicked one's actual experience of light as color, and its effect on the perception of forms in space. But Monet still adhered to a more subtle convention—that one's gaze upon the world was static, though nature might indeed be in flux. When looking at paintings, one often takes for granted the fact that our view of the world (the illusionistic world inside the painting) is static and fixed. Our gaze is steady and absolute, with items supposedly closest to our vantage point in sharper focus than those in the background. But is this the way we actually see? And furthermore, is such a view representative of the artist's vision of the world? The artist most responsible for taking the dramatic leap into the world of unfixed perception was Paul Cézanne (1839–1906), and in his questioning of some of the most basic assumptions about observation, we witness what was arguably the most revolutionary development in painting since the Renaissance.

To get a better understanding of the nature of Cézanne's departure from traditional norms, a simple experiment might be useful. Place one of your fingers about 6 in (15 cm) away from your nose, and stare at it. You will note that in order to register the form of your finger clearly, your eyes blur all background visual information into a flat pattern of color. Now reverse the process, and register any item in the background. Your finger, now out of focus, dissipates into a "ghost" —suggested rather than clearly articulated. This is the nature of perception, and it implies that our visual concentration upon one form often requires the active disintegration of another. This should not come as much of a surprise, as such a manner of seeing is one of the ways we order our world—a survival mechanism, if you will. Now flip back through this book to any one of a number of Western paintings executed since the Renaissance, and you will note that the views represented abide by a very different principle of perception. In traditional painting, we are often able to see figures, trees, and other items in conjunction with each other that could not in reality be received by the eye at the same time. This indeed is one of the miracles of painting: viewers are given the powers of observation and order they neither possess nor experience in the real world. It is perhaps an engaging idea, but it certainly is not an accurate representation of what or how an individual sees. Cézanne desired a painting that not only mimicked the dynamics of the natural world around him but addressed the nature of human perception as well.

■ 7.46 Paul Cézanne
The Vase of Tulips c. 1890–92
Oil on canvas
23½×16⅝ in (59.6×42.3 cm)
The Art Institute of Chicago
Mr. and Mrs. Lewis Larned
Coburn Memorial Collection, 1933. 423

■ 7.47 Paul Cézanne
Mont Sainte-Victoire seen from Les Lauves 1902–04
Oil on canvas
27⅞×36⅛ in (70.5×92 cm)
Philadelphia Museum of Art
George W. Eikins Collection

CÉZANNE

Cézanne's early experiments were relatively conservative in nature when compared to his breakthrough work at the turn of the century. Yet even in earlier pieces there is a persistent questioning of space that culminates in what might be called "wandering perspective"—the design simply does not correspond to established conventions. Take, for instance, *The Vase* *of Tulips* (Fig. **7.46**) of 1890–92. The rendering of the table is at a peculiar and unreliable angle: it is hard to believe that the fruit and the vase could have actually sat on that surface. The distortion is, however, so evident that one finds it difficult to believe an artist of Cézanne's stature could have simply erred in observation. On the contrary, this obvious internal inconsistency is perhaps a more truthful representation of the still life—not of a vase and some fruit on a table, but

of the very act of looking at these items. Cézanne once claimed that he was never able to see the same scene twice; every time he blinked, shifted, reorganized his focus, or even scanned a view, his image would alter. Thus his paintings quickly became experiments in documenting the process of perception, complete with all its inconsistencies. The result is a significant distortion in the interior space of the painting, which when combined with the flat massing of color throughout the work, diminishes our ability to perceive illusionistic depth.

Cézanne's most radical paintings were produced toward the end of his life, and based almost entirely on one solitary motif: Mont Sainte-Victoire (see Fig. **7.47**). The traditional landscape subject provided the artist not only with an infinite variety of natural occurrences (wind, sunlight, cloud cover, etc.) but further gave him the opportunity to integrate the idiosyncrasies of human perception with an equally unreliable source —his immediate environment. The result is a painting that seems to fold and unfold as one's eye scans the surface. Each perceived color only partially implicates its descriptive source; the dynamic activities of the wind, the splattering of light, the eye's desire to focus, the tilt of the head, the fatigue in the back, and most importantly the act of painting itself, all contribute to the active disintegration of form. In Cézanne's work, one's consciousness of the vulnerability of perception is tantamount to truth in painting. In this way, Cézanne's paintings are about time—change and flux that are only truly understood by those with the courage and patience to recognize their effect. But Cézanne also hoped to provide a degree of order to the chaos he saw manifest in looking. As a result, like those before him, he too unapologetically implied a strong underlying structural order to his paintings (note the unmistakable vertical–horizontal orientation of the marks). Apparently, even within the chaos of such a vision, Cézanne still believed that order could and indeed should prevail—and this was a matter of conviction.

Cézanne saw the act of perception as the true subject of painting, and he wrestled with the repercussions of this position for the process of creating art. But he was categorically tied to the world of observation, and thus even in repeated motifs such as Mont Sainte-Victoire, there is never a true "system" in his painting—each piece acquired the nuances of the day filtered through Cézanne's eyes. But a systematic dissection of the world was not long in coming, primarily in the hands of young painters who understood the enormous repercussions of Cézanne's vision. The breakthrough came in 1907, and the artist was a Spaniard named Pablo Picasso (1881–1973).

PICASSO

Les Demoiselles d'Avignon (Fig. **7.49**) has long been considered a revolutionary work in the history of Western art. It was initially designed to be a moralizing tale about desire, vanity, and the corruption of the flesh, and at least in that respect it seems hardly new. But this is no didactic painting in the traditional sense of the word, and it certainly does not operate within the confines of conventional representation. There is almost no space within the interior of the scene; everything is pushed up against the front plane and depth is collapsed. Here the human figures no longer claim

■ **7.48 Ceremonial mask, Ivory Coast, Africa**
Black wood
9⁷⁄₁₆×6½ in (24.5×16.5 cm)
Musée de l'homme, Paris

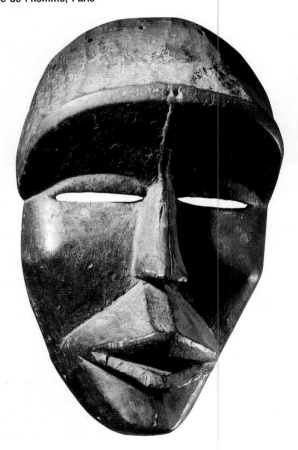

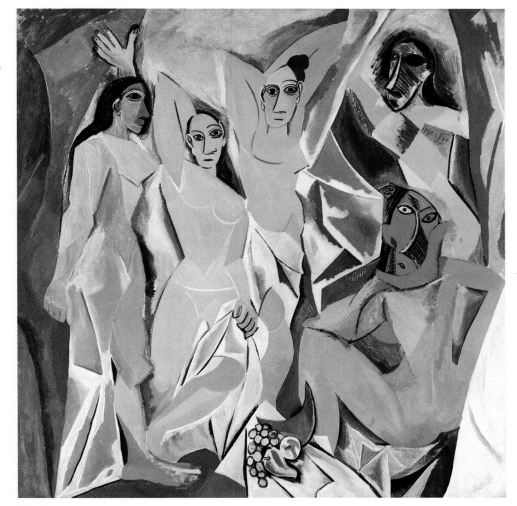

■ **7.49 Pablo Picasso**
Les Demoiselles d'Avignon 1907
Oil on canvas
96 × 92 in (244×234 cm)
Collection, The Museum of Modern Art,
New York
Acquired through the Lillie P. Bliss
Bequest

privileged status, carefully articulated as in the past to define them as separate from the dynamics of the world; instead, their mutilated bodies have become intersecting planes of flatly rendered flesh. Further, those faces—the most essential generators of individuality and meaning within the bodies—have become macabre masks, ideally suited to the demands of the painting. This is certainly not a typical painting of a brothel.

Les Demoiselles is rooted in two pictorial sources: late nineteenth-century painting and African masks. The assimilation of previous painting advances reads something like a *Who's Who* of art: we acknowledge Cézanne's shifting planes that corresponded to the insecurity of his perception, Manet's large areas of undifferentiated color that flatten space, and the strong outline reminiscent of a Gauguin or a Van Gogh. What

is most dramatic about this work is the violence with which Picasso assaults the image, and further that he was willing to take on the sanctified image of the human body to do it. Never before in the history of Western art had an artist so openly mutilated the image of the body, as if the environment was itself a weapon which destroys and reorganizes at will. Here the dynamic tensions in nature and the artist's insecurity of perception meet the symbol of a static, controlable, egocentric world—the human body—and in the end the force of history seems too great.

Much has been written on the parallels between the disintegration of volume in turn-of-the-century painting and the equally revolutionary findings in science at the time, and this raises some interesting considerations. In 1905 a little-known physicist named Albert Einstein published his famous *Special Theory of Relativity*,

in which he presented his controversial equation $E = mc^2$. This formula presented a coherent argument for a world in flux, with energy exchanging on every level at every second. This put in crisis the very idea of fixed being, and with it came the discomforting possibility that notions such as self, soul, and ego were simply conventions to make life easier to live. Though Picasso was certainly not influenced or even interested in such findings, the parallels are indeed uncanny.

Picasso's use of African masks as a pictorial source serves an important visual function in the painting, but it also reminds us how such images often carry other implicit connections to their age. In African masks (see Fig. **7.48**) Picasso saw the radical flattening of features and bold descriptive markings that corresponded rather well to his own predisposition for depicting forms, and it solved the tricky problem of dealing with the face. But it would be wrong to see such overt allusion as a form of respect or even appreciation for the motif's function or origin. Picasso saw such work simply as powerful imagery, ready to be used. In this way, artists such as Picasso paralleled many of the less articulated attitudes of Europe toward the African continent at the turn of the century—a source of raw material, cheap labor, and exotic subject matter, with little knowledge of the cultures that informed such work. This is not meant to be an indictment of such work; rather it helps explain how artists as individuals are often implicitly bound to their world, and their work is the carrier of those contradictions.

Les Demoiselles was still a long way from the systematic treatment of the painting surface that would mark Picasso's later work (see Chapter Nine for an indepth discussion of Cubism). In fact, it seems to pose more questions than it answers, and it would take time to comprehend fully the repercussions of such a departure from the norm. Yet it remains the most visible breakthrough into twentieth-century art, and it started a dialogue that would eventually bring us to the present day.

▶ SUMMARY

● Cultural historians have come to view the nineteenth century as a period obsessed with the seemingly endless possibilities afforded by mechanization and progress, while simultaneously reeling from what some have aptly called the "shock of de-christianization." As a result, the art of the era possesses these dual, often contradictory, characteristics of unbridled enthusiasm and an increasingly disturbed psyche. The role of the artist, once chiseled in the stone of patronage and representation, also underwent dramatic changes: the advent of photography, optics, color theory, art for art's sake and a rising middle class, all contributed to a view of the artist as autonomous, adventurous, heroic, moral—or more commonly avant-garde. This in turn led to a radical reconsidering of time-honored conventions for art production, including a move away from the pedestal in sculpture, a consideration of material properties in painting, and a general assumption that the artist's responsibility was to act as a catalyst for change. And if this implicitly moral, hierarchial view of art making was considered fundamental to the notion of being modern, it is to the thoughts and cultural artifacts of the nineteenth century that we owe much of our current iconography.

Glossary

Avant-garde (*page 296*) From the French, "before the rest," this was a term applied to artists of various persuasions to imply a self-appointed role as explorer or adventurer. It has implicit connotations of heroic will and the artist as savior of society, ideas in keeping with the progressive doctrines of the Romantics and the Idealists of the nineteenth century.

daguerreotype (*page 301*) A chemically derived silver-plated copper sheet invented in 1837 by Louis Daguerre that produced a clearer image in far less exposure time. This invention meant that animate objects (such as humans) could be documented clearly in photographs. It had enormous repercussions for both photography and painting.

Expressionism (*page 329*) A term historically applied to art that is involved not so much with a faithful, seemingly objective description of nature (implicit within the terms "Impression"ism, "Real"ism, etc.) but with the expression of less tangible and often psychological states. Typical devices are aggressive paint handling and the use of bright unnatural color.

Impressionism (*page 308*) An art movement which took its name from one particular painting by Claude Monet, *Impression: Sunrise* of 1872. Arising out of the naturalism of the Realists (such as Courbet), as well as an interest in the transitory experience of light and color on objects, Impressionism did two distinct things to painting: it elevated color to the status of subject matter, liberating the artist's marks from previous craft constraints, and it inadvertently asserted painting's relationship to the flat surface.

mark making (*page 311*) The gestures, scribbles, and gouges produced by an artist during the execution of a work that are left visible to the viewer, thus becoming an essential part of the overall subject matter.

pedestal (*page 315*) A sculptural device used to separate an object from the space and scale of the viewer; it elevates and sanctifies the object as "other," "different," and usually "heroic." The removal of the pedestal thus implies a movement back into the physical, tangible world of the viewer.

photography (*page 300*) From the Greek, meaning to write or describe with light, the term was first applied to a technical process in 1826 when Nicéphore Niépce first placed light-sensitive silver salts onto a surface, enabling a truthful reproduction of a projected image to be made. Though the initial exposure time was a lengthy eight hours, it set off a wave of pioneering developments that made the medium accessible, practical and affordable.

positive–negative space (*page 307*) An element of design where positive refers to the shapes of forms representing the subject matter, and negative to the open spaces surrounding the subject, often called the background. The term is used in both two- and three-dimensional art to describe the relationship between parts of a work.

Suggested Reading

As this chapter has pointed out, modern art functioned within a complex web of social and intellectual upheavals. One of the best of many recent studies of the situation is A. Boimé, *A Social History of Modern Art* (Chicago: University of Chicago Press, 1987). A thorough overview of the period is found in G. H. Hamilton's *Painting and Sculpture in Europe 1880–1940* (Harmondsworth and New York: Penguin Books, 3rd edn 1981). Finally, a classic in nineteenth-century art is Phoebe Pool's *Impressionism* (London and New York: Oxford University Press, 1967).

ART IN THE AMERICAS

■ 8.1 *Painted Buffalo Robe* (detail) 1909
Royal Ontario Museum, Toronto
Edward Morris Collection

*Colonies do not cease to be colonies
because they are independent.*

BENJAMIN DISRAELI

Since art, like all forms of communication, possesses the characteristics of language, it often runs the risk of being misunderstood by those who are not fluent in the subjects, contexts, or even materials of other cultures. Each time an image, object, or monument enters into a cultural context which is not its own, it must inevitably go through a process of translation to make it intelligible to the inheriting community. Throughout this book we have seen this type of transformation taking place; the influence of Japanese prints and African masks on the early Modernism of the last chapter are but two examples. Since no two communities share an identical set of circumstances or conditions, their lives and thus their art develop around a set of understood ideas and images specific to their locale. When outside images enter, the process of acceptance and assimilation creates what we might call a hybrid form, possessing characteristics of both cultures. Certain communities are more susceptible to such cross-fertilization than others, and often it is the forced imposition of one culture upon another that creates the most dramatic deviations. In this way, the history of art (like the history of all ideas and all cultures) can be seen as a series of mutations, with the dominant view exerting the strongest force—and there is no better place to witness the truth of such a dynamic than in the Americas. Since the second half of Chapter Nine will concentrate almost exclusively on America itself, it is essential at this point that we consider the rich and varied history of art and art making in the Americas as a whole.

▶ ART IN THE NOMADIC COMMUNITIES

● The Americas are a land of immigrants. Even the earliest indigenous peoples were once nomads, crossing the frozen Bering Strait from North Asia into the new continent in search of better lands and herds. It appears that there was no sign of human life in the Americas until those first settlers came, in or around on 10,000 BC. They were Paleolithic in social organization and habit, moving with the hunt and presumably making little that they could not haul with them. Slowly but surely, these nomadic groups moved south and east, following the continent down into Central and South America. The last of the indigenous peoples to cross over into the Americas were most likely the Inuit and Eskimo of Canada and Alaska, who retain a distinct physical resemblance to their Asian ancestors. No artifacts survive from the earliest of the Paleolithic tribes that were later to populate the southern expanses of the continent, but a number of more northern indigenous communities continued to exist in an undisturbed state well into the twentieth century, and this gives us valuable insights into art making in the early Americas.

In our first chapter, some time was spent considering the practical realities of art making in a Paleolithic context, and it was noted that the criteria were often simple: items had to be transportable and thus small in scale; they usually carried a direct relationship to issues of basic survival for the community (sustenance and procreation), and were thus designed around a set of guiding principles which were generally understood as "truth" to explain existence (a myth structure and a corresponding visual language or "iconography"). An excellent example of such imagery can be seen in a turn-of-the-century painted buffalo hide decorated with images of the hunt (Fig. **8.2**). It seems the artists responsible for this work understood the desirability of flat design for translating events or ideas on a surface; here pictures become a formal kind of language, reminiscent of handwriting. Horses, warriors, and buffalo are all rendered as generalized shapes (what are sometimes referred to as "idea-forms"), which merge actual representation with a corresponding concept. Together, the artist creates not simply a representation of an event but a symbolic language capable of merging

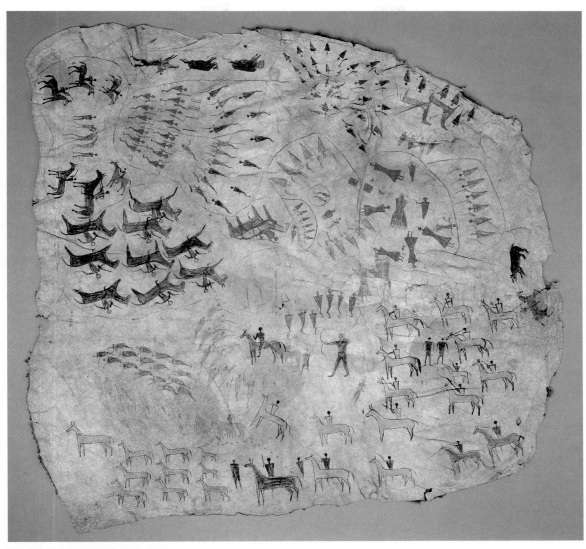

■ 8.2 *Painted Buffalo Robe* 1909
Royal Ontario Museum, Toronto
Edward Morris Collection

the physical reality of the hunt with the community's consciousness of its position in the world. In other words, events are seen within the context of the larger mysteries of life, and thus the concept of naturalism seems meaningless in such discussions.

The abundance of herds throughout the continent meant that any move toward a more settled, agricultural existence was slow in coming—if it came at all. It is interesting to note that the primary reason behind the shift to agriculture in Europe and Asia was the recurring problem of keeping up with the wandering food supply (the herds), and thus Neolithic culture (the

foundations of civilization) was more a practical solution than a noble, conscious decision. In the Americas the abundance of natural food resources, combined with the adaptive qualities of the peoples, meant that organized communities could and often did develop outside the realm of agriculture, with social structures as complex as their European and Asian counterparts. However, a number of the largest indigenous communities did turn to and subsequently thrived on agriculture, which in turn led to a more stable social organization and the specialization of labor.

To make art one must have materials with which to

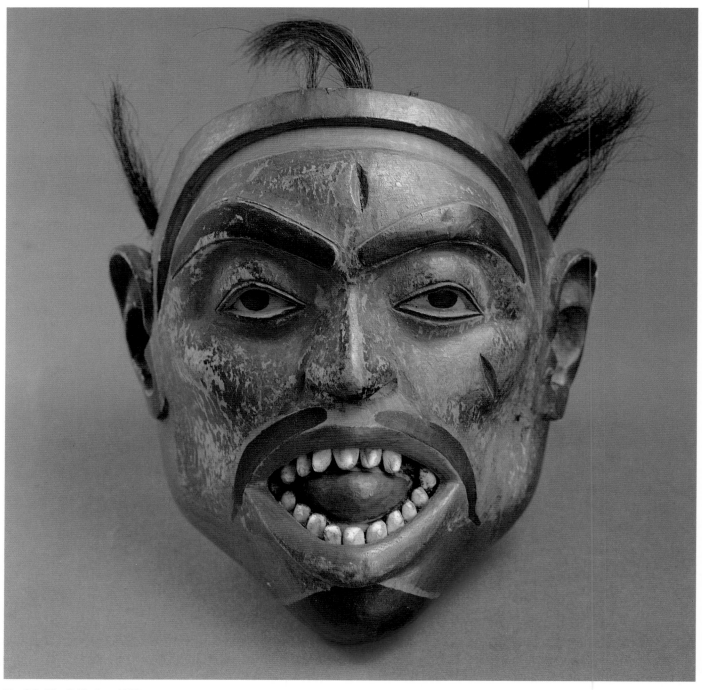

■ 8.3 *Tlingit Mask* c. 1850
McMichael Canadian Collection, Kleinburg

work, and often the materials themselves had a profound effect on the images and the workmanship of the objects in question. Take, for instance, a mask (Fig. **8.3**) created by the Tlingit Indians of the northwest coast, who utilized materials as native to them as the development of their myths. The materials (seashell for teeth, cedar for the face, huckleberry dye for coloration, and human hair) form an important, if often overlooked,

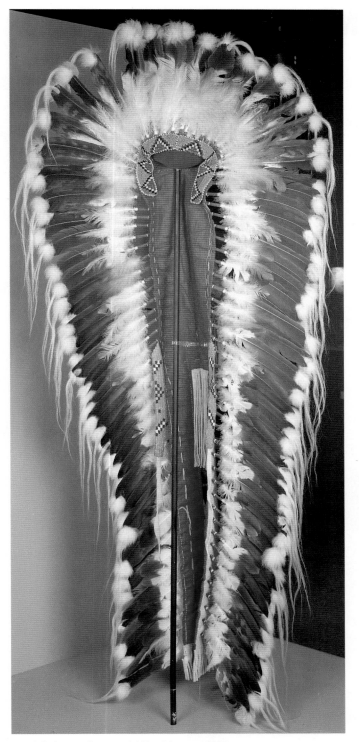

■ 8.4 *Stoney Ceremonial Headdress* c. 1900
Height 68 in (172.8 cm)
Courtesy of the Glenbow Museum, Calgary, Alberta, Canada

link to the subject matter itself. In Tlingit society, like many other native communities, the preoccupation with transformation—of individual into animal back into individual—was vital to the overall myth structure; one which both parallels natural processes of the world around them and gives meaning to existence. Ceremony is one such way of visualizing myths, and the mask, which disguises the human in another persona, provides a pivotal role in the playing out of this world view. In this case, the function of the mask (implying transformation) and its form (the materials gathered from the immediate vicinity) produce an image with direct connotations to the lives and environment of its audience. If ceremony can be seen as a celebration and meditation on a village's life, then it seems both fitting and right that its various costumes and props also provide a visual bond to its world. In self-sufficient communities such as the Tlingit, the strength of this relationship between the natural world and human ideas gives their objects an unmistakable presence.

Ceremony has historically played a vital role in any community's self-expression. In more nomadic communities, the necessity of quick migration had a profound effect on the objects and visual images produced for such occasions. In such communities, music and dance often played a primary role in ceremony, and visual imagery was used to heighten the effect of the other activities. Thus costume became an important vehicle for visual expression in communities such as the Plains Indians. Take this Stoney Indian ceremonial headdress of around 1900 (Fig. **8.4**). In the Stoney community, the wearer of the headdress had a vital role in its creation. The designs were passed down not from elder to apprentice (as is traditionally the case in Western art) but from God or the Great Being to warrior in a dream. Everything, from the materials to the design, was considered in light of the dream, and in this way we again witness a direct link between the making of the object and its meaning. In many such pieces, the idea of transformation (or metamorphosis) is present; in this example, the use of eagle feather was both a homage to the Great Spirit embodied in the bird and a visual cue for the warrior's flight into and through battle. The sight of a young brave with headdress and ornamental leggings moving at full gallop must have elicited an overwhelming psychological response in those watching. And that must have been the idea.

▶ EARLY CIVILIZATIONS

● Not all early American communities needed to migrate with their herds, and, as with Neolithic culture elsewhere, a more stable lifestyle usually sparked an increase in architecture and monumental sculpture, and with it a specialized workforce. The subsequent refinement of skills and surplus of goods culminated in a number of substantial city complexes—none more impressive than Teotihuacán (Fig. **8.5**). Teotihuacán is located about 35 miles (56 km) northeast of present-day Mexico City, and during its heyday (100 BC–AD 650) it was the largest city in the New World, with well over 200,000 residents.

The shift from nomadic to civic life has historically had a profound effect on how a culture understands and expresses itself in the world. Teotihuacán's massive population (probably developed through the combination of its assimilation of smaller communities and its ideal location near food and water supplies) created both a workforce capable of large-scale construction and a class of specialized craftspeople to put into practise such interests. As is the case in most communities, the largest building projects executed at Teotihuacán were religious in nature, reflecting the concerns of the community for the appeasement of the gods. Perhaps

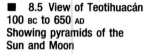

■ 8.5 View of Teotihuacán
100 BC to 650 AD
Showing pyramids of the
Sun and Moon

■ 8.6 View of Macchu Picchu c. 1500
Inca

■ 8.7 Detail of masonry work from
Ollantaytambo, Peru
Contemporary to Macchu Picchu

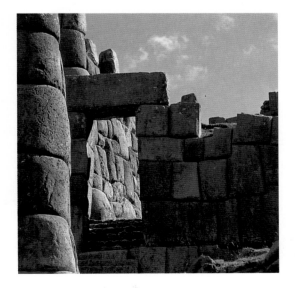

the most ambitious of these architectural projects were the Pyramids of the Sun and Moon, which are reminiscent of the pyramid constructions of ancient Egypt. The form probably derived from two sources —the burial mound and the mountain—but unlike the pyramids in Egypt, those here appear never to have been used as burial chambers. Instead, the monuments speak of life and death in more subtle ways, reflecting the passing of time and the workings of nature through a careful consideration of the structure's relationship to its environment. For instance, the Pyramid of the Sun is designed to fall into direct line with the position of the sun at the summer solstice—the point in the seasons when life gives way to death, and light to darkness (much like what was encountered in the discussions of Stonehenge, Fig. **1.7**, in Chapter One, where the design was fixed upon the winter solstice). Even the number of steps has been carefully considered within the context of the calendar, numbering 365, with the last step being the summit. The stepped outline of the pyramid

also implies ascent, as if the viewer is welcomed as a participant to engage with the structure. The Pyramids of the Sun and Moon remain primary to the layout of the city, which fans out to encompass an area of over 13 square miles (34 sq. km). Following the orientation of the pyramids, the layout of Teotihuacán is organized to precise astronomical observations, and in this regard it remains one of the most sophisticated examples of urban design intact from that era.

Another remarkable urban design is the spectacular Macchu Picchu (Fig. **8.6**), built in the late fifteenth and early sixteenth centuries in the Peruvian Andes by the Incas. Though the Incas were better known for their warring than their domestic interests, the great skill apparent in the masonry at Macchu Picchu points to a community not out of touch with design and structural considerations. How Inca masons were able to join such huge pieces of rock without mortar in their construction of the walls (Fig. **8.7**) remains a mystery, but we can surmise that painstaking effort and technical perfection were common attributes in Inca construction.

Little remains today of the once famous Inca sculpture and jewellery. The reasons for this are both economic and esthetic, and they center around one material: gold. An object such as the *Seated Female Figure* (Fig. **8.8**) from Cauca, Colombia, seems to be indicative of Inca sculpture, which was often small and portable, and made from the soft gold of the Andes mountains. It was most likely a cult figure, and with its accentuated breasts and crotch, it probably functioned as a fertility goddess. After the Spanish conquest of Central and South America, most of these objects, once essential expressions of Inca culture, were melted down for their gold—the currency of the age in Europe. On the surface, such a decision to destroy objects for their crude material worth appears to be solely a matter of economics, but implicit in such activity is the underlying assurance that these items were not art, and thus had no value outside their weight in gold. To the self-proclaimed Spanish art critics of the New World (who were often either military men or clergy), the exaggerated features, sexually charged imagery, and "pagan" subject matter did not abide by the set conventions of Europe which marked one item as more worthy of the label art than another. In short, much of the legacy of the Inca, as well as Mexican Aztec material culture, was melted down to make Spanish coinage.

■ 8.8 *Seated Female Figure* (Quimbaya) c. 11th to 14th century
From Cauca, Colombia
Gold
Height 11½ in (29.2 cm)
Museo Arquelógico de América, Madrid

▶ TWO WORLDS COLLIDE

● The colonization of the Americas by Europeans had an enormous effect on the course of art making in the Americas. From the outset we must remind ourselves that this was, even at the best of times, a matter of conqueror and conquered, with those in power dictating the values and thus the art of the communities. Through slaughter and treaty, the ravenous European states carved up indigenous culture to suit their own material needs, while ironically trying to "save" the native peoples from hell by introducing a God that was as foreign to them as the gun. But such impositions take time, and often ideas and images do not translate as effectively as one might have assumed. As a result, the mixing of two disparate cultures resulted in a number of fascinating deviations.

Some of the first images to be produced by Westerners in the "New World" were supposedly anthropological in nature, using drawings, paintings, and prints as a way of documenting events and individuals for an anxiously waiting European public. These images, produced and accepted as accurate representations of the Americas, are extraordinary examples of how one's notions of "realism" are often filtered through a number of preconceptions and stereotypes. Take, for instance, a print of an Iroquois (Fig. **8.9**), published in the late eighteenth century, which depicts the Indian as a bloodthirsty savage, equipped (one might say a bit overequipped) with the accoutrements of war: an ax, a war club, and even a musket for good measure. The costuming is particularly interesting, as the artist deemed it appropriate to give his subject snowshoes while dressed in summer attire. No doubt the Iroquois did wear snowshoes, used war clubs, and even appropriated the occasional musket, but the artist's conscious exploitation of the exotic over the actual, and the violent over the social, only further reinforced a common European stereotype of the native community as "savage"—less civilized, and therefore necessary to control. Here again, the popular understanding of art as disinterested representation takes a beating; realism and reality are based as much upon one's feelings toward an event as they are upon steadfast observation. As the old adage reminds us, we see what we want to see, and no doubt our jaundiced view of this image now is also a reflection of our own current interests and values.

One thing the indigenous peoples of the Americas and their European conquerors had in common was the centrality of visual art in religious teaching and ceremony. The first Christians brought with them not only the Bible but also an established iconography which they hoped to transplant into native communities. In the more urban centers, such as Mexico City and Ascension, the considerable European population that had immigrated to the colonies during the seventeenth through nineteenth centuries gave Church officials strict control over the artistic enterprises through commissions; but in the more isolated regions of the col-

■ **8.9** *Iroquois allant a la découverte* 1796
Etching by J. Laroque after a drawing by J. Grasset St. Sauveur, Paris
Public Archives of Canada, Ottawa

■ 8.10 *La Santisima Trinidad* (The Holy Trinity) (undated)
Wood and pigment
Height 10 ins (25.4 cm)
The Taylor Museum, Colorado Springs

onies, the strength of the native pictorial traditions provided a very different context for Christian symbolism. Perhaps the most celebrated examples of such cross-fertilization in artistic traditions are the "Santos" figures of Mexico and New Mexico, which effectively demonstrate the intriguing results of such a collision.

The word "*santos*" simply means saints, and it refers to the devotional images produced for households in the converted regions of Mexico and New Mexico from around 1540 onwards. The spread of Christianity through these communities was immensely successful, and soon there arose a need for religious imagery capable of visually translating biblical scenes. However, the isolation of many of these areas from established trade routes made the acquisition of Spanish art impractical, and often economically unfeasible. The inevitable result was the emergence of devotional images produced by local artists who carried over many of the technical and material interests of the area. *The Holy Trinity* (Fig. **8.10**) is one such example of a New Mexican "*bulto*" (a Santos figure constructed in three dimensions), carved in native cottonwood, primed with "*yeso*" (a local variety of gesso made by mixing animal glue, water, and baked gypsum powder together), and then painted with locally derived vegetable and earth pigments. What is perhaps most interesting about these Santos images is how they engage the traditional Christian iconography. Often, as in the case of *The Holy Trinity*, the images make visually explicit many of the contradictions implicit within the Christian dogma, and accentuate some of the more literal interpretations of the Scriptures. The threefold nature of the Christian God, as Father, Son, and Holy Spirit, is a puzzling abstraction to most Christians, and it should come as little surprise to find artists wrestling with its meaning over the centuries. Though today the Trinity is most generally represented with both Christ and God in human form and the Holy Spirit as a Dove, this was not always the case. The three-headed deity, of which our image of the Holy Trinity is a direct heir, was actually an accepted motif in Europe during the Middle Ages, only to be later banned in 1745 as an heretical image. However, such edicts were often slow in making their presence felt in the New World, and the image, which has precedents as well in the earlier devotional images of the indigenous culture of the region, remained an essential part of the local iconography.

Most of the religious art executed in the New World was produced in the colonies with direct affiliation to

■ 8.11 Anon.
Ex-Voto "Les Trois Naufrages" (Ex-voto of the Three Castaways) 1754
Oil on panel
The Museum of Ste. Anne de Beaupre, Quebec City

the Catholic Church, such as Portugal, Spain, and France (you will remember that the Dutch and British, both of whom had interests in the Americas, were officially Protestant and thus had little interest or regard for Church art). New France was settled much later than the Spanish colonies, primarily along the St. Lawrence River and Basin, and certain aspects of its religious art offer further unique insights into the relationship between a place, its culture, and its images. The votive painting is a particular genre of religious art which commemorates the mercy of God or the saints in the saving of a life or rescue of an endangered worshipper, and it has its roots in early European art. However, by the eighteenth century there were few who still practised the art, and fewer still who found themselves in such harrowing positions as to necessitate divine intervention. But New France was different: its climate

was often severe and merciless, and working in the woods and on the seas made many a colonist a likely candidate for heavenly help.

The *Ex-Voto of the Three Castaways* (Fig. **8.11**) is typical of such votive paintings, executed by a local artist in an uncompromising fashion. In this scene, two men and three women were crossing the St. Lawrence River when their boat overturned. Both men were able to climb aboard the hull of the boat, and secure one of the three drowning women—the others perished. Above appears St. Anne, from whom the unfortunate group seek comfort and to whom they recommend their souls. The painting was commissioned by the survivors, as stated on the inscription, in recognition of divine intervention on their behalf. It appears that there is a direct correlation between the severity of the environment and the degree of respect and even reverence a

■ 8.12 John Singleton Copley
Portrait of Nathaniel Hurd c. 1765
Oil on canvas
30×25½ in (76.2×65 cm)
The Cleveland Museum of Art
Gift of the John Huntington Art and Polytechnic Trust, 15.534

which attention will be turned shortly).

A significant amount of the New World was colonized by Britain, a country whose chief interests lay predominantly in the northeast region of what is today North America. Unlike their competitors, the French, Spanish, and Portuguese, the production of art in British North America had almost no links to the devotional needs of the community; instead, it rested on the fancies of the marketplace, both in the colonies and in the "old country." Similar to the established art market of the Dutch Golden Age, the artists of British North America produced work covering a wide range of interests, including still life, portraiture, landscape, and genre scenes, which appealed to the domestic interests of their clientele. In 1776, the American Revolutionary War severed direct political and economic links with Britain, but it had little effect on the overall production of art. Tastes remained rather puritan, with small-scale portraits and landscape painting being most popular and commanding the highest prices. Sculpture (outside large government monuments) and large-scale religious art had almost no market in such societies, and as a result little of any substance was produced during the period.

One of the first American artists to emerge from the postrevolutionary era into significance was John Singleton Copley (1738–1815), whose early portraits such as his *Portrait of Nathaniel Hurd* (Fig. **8.12**) of *c.* 1765 exhibit a love for close observation and spartan design. If one compares Copley's portraiture with that of an English contemporary (for example, Reynolds's *Portrait of the Artist*, Fig. **6.12**, of 1773) one is immediately taken by the reserve with which the American handles both his materials and his subject. In producing work that so capably mimicked the qualities of his efficient, disciplined, and moralizing young nation, Copley responded not so much to the idiosyncrasies of his subjects as to a pervasive attitude in the young United States.

culture pays to it through expressions such as art, and in the case of the early settlers in regions like New France, prosperity and stability were often equated with notions of mercy and awe. This might help explain the later authority of landscape painting in such regions throughout the nineteenth and twentieth centuries (to

▶ THE EARLY AFRO-AMERICAN EXPERIENCE

● America must have seemed a land of endless possibilities for those who could harvest its resources. But such enterprise required cheap labor, and few colonists were willing to engage in such demeaning work. The secret to success, then, seemed to lie in the ability to identify and secure a source of labor that required little or no maintenance, could be forced to provide services below the standards of the ordinary citizen, and could be morally justified to the greater community. Such a resource was found in the peoples of Africa, who were bought and sold as slaves.

The Atlantic slave trade provided a steady supply of forced labor to most of the New World from Brazil to New York, and in the process displaced and nearly destroyed a number of age-old African communities. The slave traders preyed specifically on African communities that lived in urban environments, due primarily to the practical considerations of capturing and transport. This in turn meant that individuals chosen for export to the Americas were often part of a highly complex and developed social structure, vital to any rich artistic heritage. Of the numerous African traditions destroyed during these inhuman raids, the cultures of the Yoruba, Kongo Dahomean, Mande, and Ejagham were hardest hit. The Yoruba and the Kongo, two of the most advanced communities to suffer at the hands of the traders, were destined for North America and the Caribbean.

The Yoruba were arguably the most complex and urban African society in existence when the slave traders first dropped anchor in Africa. Their cities were efficient and densely populated, with a highly specialized labor force organized around the needs of the community (as late as the middle of the nineteenth century, after years of persecution at the hands of competitors and slave traders, the city of Abeokuta still had a population of over 200,000 and was thriving). As is the case in any organized society, Yoruba religious ritual formed around a series of assumptions about the workings of the world and the elemental forces to which each individual is bound. An example of a Yoruban deity is Ogún, the "hard god," the god of war and of iron. Ogún possesses a complex duality and ambivalence (much like Shiva in the Hindu pantheon), embodied in the activities of the blacksmith, who trans-

forms iron. As a material, iron is understood both as a liberating and a destructive force in nature, the material of tools such as the machette and the hoe which clear the forest, and of the knife, a weapon of war and death. Here, the use of iron as the artist's material not only describes or initiates an expression; it embodies the experience, with all its innate complexities.

The forced migration of Yoruba culture to areas such as Cuba did not stifle such motifs, but circumstances significantly altered their manifestations in art. Take, for instance, two liturgical pieces devoted to Ogún: one produced at the turn of the century in Ilesha, Nigeria (Fig. **8.13**), the other a contemporary work from an anonymous artist from western Cuba (Fig. **8.14**). The Nigerian example, a piece of jewellery worn in religious festivals, is in keeping with traditional visual manifestations of the god, who is commonly symbolized by both the blacksmith and his fire. Each of the roughly hewn tools which decorates the pendant acts as a visual reminder of the process of transformation implicit within the blacksmith's craft, while also suggesting the ambivalence of Ogún's nature through the assortment and often contradictory uses of the tools (dagger and spoon shapes displayed side by side).

The Cuban devotional cauldron (*"caldero de ogún"*) is made of cast iron, and holds an assortment of found everyday objects of the same material, such as nails, chains, bracelets and so forth, as if containing a simmering broth of metal. The items, ranging from horseshoes to arrows, parallel the visual operations implicit in the Ilesha pendant, focusing on the contradictory nature of

■ **8.13** From the Oginnin Ajirotitu Forge, Ilesha
Amula ogún (Ogún pendant) c. 1900–25
Brass and iron

■ 8.14 *Caldero de ogún* (Ogún cauldron), Cuban, c. 1970
Iron

associated with both the Yoruban and Dahomean Ogún. The banner motif, often illustrated alongside representations of the warrior saints, also had direct visual parallels in African society, and it was not long before the format of these Christian religious banners took on new meanings.

A marvelous example of this appropriation and assimilation of the banner format can be seen in a vodun (voodoo) flag dedicated to the unified spirits of both Ogún (Ogoun) and St. James, produced in Haiti around 1945 (Fig. **8.15**). Unlike the Christian banners from which they are stylistically derived, the coloration of such flags was often enhanced by the use of reflective materials such as sequins and bright, chromatically rich fabrics. The decorative embellishment hints that they might also derive inspiration from traditional costuming used in religious parades; banners of a similar design and makeup can still be seen today in Mardi Gras celebrations.

It is interesting to note that the most prolific visual art produced within slave communities was in areas with strong ties to the Catholic Church (the Caribbean and South America). It seems that such societies condoned

the iron creations. In this case, the artist has made accommodations to the New World, utilizing found, prefabricated objects. Yet despite the differences in appearance between the two objects, there remains a commitment to the materials as content—not simply illustrating an idea, but existing as the idea. In recent years the *"caldero de ogún"* has found its way into the Cuban communities of New York and Miami, continuing one of many such traditions that arrived with the first slaves.

Few of the early slaves were given any say in the religion they were to follow in the New World. In areas such as Haiti, they were forcibly baptized by law, and given cheap reproductions of the various saints to help them understand Catholicism. Predictably, such a collision of Western and African religious and pictorial traditions created yet another set of hybrid forms and ideas—something we have already noted as a fundamental characteristic in the art of the Americas. One example is the transformation of St. James, the patron saint of Spain, who was popularly envisioned as a soldier clad in armor, iron sword in hand, trampling Saracens under his feet. Such imagery had a profound effect on the slaves who drew distinct parallels between such violent imagery and the notion of death by iron

■ 8.15 Adam Leontus
St. James/Ogun Flag, Haitian, c. 1945
Gold sequins sewn on crimson silk

the use and production of images to enhance religious teachings, and hence the fascinating mutations. In North America, most early slave art centered around crafts such as basket weaving, quilt making, and pottery. The relative lack of activity in painting and sculpture in these slave lands can be attributed to both the prominence of Protestantism in the region (and in particular the strongly anti-pictorial Baptist community of the South), and the rich craft tradition from which Afro-Americans drew both inspiration and technical proficiency. As a result, many of the early items produced in North America were utilitarian in nature,

but with a regard for pattern and color missing from the often austere colonial esthetic. A good example of the technical virtuosity manifest in such work is a coverlet (Fig. **8.16**) produced in the first half of the nineteenth century at a plantation in Virginia. Often, such work was produced from shreds and scraps—virtually anything the artists could scavenge from among the waste of the plantation. It is indeed a testimony to the vision and conviction of these early Afro-American artists that despite almost impossible conditions and few materials, they kept their rich visual tradition alive.

By 1900 American communities began to thrive in

■ 8.16 *Coverlet*
c. 1800–50
From the William J. Fitzgerald Plantation, Pittsylvania, Virginia
106×96 in
(269.2×243.8 cm)
Los Angeles County Museum of Art
Gift of Mr. and Mrs. H. W. Duncanson

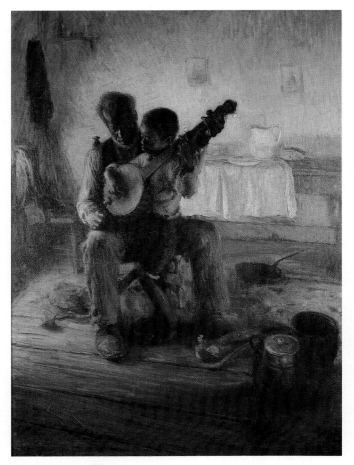

■ 8.17 Henry O'Tanner
The Banjo Lesson c. 1893
Oil on canvas
48×35 in (122×89 cm)
The Hampton Institute, Hampton, Virginia

urban centers such as New York, Philadelphia, and Washington, brought on by a steady migration of rural black families to the large labor pools in the industrial Northeast. The combination of access to schooling and supplies, and the tenuous integration of the American black into mainstream white conservative European culture had an enormous effect on the community's artists. A few black artists traveled and studied abroad, assimilating the advances in Impressionism and Expressionism, and reworking such conventions to suit their own vision. Henry O' Tanner's *The Banjo Lesson* of 1893 (Fig. **8.17**) is a good example of the integration of then current pictorial strategies (the emphasis on mark making, strong outline, and paint application) into the work of the black American painter—perhaps the premier American painter working in Paris during the time.

In time, such popular painting ideas found their way into the art communities at home. This in turn created a generation of sophisticated artists nurtured on both contemporary European trends and traditional black motifs. One of the pre-eminent hubs for such activity was Harlem, which provided an essential focus for black culture during the first decades of the twentieth century. During this period, a number of artists associated with the "Harlem Renaissance" were to come into national prominence, including the prolific Jacob Lawrence (b. 1917).

Lawrence is a good example of an artist acutely aware of his position as both an artist and a member of a disenfranchised group. He used the conventions of modern painting as a springboard for his own brand of social commentary. A work like *One of the Largest Race Riots Occurred in East St. Louis* (from *The Migration of the Negro* series) (Fig. **8.18**) of 1940–41 exhibits the artist's assimilation of Modernist ideas such as the flattening out of the space and the graphic potential of undifferentiated planes of color, but these conventions are kept in check by an overwhelming need to create an intelligible narrative for the viewer. The choice of such Modernist strategies for the description of events is a conscious and noteworthy one; Lawrence embraced ideas that themselves derived from African conventions and, like Picasso, used them for more personal ends. They combine to produce work which is at once both contemporary and relevant—a piece of Modernist art with didactic aims.

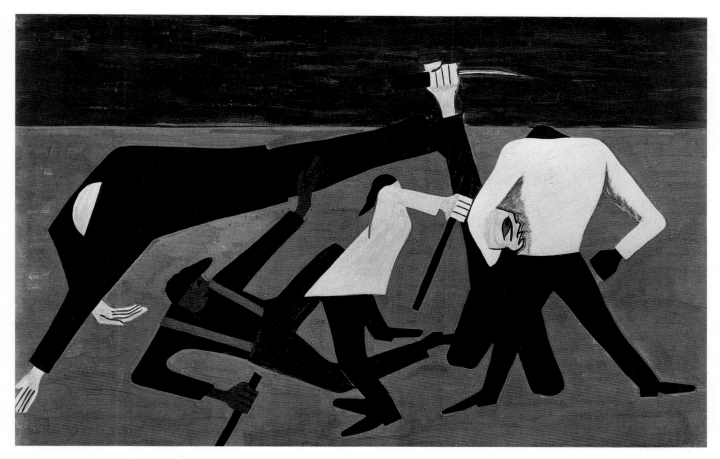

■ 8.18 Jacob Lawrence
One of the Largest Race Riots Occurred in East St. Louis 1940–41
From the series *The Migration of the Negro*
Tempera on gesso on composition board
12×18 in (30.5×45.7 cm)
Collection, The Museum of Modern Art, New York
Gift of Mrs. David M. Levy

▶ A REVERENCE FOR THE LAND

● The circumstances behind the immigration of Africans and Europeans to the Americas were often very different—so different, in fact, that they were bound to have an effect on the art each group produced. To an immigrant leaving a Europe of increased congestion and industrial squalor, the Americas must have seemed like a natural oasis. The vastness of the terrain and its untainted majesty must have been a profound inspiration to many settlers—an admiration that was bound to find its way into art. In the young United States, landscape painting quickly took on nationalistic pretensions: it was identifiably different, non-European, and thus considered a unique expression.

Furthermore, natural beauty, which in the eyes of many of these early artists triggered an understanding of the unity of all things, was also deemed morally good, and as a result, landscape assumed the weight of transcendental and nationalistic fervor (hence the term "Transcendentalists"). The group of artists which best epitomizes this rapture with the natural world was known as the Hudson River School, of which the painter Thomas Cole (1801–48) is perhaps best known.

Cole's *Schroon Mountain, Adirondacks* (Fig. **8.19**) of 1838 is representative of the artist's mature work. Stylistically, there is little to differentiate it from the European landscape tradition from which it springs:

■ 8.19 Thomas Cole
Schroon Mountain, Adirondacks 1838
Oil on canvas
39⅜×63 in (100.3×160 cm)
The Cleveland Museum of Art
Hinman B. Hurlbut Collection, 1335.17

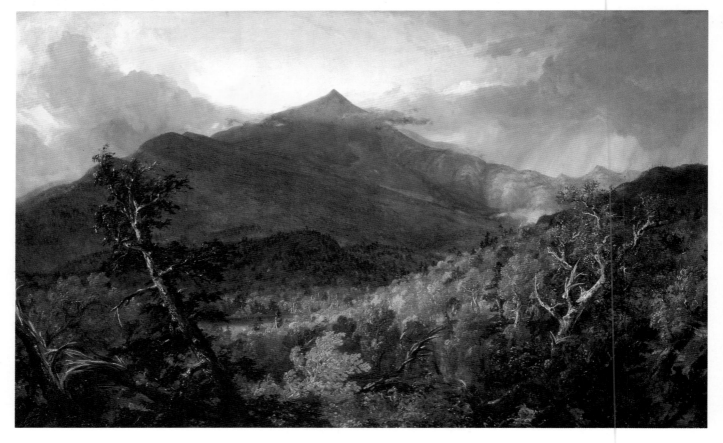

the sweeping panorama is certainly reminiscent of earlier Dutch Baroque painting. What is different, though, is the vibrancy of the color, particularly the autumn hues and the blue northern light of the Adirondacks. The simple appearance of the landscape energized such work with a freshness and grandeur we have come to take for granted in North America, but during this period taste was still in the hands of the Europeans—and certainly not of the colonists. As one might expect, these images were far more popular at home than abroad. This might help explain the reverence and implicit patriotism that surround the work. Take, for instance, the painter Asher Durand's proclamation that every American family should own a painting of the American landscape, which should be hung above the family Bible. Here the suggestion of religious awe and the wonder of God's creative power

manifest in nature are addressed in terms of the landscape. As a result, one might say that the artist's representation of the landscape filled a visual void in the religious meditations of a fundamentally image suspicious community.

Winslow Homer (1836–1910), arguably the best-known American landscape painter of the late nineteenth and early twentieth centuries, was brought up within the myth of the American landscape, yet his work retains the intimacy of human contact often overlooked in the grandeur of earlier paintings. This intimacy is produced by placing humans as active, even equal participants in the unfolding of nature—something the Transcendentalists would have found an unwarranted distraction. The result is not, as one might assume, sublime (as was the case with the Romantic landscapists) but on the contrary a picture of harmony

■ 8.20 Winslow Homer
Fog Warning 1885
Oil on canvas
30×48 in (76.2×121.9 cm)
Museum of Fine Arts, Boston
Otis Norcross Fund

and precious balance—not sentimental, but sympathetic to the fragile human condition in the larger scheme of things. Homer's beloved *Fog Warning* (Fig. **8.20**) of 1885 focuses one's attention on the human subject as an essential participant in the overall meaning of the scene; the viewer relates not so much to the blind anger of the sea but to how such anger monumentalizes the fisherman as a symbol of human dignity and simple, everyday triumph. As Americans slowly but surely gained control of their majestic wilderness, such imagery found an increasingly sympathetic audience in a population that saw its identity fixed more to marketable human attributes such as discipline and effort than to an awe for what they could not conquer. In this way, Homer's choice of subject matter is indeed a testimony to its age.

The United States was not the only nation in the Americas to develop great regard for the landscape genre. Indeed, there were some areas on the continent where geography and climate posed a very real threat to human safety and stability, and again this manifested itself in an almost religious attitude toward the landscape. Canada is a young nation by almost any standards, and its cultural expressions developed around two equally contentious issues: what Canada was and what Canada was not. The answer to what Canada was seemed to lie in the exposing of a people who struggled and continued to survive in a landscape with awesome beauty and little mercy. This, like any generalization about national identity, was a myth, as most Canadians lived not in the Shield or the tundra, but in farming communities and cities along the southern border. But myths are constructed for very important reasons: they help a community understand and develop its distinctive identity, and in Canada the landscape helped mold that identity. Furthermore, it helped express what Canada was not—the United States. In producing work about a place and a light and a consciousness very different from its neighbor's, the young nation developed a cultural vision identifiably its own.

The "Group of Seven" embodies this Canadian sense of identity in art. They were a loose association of artists who painted together from around 1911 through the

early 1920s, and who shared a desire to express the national landscape "as it was" rather than through the tired conventions of European painting, which seemed to make the Canadian landscape look like a scene from the Dutch Baroque. To do so, they employed a variety of more contemporary conventions, such as thicker applications of paint to imply the importance of the artist's experience of place through the process of painting, a heightened interest in color, and a desire to paint almost exclusively outdoors. Even their choice of seasons seems appropriately Canadian: the brilliance of autumn with its singular chromatic intensity, seen here in *Autumn Foilage* by the legendary Tom Thomson (1877–1917) (Fig. **8.21**), and, the pastel hues of late winter snow, envisioned in *Frozen Lake, Early Spring, Algonquin Park* by A. Y. Jackson (1882–1974) (Fig. **8.22**). Here, the palette—one which parallels the unique quality of northern light on the Canadian soil—takes on a distinctiveness all its own: vibrant, intense, geographically specific. Thomson, a self-trained artist who came to painting late in life, was in fact a professional outdoorsman by training and was therefore acutely aware of the subtle nuances at work in the natural world. This consciousness, perhaps even self-consciousness of the artist within the environment, is the essence of the Modernist landscape painter. Yet in Thomson's work one is ultimately seized by the apparent rightness and ease, the very naturalness of the artist's craft in the face of this dispassionate world. The recurring motifs of the hardrock Canadian Shield, the lonely white pine, the crispness of winter light and the ferocity of autumn winds all came to embody a very Canadian response to the problem of communal identity. And this point was not lost on the artists themselves. In an exhibition of paintings by the Group of Seven in 1921, the artists summed up their desires for the landscape genre: "These pictures . . . express Canadian experience, and appeal to that experience in the onlooker. Someday, we think, the land will return the compliment and believe in the artist . . . as a real civilizing factor in the national life." The parallels between the American Hudson River School and the aims of the Group of Seven are indeed striking, and they are a reminder of how art and art making are often invested with a series of meanings and justifications that fall outside the confines of simple composition and technical virtuosity. In both cases, seemingly neutral and disinterested subject matter became a vessel for a national consciousness.

◄ **8.21** Tom Thomson
Autumn Foilage 1916
Oil on wood
10½×8½ in (26.7×21.5 cm)
National Gallery of Canada, Ottawa

■ 8.22 A. Y. Jackson
Frozen Lake, Early Spring, Algonquin Park 1914
Oil on canvas
32×39 in (81.4×99.4 cm)
National Gallery of Canada, Ottawa
Bequest of Dr. J. M. MacCallum, Toronto, 1944

▶ THE ARTIST AS SOCIAL CRITIC

● Sometimes, as was the case with landscape painting in Canada and the United States, art embodies a popular vision; at other times it can become a tool of revolt and challenge. The way artists approach the problem of "intent" can have a tremendous effect on both the work methods and the outcome of their art. Take, for instance, the issue of how a landscape painter and an artist involved in political commentary attack and justify meaning in their works of art. A good example here might be the Group of Seven—artists who saw the landscape as a vehicle for larger issues such as identity and a sense of place. The emphasis with this kind of intent is on discovery, brought about by the intimate contemplation of one's world. When this kind of insight occurs, the result is an image charged with qualities that come to "embody" larger concerns. With the Hudson River School and the Group of Seven, this embodiment took on nationalist pretensions, since the intense contemplation of their immediate geography "implied" that the work was about a specific locale and thus a specific, identifiably different poeple. Thus, through a long process distinct from the subject itself, the work may become a channel for political ideas. In such cases, political or social relevance is "projected" onto the subject as a way of extrapolating the greater meaning of the art for the culture. Such a road is long, treacherous, and impractical for a political artist, whose message may get lost among the bravado of the paint and the beauty of the subject matter. Instead, the political artists' intent is to provide commentary, communicating an idea as clearly and directly to their audience as the subject permits.

Political artists have always functioned in the gray area between the established pictorial conventions of their age and a desperate need to communicate. During the Renaissance and Baroque eras, the two could go hand in hand, as the premise behind conventions such as perspective and chiaroscuro was to order the natural world in a clear and logical fashion. However, as such conventions fell out of favor, the images themselves changed, making instant communication and understanding a more difficult and often less desirable motivation. In some cases, the two did merge with success, but in times of turmoil many an artist fell back on old conventions in order to be understood—the

events simply necessitated a clear, intelligible voice. Such was the case with the Mexican muralists, who produced some of their most important work in the early to mid-twentieth century.

The Mexican Revolution began in 1911 with the fall of the dictator Diaz and inspired almost two decades of revolt, bloodshed, and some lasting and significant reforms for its people. The turbulence of the age had an enormous effect on many of the country's young painters, who saw the traditional art of the academies as incompatible with their desire for social consciousness, nationalistic fervor, and socialist aims. In response, their choice of format was the mural, which had a rich history in the religious art of Mexico. It also had a decidedly populist component, decorating exterior façades and thus being accessible to all, not hidden away in a collection or a museum. The artists even rediscovered fresco, which gave the compositions a permanence and coloration unlike any other form of painting. The result was imagery rich in content, political in motivation, and indebted to historical conventions.

Diego Rivera (1886–1957) was one of the first of the young Mexican muralists after the fall of Diaz to establish a reputation for insightful, uncompromising images of revolt and social commentary. His *Night of the Rich* (Fig. **8.23**) of 1923–8, part of a massive cycle of twenty-four frescoes illustrating the ongoing class struggle in Mexico, combines a clear, intelligible narrative detailing the excesses of the rich with an idiosyncratic depiction of volume which derives from an investigation of pre-Columbian figures (see Fig. **8.24**), which littered his homeland. In this manner, Rivera's art opens itself up to nationalist interpretations, either directly through images or indirectly by suggesting a collective Mexican past by way of a specific conventional language—sentiments in keeping with the young nation's desire for self-determination. Here, the fresco muralist of Mexico has parallels with the landscape painter of Canada during the early decades of the twentieth century, as each attempts to assert a voice of difference and individuality through his/her art.

José Clemente Orozco (1883–1949) was another Mexican muralist who rose to some prominence during the post-Diaz period. His figures show little of the overt

■ 8.23 Diego Rivera
Night of the Rich 1923–28
Fresco
The Ministry of Education,
Mexico City

■ 8.24 Massive stone head, Olmec, Ancient Mexico
University Museum of Anthropology, Jallapa, Mexico

■ 8.25 José Clemente Orozco
Victims 1936
Fresco
University of Guadalajara

political interests of Rivera, instead concentrating on a more personal expression of the human condition. The result is a body of work that can be both poignant and subtle, as his *Victims* (Fig. **8.25**) of 1936 attests. There is a clarity and vigor to Orozco's work, and his images seem to embody suffering rather than simply illustrating its results. In *Victims*, the slashing gestures of paint seem to lacerate the bodies as much as describe them, and as a result we empathize with the participants rather than simply read the work as a set of instructions. Here, the personalities of Rivera and Orozco differ, and it is their particular intent that dictates to a very large extent the choices they make in their art.

Politically motivated art was by no means limited to Mexico during these years, as an unprecedented econ-

omic depression caused many to reconsider the political and social structures of their respective nations. American Ben Shahn (1898–1969) saw his art as a vehicle for exposing the injustices of American society. His *Death of a Coal Miner* (Fig. **8.26**) of 1949 is yet another example of an artist who walks the fine line between accepting contemporary conventions such as the flattening of space (which was considered radical and anti-establishment) and desiring to communicate

■ 8.26 Ben Shahn
Death of a Coal Miner 1949
Tempera on wood
27×48 in (69×122 cm)
The Metropolitan Museum of Art
Arthur Hoppock Hearn Fund, 1950 (50.77)

clearly to an audience. Shahn's flat figures are somewhat reminiscent of Matisse's designs, but he remained committed to a clear translation of his thoughts throughout his career, and thus his work always retained a degree of illustration.

The American continent was a land of promise and often a land of escape for its first settlers. It brought into close proximity cultures and peoples who would have had little to do with each other in their previous homes.

The sometimes volatile mixing of cultural ideas and their conventions has led to a rich, dynamic legacy of art in the Americas. It also contributed to an overall prosperity of which the world was soon to take notice. After years of artists and ideas germinating in the Old World and then being transplanted to the New, the time was about to come when the tide would start to flow the other way.

▶ SUMMARY

● An examination of the art of the Americas reveals the extent to which art, like all culturally significant ideas, deviates and changes as its original context shifts. The history of the art of the Americas is a history of integration; as the ideas of one dominant community surface (often, as we have seen, through force), so too do the conventional languages of its culture manipulate (as they are manipulated by) the existing status quo. As a result, the images of the post-Columbian Americas remain an eclectic array of hybrid visual ideas, providing a fascinating glimpse into the evolution and deterioration of cultures, nations, and ethnic communities. Here, and perhaps most vividly through art, we are witness to the exhilarating and often tragic consequences of the cross-fertilization of Western and indigenous cultures.

Glossary

Group of Seven (*page 361*) A loose affiliation of Canadian painters between 1913 and the mid-1920s whose work centered around the northern landscape as the source for a national art movement different from the art of their neighbors to the south and in Europe.

Santos (*page 350*) The Spanish for "saints," it refers to the devotional images produced for households in the converted regions of Mexico and New Mexico from around 1540 onwards. A "*bulto*" (a Santos figure constructed in three dimensions) is often carved in native cottonwood, primed with "*yeso*" (a local variety of gesso made by mixing animal glue, water and baked gypsum powder together), and then painted with locally derived vegetable and earth pigments.

Transcendentalists (*page 358*) A group of American landscape painters who considered the painting of nature as a meditation on the absolute. By using the American landscape as the source for such work, there was an implicit degree of nationalism inherent in both the rhetoric and the criticism around the movement.

Suggested Reading

Readings in the art of the Americas are quite new in most cases, since serious scholarship on the subject has just surfaced over the past thirty years (a vivid indication of art history's ties to the European tradition). Below are listed some excellent one-volume introductions to the topic: George Kubler's *Art and Architecture in Ancient America* (Harmondsworth: Penguin Books, 1975) on pre-Columbian art, David Driskell's *Two Centuries of Black American Art* (Los Angeles and New York: Alfred A. Knopf/Los Angeles County Museum of Art, 1976) and Robert Farris Thompson, *Flash of the Spirit: African and Afro-American Art and Philosophy* (New York: Vintage Books, 1984), which is highly recommended, on the Afro-American experience, Dennis Reid's informative paperback, *A Concise History of Canadian Painting* (Oxford and Toronto: Oxford University Press, 1973), John McCoubrey's sources and documents text, *American Art 1700–1960* (Englewood Cliffs, NJ: Prentice-Hall, 1965), and E. W. Weismann's *Art and Time in Mexico* (New York: Harper and Row, Icon Editions, 1985).

9
ART IN THE TWENTIETH CENTURY

■ 9.1 Joan Mitchell
Low Water (detail) 1969
Oil on canvas
112×79 in (284.5×200.7 cm)
Carnegie Museum, Pittsburgh
Patrons Art Fund, 70.63.2

*I want to express my feelings
rather than illustrate them.*
JACKSON POLLOCK

It has been said that the nature of art and art making has changed more in the past ninety years than it had in the preceding 20,000. In this regard, art has simply paralleled the social and technological upheavals of which it is a part, so though it is certainly true that the creative and critical outpourings of our century are without precedent in the history of culture, they must always be viewed in the light of the greater dynamic in which they inevitably function. The twentieth century will be remembered as the century of technological evolution: the automobile, the airplane, the atomic bomb. Art also faced up to a world that operated on very different principles from those of the happy years of Impressionism, as mass industry and global strife made notions of basic survival and human dignity uncertainties. In this quagmire of anxiety, self-absorption, and constant titillation, the once resonant voice of art and the artist seemed horribly nostalgic and sentimental. As the Marxist critic Theodor Adorno noted with regard to Expressionist painting after the Second World War; in the face of the gas chambers and mass graves of Dachau, there can be only silence—any attempt at expression would simply be meaningless. One can easily go on from these circumstances to include the ever-present excesses of neon, billboards, and loudspeakers, all of which scream in a world already deaf from the clamor. But in the early years of our century, the notion of excess was still in its infancy, and minds relished the opportunities afforded by progress.

▶ FLATNESS AS AN IDEA

● We left our discussion of the avant-garde in Chapter Seven with a particular painting, which apparently signaled a new attitude in art. The painting was *Les Demoiselles d'Avignon* (Fig. **7.49**) and its painter, Pablo Picasso, was still a young man in search of a personal statement in painting. Soon after his breakthrough piece, he began a series of what he called "investigations" in collaboration with another eager young artist, the Frenchman Georges Braque (1882–1963). The term investigation is appropriate here in addressing such an artistic enterprise, for it implies an almost scientific dissection of the established "truths" of painting, and at least to some extent their subsequent work is a reflection of such skepticism. What exactly were Braque and Picasso skeptical of? Primarily the age-old conventions of observing illusionistic space on a flat plane. There had been works, particularly in the late paintings of Paul Cézanne, which challenged the notion that the world of perception could be fixed, but this was not enough. Painting is an art of conventions, and anyone wishing to challenge the previous language has to do more than just destroy it; he/she has to replace it with another, or else there is no art. Cézanne, despite the radical quality of his late work, still adhered to the principles of observation, and thus affirmed the notion that painting was about representation. Taking the visual hint from Cézanne, Picasso and Braque began seriously questioning the legitimacy of such claims, and sought to replace the old "system" of painting with a revitalized, new vision. Their approach was called Cubism.

CUBISM

Cubism was never a term that either artist really liked; it was mockingly suggested by a rather conservative critic who claimed the paintings looked like they were made up of "little cubes." At first glance, Cubism appears to be a purposeful distortion of visual experience, as if the artists have consciously tried to shatter and splinter their subjects into an incredibly cramped space. But this is only partially true, and is more a result of visual priorities than outright mischief. Compare an early pre-Cubist painting such as *Les Demoiselles d'Avignon* (Fig. **7.49**) to a more traditionally inspired work by a contemporary, Pierre Bonnard (1867–1947).

THE 20TH CENTURY WORLD

1900	1925	1950	1975	1990

1914-18 World War I 1939-45 World War II 1950-90 The Cold War

1904 *The Psychopathology of Everyday Life* – Freud

1917 Russian Revolution

1929 Stock Market collapse

1969 First man on the moon

1919 Treaty of Versailles

1936 Hitler seizes power

FAUVISM

ABSTRACT EXPRESSIONISM

CUBISM

MODERNISM AND MINIMALISM

POST-MODERNISM

Kandinsky (1866-1944) *Improvisation No. 30* (p.395)

Bonnard (1867-1947) *The Dressing Room Mirror* (p.372)

Mondrian (1872-1944) *Composition* (p.393)

Brancusi (1876-1957) *Newborn* (p.394)

Malevich (1878-1935) *Suprematist Composition* (p.396)

Leger (1881-1955) *The Cardplayers* (p.378)

Picasso (1881-1973) *The Accordonist* (p.375), *Still Life with Chair Caning* (p.381)

Boccioni (1882-1916) *The Street Enters the House* (p.379)

Frankenthaler (b. 1928) *The Bay* (p.405)

Judd (b. 1928) *Untitled 1989* (p.413)

Braque (1882-1963) *Houses at L'Estaque* (p.373)

Gris (1887-1927) *La Place Ravignan* (p.377)

Andre (b. 1935) *Lever* (p.412)

Schwitters (1887-1948) *Merz 19* (p.383)

Arp (1887-1966) *Collage Arranged According to the Laws of Chance* (p.386)

Ernst (1891-1976) *Two Children are threatened by a Nightingale* (p.387)

Miró (1893-1983) *Woman in the Night* (p.391)

Magritte (1898-1967) *The False Mirror* (p.389)

Rothko (1903-70) *Untitled* (p.407)

Dali (1904-89) *Premonition of Civil War* (p.390)

Newman (1905-70) *Ver Heroicus Sublimis* (p.409)

Smith (1906-65) *Cube XVII* (p.406)

de Kooning (b. 1906) *Woman and Bicycle* (p.403)

Pollock (1912-56) *Number I, 1950* (p.401)

■ 9.2 Pierre Bonnard
The Dressing Room Mirror 1908
Oil on canvas
40×38 in (101.6×96.5 cm)
Pushkin Museum, Moscow

His *The Dressing Room Mirror* (Fig. **9.2**) of 1908 is an exquisite example of the colorist's adherence to the pictorial values of Impressionism, from which his work is inspired. The sensuality of his brushwork is kept in check by the overall needs of the composition—one which places volume and an articulated space over all other concerns. In doing so, Bonnard sets up a traditional forum in which to discuss his predominant concern—color. What is perhaps most interesting about this work (outside its painterly prowess) is Bonnard's acknowledgment of the multiple viewpoint; his recurring use of the mirror motif as a tool for more fully describing the nature of his three-dimensional objects on a flat plane is an effective if not terribly original way of describing forms. However, the boundaries of such spontaneous painting from nature allowed only for a small degree of movement on this revolutionary front, and Bonnard's profound interest in natural light and color always kept him in the realm of more traditional modes of representation.

■ 9.3 Georges Braque
Houses at L'Estaque 1908
Oil on canvas
28¾×23⅝ in (73×59.5 cm)
Kunstmuseum, Bern
The Hermann and Margrit Rupf
Endowment Collection

It appears that the Cubist Braque was more willing to sacrifice volume and space in order to assert the surface of his painting. His *Houses at L'Estaque* (Fig. **9.3**) of 1908, produced the same year as Fig. **9.2**, shows little concern for illusionistic space. On the contrary, it appears that the artist went out of his way to contradict traditional methods of organizing space: his perspective lines do not correspond with each other, and his use of light and shade is what one might refer to as consistently irregular. You will note that as early as 1908, Braque already had the beginnings of a coherent system for painting, based on an inversion of previous conventions once responsible for the depiction of illusionistic space on a flat plane. To make this clearer, it might help to consider the nature of these conventions a little further.

We were first introduced to the conventions of perspective and volume through light and shade during the Renaissance, when they re-emerged as important criteria for the production of art. The idea of illusionistic

■ 9.4 Pablo Picasso
Portrait of Gertrude Stein 1906
Oil on canvas
39¼×32 in (99.7×81.3 cm)
The Metropolitan Museum of Art
Bequest of Gertrude Stein 1946

▶ 9.5 Pablo Picasso
Girl with a Mandolin
(Fanny Tellier) 1910
Oil on canvas
39½×29 in (100.3×73.7 cm)
Collection, The Museum of
Modern Art, New York
Nelson A. Rockefeller Bequest

space, which was produced by the successful implementation of these techniques, was based on the assumption that art responded to certain mutually understood "truths" about the nature of reality and our participation in it. Of course, any notion of "truth" or "reality" is always grounded in a number of assumptions about the way the world works, and in the world of Western painting between the Renaissance and the twentieth century the world fell along assuredly pre-

dictable, calculable lines. It is interesting to note that the conventions responsible for such an ordered "world view" began to fall out of favor with artists just as Western civilization entered its own crisis of faith in historical institutions, culminating in the First World War. By inverting the conventions that once defined the nature of reality in the Western world, the Cubists were in effect "reinventing" the world of painting through a decidedly twentieth-century temperament.

The idea of flatness takes its premise from the notion that "truth" in painting must correspond to two primary features of the activity: the physical reality of the two-dimensional plane and the shifting nature of perception. We have already witnessed in painters such as Monet and Van Gogh an acceptance of the physicality of paint, which in turn amplifies surface qualities. But to make flatness an "idea," it was necessary to reconsider how an artist arrived at a satisfactory representation of the world on a two-dimensional plane, without adhering to old conventions that held little relevance in a modern world.

A series of examples may prove helpful in illustrating this concept. The evolution of Picasso's Cubist portraiture between 1906 and 1911 shows the steady dissection of the artist's perceptual experience down to its most basic parts. In following the artist's development from his *Portrait of Gertrude Stein* (Fig. **9.4**) of 1906, through the *Girl with a Mandolin* (Fig. **9.5**) of 1910,

■ 9.6 Pablo Picasso
The Accordionist 1911
Oil on canvas
51¼×35¼ in (130.2×89.5 cm)
Solomon R. Guggenheim Museum, New York
Gift, Solomon R. Guggenheim, 1937

to his *The Accordionist* (Fig. **9.6**) of 1911, one can see a clear movement away from natural appearance and traditional conventions for the depiction of volume. In the *Girl with a Mandolin*, the viewer witnesses the body as a fragmented, dislocated, yet still identifiable assemblage of forms, existing in a shallow space reminiscent of relief sculpture. There remain references to volume (and thus to the conventions that made such illusionism possible) throughout the piece, particularly in the neck, breasts, and arms, yet even these are greatly diminished by the dissection and splitting of the face and shoulders. Further, Picasso's collapse of the middle and background into the immediate vicinity of the figure enhances the dispersion of the body across the picture plane. The result: a picture that hugs the surface.

How did the artists achieve such a seemingly systematic destruction of space on the two-dimensional plane? The easiest and perhaps most helpful answer is that they simply reversed the conventions responsible for producing illusionistic space, and in doing so achieved a kind of art that embodied the prevalent ideas of its age. Take, for instance, the accepted technique of exhibiting a consistent and often directed light source for depicting volume—the kind that has illuminated the interiors of paintings from Masaccio, through Caravaggio and Rembrandt, to the Impressionists. This accepted convention takes as its premise the general assumption that a consistent and predictable light source produces a series of highlights and shadows that imply depth and volume in a regular fashion—hence our "belief" in the illusionistic space. Picasso and Braque equated this convention with the suggestion of a space they so emphatically dismissed as inaccurate and untruthful. But if a consistent light source was of primary importance for the depiction of space, then an inconsistent light source could be used to flatten dramatically such a space and such an illusion. Take a close look at the extended arm of the figure in the *Girl with a Mandolin*, and you will see Picasso toying with the notion that a consistent light suggests space. The upper arm is defined by a light source which emerges from the side of the painting, illuminating the exterior surface of the arm; the modeling is thus consistent in its approach with more traditional forms of painting. But now look at the elbow joint. If Picasso was indeed interested in defining the arm as a round appendage with volume, he would most certainly have gone to the trouble of wrapping the elbow with the same light that graces the outside surface of the upper arm. But instead, the outside aspect of the joint is described in shadow, as if the light source has suddenly shifted direction completely. The forearm continues such an inconsistency of directed light, painted flush to the canvas, while the mandolin, supposedly on the same external plane as the upper arm, is shrouded in shadow. This deliberate "misuse" of the light source is effective precisely because it is so consistently inconsistent (hence the suggestion of a system or organized method, and not a random, thoughtless activity). By the summer of 1911, the process of dispersing volume across of the plane was complete, as Picasso's *The Accordionist* gives only the slightest hints of the origin of its subject.

In Picasso's *Man with a Hat* (Fig. **9.7**) of 1912, the

radical ideas germinating in his *Girl with a Mandolin* come to full maturity. Here, the earlier experiments in light and shade are pared down to a synthesized and harmonious whole. As well, the artist has developed a form of shorthand for representing not the subject in front of him, but the very act of perceiving a three-dimensional form. In this case, a head is depicted in both frontal and profile positions simultaneously, as if we are scanning the subject from one direction to the other. Here, the side of the nose and the two eyes share the same façade, creating a hybrid kind of representation unlike anything that had come before it in Western art. This is Cézanne's doubt taken to its logical conclusion, as now the figure lies flush to the surface, like the skin of an orange peeled from its fruit. Perhaps an even better analogy is to a map, where surfaces which are conveniently projected flat, and though still very much a representation of the world, are certainly not reality as one usually envisions it.

Cubism dismantled the methods of earlier art by

◄ 9.7 Pablo Picasso
Man with a Hat 1912–13
Cut-and-pasted papers, charcoal and brush
and ink on paper
24½×18⅝ in (62.2×47.3 cm)
Collection, The Museum of Modern Art,
New York
Purchase

■ 9.8 Juan Gris
La Place Ravignon
(*Still Life Before an Open Window*) 1915
Oil on canvas
45⅞×35⅛ in (116.3×89.3 cm)
Philadelphia Museum of Art
Louise and Walter Arensberg Collection
(50–134–95)

attacking its sacred conventions, and though the tech-
niques of Cubism soon found immense popularity with
artists, during its most radical early years it successfully
destroyed centuries of assumptions about the nature of
painting. If one places such an artistic investigation
within the greater context of all forms of human
inquiry, Cubism can be best understood as a child of its
time. Its radical posturing and disregard for established
truths was part of a more general cultural and intellec-
tual overhaul taking place in the first decade of the new
century—epitomized not only by Cubist art but also by

Einstein's relativity theories, Lenin's Bolshevik ideals,
and Henry Ford's assembly lines. In those days, it was
called progress.

Many mimicked the work of Picasso and Braque
during those first years, but few attained the forceful-
ness of vision that so often accompanies new dis-
coveries, and so rarely guides those who follow. Some,
like Juan Gris (1887–1927), assimilated the basic tenets
of Cubism thoroughly, making remarkably poetic
paintings within the constraints of Cubist geometry and
fractures (see Fig. **9.8**). Others, like Fernand Léger

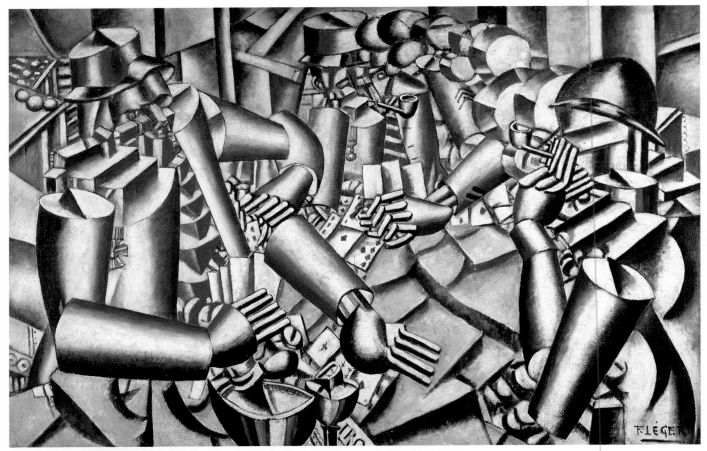

■ 9.9 Fernand Léger *The Cardplayers* 1917
Oil on canvas, 50⅞×76 in (129×193 cm), Rijksmuseum Kroller-Müller

(1881–1955), saw the radical dismantling of the figure in space as an opportunity to investigate other interests that lay outside the boundaries of pure observation. Léger's figures are rendered with the mechanical prowess and shiny, predictable surfaces of machines—efficient, steady, and disciplined at all times. *The Cardplayers* (Fig. **9.9**) of 1917 is a good example of the then persuasive argument for an art that placed observation behind the new pictorial strategies for the flattening of space. You will note that this attitude is tantamount to an outright dismissal of the earlier Impressionist wish for an art of "looking" rather than "thinking," and at least in this regard it is not inappropriate to see parallels between the theoretical projections of Renaissance art and the conventions of Cubism; both sought to organize the world of their painting around governing principles first and naturalism second.

● We have discussed at great length how art functions as a manifestation of an individual's experience of the world, and that every expression needs a language or commonly accepted communication system to be understood. As a result of this ongoing dialogue between individuals and their world, there develops a series of "constructions" or strategies, whose popularity (or appropriateness) is determined by larger historical conditions. Throughout this book such accepted visual ideas as linear perspective, chiaroscuro, and even color theory have been called "conventions" —pictorial expressions developed around a kind of "truth" that seems as changeable as the seasons. Cubism is no exception to this rule, and the visual language that revolved around it soon became a vessel of other, less obvious agendas also popular at the time. Perhaps the most interesting use of the Cubist visual shorthand (at least from a political perspective) was the

art of the Futurists, whose calling cards were images of speed, dislocation, automation, and anarchy (in no specific order).

FUTURISM

Futurist painting is a fascinating example of how seemingly innocuous pictorial conventions can take on larger than life political and social agendas. The Futurists were for the most part a collection of Modernist Italian painters who saw the destruction of the old and the glorification of the new as the hallmarks of a truly modern artist. They went so far as to draw up a list of "club rules" governing their art and thoughts, the most famous of which was the *Futurist Technical Manifesto* of 1910 which consisted of nine declarations and an

additional four demands. In it, they declared, among other things, that all forms of imitation should be despised and all forms of innovation glorified (declaration number 1), that it was essential to rebel against the notions of good taste and harmony (number 2), that art critics were useless (number 3), and that the title madman should be looked upon as a badge of honor (number 5).

What exactly did their art look like? Perhaps the most talented Futurist artist to emerge from the group was Umberto Boccioni (1882–1916), whose work and interests spanned both painting and sculpture. In his *The Street Enters the House* (Fig. **9.10**) of 1911, it is quite apparent that he was indebted to Cubist inventions for the depiction of a fractured space and the breaking down of forms across the picture plane. But to this he

■ **9.10** Umberto Boccioni
The Street Enters the House 1911
Oil on canvas
39⅜×39⅝ in (100×100.6 cm)
Sprengel Museum, Hanover

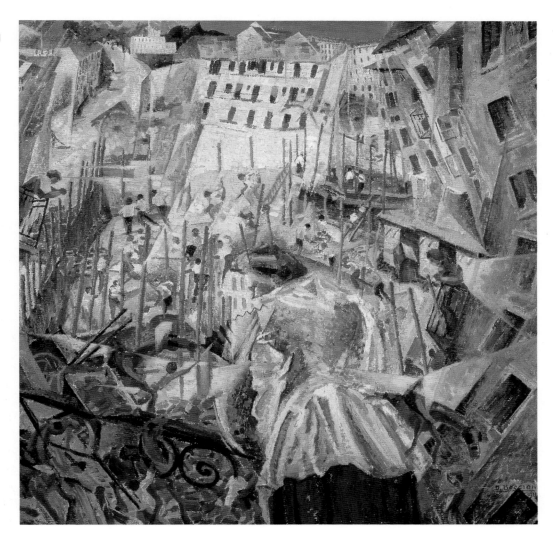

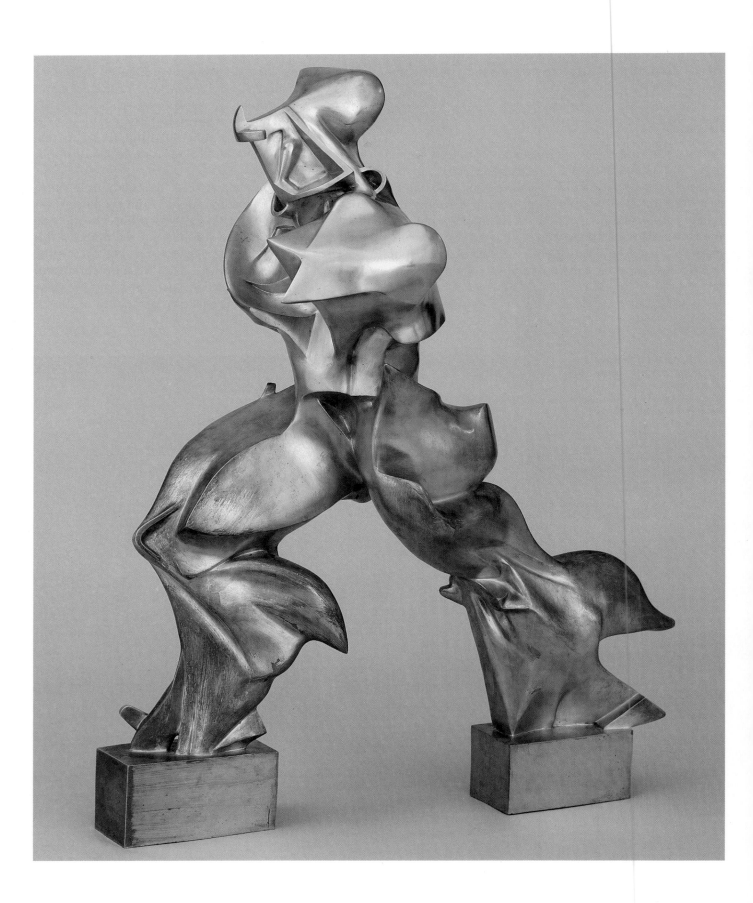

9.11 Umberto Boccioni
Unique Forms of Continuity in Space 1913
Bronze
Height 43½ in (110.5 cm)
Collection, The Museum of Modern Art, New York
Lillie P. Bliss Bequest

adds something Braque and Picasso had noticeably shied away from: color—the kind which illuminated and even decomposed forms in Impressionist painting with its resonance and brilliance. In such work, forms, light, and color melt into a frenzy of simultaneous activities, each actively pursuing the other for clarity and visual authority. The result is something like visual noise, where each gesture or diminished form takes on the personality of a boisterous shout in a turbulent crowd.

Yet it appears that the radical Boccioni's treatment of forms within this Cubist space was actually much more conservative than that of his less political friends Picasso and Braque, and he never completely let go of the descriptive character of his work. In his sculptural work (see Fig. **9.11**) he also maintains an awkward balance between the radical character of Cubist conventions, and his deire to maintain a likeness. In this case, it appears that the environment is the culprit, pushing and reshaping the body at will. The piece looks like an icon to motion and progress and, ironically, also necessarily refers back to the whole history of figurative sculpture it supposedly disdains. Perhaps the greatest irony of all was the artist's welcome embrace of the First World War as a "cleansing" of culture. When war was declared, he, like many of his Futurist comrades, immediately enlisted, and shortly after he was killed. Thus, with the horrors of the First World War, Futurism died too, and with it the aspirations of a world governed by the omnipotent machine.

▶ COLLAGE AS AN IDEA

● In the winter of 1911–12, Picasso painted his *Still Life with Chair Caning* (Fig. **9.12**), which again challenged the traditions of earlier art. This rather inconspicuous work has remained one of the most influential paintings of the twentieth century in that it was the first to incorporate "collage" into the mainstream of artistic expression. Collage is so common today in everything from kindergarten art to the New York galleries that one takes it for granted, but the technique is less than ninety years old. Collage, which simply means "gluing," is a way of introducing actual items or their facsimiles into a painting as subject matter. To put it another way, collage enabled the artist to use materials as part of the piece, rather than having to go to the trouble of representing them (and in the case of Cubism, such representations or illusions were considered illegitimate in the first place). This initial attempt on Picasso's part to embellish both his subject and his surface is in retrospect quite charming in its wit; the supposed chair caning is, on closer inspection, not caning at all but a piece of oil cloth with a printed surface to simulate (read represent) the actual material. Thus what one initially considers most "real" is in fact the most false, and thus the Cubist conventions, which lie outside the confines of representation, are perhaps most real since they have pretenses to imitation. The result is a push and pull dialogue within the piece, as

■ 9.12 Pablo Picasso
Still Life with Chair Caning 1912
Oil and pasted oilcloth, rope
Oval 10⅝×13¾ ins (27×34.9 cm)
Musée Picasso, Paris

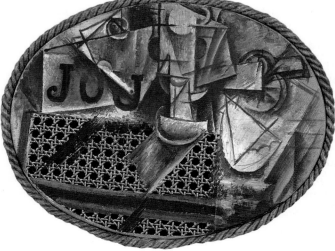
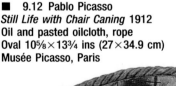

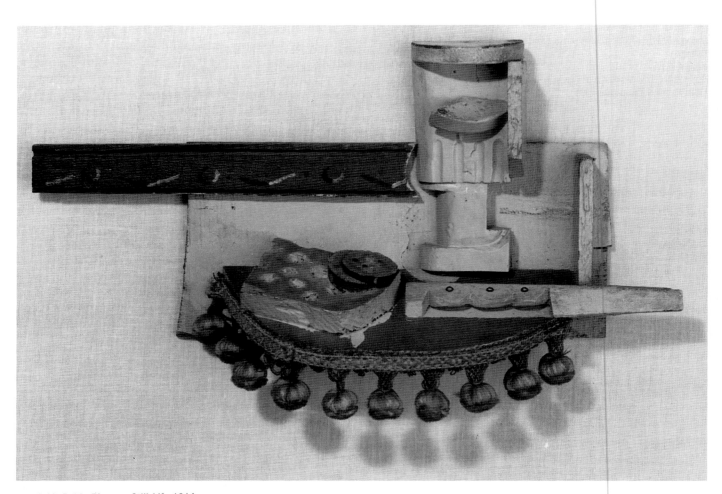

■ 9.13 Pablo Picasso *Still Life* 1914
Painted wood and upholstery fringe, width 18⅞ in (47.8 cm)
Tate Gallery, London

our notion of "real" continuously shifts back and forth from the artist's hand to the appropriated materials. The final wrapping or "framing" of the work in rope further reiterates the "objectness" of the painting, pulling our eyes around the perimeter and making us aware of the surface edge. Here, Picasso challenges the viewer to deal with the contradictory notions of painting as image versus painting as object, and the result is a dynamic and energized experience.

Painting was by no means the only art discipline to succumb to the charm and efficiency of collage. Soon, sculpture too freed itself from centuries of restrictive technical conventions with the collage esthetic—once more thanks to Pablo Picasso. The notion of "assemblage," whereby items rather than flat shapes are assembled to produce a completely new object, was a logical outgrowth of Picasso's earlier Cubist explorations with collage. His *Still Life* (Fig. **9.13**) of 1914 exhibits many of the characteristics already discussed in his painting, but it is the artist's unrestrained use of what appears little more than refuse as the impetus for art making that is indeed radical. This in turn freed sculpture from its traditional reliance on craft, where painstaking techniques for casting in bronze and carving in stone could, and soon did, fall by the wayside. Assemblage was instrumental in separating sculpture from the time constraints and tedious technical considerations that so often blocked an artist's spontaneity. The result was nothing short of spectacular.

Collage seemed to hold unlimited promise for artists interested in incorporating fragments of everyday life directly into their work. Items such as newspaper,

■ **9.14 Kurt Schwitters**
Merz 19 1920
Collage on paper
7¼×5⅞ in (18.4×14.7 cm)
Yale University Art Gallery,
New Haven, Connecticut

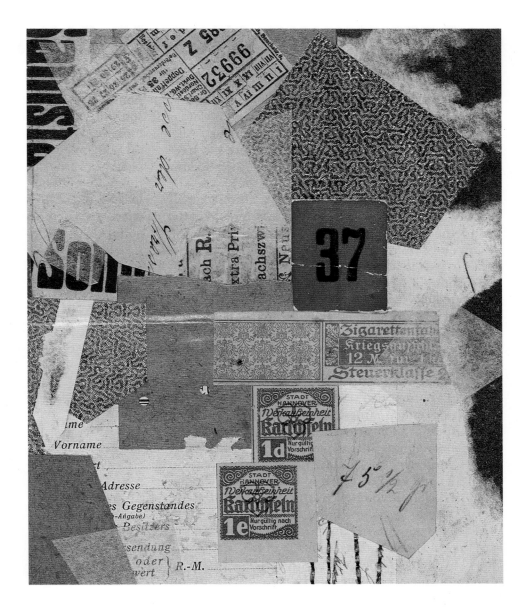

cardboard, advertisements, mechanical reproductions, and the like all found their way into the art of the age, paralleling the proliferation of mass imagery in the public domain brought on by the advances in industrial printing technology. Of course, collage could, and often did have a decidedly anti-academic side to it as well, as the notion of "refuse turned art" tended to infuriate those who held art up as a bastion of painstaking craft and subtlety.

German artist Kurt Schwitters (1887–1948) is perhaps best known for his "Merz" pictures, in which a series of remarkable collages forms the backbone. *Merz 19* (Fig. **9.14**) of 1920 is indicative of Schwitters's

sensitivity to discarded material, out of which he constructs a sense of meaning and dignity. The shifting planes and shallow space of this collage have obvious pictorial precedents in Cubist art, but nowhere in Picasso or Braque does one experience the sense of loss and abandonment inherent in the torn scraps of handwriting and of tickets—fragments of people's lives —that confront the viewer on the picture surface. Schwitters's collages thus act as a kind of social portrait in those humiliating days after the First World War, and it is to his credit that these fragments of loss and dislocation are composed with such dignity and affection.

▶ RETHINKING ANOTHER OLD IDEA

● To appreciate fully the nature of twentieth-century art making, it is necessary to consider the enormous effect two disparate phenomena had on our visual culture: Cubism and the First World War. We have already looked at the radical nature of Cubism and how it questioned earlier conventions in art, but it was the brutal reality of war that was to give abstraction its edge. To those of us brought up in the latter half of the twentieth century, the First World War remains a distant and confusing episode in history. But to those who survived it, it came to embody something greater: the collapse of traditional Western culture. Perhaps a few incredible statistics will give an indication of the extent of the carnage: 60 million men mobilized, 9 million killed, total civilian casualties close to 30 million. It is estimated that one out of every two households in Europe lost a loved one, and that approximately half a generation of young men were annihilated. What had started as an exercise in honor and chivalry ended as mass destruction, and those once wonderful machines proved themselves as efficient at killing and maiming as they were at producing cars and clothes. Moreover, the First World War forced many to reconsider the kind of value system and culture that could have permitted such an atrocity in the first place. As the war dragged on, more and more artists felt themselves compromised by the act of making art—at least the kind of work that seemed so much a part of the larger, hypocrisy-ridden cultural machine. For many, to continue meant a drastic re-evaluation of the role of art for themselves and their society. The result was a radically new way of looking at the world and at art—one that survives to this day.

DADA AND ITS LEGACY

It is not to the more established artists that one must look to try and get an idea of the nature of art making during those lost years of the war, but to the generation that lost so many of its own—the younger and less settled members of the avant-garde. One of the first art centers to show signs of radical activity was Zurich, in neutral Switzerland. Here, a collection of artists, including poets, actors, painters, and sculptors, gathered to ''form'' (in the loosest of senses) Dada, a

nonsensical name meant to be in keeping with the spirit of the group (see **9.15**). Together, they attacked most of Western culture's sacred cows, and in the process invented such novel forms as simultaneous poetry (a variety of poems recited by various readers at the same time), phonetic poems (verses based exclusively on sounds), automatic writing, and art by chance (where shapes and lines are dictated by accident, or even the roll of dice). Now, if all of this seems a bit anarchic, then perhaps it is important to remember that Dada was born as much out of anger as

■ 9.15 Marcel Janco
Mouvement DADA, Zur Meise 1918
Lithograph poster
18¾×12⅞ in (47.6×32.5 cm)

it was a legitimate artistic alternative. Like the phenomenon of "punk rock" that was to surface sixty years later, it set out to disturb and destroy many of art's most highly valued ideas, seeing them as complicit with the very value system that had promoted and glorified such destruction (remember, art not only expresses the nuances of its age but also helps define the parameters of meaning and acceptability). At times, Dada bordered on outright nihilism, such as in some of the infamous Dada gestures. Take, for instance, the story of the American Dadaist Arthur Craven, who once challenged the heavyweight boxing champion Jack Johnson to a fight, stripped during a lecture on art he gave to a prestigious social club, and in true Dada style, set out for Mexico from New York harbor in a row boat—and was never seen again. Such exhibitions, though at least partly the eccentric antics of an artist bent on notoriety, were nonetheless the foundations for later performance art, where the artist becomes the sole vehicle for expression.

There are, of course, thousands of historical precedents for performance art, ranging from Catholic mass to war dances. Unlike theatre, performance is executed within the confines of tangible, experiential time and space rather than "through" an artificial construct. In other words, both the artist and the viewer are placed in the same perceptual and spatial experience. One of the most noted practitioners of performance work throughout the 1960s and 1970s was Chris Burden (b. 1946), whose often conspicuously violent acts directed at himself are a direct heir to the original Dada gesture. The artist's *Trans-Fixed* (Fig. **9.16**) of 1974 is indicative of Burden's mature work; here the mediating (and Burden would say comforting) structure of traditional art making (the materials which are used to make art objects) is sacrificed for a more immediate, less removed form of experience. This type of work resolutely disputes the commonly held notion that art and artists must operate within the confines of a museum or commercial gallery; instead, it draws attention to the art act over the art object (which in this case is nothing more than two nails) taking the art out of mainstream culture. In *Trans-Fixed*, Burden draws explicit parallels to the pictorial tradition of the crucifix, using himself as art object, material, activity, and artist in one sweeping gesture. (Burden was nailed to the hood of a Volkswagen with two nails through his palms. The car was backed out into a speedway, revved for a period of two minutes, and then returned to its

■ 9.16 Chris Burden
Trans-Fixed 1974
Performance in Venice, California
April 23, 1974
Courtesy of the artist

housing.) It was this very notion of creative autonomy, inherent in later performance work, that made such activity popular with many Dada artists. Also, its cross-disciplinary nature (performance can include sound, video, costumes, and a host of other media) was an open attack on the widely held belief that mixing media—particularly "high art" with popular culture—was in decidedly poor taste. This, of course, gets to the heart of the matter: the rather conspicuous dose of vaudeville inherent in early Dada performance work clearly illustrates many an artist's distrust of the more traditional forms of expression. Culture, at least in the eyes of the Dada artists, had failed its citizens. Viewed from the muddy trenches of the Great War, art looked no different from politics or the notion of good guys and bad guys. If art was an expression of its age, few thought

the vision worthy of any praise. The tradition of performance was born out of such a situation, but it was by no means the only constructive idea to mature during the heights of Dada; the rather limited assortment of happy or inspiring sights to greet the artist of the postwar period pushed many an adventurous soul to begin documenting less well-traveled territory—the unconscious.

The issue of trust—in a vision, a world, or even a method connected with art—was of paramount concern for many younger artists shortly after the war. They began to look skeptically at the very social and intellectual systems that they, and the rest of the Western world, had been so eager to embrace since the Renaissance. The foundation of most time-honored institutions has been the ability of humans to understand, control, and evaluate the world around them —and then use this information to produce a more humane, compassionate world for all. The crisis of 1914–18 mocked such outright optimism in human rationality; it did not take a genius to see the carnage as a definitive rebuff to those who saw progress as the wellspring of happiness.

Humans are first and foremost social animals, defined and manipulated by pressures of which they are rarely conscious. By the turn of the century, Western rationalism was not simply a popular method or intellectual construct for testing ideas, it had become the very substance of human consciousness. In this forum, truth was only truth if it fit within the boundaries of the system, and when the supposedly infallible system showed its first signs of stress, many began to question whether the very view of reality had been tarnished in the process. Dada recognized this instinctively, and set about developing an art program free of previous systems (or so they thought). The problem was how to produce an art free of all social and intellectual baggage, since art had always involved a process of selection and refinement which was based in thought. The answer came in the simple acknowledgment of chance as an acceptable part of art making—an idea which would have seemed ludicrous to an artist of the stature of Cézanne only fifteen years earlier. But then again, Cézanne didn't have the opportunity to see Western culture turn upon itself, as this younger generation had.

The main practitioner of the art of chance was Jean (Hans) Arp (1887–1966), a Dada artist less bent on the grand gesture than on establishing a liberating (and in

■ 9.17 Jean Arp
Collage Arranged According to the Laws of Chance 1916–17
Torn and pasted paper
19⅛×13⅝ in (48.6×34.5 cm)
Collection, The Museum of Modern Art, New York
Purchase

his eyes moral) work method for his art. The result can be seen in his *Collage Arranged According to the Laws of Chance* (Fig. **9.17**) of 1916–17. In this particular case, the actual work method is perhaps more noteworthy than the image it produced (though Arp would have vehemently disagreed), and it hints at a much larger issue in later art making: the supposed unlocking of the unconscious. Arp steadfastly believed that the unconscious existed and could be triggered, but unearthing it required a radically different approach to art making. To produce this image, Arp simply dropped pieces of torn paper in a random manner onto a field of background color, and then glued the shapes down exactly where they fell. Note that such a method denies

all possibility of craft concerns, technical prowess, or even the simplest discretionary gesture on the part of the artist; all aspects of its production are left to chance—or perhaps, more correctly, to the innate laws of nature. Thus these pieces were seen as a triggering mechanism to the unconscious, an activity in harmony with nature rather than against it. Now, one might rightly ask how true such work is to the notion of chance, particularly considering the significant amount of decision making still apparent in the activity (what color paper to use, what pieces to exclude, which images to exhibit, etc.). No doubt Arp could never bring himself to produce a completely random, chance art—his very acknowledgment of it as "art" requires a process of conscious decision making (another in our ongoing list of perplexing paradoxes). Yet, the importance of Arp's work lies in its acceptance of the uncontrolable event as at least as real and truthful as all of the intellectual conventions on which the Western tradition was grounded. And at a time when many of those intellectual and cultural ideals were being poisoned by the lethal stench of mustard gas, the unconscious might have indeed seemed like a breath of fresh air.

If Arp's work was not an end in itself, it at least led the way to other, more complex investigations into the role of art in unlocking the secrets of the human unconscious. Max Ernst (1891–1976) was one of the first artists to use the freedoms afforded him by his Dada background to investigate, and even reassemble, the world of appearances. Using collage, he effectively produced odd assemblages out of bits and pieces of commercial print and throw-away culture. Yet unlike Schwitters (who used collage as a form of commentary on cultural decay and the powerlessness of earlier art), Ernst seemed content to create images that can only be compared to the dream state—tangible, vivid, and yet absurd. Today, it seems that every child goes through a period of gluing cut-out heads on magazine bodies; such nonsensical arrangements often make us laugh. But during the early 1920s, this activity was deadly serious; it was a radical new way of connecting disparate items into a new pictorial whole. Like Arp's "chance" collages, the idea behind such work was to stimulate responses that lay outside normal, everyday understanding. Ernst's assemblages reach out, not so much to one's rational faculties, but to that special place inside each individual that is neither familiar nor controlable—the unconscious. Ernst's *Two Children are*

threatened by a Nightingale (Fig. **9.18**) of 1924 is a good example of these seemingly "irrational" compositions, where the given scene before us has no precedents in everyday reality. Instead, it draws inspiration from dreams—imagery as powerful and persuasive as anything in the conscious, but untainted by social conditions. Ernst searched the world of the everyday for possible clues to unlock the unconscious, and by reassembling and distorting common fragments, he believed he could parallel the processes of dreams. To this end, the artist invented "frottage," which is simply the transferring of surface designs through rubbing charcoal and graphite on paper. In this way, the most common items such as wood were transformed into mysterious images, resembling everything from faces to landscapes.

■ 9.18 Max Ernst
Two Children are threatened by a Nightingale 1924
Oil on wood with wood construction
27½×22½×4½ in (69.8×57.1×11.4 cm)
Collection, The Museum of Modern Art, New York
Purchase

▶ UNLOCKING THE UNCONSCIOUS

● As the work of Arp and Ernst attests, a number of prominent artists began investigating less traditional avenues as a new source of subject matter and a fresh approach to the creative process during the post-war period. The unconscious provided the avant-garde artist with images and ideas rooted not so much in the past as in the mysterious present, and for at least a few years the human mind appeared a wellspring of source material. Furthermore, by the 1920s the work of psychoanalyst Sigmund Freud had opened the way to discussion of human sexuality and neurotic behavior —topics rich in forbidden imagery. Yet most of all, directing one's energies toward the "interior land-scape" was a practical way for many artists to avoid the humiliating realities they were forced to face almost daily in those anxious years between the two wars. From this background came the "Surrealist" move-ment, which though originally conceived as a radical literary group, soon came to embrace the visual arts as well.

One might rightly describe Surrealism as Dada without the cynicism. One of the great ironies of Dada was the built-in nihilism of its radical dismissal of culture; as someone once aptly put it, the true Dadaist was against even Dada. At least in this sense, Surreal-ism pointed a way out for committed artists, by rather optimistically forecasting the unconscious as the new threshold of revelation and liberation for a stagnant culture. To unlock such fleeting and temperamental subjects, many artists began experimenting with dream states, and accepted chance as both a tool of inspiration and an applied method for developing imagery in their art.

The writings of psychoanalysts Sigmund Freud and Carl Jung were important catalysts for the Surrealists. Both men had spent their professional lives in the pursuit of the unconscious, and their findings were at once alarming and exhilarating. Freud saw the human mind as a complex array of sexual tensions and multiple repressions which inevitably led to neurosis, which was at the heart of our social relations, govern-ing our perception of self and reflected in the very construction of our societies. Freud's view of labor (the selling of one's time for money) and its connection to psychological illness is significant in that it correlates

the postponement of our fundamental desires (what he called the pleasure principle) brought on by the need to work with a capitalist economic system. In this way, sexual repression is seen as a catalyst, and indeed an anchoring for the alienation many feel in the high capitalism of the twentieth century, bringing about not simply individual but also collective neurosis. This, of course, delighted many of the more politically radical Surrealists, who saw the cultural taboo of sexuality as a provocative challenge to the status quo—both in art and society.

It is in the writings of Jung, a student of Freud, that the parallels between Surrealism and psychoanalysis find their most deliberate course. Jung was convinced that social and interpersonal relations are the very foundations of the unconscious. Since all humans develop social constructs as a matter of survival, Jung thought it was altogether possible for different, even isolated cultures to share a basic unconscious structure. He noted the existence of a variety of cross-cultural myths and symbols (the cross, the triangle, the circle) that showed up in the most isolated of societies—com-munities that appeared to have had no physical contact with one another. Jung believed this to be the function of an inherent visual language rooted in the unconscious, and released through creative activities. He called this basic vocabulary of images, sounds, and stories "archetypes" and was convinced that all humans shared an intuitive level of understanding through the contemplation of such forms. Of course, the problem was how to recognize archetypes, and further how to trigger an unmediated response to such imagery without falling back on rational faculties. The answer came in an idea called "synchronicity," which can perhaps be best explained through the use of an example.

SURREALISM

The paintings of René Magritte (1898–1967) are excel-lent visual examples of synchronicity. *The False Mirror* (Fig. **9.19**) of 1928 shows the artist's method of bring-ing two or more disparate elements into direct contact with one another, which in turn creates a visual entity with few parallels in ordinary life (what artists called

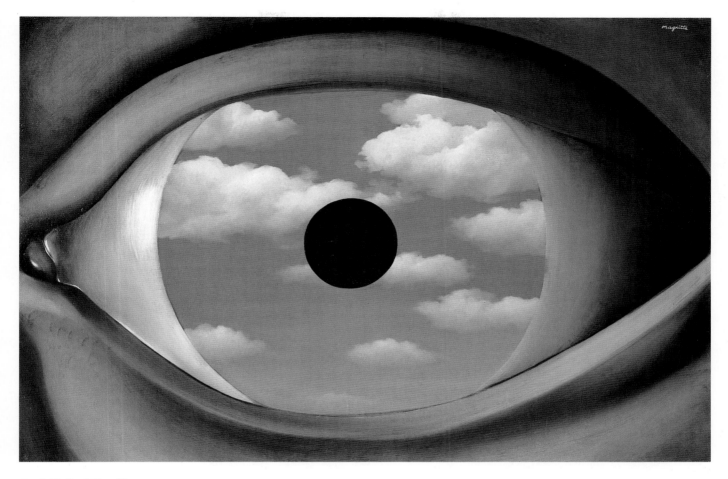

■ 9.19 René Magritte
The False Mirror 1928
Oil on canvas
21¼×31⅞ in (54×80.9 cm)
Collection, The Museum of Modern Art, New York
Purchase

''juxtaposition''). In this instance, the artist has combined an eye and the sky to produce a new image, which effectively subverts any rational explanation. The end result is a kind of visual and intellectual discord, which is supposed to trigger an unconscious response. Jung believed synchronicity to be an effective tool in activating the unconscious, and it often found its way into the work methods of Surrealist artists.

Salvador Dalí (1904–89) was another practitioner of distorted reality, and his obsessive paintings appear as almost direct translations of nightmares and hallucinations. At their best, Dalí's images can have a paralyzing effect on the viewer, as his *Premonition of Civil War* (Fig.

9.20) of 1936 attests. Here, images expand, change identity, and decompose before our very eyes in a series of exotic transformations which have all the coherence of a vivid nightmare. It is interesting to note that both Magritte and Dalí chose to work within the constraints of traditional picture making in producing such images. The reasons for this seem pretty clear; by utilizing such conventions as perspective and modeling with light and shade, both artists effectively distort commonsense reality in a manner that mimics the visual experiences born out of the dream state. Since each artist desired his work to function in that gray area between known and unknown, the familiar and the unfamiliar, the use of

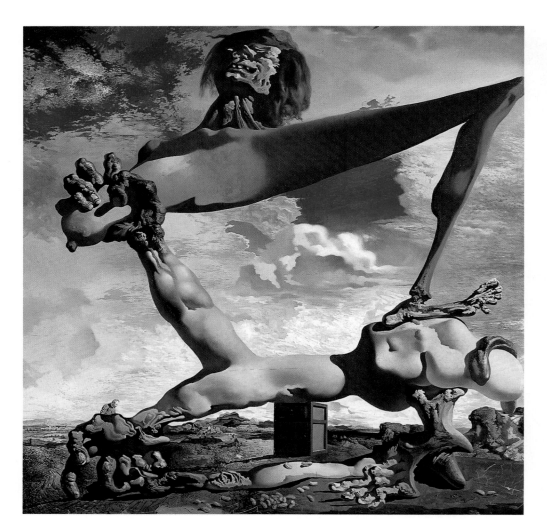

■ **9.20** Salvador Dalí
Premonition of Civil War 1936
Oil on canvas
43¼×33⅛ in (109.8×84.2 cm)
Philadelphia Museum of Art
Louise and Walter Arensberg
Collection

more traditional picture making allowed them greater freedom to explore the possibilities inherent in distortion.

Needless to say, the popularity of the human unconscious as subject matter led to a general proliferation of quirky and otherwise uninspired "trick art"—an unfortunate label that still persists in some discussions of Surrealism today. At its best, it provided viewers with a disarming look into a world of confusion and neurosis, and at its worst, it became a tedious and predictable sleight of hand, or as one critic put it, "a never-ending opera of self-indulgence." What many an artist passed as dream imagery seemed little more than an exercise in manipulating realist techniques—a work method many thought had died in the trenches along with all the other traditions. There were, however, a number of artists who managed to avoid the

predictability of dream illustration, and perhaps none was better than Joan Miró (1893–1983).

Miró is one of those rare figures in art whose work bridges a number of prevalent sensibilities in one coherent vision. Never a "card-carrying" Surrealist, and always a bit suspicious of the group's self-importance, Miró nonetheless embraced the idea of change and metamorphosis as a feature of one's view of the world. To this he added a distinctly Cubist sensibility toward space and a splash of his own Spanish iconography to produce a body of work that merges the affairs of the conscious and the unconscious in a neat package. *Woman in the Night* (Fig. **9.21**) of 1945 shows Miró playfully indulging in a variety of invented shapes and characters, which seem to grow out of a seemingly spontaneous arrangement of black circle forms. The emphasis here is not so much on a naturalistic

representation that is then distorted as on producing forms as idiosyncratic and undigested as the unconscious itself. But do not get the impression that Miró was simply a sensitive transmitter for child-like imaginings; his thorough understanding of the languages of twentieth-century art make his work function on a formal as well as an intuitive level. Take, for instance, his dispersion of space across the surface of the canvas; the apparently random collection of black dots is held together through a variety of thin linear gestures, which are repeated throughout the painting as a unifying motif. In this way, Miró implies an inner order and logic within the playfulness and supposed spontaneity of the scene, creating a harmony and a stasis in what could have been a series of idle wanderings. Here one witnesses the successful integration of the tradition of formal painting (to which Cubism is heir) into the more romantic vocabulary of the Surrealists, and in this manner Miró pointed a way for the next generation of artists.

■ 9.21 Joan Miró
Woman in the Night 1945
Oil on canvas
51⅛×63¾ in (130.2×161.9 cm)
Solomon R. Guggenheim Museum, New York, Gift, Evelyn Sharp, 1977

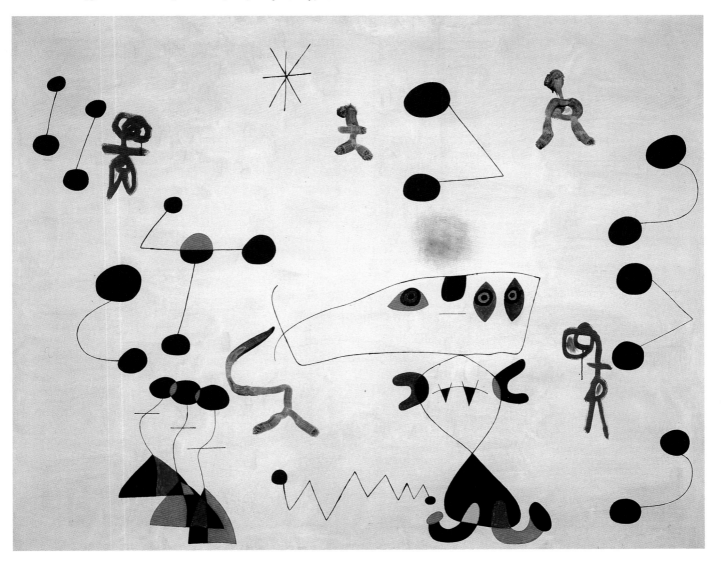

▶ THE QUEST FOR A PURER ART

● If you look back over the various works examined so far in this chapter, it will become apparent that a lot of different approaches to art making ran simultaneously between 1900 and 1945: Cubism, Fauvism, Futurism, Expressionism, Dada, Surrealism, and a host of other movements all claimed a degree of sovereignty at one time or another, only to be assimilated or deviate into another movement. Yet the question remains, if one is willing to accept the premise that art visually reflects the tensions and ideas of its age, then how does one reconcile the disparate nature of many of the activities? And further, how does an intelligent viewer determine standards of quality among all the confusion? A simple analogy might help. Suppose a nagging ailment forces you to see a physician, who then recommends immediate surgery. Thinking this action a bit dramatic for such

■ 9.22 Piet Mondrian
The Gray Tree 1912
Oil on canvas
27¼ × 42⅜ in (70.5 × 107.5 cm)
Gemeentemuseum, The Hague

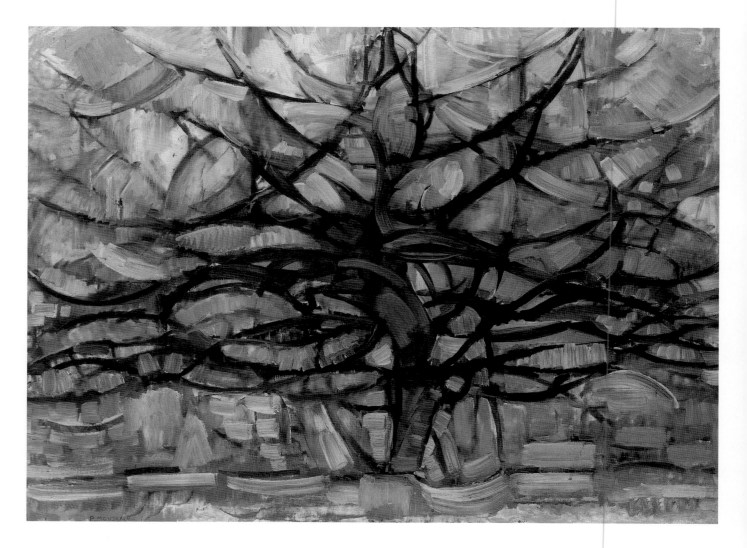

a tiny pain, you proceed to yet another physician, who examines the same ailment and recommends extended physiotherapy. Confused by these contradictory opinions, you return home and decide on another option—to take a few days off work. Is one opinion necessarily right and the others wrong? Probably each opinion is the end result of an honest attempt to perceive, isolate, understand, and diagnose an ailment, and perhaps all will work effectively. Furthermore, each treatment will embody a certain amount of the diagnostician's own view of the correct way to proceed, which might have developed out of their education, their personal idiosyncrasies, and even their cultural background. But in the end, all attempt to cure rather than to complicate. So it was with art during the first half of the twentieth century, as a vast number of genuinely concerned individuals throughout the various arts attempted to fix what they perceived as a sick culture. We have already witnessed the anger of Dada, and formal removal of Cubism, and even the angst of Expressionism, but despite repeated attempts to overthrow the traditional reverence afforded the art object, there were still artists who invested their work with an enormous amount of spiritual weight. The trick was to uncover the good that lay inside the bad and the polluted, and to do this required a dramatic paring down of forms and images to their bare essentials. And this rather formidable task was to be the life's work of artists Piet Mondrian (1872–1944), Constantin Brancusi (1876–1957), Wassily Kandinsky (1866–1944), and Kazimir Malevich (1878–1935).

ABSTRACT ART

Mondrian's first excursion into twentieth-century painting came as a result of his interest in Cubism. His initial experiments in fracturing space and asserting the picture plane relied heavily on a vertical–horizontal configuration—nature seen through God's imposed grid system (see Fig. **9.22**). Eventually, the grid format acquired the symbolic equivalence of a universal order, assuming compositional authority over all other forms in his work. A series of calculated black lines were soon to embody an entire world view, where the vertical–horizontal orientation of the composition mimicked one's most basic gravitational experience of the world (humans as vertical, earth as horizontal). Even the shape of the painting (the perfect square) suggested a supreme and all-inclusive order. Having engaged in

■ 9.23 Piet Mondrian
Composition in a Square 1929
Oil on canvas
19¾ × 19¾ in (50 × 50 cm)
Yale University Art Gallery, New Haven, Connecticut
Gift of the Collection Société Anonyme

this selective paring down of visual experience, Mondrian then considered color. In the light of his desire to exclude extraneous information from his paintings for a clearer view of the world, it seems appropriate that he was equally selective in his choice of palette. The result was a combination of primaries—red, blue, and yellow—within the confines of his superimposed ordering sysem (see Fig. **9.23**). If you think back to the discussion of the color wheel in Chapter Seven, all color can be derived from the mixing of the primaries, which is another way of saying that the primaries are the essential building blocks of perception. Together, the steady combination of primary color and a rigid grid pattern became the painterly equivalent to life itself—all experiences pared down to their purest visual approximations. Like Einstein's theory of relativity before it, Mondrian aspired to painting that could become the blueprint for a new, more truthful experience of life through art. With this in mind, it is hardly surprising that he saw these works as deeply spiritual, and a source for renewal at a time when the world seemed in complete disarray.

The closest kindred spirit to Mondrian in sculpture was Constantin Brancusi. Romanian by birth and trained as a master stonecutter, the artist arrived in Paris in 1904 and quickly assimilated both the technical and visual aspects of the aging Rodin's sculpture. His initial attempts, of 1908, are reminiscent of both Rodin and even Michelangelo in their desire to unlock their captive subject matter from within the marble confines. The idea that natural materials such as wood and marble suggest certain subjects to their makers has a long tradition in many cultures, and most probably developed as a way of compromising with sometimes less than adequate starting materials (such as odd-shaped wood or fractured stone). But in Brancusi's work, this old-fashioned relationship between the ever-sensitive artist and his/her suggestive materials took on heightened significance, and soon the work became more distilled and pared down. His famous *The New Born* (Fig. **9.24**) of 1915 shows many of the characteristics of the artist's mature work: an emphasis placed on the primacy of the form, a deletion of representational elements that might individualize the subject, and a suggestion of purity. It is interesting to note that despite the level of synthesis and obvious disregard of representational elements, Brancusi refuted the notion that such forms were abstract. In a statement that sounds reminiscent of the Neo-Platonists, Brancusi proclaimed, ". . . that which they call abstract is the most realist . . . what is real is not the exterior form but the idea, the essence of things." Here art has come full circle, as an artist of the twentieth century embraces the Greek notion of pure essences privy to the artist. Many have gone so far as to claim that the genius of Brancusi lay in his ability to run with the Classical notion of essences, and push it to its logical conclusion. In the process, he created a body of work that convincingly suggests a world of forms and objects that exists above the corruptions and distorted realities of the everyday (Fig. **9.25**).

Wassily Kandinsky was another artist who saw the breakthroughs of Cubism as a chance to distill a purer art from the confines of representation. Like Mondrian and Brancusi, he isolated the elements of his craft, which were in painting line, color, gesture, and the relationship of the image to the surface, and put everything else in brackets. In this manner, emotional states and their expressions were freed from their age-old reliance on representation, which in Kandinsky's eyes diluted the authority and power of an individual's most

■ **9.24 Constantin Brancusi**
The New Born 1915
Marble, limestone base
6×8½ in (15.2×21.5 cm)
Philadelphia Museum of Art
The Louise and Walter Arensberg Collection

basic human experiences. Like many of his predecessors, Kandinsky came to abstraction via representational painting, and in many of the early abstractions (or what he often called improvisations), elements from observation remain, though in somewhat schematic form (see Fig. **9.26**). What is different about these works is the conscious disengagement of color from its traditional role as a descriptive tool in the development of a naturalistic scene. The story of how Kandinsky first discovered the "inherent expressive properties of color" outside their relation to the "real" world is interesting. One evening, after a long day of painting, he was confronted by an image of "extraordinary beauty, full of an inner radiance"—the very thing he was struggling to create in his own landscapes. Upon closer inspection, he was astonished to learn that the image he so admired was actually one of his earlier paintings, accidentally placed upside down, destroying its original representational scene. From this moment, the story goes, color became the subject of almost religious reverence for Kandinsky, as he was increasingly convinced that the path to the heart and soul lay not in painting pictures "of things," but in isolating the purer expressions embodied in color and line. The religious icons of his native Russia also became a significant source in the development of his "spiritual" (his

word) painting. If you remember from Chapter Three, mention was made of the enormous success and longevity of traditional icon painting in Orthodox Christianity; a point attributed to a highly convincing (even hallucinatory) arrangement of pictorial devices which transcend simple representation. Kandinsky grew up around such images, and the deeply seeded religious overtones to both his painting and his writing seem to verify that he saw his work operating on a similar plane.

Perhaps the most tragic player in this story of artistic autonomy and "pure" art is the Russian Kazimir Malevich, whose career is a sad reminder of the devastating effects authoritarian politics have on artistic and intellectual freedom. Working initially in the dynamic and art-conscious atmosphere of pre-revolutionary Moscow, Malevich quickly immersed himself in the prevailing ideas and attitudes of his time; by 1915 he had successfully worked his way through Impressionism, Expressionism, and Cubism and

◄ 9.25 Constantin Brancusi, *Bird in Space* c. 1928
Bronze (unique cast), height 54 in (137 cm)
Collection, The Museum of Modern Art, New York

■ 9.26 Wassily Kandinsky
Improvisation No. 30 (Cannons) 1913
Oil on canvas
43⅝ × 43⅝ in (109.2 × 109.2 cm)
The Art Institute of Chicago
A.J.E. Memorial Collection

was beginning to explore new avenues. He called his one-man "school" Suprematism and based his paintings on the primacy of the square—a shape impossible in the world of nature and thus in his eyes full of metaphysical connotations. These were arguably the most radical paintings to come out of the young legacy of abstraction in their simplicity and clarity. Consider, for instance, his famous *Suprematist Composition: White on White* (Fig. **9.27**) of *c.* 1918, where one square floats within the confines of the outer square edge, each differentiated by only the slightest change of value. In this simple geometry Malevich saw the essence of all art, stripped bare of the impediments of representation, which had historically obscured the transcendent quality of pure visual sensation. After completing this work, Malevich asserted, "I have broken the blue boundary, I have emerged into white. Beside me, comrade pilots, swim the sea of infinity. I have established the semaphore of Suprematism. Swim! The free white sea of infinity lies before you."

Malevich believed art was meant to be useless (meaning without use), and thus it should not seek to satisfy material needs. In his eyes, it was important for an artist to keep a certain amount of autonomy from everyday events in order to nurture pure, unrestrained images. It was here that he found himself at odds with many of his Russian cohorts from before the October Revolution of 1917. Though a supporter of the Revolution and its aims, he was suspicious of any art that was too directly tied to the political agendas of the day. As a consequence, Malevich and his philosophy of art were pitted against the more utilitarian "people's" art of the Russian Constructivists, who attempted to merge avant-garde sensibilities with everyday life in the cause of Communism (see, for example, El Lissitzky's street poster *Beat the Whites with the Red Wedge*, Fig. **9.28**, of 1920).

At first, both attitudes coexisted in a spirit of artistic freedom, but as Lenin consolidated his power throughout the region, the once seemingly endless supply of funding for the arts began to dry up in a cloud of economic despair. By the early 1920s, only those artists whose work reflected the "correct" revolutionary spirit (read the aims of the government) were able to secure much-needed funds, leaving those who operated outside these boundaries of art making to fend for themselves. In other countries, this arrangement might have seemed workable, even commonplace, as artists have always relied on some sector of the marketplace for their income. But in the Soviet Union, the Revolution had all but wiped out that sector of society which had been capable and willing to support such "useless" work. This left virtually no outlet for Malevich's radically apolitical Suprematist paintings, and with the death of Lenin and the rise of Stalin, things worsened.

Stalin's interest in what he called "agri-culture," a nationalist art program based on the glorification of the worker and the land, further disenfranchised the avant-garde artist from political grace. Indeed, avant-garde art, once a bastion of radical politics in pre-revolutionary Russia, was by the late 1920s looked upon with suspicion—a suspicion that often resulted in extended visits to the nearest gulag. Malevich was not unmoved by the traumas that surrounded both himself and his work, and by the end of his life he found himself retreating back toward the safer political confines of his earlier representation.

■ **9.27 Kazimir Malevich**
Suprematist Composition: White on White c. 1918
Oil on canvas
31¼×31¼ in (79.4×79.4 cm)
Collection, The Museum of Modern Art, New York

■ 9.28 El Lissitzky
Beat the Whites with
the Red Wedge 1920
Lithograph
20⅞×27½ in
(53×70 cm)
Lenin Library, Moscow

THE BAUHAUS

If this search for a purer art ever had an institutional manifestation, it was certainly in the guise of the Bauhaus. The term Bauhaus, German for "building house," was chosen by founder-architect Walter Gropius (1883–1969) from the idea of the medieval common lodgings where craftspeople engaged in the construction of cathedrals lived. The term is significant in that it asserts a collective vision of art making, where the subjective experience of the individual artist and the autonomy of the object gives way to the notion of a community of workers and the integration of all items into a unified and, in Gropius's view, universal totality. This esthetic philosophy of valuing the clean, the unornamented, and the supposedly objective over the highly personal, idiosyncratic, and subjective experience is yet another reiteration of a general mood of suspicion that permeated much of 1920s art; the nineteenth-century belief in the centrality of individual experience was seen by many, Gropius included, as at the heart of the tragic First World War. Gropius's design concept, best reflected in the school itself (Fig. **9.29**), possesses neither a regional nor a national architectural identity—attributes we have come to expect from important structures. Instead, its mechanical, perhaps even industrial, appearance asserts a purity of design outside the boundaries of individual preference and toward a more universal, "world-community"-embracing view of the future of architecture. To this end, Bauhaus design went far beyond straightforward architectural concerns; everything, from rugs to lighting to furniture, was considered in terms of the total experience.

The Bauhaus survived as an active art and design center until 1933. It was in that year that the National Socialists under Hitler shut its doors, accusing it of degeneracy, and a legacy of exceptional educational and artistic energy disbanded. There were many others like Gropius, Mondrian, Brancusi, and Kandinsky who carried on the traditional line that art could be a vehicle for special, universal, even sacred experiences—even after the horrific outbreak of the Second World War. But it appears few still believed traditional art conventions could carry the burden of an increasingly alienated soul by the middle of the twentieth century. As movies, radio, and print carried the daily horrors of a world once again under siege, and the name Hitler became a household word, the efforts of avant-garde artists to make even a small contribution among the carnage appeared a rather nostalgic dream—at least in Europe.

■ 9.29 Walter Gropius
Bauhaus, Dessau, Germany 1925–26
Photograph courtesy, The Museum of Modern Art, New York

▶ THE AVANT-GARDE IN AMERICA

● One of the repercussions of a Europe under siege during the Second World War was the exodus of prominent European artists to the safer shores of America. They brought with them an assortment of current trends, including aspects of Dada, Surrealism, and a variety of abstract programs. In a new land, a once euphoric avant-garde found a sustaining second wind, away from the despair, cynicism, and creative frustration of war-torn Europe. The new center of modern art was to be New York, which displaced an occupied Paris and became the melting pot of European art and American artists. The result was nothing short of spectacular.

Assuming that modern art is born out of innovation and experiment (and according to most artists, this is certainly the case), one might rightly ask what was left for the generation of young American artists to discover after the likes of Mondrian and the Surrealists. After all, by 1945 art had been effectively pared down to the sparest of elements, and even chance accidents were now standard fare in most progressive work. Yet Modernist art remained rather timid in its ambitions for the audience, and it was here that the boldness and self-assurance of the American landscape made its presence known, creating the most unabashedly heroic period in twentieth-century art.

To create any myth of heroes effectively, it is first absolutely necessary to lay out strict criteria or boundaries by which we measure prospective candidates (think no further than the Catholic Church's criteria for canonization). In post-war America, there were two individuals primarily responsible for setting such standards: the critics Clement Greenberg and Harold Rosenberg. Both came to contemporary art from more politically volatile concerns, but like so many other intellectuals during the heights of the "Red scare," the lack of enthusiasm for "radical" ideas pushed them into less conspicuous fields. Greenberg's *Avant-Garde and Kitsch* (*Partisan Review* VI: 6, Fall 1939) of 1939 paved the way for later American art when he wrote, "Today, the medium is the public content of the abstract painter's craft." What does this enigmatic statement mean? In simple terms, Greenberg believed that formal considerations were the heart and soul of Modernist art, and thus painting, sculpture, photo-graphy, or what have you was most valid and truly radical when it openly exhibited its direct relation to the physical factors behind its creation. Greenberg has been labeled a formalist critic, because of his insistence that great art acknowledge its physical parameters. Thus a great painting would first and foremost set up a dialogue between the subject and the physical realities of the edge, surface, and the paint material. As early as Cubism, the subject had become transformed by these considerations, to the point where traditional notions of painting as an illusionary window onto the world had been overcome by a new ideal, which reiterated the non-illusionistic or "truthful" aspects of the work. But to this rather bland formula, Greenberg added the notion of the artist's hand, which too could be the vehicle for more intriguing subject matter. To understand fully the ramifications of the "artist's mark" and its important relation to American Abstract art, it is perhaps appropriate at this point to examine the work of an artist Greenberg particularly admired: the tumultuous Jackson Pollock.

ABSTRACT EXPRESSIONISM

Pollock (1912–56) remains one of the most celebrated (and in his day, the most ridiculed) artists in American history. His seemingly random and incoherent method of painting elicited the mockery of conservative critics and the public alike, who saw his work as a joke produced by a man out of control (see Fig. **9.30**). What appeared at stake for those critics was the very validity of the craft of painting, since Pollock's "drip" method seemed without technical skill or even much thought. Of course, this was not the case, but it is true that Pollock's use of materials has its precedents in the spontaneous and the accidental experiments of European Surrealism and its celebrated attempts to unlock the unconscious—freeing the artist from restrictive technical conventions. Pollock was aware of these developments by way of the works of a number of expatriate Europeans living in New York during the late 1930s—in particular, Archile Gorky (1904–48) (see Fig. **9.31**). Yet for all of the radicality supposedly inherent in Pollock's work (see Fig. **9.32**), there were elements as old as time embodied within those drips.

■ 9.30 Hans Namuth
Photograph of Jackson
Pollock in his Studio
East Hampton, New York
1950

A seldom mentioned yet noteworthy parallel to Pollock's spontaneous gesture is the Zen Buddhist method of meditative ink painting, which was discussed in Chapter Three. You will remember that the idea behind virtually every aspect of this method was an attempt to reunite opposites, or opposing forces at work in the act of creation. The relationship between the artist's hand (which attempts to bring order and ideas to the work) and the natural behavior of the materials (the inherent ink splashes and paper bleeds that work against an imposed order by producing a wide range of unpredictable events) was thus used as a working metaphor for the spiritual and psychological conflicts individuals confront daily (the polarities of nature and nurture, planning and chance, male and female, aggressive and passive, etc.). By the late 1940s, such ideas were beginning to be fashionable in America, arriving with the GIs stationed in the Orient after the war. And though it is difficult to know to what extent Pollock was influenced or even aware of these notions, his few statements exhibit a striking sympathy for such ideas. As the celebrated photograph of Pollock in his East Hampton studio attests, the artist did not always use conventional painting tools to produce his marks; in fact, he often preferred working with sticks rather than brushes, and even poured paint right out of the can to keep his control of it to a minimum. The idea was to let the materials respond naturally to the motions of the artist's hand, and by working on the floor on large areas of canvas, Pollock achieved a convincing visual re-creation of a body in motion. Pollock talked of the feeling of being "in" his paintings, like an active participant in an unfolding drama rather than an omniscient creator. In part, this almost uncanny feeling of motion and

■ 9.31 Archile Gorky
Agony 1947
Oil on canvas
40×50½ in (101.6×128.3 cm)
Collection, The Museum of Modern Art,
New York
A Conger Goodyear Fund

■ 9.32 Jackson Pollock
Number 1, 1950 (*Lavender Mist*) 1950
Oil, enamel and aluminum on canvas
87×118 in (2.21×2.99 cm)
National Gallery of Art, Washington, D.C.
Alisa Mellon Bruce Fund

energy can be attributed to Pollock's willingness to enlarge the parameters of modern painting beyond the easel scale of a Picasso. The vastness of some of Pollock's canvases allowed the artist literally to dance with paint as an extension of his body, which in turn left a trail of motion within a complex web of color and line.

Yet despite the overwhelming desire to read Pollock's paintings as simply raw documents of primal energy, it would be misleading to see paintings such as *Lavender Mist* as only expressive outpourings. The label "Abstract Expressionism" has been commonly applied to many of the first-generation American abstract painters after the Second World War, due to the primacy of gesture and color over all other pictorial concerns. No doubt this is a vital feature of Pollock's work, but it fails to recognize the importance of the formal issues these paintings address. The all-over application of paint and the dispersal of depth across the surface of the picture plane both directly relate to the earlier investigations of the Cubists and Mondrian. The gestures of paint force one's eyes to travel in and out of shallow space and across the whole area of the canvas—gone completely is "window onto the world" illusionism, replaced by a seemingly endless universe of movement "on" the surface plane. Also, the viewer is made aware of the limits of this plane, since the surface design is often pushed in a uniform manner to the boundaries of the painting's edge. Here, in these straightforward and uncompromisingly intelligent paintings, critic Clement Greenberg's ideal of an art that embraced the truth of its "objectness" and the spirit of its making becomes a reality—the pictorial marriage of form and content in a convincing, though deceptively complex body of work.

It is to the critic Harold Rosenberg that we owe the celebrated analogy of the "Coonskins and the Redcoats" with regard to the rise of American abstract art. In this rather romantic scenario, the Americans were, of course, the coonskins, who though less refined than their European counterparts, would nonetheless over-run the decadent and bankrupt traditions across the sea. What both Rosenberg and Greenberg (to whom we owe the phrase "American Style Painting") were attempting to address was a seemingly new kind of energy embodied in American art after 1945. Though the criteria were never steadfast, generally speaking the work was: large in scale (which was poetically related to the expansive American landscape, even though most of the artists were urban New Yorkers and thus probably more influenced by billboards), devoid of

■ 9.33 Franz Kline
Vawdivitch 1955
Oil on canvas
62×80 in (157×203 cm)
Private Collection, New York

overt representational imagery, paying close attention to the formal qualities inherent in the medium, and ripe with an unprecedented degree of rhetorical baggage. There were some, like Franz Kline (1911–62), whose work followed a more violent and gestural course, mimicking both architecture and calligraphy in a few dramatic strokes (see Fig. **9.33**). Others, such as Dutch expatriate Willem De Kooning (b. 1906) continued to paint on the borders of the figurative tradition, desecrating images under a convulsion of painterly gestures. His most famous works from the 1950s are his provocative "Woman" paintings, which walk a fine line between exuberant, almost rapturous, painting and violent dismemberment (see Fig. **9.34**). This is Picasso's *Demoiselles* taken to the extreme—the "Breck" shampoo girl of the 1950s with fangs. What is perhaps most disconcerting about such work is the

■ 9.34 Willem De Kooning
Woman and Bicycle 1952–53
Oil on canvas
76½×49 in (194.3×124.5 cm)
Collection of Whitney Museum
of American Art, New York
Purchase

■ 9.35 Joan Mitchell
Low Water 1969
Oil on canvas
112×79 in (284.5×200.7 cm)
Carnegie Museum, Pittsburgh
Patrons Art Fund

▶ 9.36 Helen Frankenthaler
The Bay 1963
Acrylic on canvas
80¾×81½ in (205×207 cm)
© The Detroit Institute of Art
Gift of Dr. and Mrs. Hilbert H. DeLawter

authority and power of De Kooning's mark making—his painting becomes violence manifest. There are a number of critics who, with some justification, have come to view the abstraction of a Pollock or a De Kooning as saturated with a number of unsettling assumptions about art making as the domain of the virile male—aggressive, violent, heroic, misogynist. Yet women too embraced the new freedom of gestural painting as a way of freeing themselves from the restrictive confines of the earlier pictorial traditions from which they had been excluded. Artist Joan Mitchell (b. 1926) was one of the pioneering women painters of the post-war era, and despite differences in gender her work exhibits many of the visual characteristics of her male counterparts (see Fig. **9.35**). Others, such as Helen Frankenthaler (b. 1928), exploited the more lyrical

possibilities of gesture afforded by the direct staining of her canvases with thin washes of paint (see Fig. **9.36**). Whether the "lyrical" slow curve and thinly veiled mark of a Frankenthaler are more innately feminine than the crisper, more defined gesture of a Mitchell is open to debate—the issue will be taken up at greater length in the Epilogue, pages 436–43.

Though painting was not alone among the visual arts in its embrace of the new abstraction, it was certainly the most suited. Considerations such as color and gesture (which, of all the various visual conventions utilized in art making, appeared most directly tied to emotional responses in the viewer), which by 1950 were an integral part of the painter's vocabulary, seemed difficult to translate into other fields of art. However, there were some notable exceptions, such as

■ 9.37 David Smith
Cube XVII 1963
Stainless steel
Height 9 ft (2.74 m)
Dallas Museum of Art
Eugene and Margaret
McDermott Fund

sculptor David Smith (1906–65). Originally trained as a painter, Smith put himself through school with his skills as a welder. Interested in collage as a way of building images, he soon seized the opportunities afforded by welding to begin assembling three-dimensional constructions. From this point on, he abandoned the suggestive and atmospheric qualities of painting for the physical demands of sculpture.

Cube XVII (Fig. **9.37**) of 1963 is one of many pieces executed by the artist in steel—a material not often associated with great art at the time. Why steel instead of casting elements in bronze, or carving in stone, as was traditional? Smith was deeply influenced by the assemblage constructions of Picasso, which he saw as a successful three-dimensional solution to collage. His first works combined metal elements, using welding techniques as the collage artist uses glue, slowly layering information. However, many materials did not possess the strength or resilience necessary to produce works with the degree of ease and spontaneity implicit in collage. The answer came in steel, an industrial material of great strength that could be fabricated and assembled into a variety of interesting configurations

without worry of collapse. *Cube XVII*'s rather precarious posture suggests the speed and energy of collage, but in a far more tangible, physical manner. Yet Smith recognized that sculpture too has its surfaces, and began grinding or sometimes painting his work to bring more visual information to bear upon the piece. In *Cube XVII*, the auto grinder becomes the rough equivalent of Pollock's sticks, circulating visual energy around the piece as light reflects off its surfaces. With his acceptance of the formal characteristics of traditional sculpture (volume, the engaging of space and materials), combined with a highly personal investment in the work through his use of gesture, it is little wonder that Greenberg saw David Smith as one of the foremost artists of the post-war period.

MARK ROTHKO AND BARNETT NEWMAN

Gesture and luscious material handling were not the only attributes of abstract painting embraced by the avant-garde in post-war America. There were a number of artists who placed their energies in unifying the picture plane in a more resonant, less overtly physical

■ 9.38 Mark Rothko
Untitled 1960
Oil on canvas
69×50⅛ in (175.3×127.4 cm)
The Museum of Modern Art,
San Francisco
Acquired through a gift of
Peggy Guggenheim

manner, producing eloquent expressions of harmony, balance, and equilibrium. Due in part to the large areas of undifferentiated color in many of the works, this loose association of artists has come to be known as the "color field painters" and includes the likes of Mark Rothko (1903–70) and Barnett Newman (1905–70). Rothko's *Untitled* of 1960 (Fig. **9.38**) is indicative of the artist's mature work, with flooded fields of resonant color bleeding to the extremities of the surface's edge, suggesting everything from landscape to the dream

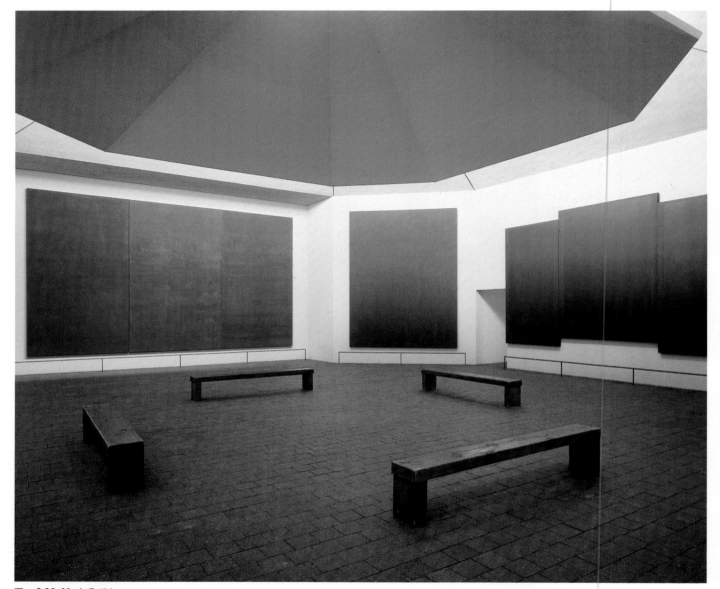

■ 9.39 Mark Rothko
View of The Rothko Chapel, Houston 1965–66
Oil on canvas
North, Northeast, and East paintings

state. The relationship between colors, fluctuating between harmony and discord, gives these works an undeniable moodiness and solemn quality often associated with great religious art. This point was not lost on the artist, who said, "The most important tool the artist fashions through constant practise is faith in his ability to produce miracles when they are needed. Pictures must be miraculous." (*Possibilities* I, 1947, p. 84.) Here is yet another example of an art work that traverses the expanse between formal concerns popular since Cubism and the desire for an exalted, universal subject matter accessible to all with a meditative and patient eye. Rothko's evocative paintings lend themselves readily to the introspective viewer and, like other religious works, function most effectively when granted a quiet, traffic-free setting for their contemplation. To facilitate such demands, Rothko was given what was perhaps the last great religious commission in Modern-

ism, maybe even Western art—the production of a series of paintings for a non-denominational chapel outside Houston (Fig. **9.39**), which has been aptly described as one of the most solemn places on earth.

A word on "untitled" works. Over the past half-century, many artists have made the conscious decision to leave their art titleless. This does two things: first, it implies that there is no one correct meaning to the work, and second, it invites the viewer to be an active participant in the process of art making—both of which require explanation. The notion of a single correct meaning in a work of art has always been contingent upon the audience's ability to recognize the subject matter, and then have an intimate knowledge of the artist, his/her ideas, the context of the piece, the specific historical context, etc. This, of course, is impossible; the infinite combination of personalities, experiences, cultural prejudices, and their subsequent influences makes the argument of a single "true" meaning a fallacy. In traditional representation, this gulf between one universal "meaning" and various individual "meanings," though it still existed, was minimized to some extent by the viewer's instant recognition of the subject, which when placed within the context of the

title, helped restrict the subject "matter" into a more channeled number of possibilities. In non-representational work such as Rothko's, the absence of easily identifiable images to hang presumed meaning on forces the viewer to consider more personal explanations for its content. In this way, the viewer creates meaning in the work; or in other words, the traditional proposition "this is what I am experiencing" becomes "what is this I am experiencing?". The untitled work is obviously not for every artist, since its reliance on the viewer's active participation minimizes the artist's own voice (hence its unpopularity with politically motivated artists, who often use their work as a platform for issues). But in the case of a Mark Rothko, the openness of meaning afforded by the untitled label seems absolutely appropriate when one considers his desire to address a more intuited range of emotions in his audience.

Like Rothko, Barnett Newman believed that art could still carry the weight of human consciousness and renewal, but his stricter adherence to formal issues has made his painting less accessible to the average viewing public. *Ver Heroicus Sublimis* (Fig. **9.40**) of 1950–51 operates first and foremost as a painting about painting;

■ **9.40 Barnett Newman**
Ver Heroicus Sublimis 1950–51
Oil on canvas
7 ft 11⅜ in × 17 ft 9¼ ins (2.42×5.41 cm)
Collection, The Museum of Modern Art, New York
Gift of Mr. and Mrs. Ben Heller

that is, the artist has concentrated the audience's visual energies upon the physical relationship of the surface (a uniformly flat application of saturated red) to the edges of the canvas, which is further accentuated by the thin vertical lines (what he calls "zips") that act as parallels to those edges. Newman saw these vertical zips on the horizontal plane as functioning on two distinct levels: first, as a formal device to reassert the presence of the outside edge, and second, as a body metaphor. The vertical marks on the horizontal plane mimic the fundamental way in which humans interact with their world, and in this way a highly abstract formal painting comes to embody a variety of more personal attributes. Put another way, Newman's suggestion of the body (even if highly abstracted) as a straightforward formal device enables what might on first glance appear little more than a spartan canvas to take on highly personal, even universal characteristics—body and world unified in harmony and stasis. Within this context, Newman's grandiose choice of title (*The Heroic Sublime*) serves a vital function in suggesting a deeper significance to what on the surface may appear little more than a formal exercise.

THE ADVENT OF MINIMALISM

Barnett Newman is quoted as saying that American abstract art was "asserting man's natural desire for the exalted . . . a concern with the absolute emotions." Looking back at *Ver Heroicus Sublimis*, it is perhaps fair to say that a chasm existed between what was said about the art and what the art actually looked like during the heights of American post-war abstraction. The rhetoric that surrounded such self-proclaimed "heroic" work was indeed dense and often intolerable to those artists a generation younger who were forced to grow up under its formidable weight. The subsequent backlash was to signal the beginnings of a crisis in art making, as increasingly artists began questioning the authority of their elders and, more importantly, stopped believing the heroism. Some of the younger artists openly confronted the ideals of Modernism, criticizing both its message and its ability to change the world in any significant way. These were the Pop Artists, who helped usher in our current Postmodern era (see Epilogue, pages 418–35). But before a movement can truly be said to have ended, it must first show the signs of exhaustion. One of the most basic tenets of Modernism was the belief in innovation; artists, like their col-

leagues in science and business, had openly embraced the notion of innovation as progressive and thus good (or "modern"). Yet there are only so many variables available to the artist in producing art, and eventually this seemingly endless supply of new combinations was going to run out. Abstract Expressionism had pushed the limits of art making almost to the edge; it was now simply a matter of pushing it over. This last phase of Modernism has aptly been described as Minimalism.

When painter Frank Stella (b. 1936), one of the most influential of the Minimalist artists, was asked to express his thoughts as he was producing his series of "black paintings" in 1959–60, he claimed he wanted to "paint a picture no one could write about." *Die Fahne Hoch!* (Fig. **9.41**) of 1959 is the result of that approach—an image that defies both the easy symbolism and heroic stature of its predecessors in Abstract Expressionism. Stella's painting consists of little more than an arrangement of flatly applied black enamel lines on raw canvas, which radiate from the center in a predictable, uniform manner. All components of the painting work in remarkable harmony and coherence. Consider the issue of paint. Instead of using traditional oil paint, which dries to a rich, suggestive black, Stella chose an industrial enamel, which dries absolutely flat and is absorbed into the canvas. The canvas in turn is left unprimed, without its typical application of gesso or lead white to protect the surface. Visually, this decision helps bind the canvas to the paint as one complete object, and it also reasserts the painting as a form rather than simply a surface—a piece of stretched material over a rectangular frame, which creates edges. The result is a work that successfully destroys any vestige of illusion by methodically dissipating space, as the bar-like black stripes push the eye away from the center of the picture plane, bringing attention to the edge. Gone is the space, gone is the illusionism, gone are practically all suggestions of subject matter other than the apparent "objectness" of the painting. This is what might be referred to as a self-enclosed work—an image that is internally consistent, and requires no information outside the boundaries of its own edges to function. Here, painting has collapsed into sculpture, referring more to three-dimensional concerns than earlier painting conventions.

Minimalism was primarily a sculptural movement, and it put tremendous emphasis on structural unity, synthesis of parts, and absolute intelligibility. Carl Andre (b. 1935) worked as a studio mate of Stella's

■ 9.41 Frank Stella
Die Fahne Hoch! 1959
Black enamel on canvas
121½×73 in (308.6×185.4 cm)
Collection of Whitney Museum of
American Art, New York

■ 9.42 Carl Andre
Lever 1966
137 firebricks, assembled:
4½×8⅞×348 in
(11.4×22.5×883.9 cm)
each brick: 4½×8⅞×2½ in
(11.4×22.5×6.4 cm)
National Gallery of Art, Ottawa

during the early 1960s, yet his vision was even less grounded in traditional forms. His first works involved both stacking and carving wood, which implied architecture and also totemic sculpture. But the referential quality of this early sculpture seemed too tied to history and to craft for Andre's temperament, and soon carving (which implied the artist's hand) gave way to simple, regular stacking. The next move was away from the vertical plane, toward the horizontal, which hugged the earth and denied figurative and architectural associations. *Lever* (Fig. **9.42**) of 1966 consists of 137 unconnected commercial firebricks assembled across the floor, and it sums up Andre's interests during the middle 1960s: sequence, horizontality, the assertion of gravity, and a steadfast denial of craft or expression.

When it was first shown in 1966, it immediately caused an outcry from public and critics alike, who saw no "merit" in a row of bricks.

How does a viewer make sense of a row of bricks? And furthermore, what would possess an artist to produce this kind of work? First, it is important to acknowledge that if *Lever* is art, then it necessarily opens itself up to a dialogue with history, since all art, even the most radical, relies on that history as a point of departure. In this regard, there is much of interest in *Lever*, since it seems to provoke comparisons with traditional sculpture—traditional sculpture is vertical, often figurative, and even in its most radical form material-oriented, whereas *Lever* is horizontal, anti-figurative, component-like (each piece having

attributes of the whole), and conspicuously without technical prowess (compare David Smith's *Cube XVII*, Fig. **9.37**). Taken within this context, Andre's line of bricks appears an affront to traditional values in sculpture, and when viewed within the context of sculpture in a museum, say, it acts as an informed critique of that tradition. But can that alone make it art? Perhaps the most troubling aspect of this work for most viewers is its lack of technique; the simple fact that anyone could have assembled it insults the traditional view of artists as skilled technicians, whose work comes as a result of years of arduous training. What is most ironic about such claims is that the Minimalists remain some of the most informed and critically aware artists of the twentieth century, whose decision to produce anti-craft work was the result of choice and thought, rather than a lack of skill or conceptual immaturity. Andre, like other Minimalists, questions the validity of technique and craft, which were viewed as romantic, nostalgic nonsense in a world of automation and conformity. Without technique, the viewer is forced to consider the intrinsic merits of the piece as a visual phenomenon—a conceptual cuing device, if you will. Since you cannot be distracted by seductive technical work which suggests the artist's hand and thus an external subject matter, you are forced to deal with it on other terms. In addressing those visual concerns, Minimalist art enters into a dialogue not only with other art but also with the history of speculation that surrounds the very idea of merit.

Donald Judd (b. 1928) was an early Minimalist who has continued to pursue an art that openly criticizes aspects of Cubism that so influenced twentieth-century art. In Cubism, the audience is granted a simultaneous view of all angles of the perceptual field—different views brought together to form a visual approximation of the process of observing the whole. Judd wanted an art that could be understood at once, in an instantaneous rather than a fractured manner. The result is work whose components are interchangeable, machine-assembled, modular, and thus absolutely predictable. *Untitled* (Fig. **9.43**) of 1989 is typical of Judd's obsession with modular construction, and it purposefully leaves little of significance to the imagination. Here, the subjectivity of the viewer, so important to the Abstract Expressionists, dissipates into an absolute view—coherent, static, whole. This is sculpture pared down to its most fundamental characteristics, and if the view is none too inspiring, it is perhaps because

■ 9.43 Donald Judd
Untitled 1989
Copper, red plexiglass
each 9×40×31 in (23×101.6×78.7 cm)
Courtesy Paula Cooper Gallery, New York

Minimalism appears as an art without a voice. And in the muteness of Judd's sculpture, the final exhaustion of the Modernist ideal became increasingly apparent. Decades of relentless innovation had led to a virtual vacuum, but to turn back was to admit defeat. Minimalism closed the door on Modernist optimism once and for all in its sterile fabrications and now it seemed more a question of how to go forward when everything appears to have been done. This is the crisis of contemporary art.

▶ THE END OF AN ERA

● As an idea or movement, Modernism was intimately linked to a series of popular assumptions about the world that surfaced in the late nineteenth and early twentieth centuries. The machine age had promised, and had often delivered, a better life for those held so tightly in its grasp. But as today's mind-boggling accoutrements of civilized warfare so dramatically attest, the machine is little more than an extension of human conscience and frailty—no better, no worse, but certainly imperfect. Art too had openly embraced innovation and progress as cures for a complacent culture, and soon the mystique of the artist as an explorer of the great unknown took on heroic proportions. Modernist art actively sought to separate itself from everyday pedestrian concerns in order to focus on creating a visual strategy that could point the way for future generations. Yet deep within this complexity of ideas there existed one underlying assumption: that the evolutionary theories of science proved that progress was inevitable, and thus could be transferred to all fields of human endeavor. Thus innovation, despite an occasional setback, became a motive for art making, and as with science, notions of art as a process of almost religious discovery or exploration soon became an integral part of artists' vocabulary.

Modernist art certainly did not save the world, and even at the best of times it was terminally myopic—but at least it was a conviction. And at a time when cynicism has become increasingly fashionable, perhaps one can take solace from the knowledge that there are, or were people who believe/d ideas can/could save the world.

One of the most eloquent obituaries for the Modernist movement was written by the critic Peter Schjedahl in a recent article on abstract painting:

> Art as a substitute religion (and it was no less than this for Rothko as well as Mondrian) has disappointed us, and there is a general understanding, I think, that artistic grandeur is not worth the terrible human cost required to attain it. It would be a shame, however, to let our present cynicism be retroactive, denigrating the great work created in the last tide of faith. Rothko lacked the wisdom of the 1980s, which is that to believe in anything these days is messy and dangerous—and that does give us an edge on him. (Quoted in Suzi Gablik, Has Modernism Failed?)

▶ SUMMARY

● Like the culture that gives it meaning, the art of the twentieth century is the focus of considerable debate and will continue to be so for the foreseeable future. Perhaps it is our current lack of historical distance that makes any process of evaluation treacherous, but it also suggests that the revolutionary attitudes inherent in the idea of Modernism are perhaps still our own. Within the sixty years that separate Cubism from Minimalism, Modernist art traveled its precarious path through two world wars, the Depression, the advent of nuclear bombs, and the Cold War. Its flat paintings and environmental sculptures, its embrace of nature, chance, and the unconscious, its paradoxical deification and suspicion of the machine, and its rejection of traditional standards of quality and values, all parallel our century's struggle for definition and meaning. And if the underlying attitude that permeates the words and work of these artists now seems sadly out of date, then perhaps it is because we lack the necessary faith that artists can indeed bring about change; that they can not only reflect their world but actively participate in its creation. If cynicism prevails, it is our loss, and will certainly remain their strength.

Suggested Reading

There is no shortage of excellent texts that give a general introduction to the world of twentieth-century art. One of the most thorough and comprehensive is George Hamilton Heard's *Painting and Sculpture in Europe, 1880–1940* (Harmondsworth and New York: Penguin Books, 1981). For a more leisurely pace, Herbert Read's *A Concise History of Modern Painting* and *A Concise History of Modern Sculpture* (both Oxford, New York, and Toronto: Oxford University Press, 1974) have become very popular single-volume introductions to the subject. Robert Rosenblum's *Cubism and Twentieth-Century Art* (Englewood Cliffs, NJ, and New York: Prentice Hall and Abrams, 1976) is a fascinating read on the enormous influence of Cubism on future art, and is very highly recommended for those who seek a more indepth analysis. For a closer look at post-war art, Edward Lucie-Smith's *Late Modern: The Visual Arts since 1945* (Oxford, New York, and Toronto: Oxford University Press, 1980) and Nikos Stangos's collection of essays *Concepts of Modern Art* (New York and London: Thames and Hudson, 1981) are both informative and insightful. Finally, if you would like to read what the artists and critics actually thought about their work and that of others, H. B. Chipp's *Theories of Modern Art: A Source Book of and by Artists and Critics* (Berkeley: University of California Press, 1968) is considered a classic.

Glossary

Abstract Expressionism (*page 399*) A common appellation for first generation American abstract painting after the Second World War, due to the primacy of gesture and color while keeping consistent with the aims of formalism (the all-over application of paint and the dispersal of depth across the surface of the picture plane).

Bauhaus (*page 398*) Derived from the German "building house," it was a school of art and design developed under the guidance and esthetic philosophy of architect/designer Walter Gropius. Active in the 1920s and early 1930s, it attempted a collective vision of art making, where the traditional subjective experience of the artist and the autonomy of the object were relinquished in favor of a more communal attitude to the problem of design. It put emphasis on pure, unornamented structures devoid of subjective or regional idiosyncrasies.

collage (*page 381*) Meaning "gluing," it is a method of applying extraneous material (and thus subject matter) to an art work. It has been used to reiterate objects and ideas from the real world, as well as to suggest history, nostalgia and the build up of superficial material culture.

Cubism (*page 370*) The first art movement of the twentieth century systematically to reconsider the conventions of painting since the Renaissance. It was an attempt to represent fully and exhaustively on a flat surface all aspects of what the artist saw in three dimensions.

Dada (*page 384*) A radical art movement initiated in Zurich during the First World War as an affront to what it saw as the hypocrisy of conventional culture. It attempted to set new standards for art and art making by abandoning traditional picture making in favor of performance work and other non-traditional gestures. It also used chance as an important part of the art process, in the hopes of producing work free of the trappings of rational culture.

Minimalism (*page 410*) A painting and sculpture movement of the 1960s based on the primacy of the art object in its purest formal condition.

non-illusionistic painting (*page 399*) A term used to identify paintings which refers essentially to their physical and material character. Such work attempts to deny conventional pictorial constructs (such as perspective, chiaroscuro) for organizing space, hence its non-illusionism.

Surrealism (*page 388*) A literary and visual art movement interested in unleashing and exploring the potential of the human psyche. Loosely based on both Freud's and Jung's investigations into the mind, it is also direct heir of earlier Dada strategies of the unlocking of the unconscious by the use of chance.

EPILOGUE
Contemporary Art, Issues, and Ideas

This final section of the text is designed as a series of contemporary studies centered around particular works of art. It aims to act as a brief introduction to the world of recent art and art criticism. Each study will consider a specific aspect of the current art debate and, through a brief discussion of an artist's work, a critical position, or even a current re-evaluation of art history, and give an indication of the diversity of ideas prevalent today.

The controversial and often misunderstood term Postmodernism, the status of women in art history, the effectiveness of political art and the disquieting revisionism of art history will all be briefly addressed and placed within the context of earlier discussions. It is to be hoped that readers will look at these ideas with a critical eye and come to their own conclusions. No author will ever be in a position to put enough distance between him/herself and the world to present a comprehensive survey of events as they unfold. With this in mind, consider these short essays as jumping-off points for further discussion and contemplation.

■ 10.1 Georg Baselitz
Nachtessen in Dresden (detail) 1983
Oil on canvas
110×177 in (280×450 cm)
Saatchi Collection, London

■ 10.2 Roy Lichtenstein
Masterpiece 1962
Oil on canvas
4 ft 6 in × 4 ft 6 in (1.37 × 1.37 m)
Private Collection, New York

▶ POP ART AND THE RISE OF POSTMODERNISM

The real answer to the question of whether or not modernism has failed can only be given, in the end, by changing the basic dimensions in which we measure not only happiness and unhappiness in our society, but also success and failure.

SUZI GABLIK, *Has Modernism Failed?*
(New York and London: Thames and Hudson, 1984, p. 128.)

In 1962, American artist Roy Lichtenstein painted *Masterpiece* (Fig. **10.2**), a work that functions both on the level of "serious" art and as a critique of that very same tradition. Derived from comic strip images, and mimicking the commercial "ben day dot" configuration popular in cheap reproductions, the work seems to rejoice in its easy accessibility and popular appeal. It is work about popular culture, art as a commodity, and of the gulf between high and low art. It is also art about the hypocrisy and failings of Modernist culture in the age of the media blitz. It has been fittingly called Pop Art.

This work is very different from the Pollocks or Rothkos of the previous chapter. It espouses little of the heroic standards of the previous generation of American painters, who invested their work with an enormous amount of personal and cultural significance (see Fig. **10.3**). To the Abstract Expressionists, art had been about very specific things: autonomy, artistic will, the search for a universal or archetypal language, and a respect for the formal tradition and the physical realities of the materials, epitomized in the work of Jackson Pollock (Fig. **10.4**). This was quintessential Modernism, born of progress and sustained by will; it was also a myth that was beginning to show signs of terminal exhaustion by the late 1950s. By the early 1960s, there were those who still embraced formal abstraction as a vital and necessary form of investigation (such as Frank Stella and Donald Judd), but it is noteworthy that even these artists recognized how the romantic rhetoric of

the previous generation had outstripped the work (hence Stella's claim that he "wanted to paint something that no one could write about") (see Fig. **10.5**). For all of their apparent radicality, the works of Pollock and Newman and Rothko were now firmly entrenched as part of "high American culture," showing in exclusive galleries and selling for considerable amounts of money. They were sanctioned by being placed alongside other "masterpieces" in important public museums, and their images now appeared on everything from postcards to backdrops for fashion

■ **10.3 Ad Reinhardt**
The Rescue of Art
Cartoon published in Newsweek, 12 August, 1946

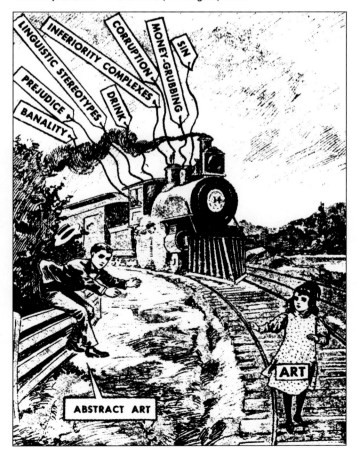

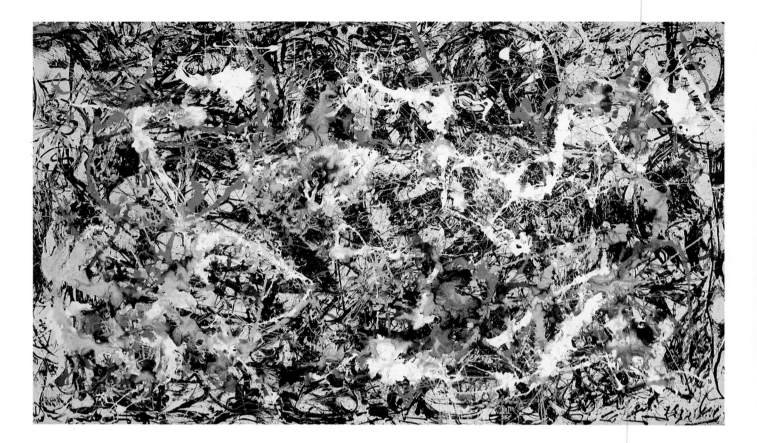

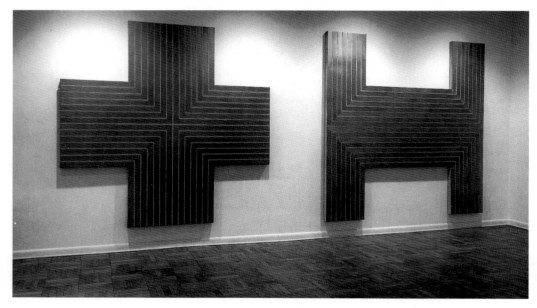

■ 10.4 Jackson Pollock
Convergence 1952
Oil on canvas
8×13 ft (2.43×3.96 m)
Albright-Knox Art Gallery, Buffalo,
New York
Gift of Seymour H. Knox, 1956

■ 10.5 Frank Stella
Installation at the Leo Castelli
Gallery, New York, 1962

advertisements. In short, the blood, sweat, and tears that had been so much a part of the Abstract Expressionist persona had proven itself to be no more radical or difficult to neutralize than any other form of culture; it simply became a precious object, invested with value and thus part of the larger mechanism of the marketplace.

There were a few members of the avant-garde very

■ 10.6 Marcel Duchamp
Nude Descending a Staircase No. 2
1912
Canvas
58×35 in (147×89 cm)
Philadelphia Museum of Art
The Louis and Walter Arensberg
Collection

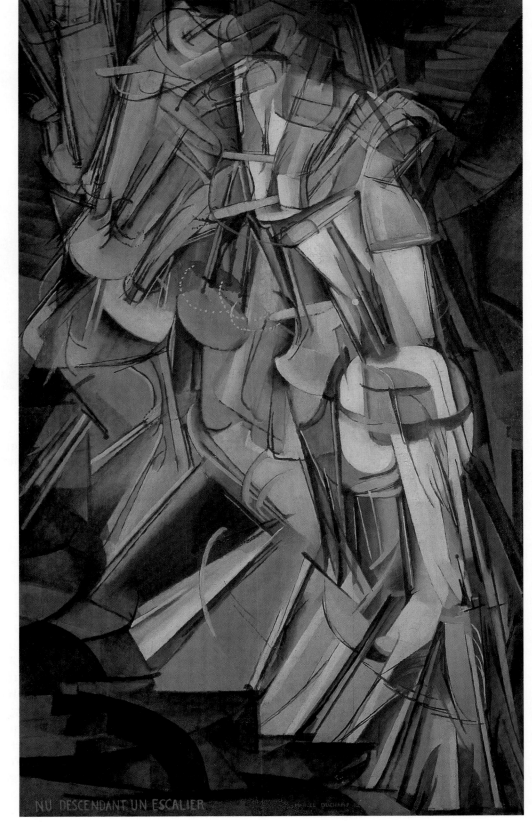

NU DESCENDANT UN ESCALIER

early in the century who challenged the accepted notion of art as a specifically sacred, romantic endeavor. Seeing art as a decidedly social construction and recognizing how seemingly arbitrary our foundations of quality have often been, one particularly innovative and skeptical individual used his art as a form of Modernist critique—and his name was Marcel Duchamp. Duchamp (1887–1968) was trained as a painter, and during the early 1910s produced a series of Futuro-Cubist paintings culminating in his *Nude Descending a Staircase* (see Fig. **10.6**) of 1912. It was

■ 10.7 Marcel Duchamp
Bicycle Wheel (3rd version after lost original of 1913)
Assemblage: metal wheel, 25½ (64.8 cm) diameter, mounted on painted wood stool, 23¾ in (60.3 cm) high, overall, 50½×25½×16⅝ in (128×64.8×42 cm)
The Museum of Modern Art, New York
The Sidney and Harriet Janis Collection

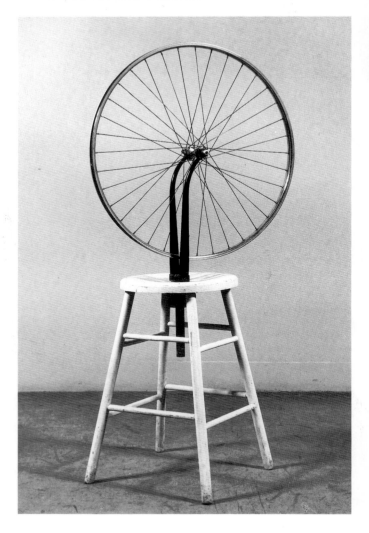

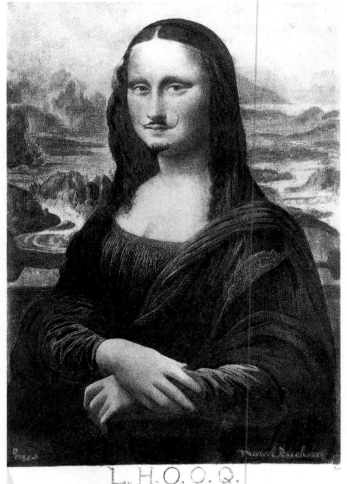

L.H.O.O.Q.

■ 10.8 Marcel Duchamp
La boite en valide (L.H.O.O.Q.) 1919
Rectified readymade, pencil on reproduction
7¾×4⅞ in (19.7×12.2 cm)
Collection of Mrs. Mary Sisler

shortly after this that Duchamp began his breakthrough series of what he called "ready-mades"—objects in and of this world reassembled or recontextualized to alter their meaning. An example may help clarify this idea. Duchamp's *Bicycle Wheel* (see Fig. **10.7**) originally of 1913, and reproduced in limited edition in 1951, consists of a bicycle wheel positioned upright on a simple stool. Both items are accepted as viable art materials by the artist without the typical alterations which might have made them appear more personal, or idiosyncratic—more art-like. Instead, we are simply given an assemblage of parts, put together in an unorthodox manner. As a consequence of its peculiarity, the *Bicycle Wheel* presents the viewer with a number of puzzling suggestions. Is it art? What constitutes the designation art? How does the context in which this piece functions (a gallery or other art space)

change or effect its meaning? And to what extent are the subjective experience of the artist and his use of materials important parts of the idea of art? Such work stretches the traditional boundaries of art by implicating the viewer in the process of the piece's construction and meaning. *Bicycle Wheel*, like other Duchamp ready-mades, asks serious questions about how we come to understand something, and how art is as much a matter of context as it is of content. Such simple items also suggest that the sacred esthetic experience we have come to demand of art can be expanded to embrace objects and ideas from every part of our lives. All that can be said for certain is that there are no clear answers to be had from these ready-mades, only challenging, even disturbing questions—questions few in the early part of the century were willing to answer.

Though Duchamp was only loosely associated with Dada, his work shows certain underlying sympathies with their anger and their aims. His *L.H.O.O.Q.* (Fig. **10.8**) of 1919 is a deliciously nasty attack on high culture through one of its sanctioned icons, the *Mona Lisa* (the initials L.H.O.O.Q. pronounced together in French produce the phrase "she's got a hot ass"). The witty imposition of an almost childlike mustache and beard drawing not only "defaces" the portrait, but also suggests a rather floating sexuality both in the subject and the artist (many continue to consider the *Mona Lisa* as a Leonardo self-portrait in women's clothes). The idea of androgyny, fluctuating between defined social constructions, both sexually and culturally, was to be a recurring critical theme for Duchamp for the next decade, when he "gave up" art to concentrate on chess. But in these pivotal works, the artist initiated a level of critical inquiry and skepticism that was dramatically to affect the idea of art making in the late twentieth century.

During the heights of 1950s abstraction in New York, there emerged two young artists of Duchampian temperament who with cold detachment began to reconsider the uneasy relationship between high and low or popular art so mocked by Clement Greenberg, and their work forms an important bridge between the lofty heights of Abstract Expressionism and the later cynicism and hyper-criticality of Pop Art. Their names are Robert Rauschenberg (b. 1925) and Jasper Johns (b. 1930).

Rauschenberg's *Bed* (Fig. **10.9**) of 1955 was one of a series of works done on/with found materials, collected from around the artist's neighborhood. Upon first

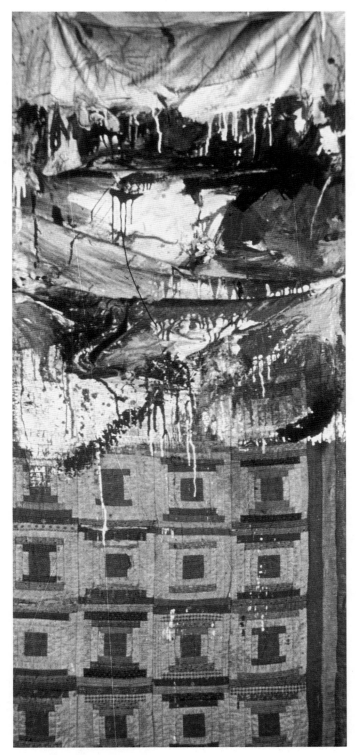

■ 10.9 Robert Rauschenberg
Bed 1955
Mixed Media
74×31 in (188×78.7 cm)
Collection Leo Castelli Gallery, New York

glance, it is difficult not to view the painting in light of Abstract Expressionist ideals; the application of paint seems satisfyingly akin to the meaty gestures of a De Kooning, dripping freely and mimicking the experience of the artist's hand. Indeed, most of the attributes of American Abstract painting seem at least suggested within the context of this work; the only problem is that all of this so-called "high art" activity is taking place on an old quilted cover and pillow. It is here that Rauschenberg makes his decisive break from that tradition; the conventions of abstract painting are placed within the context of the discarded object, a strategy that elevates the mundane or the everyday while simultaneously questioning the assumed sacredness of the art object. This process is called "recontextualization" in that it reconstitutes certain images or devices outside their traditional frame of reference. Take, for instance, the bed: it is as if the artist has taken an element understood as both functional and oriented on the horizontal (we see the bedspread on a bed, we lie under it) and by turning it upon the vertical and divorcing it from its original function, made it appear new and strange. In doing so, commercial, discarded material culture is elevated to high art, and conversely the high-art conventions of Abstract Expressionism appear as little more than crude encrustations on its surface. The result is work that seems to flip-flop between an outright criticism of Abstract Expressionism and an embrace of such a conventional language.

Jasper Johns's *Flag above with white collage* (Fig. **10.10**), also of 1955, shows a similar cool ambivalence toward the recent history of painting from which it emerges. Johns's use of the flag motif is at once a brilliant, witty play on Greenbergian formalism (painting referring first and foremost to its physical and material characteristics). Applied in encaustic (a technique of painting with pigment suspended in molten wax, which creates a translucent, slightly matt surface), perhaps the most vivid and universally understood symbol of American national identity (read culture) is rendered flat, neutered, recontextualized, and formally correct. It is at once the height of formal abstraction and the dissolving of such high principles into mainstream, digestible culture. Flags are graphic, meant to be perceived quickly and understood within the context of a host of historical and social messages. High art, on the other hand, is about looking slowly, about craft, elevated subject matter, and whatever else might be invested in the work. Art is supposed to take time, rise

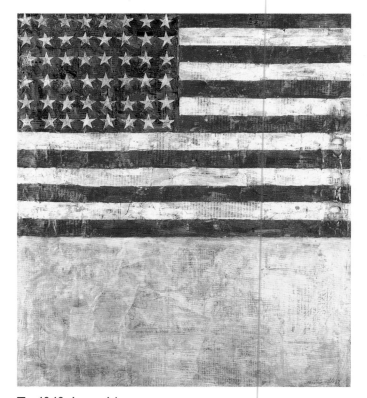

■ 10.10 Jasper Johns
Flag above with white collage 1955
Encaustic with collage
22½×19¼ in (57.1×48.9 cm)
Loan, Offentliche Kunstsammlung Basel, Kunstmuseum

above pop culture, be "significant." Here, that slippery relationship has been brought to a finely honed edge, as the commercial and the precious slowly collapse into one fitting embodiment of the times.

By the year 1960, art had found itself in direct competition for the public's visual attention, engaged in a fight it could not possibly win. Televisions were now commonplace and billboards and neon littered the cityscape. Indeed, the whole visual environment of the Western world had become a hyper-intense, synthetic experience of endless perceptual stimulation—a situation that dwarfed even the heroic scale and vivid palette of Abstract Expressionism. Furthermore, there was a general feeling among most of the younger members of the avant-garde that Modernism had failed in its attempts to elevate consciousness and provide a radical, progressive role model for the larger community. No doubt art and art making had mimicked the upheavals of Western culture credibly and effectively,

yet through it all, avant-garde art had not been able to effect change outside the boundaries of its own discourse. But perhaps the most disheartening aspect of the whole Modernist era (particularly for the generation of artists to arise out of the shadow of heroic American abstract painting) was the absolute lack of reasonable alternatives afforded to them for positive change and innovation after drip painting and color fields. Thus while the Minimalists were taking formalist art to its logical conclusion, there appeared on the scene a group of young, disenchanted artists who began openly to criticize the rhetoric and failings of the Modernist view. By embracing the mundane and the commercial and dismissing the heroic and the masterpiece, they came to be called Pop Artists.

Roy Lichtenstein's *Masterpiece* is a good example of what such a critique looks like as an art image. In terms of its formal makeup, it adheres to many of the tenets of Modernist painting: the flatness of the plane is asserted by the use of uniform black borders, it engages large areas of undifferentiated color, and in a delightful bit of tongue-in-cheek, it is even overtly self-referential (since the internal dialogue revolves around the issue of painting). But what is missing is equally important here: material is applied in a generic, non-specific manner rather than as an assortment of grand, juicy, autobiographic gestures; the subject matter is not heroic or elevated but blatantly overt, accessible, and crassly focused on the marketplace; and the rendering is not subjective but follows very specific commercial conventions for imaging figures in space. In short, the artist has removed virtually every last vestige of the subjective, heroic condition of art making that had been implicit in Modernist culture since Manet.

Again, the discussion comes back to the issue of form and content, as Lichtenstein has been very careful to maintain certain painting conventions in order to criticize others. For instance, you will note that despite the numerous radical changes from earlier images taking place in the painting, this work still adheres to traditional oil on canvas construction—historically the materials of Western painting. This way, the work opens itself up to a more fruitful and obvious dialogue with the tradition from which it emerges. Even the square format suggests artists such as Mondrian, who elevated the shape to a status of almost religious significance. It is this tradition that Lichtenstein hopes to comment upon, and by suggesting some affinity to it through this limited shared visual language, the work functions as a witty, critical evaluation of the state of art making after the likes of Jackson Pollock (see Fig. **10.11**).

■ 10.11 Roy Lichtenstein
Big painting Number Six 1965
Canvas
Collection of Robert Scull, New York

426

Lichtenstein has continued to maintain a formal dialogue with Modernist art, reworking such images as Monet's cathedral and haystack series, and even Picasso's Cubist works through the arbitrating and neutralizing filter of the ben day dot configuration. Other Pop Artists have been less concerned with such critical directions, relying instead on exercising the Pop "sensibility" to its extreme. Of these, no artist so fully embodied Pop Art as Andy Warhol (1930–87). His mechanized lifestyle and constant flirtation with the social élite made him the very personification of the Pop attributes of alienation, commodity fetish, fashion, and the neutralized individual. He once said, "I want to become a machine," and by mimicking the reproductive characteristics of the marketplace, he became a

living parody of the Modernist dream.

Like Lichtenstein, Warhol used commercial art processes as a means of paralleling artistic and mass-reproductive methods. His use of silk screening (a printing technique usually associated with cheap mechanical reproductions) on a traditional canvas ground is an immediate affront to the great subjective gestures of abstract painting: screen printing is absolutely flat, consistent, and generic, and in this way it both reasserts the flatness of the plane and simultaneously destroys the notion of the artist's hand as a significant part of the work. His *A Set of Six Self-Portraits* (Fig. **10.12**) of 1967 is indicative of the Warhol approach to image making: flat applications of highly saturated color, repeated in series as if to suggest end-

■ 10.12 Andy Warhol
A Set of Six Self-Portraits 1967
Oil and silk screen on canvas
Each 22½ in square (57.2 cm)
Museum of Art, San Francisco
Gift of Michael D. Abrams

■ 10.13 Andy Warhol
Dollar Signs 1981

less mechanical reproduction. Gone is the notion of a singular, precious creation; instead, Warhol grants us mechanical ghosts, desensitized images not once, or even twice, but three times removed from true experience—mimicking the leveling effect of the mass media on our perception of the world. Warhol even went so far as to have many of his works produced in factory-like environments, denying himself any contact with the finished product. Even the traditional notion of the artist's signature was reconsidered in terms of mechanization; instead of signing his name on the back of the paintings, he often used a rubber stamp. In this way, the artist rejoiced in the demystification of

what was once a sacred, highly personal experience (see Fig. **10.13**); in Warhol, the artist as hero turns unapologetically into the cult of personality.

In the work of Lichtenstein and Warhol, it is possible to see the beginnings of a "Postmodern" sensibility. By breaking down the boundaries between high and low art, and criticizing the artistic persona and the myth of the sacred object, they suggested that the Modernist movement was exhausted, no longer able to produce meaningful, contemporary representations of the world. Postmodernism implies a historical period after Modernism—a new way of thinking about the world, not simply a change of artistic direction.

■ 10.14 Mies Van Der Rohe and Philip Johnson
Seagram Building, New York, 1954–58

The term Postmodernism was first coined by architectural critic Charles Jencks in relation to the rejection by certain architects of International Style architecture in the late 1970s. International Style architecture was supposedly the crowning achievement of Modernist building design, a perfect structural system based on the glass box. Its roots were in the Bauhaus, and it shared a sympathy for clean, unornamented design. It was elegant, refined, proportionally considered; in fact, the architectural embodiment of formalist Modernism. Mies Van Der Rohe's and Philip Johnson's Seagram Building (Fig. **10.14**) of 1954–8 is an example of the International Style, which found widespread acceptance throughout the West during the 1960s and early 1970s. However, the problem confronting young

architects reared in this school was in essence identical to the problem confronting their peers in the visual arts: how does one develop further a style that is already so severely pared down as to allow almost no deviation? In other words, any architectural movement that arose as a reaction to the International Style would necessarily be construed as a step back into extraneous ornament and superfluous design.

It is here that two important principles of Postmodernism surface: the denial of innovation and the appropriation of previous artistic mannerisms. Edward Jones's and Michael Kirkland's Mississauga City Hall (Fig. **10.15**) of 1982–6 is an excellent example of the Postmodern sensibility applied to architecture. Gone is the glass and steel symmetry of the International Style, replaced with an assortment of building forms derived from various historical contexts. The architects have reconsidered the historical concept of the municipal building, and have drawn at will from a variety of sources such as medieval clock towers. This is indeed a form of historical pirating, as items, even building

■ 10.15 Edward Jones and Michael Kirkland
Mississauga City hall, Mississauga, Ontario, 1982–86

materials, have been reassembled outside their original context to produce a new architectural form. Consider the re-emergence of brick and stone as building materials—items many had thought were obsolete and nostalgic in the late twentieth century. This might tell us something about the issue of innovation and many an individual's desire to be free of such esthetic constraint. For if virtually all options for innovation are exhausted, there remain only two possible avenues for an artist: one is to accept that what one creates is a recapitulation of or direct copy from past forms and styles; the other is simply to stop producing work.

The idea of innovation has not always been part of art making. For centuries, artists did quite well without feeling they needed to keep up with the relentless pace of the marketplace. In this regard, innovation, as a Modernist idea, has slowly given way over the past two decades to an endless assortment of historical allusions, as artists and architects alike become stylistic nomads, in search of a conventional language they can use in their work. This has in turn led to an abundance of stylistic variations—many of which look remarkably like earlier art. Such is the case with the Neo-Expressionists.

Neo-Expressionism is, as the name implies, a reworking of the early twentieth-century Expressionist vocabulary. It aims at penetrating the human psyche with high-key, violent applications of paint which are often used in a semi-naturalistic, subjective manner. Take, for instance, German artist Georg Baselitz's *Nachtessen in Dresden* (Fig. **10.16**) of 1983, a massive oil painting of dislocated, inverted figures. This is about as far away from Minimalism as one can get in its unapologetic embrace of what was once considered a spent or dead conventional language. Italian artist Sandro Chia also develops his images around a set of

■ 10.16 Georg Baselitz
Nachtessen in Dresden 1983
Oil on canvas
110×177 in (280×450 cm)
Saatchi Collection, London

■ 10.17 Sandro Chia
Rabbit for Dinner 1981
Oil on canvas
Stedelijk Museum, Amsterdam

already established conventions, which in the case of his *Rabbit for Dinner* (Fig. **10.17**) of 1981 mimics the bright, excited color and emphasis on motion found in the work of the earlier Italian Futurists. Chia has been quoted as saying, "Today there are only mannerisms, and I am simply an historical nomad."

In the case of both the Italian "Transavant-gardia" and German Neo-Expressionists, a considerable amount of the pictorial allusion is derived from earlier, often overtly nationalistic sources. Sometimes, it is the very notion of history itself that comes under scrutiny. Anselm Kiefer's *Wayland's Song (Wolundlied)* (Fig. **10.18**) of 1982 is part of the artist's ongoing re-evaluation of German consciousness after the Second World War. Born in 1945, the year the war ended, Kiefer has been obsessed with reclaiming a personal history from among the ruins and conspicuous silence of the previous generation. His "burnt landscapes" of straw

and emulsion scattered on photographs are at once nostalgic and heroic. His use of lead, the material of alchemy (where lead and other base materials are transformed into gold), speaks of a distant rebirth and flight; the wing rises out of the landscape of history as a symbol of both hope and resurrection, while its lead construction speaks only of impotence and frustration. These are massive paintings, whose heroic scale only furthers the suggestion of a monument implicit within the subject matter. Often, the titles of his paintings will refer to specific German campaigns during the Second World War, or to ancient German mythology. In this way, Kiefer has brought back nationalism and nostalgia to contemporary painting—ideas both enchanting and troubling. This reliance on visual sources which are at once aggressive, dominating, and sentimental does indeed have a darker side; of the major figures in German and Italian Neo-Expressionism, not one is a woman.

■ 10.18 Anselm Kiefer
Wayland's Song (Wolundlied) 1982
Oil, emulsion, straw, photography (on projection paper) on canvas
with lead wing
110×150 in (280×380 cm)
Saatchi Collection, London

■ 10.19 Susan Rothenberg
United States 1975
Acrylic and tempera on canvas
114×189 in (289.6×480 cm)
Saatchi Collection, London

The return to the figure in North America has paralleled in many ways the work of the Europeans, but the wider variety of source material has meant that the appellation Neo-Expressionist does not fit well. Arising out of the Minimalist esthetic, painters such as Susan Rothenberg (b. 1945) (see Fig. **10.19**) have attempted to re-engage imagery into the formal considerations of late abstraction. In this case, the contour of the horse both acts as a line gesture, pushing one's eye to the edges of the canvas, and suggests a banner motif, simplifying the subject matter into a schematic, intelligible whole. Others, such as Julian Schnabel (b. 1951), have countered the purity of Minimalism with a form of "Maximalism" or an "everything but the kitchen sink" mentality (see Fig. **10.20**). Here, broken crockery, discarded wood, and Bondo all become the materials of high art; the few suggestions of imagery in the work evolve slowly in one's consciousness from a captivating

variety of surface events. The implication of an archeological site turned up on a wall is interesting here; the rich surfaces are as much topographical maps as they are illusionistic space, and in this way they are a fitting 1980s commentary on discarded and indeed discardable culture.

While some artists have reinvested the act of art making with meaning, others have followed the more critical path of the Pop Artists. One practitioner of the Duchamp–Warhol school of hyper-criticality is Jeff Koons (b. 1955), whose *Ushering in Banality* (Fig. **10.21**) of 1988 posits an almost Warholian flip-flop between known and unknown, real and artificial, craft and kitsch. In this case, an overtly cute, Disneyland-type scene is recontextualized by the use of polychrome wood—the traditional material of medieval religious sculpture. The labor-intensive craft involved in such carving thus acts as a direct counter to the kitsch nature

■ 10.20 Julian Schnabel
Affection for Surfing 1983
Oil, plates, wood, bondo on wood
108×228×24 in
(276.9×579.1×60.9 cm)
The Pace Gallery, New York

■ 10.21 Jeff Koons
Ushering in Banality 1988
Polychromed wood, edition of 3
38×62×30 in (96.5×157½×
76¼ cm)
Sonnabend Gallery, New York

of the subject matter—the uneasy elevation of the crass to the status of high art. There is an undeniable sense of both anxiety and tragedy implicit in such work, as the viewer's equilibrium and sense of order, of good and bad, of right and wrong, are kept off balance. In this way, Koon's work mimics the confusing state of affairs that confront the average individual on a daily basis.

The critic Fredric Jameson wrote in 1982 that today it appears "we are unable to focus our attention on the present, as though we have become unable to, or incapable of, achieving esthetic representations of our own current experience." Whether or not this is true is open to debate. Perhaps the recycling of styles and mannerisms is an accurate representation of our society's endless desire to parcel past histories and ideas into neat, marketable packages; or perhaps artistic production is simply mimicking the value system as it now exists (see Fig. **10.22**). Still, there are more artists at the present time producing work than at any other point in the history of the world, and with the general consensus that Modernism is exhausted as a pictorial program, the art world has come to embrace a wide variety of exciting and fruitful alternatives.

◄ 10.22 Barbara Kruger
Untitled (When I hear the word culture, I take out my checkbook) 1985
Photograph
138×60 in (350.5×152.4 cm)
Courtesy Mary Boone Gallery, New York

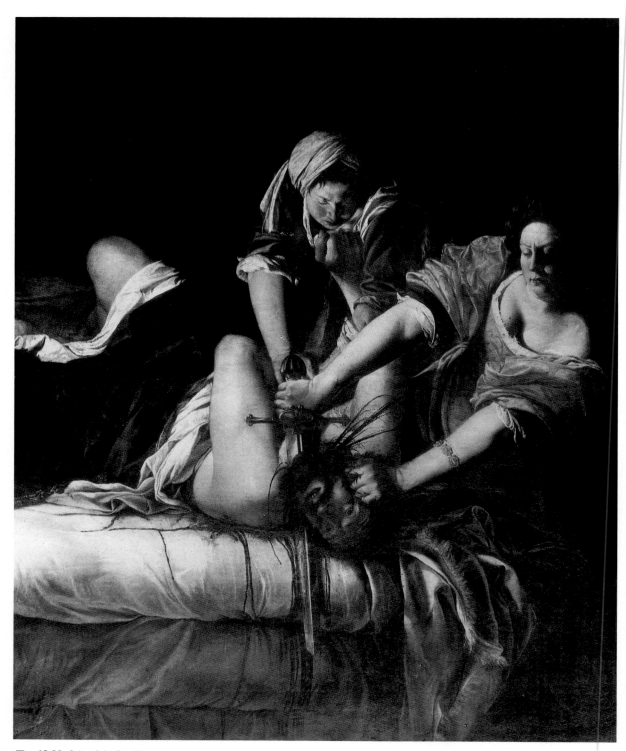

■ 10.23 Artemisia Gentileschi
Judith and Maidservant with the Head of Holofernes c. 1625
Oil on canvas
72½×55¾ in (184.2×141.6 cm)
© The Detroit Institute of Art
Gift of Leslie H. Green, 1952

▶ WOMEN'S ART AND FEMINIST CRITICISM

Why has it been necessary to negate so large a part of the history of art, to dismiss so many artists, to denigrate so many works of art simply because the artists were women? What does this reveal about the structures and ideologies of art history . . . ?

ROZSIKA PARKER and GRISELDA POLLOCK,
Old Mistresses: Women, Art, and Ideology.
(New York: 1981, pp. 132–3.)

■ 10.24 Judith Leyster
The Gay Cavalier c. 1628–29
Oil on canvas
35⅛×29 in (89.3×73.7 cm)
Philadelphia Museum of Art
The John G. Johnson Collection (J.440)

Artemisia Gentileschi's *Judith and Maidservant with the Head of Holofernes* (Fig. **10.23**) of *c.* 1620–25 is one of the great examples of the Caravaggesque in Italian Baroque painting; its dramatic chiaroscuro and emotional content make it the stuff of true Counter-Reformation spirit. Yet despite its considerable merit and technical proficiency, its singular status in art history circles is owed almost exclusively to one important characteristic: it was painted by a woman. It is rare indeed in art history books for the work of a woman to be compared favorably with that of a man. There are, of course, some exceptions: genres scenes by Judith Leyster (1609–90) in the Dutch Baroque (see Fig. **10.24**), society portraits by Élisabeth Vigée-Lebrun (1755–1842) (see Fig. **10.25**), and the intimate Rococo stylings of Rosalba Carriera (1675–1757) (see Fig. **10.26**) have all achieved a degree of consideration in survey texts on the period. However, the percentage of male to female artists in the history books is so outrageously high that one is left with three possible explanations: one, that there have been very few women artists; two, that the work produced by women artists was of consistently poorer quality; or three, that the work produced by women artists fell outside the categories of high art. Each of these explanations has had an effect on the focus of recent feminist criticism, which has attempted to understand and evaluate this blatant discrepancy of numbers between male and female artists, and their speculations on the political nature of art making have shaken contemporary art and art history.

Where were all the women artists? There is no simple answer to this question, since gender issues are, like all matters of social and cultural significance, tied tightly to a complex set of problems. Let us begin by attempting to tackle the three hypotheses we have put forward for the historical absence of women's art. The first possible justification—that throughout history, there have simply been far fewer women producing art, and consequently there exist far fewer examples of works by women in prominent collections and museums—is certainly borne out by statistics, but the more important question is, Why is this so? It appears that art making, like politics, medicine, philosophy, and jurisprudence, has historically been the domain of men, and

10.25 Elisabeth Vigée-Lebrun
Portrait of Marie-Gabrielle de Gramont, Duchesse de Caderousse 1784
Oil on oak panel
41⅜×29⅞ in (105×76 cm)
The Nelson-Atkins Museum of Art, Kansas City, Missouri
Acquired through the generosity of Mrs. Rex L. Dively; Mary Barton
Stripp Kemper and Rufus Crosby Kemper, Jr. in memory of Mary Jane
Barton Stripp and Enid Jackson Kemper; The Nelson Gallery
Foundation; Mrs. Herbert O. Peet; Mrs. George Reuland through the
W. J. Bruce Charitable Trust; and the Estate of Helen F. Spencer, by
exchange (86–20)

since men set down standards for social behavior, it is
not surprising that women found themselves playing a
secondary role in valued cultural fields such as the
visual arts. This, of course, leads to the second hypo-
thesis—the issue of quality: the work of women artists
has been of inferior quality and therefore lacks suf-
ficient merit to be considered alongside the work of
men. This is a most interesting proposition and, though
flawed, it has been used repeatedly in art historical
circles to ignore the contributions of women.

In order to produce work of quality, most artists,
particularly those brought up in the age of the
academies, spent a considerable amount of their train-
ing in a formal studio situation, studying everything
from anatomy to color mixing and esthetics. The result
was generation after generation of artists schooled
under the strict quality control of a governing body—a
governing body that also had strict quotas on the
number of women allowed to enter its program.
Though one can be sure that many women possessed
the skills to study at an academy, few were ever granted
the opportunity. Consider again Zoffany's portrait of
members of the Royal Academy (Fig. **10.27**). You will
remember that those women lucky enough to study at
the Academy were constrained by the moral standards
of the day—a morality which forbade women to look at
a nude and thus to work in the life drawing studios. In
this respect, the issue of quality, seemingly so import-

10.26 Rosalba Carriera
Louis XV as a Young Man 1721
Pastel on paper
18½×14 in (47×35.6 cm)
Courtesy of Museum of Fine Arts, Boston
The Forsyth Wickes Collection

■ 10.27 Johan Zoffany
Life Drawing Class at the Royal Academy 1772
Oil on canvas
40×58 in (101.6×147.3 cm)
Copyright Her Majesty the Queen, Windsor Castle

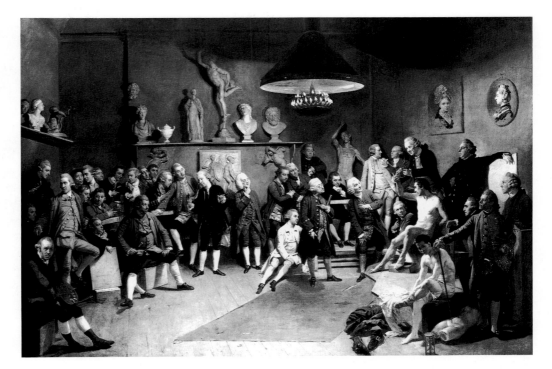

ant to some art historians, becomes shrouded in a number of gender attitudes commonplace at the time. And if some of the women artists from the past produced works that seem less "convincing" than those of their male counterparts, it is perhaps because they were handicapped from the very outset—the system of art training never allowed women equal access to the study of art. This also makes the accomplishments of artists such as Angelica Kaufmann and Élisabeth Vigée-Lebrun that much more remarkable, bearing in mind the less than ideal social milieu in which they operated.

If women are no less inclined to create visual expressions than males and yet few examples of their output exist, then perhaps it is the definition of art itself that needs reworking. If we acknowledge that the arena of "high art" (sanctioned as such by men, of course) was limited to men, then by looking at the so-called "domestic arts," we can consider a completely different set of artistic principles—ones governed almost exclusively by women. This path has been extremely fruitful for elevating the status of many historical women artists whose work necessarily falls outside traditional definitions of art. Items such as quilts, basketry, needlepoint, and clothing have all recently been the stuff of exhibitions of women's art in prominent museums. This reclamation of domestic crafts by

women as mainstream "high art" was particularly popular during the 1970s and 1980s, as evidenced in the narrative, often politically motivated, quilts by Faith Ringgold (b. 1934) (see Fig. **10.28**). This critical strategy has fittingly been labeled "inclusive," as it attempts to broaden the boundaries of "high art" to embrace the creative output of women artists who were not afforded the luxury of operating in the same artistic context as their male counterparts.

Critical opinion about the role of women's art and feminist discourse often falls into two camps: first- and second-generation criticism. Roughly speaking, these strategies follow a logical progression from an inclusive view of art to that of re-examining the very foundations of the art historical canon. Typical of so-called first-generation women artists is Judy Chicago (b. 1939), whose *Dinner Party* (Fig. **10.29**) of 1978 possesses a number of popular characteristics of early feminist art: an embrace of traditional domestic arts such as stitching, weaving, and china painting, the use of the woman's body (in particular the genitalia, which act as the site of difference between women and men), and the use of famous and not-so-famous women from history as subject matter (Fig. **10.30**). Such an installation celebrates the meaningfulness of women's culture and biological "difference"—a difference that makes

■ 10.28 Faith Ringgold
The Purple Quilt 1986
Acrylic on cotton, tie-dyed, printed and pieced fabric
7 ft 7 in × 6 ft (231×182.9 cm)
Bernice Steinbaum Gallery, New York

■ 10.29 Judy Chicago
The Dinner Party 1979
Mixed media
48×48×48 ft
(14.6×14.6×14.6 m)
Copyright Judy Chicago 1979
Photo Donald Woodman

■ 10.30 "Virginia Woolf" place
setting from *The Dinner Party*
China paint on porcelain,
ceramics and needlework
Plate diameter 14 in (35.5 cm)
Copyright Judy Chicago 1979

women's art unique in both sensibility and production. As a huge collaborative enterprise (300 men and women worked five years to complete the piece), it also acts as a pointed critique of the age-old idea of the artist as solitary genius, embracing a more communal, shared experience of art making—mimicking the social nature of traditional domestic arts such as quilting (see Fig. **10.28**).

First-generation art criticism shares many of the same attitudes as the work of Ringgold and Chicago, including a more inclusive view of art and an interest in the role of the female body. Crucial to the reception of women's art in the 1970s were the works of art historians Linda Nochlin and Ann Sutherland Harris (who in 1976 put together *Women Artists 1550–1950*, an exhibition and accompanying catalogue which brought to light the achievements of women artists through Western art history) and critic Germaine Greer (whose *Obstacle Race: The Fortune of Women Painters and Their*

Work of 1979 espoused that there were indeed "great" works of art produced by women), who attempted to open up the art historical canon, placing the work of men and women side by side.

There were, however, problems with such an approach from the very outset, since any attempt to include women's art in "mainstream" art history meant that women artists, who were not granted the same privileges as their male counterparts, were being evaluated on the same terms. To elevate the role and production of women artists through the ages, it was going to be necessary to reconsider the very structures of quality in art. This approach has proven itself fruitful not only for feminist critics but also for other under-represented groups, such as Afro-Americans and Third World artists, who have historically been excluded from consideration in art circles due to the incompatibility of their work with Western standards. Two of the most prominent exponents of recent second-generation feminist criticism have been Roz-sika Parker and Griselda Pollock, whose 1981 *Old Mistresses: Women, Art, and Ideology* shows the subtle but all-important relationships that tie the production of art to a series of power and ideological issues—issues which determine the values of a community and consequently the notion of quality in art. By deconstructing the old model to expose its ingrained sexism, such vital research has forced many scholars and artists to rethink their traditional assumptions.

■ 10.31 Cindy Sherman
Untitled #74 1980
Color photograph
20×24 in (50.8×60.9 cm)
Iris and Ben Feldman, New York

■ 10.32 Cindy Sherman
Untitled #122 1983
Color photograph
34⅝×20⅝ in (87.9×52.3 cm)
Pamela and Arnold Lehman, Baltimore

A number of women artists have taken up this approach in their art, questioning the legitimacy of previous programs and searching for suitable representations. One of the more interesting of contemporary artists dealing with issues of representation is Cindy Sherman (b. 1954), whose self-portraits such as *Untitled #74* (Fig. **10.31**) of 1980 and *Untitled #122* (Fig. **10.32**) of 1983 are disturbingly inviting images of media-induced "types." Using herself as both creator and subject, her suggestions of woman as a victim of characterization appear almost tragic; the hollowness of such façades speaks of the collapse of individuality into the oppressive desire to conform. Barbara Kruger's (b. 1945) work, such as *Untitled (We won't play nature to your Culture)* (Fig. **10.33**) of 1984, takes a more confrontational approach, utilizing the conventions of graphic design to provoke response in the viewer. Here issues of control and the oppression of a woman's body are

■ 10.33 Barbara Kruger
Untitled ("We won't play nature to your culture) 1984
Photograph, 72×48 in (182.9×122 cm)
Courtesy Mary Boone, Gallery, New York

troversial antics of the Guerrilla Girls have been pivotal in the current art debate.

Though still relatively young as critical movements go, feminist art and criticism have been essential in broadening the narrow parameters of art and exposing culture's unspoken relation to issues of gender and power. Their influence can be seen in the work of a variety of disenfranchised groups, and by the intelligence of their reasoning, they have become the anchors of a more inclusive, sensitive view of the role of creative activity in the community. Perhaps more than any other critical and social program of the late twentieth century, feminism has provided the most solid foundations for a new view of art, and one that will pave the way into the twenty-first century. And at least in this regard, suspicions about art being terminally exhausted seem to have been greatly exaggerated.

■ 10.34 The Guerrilla Girls
Relax Senator Helms, The Art World is Your Kind of Place 1988–89
Silk screen, 17½×22¼ in (44.5×56.5 cm)
Courtesy The Guerrilla Girls

RELAX SENATOR HELMS, THE ART WORLD IS YOUR KIND OF PLACE!

● The number of blacks at an art opening is about the same as at one of your garden parties.

● Many museum trustees are at least as conservative as Ronald Lauder.

● Because aesthetic quality stands above all, there's never been a need for Affirmative Action in museums or galleries.

● Most art collectors, like most successful artists, are white males.

● Women artists have their place: after all, they earn less than 1/3 of what male artists earn.

● Museums are separate but equal. No female black painter or sculptor has been in a Whitney Biennial since 1973. Instead, they can show at the Studio Museum in Harlem or the Women's Museum in Washington.

● Since most women artists don't make a living from their work and there's no maternity leave or childcare in the art world, they rarely choose both career and motherhood.

● The sexual imagery in most respected works of art is the expression of wholesome heterosexual males.

● Unsullied by government interference, art is one of the last unregulated markets. Why, there isn't even any self-regulation!

● The majority of exposed penises in major museums belong to the Baby Jesus.

Please send $ and comments to: **GUERRILLA GIRLS** CONSCIENCE OF THE ART WORLD
532 LAGUARDIA PL. #237
NEW YORK, N.Y. 10012

represented with the same media-induced stylings that are traditionally used to "type" woman—the quick slogan and the digestible image both mimic the advertisement and aggressively confront the viewer (who is often suggested as either victim or villain).

Recent figures suggest that though women artists make up a sizable proportion of the art community, there is still a considerable lack of women's art being shown in commercial galleries. Radical feminist art groups such as the Guerrilla Girls have attempted to expose such inadequacies through a series of events and ad campaigns (see Fig. **10.34**), designed to expose the continued omission of women from art circles. Such pressure tactics are launched not so much at the art historical canon, or even art making for that matter, but at the institutions and galleries that inevitably make or break an artist's career. As part of a larger reorganization of institutions and attitudes, the sometimes con-

■ 10.35 Robert Colescott
Les Demoiselles d'Alabama: Vestidas 1985
Acrylic on canvas
96×92 in (243.8×233.7 cm)
Phyllis Kind Gallery, New York, Chicago

▶ ETHNICITY, THE CONTEMPORARY ARTIST, AND REVISIONISM

The word quality is used as if it were synonymous with skin pigmentation and ancestry, but is stated publicly as signifying an unsullied and courageous color-blind standard.

HOWARDENA PINDELL, "Breaking of the Silence," *New Art Examiner*, October 1990, p. 19.

The term "revisionism" has come to reflect a strategy of correction: something in the past is deemed to have been wrongly perceived and that perception is to be reconsidered. As a community, we often "rethink" ideas in the hope that by re-evaluating an apparent "truth" or traditional assumption, we might finally get it right. Since this phenomenon is part of basic human inquiry, it should come as little surprise to find many contemporary artists taking a good hard look at the relative merits and inconsistencies of art history as it has been explained to them. Of course, the history of Western art is predominantly the history of white male Europeans, and subsequently it has been those individuals cast outside the "mainstream" who have found themselves most intimately linked to the notion of revisionism. By visually and critically evaluating the exclusive nature of assumptions about masterpieces and great artists, revisionist thinkers have begun an important process of broadening the boundaries of "art."

Robert Colescott (b. 1925) is an Afro-American artist who has been at the forefront of an ongoing visual examination of the "canonized" Western pictorial tradition since the mid-1970s. His poignant and witty *Les Demoiselles d'Alabama* (Fig. **10.35**) of 1985 is typical of his visual strategy; here he quotes directly from Pablo Picasso's *Les Demoiselles d'Avignon* (Fig. **7.48**) of 1907 (a vital Modernist document), cleverly replacing the three central proto-Cubist figures with Afro-American women. The direct evocation of Picasso is important here, and the figures mimic almost exactly the poses of the originals, only now the once-discomforting objects

of desire (Picasso's idea was for his painting to be a moralizing tale about brothels and sexually transmitted disease) are transformed into slightly raw, humorous caricatures of blacks and their attendant white counter-parts (note how even the knife-like piece of still-life fruit in Picasso's image is rendered as watermelon in the Colescott—part of the traditional diet of the slave). A multiplicity of ideas is generated by such a work, but perhaps the clearest of voices rises from one specific issue: the damning silence that traditionally followed discussions on the cultural significance granted to the Afro-American experience in art history. It is here, among the masterworks of the Western tradition, that Colescott illuminates this undeniable absence; here, art is seen as embodying not only a host of higher ideals but also a number of implicit notions about race relations and stereotypes.

The notable absence of many groups from the art historical canon has paralleled a similar lack of status afforded such individuals in all aspects of society. We have seen how the feminist movement successfully launched a campaign of critical inquiry into the "cult of masterpieces." Other disenfranchised groups have also benefited from this form of critique, including Afro-Americans, Hispanic-Americans, and indigenous Americans. The result has been the emergence of a brand of art and criticism often tied to issues of domination, identity, and cultural difference.

As was pointed out in Chapter Eight, the Afro-American contribution to American art and culture has been both rich and varied, enveloping the craft traditions of the American South and the more pictorial and religious preoccupations of the Caribbean. Black artists such as Faith Ringgold (see page 440) have paid direct homage to such craft interests by mimicking many of the formal features of that tradition. Sculptor Martin Puryear (b. 1941) (see Fig. **10.36**) also evokes a rich material consciousness in his elegant, simple forms. The artist's enthusiastic embrace of methods and techniques from the pre-industrial era speak eloquently of the history of objects and images produced by those who had no access to the "miracle" of heavy

■ 10.36 Martin Puryear
Lever 3 1989
Ponderosa pine, painted
84½×162×13 in (214.6×411.5×33 cm)
Courtesy of Margo Leavin Gallery, Los Angeles

machinery and technical innovations. Subsequently, his work speaks of nurturing, of slow and methodical labor, and of a deeply felt sensitivity to materials—all elements of a visual tradition outside the increasingly progressive nature of Modern art. Indeed, one of the major criticisms launched at Puryear's work is its sometimes "excessive craftsmanship"—a quintessentially Modernist prejudice that fine craftsmanship in some way denies the piece a radical posture. In this manner, Puryear's merging of late Modernist formal sculpture with craft traditions that derive from as far back as the first slave from Africa appears both quietly articulate and sincere.

Many Afro-American artists have attempted to merge Western pictorial conventions with issues of race and identity, though perhaps none better than Romare Bearden (d. 1988). His collages (see Figs. **10.37** and **10.38**) embrace the flattened space and overall design reminiscent of Cubism, but they further accentuate the fragmentation and dislocation of a people—a collection of parts rather than a functional, organic, and psychologically whole being. It is ironic to note that such "modern" conventions as flattened space were partly derived from African sources; here they resurface as a fitting representation of the ongoing struggle for identity and cultural wholeness in the black community.

■ 10.37 Romare Bearden
The Block
Cut and pasted papers on masonite
Six panels
Overall 4×18 ft (1.22×5.49 m)
The Metropolitan Museum of Art
Gift of Mr. and Mrs. Samuel Shore, 1978
(1978.61.1–6)

■ 10.38 Detail showing Block #6
from *The Block*
49×36 in (124.5×91.4 cm)

■ 10.39 Allan McCollum
Plaster Surrogates 1982
Enamel on Solid-Cast Hydrostone
Installation: Marian Goodman Gallery, New York City, 1983

The current reexamination of the art historical canon and its hierarchy of quality has had dramatic repercussions on contemporary visual discourse; everything from art school curriculums to government funding and museum acquisitions have been in some way affected by this important and healthy debate. At the heart of such matters is the problematic relationship between taste and values, and further how those seemingly colorblind values suggest very specific and ongoing social and political constructions. This simple (and some would say even obvious) acknowledgment that cultural institutions have in the past reflected very specific biases on the basis of race or gender, has had a liberating effect on the work and reception granted to disenfranchised individuals or communities. Yet the question remains: how do such groups, once tracked into the mainstream through such validating mechanisms as periodicals and major museum shows, retain their autonomy and legitimacy as a separate and distinct voice—particularly in a marketplace which values novelty over integrity?

An interesting example of such a flattening capability, implicit within the very idea of an art marketplace, can clearly be seen in the increasing popularity of Mexican artist Frida Kahlo—an artist whose lifetime's work had been all but forgotten until the late 1980s, when feminist scholars and historians saved her from virtual obscurity. Poignant and expressive in their search for a personal feminine identity in a male dominated Mexican art world of the 1930s, Kahlo's paintings have recently taken on the trappings of feminist icons, and the artist has become something of a cult heroine. Yet once such an artist is deified, he or she can be conveniently commodified, and it wasn't long before Kahlo's works appeared on everything from album covers to T-shirts, and even pop stars such as Madonna began citing Kahlo as an inspiration. Though one may claim that such exposure is long

overdue, the speedy transition of Kahlo from disenfranchised artist to Kahlo as cult heroine has destroyed much of the initial radicality these works once embodied. And if it is indeed the uncompromising content of such works that makes them at once arresting to a Western public, then it is the market which ultimately neutralizes and trivializes the voices of disenfranchised artists into something a little more digestible.

In the light of this previous discussion, one may ask the rather uncomfortable question of how do artists actually "beat the system" anymore. Or to put it another way: how do artists, posturing themselves as radical voices, avoid almost certain complicity with a system bent on commodifying almost any gesture? One answer comes in the rather depressing and cynical guise of what some artists proclaim as a "hovering" or "rear-guard" (as opposed to avant-garde) strategy. Artist Allan McCollum's *Plaster Surrogates* (**Fig. 10.39**), a series of "pseudo-artifacts" constructed to look like painting, are in actuality nothing more than cheap,

mass produced plaster casts. The artist's "orchestration of a charade" (his words) isolates this policy of giving the viewer everything and nothing, where close examination thwarts an original desire to look at these images. In this manner, such work literally hovers between anticipation and outright banality, paralleling the artificial nature of much of our visual experience. The work's apparent radicality lies specifically in its ready acceptance of self-perpetuated boredom—and further, our collective inability to distinguish truth from falsehood.

If hovering seems a pessimistic pictorial strategy, it nonetheless has many subscribers, particularly amongst younger artists attempting to reconcile art with the traumas of our world. However, one may question whether the current fashion of embracing banality and cynicism is indeed a fruitful strategy for the generation of art, or simply a posture. Already the catch phrase of the 1990s seems to be "reenchantment," where 1980s irony is replaced by a desire for sincerity and collective action. Time will tell.

▶ SUMMARY

● As was mentioned in the Introduction, this text is a child of its time, and consequently it reflects many of the contradictions that face the artist, the critic, and the historian of today. The issues covered in the Epilogue are meant to provoke fruitful discussions; like the book proper, they are open to charges of bias. For example, to what extent has the layout and sequencing of this text broken with traditional assumptions about art making?

Has the process of inclusion and exclusion necessary to the production of the text suggested implicit assumptions about the nature of art? And are there specific critical sympathies which underlie the writing? These are all valid concerns, and it is my hope that this Epilogue, as a document of late twentieth-century art appreciation, will itself serve as a point of further discussion.

GLOSSARY

Abstract Expressionism A common appellation for first-generation American abstract painting after the Second World War, due to the primacy of gesture and color while keeping consistent with the aims of formalism (the all-over application of paint and the dispersal of depth across the surface of the picture plane).

arabesque Meaning "Arab-like," it is commonly used to describe Islamic ornamental work, which combines both vegetal and geometric configurations into a unified composition. The result is a balance of hard-edged and curvilinear marks, which, like the "yin and yang" (see separate entry) of Taoism, combine to produce a visual equivalent of harmony in life and conduct.

architecture Commonly defined as the art of designing space. Its roots are in the Greek "arch" (meaning higher or better) and "tecture" (meaning construction or building), but it is popularly used to address virtually all facets of the organization of spaces (landscapes and interiors, for example, as well as buildings).

architrave See Doric order.

atmospheric perspective A convention for developing depth within a painting by making objects appear less defined as they recede in space. Often, this was combined with a slow transition toward the color blue in the background that was supposed to mimic our perception of faraway scenes.

audience The viewers of an object who complete the process of communication between themselves, the artist, and the art, thus an intrinsic part of the art-making process. Each member of an audience brings to bear a multitude of personal experiences and learning upon the work in question, and as a result the message a work gives is never absolutely identical to any two individuals. There is, in essence, a constant process of re-creation every time an individual enters into a dialogue with a piece.

avant-garde From the French "before the rest," this was a term applied to artists of various persuasions to imply a self-appointed role as explorer or adventurer, blazing a trail for others in the community to follow. It has implicit connotations of heroic will and the artist as savior of society, ideas in keeping with the progressive doctrines of the Romantics and the Idealists of the nineteenth century.

Baroque A term used to identify the period in Western art from 1600 to 1750. Its linguistic origins indicate something complex, intricate, or irregular, and it most likely refers to the increase in emotional content and exuberant composition over the restraint of the Renaissance.

basilica An early form of Christian church architecture based on Roman secular designs which would set precedents for later Christian building projects. It possessed an "atrium" or outer courtyard, a long central hall or "nave" with side aisles, an intersecting "transept" at one end, and a second-level "clerestory" which enabled a uniform lighting of the interior.

Bauhaus Derived from the German "building house," it was a school of art and design developed under the guidance and esthetic philosophy of architect/designer Walter Gropius. Active in the 1920s and early 1930s, it attempted a collective vision of art making, where the traditional subjective experience of the artist and the autonomy of the object were relinquished in favor of a more communal attitude to the problem of design. It put emphasis on pure, unornamented structures devoid of subjective or regional idiosyncrasies.

black-figure style The painting in early Greek pottery of figures in black slip on terracotta surfaces, which were then scratched into with styluses to articulate forms. See also *red-figure style*.

calligraphy Literally the art of writing, it is the written word or words as a visual document. Often painted, it can take on visual characteristics much like a painting, embodying a series of other visual and cultural issues.

calligraphy

capital See Doric order.

chiaroscuro From the Italian "light and shade," it is a technique for suggesting three-dimensions by modeling figures in highlight and shadow. Its more dramatic cousin "tenebroso," which infers a more theatrical use of light with deep shadow, is also used to describe such a visual effect. Artists often will use a directed or "raking" light source, which produces predictable shadows, to achieve this effect.

civilization Derived from Latin words for citizen and town dweller, it has come to imply the social interrelations between people and ideas, rather than concrete events and objects.

closed-form Sculptural forms which keep a certain visual connection to their original block shape; generally sculptures which have little articulation and do not visually activate the surrounding space, giving the appearance of being self-enclosed. See also *open-form*.

collage Meaning "gluing," it is a method of applying extraneous material (and thus subject matter) to an art work. It has been used to reiterate objects and ideas from the real world (Picasso), as well as to suggest history, nostalgia, and the build-up of superficial material culture (Schwitters). Collage usually implies two-dimensional art such as drawing, whereas "assemblage" often refers to three-dimensional strategies.

contour drawing A method of rendering an item on a two-dimensional plane using its external edges as a guide. Often, these edges will suggest volume, mimicking the folds and undulations of the surface, and hence it is an effective way of creating illusionistic space.

contrapposto A figure pose first developed by Polyclitus with his *Doryphorus* (Fig. **2.25**) model in Classical Greece, it combines a "fixed" or "engaged" leg with a "free" leg—a motion which creates a sway in the hips and is subsequently counterbalanced by the upper torso. During the Renaissance, such a pose took on greater importance as the harmonious embodiment of the active and contemplative lives which direct all human conduct, and thus was considered an ideal form.

conventions The specific communicative tools or strategies used to form a cultural code. In art, these tools range from a symbolic use of color to forms of perspective or even the shape or dimensions of a piece. Conventions are also inherently social in nature; they come into existence through common agreement and are maintained through custom.

Cubism The first art movement of the twentieth century systematically to reconsider the conventions of painting since the Renaissance. Such work is epitomized by the severe flattening of the space across the picture plane, a consistently inconsistent light source, and an imploding of the traditional fore-, middle- and background areas in painting composition.

cuneiform Mesopotamian script derived from pictures arranged in a narrative order named after the wedge-shaped marks created by the writing styles. Ancestor of our own script, it is the logical extension of earlier two-dimensional designs.

Dada A radical art movement initiated in Zurich during the First World War as an affront to conventional wisdom and traditional culture. Born from outrage at the apparent hypocrisy of European culture, it attempted to set new standards for art and art making by abandoning traditional picture making in favor of performance work and other non-traditional gestures. It also used chance as an important part of the art process, in the hopes of producing work free of the trappings of rational culture.

daguerreotype A chemically derived silver-plated copper sheet invented in 1837 by Louis Daguerre that produced a clearer image in far less exposure time. This invention meant that animate objects (such as humans) could be documented clearly in photographs (the

natural movements of a human and the long exposure time made it almost impossible to photograph individuals before this point). This discovery had enormous repercussions for both photography and painting.

Doric order The first architectural system developed by the Greeks, it had its roots in earlier timber post and lintel design. Like the older timber forms (which were essentially long sections of fallen tree propped up to support an overhang), Doric columns rest directly on the floor or stylobate, and taper like tree trunks as they move upwards. The top or head of the column (called the capital) mediates between the cylindrical shape of the column and the angular forms of the supporting structure, called the entablature, which is comprised of three distinct parts. The band of rectangular blocks immediately supported by the columns is called the architrave. Above it stands the frieze, which consists of alternating blocks of relief sculpture or painting (the metope) and vertical bands (the triglyph). Above this is the crowning pediment—a triangular-shaped construction which forms the roof. All other Classical building design emerged from the Doric order.

empiricism A philosophical position holding that one can gain knowledge and insights into existence through the close observation of nature. Originating in the writings of Aristotle, it had sweeping implications for the study of science in the medieval period. Its effect on art making can be seen in the high degree of naturalism and close observation in the works of many northern Renaissance artists.

engaged columns Non-structural decorations used on exterior walls in Roman temples to give the appearance of true vertical columns which support the entablature. A practical solution to the problem of integrating the earlier Greek temple design with the Roman interest in defining interior spaces (which walls provide).

entablature See Doric order.

etching Derived from the old High German word *"azzen"* or the Dutch *"etsen,"* to eat, it is a printmaking process which involves the drawing of lines into a resist already painted on a metal plate. Drawing removes the resist, exposing the metal, which is then submersed in acid (called "biting"). The exposed metal is then eaten into, leaving a series of lines "etched" in the metal. When the plate is inked (the artist applies ink to the whole plate surface, then wipes away the excess on the surface, leaving ink in the small etched grooves) printing will faithfully reproduce the original lines.

Expressionism A term historically applied to art that is involved not so much with a faithful, seemingly objective description of nature (implicit within the terms "Impression"ism, "Real"ism, etc.) but with the expression of less tangible and often psychological states through images. Through devices not often associated with observation (aggressive paint handling, bright unnatural color) Expressionist artists believed they were more capable producing intimate, egocentric visions of their world. Often, such artists would pirate less refined techniques such as the woodcut print, which they saw as raw, physical and very graphic. In appreciating non-Western and naïve work, artists (often mistakenly) saw

what they considered a more pure and less repressed expression, and took from these cultures freely. In Expressionist art, reality is understood as the production of each individual, with all of the idiosyncrasies inherent in being human.

flying buttress A supporting armature used on Gothic cathedrals to take the strain of the vast vaulted ceilings. The buttress distributed the mass of the building away from the walls to the area around the foundation, allowing architects to build higher and more structurally sound churches, with more window space and thus greater light in the interior.

fresco A painting method by which colored pigments immersed in water are applied to fresh plaster, which absorbs the paint and dries rockhard. This method was particularly popular for decorating interior spaces during the Renaissance.

frieze See Doric order.

Group of Seven A loose affiliation of Canadian painters between 1913 and the mid-1920s whose work centered around the northern landscape as the source for a national art movement different from the art of their neighbors to the south and in Europe.

iconoclasm The practise of denying representational imagery in a community, often on moral or religious grounds. In religious art, this concept often parallels ideas on the blasphemy of figurative art as a direct confrontation to the creative powers of God—usually associated with monotheistic faiths such as Judaism, Christianity, and Islam.

iconography The meanings and symbolic associations attributed to a figure or idea.

ideal-forms Generalized shapes which combine actual representation with a corresponding concept. Together, the artist creates not simply a reproduction of a specific event but a symbolic language capable of merging such a physical reality with the community's consciousness of its world (sometimes also referred to as pictographs).

idealism To imbue an item (often the human figure) with a greater degree of stature and significance by observing not specific features of the individual but rather the more universal and distinguished characteristics of the human form as accepted by a given culture.

ideal measurement A system for the development of images/objects based on an external source (natural or supernatural) deemed central to a given community. Thus an item such as a bird or a rock could be utilized as the fundamental unit for determining the size of a figure.

impasto A thick application of paint, usually in layers, producing a rough, textured surface.

Impressionism An art movement named specifically after one particular painting by Claude Monet, *Impression: Sunrise* (Fig. **7.14**) of 1872. Arising out of the naturalism of the Realists (such as Courbet), as well as an interest in the transitory experience of light and color on objects, Impressionism did two distinct things to painting: it elevated color to the status of subject matter, liberating the artist's marks from previous craft constraints, and it inadvertently asserted painting's relationship to the flat surface.

intent The interests of the artist as perceived by the audience, or why an artwork was made. This becomes an important issue in objects that have little referential character (such as paintings).

Ionic order A more refined and slender version of the earlier Doric design, its most noteworthy feature is the double-scroll "volute," which acts

as a mediation point between the entablature and the column.

kouros　A generic term for early Greek figurative sculpture (the female types called ''kore,'' the male ''kouros''), many of which exhibit features evident in earlier Egyptian models, including a stiff frontal posture and relatively little articulation of joints.

linear perspective　A geometric system for defining items in space, probably first invented by the Romans and then rediscovered by Brunelleschi in the early fifteenth century. It implies that all lines receding back into space have as their point of origin a central vanishing point or points, depending on the circumstances. Implicit within this method is a certain centrality in the viewer's gaze (particularly in one-point perspective), which parallels the Renaissance belief in the centrality of human existence.

lithography　A method of making prints from a flat surface, usually a stone or metal plate (in offset lithography); often used in early newspapers. An

image is drawn onto the surface with an oil-based crayon (litho crayon), which resists water when the surface is wiped with a wet sponge. An oil based ink is then rolled across the surface and adheres only to the oil of the crayon drawing, leaving the damp areas of the plate clean (since oil and water do not mix). Paper is then placed on top of the stone, and run through a press, producing an image. The process became popular among artists around the middle of the nineteenth century for its similarity to drawing and the sensitivity of mark such prints possessed.

mark making　The gestures, scribbles, and gouges produced by an artist during the execution of a work that are left visible to the viewer, thus becoming an essential part of the overall subject matter. Since paint is extremely tactile, it can become a carrier of physical messages and events when allowed to exist undiluted; its paste-like consistency takes brush marks and other gestures and transforms them into intimate suggestions of the artist's method of work.

metope　See Doric order.

Minimalism　A painting and sculpture movement of the 1960s based on the primacy of the art object in its purest formal condition.

mosaic　The art of creating images using colored stone, terracotta, and glass ''tesserae.'' This art form was originally used to decorate the floors and walls of buildings.

motif　A recurring image or theme.

narrative　The progression of an idea from one image to another, often implying a passage of time. To arrange images in narrative, it is necessary clearly to identify a direction of movement, suggesting a possible entrance into the plot, as well as an exit.

naturalism　An attempt to imitate the world of everyday perception, or as things exist naturally. Art which draws from the world as it exists in perception, without idealization (often opposed to the precepts of Classicism, which forms ideals from natural phenomena).

Neo-Classicism　The term used to describe the revival of Classical conventions such as symmetry, a reliance on draftsmanship over color (in painting), and the evocation of a determined and disciplined order to the world. The development of the movement corresponds with the prevailing revolutionary attitude in Europe and America against the excesses of the state and the aristocracy (hence its deliberate critique of the preceding Rococo period).

non-illusionistic painting　A term used to identify paintings which refers essentially to their physical and material character. Such work attempts to deny conventional pictorial constructs (such as perspective, chiaroscuro) for organizing space, hence its non-illusionism.

open-form　Sculptural work that engages its surrounding space as an extension of the sculpture, activating the area around the figure and interacting with the viewer's space. Many such pieces show little suggestion of their original source shape. See also *closed-form*.

pedestal　A sculptural device used to separate an object from the space and scale of the viewer; it elevates and sanctifies the object as ''other,'' ''different,'' and usually ''heroic.'' The removal of the pedestal thus implies a movement back into the physical, tangible world of the viewer.

pediment　See Doric order.

perfect proportion　A system of determining the scale of a figure based on an interrelationship of parts within the body (the figure thus becomes its own gauge for ideal measurement). Proportion supports the idea of an internal harmony, rather than imposing a set of standards or restrictions on the body, gathered from external considerations.

photography　From the Greek, meaning to write or describe with light, the term was first applied to a technical process in 1826 when Nicéphore Niépce first placed light-sensitive silver salts onto a surface, enabling a truthful

reproduction of a projected image to be made. Though the initial exposure time was a lengthy eight hours, it set off a wave of pioneering developments that made the medium accessible, practical, and affordable.

prehistoric Meaning before historical documentation.

primitive A value judgment used to identify and label the visual artifacts produced by certain traditional cultures in recent times as less sophisticated, and thus of poorer quality.

positive–negative space An element of design where positive refers to the shapes of forms representing the subject matter, and negative to the open spaces surrounding the subject, often called the background. The term is used in both two- and three-dimensional art to describe the relationship between parts of a work.

realism A commonly accepted understanding of one's world. The art of reality is an expression of how one understands the world, and not necessarily contingent upon what one sees (see *naturalism*). In this sense, most visual artifacts address the nature of reality as seen through the eyes of an historical period.

red-figure style The opposite procedure of the black-figure style (see entry) evolving in the mid-sixth century BC, here the artist paints the background areas in black slip, leaving figures in terracotta, which are then articulated through painted lines, giving them a greater sense of form and detail.

Renaissance Meaning "rebirth," it is generally used to define the period in European culture between 1400 and 1600 when there was a renewed interest in Classical scholarship and art.

repoussoir figure One or more silhouetted figures situated in the immediate foreground, facing away from the viewer, creating a sense of space in the middleground area. This convention gives the work an increased sense of intimacy, since the viewer's gaze is somewhat blocked by the suggestion of these foreground figures.

Rococo Deriving from "*rocaille*," a delicate and ornate form of shell and rock work used to decorate walls and floors, the term refers to a period in European art *c.* 1700 when technical exuberance and pleasurable sensations were popular, signaling a shift away from the rigid formulas of the Baroque Classicists.

Romanticism A movement in early nineteenth-century culture against earlier rationalism, Classicism, and mechanism. It sought to elevate the fantastic, the sublime, and the pleasurable (ideas bound to the psyche rather than learned through rational processes). It asserts the primacy of human beings' relationship to their world, and the isolation of the artist after the fall of patronage.

Santos The Spanish for "saints," it refers to the devotional images produced for households in the converted regions of Mexico and New Mexico from around 1540 onwards. A "*bulto*" (a Santos figure constructed in three dimensions) is often carved in native cottonwood, primed with "*yeso*" (a local variety of gesso made by mixing animal glue, water, and baked gypsum powder together), and then painted with locally derived vegetable and earth pigments.

sculpture Objects produced in the round, possessing volume and interacting with real space. They have the ability to be viewed from any angle, a process which mimics our experience of the world. Also, like our own bodies, they occupy tangible space.

self-referentiality An object or image that appears to serve no practical or obvious function, and as a result the viewer is forced to consider it in terms of its own intrinsic characteristics. An object is referential when it shows obvious relations to other external functions.

stylobate See Doric order.

Surrealism A literary and visual art movement interested in unleashing and exploring the potential of the human psyche. Loosely based on both Freud's and Jung's investigations into the mind,

it is also direct heir of earlier Dada strategies of unlocking of the unconscious by the use of chance.

symbol A set of communally accepted meanings associated with a form.

symmetry A compositional device to produce balance between parts through offsetting items on either side of center (almost like a mirror). The result is an image or building that appears in perfect equilibrium.

Transcendentalists A group of American landscape painters who considered the painting of nature as a meditation on the absolute. By using the American landscape as the source for such work, there was an implicit degree of nationalism inherent in both the rhetoric and the criticism around the movement.

triglyph See Doric order.

volute See Doric order.

wood engraving A relief printmaking method whereby areas not to be printed are carved out of a flat wood surface, leaving the intended image raised to take ink. A roller of ink is applied to the surface, paper placed on top, and then pressure applied, transferring the image onto the paper.

yin and yang Described as the unity of opposites popular in Taoism and Buddhism, this circle symbol combines its halves to create a perfect harmonious whole—the decline of one is supported by the rise of the other (implying such opposites as intuition versus rationality, etc.). Harmony is thus attained when one finds the perfect equilibrium between these two polar qualities. The artistic ideal is then achieved through the relationship between artist and materials, or rational conception and the accidents of nature.

SUGGESTED READING

General

Norma Broude and Mary D. Garrard, *Feminism and Art History: Questioning the Litany*. New York: Harper & Row, 1982.

John Fleming, Hugh Honour and Nikolaus Pevsner, *The Penguin Dictionary of Architecture*. Harmondsworth: Penguin Books, 1980.

Hugh Honour and John Fleming, *The Visual Arts: A History*, 3rd edition. Englewood Cliffs, N.J.: Prentice-Hall, 1991.

H. W. Janson, *History of Art*, 4th edition. New York: Harry N. Abrams Inc., 1991.

Sherman Lee, *A History of Far Eastern Art*. New York: Harry N. Abrams Inc., 1982.

Linda Nochlin, *Women, Art, and Power and Other Essays*. New York: Harper & Row, 1988.

Henry M. Sayre, *Writing About Art*. Englewood Cliffs, N.J.: Prentice-Hall, 1989.

CHAPTER 1
The Beginnings of Art

Cyril Aldred, *Egyptian Art in the Days of the Pharaohs 3100–320 BC*. New York: Oxford University Press, 1980.

Pierre Amiet, *The Ancient Art of the Near East*. New York: Harry N. Abrams Inc., 1980.

H. A. Groenwegen-Frankfort and Bernard Ashmole, *Art of the Ancient World*. Englewood Cliffs, N.J.: Prentice-Hall, 1972.

CHAPTER 2
The Art of the Classical World

John Boardman, *Greek Art*. London: Thames and Hudson, 1985.

John Boardman, J. Griffin and O. Murray, *The Oxford History of the Classical World. Volume One: Greece and the Hellenistic World. Volume Two: The Roman World*. Oxford and New York: Oxford University Press, 1988.

Denys Haynes, *Greek Art and the Idea of Freedom*. London and New York: Thames and Hudson, 1981.

J. J. Pollitt, *The Art of Greece 1400–31 BC*. Englewood Cliffs, N.J.: Prentice-Hall, 1965.

J. J. Pollitt, *The Art of Rome c. 753 BC–AD 337*. New York: Cambridge University Press, 1983.

Martin Robertson, *History of Greek Art*. Cambridge: Cambridge University Press, 1975.

Anne Sheppard, *Aesthetics*. Oxford and New York: Oxford University Press, 1988.

Donald Strong, *Roman Art*. Harmondsworth: Penguin Books, 1988.

CHAPTER 3
Art and Religion

C. Davis-Weyer, *Early Medieval Art 300–1150*. Engelwood Cliffs, N.J.: Prentice-Hall, 1971.

Richard Etthighausen and Oleg Grabar, *The Art and Architecture of Islam, 650–1250*. New York: Viking Penguin, 1987.

Michael Gough, *The Origins of Christian Art*. London: Thames and Hudson, 1973.

Oleg Grabar, *The Formation of Islamic Art*. New Haven: Yale University Press, 1973.

Susan Huntington, *Art of Ancient India: Buddhist, Hindu, Jain*. New York: Weatherhill, 1985.

Cyril Mango, *The Art of the Byzantine Empire 312–1453*. Englewood Cliffs N.J.: Prentice-Hall, 1972.

A. C. Moore, *Iconography of Religions*. London: SCM Press, 1977.

B. Rowland, *The Evolutions of the Buddha Image*. New York: Harry N. Abrams Inc., 1963.

CHAPTER 4
Issues and Ideas in Renaissance Art

M. Baxandall, *Painting and Experience in Fifteenth Century Italy*, 2nd edition.

London and New York: Oxford University Press, 1988.

A. Chastel, *A Chronicle of Italian Renaissance Painting*. Ithaca: Cornell University Press, 1983.

S. J. Freedberg, *Painting in Italy 1500–1600*. Harmondsworth and New York: Penguin Books, 1971.

T. G. Frisch, *Gothic Art 1140–ca. 1450*. Toronto: University of Toronto Press, 1987.

Creighton Gilbert, *Italian Art 1400–1500*. Englewood Cliffs, N.J.: Prentice-Hall, 1980.

James Snyder, *Medieval Art: Painting, Sculpture, Architecture, 4th–14th Century*. New York: Harry N. Abrams Inc., 1989.

James Snyder, *Northern Renaissance Art*. New York: Harry N. Abrams Inc., 1985.

Wolfgang Stechow, *Northern Renaissance Art 1400–1600*. Englewood Cliffs, N.J.: Prentice-Hall, 1966.

Lawrence Wright, *Perspective in Perspective*. London: Routledge and Kegan Paul, 1983.

CHAPTER 5
Art, Issues, and Innovations in the Baroque Era

Anthony Blunt, *Art and Architecture in France 1500–1700*. Harmondsworth and New York: Penguin Books, 1973.

R. Enggass and J. Brown, *Italy and Spain 1600–1750*. Englewood Cliffs, N.J.: Prentice-Hall, 1970.

Julius Held and Donald Posner, *Seventeenth and Eighteenth Century Art: Baroque Painting, Sculpture, Architecture*. New York: Harry N. Abrams Inc., 1971.

A. Hyatt Mayor, *Prints and People*. Princeton: Princeton University Press, 1971.

J. C. Rich, *The Materials and Methods of Sculpture*. New York: Oxford University Press, 1947; reprinted New York: Dover Books, 1975.

Jakob Rosenberg, Seymour Slive and E.

H. ter Kuile, *Dutch Art and Architecture 1600–1800*. Harmondsworth: Penguin Books, 1977.

D. Saff and D. Sacilotto, *Printmaking: History and Process*. New York: Holt, Rinehart and Winston, 1978.

Simon Schama, *The Embarrassment of Riches: An Interpretation of Dutch Culture in the Golden Age*. New York: Alfred A. Knopf, 1987.

Rudolf Wittkower, *Art and Architecture in Italy 1600–1750*. Harmondsworth and New York: Penguin Books, 1973.

CHAPTER 6
Reason and Revolution

Thomas E. Crow, *Painters and Public Life in Eighteenth-Century Paris*. New Haven: Yale University Press, 1985.

Lorenz Eitner, *Neoclassicism and Romanticism 1750–1850*. Englewood Cliffs, N.J.: Prentice-Hall, 1970.

Michael Levey, *Rococo to Revolution: Major Trends in Eighteenth-Century Painting*. London, New York and Toronto: Oxford University Press, 1977.

William Vaughan, *Romantic Art*. London, New York and Toronto: Oxford University Press, 1978.

CHAPTER 7
The Modern World and Its Art

H. H. Arnason, *History of Modern Art*. New York: Harry N. Abrams Inc., 1986.

A. Boimé, *A Social History of Modern Art*. Chicago: Chicago University Press, 1987.

T. J. Clark, *The Painting of Modern Life: Paris in the Art of Manet and His Followers*. Princeton: Princeton University Press, 1986.

Jean-Luc Daval, *Photography: History of an Art*. New York: Rizzoli, 1982.

G. H. Hamilton, *Painting and Sculpture in Europe 1880–1940*, 3rd edition. Harmondsworth and New York: Penguin Books, 1981.

Elizabeth G. Holt, *From the Classicists to the Impressionists*. Garden City, N.Y.: Doubleday, 1966.

Phoebe Pool, *Impressionism*. London and New York: Oxford University Press, 1967.

Robert Rosenblum and H. W. Janson, *Nineteenth-Century Art*. New York: Harry N. Abrams Inc., 1984.

CHAPTER 8
Art in the Americas

Matthew Baigell, *A Concise History of American Painting and Sculpture*. New York: Harper & Row, 1984.

David Driskell, *Two Centuries of Black American Art*. Los Angeles and New York: Los Angeles County Museum of Art and Alfred A. Knopf, 1976

Robert Farris Thompson, *African Art in Motion: Icon and Act*. Berkeley: University of California Press, 1974.

Robert Farris Thompson, *Flash of the Spirit: African and Afro-American Art and Philosophy*. New York: Vintage Books, 1984.

George Kubler, *Art and Architecture in Ancient America*. Harmondsworth: Penguin Books, 1975.

John McCoubrey, *American Art 1700–1960*. Englewood Cliffs, N.J.: Prentice-Hall, 1965.

Dennis Reid, *A Concise History of Canadian Painting*. Oxford and Toronto: Oxford University Press, 1973.

E. W. Weismann, *Art and Time in Mexico*. New York: Harper and Row, Icon Editions, 1985.

CHAPTER 9
Art in the Twentieth Century

H. B. Chipps, *Theories of Modern Art: A Source Book of and by Artists and Critics*. Berkeley: University of California Press, 1968.

Edward Fry, *Cubism*. London: Thames and Hudson, 1966.

Silvio Gaggi, *Modern-Postmodern: A Study in Twentieth-Century Arts and Ideas*. Philadelphia: University of Pennsylvania Press, 1989.

George Hamilton Heard, *Painting and Sculpture in Europe 1880–1940*. Harmondsworth and New York: Penguin Books, 1981.

Robert Hughes, *The Shock of the New*. New York: Alfred A. Knopf, 1981.

Kim Levin, *Beyond Modernism: Essays on Art from the '70s to '80s*. New York: Harper & Row, 1988.

Edward Lucie-Smith, *Late Modern: The Visual Arts since 1945*. Oxford, New York and Toronto: Oxford University Press, 1980.

Edward Lucie-Smith, *Movements in Art Since 1945*. New York: Thames and Hudson, 1984.

Herbert Read, *A Concise History of Modern Painting*. Oxford, New York and Toronto: Oxford University Press, 1974.

Herbert Read, *A Concise History of Modern Sculpture*. Oxford, New York and Toronto: Oxford University Press, 1974.

Robert Rosenblum, *Cubism and Twentieth-Century Art*. Englewood Cliffs, N.J.: Prentice-Hall and Harry N. Abrams Inc., 1976.

Peter Seiz, *Art in Our Times*. New York: Harry N. Abrams Inc., 1981.

Howard Smagula, *Currents: Contemporary Directions in the Visual Arts*. Englewood Cliffs, N.J.: Prentice-Hall, 1983.

Nikos Stangos, *Concepts of Modern Art*. New York and London: Thames and Hudson, 1981.

The author and publishers wish to thank the artists, museums, galleries, collectors, and other owners who have kindly allowed works to be reproduced in this book. In general, museums have supplied their own photographs; other sources, photographers, and copyright holders are listed below.

I.1 Photo: Vatican Museum
I.2 Hulton Picture Library
I.3 Photo courtesy Ralph Lauren
I.4 Photo courtesy Calvin Klein
I.5 J. P. Tarcher
I.13 Photographie Paris
1.1,9,15 Zefa Picture Library
1.3,4,5 Colorphoto Hans Hinz
1.6 Arlette Mellaart
1.7 Skyscan Balloon Photography copyright
1.16 Photo Fleming/Honour
1.18 Kurt Lange, Obersdort/Allgau, Germany
1.19,21,22 Hirmer Verlag
1.20 Spectrum Picture Library
1.23 TAP Service, Athens
1.24 Ancient Art and Architecture
2.1 Scala, Florence
2.2 Photo: Vatican Museum
2.3,5,27,30,33,38,39,40 Archivi Alinari
2.8 Photo DAI Athens, Ker.7750
2.9 TAP Service, Athens
2.11,13 Hirmer Fotoarchiv
2.14 Devos, Boulogne-sur-Mer
2.29 Photo: left; Photographie Bulloz, Paris; right, Lauros-Giraudon, Paris
2.41 Leonard von Matt, Buochs, Switzerland
2.42,43 Scala, Florence
3.1,20 Hirmer Fotoarchiv
3.4,5,6 Israel Museum, Jerusalem
3.7 Photo: Vatican Museum
3.8,9 Pontificia Commissione per L'Archeologia Cristiana
3.13 Kenneth J. Conant
3.18 Corinium Museum
3.19 Scala, Florence
3.21,22 Photographs: Vadim Grippenreiter
3.23 Roger-Violette, Paris
3.24 Clive Hicks, London
3.25 Photographie Bulloz
3.26 Giraudon
3.28 A. F. Kersting, London
3.30 Sonia Halliday
3.34,5 Spectrum Picture Library
3.36 V & A

3.37 Photo: Picterse-Davison International, Dublin
3.38 Ashmolean
3.40 Sonia Halliday
3.41 A. F. Kersting, London
3.45 British Library
3.47 Werner Former Archive
4.4,10,11,12,13,14,18,19,32,40 Scala, Florence
4.2 Cameraphoto Venice
4.15,24 Mansell Collection, London
4.20 Alinari
4.22 Quattrone Mario Fotostudio, Florence
4.25,47 British Museum
4.26 British Library
4.43 Spectrum Picture Library
4.44 Cliches des Musées Nationaux, Paris
4.52 MAS, Barcelona
5.1,7,8,9,10,13,14,21,22,23,25,26,38 Scala, Florence
5.2 Photo Vatican
5.3 British Museum
5.6 Photo: Zentralbibliothek Zurich
5.12 Cliches des Musées Nationaux, Paris
5.30,34,40 Arthothek, Peissenberg
5.36 The Bridgeman Art Library
5.49 A. F. Kersting, London
5.53 Stadelsches Institut, Frankfurt
6.1 The Bridgeman Art Library
6.3,20 Scala, Florence
6.8,13,14,25,27 Cliches des Musées Nationaux, Paris
6.11 Reproduced by permission of Lord St. Oswald and the National Trust
6.15 Cliches Musées de la Ville de Paris © by SPADEM 1992
6.17 Musées Royaux de Beaux Arts de Belgique
6.28 Ralph Kleinhempel, Hamburg
6.32 John Bethell, St. Albans
6.32 A. F. Kersting, London
7.1,12,16,18,19,32 Cliches des Musées Nationaux, Paris
7.7,24 Photographic Giraudon
7.8 Tintometer Ltd., Salisbury
7.10,13,14 The Bridgeman Art Library
7.21 Photographic Giraudon
7.22 Photo courtesy Tate Gallery
7.41 © Nolde-Stiftung Seebull
7.42 © Succession H. Matisse/DACS 1992. Photo: The Bridgeman Art Library
7.43 © Succession H. Matisse/DACS 1992

7.44 © ND-Roger-Viollet, Paris
8.5,7 Zefa Picture Library
8.6 South American Pictures
8.21 Photo by Wellard
8.22 Courtesy Dr. Naomi Jackson Groves
8.24 Werner Forman Archive
8.26 © Ben Shahn/DACS, London/VAGA, New York 1992
9.2 © ADAGP/SPADEM, Paris and DACS, London 1992. Photo: The Bridgeman Art Library
9.3 © 1991 Copyright by ADAGP, Paris
9.4,5,6,7 © DACS 1992
9.12 Photographie Giraudon. © SPADEM
9.14 Photo: Joseph Szaszfai. © DACS 1992
9.20 © DEMART PRO ARTE BV 1991
9.21 ©ADAGP, Paris and DACS, London 1992
9.26 © ADAGP, Paris and DACS, London 1992
9.32,10.4 © 1992 Pollock-Krasner Foundation/ARS, N.Y.
9.34 © 1992 Willem de Kooning/ARS, N.Y.
9.36 Photo by Geoffrey Clements, New York, N.Y.
9.39 Photo by Hickey and Robertson
9.41 © 1992 Frank Stella/ARS, N.Y.
9.42 © Carl Andre/DACS, London/VAGA, N.Y. 1992
10.2,11 © Roy Lichtenstein/DACS, London 1992
10.5 © 1992 Frank Stella/ARS, N.Y. Photo: Leo Castelli Gallery, New York
10.8 Musée National d'Art Moderne, Paris
10.9 © Robert Rauschenberg/DACS, London/VAGA, N.Y. 1992. Photo: Leo Castelli Gallery, New York
10.10 © Jasper Johns/DACS, London/VAGA, N.Y. 1992. Photo: Colorphoto Hans Hinz
10.11 Photo: The Bridgeman Art Library
10.14 Esto, New York
10.15 © Robert Burley, Design Archive, Ontario
10.20 Photo: Zindman/Freemont; courtesy The Pace Gallery New York, New York
10.22 Courtesy Barbara Kruger
10.31,32 Photographs: Metro Pictures, New York, N.Y.
10.34 Courtesy The Guerrilla Girls

INDEX